Stuart Hall

Stuart Hall's work has been central to the formation and development of cultural studies as an international discipline. *Stuart Hall: Critical Dialogues in Cultural Studies* is an invaluable collection of writings by and about Stuart Hall. The book provides a representative selection of Hall's enormously influential writings on cultural studies and its concerns: the relationship with marxism; postmodernism and 'New Times' in cultural and political thought; the development of cultural studies as an international and postcolonial phenomenon and Hall's engagement with urgent and abiding questions of 'race', ethnicity and identity.

In addition to presenting classic writings by Hall and new interviews with Hall in dialogue with Kuan-Hsing Chen, the collection provides a detailed analysis of Hall's work and his contribution to the development of cultural studies by leading cultural critics and cultural practitioners. The book also includes a comprehensive bibliography of Stuart Hall's writings.

Contributors: Ien Ang, Charlotte Brunsdon, Iain Chambers, Kuan-Hsing Chen, John Fiske, Lawrence Grossberg, Stuart Hall, Hanno Hardt, Dick Hebdige, Isaac Julien, Jorge Larrain, Angela McRobbie, Kobena Mercer, David Morley, Mark Nash, Jennifer Daryl Slack, Colin Sparks, Jon Stratton.

David Morley is Professor of Communications, Goldsmiths' College, London. **Kuan-Hsing Chen** teaches at the Center for Cultural Studies, National Tsing Hua University, Hsinchu, Taiwan.

Comedia
Series editor: David Morley

Stuart Hall

Critical Dialogues in Cultural Studies

Edited by David Morley and
Kuan-Hsing Chen

London and New York

First published 1996
by Routledge
11 New Fetter Lane, London EC4P 4EE

Simultaneously published in the USA and Canada
by Routledge
29 West 35th Street, New York, 10001

Reprinted 1996, 1997

© 1996 Selection and editorial matter: David Morley and
Kuan-Hsing Chen
Individual chapters: the respective authors

Typeset in Times by
J&L Composition Ltd, Filey, North Yorkshire

Printed and bound in Great Britain by
Clays Ltd, St Ives PLC

British Library Cataloguing in Publication Data
A catalogue record for this book is available from the British Library

Library of Congress Cataloguing in Publication Data
A catalogue record for this book is available from the Library of Congress

ISBN 0–415–08803–8 (hbk)
ISBN 0–415–08804–6 (pbk)

Contents

Contributors

Ien Ang is Director of the Centre for Research in Culture and Communication in the School of Humanities, Murdoch University. She is the author of *Watching Dallas* (1985), *Desperately Seeking the Audience* (1991) and *Living Room Wars: Rethinking Media Audiences for a Postmodern World* (1995).

Charlotte Brunsdon teaches in the Department of Film and Television Studies at the University of Warwick. She is an editor of the collection *Feminist Television Criticism* (1996).

Iain Chambers is Professor of History and Culture of English Speaking Countries at the Istituto Universitario Orientale, Naples. He is author of *Border Dialogues: Journeys in Postmodernity* (1990) and *Migrancy, Culture, Identity* (1994), as well as co-editor, with Lidia Curti, of *The Post-Colonial Question: Common Skies, Divided Horizons* (1995).

Kuan-Hsing Chen teaches at the Center for Cultural Studies, National Tsing Hua University, Hsinchu, Taiwan. He is the author of *Media/ Cultural Criticism: A Popular-Democratic Line of Flight* (Taipei, 1992) and the co-editor of *Cultural Studies: the Implosion of MacDonalds* (Taipei, 1992) and *Trajectories: A New Internationalist Cultural Studies* (forthcoming).

John Fiske is Professor of Communication Arts at the University of Wisconsin-Madison. His most recent books are *Power Plays, Power Works* (1993) and *Media Matters* (1994).

Lawrence Grossberg is Morris Davis Professor of Communication Studies at the University of North Carolina, Chapel Hill. He is the co-editor of *Cultural Studies*, both the book and the journal. His most recent books are *We Gotta Get Out of This Place: Popular Conservatism and Postmodern Culture* (1992) and *Dancing in Spite of Myself: Selected Essays* (forthcoming). He is currently working on a critique of the modernist foundations of cultural studies.

Hanno Hardt is John F. Murray Professor of Journalism and Mass Communication at the University of Iowa and Professor of Communication at the University of Ljubljana. His most recent book projects include *Critical Communication Studies: Communication, History and Theory in America* (Routledge, 1992) and *Newsworkers: Towards a History of the Rank and File*, co-edited with Bonnie Brennen, and to be published by the University of Minnesota Press.

Dick Hebdige is Dean of Critical Studies at the Californian Institute of the Arts in Los Angeles. He is the author of *Subculture: The Meaning of Style* (1979), *Cut ' n' Mix: Culture, Identity and Caribbean Music* (1987) and *Hiding in the Light: On Images and Things* (1988).

Isaac Julien is a film director and theorist who is a visiting professor of History of Consciousness at Santa Cruz University, as well as a Rockefeller Humanities Scholar at the NYU Center for Media Culture and History. His films include *Looking for Langston* (1989), *Young Soul Rebels* (1991), *The Attendant* (1993) and *Finding Fanon* (1995).

Jorge Larrain is Professor of Social Theory in the Department of Cultural Studies at the University of Birmingham. He was head of department from 1988 to 1993 and has published several books on the theory of ideology. His most recent contribution is *Ideology and Cultural Identity: Modernity and the Third World Presence* (1994).

Angela McRobbie is Reader in Sociology at Loughborough University of Technology and is the author of *Postmodernism and Popular Culture* (Routledge, 1994) and of *Fashion and the Image Industries* (Routledge, forthcoming).

Kobena Mercer is an independent writer and critic based in London. Formerly Assistant Professor in the Art History and History of Consciousness programmes at University of California, Santa Cruz, he has lectured and published widely on the cultural politics of race and sexuality in visual culture and is the author of *Welcome to the Jungle: New Positions in Black Cultural Studies* (Routledge, 1994).

David Morley is Reader in Communications at Goldsmiths' College, London University and is the author of *Television, Audiences and Cultural Studies* (Routledge, 1992) and (with Kevin Robins) *Spaces of Identity: Global Media, Electronic Landscapes and Cultural Boundaries* (Routledge, 1995).

Mark Nash was one-time editor of *Screen* and is currently collaborating with Isaac Julien on a film on Frantz Fanon. He is also working on a book on queer theory and cinema for the British Film Institute.

Jennifer Daryl Slack is Associate Professor of Communication and Cultural Studies at Michigan Technological University. She began her

engagement with cultural studies in 1975, studying with Larry Grossberg at the University of Illinois. Currently a book review editor for the journal *Cultural Studies*, she publishes in cultural studies, technology and the environment. Her books include *Communication Technologies and Society* and a co-edited collection *The Ideology of the Information Age*. She is working on a book on cultural studies and the environment.

Colin Sparks works at the Centre for Communication and Information Studies at the University of Westminster. He is a low-flying materialist.

Jon Stratton is Senior Lecturer in the School of Communication and Cultural Studies at Curtin University of Technology. At present he is Visiting Associate Professor in Cultural Studies at Murdoch University. He has published extensively on a wide variety of topics including popular music, sport and American postcoloniality. His latest book, *The Desirable Body: Cultural Fetishism and the Erotics of Consumption*, is in press. He and Ien Ang have collaborated on a number of articles on multiculturalism, the postmodernization of soap opera, and the transnationalization of cultural studies.

Acknowledgements

The editors thank the following for permission to include the essays collected in this book: for articles which originally appeared in the *Journal of Communication Inquiry* (1986), vol. 10 no. 3, we would like to thank the Iowa Center for Communication Study, School of Journalism and Mass Communication, University of Iowa, and especially Professor Hanno Hardt, for his generous support; David Tetzlaff, without whom the 1986 project would never have been completed, and Larry Grossberg, who helped tremendously in putting the original project together. For Jorge Larrain's article from *Theory, Culture & Society* we thank the editors and Sage for permission to reprint it here; for Kuan-Hsing Chen's article from *Media, Culture and Society* we thank the editors and Sage; for Stuart Hall's 'What is this "black" in black popular culture?' we thank the Dia Arts Centre; for Hall's 'The meaning of New Times' we thank Lawrence & Wishart; for Hall's 'For Allon White: metaphors of transformation' we thank Oxford University Press; for Hall's 'New ethnicities' we thank the Institute of Contemporary Arts; for Isaac Julien and Kobena Mercer's 'De Margin and De Centre' we thank the editors of *Screen* and the John Logie Baird Centre.

We would also like to thank those contributors to the original JCI project who either updated or rewrote their contributions for this volume (Iain Chambers, John Fiske, Angela McRobbie and Colin Sparks). Kuan-Hsing Chen wishes to thank the National Tsing Hua University, especially the former Acting President C.T. Lee, for his generosity and constant warm support and for providing funding for necessary administrative assistance, and he would also like to thank Naifei Ding for her patient help with transcribing and editing the interviews. David Morley would like to thank Charlotte Brunsdon for her help with the compilation of the material in Part V of this volume and Jessie Cartner Morley for one particularly complicated piece of copy-editing. Finally, we would both like to thank Stuart Hall for giving his time and thoughts to the project: clearly, without his intellectual and political commitment, this book would not exist.

David Morley and Kuan-Hsing Chen

Introduction

David Morley and Kuan-Hsing Chen

This book has already had a life of its own, a history of a decade. Back in the mid-1980s, as an alternative to formalist and positivist paradigms in the humanities and social sciences, British cultural studies, and Stuart Hall's work in particular, began to make an impact across national borders, especially in the American academy. In 1985, Stuart Hall was invited, as Ida Beam Professor, to deliver a series of lectures on the University of Iowa campus. Intrigued by his 'passion, intensity and intellectual generosity', the *Journal of Communication Inquiry*, organized by graduate students of the School of Journalism and Mass Communication, decided to devote a *Special Issue* of their journal to Stuart Hall, in recognition of his long-term contribution in opening up spaces for critical scholarship. That *Special Issue* was edited by Kuan-Hsing Chen, one of the editors of this collection. In preparing the project, it was clear that the task was not naively to celebrate the work of a committed intellectual but rather to take the opportunity to productively facilitate further 'critical dialogues'.

In that historical conjuncture, postmodernism had already emerged as a key site of debate, and practitioners of cultural studies had begun to engage on that terrain. Captured by the intellectual mood of the day, the editorial board members of the *Journal* conducted an interview with Hall, inviting him to enter the debate on postmodernism, with particular reference to the work of Habermas, Lyotard, Foucault, Deleuze and Guattari, and Baudrillard. In collaboration with members of the Unit for Criticism and Interpretive Theory of the University of Illinois, who discussed with Hall the then just released, seminal book, *Hegemony and Socialist Strategy* (a key statement of postmodern political theory), by Ernesto Laclau and Chantal Mouffe (1985), we merged the two interviews together, into what became later the often cited interview with Hall, 'On postmodernism and articulation'. We then invited Iain Chambers, John Fiske, Lawrence Grossberg, Hanno Hardt, Dick Hebdige and Angela McRobbie, who were familiar with Hall's work and had also themselves begun to engage with the debate on postmodernism, from within cultural studies, to respond to

the interview. Together with Hall's 'Gramsci's relevance for the study of race and ethnicity' (a formative text for Hall's later thinking on these questions), and 'The problem of ideology: marxism without guarantees', that interview and 'responding' essays formed the *Special Issue* on Stuart Hall.

What was generated was a dialogue between postmodernism and cultural studies. When we look at it retrospectively, it can be seen as a starting-point, from which cultural studies moved on, through another round of configuration, during the next decade, in succession to its previous engagements with humanist marxism, structuralism, feminism, post-structuralism, etc. In the context of 1986, postmodernism provided the key terrain which cultural studies had to work through, in order to advance. At that time Hall was highly suspicious of the 'postmodern project', but parts of his later work (see for example 'The meaning of New Times', in this volume), read more like a localized, 'postmodern' enunciation of the ruptures and breaks taking place in the structures of British society. In some ways, the identity of cultural studies has always been constituted and reconstituted by its dialogues with the issues raised in and by particular historical conjunctures. In retrospect, we can see that in the debates that ensued, cultural studies not only changed the shape of postmodernism, but was also reshaped by it.

Soon after the *Special Issue* was released, it went quickly out of print. Nonetheless, it became clear that the *Special Issue* was being heavily used in graduate seminars, and often cited, across a range of disciplines. There were requests to reprint it, but the reprint never materialized. The idea of republishing the 1986 *Journal of Communication Inquiry*'s *Special Issue*, 'Stuart Hall' as a historical document, took shape in 1990, when the two editors of the present book met and discussed that possibility. Of course, we know very well that both postmodernism and cultural studies look very different in the 1990s from how they looked in the 1980s. With the influence of works coming after 1986, such as David Harvey's *The Condition of Postmodernity* (1989), Edward Soja's *Postmodern Geographies* (1989) and Fredric Jameson's *Postmodernism or the Cultural Logic of Late Capitalism* (1991), postmodernism has itself become an intellectual 'establishment' – the recent appearance of a range of introductory text-books on the subject is one undeniable sign of that. On the other hand, in dialogue with postmodernism, cultural studies has also changed gear, moving beyond the discursive space of its own previous formation. Simply by looking at the authors involved in the 1986 debate, we can see the postmodern 'take' in their own work: in fact, some of these texts have become essential accounts of the postmodern. Chambers' *Border Dialogues* (1990) and his later *Migrancy, Culture, Identity* (1993), Grossberg's *We Gotta Get Out of this Place: Popular Conservatism and Postmodern Culture* (1992), Fiske's *Reading the Popular* (1989) and his *Power Plays, Power Works* (1993), Hardt's *Critical Communication Studies* (1992),

Hebdige's *Hiding in the Light* (1988), McRobbie's *Feminism and Youth Culture* (1991) and her *Postmodernism and Popular Culture* (1994) have all gone beyond the originary terrain of cultural studies and addressed various postmodern problematics. As for Hall himself, moving on from the analysis of Thatcherism and the 'New Times' project, his more recent work has focused on the problematics of cultural identities, race and ethnicities. These concerns, with the formation of the nation-state and globalization of culture, are now often cited as the forerunners of the discourse on 'postcoloniality', which in certain respects has taken over and politicized the discursive space of the postmodern, in the works of subaltern studies, Kwame Anthony Appiah (1993), Rey Chow (1993), Henry Louis Gates Jr (1986), Paul Gilroy (1993a and 1993b), Kobena Mercer (1994), Edward Said (1978 and 1993) and Gayatri Spivak (1987 and 1990), to name only a few. The fluidity and ever-changing nature of these intellectual concerns have thus constituted a difficulty in finalizing this book. It is one of our tasks here to try to capture the key aspects of these changes of intellectual mood and concern, over the last decade.

CRITICAL DIALOGUES AND NEW TRAJECTORIES

Against this historical background, it is quite obvious that this is not simply a book 'about' Stuart Hall; rather, the book focuses on Hall's work as a catalyst for 'critical dialogues' and as a key site on which they have taken place within cultural studies, since the mid-1980s. For us, Hall's major intellectual contribution does not lie in making definitive statements on theoretical and political issues, but rather in his involvement with a wide range of collective projects, and in his capacity and willingness to take on new issues and to constantly move on, beyond his own previous limits. Although his full influence remains to be researched and documented, one thing is certain: the impact of his work cannot be limited to the academic context; his analyses have been appropriated by social movements within and outside academia and well beyond 'British' boundaries, in places such as America, Australia and Taiwan.

In organizing these critical dialogues, we have had several goals in mind:

1 to trace continuities and breaks in Hall's work, and in particular, to examine his own persistent 'critical dialogue' within marxism;
2 to document and explore the impact of 'postmodernism' in cultural studies and to investigate some of the theoretical consequences of these postmodern interventions;
3 to mark out some of the new directions of development in the field, as debates about postmodernism have rapidly been transformed by debates about postcolonialism, 'race' and identity;
4 through the interviews with Hall, to reinterrogate the accepted story of

the 'genealogy' of cultural studies, and to raise questions concerning its future as a field of study.

Although Hall's position and concerns have always been conjunctural in nature, developing in response to emerging social and political questions, and hence have changed considerably over the past forty years (and will, no doubt, continue to change), we do want to argue that his intellectual formation in a significant way arose from, and has, in key respects, to be situated in relation to, the marxist tradition. In fact, it could be argued that Hall's more recent work has taken on board neglected questions and confronted different schools of thought in a way that potentially enriches and opens up the discursive space of marxism, in response to new historical currents and movements.

To highlight this marxist influence, Part I, '(Un)Settling accounts: marxism and cultural studies', begins with Hall's 'The problem of ideology: marxism without guarantees', which situates his own theory of ideology in relation to the key trajectories of contemporary marxism. Jorge Larrain's 'Stuart Hall and the marxist concept of ideology' takes issue with Hall's theoretical account of Thatcherism, arguing for a balance between the classical marxist concept of ideology and Hall's Gramscian one. Colin Sparks, in 'Stuart Hall, cultural studies and marxism', speaking from a more traditional British marxist position, traces historically how, in his view, the cultural studies tradition, under the influence of Hall's work, initially encountered and then moved away from the classic marxist priority given to the economic and thus came closer to a convergence with the approaches of discourse theorists such as Foucault. Interestingly, Sparks also identifies certain key continuities between the arguments made by Hall in his early work, in relation to the thesis of the 'embourgeoisment' of the British working class (see Hall 1958 and 1960) and some of Hall's later arguments concerning the break-up of traditional class structures, in his work on the 'New Times' project. Sparks' arguments (even if one disagrees with his conclusions) do point to a recent tendency to de-emphasize class in the work of cultural studies: a tendency which, in our view, now needs to be reconsidered. How to balance and re-theorize the question of articulating social classes, race and ethnicity, gender and sexuality, nation and global capital together, into a forceful explanatory framework, able to confront the 'New Times' we face politically, does seem to be an urgent issue on the agenda of cultural studies. Hanno Hardt's 'British cultural studies and the return of the "critical" in American mass communications research', originally published in the 1986 JCI *Special Issue*, considers the dangers of the American academic appropriation and professionalization of 'British' cultural studies, which has tended to result in the loss of its original political commitments. Regrettably, the subsequent development of

cultural studies in the American context does, on the whole, seem to validate Hardt's early observations. Nonetheless, we would maintain that, in its 'post-marxist' and postmodern phase, cultural studies has offered more space to voice the concerns of a wider range of radical discourses (gay and lesbian, minority discourses, third world issues, etc.). Jennifer Daryl Slack's essay on 'The theory and method of articulation in cultural studies' sketches out the ways in which the concept of 'articulation' has been, and can be, used to develop a non-essentialist cultural politics which is sensitive to discursive issues, but which avoids lapsing, as she puts it, into 'intertextual literary analysis'.

Part II ('Postmodernism and cultural studies: first encounters') documents the 1986 debate on postmodernism, partly reprinting items from the original *Special Issue*, including the interview with Hall and the commentary by Grossberg on the issues of postmodernism and articulation, and Dick Hebdige's exposition of postmodern theory, which ends with an important attempt to 'rethink' postmodernism from a Gramscian perspective. Iain Chambers' 'Waiting on the end of the world?' has been updated for this publication and John Fiske and Jon Watts' original contribution 'Articulating culture' has been replaced by a new piece by Fiske, 'Opening the Hallway', which further develops some of the ideas in their original, jointly written piece.

In Part III ('New Times, transformations and transgressions'), we chart what came after the 'postmodern' debate. In 'The meaning of New Times', Hall reads the discourses on 'the post-industrial', 'post-Fordism', 'revolution of the subject', and 'the postmodern', in relation to each other, as different dimensions (or 'levels') of the structural changes, which constitute the 'New Times' in which we live. McRobbie's 'Looking back at New Times and its critics' engages with the 'New Times' project from the perspective of cultural studies, developing further many of the arguments of her original contribution to the *Special Issue*, 'Postmodernism and popular culture'. This is followed by the published version of Hall's key paper to the conference 'Cultural Studies Now and in the Future', held at the University of Illinois, Urbana – Champaign, in 1990 (see Grossberg, L., Nelson, C. and Treichler, P., 1992). In his paper, Hall attempted to deal critically with the geneaology of cultural studies (and self-reflexively with his own positioning within that genealogy) and also to indicate some of the possible ways forward for politically engaged intellectual work in this field, in the context of the rapid institutionalization of cultural studies, especially in the North American academy.

Among the stories which Hall tells here, concerning the genealogy of cultural studies, is a crucial one about the disruption of cultural studies' initial focus on questions of class by the emergence, within Birmingham University's Centre for Contemporary Cultural Studies (CCCS) itself, of the Women's Liberation Movement, in the early 1970s. Charlotte

Brunsdon's 'A thief in the night' is designed, as she puts it, to offer 'other elements of an account to lie alongside Stuart's, to contribute to a thicker description of a time and topic of conflict.' Brunsdon is concerned, on the one hand, to emphasize just how painful these conflicts were, for all concerned – to recognize the real difficulties of living through political and theoretical disagreements, in a context in which 'sometimes only door slamming create(d) the silence in which to be heard', as she and other women at CCCS attempted to destabilize (and were experienced as transgressing) the basic groundrules of the 'boy-zone'. Her point is also to resist any current temptations to think of cultural studies as somehow 'always already politically chic' and to remind us just how explosive the 'gender agenda' was, in 'interrupting' the concerns of the marxism whose centrality, at that time, was as taken-for-granted as that of gender issues is today. Of course, as Brunsdon notes, 'interruptions' themselves are interruptible. In this case, the eruption of issues of gender onto the agenda of cultural studies was itself then 'interrupted' by the emergence of the issue of race (and later again, of ethnicity). There are also a number of close parallels here: Brunsdon's comments on the way in which the Women's Studies Group at CCCS was initially 'pigeonholed' as simply 'filling in the gaps in an already existing analysis' can usefully be read in conjunction with Julien and Mercer's comments (chapter 22) on the ways in which the 'politics of marginalization' have often operated so as to leave questions of race (as much as questions of gender) as the preserve of the 'Special Issue'. Equally, Brunsdon's comments on the significance of the shift from the emphasis on the category of 'women' to that of 'feminism' (see her comments on McRobbie and McCabe, 1981, as a marker of this shift) offer clear parallels with the later shifts away from essentialism in concepts of race and ethnicity (see Part V, below). Her comments on the extent to which 'identity'-based politics can, in the end, only offer starting-points (if crucial ones), rather than conclusions to political debates, resonates clearly with Gilroy's (1990) formulation that 'it ain't where you're from, it's where you're at.'

Brunsdon's essay is followed by Hall's (1993) 'For Allon White: metaphors of transformation' which, in its focus on questions of transgression (not least, in relation to the body and sexuality) perhaps most clearly demonstrates the significance, for Hall's own later work, of the encounter with the 'gender agenda' at CCCS. 'For Allon White: metaphors of transformation' is the text of a Memorial Lecture which Hall gave at the University of Sussex, after the premature death of one of his ex-students, Allon White (published initially in White, 1993). The text takes the form of an extended commentary on the significance of White's work, and that of his collaborator Peter Stallybrass, and especially their (1986) joint book, *The Politics and Poetics of Transgression*. The full significance of that

work, Hall argues, is only now beginning to be recognized as the precursor of much recent debate around the figure of Mikhail Bakhtin (and/or 'P.N. Medvedev' and 'V.N. Volosinov'). This can be seen not only with reference to the figures of the 'dialogic imagination' (see Volosinov, 1973; Bakhtin, 1981; Bakhtin/Medvedev, 1978), and the symbolic space of 'carnival' but also, and most importantly for Hall's argument here, in the move from simplistic metaphors of transformation (thought in terms of mere reversal and substitution) to the more complex metaphors of transgression (with their implications of hybridity and impurity) which are the focus of Stallybrass and White's work, and of Hall's own more recent interests.

Part IV ('Critical postmodernism, cultural imperialism and postcolonial theory') opens with Kuan-Hsing Chen's 'Post-marxism' essay, which seeks to negotiate a site between postmodernism and cultural studies, unravelling the distinctive histories of what he terms the 'dominant' and 'critical' forms of postmodernism, and outlining the possibilities for a post-marxist form of cultural studies. This is followed by David Morley's 'EurAm, modernity, reason and alterity' which, rather than commenting directly on Hall's work (as we have done so, at length, in this Introduction), takes the opportunity to develop some more general arguments concerning the linkages between postmodernism and cultural imperialism. In particular, this essay focuses on the EurAmerico-centric nature of much postmodern theory, in the context of debates in contemporary anthropology and geography, concerning the problematic status of concepts such as 'the West' or 'modernity', in the wake of the now well-established critique of 'Orientalism' (Said, 1978). Jon Stratton and Ien Ang's 'On the impossibility of a global cultural studies' is a forceful attempt, in a self-reflexive manner, to confront the politics of 'internationalizing' cultural studies. Ang and Stratton challenge the dominant myths of 'origins' presented in various historical narratives of cultural studies, and seek to open up the possibility of rethinking the global contexts within which 'British' cultural studies is now constituted, and therefore has to be deconstructed. They are cautious about the dangers of cultural studies becoming just another academic discipline. More than anything else, they pinpoint the increasing tendency of 'nationalism' in 'international' cultural studies and its tendency towards a regrettable complicity with the political nation-state. In so far as it takes the nation-state as the 'natural', unreflexively distinctive, and unquestioned (local) context of analysis, cultural studies reconstitutes national(ist) boundaries and betrays the fluid political figures of 'the diasporic, the postcolonial and the subaltern'. Again, in our view, rather than reproducing existing global power relations/structures, and rather than renaming itself as 'transnational' or 'multinational', cultural studies has to put on its agenda the issue of how to come up with alternative ways of operating, if

people identified with the project are still to maintain a counter-hegemonic political position.

This section concludes with an interview conducted with Hall by Kuan-Hsing Chen in 1992, 'Cultural studies and the politics of internationalization', in which he directly addresses the questions of the historical Eurocentrism (and, indeed, Anglocentrism) of much work in this field, in relation to current developments in postcolonial theory and debates concerning transnationalism and globalization in cultural studies.

The final Part ('Diasporic questions: ''race'', ethnicity and identity'), focuses on the debates in cultural studies which, over the last few years, have moved these questions centre-stage. The section begins with Hall's (1985) essay on 'Gramsci's relevance for the study of race and ethnicity', originally written under the auspices of UNESCO's Division of Human Rights and Peace. In this paper we see a crucial link in the development of Hall's work, as he mobilizes the theoretical resources developed in the attempt to formulate a non-essentialist analysis of questions of class to produce a similarly non-essentialist analysis of questions of 'race' and ethnicity. This is followed by Hall's path-breaking (1988) essay on 'New ethnicities', in which he articulates what he describes as a crucial shift between two phases of black cultural politics – 'from a struggle over the relations of representation to a politics of representation itself', which, he argues, marks 'the end of the innocent notion of the essential black subject' and the recognition that the 'black subject cannot be represented without reference to the divisions of class, gender, sexuality and ethnicity.' This involves not only 'crossing the questions of racism irrevocably with questions of sexuality', destabilizing 'particular conceptions of black masculinity' and overcoming black politics' 'evasive silence with reference to class', but more generally, 're-theorizing the concept of difference', so as to develop a 'non-coercive and more diverse concept of ethnicity'.

'New ethnicities' was originally delivered as an address to a conference 'Black Film, British Cinema' held at the Institute of Contemporary Arts in London in February 1988 (and published in a collection of conference papers under the same title, edited by Kobena Mercer; see Mercer, 1988). The conference brought together film practitioners, theorists and critics concerned both with the politics and aesthetics of contemporary film production (especially in the independent sector) and a wider audience of those concerned with how to address and make sense of the relation between the categories 'black' and 'British'. The particular 'critical dialogue' that emerged from that conference (foreshadowed by the 'Third Cinema' conference, held at Edinburgh in 1986 – see Pines and Willemen (eds), 1989) can also be traced through the following chapter, Isaac Julien and Kobena Mercer's 'De Margin and De Centre', initially published in late 1988 as the Introduction to the 'Last Special Issue on Race' of the film studies journal, *Screen* (vol. 29, no. 4), edited by Julien and Mercer, some

months after the ICA conference. While this essay was initially conceived as an 'Introduction' to a particular edition of *Screen*, the authors' careful commentary on the articles in that issue (for details of which, see our 'Editors' note' to chapter 22) and their extensive notes and references to work on 'race', ethnicity and representation throughout the 1980s, allows it to be read retrospectively as a valuable overview of that body of work, at a crucial turning-point in its development. Julien and Mercer note that they are well aware that the editorial strategy and logic of a 'Special Issue' on 'race' can easily 'reinforce rather than ameliorate, the perceived otherness and marginality of the subject itself' as yet one more instance of 'expedient inclusion, as a term for the legitimation of more general forms of exclusionary practice', in which 'the subject of race and ethnicity is still placed on the margins conceptually'. In the face of this difficulty, rather than 'attempt to compensate for the "structured absences" of previous paradigms', their strategy is to attempt to deconstruct and 'undermine the force of the binary relation that produces the marginal as a consequence of the authority invested in the centre'.

Thus, not only do they pursue Hall's arguments (in 'New ethnicities') concerning, in their terms, the 'acknowledgement of the *diversity* of black experiences and subject-positions' but they also extend the terms of his argument there, that 'we are *all* . . . ethnically located' to examine the usually 'naturalized' (or 'ex-nominated') category of 'Whiteness' (see Richard Dyer's article in *Screen* 29, 4). Thus, Julien and Mercer note Coco Fusco's crucial point that the hegemony of white ethnicity is redoubled and 'naturalized' if it is, itself, ignored. As they argue, 'a one-sided fixation with ethnicity as something that "belongs" to the Other alone', where 'white ethnicity is not under question and retains its "centred position"', necessarily means that, still, 'the burden of representation falls on the Other.' This perhaps is part, at least of 'the black person's burden' of which Hall declares he wishes to absolve himself, in the introductory passage of his address to the Illinois 'Cultural Studies' conference (see page 277 in Grossberg *et al.*, 1992; page 262 in this volume). Hall's own more recent work in this field is represented by his (1992d) essay 'What is this "black" in black popular culture?', in which he surveys recent debates concerning the political need for the deployment of forms of 'strategic essentialism', in counterbalance with the analytical need to develop modes of analysis which are adequate to the hybrid, transitory and always historically specific forms in which questions of 'race' and ethnicity are articulated in popular cultural forms (see below, chapter 23).

Hall's influence on the development of black cultural politics and black film culture in Britain is also addressed in the interview with Isaac Julien, by Mark Nash, in which a number of themes emerge. Firstly, the interview traces the history of Hall's practical involvement in the debates over

cultural policy and funding which were the basis of the emergence of the innovative black film workshops, such as Sankofa and Black Audio Film Collective, in the 1980s in Britain (see the details given in chapter 22). Secondly, the question of generation begins to emerge, as a key site of difference which must be addressed – for instance, in terms of the differences between those of Hall's generation, who came to Britain as immigrants, and those such as Julien, who were born and grew up in the United Kingdom, as 'black British'. Thirdly, the interview also begins to open up the connections between debates concerning racial and ethnic identity and debates concerning sexuality – so that it is not only the secure/essential black subject which can then be seen to be destabilized (in the work of both Hall and Julien) but also the secure/essential masculine subject. In this connection, the interview also brings out the important contrast between British and American perspectives on 'essentialism' in matters of 'race', and 'identity', by way of Julien's critical comments on some of Spike Lee's work. This section is concluded with a further interview with Hall, again conducted by Kuan-Hsing Chen in 1992, 'The formation of a diasporic intellectual'.

CULTURAL STUDIES AS A DIASPORIC STORY

In 'The formation of a diasporic intellectual', a number of historical and critical issues are addressed. In recounting critical moments in his own social biography, Hall theorizes how structural conditions (colonization and decolonization) come to shape one's subjectivity and, under such circumstances, to limit how the colonial subject is able (and unable) to resist. Through Hall's traumatic historical narrative, we are reminded of the necessity to go back to the history of colonialism, so as to understand present neo-colonial structures. In fact, the necessity of this reminder indicates the continuing existence of some deeply flawed political scholarship in cultural studies, which fails to connect its own analyses effectively to the global, historical structures of colonization, decolonization and recolonization. Without careful historical work focusing on this issue, cultural studies will never escape its complicity with 'western centrism'. The glib announcement of a 'postcolonial' era can easily hide its own enunciative position, within the centering location of neo-colonial power. From the geopolitical position of the third world, the traces of colonialism cannot be so easily erased, and the economic and cultural forces of neo-colonialism can perhaps more readily be seen to be alive and well. Cultural studies' recent attempt to move out of the 'local', to take into account the globalism of culture, thus has to address these issues historically, structurally and politically (on these issues, see also Ahmad, 1994).

In the 'Introduction' to his *Blood and Belonging* (1994), Michael Ignatieff takes issue with the presumptions of what he describes as the easy

cosmopolitanism of the affluent West, arguing that 'globalism in a post-imperial age only permits a post-nationalist consciousness for those cos-mopolitans who are lucky enough to live in the wealthy West . . . (for) . . . cosmopolitanism is the privilege of those who can take a secure nation-state for granted' (9). As he goes on to put it, more polemically, from this perspective 'if patriotism, [as] Samuel Johnson remarked, is the last refuge of a scoundrel, so post-nationalism and its accompanying disdain for the nationalist emotions of others, may be the last refuge of the cosmopolitan' (ibid.: 11).

The continuing relevance of colonial histories is further emphasized in Hall's narrative of the formation of the British 'New Left', as a precursor of cultural studies. According to the accepted history, the development of the New Left is usually understood as a peculiarly 'British' response to the events of 1956. Certainly, without the New Left, the shape of cultural studies would have been very different. But in Hall's account of this story, a key role in the formation of the New Left was played by various (then student) colonial intellectuals, who came from outside Britain, and who were connected to, but never part of the dominant institutions of the British left. Perhaps it was precisely the impossibility, for these non-English intellectuals, of ever 'breaking into' the established and traditional bases of the British left that produced the conditions of possibility of the New Left. This is a critical point in understanding (and rethinking) the history of both the New Left and 'British' cultural studies. It not only decentres its 'Britishness', but also stresses the 'outside' forces which these colonial intellectuals represented. Without the history of colonial relations, these 'outsiders' would not have been there, to begin with (why study in England?); without the 'outside' ideological forces and voices (which were, of course, still deeply connected to the culture and society of the colonial 'homeland'), from which to form different positions in dialogue with the traditional left, there would perhaps have been no Socialist Club, no *Universities and Left Review*, and no British New Left. Of course, these tentative speculations would need much more thorough historical research, to validate them (see Schwarz, 1994, for a preliminary explanation of these issues). However, Hall's story does open up a quite new and different perspective on the history of the New Left, as well as the history of cultural studies – a perspective from which it is much less simply a 'British' story and rather more an international(ist) one, from its very beginnings.

What also emerges in the interview, is the central figure of the 'dia-spora' in the context of the problematics of race and ethnicity. Hall's recent work on these issues can be seen as continuous with a long thread of concern with the politics of 'race', and with the mobilization of racial tropes and imagery, as central to the emergence of the authoritarian forms of populism, promulgated by Conservative 'law and order' campaigns,

from the mid-1970s onwards, in Britain. Graduate students and staff at the Centre for Contemporary Cultural Studies initially became involved in these issues in the wake of the mobilization of a moral panic concerning teenage street crime, which can be traced back to the wave of publicity given to the conviction of three Birmingham teenagers (Paul Storey, James Duignan and Mustafa Fuat) for the 'mugging' of a man, Robert Keenan, in the Handsworth area of the city (later the site of the inner city 'riots' of 1981), on 5 November 1972. The initial public concern with the phenomenon of teenage street crime was rapidly transferred into a full-blown 'moral panic' about the threat of black street crime, and more generally, the threat posed by black youths to 'law and order'. Following their involvement in work on the pamphlet *'20 years'*, published by the Support Committee set up by relatives and friends of Storey, Duignan and Fuat, graduate students and staff at the Cultural Studies Centre became involved in a much larger project concerned with 'race', law and order and policing in Britain. This was the genesis of the influential *Policing the Crisis: 'Mugging', the State and Law and Order*, written by Stuart Hall, Chas Critcher, Tony Jefferson, John Clarke and Brian Roberts, and published in 1978, a year before Mrs Thatcher came to power in Britain on a 'law and order' platform (see also the slightly later collection *The Empire Strikes Back: Race and Racism in 70s Britain*, CCCS, 1982), produced by the 'Race and Politics' subgroup at the Cultural Studies Centre, which includes contributions by Hazel Carby, Bob Findlay, Paul Gilroy, Simon Jones, Errol Lawrence, Pratibha Parmar and John Solomos).

In this respect again, Hall's work in this field is by no means of purely theoretical concern; it is deeply rooted in the history and politics of the international flow of labour and migration, and subsequently in the reconfiguration of British society under and after Thatcherism. In this sense, Hall's recent formulations are continuous with his decade-long struggle with Thatcherism. Thatcherite 'new conservatism' attempted to incorporate, into its hegemonic project, a crucial element: the reconstruction of national culture, in order to win the legitimacy of governmentality. In the process of constructing this hegemonic politics, the 'recovery' of the British empire was used to mobilize different social classes. Constructing a 'racially' unified image of 'Britishness', and correspondingly attempting to erase class differences, became the cornerstone of the neo-conservative strategy of 'born-again' nationalism. The 'new immigrants' (from the West Indies, or Asia) were scapegoated as the 'Others' responsible for the destruction of 'law and order' in British society, which (it was implied) was what had led to the decline of Britain and its empire. These 'blacks' were constructed in opposition to 'pure' or 'real' Englishmen, and thus symbolically excluded from the heartland of 'British' society. At the same time, in reality, numbers of immigrants, from the 1950s on, have gradually established their own, semi-autonomous living and cultural spaces in the

United Kingdom; how to maintain their autonomy, in relation to the rising tide of British nationalism and racism, and how to redefine the very idea of a 'national culture', so that ethnic minorities can find legitimate positions from which to speak within it, now became urgent political issues (for a more detailed discussion of Hall's work on 'race' and ethnicity, see Chen, 1993).

It is within this historical conjuncture that Hall's interventions must be seen as strategically and politically motivated. It could be argued that this engagement, with questions of race and ethnicity, in relation to the politics of national culture, within the newer movement of globalization, might well constitute the next key challenge that cultural studies has to face. In this connection, the interview in Part IV, 'Cultural studies and the politics of internationalization', takes the 1992 'Trajectories: Towards a New Internationalist Cultural Studies' conference, organized by the Institute of Literature, National Tsing Hua University, Taiwan, as a reference point, in order to address current problems in the 'internationalizing' trend of cultural studies. We hope this interview, in particular, will generate further discussions in 'internationalist' cultural studies circles.

A POSTMODERN AUTOBIOGRAPHY?

At one point, in his presentation to the Illinois 'Cultural Studies' conference, in 1990, Hall spoke autobiographically of his own experience of the tensions and difficulties of the development of cultural studies work at CCCS during the 1970s. In doing so, he was at pains to stress that he spoke autobiographically, on this particular occasion, not in order to '(seize) the authority of authenticity', but in order *not* to be authoritative. In the interviews in this collection, Hall again speaks autobiographically, of his family and his upbringing in Jamaica – of being the 'blackest' in his family, the 'one from the outside', who didn't 'fit' and who found that experience of marginality both replicated and amplified, on coming to England to study: finding that he 'knew both places intimately' but 'was not wholly of either'. The Irish poet, Patrick Kavanagh once remarked that 'the self is only interesting as an illustration'. What Hall does here is to offer parts of his 'story' as, among other things, a way of illuminating not simply his own autobiography, but also the diasporic experience itself: precisely the awareness he refers to, of being (often doubly) peripheral, displaced or marginalized. The experiential account is rendered in tandem with its own theorization. The moral of the story, which Hall tells in 'The local and the global' (1991a) – the story of how 'in the very moment when finally Britain convinced itself it had to decolonize . . . we all came back home. As they hauled down the flag, we got on the banana boat and sailed right into London' – is also the story 'theorized' in the CCCS collection, *The Empire Strikes Back* (1982). When, in 'Old and new identities'

(1991b), Hall 'figures' himself as 'the sugar at the bottom of the English cup of tea . . . the sweet tooth, the sugar plantation that rotted generations of English children's teeth' (48), there is a sense of wicked delight (if not sweet revenge) in the destabilization of this category of 'Englishness', central to the politics of Thatcherism, which Hall has spent so much of his recent intellectual life fighting.

In the interview in Part II 'On postmodernism and articulation', Hall is scathing about the vacuous (and implicitly imperialist) presumptions of some versions of postmodernism (see the piece by Morley in Part IV for more on this), characterizing it simply as 'another version of that historical amnesia, characteristic of American culture – the tyranny of the new', or even more simply as 'how the world dreams itself to be American . . .' – an instance of the 'ideological effect' and of the belief that 'history stops with us' (see Fukuyama, 1992). Hall's critical point concerns precisely the failure of certain theorists of postmodernism to reflexively take account of their own (privileged) positions – (cf. West, 1991: 5) 'who is he (Lyotard) talking about . . . he and his friends hanging out on the Left Bank?' in a world in which, as Hall puts it, the majority of the population have not yet properly entered the modern era, let alone the postmodern. Indeed Hobsbawm (1994) argues that for 80 per cent of humanity, the Middle Ages (defined in European terms) only ended in the 1950s. Clearly, much postmodern theory, from this perspective, amounts not only to a form of orientalism (see Said, 1978) but to a form of 'egology' or 'ontological imperialism', in Levinas' terms (1983). The same point can, of course, be made in relation to the concept of 'postcolonialism'. As a very significant number of the world's population still live in (at best) neo-colonial conditions, it may well be premature to speak of a 'postcolonial era' (see Chen, forthcoming).

However, as West (op. cit.) also argues, there is another way of understanding postmodernism, as 'a set of responses to the decentring of . . . (that) European [or perhaps "western" – KHC/DM] hegemony that began in 1492' (op. cit.: 6). In his later work, this is precisely the perspective which Hall has developed most effectively, in essays such as a 'The West and the rest' (1992b), 'The question of cultural identity' (1992a) and 'Cultural identity and diaspora' (1990). In these essays, the autobiographical experience of the migrant – the experience of dis-location, dis-placement and hybridity – is treated as structurally central to the 'condition of postmodernity'. Thus, as Hall puts it in 'Cultural identity and diaspora', the migrant can be seen as 'the prototype of postmodern . . . nomad, continually moving between centre and periphery' (1990: 234). As he puts it, in the interview in Part V, 'postcoloniality . . . prepared one to live in a rather postmodern relationship through identity. I don't feel that as a typically western experience at all. Its a very diasporic experience. The classic postmodern experience is the diasporic experience.' Seen from this point

of view, in which the material relations of imperialism and colonialism are reinscribed, the 'postmodern' is clearly then of considerably greater interest than what Hall elsewhere has called 'ideological postmodernism' or 'what happens to ex-marxist French intellectuals when they head for the desert' – a form of postmodernism which Hall simply observes 'I don't buy' (1991a: 33).

Again, the point also has an autobiographical inflection. Speaking at the ICA in London in 1987, at a conference on 'Postmodernism and the Question of Identity', Hall put the theoretical point in quite personal terms: 'My own sense of identity has always depended on the fact of being a migrant . . . (now) I find myself centred at last. Now that, in the postmodern age, you all feel so dispersed, I become centred: what I've thought of as dispersed and fragmented comes, paradoxically, to be *the* representative modern experience . . . welcome to migranthood!' (1987: 44).

THE GHOSTS OF MARXISM

In 1989, in discussion at the State University of New York, in Binghampton, following his talk there on 'Old and new identities', Hall replied to a question concerning his own politics by saying 'I remain marxist' (quoted in Hall, 1991b: 68). As to the exact meaning of this statement, we might do well to remember Marx's own pronouncement on the subject: 'Je ne suis pas marxiste.' For Hall's contemporary position on these issues the reader is referred to his comments in the interviews in this volume. Certainly Hall's relation to the marxist tradition is, and always has been both a complex and a creative (if necessarily troubled) one. He has noted that one crucial aspect of his own political formation was in the 'moment' of 1956 – 'the moment of the disintegration of a certain kind of marxism' – so that, from the very beginning, his relation to marxism has been a contentious one: he describes himself as having come 'into marxism backwards, against the Soviet tanks in Budapest' (1992c: 279).

On the one hand, Hall has always been dissatisfied with any form of 'idealist' analysis, which ignores the materialities of power and inequality. Thus, in his presentation to the Illinois 'Cultural Studio' conference (chapter 13, here) Hall went out of his way, in his critique of what he called the astonishing 'theoretical fluency of cultural studies in the US', to characterize this as also a 'moment of profound danger' is so far as 'the deconstructive deluge' of American literary formalism can be argued to have led to an 'overwhelming textualization of cultural studies' own discourses', to the extent that power and politics have now come to be constituted, within much of cultural studies, as '*exclusively* matters of language and textuality' (emphasis added). This is not to deny, as Hall immediately goes on to note, that 'questions of power and the political

have to be and are always lodged within representations of textuality' (ibid.: 286) but it is to suggest, as he notes earlier in that same presentation, that 'textuality is never enough'.

On the other hand, in his retrospective discussion of the significance of CCCS's encounter with the work of Volosinov ('For Allon White: metaphors of transformation', 1993; chapter 15 here) Hall is at pains to stress not only the decisive importance of the recognition of the definitively discursive character of ideology but also the further significance of the shift in CCCS's work, in the wake of the encounter with Volosinov, from 'any lingering flirtation with even a modified version of the "base-superstructure" metaphor to a fully discourse-and-power conception of the ideological' (page 297), which would preclude any return to old fashioned, essentialist, marxist conceptions of the 'reducibility' of questions of culture (or ideology) to questions of class.

In a similar vein, in his introduction to the Open University's recent undergraduate sociology course, 'Understanding Modern Societies', Hall offers a definition of the discipline in which cultural, symbolic and discursive practices are given a much greater prominence (and a rather higher explanatory status) than is customary within sociology. Discursive and textual processes are, from this perspective 'considered to be, not reflective but *constitutive* in the formation of the modern world: as constitutive as economic, political or social processes' which themselves, he argues 'do not operate outside of cultural and ideological conditions' (culture thus lies *beneath* the 'bottom line' of economics) in so far as these material processes 'depend on "meaning" for their effects and have cultural or ideological conditions of existence' (1992e: 13). If textuality is 'never enough', clearly it nonetheless remains central to Hall's conception of any adequate analysis of society.

Moreover, beyond the general question of the relation of the textual or (discursive) and material fields, there lies the more specific question of the significance, for cultural studies, of the impact of feminism and psychoanalytic work, in completely unsettling the terrain previously established by marxism. When, at the Illinois conference, Hall spoke of the need to live in and with the tensions created by these radically incommensurable perspectives, in developing an 'open-ended' cultural studies perspective, it was specifically to this field of contention that he referred, when pressed on the point, in discussion:

The interrelations between feminism, psychoanalysis and cultural studies define a completely and permanently unsettled terrain for me. The gains of understanding cultural questions in and through the insights of psychoanalytic work . . . opened up enormous insights . . . But every attempt to translate the one smoothly into the other doesn't work. . . . Culture is neither just the process of the unconscious writ large, nor is

the unconscious simply the internalization of cultural processes . . .
(psychoanalysis completely breaks that sociological notion of socializa-
tion . . .). I have to live with the tension of the two vocabularies, of the
two unsettled objects of analysis and try to read the one through the
other, without falling into psychoanalytic readings of everything.

(1992c: 291)

This tension is most clearly addressed in the interview 'The formation of a
diasporic intellectual' (chapter 25).

ESSENTIALISMS, POLITICS AND IDENTITIES

At the Illinois conference, Hall also referred to the way in which his
relation to marxism was necessarily inflected by his 'not-yet completed
contestation with the profound Eurocentrism of marxist theory' (chapter
13, 265). The major problem he identifies there concerns traditional marx-
ist theory's basic stress on the internal dynamic of the development of
capitalism and its relative neglect of the question of imperialism and
colonialism. As he puts it in 'Cultural identity and diaspora', the missing
('third') term is, in a sense, quite particularly his own – the Caribbean, as
the 'Third . . . New World . . . the "empty" land . . . where strangers from
every other part of the globe collided' (1990a: 234). In a striking use of a
psychoanalytic figure, he proposes that 'The New World is the third term –
the primal scene – where the fateful/fatal encounter was staged between
Africa and the West' (ibid.: 234; for the development of these arguments,
see, in particular, 'The West and the rest', 1992).

As noted earlier, Hall's (1985) essay on 'Gramsci's relevance for the
study of race and ethnicity' (chapter 20, here) can be seen as a turning-
point in the substantive focus of his work, as it moved towards its present
central concerns – with questions of 'race', ethnicity and cultural identity.
Nonetheless, the essay also contains a set of important theoretical con-
tinuities, in its arguments concerning the need to develop modes of analysis
– whether to be applied to questions of class, 'race', gender or ethnicity (or
indeed, their intersections) – which are non-reductive and non-essentialist.
It is from Gramsci's militantly conjunctural historical perspective on class
formations that Hall derives, in part, the conceptual model for his later, non-
essentialist analyses of race and ethnicity. It is, as it were, in substantial part
on the basis of the theoretical gains made in the formative encounter with
Gramsci that, in his influential essay on 'New ethnicities' (1988; reprinted
here as chapter 21), Hall declares the 'end of the innocent notion of the
essential black subject' (see the parallel debates between Hall et al. and
Coward, concerning 'Class, culture and the social formation', 1977).

In the 'New ethnicities' essay, Hall insists that, rather than falling into
essentialist perspectives on the issues at stake (which would replicate

traditional marxism's mistakes, concerning the nature of 'pre-given' class subjects – (see Laclau and Mouffe, 1985) we must recognize that 'black' is a 'politically and culturally constructed category, which cannot be grounded in a set of fixed, trans-cultural or transcendental racial categories, and which therefore has no guarantees in Nature' (1988: 28) – just as, from a non-essentialist perspective, socialist politics can find no 'guarantee' in the economic sphere. It is for these very reasons, Hall argues in 'Old and new identities' (1991b), that what he calls 'Identity Politics One' – the invocation of homogenized racial, ethnic or cultural categories as (idealized) 'natural communities' – had to be abandoned as inadequate. And yet, even then, as indicated earlier, Hall is aware of the tensions (historical and intellectual) inevitably in play, in this context: as he notes in 'What is this "black" in black popular culture?' (chapter 23), 'historically, nothing could have been done to intervene in the dominated field of mainstream popular culture, to try to win some space there, without the strategies through which those dimensions were condensed into the signifier "black" . . .' (page 471). As he then asks, not entirely rhetorically: 'where would we be, as bell hooks once remarked, without a touch of essentialism . . . or what Gayatri Spivak calls "strategic essentialism", a necessary moment?' (page 472) – even if the question is now, as Hall avers, 'whether we are any longer in that moment, whether it is still a sufficient basis for the strategies of new interventions' (page 472).

In 'Cultural studies and the politics of internationalization' (chapter 19), Hall also returns to the question of class, and how that question appears now, after the impact of feminism, psychoanalysis, anti-racism and identity politics. Hall notes that, in relation to the previous, essentialist marxist tendency to treat class as the 'master category' of social analysis, in recent years the question of class has largely fallen off the agenda of cultural studies. As he points out, it is not only that some address to the question of class (even if in a more de-centred way) remains absolutely necessary, if we are to understand the development of the contemporary global economy and how that affects all our lives. Further, as he goes on to note, the politics of experience and of subjectivity and the focus on questions of personal identity (even if all of those developments have many positive aspects) can also have, unless one is extremely careful, what he describes as a regressive, socially 'narrowing' effect. As he puts it,

> In the early stages, perhaps we spoke too much about the working class, about subcultures. Now nobody talks about that at all. They talk about myself, my mother, my father, my friends, and that is, of course, a very selective experience, especially in relation to classes
>
> (402)

To be sure, Hall's invocation of a possible 'return of the question of class' is made with reference to a 'return' in which the question itself

would be quite 'decentred' and transformed – but it is nonetheless char-
acteristic of his mode of working that he should, at this point, wish to return
to a question which, from another point of view, would now seem super-
seded or outmoded, in relation to current orthodoxies. Indeed, we would
want to suggest that Hall's intellectual practice is, in this respect, quite
exemplary. Hall has never been interested either in 'orthodoxy' or in
'theory', and 'theoretical orthodoxies' (especially ones which, in absolu-
tist terms, present themselves as definitively superseding all that went
before) have always been anathema to him. In his presentation to the
Illinois conference, quoted earlier, Hall also referred to what he called
the 'necessary modesty of theory' in cultural studies. More polemically, in
'Old and new identities' (1991a) he remarks that 'theory is always a detour
[if a necessary detour – DM/KHC] on the way to something more inter-
esting' (op. cit.: 42). In 'On postmodernism and articulation' Hall says 'I
am not interested in Theory, I am interested in going on theorizing . . . in
the postmodern context' (chapter 6: 150). This interest in theorizing the
concrete historical issues confronting us in any particular conjuncture
would seem to us to be essential to the spirit of, as Hall himself puts it
in that interview, how and why 'cultural studies must remain open-ended.'
 However, we want to suggest that what is particularly impressive and
important in Hall's own approach is not only an open-endedness about the
future development of the discipline, but also a certain kind of open-
mindedness about its past – or rather about the process through which its
past is to be constituted – and about how debates 'progress' within cultural
studies, about how one set of ideas come to 'disturb' or displace another.
The question is, what happens to what is displaced? (see the comments
above, about the contemporary possibilities of a 'return' to the question of
class in cultural studies): is it to be entirely discarded or rejected? If so, we
are likely to enjoy a succession of exclusive orthodoxies, each enjoying a
brief, if absolute, intellectual reign, prior to being dethroned by the next
intellectually fashionable paradigm and itself removed to the dungeons
reserved for the intellectually *passé*. Hall simply does not operate in this
way: he has always refused the temptations of the easy point-scoring,
negative critical perspective, which is concerned to enhance its own
arguments by rubbishing those of others. His tendency has, rather, always
been to the most productive sort of eclecticism, in which he will always look
for the best, the most useful part – which can be taken from another (often
opposed) intellectual position and worked with (and on) positively. It is a
tendency towards a selective, syncretic, mode of inclusiveness, dialogue
and transformation – rather than to 'critique' and rejection of that which is
opposed to his own point of view or position. The politics of discipleship or
denunciation are equally anathema to him. As he puts it in 'Cultural studies
and the politics of internationalization' (chapter 19), he has always been
opposed to the view that a given theorist's work (his example here is that of

Raymond Williams) should be repudiated *en bloc*, just because it can be identified as having significant absences or deficiencies (for instance, in relation to questions of race and feminism, in Williams' case). That kind of (all too common) combative polarization of intellectual 'debate', in which one either 'advocates' everything, as a disciple of a certain intellectual position, or automatically 'refuses' and denies it in its entirety, once it has been found wanting in some particular respect, offers little prospect of getting us anywhere, and it is greatly to Hall's credit that he offers us such a good model of an alternative intellectual practice.

Speaking of continuities and their virtues (and positive usages), it is perhaps worth, in conclusion, noting a certain continuity, or parallel, between Hall's career trajectory and that of the other two key figures in the history of cultural studies, Williams and Hoggart, with whom Hall's name is customarily linked. Like Williams and Hoggart, Hall has always had a commitment to the politics of education itself, and especially to the education of the less privileged. As he explains in one of the interviews here, for him, a large part of the motivation for his move from teaching graduate students at CCCS (up until 1979) to teaching non-traditional undergraduates via the Open University (where he has worked since) was the attempt to take the most advanced ideas from the intellectual work of CCCS and to try to make them work as a form of 'popular pedagogy'. Quite apart from all his other achievements, Hall's work at the Open University, in this respect alone, offers the finest testament to his ability to make the crossing of boundaries, in all their forms, a matter of intellectual adventure and innovation.

In 'Cultural studies and its theoretical legacies' Hall argues that cultural studies always needs to hold both theoretical and political questions 'in an ever irresolvable, but permanent, tension' (shades perhaps of Althusser's conception of moments of what he called 'teeth-gritting harmony'), constantly allowing 'the one to irritate and bother and disturb the other', because 'if you lose that tension, you can do extremely fine intellectual work, but you will have lost intellectual practice, as a politics'. As so often with Hall, the key to this perspective is Gramsci, and, in particular, Gramsci's conception of the role of the 'organic intellectual'. In his own actions, Hall has demonstrated his commitment to living out the contradictions of the role of the 'organic intellectual' identified by Gramsci – the commitment to being at the very forefront of intellectual, theoretical work and, simultaneously, the commitment to the attempt to transmit the ideas thus generated, well beyond the confines of the 'intellectual class'.

BIBLIOGRAPHY

Ahmad, A. (1994) *In Theory: Classes, Nations, Literatures*, London: Verso.
Appiah, K. A. (1993) *In My Father's House*, London: Methuen.

Bakhtin, M. (1981) *The Dialogic Imagination* (ed. M. Holmquist), Austin: University of Texas Press.
Bakhtin, M. and Medvedev, P. (1978) *The Formal Method in Literary Scholarship*, Baltimore: Johns Hopkins University Press.
Centre for Contemporary Cultural Studies (1982) *The Empire Strikes Back*, London: Hutchinson.
Chambers, I. (1990) *Border Dialogues*, London: Comedia/Routledge.
—— (1993) *Migrancy, Culture, Identity*, London: Comedia/Routledge.
Chen, K. H. (1993) 'Introduction' to S. Hall 'Minimal selves', *Isle Margin*, 8 (Taipei).
—— (forthcoming) 'Not yet the postcolonial era', *Cultural Studies*.
Chow, R. (1993) *Writing Diaspora*, Bloomington: Indiana University Press.
Coward, R. (1977) 'Class, culture and the social formation', *Screen*, 18(1).
Fiske, J. (1989) *Reading the Popular*, London: Unwin Hyman.
—— (1993) *Power Plays, Power Works*, London: Verso.
Fukuyama, F. (1992) *The End of History and the Last Man*, Harmondsworth: Penguin.
Gates, H. L. (ed.) (1986) *'Race', Writing and Difference*, Chicago: Chicago University Press.
Gilroy, P. (1990) 'It ain't where you're from, it's where you're at: the dialectics of diasporic identification', *Third Text* (13).
—— (1993a) *The Black Atlantic*, London: Verso.
—— (1993b) *Small Acts*, London: Serpents' Tail.
Grossberg, L. (1992) *We Gotta Get Out of This Place*, London: Routledge.
Grossberg, L., Nelson, C. and Treichler, P. (eds) (1992) *Cultural Studies*, London: Routledge.
Hall, S. (1958) 'A sense of classlessness', *Universities and Left Review*, 1(5).
—— (1960) 'Crosland territory', *New Left Review*, (2).
—— (1985) 'Theoretical perspectives in the analysis of racism and ethnicity', Paris: Unesco. Later (1986) published as 'Gramsci's relevance for the study of race and ethnicity', *Journal of Communication Inquiry*, 10(2).
—— (1987) 'Minimal selves' in L. Appignanesi (ed.) *The Real Me: Postmodernism and the Question of Identity*, ICA Documents 6, 44–6.
—— (1988) 'New ethnicities' in K. Mercer (ed.) *Black Film, British Cinema*, London: Institute of Contemporary Arts.
—— (1990) 'Cultural identity and diaspora' in J. Rutherford (ed.) *Identity: Community, Culture, Difference*, London: Lawrence & Wishart.
—— (1991a) 'The local and the global' in A. King (ed.) *Culture, Globalization and the World System*, London: Macmillan.
—— (1991b) 'Old and new identities, old and new ethnicities' in A. King (ed.) op. cit.
—— (1992a) 'The question of cultural identity' in S. Hall, D. Held and T. McGrew (eds) *Modernity and Its Futures*, Cambridge: Polity Press.
—— (1992b) 'The West and the rest: discourse and power' in S. Hall and B. Gieben (eds) *Formations of Modernity*, Cambridge: Polity Press.
—— (1992c) 'Cultural studies and its theoretical legacies' in L. Grossberg *et al.* (eds) *Cultural Studies*, London: Routledge.
—— (1992d) 'What is this "black" in black popular culture?', in G. Dent (ed.) *Black Popular Culture*, Seattle: Bay Press.
—— (1992e) 'Introduction' to S. Hall and B. Gieben (eds) *Formations of Modernity*, Cambridge: Polity Press.

Hall, S., (1993) 'For Allon White: metaphors of transformation', 'Introduction' to A. White, *Carnival, Hysteria and Writing*, Oxford: Clarendon Press.

Hall, S., Connell, I., Curti, L., Chambers, I. and Jefferson, T. (1977) 'Marxism and culture: a reply to Ros Coward', *Screen*, 18(4).

Hall, S., Critcher, C., Jefferson, T., Clarke, J. and Roberts, B. (1978) *Policing the Crisis: 'Mugging', the State and Law and Order*, London: Hutchinson.

Hall, S. and Jacques, M. (eds) (1990) *New Times*, London: Lawrence & Wishart.

Hardt, H. (1992) *Critical Communication Studies*, London: Macmillan.

Harvey, D. (1989) *The Condition of Postmodernity*, Oxford: Basil Blackwell.

Hebdige, D. (1988) *Hiding in the Light*, London: Comedia/Routledge.

Hobsbawm, E. (1994) *Age of Extremes: The Short Twentieth Century*, London: Michael Joseph.

Ignatieff, M. (1994) *Blood and Belonging: Journeys into the New Nationalism*, London: Vintage Books.

Jameson, F. (1991) *Postmodernism or the Cultural Logic of Late Capitalism*, London: Verso.

Laclau, E. and Mouffe, C. (1985) *Hegemony and Socialist Strategy*, London: Verso.

Levinas, E. (1983) 'Beyond intentionality', in A. Montefiore (ed.) *Philosophy in France Today*, Cambridge: Cambridge University Press.

McRobbie, A. (1991) *Feminism and Youth Culture*, London: Macmillan.

—— (1994) *Postmodernism and Popular Culture*, London: Routledge.

McRobbie, A. and McCabe, T. (1981) *Feminism for Girls*, London: Routledge.

Mercer, K. (ed.) (1988) *Black Film, British Cinema*, London: Institute of Contemporary Arts.

—— (1994) *Welcome to the Jungle: New Positions in Black Cultural Studies*, London: Routledge.

Pines, J. and Willemen, P. (eds) (1989) *Questions of Third Cinema*, London: British Film Institute.

Said, E. (1978) *Orientalism*, Harmondsworth: Penguin.

—— (1993) *Culture and Imperialism*, London: Chatto.

Schwarz, B. (1994) 'Where is cultural studies?', *Cultural Studies*, 8(3).

Soja, E. (1989) *Postmodern Geographies*, London: Verso.

Spivak, G. (1987) *In Other Worlds: Essays in Cultural Politics*, London: Methuen.

—— (1990) *The Post-Colonial Critic: Interviews, Strategies, Dialogues*, (ed. S. Harasyn), London: Routledge.

Stallybrass, P. and White, A. (1986) *The Politics and Poetics of Transgression*, Ithaca: Cornell University Press.

Volosinov, V. (1973) *Marxism and the Philosophy of Language*, New York: Seminar Press.

West, C. (1991) 'Decentring Europe', *Critical Quarterly*, 33(1).

White, A. (1993) *Carnival, Hysteria and Writing*, Oxford: Oxford University Press.

(Un)Settling accounts

Marxism and cultural studies

Chapter 1

The problem of ideology
Marxism without guarantees

Stuart Hall

In the past two or three decades, marxist theory has been going through a remarkable, but lop-sided and uneven revival. On the one hand, it has come once again to provide the principal pole of opposition to 'bourgeois' social thought. On the other hand, many young intellectuals have passed *through* the revival and, after a heady and rapid apprenticeship, gone right out the other side again. They have 'settled their accounts' with marxism and moved on to fresh intellectual fields and pastures: but not quite. *Post-marxism* remains one of our largest and most flourishing contemporary theoretical schools. The post-marxists use marxist concepts while constantly demonstrating their inadequacy. They seem, in fact, to continue to stand on the shoulders of the very theories they have just definitely destroyed. Had marxism not existed, 'post-marxism' would have had to invent it, so that 'deconstructing' it once more would give the 'deconstructionists' something further to do. All this gives marxism a curious life-after-death quality. It is constantly being 'transcended' and 'preserved'. There is no more instructive site from which to observe this process than that of ideology itself.

I do not intend to trace through once again the precise twists and turns of these recent disputes, nor to try to follow the intricate theorizing which has attended them. Instead, I want to place the debates about ideology in the wider context of marxist theory as a whole. I also want to pose it as a general *problem* – a problem of theory, because it is also a problem of politics and strategy. I want to identify the most telling weaknesses and limitations in the classical marxist formulations about ideology; and to assess what has been gained, what deserves to be lost, and what needs to be retained – and perhaps rethought – in the light of the critiques.

But first, why has the problem of ideology occupied so prominent a place

Reprinted from the *Journal of Communication Inquiry* (1986), 10(2), 28-44. This essay originally appeared in *Marx: 100 Years On*, B. Matthews, (ed.) London: Lawrence & Wishart, 1983, 57–84. We wish to thank the publisher for permission to reprint it here.

within marxist debate in recent years? Perry Anderson (1976), in his magisterial sweep of the western European marxist intellectual scene, noted the intense preoccupation in these quarters with problems relating to philosophy, epistemology, ideology and the superstructures. He clearly regarded this as a deformation in the development of marxist thought. The privileging of *these* questions in marxism, he argued, reflected the general isolation of western European marxist intellectuals from the imperatives of mass political struggle and organization; their divorce from the 'controlling tensions of a direct or active relationship to a proletarian audience'; their distance from 'popular practice' and their continuing subjection to the dominance of bourgeois thought. This had resulted, he argued, in a general disengagement from the classical themes and problems of the mature Marx and of marxism. The over-preoccupation with the ideological could be taken as an eloquent sign of this.

There is much to this argument – as those who have survived the theoreticist deluge in 'western marxism' in recent years will testify. The emphases of 'western marxism' may well account for the *way* the problem of ideology was constructed, *how* the debate has been conducted and the *degree* to which it has been abstracted into the high realms of speculative theory. But I think we must reject any implication that, but for the distortions produced by 'western marxism', marxist theory could have confortably proceeded on its appointed path, following the established agenda: leaving the problem of ideology to its subordinate, second-order place. The rise to visibility of the problem of ideology has a more objective basis. First, the real developments which have taken place in the means by which mass consciousness is shaped and transformed – the massive growth of the 'cultural industries'. Second, the troubling questions of the 'consent' of the mass of the working class to the system in advanced capitalist societies in Europe and thus their partial stabilization, against all expectations. Of course, 'consent' is *not* maintained through the mechanisms of ideology alone. But the two cannot be divorced. It also reflects certain real theoretical weaknesses in the original marxist formulations about ideology. And it throws light on some of the most critical issues in political strategy and the politics of the socialist movement in advanced capitalist societies.

In briefly reviewing some of these questions, I want to foreground, not so much the theory as the *problem* of ideology. The *problem* of ideology is to give an account, within a materialist theory, of how social ideas arise. We need to understand what their role is in a particular social formation, so as to inform the struggle to change society and open the road towards a socialist transformation of society. By ideology I mean the mental frameworks – the languages, the concepts, categories, imagery of thought, and the systems of representation – which different classes and social groups deploy in order to make sense of, define, figure out and render intelligible the way society works.

The problem of ideology, therefore, concerns the ways in which ideas of different kinds grip the minds of masses, and thereby become a 'material force'. In this, more politicized, perspective, the theory of ideology helps us to analyse how a particular set of ideas comes to dominate the social thinking of a historical bloc, in Gramsci's sense; and, thus, helps to unite such a bloc from the inside, and maintain its dominance and leadership over society as a whole. It has especially to do with the concepts and the languages of practical thought which stabilize a particular form of power and domination; or which reconcile and accommodate the mass of the people to their subordinate place in the social formation. It has also to do with the processes by which new forms of consciousness, new conceptions of the world, arise, which move the masses of the people into historical action against the prevailing system. These questions are at *stake* in a range of social struggles. It is to explain them, in order that we may better comprehend and master the terrain of ideological struggle, that we need not only a theory but a theory adequate to the complexities of what we are trying to explain.

No such theory exists, fully prepackaged, in Marx and Engels' works. Marx developed no general explanation of how social ideas worked, comparable to his historico-theoretical work on the economic forms and relations of the capitalist mode of production. His remarks in this area were never intended to have a 'law-like' status. And, mistaking them for statements of that more fully theorized kind may well be where the problem of ideology for marxism first began. In fact, his theorizing on this subject was much more *ad hoc*. There are consequently severe fluctuations in Marx's usage of the term. In our time – as you will see in the definition I offered above – the term 'ideology' has come to have a wider, more descriptive, less systematic reference, than it did in the classical marxist texts. We *now* use it to refer to *all* organized forms of social thinking. This leaves open the degree and nature of its 'distortions'. It certainly refers to the domain of practical thinking and reasoning (the form, after all, in which most ideas are likely to grip the minds of the masses and draw them into action), rather than simply to well-elaborated and internally consistent 'systems of thought'. We mean the practical as well as the theoretical knowledges which enable people to 'figure out' society, and within whose categories and discourses we 'live out' and 'experience' our objective positioning in social relations.

Marx did, on many occasions, use the term 'ideology', practically, in this way. So its usage with this meaning *is* in fact sanctioned by his work.

Thus, for example, he spoke in a famous passage of the 'ideological forms in which men become conscious of . . . conflict and fight it out' (Marx, 1970: 21). In *Capital* he frequently, in asides, addresses the 'everyday consciousness' of the capitalist entrepreneur; or the 'common sense of capitalism'. By this he means the forms of spontaneous thought

within which the capitalist represents to himself the workings of the capitalist system and 'lives out' (i.e., genuinely experiences) his practical relations to it. Indeed, there are already clues there to the subsequent uses of the term which many, I suspect, do not believe could be warranted from Marx's work. For example, the spontaneous forms of 'practical bourgeois consciousness' are real, but they cannot be *adequate* forms of thought, since there are aspects of the capitalist system – the generation of surplus value, for example – which simply cannot be 'thought' or explained, using those vulgar categories. On the other hand, they can't be *false* in any simple sense either, since these practical bourgeois men seem capable enough of making profit, working the system, sustaining its relations, exploiting labour, without benefit of a more sophisticated or 'truer' understanding of what they are involved in. To take another example, it is a fair deduction from what Marx said, that the *same* sets of relations – the capitalist circuit – can be represented in several *different ways* or (as the modern school would say) represented within different systems of discourse.

To name but three – there is the discourse of 'bourgeois common sense'; the sophisticated theories of the classical political economists, like Ricardo, from whom Marx learned so much; and, of course, Marx's own theoretical discourse – the discourse of *Capital* itself.

As soon as we divorce ourselves from a religious and doctrinal reading of Marx, therefore, the openings between many of the classical uses of the term, and its more recent elaborations, are not as closed as current theoreticist polemics would lead us to believe.

Nevertheless, the fact is that Marx most often used 'ideology' to refer specifically to the manifestations of bourgeois thought; and above all to its negative and distorted features. Also, he tended to employ it – in, for example, *The German Ideology*, the joint work of Marx and Engels – in contestation against what he thought were incorrect ideas: often, of a well-informed and systematic kind (what we would *now* calls 'theoretical ideologies', or, following Gramsci, 'philosophies'; as opposed to the categories of practical consciousness, or what Gramsci called 'common sense'). Marx used the term as a critical weapon against the speculative mysteries of Hegelianism; against religion and the critique of religion; against idealist philosophy, and political economy of the vulgar and degenerated varieties. In *The German Ideology* and *The Poverty of Philosophy* Marx and Engels were combating bourgeois ideas. They were contesting the anti-materialist philosophy which underpinned the dominance of those ideas. In order to make their polemical point, they simplified many of their formulations. Our subsequent problems have arisen, in part, from treating these polemical inversions as the basis for a labour of *positive* general theorizing.

Within that broad framework of usage, Marx advances certain more fully elaborated theses, which have come to form the theoretical basis of the

theory in its so-called classical form. First the materialist premise: ideas arise from and reflect the material conditions and circumstances in which they are generated. They express social relations and their contradictions in thought. The notion that ideas provide the motor of history, or proceed independent of material relations and generate their own autonomous effects is, specifically, what is declared as speculative, and illusory about bourgeois ideology. Second, the thesis of determinateness: ideas are only the dependent effects of the ultimately determining level in the social formation – the economic in the last instance. So that transformations in the latter will show up, sooner or later, as corresponding modifications in the former. Thirdly, the fixed correspondences between dominance in the socio-economic sphere and the ideological; 'ruling ideas' are the ideas of the 'ruling class' – the class position of the latter providing the coupling and the guarantee of correspondence with the former.

The critique of the classical theory has been addressed precisely to these propositions. To say that ideas are 'mere reflexes' establishes their materialism but leaves them without specific effects; a realm of pure dependency. To say that ideas are determined 'in the last instance' by the economic is to set out along the economic reductionist road. Ultimately, ideas can be reduced to the essence of their truth – their economic content. The only stopping-point before this ultimate reductionism arises through the attempt to delay it a little and preserve some space for manoeuvre by increasing the number of 'mediations'. To say that the 'ruling-ness' of a class is the guarantee of the dominance of certain ideas is to ascribe them as the exclusive property of that class, and to define particular forms of consciousness as class-specific.

It should be noted that, though these criticisms are directly addressed to formulations concerning the problem of ideology, they in effect recapitulate the substance of the more general and wide-ranging criticism advanced against classical marxism itself: its rigid structural determinancy, its reductionism of two varieties – class and economic; its way of conceptualizing the social formation itself. Marx's model of ideology has been criticized because it did not conceptualize the social formation as a determinate complex formation, composed of different practices, but as a *simple* (or, as Althusser called it in *For Marx* and *Reading Capital*, an 'expressive') structure. By this Althusser meant that one practice – 'the economic' – determines in a direct manner all others, and each effect is simply and simultaneously reproduced correspondingly (i.e., 'expressed') on all other levels.

Those who know the literature and the debates will easily identify the main lines of the more specific revisions advanced, from different sides, against these positions. They begin with the denial that any such simple correspondences exist, or that the 'superstructures' are totally devoid of their own specific effects, in Engels' gloss on 'what Marx thought'

(especially in the later correspondence). The glosses by Engels are immensely fruitful, suggestive and generative. They provide, not the solution to the problem of ideology, but the starting-point of all serious reflection on the problem. The simplifications developed, he argued, because Marx was in contestation with the speculative idealism of his day. They were one-sided distortions, the necessary exaggerations of polemic. The criticisms lead on through the richly tapestried efforts of marxist theorists like Lukács to hold, polemically, to the strict orthodoxy of a particular 'Hegelian' reading of Marx, while in practice introducing a whole range of 'mediating and intermediary factors' which soften and displace the drive towards reductionism and economism implicit in some of Marx's original formulations. They include Gramsci – but from another direction – whose contribution will be discussed at a later place in the argument. They culminate in the highly sophisticated theoretical interventions of Althusser and the Althussereans: their contestation of economic and class reductionism and of the 'expressive totality' approach.

Althusser's revisions (in *For Marx* and, especially, in the 'Ideological state apparatuses' chapter of *Lenin and Philosophy and Other Essays*) sponsored a decisive move away from the 'distorted ideas' and 'false consciousness' approach to ideology. It opened the gate to a more linguistic or 'discursive' conception of ideology. It put on the agenda the whole neglected issue of how ideology becomes internalized, how we come to speak 'spontaneously', within the limits of the categories of thought which exist outside us and which can more accurately be said to think us. (This is the so-called problem of the interpellation of subjects at the centre of ideological discourse. It led to the subsequent bringing into marxism of the psychoanalytic interpretations of how individuals enter into the ideological categories of language at all.) In insisting (for example, in 'Ideological state apparatuses') on the *function* of ideology in the reproduction of social relations of production and (in *Essays in Self-criticism*) on the metaphorical utility of the base-superstructure metaphor, Althusser attempted some last-hour regrouping on the classical marxist terrain.

But his first revision was too 'functionalist'. If the function of ideology is to 'reproduce' capitalist social relations according to the 'requirements' of the system, how does one account for subversive ideas or for ideological struggle? And the second was too 'orthodox'. It was Althusser who had displaced so thoroughly the 'base/superstructure' metaphor! In fact, the doors he opened provided precisely the exit points through which many abandoned the problematic of the classical marxist theory of ideology altogether. They gave up, not only Marx's particular way in *The German Ideology* of coupling 'ruling class and ruling ideas', but the very preoccupations with the class structuring of ideology, and its role in the generation and maintenance of hegemony.

Discourse and psychoanalytic theories, originally conceived as theoretical supports to the critical work of theory revision and development, provided instead categories which substituted for those of the earlier paradigm. Thus, the very real gaps and lacunae in the 'objective' thrust of marxist theory, around the modalities of consciousness and the 'subjectification' of ideologies, which Althusser's use of the terms 'interpellation' (borrowed from Freud) and 'positioning' (borrowed from Lacan) were intended to address, became themselves the exclusive object of the exercise. The *only* problem about ideology was the problem of how ideological subjects were formed through the psychoanalytic processes. The theoretical tensions were then untied. This is the long descent of 'revisionist' work on ideology, which leads ultimately (in Foucault) to the abolition of the category of 'ideology' altogether. Yet its highly sophisticated theorists, for reasons quite obscure, continue to insist that their theories are 'really' materialist, political, historical, and so on: as if haunted by Marx's ghost still rattling around in the theoretical machine.

I have recapitulated this story in an immensely abbreviated form because I do not intend to engage in detail with its conjectures and refutations. Instead, I want to pick up their thread, acknowledging their force and cogency at least in modifying substantially the classical propositions about ideology, and, in the light of them, to reexamine some of the earlier formulations by Marx, and consider whether they can be refashioned and developed in the positive light of the criticisms advanced – as most good theories ought to be capable of – without losing some of the essential qualities and insights (what used to be called the 'rational core') which they originally possessed. Crudely speaking, that is because – as I hope to show – I acknowledge the immense force of many of the criticisms advanced. But I am not convinced that they wholly and entirely abolish every useful insight, every essential starting-point, in a materialist theory of ideology. If, according to the fashionable canon, all that is left, in the light of the devastatingly advanced, clever and cogent critiques, is the labour of perpetual 'deconstruction', this essay is devoted to a little modest work of 'reconstruction' – without, I hope, being too defaced by ritual orthodoxy.

Take, for example, the extremely tricky ground of the 'distortions' of ideology, and the question of 'false consciousness'. Now it is not difficult to see why these kinds of formulations have brought Marx's critics bearing down on him. 'Distortions' opens immediately the question as to why some people – those living their relation to their conditions of existence through the categories of a distorted ideology – cannot recognize that it is distorted, while we, with our superior wisdom, or armed with properly formed concepts, can. Are the 'distortions' simply falsehoods? Are they deliberately sponsored falsifications? If so, by whom? Does ideology really function like conscious class propaganda? And if ideology is the product

or function of 'the structure' rather than of a group of conspirators, how *does* an economic *structure* generate a guaranteed set of ideological effects? The terms are, clearly, unhelpful as they stand. They make both the masses and the capitalists look like judgemental dopes. They also entail a peculiar view of the formation of alternative forms of consciousness. Presumably, they arise as scales fall from people's eyes or as they wake up, as if from a dream, and, all at once, see the light, glance directly through the transparency of things immediately to their essential truth, their concealed structural processes. This is an account of the development of working class consciousness founded on the rather suprising model of St Paul and the Damascus Road.

Let us undertake a little excavation work of our own. Marx did not assume that, because Hegel was the summit of speculative bourgeois thought, and because the 'Hegelians' vulgarized and etherealized his thought, that Hegel was therefore not a thinker to be reckoned with, a figure worth learning from. More so with classical political economy, from Smith to Ricardo, where again the distinctions between different levels of an ideological formation are important. There is classical political economy which Marx calls 'scientific'; its vulgarizers engaged in 'mere apologetics'; and the 'everyday consciousness' in which practical bourgeois entrepreneurs calculate their odds informed by, but utterly unconscious (until Thatcherism appeared) of, Ricardo's or Adam Smith's advanced thoughts on the subject. Even more instructive is Marx's insistence that (a) classical political economy was a powerful, substantial scientific body of work, which (b) *nevertheless*, contained an essential ideological limit, a distortion. This distortion was not, according to Marx, anything directly to do with technical errors or absences in their argument, but with a broader prohibition. Specifically, the distorted or ideological features arose from the fact that they *assumed* the categories of bourgeois political economy as the foundations of all economic calculation, refusing to see the historical determinacy of their starting-points and premises; and, at the other end, from the assumption that, with capitalist production, economic development had achieved, not simply its highest point to date (Marx agreed with that), but its final conclusion and apogee. There could be no new forms of economic relations after it. Its forms and relations would go on forever. The distortions, to be precise, within bourgeois theoretical ideology at its more 'scientific' were, nevertheless, real and substantial. They did not destroy many aspects of its validity – hence it was not 'false' simply because it was confined within the limits and horizon of bourgeois thought. On the other hand the distortions limited its scientific validity, its capacity to advance beyond certain points, its ability to resolve its own internal contradictions, its power to think outside the skin of the social relations reflected in it.

Now this relation between Marx and the classical political economists

represents a far more complex way of posing the relation between 'truth' and 'falsehood' *inside* a so-called scientific mode of thought, than many of Marx's critics have assumed. Indeed, critical theorists, in their search for greater theoretical vigour, an absolute divide between 'science' and 'ideology' and a clean epistemological break between 'bourgeois' and 'non-bourgeois' ideas, have done much themselves to simplify the relations which Marx, not so much argued, as established in practice (i.e., in terms of how he actually used classical political economy as both a support and adversary). We can rename the specific 'distortions', of which Marx accused political economy, to remind us later of their general applicability. Marx called them the *eternalization* of relations which are in fact historically specific; and the *naturalization* effect – treating what are the products of a specific historical development as if universally valid, and arising not through historical processes but, as it were, from Nature itself.

We can consider one of the most contested points – the 'falseness' or distortions of ideology, from another standpoint. It is well known that Marx attributed the spontaneous categories of vulgar bourgeois thought to its grounding in the 'surface forms' of the capitalist circuit. Specifically, Marx identified the importance of the market and market exchange, where things were sold and profits made. This approach, as Marx argued, left aside the critical domain – the 'hidden abode' – of capitalist production itself. Some of his most important formulations flow from this argument.

In summary, the argument is as follows. Market exchange is what appears to govern and regulate economic processes under capitalism. Market relations are sustained by a number of elements and these appear (are represented) in every discourse which tries to explain the capitalist circuit from this standpoint. The market brings together, under conditions of equal exchange, consumers and producers who do not – and need not, given the market's 'hidden hand' – know one another. Similarly, the *labour* market brings together those who have something to sell (labour power) and those who have something to buy with (wages): a 'fair price' is struck. Since the market works, as it were, by magic, harmonizing needs and their satisfaction 'blindly', there is no compulsion about it. We can 'choose' to buy and sell, or not (and presumably take the consequences: though this part is *not* so well represented in the discourses of the market, which are more elaborated on the *positive* side of market-choice than they are on its *negative* consequences). Buyer or seller need not be driven by goodwill, or love of his neighbour or fellow-feeling to succeed in the market game. In fact, the market works best if each party to the transaction consults only his or her self-interest directly. It is a system driven by the real and practical imperatives of self-interest. Yet it achieves satisfaction of a kind, all round. The capitalist hires his labour and makes his profit; the landlord lets his property and gets a rent; the worker gets her wages and thus can buy the goods she needs.

Now market-exchange also 'appears' in a rather different sense. It is the part of the capitalist circuit which everyone can plainly *see*, the bit we all experience daily. Without buying and selling, in a money economy, we would all physically and socially come to a halt very quickly. Unless we are deeply involved in other aspects of the capitalist process, we would not necessarily know much about the other parts of the circuit which are necessary if capital is to be valorized and if the whole process is to reproduce itself and expand. And yet, unless commodities are produced there is nothing to sell; and – Marx argued, at any rate – it is first in production itself that labour is exploited. Whereas the kind of 'exploitation' which a market-ideology is best able to see and grasp is 'profiteering' – taking too big a rake-off on the market price. So the market is the part of the system which is universally encountered and experienced. It is the obvious, the visible part: the part which constantly *appears*.

Now, if you extrapolate from this generative set of categories, based on market exchange, it is possible to extend it to other spheres of social life, and to see them as, also, constituted on a similar model. And this is precisely what Marx, in a justly famous passage, suggests happens:

> This sphere that we are deserting, within whose boundaries the sale and purchase power of labour-power goes on, is in fact a very Eden of the innate rights of man. There alone rule Freedom, Equality, Property and Bentham. Freedom, because both buyer and seller of a commodity, say of labour-power, are constrained only by their own free will. They contract as free agents, and the agreement they come to, is but the form in which they give legal expression to their common will. Equality, because each enters into relation with the other, as with a simple owner of commodities, and they exchange equivalent for equivalent. Property, because each disposes only of what is his own. And Bentham, because each looks only to himself. The only force that brings them together and puts them in relation with each other, is the selfishness, the gain and the private interests of each.
>
> (Marx, 1967: 176)

In short, our ideas of 'Freedom', 'Equality', 'Property' and 'Bentham' (that is, Individualism) – the ruling ideological principles of the bourgeois lexicon, and the key political themes which, in our time, have made a powerful and compelling return to the ideological stage under the auspices of Mrs Thatcher and neo-liberalism – may derive from the categories we use in our practical, commonsense thinking about the market economy. This is how there arises, out of daily, mundane experience the powerful categories of bourgeois legal, political, social and philosophical thought.

This is a critical *locus classicus* of the debate; from this Marx extrapolated several of the theses which have come to form the contested territory of the theory of ideology. First, he established as a *source* of

'ideas' a particular point or moment of the economic circuit of capital. Second, he demonstrates how the translation from the economic to ideological categories can be effected; from the 'market exchange of equivalents' to the bourgeois notions of 'Freedom' and 'Equality'; from the fact that each must possess the means of exchange to the legal categories of property rights. Third, he defines in a more precise manner what he means by 'distortion'. For this 'taking off' from the exchange point of the recircuit of capital is an ideological process. It 'obscures, hides, conceals' – the terms are all in the text – another set of relations: the relations, which do *not* appear on the surface but are concealed in the 'hidden abode' of production (where property, ownership, the exploitation of waged labour and the expropriation of surplus value all take place). The ideological categories 'hide' this underlying reality, and *substitute* for all that the 'truth' of market relations. In many ways, then, the passage contains all the so-called cardinal sins of the classical marxist theory of ideology rolled into one: economic reductionism, a too simple correspondence between the economic and the political ideological; the true v. false, real v. distortion, 'true' consciousness v. false consciousness distinctions.

However, it also seems to me possible to 're-read' the passage from the standpoint of many contemporary critiques in such a way as (a) to retain many of the profound insights of the original, while (b) expanding it, using some of the theories of ideology developed in more recent times.

Capitalist production is defined in Marx's terms as a circuit. This circuit explains not only production and consumption, but *re*production – the ways in which the conditions for keeping the circuit moving are sustained. Each moment is vital to the generation and realization of value. Each establishes certain determinate conditions for the other – that is, each is dependent on or determinate for the other. Thus, if some part of what is realized through sale is not paid as wages to labour, labour cannot reproduce itself, physically and socially, to work and buy again another day. This 'production', too, is dependent on 'consumption'; even though in the analysis Marx tends to insist on the prior analytic value to be accorded to the relations of *production*. (This in itself has had serious consequences, since it has led marxists not only to prioritize 'production' but to argue as if the moments of 'consumption and exchange' are of no value or importance to the theory – a fatal, one-side productivist reading.)

Now this circuit can be construed, ideologically, in different ways. This is something which modern theorists of ideology insist on, as against the vulgar conception of ideology as arising from a fixed and unalterable relation between the economic relation and how it is 'expressed' or represented in ideas. Modern theorists have tended to arrive at this break with a simple notion of economic determinacy over ideology through their borrowing from recent work on the nature of language and discourse. Language is the medium *par excellence* through which things are

'represented' in thought and thus the medium in which ideology is generated and tranformed. But in language, the same social relation can be *differently* represented and construed. And this is so, they would argue, because language by its nature is *not fixed* in a one-to-one relation to its referent but is 'multi-referential': it can construct different meanings around what is apparently the same social relation or phenomenon.

It may or may not be the case, that, in the passage under discussion, Marx is using a fixed, determinate and unalterable relationship between market exchange and how it is appropriated in thought. But you will see from what I have said that I do not believe this to be so. As I understand it, 'the market' means one thing in vulgar bourgeois political economy and the spontaneous consciousness of practical bourgeois men, and quite another thing in marxist economic analysis. So my argument would be that, implicitly, Marx is saying that, in a world where markets exist and market exchange dominates economic life, it would be distinctly odd if there were no *category* allowing us to think, speak and act in relation to it. In *that* sense, all economic categories – bourgeois or marxist – express existing social relations. But I think it *also* follows from the argument that market relations are not always represented by the same categories of thought.

There is no fixed and unalterable relation between what the market is, and how it is construed within an ideological or explanatory framework. We could even say that one of the purposes of *Capital* is precisely to *displace* the discourse of bourgeois political economy – the discourse in which the market is most usually and obviously understood – and to replace it with another discourse, that of the market as it fits into the marxist schema. If the point is not pressed too literally, therefore, the two kinds of approaches to the understanding of ideology are not totally contradictory.

What, then, about the 'distortions' of bourgeois political economy as an ideology? One way of reading this is to think that, since Marx calls bourgeois political economy 'distorted', it must be *false*. Thus those who live their relation to economic life exclusively within its categories of thought and experience are, by definition, in 'false consciousness'. Again, we must be on our guard here about arguments too easily won. For one thing, Marx makes an important distinction between 'vulgar' versions of political economy and more advanced versions, like that of Ricardo, which he says clearly, 'has scientific value'. But, still, what can he mean by 'false' and 'distorted' in this context?

He cannot mean that 'the market' does not exist. In fact, it is *all too real*. It is the very life-blood of capitalism, from one viewpoint. Without it capitalism would never have broken through the framework of feudalism; and without its ceaseless continuation, the circuits of capital would come to a sudden and disastrous halt. I think we can only make sense of

these terms if we think of giving an account of an economic circuit, which consists of several interconnected moments, from the vantage point of *one* of those moments alone. If, in our explanation, we privilege one moment only, and do not take account of the differentiated whole or 'ensemble' of which it is a part; or if we use categories of thought, appropriate to one such moment alone, to explain the whole process; then we are in danger of giving what Marx would have called (after Hegel) a 'one-sided' account.

One-sided explanations are always a distortion. Not in the sense that they are a lie about the system, but in the sense that a 'half-truth' cannot be the whole truth about anything. With those ideas, you will always represent a part of the whole. You will thereby produce an explanation which is only *partially* adequate – and in that sense, 'false'. Also, if you use only 'market categories and concepts' to understand the capitalist circuit as a whole, there are literally many aspects of it which you cannot see. In that sense, the categories of market exchange obscure and mystify our understanding of the capitalist process: that is they do not enable us to see or formulate other aspects invisible.

Is the worker who lives his or her relation to the circuits of capitalist production exclusively through the categories of a 'fair price' and a 'fair wage', in 'false consciousness'? Yes, if by that we mean there is something about her situation which she cannot grasp with the categories she is using; something about the process as a whole which is systematically hidden because the available concepts only give her a grasp of one of its many-sided moments. No, if by that we mean that she is utterly deluded about what goes on under capitalism.

The falseness therefore arises, not from the fact that the market is an illusion, a trick, a sleight-of-hand, but only in the sense that it is an *inadequate* explanation of a process. It has also substituted one part of the process for the whole – a procedure which, in linguistics, is known as 'metonymy' and in anthropology, psychoanalysis and (with special meaning) in Marx's work, as *fetishism*. The other 'lost' moments of the circuit are, however, unconscious, not in the Freudian sense, because they have been repressed from consciousness, but in the sense of being invisible, given the concepts and categories we are using.

This also helps to explain the otherwise extremely confusing terminology in *Capital*, concerning what 'appears on the surface' (which is sometimes said to be 'merely phenomenal': i.e., not very important, not the real thing); and what lies 'hidden beneath', and is embedded in the structure, not lying about the surface. It is crucial to see, however – as the market exchange/production example makes clear – that 'surface' and 'phenomenal' do not mean false or illusory, in the ordinary sense of the words. The market is no more or less 'real' than other aspects – production for example. In Marx's terms production is only where, analytically, we ought to start the analysis of the circuit: 'the act through which the whole process

again runs its course' (Marx, 1971). But production is not independent of the circuit, since profits made and labour hired in the market must flow back into production. So, 'real' expresses only some theoretical primacy which marxist analysis gives to production. In any other sense, market exchange is as much a real process materially, and an absolutely 'real' requirement of the system – as any other part: they are all 'moments of one process' (Marx, 1971).

There is also a problem about 'appearance' and 'surface' as terms. Appearances may connote something which is 'false': surface forms do not seem to run as deep as 'deep structures'. These linguistic connotations have the unfortunate effect of making us rank the different moments in terms of their being more/less real, more/less important. But from another viewpoint, what is on the surface, what constantly appears, is what we are always seeing, what we encounter daily, what we come to take for granted as the obvious and manifest form of the process. It is not surprising, then, that we come spontaneously to *think* of the capitalist system in terms of the bits of it which constantly engage us, and which so manifestly announce their presence. What chance does the extraction of 'surplus labour' have, as a concept, as against the hard fact of wages in the pocket, savings in the bank, pennies in the slot, money in the till. Even the nineteenth-century economist, Nassau Senior, couldn't actually put his hand on the hour in the day when the worker worked for the surplus and not to replace his or her own subsistence.

In a world saturated by money exchange, and everywhere mediated by money, the 'market' experience is *the* most immediate, daily and universal experience of the economic system for everyone. It is therefore not surprising that we take the market for granted, do not question what makes it possible, what it is founded or premissed on. It should not surprise us if the mass of working people don't possess the concepts with which to cut into the process at another point, frame another set of questions, and bring to the surface or reveal what the overwhelming facticity of the market constantly renders invisible. It is clear why we should generate, out of these fundamental categories for which we have found everyday words, phrases and idiomatic expressions in practical consciousness, the *model* of other social and political relations. After all, they too belong to the same system and appear to work according to its protocols. Thus we see, in the 'free choice' of the market, the material symbol of the more abstract freedoms; or in the self-interest and intrinsic competitiveness of market advantage the 'representation' of something natural, normal and universal about human nature itself.

Let me now draw some tentative conclusions from the 're-reading' I have offered about the meaning of Marx's passage in the light of more recent critiques and the new theories advanced.

The analysis is no longer organized around the distinction between the

'real' and the 'false'. The obscuring or mystifying effects of ideology are no longer seen as the product of a trick or magical illusion. Nor are they simply attributed to false consciousness, in which our poor, benighted, untheoretical proletarians are forever immured. The relations in which people exist are the 'real relations' which the categories and concepts they use help them to grasp and articulate in thought. But – and here we may be on a route contrary to emphasis from that with which 'materialism' is usually associated – the economic relations themselves cannot prescribe a single, fixed and unalterable way of conceptualizing it. It can be 'expressed' within different ideological discourses. What's more, these discourses can employ the conceptual model and transpose it into other, more strictly 'ideological', domains. For example, it can develop a discourse – e.g. latter-day monetarism – which deduces the grand value of 'Freedom' from the freedom from compulsion which brings men and women, once again, every working day, into the labour market. We have also by-passed the distinction 'true' and 'false', replacing them with other, more accurate terms: like 'partial' and 'adequate', or 'one-sided' and 'in its differentiated totality'. To say that a theoretical discourse allows us to grasp a concrete relation 'in thought' adequately means that the discourse provides us with a more complete grasp of all the different relations of which that relation is composed, and of the many determinations which form its conditions of existence. It means that our grasp is concrete and whole, rather than a thin, one-sided abstraction. One-sided explanations, which are partial, part-for-the-whole, types of explanations, and which allow us only to abstract one element out (the market, for example) and explain that they arc inadequate *precisely on those grounds*. For that reason alone, they may be considered 'false'. Though, strictly speaking, the term is misleading if what we have in mind is some simple, all-or-nothing distinction between the True and the False, or between Science and Ideology. Fortunately or unfortunately, social explanations rarely fall into such neat pigeonholes.

In our 're-reading', we have also attempted to take on board a number of secondary propositions, derived from the more recent theorizing about 'ideology' in an effort to see how incompatible they are with Marx's formulation. As we have seen, the explanation relates to concepts, ideas, terminology, categories, perhaps also images and symbols (money; the wage packet; freedom) which allow us to grasp some aspect of a social process *in thought*. These enable us to represent to ourselves and to others how the system works, why it functions as it does.

The same process – capitalist production and exchange – can be expressed within a different ideological framework, by the use of different 'systems of representation'. There is the discourse of 'the market', the discourse of 'production', the discourse of 'the circuits': each produces a different definition of the system. Each also locates us differently – as

worker, capitalist, wage worker, wage slave, producer, consumer, etc. Each thus *situates us* as social actors or as a member of a social group in a particular relation to the process and prescribes certain social identities for us. The ideological categories in use, in other words, *position us* in relation to the account of the process as depicted in the discourse. The worker who relates to his or her condition of existence in the capitalist process as 'consumer' – who enters the system, so to speak, through that gateway – participates in the process by way of a different practice from those who are inscribed in the system as 'skilled labourer' – or not inscribed in it at all, as 'housewife'. All these inscriptions have effects which are real. They make a material difference, since how we act in certain situations depends on what our definitions of the situation are.

I believe that a similar kind of 're-reading' can be made in relation to another set of propositions about ideology which has in recent years been vigorously contested: namely, the class-determination of ideas and the direct correspondences between 'ruling ideas' and 'ruling classes'. Laclau (1977) has demonstrated definitively the untenable nature of the proposition that classes, as such, are the subjects of fixed and ascribed class ideologies. He has also dismantled the proposition that particular ideas and concepts 'belong' exclusively to one particular class. He demonstrates, with considerable effect, the failure of any social formation to correspond to this picture of ascribed class ideologies. He argues cogently why the notion of particular ideas being fixed permanently to a particular class is antithetical to what we now know about the very nature of language and discourse. Ideas and concepts do not occur, in language or thought, in that single, isolated, way with their content and reference irremovably fixed. Language in its widest sense is the vehicle of practical reasoning, calculation and consciousness, because of the ways by which certain meanings and references have been historically secured. But its cogency depends on the 'logics' which connect one proposition to another in a chain of connected meanings; where the social connotations and historical meaning are condensed and reverberate off one another. Moreover, these chains are never permanently secured, either in their internal systems of meanings, or in terms of the social classes and groups to which they 'belong'. Otherwise, the notion of ideological struggle and the transformations of consciousness – questions central to the politics of any marxist project – would be an empty sham, the dance of dead rhetorical figures.

It is precisely because language, the medium of thought and ideological calculation, is 'multi-accentual', as Volosinov put it, that the field of the ideological is always a field of 'intersecting accents' and the 'intersecting of differently oriented social interests':

> Thus various different classes will use one and the same language. As a result differently orientated accents intersect in every ideological sign.

Sign becomes the arena of the class struggle . . . A sign that has been withdrawn from the pressures of the social struggle – which, so to speak, crosses beyond the pale of class struggle, inevitably loses force, degenerating into allegory and becoming the object not of live social intelligibility but of philological comprehension.

(Volosinov, 1973: 23)

This approach replaces the notion of fixed ideological meanings and class-ascribed ideologies with the concepts of ideological terrains of struggle and the task of ideological transformation. It is the general movement in this direction, away from an abstract general theory of ideology, and towards the more concrete analysis of how, in particular historical situations, ideas 'organize human masses, and create the terrain on which men move, acquire consciousness of their position, struggle, etc.,' which makes the work of Gramsci (from whom that quotation (1971) is taken) a figure of seminal importance in the development of marxist thinking in the domain of the ideological.

One of the consequences of this kind of revisionist work has often been to destroy altogether the *problem* of the class structuring of ideology and the ways in which ideology intervenes in social struggles. Often this approach replaces the inadequate notions of ideologies ascribed in blocks to classes with an equally unsatisfactory 'discursive' notion which implies total free floatingness of all ideological elements and discourses. The image of great, immovable class battalions heaving their ascribed ideological luggage about the field of struggle, with their ideological number-plates on their backs, as Poulantzas once put it, is replaced here by the infinity of subtle variations through which the elements of a discourse appear spontaneously to combine and recombine with each other, without material constraints of any kind other than that provided by the discursive operations themselves.

Now it is prefectly correct to suggest that the concept 'democracy' does not have a totally fixed meaning, which can be ascribed exclusively to the discourse of bourgeois forms of political representation. 'Democracy' in the discourse of the 'Free West' does not carry the same meaning as it does when we speak of 'popular-democratic' struggle or of deepening the democratic content of political life. We cannot allow the term to be wholly expropriated into the discourse of the right. Instead, we need to develop a strategic contestation around the concept itself. Of course, this is no mere 'discursive' operation. Powerful symbols and slogans of that kind, with a powerfully positive political charge, do not swing about from side to side in language or ideological representation alone. The expropriation of the concept has to be contested through the development of a series of polemics, through the conduct of particular forms of ideological struggle: to detach one meaning of the concept from the domain of public

consciousness and supplant it within the logic of another political discourse. Gramsci argued precisely that ideological struggle does not take place by displacing one whole, integral, class-mode of thought with another wholly-formed system of ideas:

> What matters is the criticism to which such an ideological complex is subjected by the first representatives of the new historical phase. This criticism makes possible a process of differentiation and change in the relative weight that the elements of the old ideological used to possess. What was previously secondary and subordinate, or even incidental, is now taken to be primary – becomes the nucleus of a new ideological and theoretical complex. The old collective will dissolves into its contradictory elements since the subordinate ones develop socially, etc.
> (Gramsci, 1971: 195)

In short, his is a 'war of position' conception of ideological struggle. It also means articulating the different conceptions of 'democracy' within a whole chain of associated ideas. And it means articulating this process of ideological de-construction and re-construction to a set of organized political positions, and to a particular set of social forces. Ideologies do not become effective as a material force because they emanate from the needs of fully-formed social classes. But the reverse is also true – though it puts the relationship between ideas and social forces the opposite way round. No ideological conception can ever become materially effective unless and until it *can* be articulated to the field of political and social forces and to the struggles between different forces at stake.

Certainly, it is not necessarily a form of vulgar materialism to say that, though we cannot ascribe ideas to class position in certain fixed combinations, ideas *do* arise from and *may reflect* the material conditions in which social groups and classes exist. In that sense – i.e. historically – there may well be certain *tendential alignments* – between, say, those who stand in a 'corner shop' relation to the processes of modern capitalist development, and the fact that they may therefore be predisposed to imagine that the whole advanced economy of capitalism can be conceptualized in this 'corner shop' way. I think this is what Marx meant in the *Eighteenth Brumaire* when he said that it was not necessary for people actually to make their living as members of the old petty bourgeoisie for them to be attracted to petty bourgeois ideas. Nevertheless, there was, he suggested, some relationship, or tendency, between the objective position of that class fraction, and the limits and horizons of thought to which they would be 'spontaneously' attracted. This was a judgement about the 'characteristic forms of thought' appropriate as an ideal-type to certain positions in the social structure. It was definitely not a simple equation in actual historical reality between class position and ideas. The point about 'tendential historical relations' is that there is nothing inevitable, necessary or fixed

forever about them. The tendential lines of forces define only the *givenness* of the historical terrain.

They indicate how the terrain has been structured, historically. Thus it is perfectly possible for the idea of 'the nation' to be given a progressive meaning and connotation, embodying a national-popular collective will, as Gramsci argued. Nevertheless, in a society like Britain, the idea of 'nation' has been consistently articulated towards the right. Ideas of 'national identity' and 'national greatness' are intimately bound up with imperial supremacy, tinged with racist connotations, and underpinned by a four-century-long history of colonization, world market supremacy, imperial expansion and global destiny over native peoples. It is therefore much more difficult to give the notion of 'Britain' a socially radical or democratic reference. These associations are not given for all time. But they are difficult to break because the ideological terrain of this particular social formation has been so powerfully structured in that way by its previous history. These historical connections define the ways in which the ideological terrain of a particular society has been mapped out. They are the 'traces' which Gramsci (1971) mentioned: the 'stratified deposits in popular philosophy' (324), which no longer have an inventory, but which establish and define the fields along which ideological struggle is *likely* to move.

That terrain, Gramsci suggested, was above all the terrain of what he called 'common sense': a historical, not a natural or universal or spontaneous form of popular thinking, necessarily 'fragmentary, disjointed and episodic'. The 'subject' of common sense is composed of very contradictory ideological formations:

> it contains Stone Age elements and principles of a more advanced science, prejudices from all past phases of history at the local level and intuitions of a future philosophy which will be that of a human race united the world over.

> (324)

And yet, because this network of pre-existing traces and common-sense elements constitutes the realm of practical thinking for the masses of the people, Gramsci insisted that it was precisely on this terrain that ideological struggle most frequently took place. 'Common sense' became one of the stakes over which ideological struggle is conducted. Ultimately, 'The relation between common sense and the upper level of philosophy is assured by "politics" . . .' (331).

Ideas only become effective if they do, in the end, *connect* with a particular constellation of social forces. In that sense, ideological struggle is a part of the general social struggle for mastery and leadership – in short for hegemony. But 'hegemony' in Gramsci's sense requires, not the simple escalation of a whole class to power, with its fully formed 'philosophy', but

the *process* by which a historical bloc of social forces is constructed and the ascendancy of that bloc secured. So the way we conceptualize the relationship between 'ruling ideas' and 'ruling classes' is best thought in terms of the processes of 'hegemonic domination'.

On the other hand, to abandon the question or problem of 'rule' – of hegemony, domination and authority – because the ways in which it was originally posed are unsatisfactory is to cast the baby out with the bathwater. Ruling ideas are not guaranteed their dominance by their already given coupling with ruling classes. Rather, the effective coupling of dominant ideas *to* the historical bloc which has acquired hegemonic power in a particular period is what the process of ideological struggle is *intended to secure*. It is the object of the exercise, not the playing out of an already written and concluded script.

It will be clear that, although the argument has been conducted in connection with the problem of ideology, it has much wider ramifications for the development of marxist theory as a whole. The general question at issue is a particular conception of 'theory': theory as the working out of a set of guarantees. What is also at issue is a particular definition of 'determination'. It is clear from the 'reading' I offered earlier that the economic aspect of capitalist production processes has real limiting and constraining effects (i.e. determinancy), for the categories in which the circuits of production are *thought*, ideologically, and vice versa. The economic provides the repertoire of categories which will be used, in thought. What the economic cannot do is (a) to provide the *contents* of the particular thoughts of particular social classes or groups at any specific time; or (b) to fix or guarantee for all time which ideas will be made use of by which classes. The determinancy of the economic for the ideological can, therefore, be only in terms of the former setting the limits for defining the terrain of operations, establishing the 'raw materials', of thought. Material circumstances are the net of constraints, the 'conditions of existence' for practical thought and calculation about society.

This is a different conception of 'determinancy' from that which is entailed by the normal sense of 'economic determinism', or by the expressive totality way of conceiving the relations between the different practices in a social formation. The relations between these different levels are, indeed, *determinate*: i.e. mutually determining. The structure of social practices – the ensemble – is therefore neither free-floating nor immaterial. But neither is it a transitive structure, in which its intelligibility lies exclusively in the one-way transmission of effects from base upwards. The economic *cannot* effect a final closure on the domain of ideology, in the strict sense of always guaranteeing a result. It cannot always secure a particular set of correspondences or always deliver particular modes of reasoning to particular classes according to their place within its sytem. This is precisely because (a) ideological categories are developed,

generated and transformed according to their own laws of development and evolution; though, of course, they are generated *out* of given materials. It is also because (b) of the necessary 'openness' of historical development to practice and struggle. We have to acknowledge the real indeterminancy of the political – the level which condenses all the other levels of practice and secures their functioning in a particular system of power.

This relative openness or relative indeterminancy is necessary to marxism itself as a theory. What is 'scientific' about the marxist theory of politics is that it seeks to understand the limits to political action given by the terrain on which it operates. This terrain is defined, not by forces we can predict with the certainty of natural science, but by the existing balance of social forces, the specific nature of the concrete conjuncture. It is 'scientific' because it understands itself as determinate; and because it seeks to develop a practice which is theoretically informed. But it is *not* 'scientific' in the sense that political outcomes and the consequences of the conduct of political struggles are foreordained in the economic stars.

Understanding 'determinancy' in terms of setting of limits, the establishment of parameters, the defining of the space of operations, the concrete conditions of existence, the 'givenness' of social practices, rather than in terms of the absolute predictability of particular outcomes, is the only basis of a 'marxism without final guarantees'. It establishes the *open horizon* of marxist theorizing – determinancy without guaranteed closures. The paradigm of perfectly closed, perfectly predictable, systems of thought is religion or astrology, not science. It would be preferable, from this perspective, to think of the 'materialism' of marxist theory in terms of 'determination by the economic in the *first* instance', since marxism is surely correct, against all idealisms, to insist that no social practice or set of relations floats free of the determinate effects of the concrete relations in which they are located. However, 'determination in the last instance' has long been the repository of the lost dream or illusion of theoretical *certainty*. And this has been bought at considerable cost, since certainty stimulates orthodoxy, the frozen rituals and intonation of already witnessed truth, and all the other attributes of a theory that is incapable of fresh insights. It represents the end of the *process of theorizing*, of the development and refinement of new concepts and explanations which, alone, is the sign of a living body of thought, capable still of engaging and grasping something of the truth about new historical realities.

REFERENCES

Althusser, L. (1969) *For Marx*, London: Allen Lane.
——— (1971) *Lenin and Philosophy*, London: New Left Books.
——— (1976) *Essays in Self-Criticism*, London: New Left Books.

——— and Balibar, E. (1970) *Reading Capital*, London: New Left Books.
Anderson, P. (1976) *Considerations on Western Marxism*, London: New Left Books.
Gramsci, A. (1971) *Selections from the Prison Notebooks*, New York: International Publishers.
Laclau, E. (1977) *Politics and Ideology in Marxist Theory*, London: New Left Books.
Marx, K. (1967) *Capital*, vol. 1, New York: International Publishers.
——— (1970) *A Contribution to the Critique of Political Economy*, New York: International Publishers.
——— (1971) *Grundrisse*, New York: Harper & Row.
Volosinov, V. (1973) *Marxism and the Philosophy of Language*, New York: Seminar Press.

Chapter 2

Stuart Hall and the marxist concept of ideology

Jorge Larrain

INTRODUCTION

That one cannot find agreement about the marxist concept of ideology is hardly surprising or news anymore. The disagreements affect almost every aspect of the concept: its content, its effectivity and its epistemological status which is manifest in a range of questions. Is ideology subjective and ideal (created by and existing in the minds of individuals) or objective and material (existing in material apparatuses and its practices)? Is ideology a determined and epiphenomenal superstructure or an autonomous discourse with its own effectivity capable of constituting subjects? Is ideology negative and critical (a distortion or inversion) or neutral (the articulated discourse of a class, fraction or party)? Do ideological elements possess an inherent class character or are they neutral and capable of being articulated to various classes? These questions continue to haunt theoretical discussion and have hardly received a unanimous answer. I do not think this lack of theoretical agreement, confusing as it may be, should be considered so intolerable as to prompt a desperate search for *the* marxist concept of ideology. Even if one wanted to do that one would find it impossible, simply because one has to accept the fact that there are several major traditions within marxism which construct different concepts of ideology. However, it is important critically to analyse and confront these different approaches and their particular claims to explaining aspects of social reality, not only with a view to showing which is most adequate but also to explore whether they are complementary in any way.

In part this reflection has been motivated by reading Stuart Hall's[1] article 'The toad in the garden: Thatcherism among the theorists' (1988a), which seems to claim the practical superiority of a particular conception of ideology in the explanation of Thatcherism. Hall tries to show that there is one interpretation of ideology (a neutral version of Gramscian,

Reprinted from *Theory, Culture & Society* (London, Newbury Park and New Delhi: Sage), 8 (1991), 1–28.

Althusserian and Laclauian inspiration) which best accounts for the
Thatcherite ideological phenomenon, whereas there is another ('the
"classic variant" of the marxist theory of ideology, such as we find in
or derive from Marx and Engels' *German Ideology*') which cannot
adequately explain it (Hall, 1988a: 41). The purpose of this article is
to examine this claim, but more importantly, through it, to compare the
analytical capabilities of the neutral and critical versions of the marxist
concept of ideology as represented by Hall in the first case and by my
interpretation of Marx in the second. It must be clear therefore that my
aim is not a critique of Hall's analysis of Thatcherism nor a systematic
critique of Thatcherism from the point of view of Marx's concept of
ideology, although I shall claim that this can and must be done in
addition to, and not instead of Hall's analyses.

POLITICS AS ARTICULATION AND IDEOLOGY AS INTERPELLATION

The tradition which Hall represents within marxism can be traced back to
Althusser through the mediation of the early Laclau.[2] Together with other
Althusserians like Mepham, Poulantzas, Godelier and Pêcheux, Laclau and
Hall criticize the notion of false consciousness and start from the premise
that it is not the subject that produces ideology as ideas but it is ideology,
conceived as a material instance of practices and rituals, that constitutes the
subject. Yet whereas the former maintain the negative conception of
ideology present in the early Althusser and emphasize the idea of ideology
as an 'imaginary transposition', its opposition to science, and the fact that it
interpellates individuals as subjects in a fundamental misrecognition which
helps reproduce the domination system, the latter are unambiguously
critical of Althusser's shortcomings and selectively synthetic in trying
theoretically to fuse what was best in his approach with a Gramscian
perspective. Laclau and Hall know Marx very well and, at least at the
beginning, want to develop their theories within marxism, but do not
hesitate in abandoning both the original marxian negative concept of
ideology and Althusser's early negative version. The idea of a theory
of ideology 'in general', the exclusive functional role of ideology as
reproducing production relations and the opposition between science
and ideology are discarded and class struggle is reinserted at the centre
of the problematic of ideology.

Yet this reinsertion is carried out in a way which entails a renewed
attempt to depart from essentialism and class reductionism. The principles
of this attempt are, first, that difference cannot be reduced to identity and
therefore social totality cannot be conceived as constituted by a basic
contradiction which manifests or expresses itself at all levels but must be
thought of as 'a unity which is constructed through the *differences* between,

rather than the homology of, practices' (Hall, 1981b: 32); and second, that although not every contradiction in society can be reduced to a class contradiction, 'every contradiction is overdetermined by class struggle' (Laclau, 1977: 108). Laclau starts by establishing against Althusser that ideology cannot be simultaneously a level of any social formation and the opposite to science. So he decides to abandon the negative connotation of the concept (1977: 101n). Hall underlines this point by defining ideology as 'those images, concepts and premises which provide the frameworks through which we represent, interpret, understand and "make sense" of some aspect of social existence' (Hall, 1981a: 31). Three aspects of this conception are highlighted. 'First, ideologies do not consist of isolated and separate concepts, but in the articulation of different elements into a distinctive set or chain of meanings' (1981a: 31). 'Second, ideological statements are made by individuals; but ideologies are not the product of individual consciousness or intention. Rather we formulate our intentions *within ideology*' (1981a: 31). 'Third, ideologies "work" by constructing for their subjects (individuals and collective) positions of identification and knowledge which allow them to "utter" ideological truths as if they were their authentic authors' (1981a: 32).

Both Laclau and Hall take Althusser's idea that ideology interpellates individuals as subjects as the basic explanation of how ideology works. Ideologies are not really produced by individual consciousness but rather individuals formulate their beliefs, within positions already fixed by ideology, as if they were their true producers. However, individuals are not necessarily recruited and constituted as subjects obedient to the ruling class, the same mechanism of interpellation operates when individuals are recruited by revolutionary ideologies. Laclau's key insight is that ideologies are made of elements and concepts which have no necessary class belongingness and that these constituent units of ideologies can be articulated to a variety of ideological discourses which represent different classes. The class character of a concept is not given by its content but by its articulation into a class ideological discourse. Hence, there are no 'pure' ideologies which necessarily correspond to certain class interests. Every ideological discourse articulates several interpellations, not all of which are class interpellations. In fact Laclau identifies two possible kinds of antagonism which generate two types of interpellations. At the level of the mode of production there exist class contradictions and class interpellations. At the level of the social formation there are popular-democratic contradictions and interpellations, that is to say, ideological elements which interpellate individuals as 'the people', as the underdog. The idea is that class interpellations work by trying to articulate popular-democratic interpellations to the class ideological discourse:

The popular-democratic interpellation not only has no precise content, but it is the domain of ideological class struggle par excellence. Every

class struggles at the ideological level simultaneously as class and as the people, or rather, tries to give coherence to its ideological discourse by presenting its class objectives as the consummation of popular objectives.

(Laclau, 1977: 108–9)

Whereas Laclau never attempts to ascertain Marx's concept of ideology and the starting-point of his own construction is a critique and elaboration of Althusser, Hall is explicitly aware of Marx's contribution and seeks to assess it (1983). The first problem he confronts is the nature of the 'distortion' it apparently entails. But even before he addresses that problem he has already established his own definition (quoted above) which totally leaves out the idea of distortion. This does not present a problem for Hall because (a) there is no fully developed theory of ideology in Marx; (b) there are severe fluctuations in Marx's use of the term; (c) we *now* use the term 'to refer to *all* organized forms of social thinking'; and (d) 'Marx did, on many occasions, use the term ideology, practically, in this way' (Hall, 1983: 60). However, to his credit, Hall recognizes that most of the time Marx used the term as a critical weapon against other religious, philosophical and economic theories and acknowledges 'the fact . . . that Marx most often used "ideology" to refer specifically to the manifestations of bourgeois thought; and above all to its negative and distorted features' (1983: 61). Having said this, Hall critically examines the theoretical bases of the classical version: (a) ideas arise from and reflect the material conditions; (b) ideas are effects of the economic level; and (c) ruling ideas are the ideas of the ruling class. In spite of showing the insufficiency and problematic nature of these propositions Hall proposes to be constructive, especially in relation to the issue of distortion, and discovers, for instance that the way in which Marx deals with the question of truth and falsehood in relation to classical political economy is far more complex than the critics would have us believe. Distortion in this context would amount to eternalization and naturalization of social relations. Equally, Marx's analysis of the operation of the market and its deceptive appearances provides another source of sophisticated insights into the problem of distortion, this time as 'one-sidedness', 'obscuring' or 'concealment' (Hall, 1983: 67–73).

Ultimately Hall's effort to interpret Marx's notion of distortion aims at bypassing the distinction true–false, that is to say, at excluding from the definition of distortion the connotation of falsehood in the sense of illusion or unreality. In the second place, he aims to show that the 'economic relations themselves cannot prescribe a single, fixed and unalterable way of conceptualizing' reality, but that reality 'can be "expressed" within different ideological discourses' (Hall, 1983: 76). With both of these objectives I can agree except in his calling all discourses 'ideological'. This in itself is symptomatic of a theoretical decision which Hall has

legitimately taken from the beginning but which one can easily lose sight of at this point, namely, the fact that his discussion and partial rescue of the notion of 'distortion' has not been done with a view to adopting Marx's critical concept of ideology. In fact Hall continues to uphold the definition he started with, a definition which leaves out the problem of distortion as inherent in the ideological phenomenon. Nevertheless, his effort to understand and accept the best senses in which Marx spoke of distortions, leaves one the impression that for Hall, at this stage (1983), Marx's critical notion of ideology has a place; it could be partially rescued from the critics even if it is not the way in which Hall himself proposes to deal with or use the concept.

CONFRONTATION BEFORE THE TRIBUNAL OF THATCHERISM

Reading 'The toad in the garden: Thatcherism among the theorists' (1988a) leaves one a different impression. The point here, Hall states at the beginning, is not pure theoretical critique and refutation but to refer theories to the analysis of a concrete political problem, Thatcherism, in order to ascertain which theory is able to give a better account of it. In this practical confrontation the so-called classic variant of the theory of ideology derived from *The German Ideology* is said to be unable adequately to explain the Thatcherite ideological phenomenon whereas some of Althusser's key insights are said to be positively confirmed. One can only conclude from such a comparison that Marx's variant has lost its analytical capabilities to deal with new ideological developments and should therefore be replaced by a better theory. Hall presents four main arguments. First, the basic correspondence between ruling ideas and ruling class postulated by Marx overlooks ideological differences within the dominant classes and the fact that certain ideological formations, like Thatcherism, must vigorously fight against traditional conservative ideas in order to become 'the normative-normalized structure of conceptions through which a class "spontaneously" and authentically thinks or lives its relations to the world' (Hall, 1988a: 42). For Hall,

> the conventional approach suggests that the dominant ideas are ascribed by and inscribed in the position a class holds in the structure of social relations . . . it is not assumed that these ideas should have to win ascendancy . . . through a specific and contingent . . . process of ideological struggle.

> (1988a: 42)

The critique which Poulantzas (1976: 202) and Laclau (1977: 160–1) make of the classical marxist theory for conceiving of ideology as the 'number-plates' on the back of social classes and for arguing that each ideological

element or concept has a necessary class belongingness, expresses similar concerns.

Second, 'in the classical perspective, Thatcherism would be understood as in no significant way different from traditional conservative ruling ideas'. But Thatcherism for Hall is 'a quite distinct, specific and novel combination of ideological elements' (1988a: 42) which, although it integrates some elements of traditional Toryism, does so in a radically new way. Third, the classical theory of ideology can only explain the penetration and success of the ruling ideas within the working class by recourse to false consciousness. The popular classes are duped by the dominant classes, temporarily ensnared against their material interests by a false structure of illusions, which would be dispelled as real material factors reassert themselves. But this has failed during Thatcherism because 'mass unemployment has taken a much longer time than predicted to percolate mass consciousness.' 'The unemployed . . . are still by no means automatic mass converts to labourism, let alone socialism' (1988a: 43). False consciousness

> assumes an empiricist relation of the subject to knowledge, namely that the real world indelibly imprints its meanings and interests directly into our consciousness. We have only to look to discover its truths. And if we cannot see them, then it must be because there is a cloud of unknowing that obscures the unilateral truth of the real.
>
> (1988a: 44)

In contrast to this view Hall argues that

> the first thing to ask about an 'organic ideology' that, however unexpectedly, succeeds in organizing substantial sections of the masses and mobilizing them for political action, is not what is *false* about it but what about it is *true*. By 'true' I do not mean universally correct as a law of the universe but 'makes good sense'.
>
> (1988a: 46)

Fourth,

> it is a highly unstable theory about the world which has to assume that vast numbers of ordinary people, mentally equipped in much the same way as you or I, can simply be thoroughly and systematically duped into misrecognizing entirely where their real interests lie. Even less acceptable is the position that, whereas they, the masses are the dupes of history, we – the privileged – are somehow without a trace of illusion and can see right through into the truth, the essence, of a situation.
>
> (1988a: 44)

What can one say about these arguments? First of all, one must recognize that they are not at all new and that Hall had already expressed them in

other contexts, even within the same article where he dealt at length with Marx's notion of distortion (1983). However, the celebratory context of that article and the careful scrutiny of Marx's texts allowed a far more balanced outcome. In the new version (1988a), before the tribunal of Thatcherism, the criticisms take over completely and very little of Marx's theory seems to be worth saving. Second, Hall's arguments against the classical variant show some confusion in that a flawed neutral concept of leninist origin seems to be conflated with Marx's negative concept. Third, although Hall is careful to state that his criticisms are no reason to throw over some of the insights of the classical marxist explanation (1988a: 44), his account of such insights is insufficient and rather partial (only a couple of paragraphs) whereas the accent is put overwhelmingly on the fact that Thatcherism has positively confirmed Althusser's key insights. In examining Hall's arguments I shall try to demonstrate three main points. First, that Hall's approach to ideology is important and necessary to the analysis of Thatcherism and indeed of any 'ideology' which succeeds in attracting widespread support. Second, that important and necessary as that analysis may be, it is still partial and limited, and must be complemented by the critical approach. Third, that Marx's theory of ideology is also indispensable to the analysis of Thatcherism although from a different point of view.

First, one can agree with Hall that the ideological unity of classes is non-existent and that Thatcherism had to fight to gain ideological ascendancy within the ruling classes, let alone the dominated ones. But this assertion presupposes a concept of ideology which is different from Marx's. For Marx ideology was not equivalent to 'the ruling ideas', nor, for that matter, to 'those images, concepts and premises which provide the frameworks through which we represent, understand and make sense of some aspects of social existence', as Hall prefers to put it. Marx did not speak of class ideologies or 'ideological discourses' in the sense Hall does. It seems to me that there are three problems with the way in which Hall argues. First, he chooses to ignore in this particular context the negative character of Marx's concept of ideology. Second, he imputes to Marx, and particularly to *The German Ideology*, a neutral concept, albeit a flawed one. Third, in so far as the ruling class is concerned, he identifies Marx's supposedly neutral concept of ideology with the dominant ideas.

Let us clarify these issues. In general, negative or critical conceptions of ideology refer to a kind of distorted thought, whatever the way in which we choose to understand such distortion. Neutral conceptions refer to political ideas, discourses and world-views which are articulated around some principles related to the interests of some social group, party or class. A negative concept of ideology is inherently capable of discriminating between adequate and inadequate ideas, it passes epistemological judgement on thought, whatever its class origin or the expressed intention of its supporters. An ideological idea is a distorted idea. The neutral concept of

ideology does not, of itself, discriminate between adequate and inadequate ideas, it does not pass epistemological judgement on them but emphasizes that through them human beings acquire consciousness of social reality and links those ideas to some class interests or to some articulating political principle. Thus one can speak of bourgeois ideology and proletarian ideology, liberal ideology and nationalist ideology without necessarily wanting to establish or prejudge their adequacy or truth.

Within the neutral conception of ideology critical judgement can be passed on ideologies, but always from the perspective of a different ideology. Thus when marxists in the leninist tradition criticize bourgeois ideology they do it from the point of view of proletarian ideology and what they criticize is its bourgeois character, not its ideological character which their own marxist doctrine shares. In this conception, ideology of itself does not entail any necessary distortion. For the neutral version the 'ideological' is the quality of any thought or idea that serves or articulates group or class interests, whatever they may be. For the negative version, on the contrary, the 'ideological' is the attribute of any thought or idea which distorts or inverts reality.

THE INTERPRETATION OF MARX

It is of course impossible to give a full account of Marx's theory of ideology in this article, but having dwelled for considerable time on this problem in the past,[3] I can at least affirm that, in my interpretation, there is overwhelming evidence that he contributes a negative concept of ideology. When Marx speaks of ideology he always refers to a kind of distortion or inversion of reality. He never refers to his own theory as an ideology or proletarian ideology, nor does he ever consider the possibility of an ideology serving the interests of the proletariat. Marx and Engels always spoke of ideology in the singular and never referred to class ideologies in the plural,[4] as Laclau and Hall do, following the leninist and gramscian tradition. Marx and Engels are always in opposition to ideology. In this they are absolutely consistent from their early writings to their mature writings irrespective of whether they are dealing with religion, German philosophy or the spontaneous economic and political forms of consciousness fostered by the capitalist market. In fact it is possible to maintain that the mechanism of ideology remains basically the same in all of these forms of consciousness which Marx successively analysed in his intellectual career.

Marx's early critique of religion first outlines such a mechanism: religion compensates in the mind for a deficient social reality; it reconstitutes in the imagination a coherent but distorted solution which goes beyond the real world in an attempt to resolve the contradictions and sufferings of the real world. As he put it, '*religious* suffering is at one and the same time the

expression of real suffering and a protest against real suffering. Religion is the sigh of the oppressed creature' (Marx, 1975: 244). Religion appears as an inversion because God, being a creature of the human beings' minds, becomes the creator, and the human beings, who create the idea of God, become the creatures. But this inversion in the mind responds to and derives from a real inversion: 'this state and this society produces religion, which is an *inverted consciousness of the world*, because they are an *inverted world*' (Marx, 1975: 244).

When Marx criticizes the German philosophers and left Hegelians the same mechanism of inversion is present. The German ideologists believed that the true problems of humankind were mistaken, religious ideas which they could destroy by criticism. They forget, Marx and Engels aver, that 'to these phrases they themselves are only opposing other phrases, and they are in no way combating the real existing world' (Marx and Engels, 1976: 41). Their ideological inversion consisted in that they started from consciousness instead of from material reality; instead of looking at German reality 'they descended from heavens to earth'. Again, this mental inversion responds to a real inversion in reality: 'If in all ideology men and their circumstances appear upside-down, this phenomenon arises just as much from their historical life-process as the inversion of objects on the retina does from their physical-life process' (Marx and Engels, 1976: 47). Similarly, when analysing the capitalist mode of production, Marx distinguishes the sphere of appearances (the market) from the sphere of inner relations (production), and argues that there is a basic inversion at the level of production, namely, the fact that past labour dominates living labour (the subject becomes an object and vice versa), and that this inversion 'necessarily produces certain correspondingly inverted conceptions, a transposed consciousness which is further developed by the metamorphoses and modifications of the actual circulation process' (Marx, 1974: III, 45).

These examples, taken from Marx's analyses at different points in his intellectual evolution, show a consistent pattern in spite of their different nature. In all of them there is a reference to an 'inverted consciousness of the world' which corresponds to an 'inverted world'. This inverted world is practically produced by a 'limited material mode of activity' as a contradictory world and is simultaneously projected into distorted forms of consciousness which conceal and misrepresent that contradictory reality. The role of ideology is to help reproduce that contradictory world in the interest of the ruling class. But ideology is not the result of a conspiracy of the ruling class to deceive the dominated classes, nor is it an arbitrary invention of consciousness. It is rather a spontaneous or elaborated discursive attempt to deal with forms of oppression and contradictions which is unable to ascertain the true origin of these problems and therefore results in the masking and reproduction of those very contradictions and forms of oppression.

The contradictions Marx refers to in his treatment of ideology within capitalism are all derived from or express an aspect of the principal contradiction of capitalism, namely, the contradiction which is constitutive of the very essence of the capitalist mode of production, the contradiction between capital and labour. These two poles relate in a contradictory way because they presuppose and negate each other. As Marx puts it, 'capital presupposes wage labour; wage labour presupposes capital. They reciprocally condition the existence of each other; they reciprocally bring forth each other' (Marx, 1970a: 82). But this mutual conditioning engenders mutual opposition because 'the working individual *alienates* himself; relates to the conditions brought out of him by his labour as those not of his *own* but of an *alien wealth* and of his own poverty' (Marx, 1973: 541). Live labour engenders capital (dead labour), but the latter controls the former; capital reproduces itself by reproducing its opposite, wage labour. It is this contradictory process of continuous reproduction whereby capital reproduces itself by reproducing its opposite that explains the origin and function of ideology. The process, in so far as it is contradictory and alienates the worker, needs to be concealed in order to be able to continue to reproduce itself.

The way in which ideology is produced as part of the process of reproduction of the capitalist main contradiction can be ascertained by focusing on the way in which the two poles, capital and labour, relate to each other. Although the production and appropriation of surplus value occurs at the level of production, capital and labour first come into contact through the market. This contact through the market appears perfectly fair and equitable, for capital and labour exchange equivalent values. So the process of production and extraction of surplus value is concealed by the operation of the market which becomes the source of ideological representations such as the idea of a 'fair wage', equality, freedom, etc. According to Marx, the labourer's 'economic bondage is both brought about and concealed by the periodic sale of himself, by his change of masters, and by the oscillation in the market-price of labour-power' (Marx, 1974: I, 542). Because the exchange of equivalents by free individuals in the market is seen on the surface of society and conceals the hidden extraction of surplus value in the process of production, it naturally tends to be reproduced in the minds of both capitalists and labourers as equality and freedom, the linchpins of capitalist ideology.

There is no doubt that Marx proposes a form of opposition between science and ideology. If ideology is a distorted form of thought that remains trapped in appearances, science, on the contrary, is an intellectual activity which is able to penetrate the veil of appearances to reach the inner relations of reality. As Marx puts it, 'all science would be superfluous if the outward appearance and the essence of things directly coincided' (Marx, 1974: III, 817). But this opposition is not conceived in the positivist

manner which entails that science can overcome ideology as truth over-
comes error. For Marx science cannot overcome ideology because ideology
is not simply an intellectual error, but it has its sources in a contradictory
reality. Only the practical transformation of that reality, the practical
resolution of its contradictions, can overcome ideology.

So, the emphasis is put by Marx not on ideology being a world-view, or a
discourse consisting of articulated concepts and images by means of which
we try to make sense of social existence; the emphasis is put on ideology
being a specific form of distortion, not just false consciousness in general.
The specificity of the distortion is its function of sustaining domination and
reproducing the capitalist system by masking contradictions. So not all
forms of distortion are necessarily ideological. And precisely because of
this restricted and negative character, ideology cannot be confused with the
ruling ideas. The confusion would entail that all ruling ideas are distorted.
Marx never condemned the whole of bourgeois thought as ideological. He
appreciated the scientific contributions of bourgeois authors just as much as
the literary production of bourgeois artists. That he clearly distinguished
between the ideological and other 'free' forms of consciousness of the
ruling class is shown by his critique of Storch for not conceiving material
production in historical form. Storch, Marx says, 'deprives himself of the
basis on which alone can be understood partly the ideological component
parts of the ruling class, partly the free spiritual production of this par-
ticular social formation' (Marx, 1969: I, 285).

However, some ambiguities in Marx and Engels' formulations and,
especially, the fact that *The German Ideology* was not published in the
West until the 1930s, made it more difficult for the first generations of
marxists to apprehend the sense in which Marx and Engels had used the
concept. In the absence of *The German Ideology* other, more ambiguous
texts became central for the conceptualization of ideology such as Marx's
1859 Preface, Engels's *Anti-Dühring* and various letters and prefaces.
Kautsky, Plekhanov and others began increasingly to use ideology in a
neutral sense. Lenin, in the context of exploding class struggles in Russia
and driven mainly by the urgent need to theorize the working-class critique
of bourgeois ideology, finally consolidated this usage when he wrote *What
Is to Be Done?* He depicted a highly polarized political struggle which
determined that 'the *only* choice is – either bourgeois or socialist ideology.
There is no middle course (for mankind has not created a "third" ideology,
and, moreover, in a society torn by class antagonisms there can never be a
non-class or an above-class ideology)' (Lenin, 1975: 48). Ever since that
moment, the critical concept of ideology all but disappeared from marxism
until under the influence of both critical theory and, paradoxically, the
work of the early Althusser, it was rediscovered.[5]

So when Laclau, Poulantzas and Hall criticize the classical theory for
conceiving of ideology as the 'number-plates' on the back of social classes

and for overlooking ideological differences within the dominant classes, they are not criticizing Marx's concept but a version of Lenin's, and are proposing an alternative which, admittedly, improves on certain interpretations of Lenin's conception. However, by conflating Marx and Lenin on this issue, they fail to make a crucial distinction between two different traditions within marxism and they do not seem to be aware of any difference between Marx and Lenin in relation to the concept of ideology.

Second, the charge that with Marx's theory of ideology Thatcherism would be understood as in no significant way different from traditional conservative ruling ideas misses the crucial point, again, that for Marx ideology and ruling ideas are not the same. By definition, Marx's theory of ideology did not and could not address the question of competing political outlooks within a ruling party. Hall's argument is right against an interpretation of the leninist concept of ideology which rigidly imputes an ideology to a particular class position, but not right against Marx's conception. But even addressing a neutral leninist definition of ideology, the charge must be made with caution. True, Thatcherism and traditional conservatism are different forms of political thought corresponding to different stages of accumulation in the capitalist system. But one must not forget that there is also an element of continuity. Both ideological forms are concerned with the protection and expansion of the capitalist system under a different form. Mrs Thatcher was not presiding over any change of the mode of production, she was propping up and defending the same capitalist system at a different stage of development. The novelty of her position should not therefore be exaggerated.

Third, Hall criticizes Marx's alleged recourse to false consciousness in order to explain the success of ruling ideas, and its implicit empiricist connotations. First of all, it must be clarified that Marx never defined ideology simply as false consciousness or even used such expression. It was Engels who used this expression, and only once (Engels, 1975: 434). It is not that I am trying to deny that ideology for Marx and Engels involved a form of false consciousness. It certainly did, but it was not false consciousness in general, nor was it conceived as an illusion; it was a very specific form of distortion. The notion of false consciousness on its own is problematic and quite different from Marx's concept of ideology. In this I agree with Hall and other critics. First, it is an equivocal expression for it can convey both the idea of a distortion and the idea that such distortion is an invention or a delusion of individual consciousness, a mirage without any base in reality. I contend that Marx's concept of ideology entails the former but not the latter idea. I underline the fact that the problem here is ambiguity and not that false consciousness, of itself and necessarily, entails the connotation of deception by individual subjects.

Second, if ideology is simply defined as false consciousness the impression is given that it is a mere cognitive or epistemological problem which

can be put right by criticism or science. Just like Habermas's idea of systematically distorted communication, the notion of false consciousness does not make any explicit reference to the material practices and antagonisms in social reality which contribute to its emergence. Ideology appears disconnected from the real social contradictions which give rise to it and therefore it can supposedly be dealt with at a purely discursive level without requiring any alteration of social reality. Third, and most important, the expression 'false consciousness' is vague because it does not determine the kind of falsity which ideology entails. Its apparently universal and general scope seems to encompass all sorts of distortions and falsities as if they were ideological. In fact, ideology is equated with error and loses its identity as a distinct concept. It must be accepted that many errors and mistakes could exist which should not be necessarily treated as ideological distortions. For Marx the ideological distortion is specific and makes a necessary reference to the concealment of social contradictions.

If there are any remaining doubts about this issue Marx dispels them in *Capital*. It is not the ruling class directly that dupes the working class; the very reality of the market relations creates a world of appearances which deceive people. Contrary to Hall's version, Marx never thought that the material reality of capitalism would directly dispel the illusions of the workers. It was material reality itself that deceived them. But as Hall well realizes, neither deception nor liberation from deception is directly prescribed by economic relations. According to Marx, the operation of the market was

> a very Eden of the innate rights of man. There alone rule Freedom, Equality, Property and Bentham. Freedom, because both buyer and seller of a commodity, say of labour-power, are constrained only by their own free will. They contract as free agents and the agreement they come to is but the form in which they give legal expression to their common will. Equality, because each enters into relation with the other, as with a simple owner of commodities, and they exchange equivalent for equivalent. Property, because each disposes only of what is his own. And Bentham, because each looks only to himself.
>
> (1974: I, 172)

These four principles were for Marx the basis of bourgeois political ideology. And as in all ideology, these principles concealed what went on beneath the surface where 'this apparent individual equality and liberty disappear' and 'prove to be inequality and unfreedom'. This is why unemployment and/or low salaries by and of themselves do not necessarily transform the beliefs of people. There is no 'cloud of unknowing' for Marx that obscures an easily seen reality. Such a view can perhaps be attributed to Bacon and his theory of idols or to Holbach and Helvetius and their theory of prejudices, but not to Marx. This is why, for Marx, what can

dispel ideological forms are not critical ideas or science, but political practices of transformation.

As for the rest of the ruling ideas, it is not true either that Marx explained their success and penetration within the working class by recourse to false consciousness. His explanation in *The German Ideology* is quite different. If the ideas of the ruling class are the ruling ideas it is because

> the class which is the ruling *material* force of society is at the same time its ruling *intellectual* force. The class which has the means of material production at its disposal, consequently also controls the means of mental production, so that the ideas of those who lack the means of mental production are on the whole subject to it.
>
> (Marx and Engels, 1976: 59)

Hall seems to believe that for Marx 'the control over the means of mental production' is the reason why the masses have been duped. In fact Marx in this passage is not talking about ideology at all, but about the ruling ideas, which are two different things. But Hall does otherwise understand exceedingly well the point of this quotation when he describes some of the 'insights of the classical marxist explanation':

> The social distribution of knowledge *is* skewed . . . the circle of dominant ideas *does* accumulate the symbolic power to map or classify the world for others . . . it becomes the horizon of the taken-for-granted. Ruling ideas may dominate other conceptions of the social world by setting the limit to what will appear as rational, reasonable, credible . . . the monopoly of the means of intellectual production . . . is not, of course, irrelevant to this acquisition over time of symbolic dominance.
>
> (Hall, 1988a: 44–5)

For Marx neither ideologically distorted ideas nor correct ideas can be explained as emerging from an empiricist relation whereby the real world indelibly imprints its meanings, be they distorted or sound, directly into our consciousness. This assumes that the real world is simple and transparent and that subjects are rather passive recipients. For Marx, on the contrary, the real world of capitalism was not transparent; phenomenal forms created by the market concealed the real relations at the level of production. But subjects were not passive either, bound to be deceived or bound to scientifically understand reality; they were actively engaged in practices which, in so far as limited and merely reproductive, enhanced the appearances of the market, in so far as transformatory or revolutionary, facilitated the apprehension of real relations.

When Hall says that the first thing to ask about an ideology which succeeds in organizing a substantial section of the masses is not what is false about it but what about it is true, he overlooks two things. First, in talking about an ideology which succeeds in organizing masses, he is

clearly using a neutral concept of ideology in the Gramscian tradition. Marx worked with a different, negative concept and, therefore, to criticize him for not putting the problem of ideology in terms of political ideas which become popular does not make good sense. Second, even if one accepts Hall's Gramscian definition of ideology as useful, as I do, he does not seem to see the different but complementary contribution which Marx's concept of ideology could make to it. For why should we restrict ourselves to finding out what makes good sense in an ideology? Is it not also quite necessary to find out what is wrong and expose it? Assuming that nazism and fascism were ideologies in the Gramscian sense which, however unexpectedly, succeeded in organizing important sections of the German and Italian masses, was it not important to find out not only what was true about them, the good sense which seduced people into accepting them, but also to find out and expose what was false and did not make good sense about them?

Finally, Hall castigates Marx's theory for assuming that vast numbers of ordinary people could be duped into misrecognizing where their real interests lie, whereas a few privileged theoreticians could see right through into the truth. But this is a misunderstanding. For misrecognition, in Marx's terms, had nothing to do with the mental equipment or intelligence of people. The concept of ideology was not a device to label a part of the community as stupid or less intelligent. According to Marx, capitalists themselves, just as much as the workers, as the bearers and agents of the capitalist system, were deceived by the very operation of the market. As he put it,

> The final pattern of economic relations as seen on the surface, in their real existence and consequently in the conceptions by which the bearers and agents of these relations seek to understand them, is very much different from, and indeed quite the reverse of, their inner but concealed essential pattern and the conception corresponding to it.
>
> (Marx, 1974: III, 209)

> the confusion of the theorists best illustrates the utter incapacity of the practical capitalist, blinded by competition as he is, and incapable of penetrating its phenomena, to recognize the inner essence and inner structure of this process behind its outer appearance.
>
> (1974: III, 168)

The accusation that Marx's theory proposed an absolute distinction between the dupes of history and the few privileged or enlightened who can see right through into the truth, was dismissed by Marx very early in the *Theses on Feuerbach* when he argued that 'the educator must himself be educated' and criticized those who 'divide society into two parts, one of which is superior to society' (Marx, 1976: 7). However, this does not mean

that social scientists and philosophers cannot make the critique of common sense or cannot propose their theories with a claim to truth. It is not just Marx who is the only one who thinks he has a key to understand social reality (this is the most frequent criticism of Marx's theory of ideology). Surely other accounts of Thatcherism (including Hall's) are also propounded with a claim to render evident the essence of the situation, independently of whether or not it is so apprehended by the people. Why then deny the same right to Marx?

NEUTRAL VERSUS NEGATIVE VERSIONS OF IDEOLOGY

My argument so far has been to show that some of Hall's criticisms of Marx's theory of ideology do not apply because he does not adequately distinguish Marx's theory from other neutral versions. But this does not mean that Hall's Gramscian approach to ideology is inherently flawed. In order to see what is good in it, I would like now to reflect on the character and potentialities of the neutral and negative versions of ideology within marxism. In its inception, ideology was one of a group of concepts such as alienation, contradiction, fetishism, exploitation; concepts which were inherently critical, that is to say capable of passing judgement on social realities which were deemed undesirable, unjust or 'inverted' to use Marx's expression. A neutral concept of ideology does not make direct reference to a single objective truth, but underlines the fact that the interests of different classes, fractions of classes or groups are represented or articulated by different ideologies. Thus you can speak of bourgeois, Thatcherite, neo-liberal, proletarian ideologies without necessarily wanting to establish or prejudge their adequacy or truth. Criticism is either avoided or confined to identifying the class or group character, the articulating principle (for instance the bourgeois or Thatcherite nature) of an ideology. Ideology does not inherently entail any necessary distortion.

If one accepts that a critical social science necessitates critical concepts then the neutralization of ideology is a real loss. However, there are different forms of neutralization. The leninist neutralization of ideology within marxism, later adopted by Lukács and Gramsci, was carried out in a context where the trust in reason, the acceptance of universal standards and the belief in the possibility of reaching the truth were not challenged or doubted. The contemporary attack on the critical notion of ideology coming from post-structuralism and postmodernism has new and more disturbing connotations which seriously put in doubt those principles. Sabina Lovibond has understood very well this dimension of the problem even if she still refers to false consciousness:

> To reject 'false consciousness' is to take a large step towards abandoning the politics of Enlightenment modernism. For it means rejecting the

view that personal autonomy is to be reached by way of a progressive transcendence of earlier, less adequate cognitive structures.

(Lovibond, 1989: 26)

The postmodern critique of the critical concept of ideology goes far beyond the scope and intention of the leninist neutralization of ideology within marxism. It questions our ability to reach any truth which is not context-relative, partial and localized; it doubts whether a true and total understanding of social contradictions can ever be achieved and hence the passing of judgement becomes impossible; it distrusts totalizing theories which propound universal emancipation. 'There is no reason, only reasons', Lyotard argues, or, what is the same, society is a series of language games, each with its own rules and criteria of truth, each incommensurable with one another (Van Reijen and Veerman, 1988: 278). For such a conception, a negative concept of ideology which pretends to know which are the contradictions in society and how they can be truly solved, shares with other 'meta-narratives' a totalitarian character: they are not only over-simplifications but also 'terroristic' in that they legitimate the suppression of differences (Lyotard, 1984: 82).

Nevertheless, it cannot escape the attention of an attentive reader of Lyotard and Baudrillard that they end up re-introducing a universal, but even more arbitrary, critical concept of ideology through the back door. In their onslaught against meta-narratives and universalizing theories they feel able to discriminate between those which fall and those which do not fall into those categories, in order to dismiss the former as ideological and unsound. In fact Lyotard says it in so many words. 'It is never a question of *one* massive and unique reason – that is nothing but ideology. On the contrary, it is a question of *plural* rationalities . . .' (Van Reijen and Veerman, 1988: 279). Lyotard does not realize that he can affirm this only on the basis of another totalizing meta-narrative: 'the concern with "preserving the purity" and singularity "of each game" by reinforcing its isolation from the others gives rise to exactly what was intended to be avoided; "the domination of one game by another"' (Weber, 1985: 104).

Similarly, Baudrillard argues that since postmodernity is characterized by simulation, by the fact that we live in a world of images and pure simulacrum which makes reference to no other ultimate but concealed reality, a critique of ideology is no longer possible because 'ideology corresponds to a betrayal of reality by signs; simulation corresponds to a short-circuit of reality and its reduplication by signs' (Baudrillard, 1983: 146). However he also ends up re-introducing a critical concept of ideology through the back door. One example is his analysis of the Watergate affair which showed the scandals and illegalities of the Nixon administration. The ideological function of such wide media presentation, he argues, was

to conceal or mask the fact that the system of government itself is fundamentally corrupt (Baudrillard, 1983: 26). In another example Baudrillard comments on a conference about 'the end of the world' in New York, 1985. For him this makes no sense because New York is already the end of the world. But the discussion about the idea of the end of the world masks this fact (Baudrillard, 1987: 286). Another example is Disneyland. It is presented as an infantile imaginary world to conceal the fact that the rest of America is infantile, to mask the fact that the real country is Disneyland (Baudrillard, 1983: 25). True it is not an inner, twisted, inverted reality which is concealed (the real contradictions in Marx's terms); what is concealed is the fact that that which is presented as real, is no longer real but hyper-real, a mere reproduction of a model. What is masked is the fact that reality itself has been dissolved.

The change in the concept of ideology from a critical to a neutral notion is therefore less simple and innocent than it appears. In the context of postmodernism the change is celebrated as the triumph of incommensurable language games and the demise of the terroristic meta-narratives which are at the basis of the critical concept of ideology. Paradoxically, the aggressive postmodernist stand fails fully to eradicate, and implicitly postulates, the totalizing perspective it seeks to abolish and therefore ends up contradicting itself. On the contrary, the analyses within the Gramscian tradition, for instance those of the early Laclau and Hall, do not involve a loss of faith in reason and truth, and make a very important contribution to the understanding of how political discourses and currents of thought are formed or transformed, and how social groups seek to articulate their interests with those of other groups. The critical concept of ideology, and therefore Marx's concept, is certainly inadequate to account for the formation, articulation and transformation of discourses, currents of thought, political ideas, in short, ideologies in the neutral sense. But then it was not produced to perform that task, but to criticize certain distortions. What is to be lamented is the fact that these two aspects, which are different and must be complementary, should dispute over the same concept of ideology. In fact they operate with totally different logics. Ideally, the concept of ideology should be restricted to only one of them, to avoid confusions. But what is behind the alternative concept must be maintained.

This is ultimately the reason why both the negative and the neutral concept of ideology have persisted within the marxist tradition; they both perform necessary tasks within social science: one seeks critically to pass judgement on the attempted justifications and concealment of undesirable and contradictory social situations; the other seeks to provide an account of how certain political discourses in search of hegemony are constructed and reconstructed, expand or contract, gain ascendancy or lose it. I defend the importance of Marx's negative concept but I can see the value of the neutral concept, especially in its Gramscian variety. The

contributions of the early Laclau and Hall to our understanding of Thatcherism have been absolutely crucial. Unfortunately many authors using the neutral concept do not accept that there could be two different concepts in the marxist tradition which perform different tasks.[6] Hall's position among them is unique because of his attempt to prove that Marx's concept does not work in practice when applied to Thatcherism. After trying to show that Hall was really criticizing a leninist version of ideology and not Marx's concept as I understand it, it is necessary for me to address the question as to whether Marx's concept of ideology can be used to analyse Thatcherism.

THATCHERISM AND THE NEGATIVE CONCEPT OF IDEOLOGY

For a critical conception of ideology it is not enough to be able to account for the successful way in which Thatcherite ideology has been able to articulate the interests of a wide variety of groups and sections of British society, it is necessary to show, critically, its shortcomings and inadequacies. Otherwise the analysis could easily become a political celebration of the achievements of Thatcherism. This criticism has been levelled at Hall's work by Jessop and other collaborators (1984) and Hall has replied to it that he never said that Thatcherism had achieved hegemony, that he contrasted its ideological success with its economic failures and that he did not treat Thatcherism as ideologically monolithic, but fully acknowledged its contradictions (Hall, 1985). Hall's defence makes sense. The acknowledgement of the fact that the hegemonic project of Thatcherism contrasts with the lack of hegemonic drive of 'both the labourist and the fundamentalist left', the recognition of the way in which 'Thatcherism has managed to stitch up or "unify" the contradictory strands in its discourse' and the assertion that 'the left have something to learn as to the conduct of political struggle' from the Thatcherite project (Hall, 1985: 120, 122, 119) I take to be empirically accurate propositions and in no way reasons to accuse Hall of defending and celebrating Thatcherism.

There is nothing wrong in trying to learn from the success of your adversary. Gramsci did it, and never concealed, for instance, the lessons he took from the Catholic religion. He admired the role which the catechism played in pedagogically imprinting the masses with the religious conception, he also recognized and appreciated the concern of the Catholic church for keeping in one unified bloc the theologians and the common people, and its readiness to repress the intellectuals when they threatened to break that unity. However, although appreciating the hegemonic form he was simultaneously profoundly critical of its content. The church wanted to preserve the unity between intellectuals and common people but never sought to elevate the common people to the level of the intellectuals, so Gramsci was able to criticize the religious conception as antithetic to that

of the philosophy of practice which sought to construct an intellectual and moral bloc which makes possible the intellectual progress of the masses (Gramsci, 1973: 331–3). I am convinced that Hall, having appreciated the hegemonic form of Thatcherite politics has also been critical of its content, even though his emphasis has probably been on the first aspect. Yet he does not seem to recognize the specific role of Marx's concept of ideology in that critique. In wanting to rescue that role I am not arguing that this is the only way in which something radically new can be said about Thatcherism, I am just making the connection between Marx's concept of ideology and a certain necessary critical approach.

Marx's critical theory can make a limited but significant contribution to the understanding of Thatcherism as an ideological phenomenon. In fact, in so far as Hall has been critical of Thatcherism, he seems to know what this contribution is although he does not connect it with Marx's concept. I can only sketch here the general contours of such an analysis. It seems to me that Thatcherism may be seen as a return, with a vengeance, to the old and quintessential principles of bourgeois political ideology which had been progressively obscured by years of social democracy, welfare state and Keynesianism. These principles can well be encapsulated in Marx's Eden of the innate rights of man: Freedom, Equality, Property and Bentham. Mrs Thatcher's programme is basically saying, let us go back to the market, let it rule our lives. The market is fair, efficient, egalitarian, it provides wealth and freedom of choice. Hence her insistence on rolling back the frontiers of the state, on cutting taxes, on educational choice, on providing opportunities to buy your own house and shares in state enterprises, on making new proprietors and incentivating self-interest. The great conservative reformation is a return to the old ideological values of the capitalist system which seemed to have been partially forgotten.

Paradoxically, Hall is quite aware of this aspect of Thatcherism when he argues that

> In some quite obvious and undeniable ways, the whole point of Thatcherism is to clear the way for capitalist market solutions, to restore both the prerogatives of ownership and profitability and the political conditions for capital to operate more effectively, and to construct around its imperatives a supportive culture suffused from end to end by its ethos and values. Thatcherism knows no measure of the good life other than 'value for money'. It understands no other compelling force or motive in the definition of civilization than the forces of the 'free market'.
>
> (Hall, 1988b: 4)

Even more, Hall is able to formulate the return to the ideological values of the market in practically the same terms as I have just done above:

> our ideas of 'Freedom', 'Equality', 'Property' and 'Bentham' (i.e. individualism) – the ruling ideological principles of the bourgeois

lexicon, and the key political themes which, in our time, have made a
powerful and compelling return to the ideological stage under the
auspices of Mrs Thatcher and neo-liberalism.

(Hall, 1988a: 70)

Yet he fails to make the connection between this and Marx's concept of
ideology.

Habermas (1972), Marcuse (1972) and other authors had been arguing
for a long time that the traditional political ideology based on the market
had all but disappeared from advanced capitalism. The new legitimating
ideology of capitalism was technocratic, it arose not from the free market
but from state interventionism, it was the belief in the power of science and
technology, and resulted in depoliticization and the emergence of new
discursive barriers to freely achieved rational consensus. Although they
exaggerated the ideological shifts and overemphasized the demise of the
ideology based on the market, their approach pointed to some true changes
in the capitalist system and its ideological legitimation. The construction of
the welfare state after the war and the Keynesian policies of full employ-
ment seemed to go hand in hand with economic growth and were condi-
tions very different from pre-war capitalism. The Thatcherite discourse
breaks with this kind of interventionist, welfare, full-employment, rational-
ized capitalism and goes back to the supremacy of the market. So, the new
ideological values can no longer be the idea of science, full employment
and welfare. Now, once more, as in Marx's time, it is freedom, equality,
property and self-interest.

Why has this happened? Basically, because capitalism itself has changed
and entered into a crisis of accumulation and profitability which Mrs
Thatcher has tried to solve by a return to the market forces. From 1945
to the end of the 1960s capitalism enjoyed a long period of expansion
which some call the post-war settlement or the Fordist-Keynesian period.
Since the beginning of the 1970s this system has been breaking up, the
conditions of accumulation have radically changed and consequently a
serious crisis of hegemony has developed which precipitated the political
realignment which brought Mrs Thatcher to power. The new conditions for
capitalist accumulation entailed an exacerbation of the traditional con-
frontation between capital and labour, both politically and economically.
On the political front, the need for a new form of flexible accumulation
required the dismantling of the traditional sources of trade-union power
after years of corporatist co-operation with the system. On the economic
front, flexible accumulation required a new shift towards the extraction of
absolute surplus value: longer working hours, erosion of real wages and the
formation of a new underclass without work. But the return to many of the
harsh conditions which existed before 1945 must be ideologically com-
pensated for and here is where the values of the market – freedom,

equality, property and self-interest – return with a new lease of life. These are the conditions which helped crystallize Thatcherism as an ideological phenomenon which feeds from the traditional capitalist ideology Marx already knew.

However, as could be expected, there is no question of simply going back to the time of pre-welfare competitive capitalism which Marx knew. Because flexible accumulation, economic insecurity and the re-imposition of the market rules are bound to exacerbate contradictions and their manifestations such as unemployment, poverty, discrimination, criminality, national and regional divisions, new forms of violence, and so on, the ideology of freedom and equality is not enough. At times of insecurity and fragmentation the longing for stable values leads to a heightened emphasis on the authority of basic institutions (Harvey, 1989: 171). Hence the new ideological forms which emphasize the sense of authority, hard work, law and order, family and tradition, Victorian values, patriotism: a strong nation which defeats the enemy within (trade unions) and the enemy without (Argentinians). These forms serve as devices to misunderstand and displace the real origin of those conflictive manifestations and to justify the way in which they are dealt with.

Thus unemployment is treated as laziness and pricing yourself out of a job, workers' strikes are transformed into a problem of public order. Criminality and new forms of violence are treated as the result of lack of authority in the family, not enough law and order, lack of Victorian values, and so on. Terrorism is successful because of the free press and the excessive leniency of the law. Divisions and forms of discrimination are partly blamed on immigration and partly conjured away by patriotism and jingoism. Thatcherite ideology thus tries systematically to displace and conceal the real origin of British problems. It totally transfers or confines the principles of freedom, equality and self-interest to the economic sphere of the market while it attacks them in the political sphere. It erodes the political rights of the trade unions, strongly attacks civil liberties, tries to gag the press, expands the police force, etc. The authoritarian features of Thatcherite ideology are not arbitrary and contingent, they are necessitated to deal with the results of the operation of the free market. It is now necessary to 'protect' the newly acquired economic freedoms which are threatened by class struggles, criminality and racial discord.

Marx's theory of ideology does allow, then, some critical understanding of Thatcherism. This it does not only through the traditional analysis of the principles and values which inform bourgeois ideology, but also through showing how those principles, brought back into the economic sphere, are articulated with other authoritarian values which are introduced in the political sphere. In either case these principles and values perform the classic role of ideology explained by Marx: they attempt to mask, explain away or justify the greater unfreedom and inequality which the Thatcherite

government has brought about. Some may think that if this is all, then the contribution of Marx's concept of ideology to the understanding of Thatcherism is pretty skimpy and adds very little that we did not know before. This may be so, but it never was my point to maintain that Marx's concept would provide radically new insights into Thatcherism. What it does is to balance and complement the analysis made with the Gramscian concept: whereas the latter highlights the successful hegemonic and articulatory qualities of Thatcherism the former underlines the reality of unfreedom and inequality it has created but tries to conceal. Both are necessary aspects of the same complex phenomenon.

NOTES

1 Holding at present Stuart Hall's old position as Head of Cultural Studies at Birmingham University and counting myself as one of his friends, I write about his conception of ideology with some trepidation. With such a prolific and distinguished author there is always the danger of unwittingly omitting an important idea or misrepresenting his true position. Be that as it may, I must state in advance my admiration and respect for Hall's enormous intellectual contribution to social sciences.
2 I mean the Laclau of *Politics and Ideology in Marxist Theory* (1977) prior to his most recent work on *Hegemony and Socialist Strategy* (1985) with Chantal Mouffe. Hall has explicitly stated his preference for the first book. See Grossberg (1986: 56).
3 For a full account of Marx's theory of ideology see Larrain (1979 and 1983).
4 This is a point that even a liberal, non-marxist author like Boudon (1989: 37) has correctly perceived and which so many marxist authors inexplicably fail to appreciate.
5 For a more detailed discussion of the transition from a negative to a neutral concept of ideology within marxism see Larrain (1983: 46–69).
6 Apart from Hall see for instance Laclau (1977), Hirst (1979) and McCarney (1980). For a critique of such a position see Larrain (1983: 94–121).

REFERENCES

Baudrillard, J. (1983) *Simulations*, New York: Semiotext(e).
Baudrillard, J. (1987) *Cool Memories*, Paris: Editions Galilée.
Boudon, R. (1989) *The Analysis of Ideology*, Cambridge: Polity Press.
Engels, F. (1975) 'Letter to Franz Mehring in Berlin', in Marx and Engels, *Selected Correspondence*, Moscow: Progress.
Gramsci, A. (1973) *Selections from the Prison Notebooks*, London: Lawrence & Wishart.
Grossberg, L. (1986) 'On postmodernism and articulation: an interview with Stuart Hall', *Journal of Communication Inquiry* 10(2) (summer).
Habermas, J. (1972) 'Technology and science as "ideology"', in *Toward a Rational Society*, London: Heinemann.
Hall, S. (1981a) 'The whites of their eyes: racist ideologies and the media', in G. Bridges and R. Brunt (eds) *Silver Linings*, London: Lawrence & Wishart.

Hall, S. (1981b) 'Cultural studies: two paradigms', in T. Bennett *et al.* (eds) *Culture, Ideology and Social Process*, London: Batsford.

Hall, S. (1983) 'The problem of ideology: marxism without guarantees', in B. Matthews (ed.) *Marx: A Hundred Years On*, London: Lawrence & Wishart.

Hall, S. (1985) 'Authoritarian populism: a reply to Jessop *et al.*', *New Left Review* 151.

Hall, S. (1988a) 'The Toad in the garden: Thatcherism amongst the theorists', in C. Nelson and L. Grossberg (eds) *Marxism and the Interpretation of Culture*, London: Macmillan.

Hall, S. (1988b) 'Introduction: Thatcherism and the crisis of the Left', in S. Hall, *The Hard Road to Renewal: Thatcherism and the Crisis of the Left*, London: Verso.

Harvey, D. (1989) *The Condition of Postmodernity*, Oxford: Basil Blackwell.

Hirst, P. (1979) *On Law and Ideology*, London: Macmillan.

Jessop B. *et al.* (1984) 'Authoritarian populism, Two Nations and Thatcherism', *New Left Review* 147.

Laclau, E. (1977) *Politics and Ideology in Marxist Theory*, London: New Left Books.

Laclau, E. and Mouffe, C. (1985) *Hegemony and Socialist Strategy*, London: Verso.

Larrain, J. (1979) *The Concept of Ideology*, London: Hutchinson.

Larrain, J. (1983) *Marxism and Ideology*, London: Macmillan.

Lenin, V. I. (1975) *What is to be Done?* Peking: Foreign Languages Press.

Lovibond, S. (1989) 'Feminism and postmodernism', *New Left Review* 178.

Lyotard, J. F. (1984) *The Postmodern Condition: A Report on Knowledge*, Manchester: Manchester University Press.

Marcuse, H. (1972) *One-Dimensional Man*, London: Abacus.

Marx, K. (1969) *Theories of Surplus-Value*, London: Lawrence & Wishart.

Marx, K. (1970) 'Preface' to *A Contribution to the Critique of Political Economy*, in *Selected Works in One Volume*, London: Lawrence & Wishart.

Marx, K. (1970a) *Wage, Labour and Capital*, in *Selected Works in One Volume*, London: Lawrence & Wishart.

Marx, K. (1973) *Grundrisse*, Harmondsworth: Penguin (tran. M. Nicolaus).

Marx, K. (1974) *Capital*, London: Lawrence & Wishart.

Marx, K. (1975) 'A contribution to the critique of Hegel's Philosophy of Right. 'Introduction', in L. Colletti (ed.) *Early Writings*, Harmondsworth: Penguin.

Marx, K. (1976) *Theses on Feuerbach*, in K. Marx and F. Engels *The German Ideology*, in *Collected Works*, London: Lawrence & Wishart.

Marx, K. and Engels, F. (1976) *The German Ideology*, in *Collected Works*, London: Lawrence & Wishart.

McCarney, J. (1980) *The Real World of Ideology*, Brighton: Harvester Press.

Poulantzas, N. (1976) *Political Power and Social Classes*, London: New Left Books.

Van Reijen, W. and Veerman, D. (1988) 'An interview with Jean-François Lyotard', *Theory, Culture & Society* 5 (2–3).

Weber, S. (1985) 'Afterword: literature – just making It', in J. F. Lyotard and J. L. Thébaud, *Just Gaming*, Manchester: Manchester University Press.

Chapter 3

Stuart Hall, cultural studies and marxism

Colin Sparks

INTRODUCTION

The history of cultural studies is marked by continual shifts of method. This is a normal and healthy part of any developing field of enquiry, particularly one which has exploded geographically and institutionally in the way that cultural studies has in the last few years. This paper is concerned to trace two such shifts: the move towards marxism and the move away from marxism. There need be no apology for selecting the relation between marxism and cultural studies for special attention: for many years it was generally believed that marxism and cultural studies were, if not identical, at least locked into an extremely close relationship. When, for example, Lawrence Grossberg wrote an influential essay defining the intellectual framework of British cultural studies for its new US audience, he claimed straightforwardly that he was discussing: 'British marxist cultural studies, in the works of the Birmingham Centre for Contemporary Cultural Studies' (Grossberg, 1986: 61). Stuart Hall himself had, in his outline history of the Birmingham Centre, stressed the pivotal importance of 'the break into a complex marxism' as the second of the decisive breaks which defined cultural studies in Britain (Hall, 1980a: 25).

The focus of this paper will be on the contribution of Stuart Hall since, while he is not the only important thinker in this trajectory, he has without question been the central figure in the development of the internationally dominant version of cultural studies. For some years, as the quotation from Grossberg above demonstrates, to speak of cultural studies was effectively to speak of the Birmingham University Centre for Contemporary Cultural Studies (CCCS). It seems to me unarguably the case that Stuart Hall, through the brilliance of his intellect and the impact of his personality, was the driving force of CCCS. It was in the work produced during his time as Acting Director and then Director of the Birmingham Centre that 'marxist cultural studies' was born and achieved its characteristic

features. He, too, has been the central figure both in its international diffusion and in its subsequent intellectual development.

As we shall see, it is possible to put at least a rough date to the start of the identification between cultural studies and marxism. The process took place between 1968 and 1972. We can date the end of the affair with considerably more precision. In the initial publicity for his keynote address to the April 1990 University of Illinois conference on 'Cultural Studies Now and in the Future', Stuart Hall was billed as speaking on 'The marxist element in cultural studies'. In the event, the final printed version of the programme had him addressing 'Cultural studies and its theoretical legacies'. The published form of the paper carries the same title and is concerned to elaborate the proposition that: 'There never was a prior moment when cultural studies and marxism represented a perfect theoretical fit' (Hall, 1992: 279). Born in the aftermath of the student radicalism of 1968, marxist cultural studies died with the collapse of the Soviet empire.

The close association between marxism and cultural studies thus lasted for a period of around twenty years. In the course of these two decades, cultural studies went from the status of a marginal note to British literary studies to a central aspect of the humanities in the USA and Australia, as well as in Britain. If Perry Anderson were to re-write his famous essay on 'Components of the national culture' today, he would undoubtedly be obliged to place cultural studies in the place of literary criticism as the central locus of discussion about the nature of British society. The cultural studies which entered the centre of British intellectual life, and which proved such an unusually successful export, was *marxist* cultural studies.

BEFORE MARXISM

The aftermath of 1968 was not the first time there had been an encounter between marxism and cultural studies. On the contrary, the initial formation of a recognizable strand of thought we can call 'cultural studies' came in the aftermath of 1956. The foundation of cultural studies lay in a move away from, and critique of, the established marxist tradition of cultural theory embodied in the writing of authors who were members of the British Communist Party and its international affiliates. All of the multitude of introductions to cultural studies seem to be in agreement that the Founding Fathers of cultural studies were Williams, Hoggart and Thompson, ably assisted by the young Stuart Hall. Each of these writers had critical positions towards marxism.

Hoggart is the simplest case: he was not, and never had been, a marxist. His only relation to marxism was one of dismissal. There is little evidence, either in his contemporary writings or in his later autobiographical sketches and books, that there was ever any protracted engagement with marxist

ideas. Marxism is mentioned as an influence on W.H. Auden in Hoggart's first book, but there is nothing in the discussion to suggest any close study of the question (Hoggart, 1951: 156). In *The Uses of Literacy*, the 'middle-class Marxist' is dismissed out of hand and the working-class marxist, then by far the majority of those claiming such an intellectual allegiance, is not even mentioned (Hoggart, 1957: 16). Unlike Williams, Hoggart did not form his view of working class culture with reference to either the Communist Party or any other variant of marxism. His own socialism, in its early phase at least, 'was not theoretic and to have called it ideological would have been a misuse of language' (Hoggart, 1988: 130).

Williams, on the other hand, had a much longer and personally more important engagement. Marxism was a formative influence on his intellectual development. Not only had he been briefly an active member of the Communist Party, but that encounter with this version of marxism continued to mark his thought (Williams, 1958: 8; Williams, 1979: 39–51; O'Connor, 1989: 7). This influence survived the Cold War and 1956, and he explicitly acknowledged its continuing influence even during the period when he was most critical of marxism:

> When I got to Cambridge I encountered two serious influences which have left a very deep impression on my mind. The first was Marxism, the second the teaching of Leavis. Through all subsequent disagreements I retain my respect for both.
>
> (Williams, 1958: 7)

The intellectual framework within which *Culture and Society* was conceived and written was one in which marxism was a central point of reference.

In *Culture and Society*, Williams made two major criticisms of Marx and of his British adherents. In the case of Marx's own writings, Williams detected a confusion on the question of 'structure and superstructure'. He argued that Marx and his immediate followers provided little more than a stress upon the importance of the economic structure in understanding culture, which was 'still an emphasis rather than a substantial theory' (Williams, 1963: 259–62). Twentieth-century followers of Marx in England had not clarified matters. In their stress upon the incompatibility of capitalism and cultural life, they had been heirs to the tradition of romantic protest against capitalism. They took from that tradition a quite 'un-marxist' stress upon the active and transformatory nature of culture (Williams, 1963: 265–7). In the marxist writings that Williams then had available to him he claimed to detect an oscillation between a 'mechanical materialism' which attempted to derive art directly from economics at one pole and a stress upon the transformative and prefigurative elements of art which would have been more at home in the closing passage of *A Defence of Poetry* at the other pole. The force of Williams' critique of the marxists

was not that they had devoted themselves to the mistaken study of the relationship between economic and social relations and cultural relations but that they had been unable to resolve the problems involved satisfactorily.

The second, and now perhaps most surprising, charge was that marxist writers tended to use terms like 'art' and 'culture' in the narrow and restrictive sense:

> In all these points there would seem to be a general inadequacy, among Marxists, in the use of 'culture' as a term. It normally indicates, in their writings, the intellectual and imaginative products of a society; this corresponds with the weak use of 'superstructure'. But it would seem that from their emphasis on the interdependence of all elements of social reality, and from their analytic emphasis on movement and change, Marxists should logically use 'culture' in the sense of a whole way of life, a general social process.
>
> <div align="right">(Williams, 1963: 273)</div>

The latter of these formulations, of course, is the one for which the book as a whole was to become famous. Marxists made the same error as the devotees of the 'Great Tradition': they, too, reified a narrow concept of culture and constructed their own selective tradition of the best that has been thought and said. Once again, the criticism is not that the marxists were wholly mistaken. If they were to pursue their own logic consistently, they would come to the same conclusions as Williams and develop an anthropological theory of culture.

Taken together, these two criticisms seem to relate to some of the fundamental concerns which were later to become 'cultural studies'. It is not, however, clear that they constitute an approach radically different to marxism. *Culture and Society* and marxism address a common set of problems. Both lay a heavy stress on social class as the defining element of cultural experience. When Williams argued that the 'crucial distinction . . . between alternative ideas of the nature of social relationships' was the discriminating factor in class-based cultures he was very close to an orthodox marxist affirmation of the centrality of class consciousness (Williams, 1963: 312). In his assertion that political and trade union organizations formed the central cultural achievements of the British working class, Williams is again very close to the concerns of the marxists (Williams, 1958: 314). The major difference between the dominant determinist form of marxism of the 1950s and Williams' own position at that time lies in the stress he placed upon the active and conscious sense-making process in culture. This he developed most fully in *The Long Revolution* (Williams, 1961: 3–71).

The third of the Founding Fathers, Edward Thompson, was by far the most explicitly marxist. Not only had he been a long-term member of the

Communist Party and an active participant in its History Group, but his break with the party was first articulated in terms of a rediscovery and reaffirmation of what he saw as central aspects of marxism. He was the founder editor of the *New Reasoner* and contributed to it, and subsequently to *New Left Review*, a number of substantial articles which tried explicitly to develop a new form of marxism which went under the general label 'socialist humanism'. The *New Reasoner*, both in its leading personalities and in its concerns, was both a 'marxist' and a 'high cultural' journal. In the first editorial, Thompson and Saville announced their belief in the importance of the 'rediscovery and re-affirmation' of the 'Marxist and Communist Tradition in Britain' and were quite clear that 'we have no desire to break impetuously with the Marxist and Communist tradition in Britain' (Saville and Thompson, 1957: 2–3). It was hardly innovative in cultural matters. Its first five issues contained poems by Brecht, McGrath, Logue, Swingler and others, and a short story by Doris Lessing. The same issues carried articles on Blake, Diego Rivera and Daumier. This journal, clearly, was not directly a precursor of 'cultural studies'.

The emphasis on being the inheritors of a tradition which had been distorted by stalinism underwent important modifications in the course of a long debate over the status of marxism which occupied much of the life of the journal. The final issue modified the insistence upon marxism as the central point of reference. Thompson now claimed that now 'we tend to see "Marxism" less as a self-sufficient system, more as major creative influence within a wider socialist tradition' (Thompson, 1959a: 8). But despite these reservations, he summed up what he felt to be the legacy of the journal thus:

> But we still have no desire to disown our debts to the Communist tradition. . . . We would like to feel that this journal has been, not the bridge for an evacuation, but the point of junction at which this valid part of the Communist tradition has been transmitted to a new socialist generation.
>
> (Thompson, 1959a: 8)

This 'point of junction' was between a journal which issued more or less directly out of the crisis of the Communist Parties and the rather different group around *Universities and Left Review*. The latter, as its title suggests, issued out of student radicalism.

The major shift in Thompson's thinking was his developing critique of the limits and positions of stalinism, which he saw as a distortion of the real tradition of marxism which he wished to defend. In its place he developed the idea of 'socialist humanism' which had a stress on 'the question of agency . . . at the core' (Thompson, 1958: 92). The stress upon the creative aspects of human activity lead him to put forward a distinctive position on the political practice of the intellectual:

> The intellectual must work within a narrow ridge between academic
> hubris on the one hand; and on the other hand false humility, the
> abasement of the intellect before working-class experience, which
> compromises not only our own intellectual integrity, but also our own
> ideas.
>
> (Thompson, 1957: 35)

While Thompson may well have intended his intervention as a tactical
response intended to prevent talented young people pursuing the ruinous
course of joining the Socialist Labour League, his formulations had, in
practice, a strategic impact. The attempt to fulfil the difficult task of
working 'a narrow ridge' of a political practice which was neither 'work-
erist' nor 'elitist' became one of the recurrent preoccupations of first the
New Left and then of cultural studies.

Another direct consequence of the stress upon human activity as the
engine of social change was that the ideas and beliefs which human beings
hold about the world became much more central to socialist politics. If the
theoretical crime of stalinism was that it: 'forgets the creative sparks
without which man would not be man' (1957: 125), then the new vision
of socialism must be one in which creativity was both the goal of eman-
cipation and a major site of struggle itself:

> These 'cultural' questions are not only questions of value; they are also,
> in the strictest sense, questions of political power. As even the giants of
> publishing vanish from the scene, as Hultons and Nearnes give way to
> Odhams, it becomes ever more clear that the fight to control and break-
> up the mass media, and to preserve and extend the minority media, is as
> central in political significance as, for example, the fight against the
> Taxes on Knowledge in the 1830's; it is the latest phase of the long
> contest for democratic rights – a struggle not only for the right of the
> minority to be heard, but for the right of the majority *not* to be subject to
> massive influences of misinformation and human depreciation.
>
> (Thompson, 1959b: 11–12)

The stress upon culture and the mass media was not in itself a radically new
departure either for marxism generally or for its stalinist deformation, but
in most versions of the tradition the emphasis of the political programme
lay in the class struggle understood as centrally located in workplaces.
Thompson theorized a position, which was to become central to cultural
studies, in which cultural questions were regarded as at least as important
as, if not much more central than, the subjects of orthodox concern like
strikes.

Thompson, while continuing to consider himself in important ways a
marxist, had arrived in the course of his critique of the stalinist version of
marxism at a number of positions which were very close to those of the

other Founding Fathers. Of the three, he was also by far the most directly politically active, and this brought him into contact with a group of younger intellectuals of very diverse origins whose relationship to the marxism represented by the Communist Parties was mostly much more distant.

Stuart Hall, then the editor of *Universities and Left Review,* was one of the central figures of this group and it was through a dialogue with Thompson and others that his first public encounter with marxism took place. Hall has argued that left intellectual life in the late 1950s was dominated by two quite distinct currents, associated respectively with the *New Reasoner* and *Universities and Left Review.* It was these two currents which merged, briefly, in the 'first' *New Left Review* (Hall, 1989a: 19–21). The major figures of what was to become 'cultural studies', particularly Hall and Williams, were most closely associated with the *Universities and Left Review* element. The *New Reasoner,* as we have shown, both in its leading personalities and in its concerns was a 'marxist' and a 'high cultural' journal. *Universities and Left Review* could make out a much stronger case to be a precursor of cultural studies. The general editorial position was far more eclectic and much more open to explicitly anti-marxist positions. While Thompson was a regular contributor, so were marxists of other persuasions, like Deutscher and Hobsbawm, not to mention anti-marxists like G.D.H. Cole and John Strachey.

Universities and Left Review identified itself as a journal whose brief included 'a rapportage and critique of the "culture" of post-Welfare Britain' (Anon, 1958b: 3), and it published a considerable body of material which is recognizably concerned with the same issues as cultural studies. Issue 5, for example, was identified as focusing on 'the common theme of culture and community' and included a twenty-page supplement on 'Mass communication' which included articles by Hoggart, Williams and Birnbaum (Anon, 1958a: 3).

The same issue saw a major article by Hall which criticized marxism, and particularly the 'base and superstructure' metaphor, as obsolete and inadequate. He argued that the development of capitalism itself had led to a transformation of the control of industry, which now lay in the hands of salaried managers, and to a recomposition of the working class away from the unskilled towards more widespread and highly differentiated skills. These changes were part of a major shift in the nature of the system unanticipated by Marx. The old 'sense of class' was breaking up, particularly under the impact of consumerism: 'The worker *knows himself* much more as a consumer than as a producer' (Hall, 1958: 28). One consequence of this was that the old world depicted by Williams was passing:

The break up of a 'whole way of life' into a series of lifestyles . . . means that life is now a series of fragmented patterns for living for many working class people.

(Hall, 1958: 27)

The most remarkable thing about this article is that it was written in the late 1950s. The conception of the nature of the changes which were seen as taking place in working-class experience in the 1950s is strikingly similar to the analysis of 'New Times' with which Hall was to be closely identified in the late 1980s.

This theme was one which he continued to develop into the early phase of *New Left Review*:

> The rising, skilled working class, before whom Mr Gaitskell makes his obeisances, are simply new groups of people with new aspirations and new visions, living through the end of an old society. *They* are the people whose inarticulate needs are untouched by socialism, as we speak of it today.
>
> (Hall, 1960a: 4)

It was necessary for socialists to think again about the people to whom their message was addressed, and about the nature of that message. Any insistence upon an established analysis, like that offered by marxism, would be an obstacle to this new thinking. There is little in his other writings of the period to suggest anything other than that, at this early stage in his career, Hall identified marxism as an obsolete and reductivist system of thought. It was necessary to go beyond its limitations in order to understand contemporary culture.

The new world of the affluent worker, of the mass media and of upward mobility, which were seen by the other three writers as a threat to the integrity and independence of the working class and its culture, were taken by Hall as the starting-point for his analysis. In this distinctive difference, personal factors of generation and ethnicity may well have played an important role. Unlike Hoggart and Williams, for example, Hall could not look back, with a measure of sentimentality, on a provincial British childhood within which the positive values of working-class culture were embodied in concrete human behaviour. Hall's distinctive contribution to the formation of cultural studies was to insist on an urgent sense of engagement with the contemporary.

The four figures reviewed here were unanimous in their rejection of central aspects of what they understood to be marxism, and only Thompson was still prepared, after 1956, to call himself 'a marxist'. The nature and meaning of this rejection varied widely. For Hoggart and Hall, marxism was more or less unimportant except as an obstacle to understanding the real nature of contemporary culture. For Williams and Thompson, a harsh critique was tempered by a continued engagement with the central problems of marxist socialism.

There was a greater degree of unity between the four writers on the positive programme they wished to elaborate in place of the marxism they were rejecting. If one asks what common term could be most correctly

applied to these disparate positions, the obvious candidate is 'expressive humanism'. Hoggart, the least touched by any theory, let alone marxism, put the central case most clearly in discussing the impact of the affluence of the 1950s on the older patterns of working-class life:

> Will all this and much else – increased eating in restaurants, the spread of wine-drinking, the increase in telephone installations, foreign holidays – make working-class people middle-class? Not in any useful sense of the words. The essence of belonging to the middle class was to hold a certain range of attitudes, attitudes chiefly decided by that class's sense of its own position within society, and its relation to other classes within it. From this its characteristics – its snobberies as much as its sense of responsibilities – flowed. These attitudes are not brought into play merely by possessing certain objects or adopting some practical notions from the middle class.
>
> (Hoggart, 1973: 58)

It was the early programme of cultural studies to excavate this 'certain range of attitudes' in order to show how they represented not the results of a process of brutalization and brainwashing but the embodiment of positive human values of the highest order. These common human values found expression in the cultural life of the working class.

There were major difference of emphasis between the different authors as to how this project was to be realized. Williams and Thompson were concerned to show how the working class created distinctive cultural forms. Hoggart and Hall, on the other hand, concentrated more on demonstrating the possibilities of a 'discrimination' within modern cultural production between, for example: 'the work of artists, performers and directors in the new media, which has the intention of popular art behind it, and the typical offerings of the media – which is a kind of mass art' (Hall and Whannel, 1964: 68). What they shared was the effort to explore the ways in which certain kinds of life could find expression in certain forms of cultural production and consumption.

ROUND TWO: A REDISCOVERY

The version of cultural studies which developed, increasingly focused around the Birmingham Centre, in the 1960s was thus one in which the explicit legacy of marxism was more or less absent. If one examines the early self-published Occasional Papers of the Centre, its Annual Reports, or the more formally published work it inspired, there is little evidence of the kind of intellectual upheavals that were imminent. The Centre was certainly involved in trying to elaborate a project of cultural studies, but this had quite other points of reference than those which marked the earlier phase. The recurrent theme of methodological inquiry throughout this

period was the relationship between the literary and social scientific approaches. Literary approaches were, of course, personified in the figure of F.R. Leavis. The key representative of sociology was Max Weber (Anon., 1965: 3; Shuttleworth, 1966: 32–3; Hoggart, 1969: 4–5). More substantive studies, like the one of *Your Sunday Paper*, demonstrated a variety of debts, among which that to McLluhan was perhaps the most frequently cited and from which Marx was excluded (Hoggart, 1967). The Marx who was discussed in Hall and Whannel's *The Popular Arts* was Groucho, not Karl.

The absence of Marx from the universe of discussion extended to the directly political analyses of the people who were central to cultural studies. In the collective text *May Day Manifesto 1968*, edited by Raymond Williams, and involving contributions from Hall and Edward Thompson amongst many others, one might discern a trace of marxism but certainly not its full presence. What is present is an explicitly humanist theoretical standpoint:

> . . . we define socialism again as a humanism: a recognition of the social reality of man in all his activities, and of the consequent struggle for the direction of this reality by and for ordinary men and women.
>
> (Williams, 1968: 16)

One of the sources of this humanism was probably a version of marxism, but it could equally well be claimed for ethical socialism or a number of other forms of socialist thought. Whatever its origins, it placed the working-class experience of British capitalism at the centre of its analysis of the need for socialism. In a political context, the expressive humanism of cultural studies took the form of socialist humanism.

It is against this intellectual background that we have to examine the wholesale conversion of cultural studies into marxist cultural studies which took place in the aftermath of the events of 1968. This examination reveals five important features which can be shown materially to have affected the kinds of work done under the rubric of cultural studies during the 1970s.

The first of these is that the shift to marxism was more or less the same as what Stuart Hall termed the shift from the 'culturalist' to the 'structuralist' paradigms of cultural studies. As we have shown, the early texts of cultural studies saw the category of 'experience' as central to their theoretical framework. It was just at this point that the two paradigms diverged most sharply:

> We can identify this counterposition at one of its sharpest points precisely around the concept of 'experience', and the rôle the term played in each perspective. Whereas, in 'culturalism', experience was the ground – the terrain of the 'the lived' – where consciousness and conditions intersected, structuralism insisted that 'experience' could

not, by definition, be the ground of anything, since one could only 'live' and experience one's conditions *in and through* the categories, classifications and frameworks of the culture.

(Hall, 1980b: 66)

The new, marxist, intellectual framework was one which saw experience, and the human subject who had such experience, as the resultant of the operations of the economy, of ideology and so on, rather than the starting-point of social investigation.

The second feature of note is that it was a prior encounter with structuralism which governed the appropriation of marxism. The record shows that 'structuralism' made an impact upon the Birmingham Centre independently of, and earlier than, any serious engagement with marxism. Thus, the Centre published, as part of its series of Occasional Papers, work by Tim Moore and Edgar Morin, introducing structuralism and semiotics, which were based on lectures given in 1967 and 1968 (Moore, 1968; Morin, 1969). There had been no equivalent rediscovery of Marx. It is not until the 1966–7 session that even passing reference is made to Marx (Anon, 1968). When it was eventually taken up, between 1968 and 1971, marxism was only one element of a general theoretical reappraisal: 'phenomenology, symbolic interaction, structuralism and marxism were precisely the areas which cultural studies inhabited in its search for an alternative problematic and method' (Anon, 1971: 5). It was not until 1970–1 that the engagement with Marx became central: 'We chose as a coherent theory one the Centre had not previously analysed, that of Karl Marx' (Anon, 1971: 10).

At this point, marxism was conceived of as a relatively broad current of thought, in which different formulations appeared to be addressing the same or similar topics:

> Modern marxism has posed in new ways the relations of base and superstructure, consciousness and being, the ways in which social structure and their modes of production of culture and its realization in the world, the complex and mediated link between an historical epoch and its conceptions of the world.

(Anon, 1971: 5, *sic*)

There are here echoes of Althusser, in the focus on base and superstructure, but also of Sartre in the mention of 'consciousness and being', and of Lukács in the use of the idea of 'the complex and mediated link between an historical epoch and its conceptions of the world'. We may also note the absence from this discussion of the term 'ideology', which would come to dominate much of theoretical work of the Birmingham Centre, and would come to be more or less the central concern of marxist cultural studies.

The very first phase of the encounter with marxism was thus an open one,

in which there was no predominant 'structuralist' influence. The above passage reviews some of the problems of the different approaches and claims: 'No single orthodoxy prevails here.' The same heterodoxy is observable in the papers of the symposium 'Situating Marx' held at the Birmingham Centre in June 1971 (Walton and Hall, n.d.: 1–6).

A definite 'orthodoxy' did, however, soon come to prevail. Out of the range of possible versions of marxism, including some like those of Sartre and Lukács which were much closer to the humanist project of the early cultural studies, the one which was preferred, and which came to stand for 'marxism' in its entirety, was Althusserian marxism. This was the version of marxism which borrowed most heavily from structuralism. It was in fact generally known simply as 'structuralist marxism'. This version of marxism became the orthodoxy of the Birmingham Centre from around 1973. The editorial, and most of the contents, of *Working Papers in Cultural Studies 6* are clearly dominated by the new orthodoxy (Chambers *et al.*, 1974). It must be admitted that it was a very tolerant orthodoxy, which permitted various unbelievers, including even the very odd Lukácsian, to eke out a marginal existence. Nevertheless, it is demonstrably the case that a prior engagement with structuralism overdetermined the appropriation of marxism by the Birmingham Centre.

The third point concerns the consequences of adopting such a structuralist marxism for the relationship of the Birmingham Centre to its own immediate history. It is true that in its adoption of the Althusserian version of marxism the Birmingham Centre was part of the dominant mood of left intellectual culture during the period, which was overwhelmingly attracted to such a position in the wake of 1968. Not least of the attractions of Althusserianism to left intellectuals was that it offered, in the idea of theoretical practice, an excellent legitimation for occupying that 'narrow ridge' which Thompson had mapped as their proper terrain. What was unique about the Birmingham case was that they took up the version of marxism which prided itself on the fact that it was the most rigorously 'anti-humanist' of intellectual projects. As Althusser famously put it: 'In 1845, Marx broke radically with every theory that based history and politics on an essence of man' (Althusser, 1969: 227). According to Althusser, 'socialist humanism' was an ideological intrusion into the province of marxist science. The shift to marxism involved a rejection of the central theoretical premise which had characterized cultural studies from the 1950s up until that time.

The fourth major point also follows directly from the Althusserian character of the marxism which was adopted by Hall and the majority of the Centre's graduate students. The first phase of cultural studies had, as we saw above, an 'expressive' notion of culture. It was also, as Williams' persistent stress upon 'a whole way of life' and his concern with the 'structure of feeling' illustrate, one which strove towards an understanding

of the ways in which the various different aspects of human experience fitted together and formed a whole. Taken together, these views of culture constitute a native version of the 'expressive totality' on which Althusser and his followers spent so much effort in an attempt at exorcising it from the corpus of marxism.

In the place of the expressive totality, and what were seen as its irredeemable tendencies to reduce all of social life to the expression of a single dominant contradiction, Althusserianism offered a quite different model of 'the social formation'. In particular, the problem of determination was relegated to the last instance. The theoretical system held that the 'lonely hour of the last instance' really never did strike. The centre of attention shifted from the relations between base and superstructure into an elaboration of the internal articulation of the superstructure itself. As Althusser put it:

> . . . the theory of the specific effectivity of the superstructures and other 'circumstances' largely remains to be elaborated; and before the theory of their effectivity or simultaneously . . . there must be an elaboration of the theory of the particular essences of the specific elements of the superstructure.

(Althusser, 1969: 113–14, emphasis as in original, here and in all quoted material, this chapter)

It was in this respect that Althusserian marxism was at its most 'structuralist' and at its greatest distance from the earlier concerns of cultural studies. The close affinity of aim between some versions of marxism and the older cultural studies had been based upon a shared belief that the artifacts of a particular culture could be shown to in some way be the products of particular ways of life organization. In practice, whatever the rhetorical commitment to completing a similar project, Althusserian marxism prioritized an exploration of the immanent structures of particular discourses. Directly from this followed the strong emphasis on ideology which was such an important element in marxist cultural studies.

The final major consequence of the adoption of marxism in its Althusserian form was that the apparent unity of cultural studies began to break up. Hoggart himself had departed the field of battle in 1968, and ceased to be an important original creative force in the field. The other two Founding Fathers remained active but took quite different intellectual routes. Edward Thompson's lack of enthusiasm for Althusser's interpretation of Marx is famously expressed in *The Poverty of Theory*. Williams announced, in the early 1970s that he too had become a marxist, but this was part of an increasingly 'materialist' bent in his thinking which pointed in a radically different direction, both intellectually and politically, from that traced by Hall and the main current of CCCS. In terms of their public intellectual positions, and increasingly of their organized political commitments, the

adoption of Althusserian marxism by Stuart Hall and the majority of his younger followers moved them further away from the other major figures of the first phase of cultural studies. Both intellectually and organizationally, the second encounter with marxism resulted in a cultural studies which rejoined the very same 'official' current of marxism against which the earlier attempts at definition had been directed.

It was this structuralist marxism which formed the intellectual basis of what we may term the 'heroic age' of cultural studies. During the decade of the 1970s a new and unified perspective on a range of disparate topics was generated either by Stuart Hall directly or by groups of people in which he was a prominent, perhaps dominant, personality. This new marxist cultural studies involved a direct break with several of the central theoretical propositions of the earlier phase of cultural studies. The rejection of socialist humanism implied a fundamental shift in the perceptions of the importance of experience and agency in the understanding of culture. Closely allied to this was the replacement of the expressive notion of culture by an account which stressed its relative autonomy and in which the centrality of the explanatory power of material determination was under siege. Third, the new stress upon ideology gave a far greater importance to the formative power of the dominant discourse which contrasted sharply with the stress upon the independent making of working-class culture.

Such a major reformulation would be bound to produce problems under any circumstances, and one would not expect a new synthesis to emerge at once. In the case of cultural studies, these problems were compounded by the fact that the novelty of approach was not matched by a radical change in the object of study. This very often remained the same as before and the rethinking had to be done within and against the existing body of work.

We can illustrate that by looking at one of the best developed of the projects in the Centre during that period: the study of subcultures. The collective working on this produced a considerable body of material which attempted to relate the conditions of existence of young, mostly working-class, people to aspects of their taste in dress, music, behaviour and so on. This was not a new theme for the Centre, having been the subject of considerable work in the 1960s. The account of the origins of youth styles remained within the expressive framework of the earlier period:

> The 'culture' of a group or class is the peculiar and distinctive 'way of life' which realises or *objectivates* group-life in meaningful shape and form. . . . The 'culture' of a group or class, the meanings, values and ideas embodied in institutions, in social relations, in systems of beliefs, in *mores* and customs in the uses of objects and material life. Culture is the distinctive shapes in which this material and social organisation of life expresses itself. . . . Culture is the way the social relations of a

group are structured and shaped: but it is also the way those shapes are experienced, understood and interpreted.

(Clarke *et al.*, 1976: 10–11)

There is nothing in such a passage which could not have been written fifteen years earlier by Williams or Hoggart, and neither of them would have balked at the insistence that subcultures were the expression of the life experiences of subordinated groups and classes which can be distinguished from, and are often in opposition to, the culture of the dominant class.

The originality of the new material lay in the semiotically-inspired 'reading of the style' as a magical resolution of the real dilemmas faced in the lives of working-class communities. There was a stress upon the ways in which the objects and practices which mark out the subculture are identified as a coherent and internally articulated style:

> The various youth sub-cultures have been identified by their possessions and objects. . . . Yet, despite their visibility, things simply appropriated and worn (or listened to) do not make a style. What makes a style is the activity of stylization – the active organisation of object with activities and outlooks, which produce an organised group-identity in the form and shape of a coherent and distinctive way of 'being-in-the-world'.
>
> (Clarke *et al.*, 1976: 54)

The task of the analyst of youth culture was thus to attempt to understand what we might term the 'stylizing practice' of different youth groups as an internally structured activity which gave new meanings to the elements within it which bore only contingent relations to the meanings with which they were invested within other cultures.

Both the desire to trace the class origins of particular styles and the efforts at reading yielded extremely interesting and valuable material. The theoretical problem, from the standpoint of Althusserian marxism, was in the link between the two elements. The expressive theory of subcultures pointed back to the earlier humanist model, while the theory of style pointed towards the new structural marxist model.

The problem was very clearly identified by one ultra-orthodox schismatic from the Centre in a review of *Resistance through Rituals* which is worth quoting at some length. The authors, she argued, had attempted to combine a reductivist account of the class determination of culture with an 'ideological' reading of signification: they had failed to resolve this impossible contradiction:

> We now begin to see more clearly some of the consequences of these theoretical premises: the social formation is understood in terms of an essential division between capital and labour which is directly reflected in economic classes, which themselves are reflected at the level of

culture and ideology. Thus, the theory remains fundamentally committed to a conception of economic determination, with the economic understood, not as production and exchange relations, but as relations between monolithic classes, which are knowable through the object 'consciousness'. Even though the analysis appears at first to give attention to the ideological level, it becomes clear, when its conception of the social formation is analysed, that there is no autonomy attributed to the inscription of ideological or political representations which become simply functions or expressions of economic interest. In this way, issues such as the conceptualisation of the feminist movement or the possibility of politically reactionary positions of the working class are either ignored or, in the latter case, invested with a radical potential which is displaced according to the distortions operated by bourgeois ideology.

(Coward, 1977: 90)

The collective attempt to rebut these charges was not really successful and the problems remained unresolved in this phase of cultural studies (Chambers *et al.*, 1977–8).

We can observe another aspect of the problem if we briefly trace the Centre's thinking about the relationship of ideology to the mass media. The development of the 'encoding/decoding' model of television discourse, and its elaboration into a version of the 'dominant ideology thesis', was one of Hall's major intellectual achievements during the period. It seems first to have been publicly aired at the Council of Europe Colloquy at the Leicester Centre for Mass Communication Research in September 1973. This early version of the model is almost entirely 'semiotic' in its intellectual structure, and to the extent that it deals with 'ideology' it locates the question in terms of differential decodings, particularly at the level of the necessary polysemic nature of connotation:

Literal or denotative 'errors' are relatively unproblematic. They represent a kind of noise in the channel. But 'misreadings' of a message at the connotative or contextual level are a different matter. They have, fundamentally, a societal, not a communicative, basis. They signify, at the 'message' level the structural conflicts, contradictions and negotiations of economic, political and cultural life. . . . When the viewer takes the connoted meaning from, say, a television newscast or current affairs programme, full and straight, and decodes the message in terms of the reference code in which it has been coded, we might say that the viewer is operating inside the dominant code.

(Hall, 1973: 16)

This is clearly a 'Barthesian' theory of the function of the mass media and it was to be much modified in subsequent versions.

One element which is missing from all of the versions is any theoretical account of the process of encoding. In the first version, this took the form of simply bracketing out the problem of the social processes of television production on the grounds that these 'at a certain moment . . . [issue] in the form of symbolic vehicles constituted within the rules of "language"' (Hall, 1973: 3). None of the later versions made any substantial additions to this area. This model thus followed the Althusserian prescription to concentrate upon 'the particular essences of the specific elements of the superstructure' very closely. Since there was no attempt to demonstrate how the dominant ideological encoding of television discourse might be related to the structure of society, this model escaped by default the charge that it operated with a reductionist theory of culture.

The problematic aspects of the Althusserian legacy surfaced in the other, decoding, moment of the theory. Althusser's treatment of ideology had two important features. He argued that ideology was always embedded in what he termed 'ideological state apparatuses'. While there were problems with what he included in the list of such apparatuses, the proposition that the mass media or the education system functioned primarily but not exclusively through ideology could command widespread support. Much more contentious was the proposition that ideology was fundamentally an unconscious operation which was constituted through the entry of the subject into language. In order to speak, the individual had to negate itself by entering a preconstituted realm of radical alterity. Since society would be unthinkable without language, ideology was a necessary feature of all human societies. Ideology was thus essentially unitary, without history and all-pervasive. What is more, the operation of ideology was coercively to construct the individual as subject. This aspect of Althusser's theory of ideology was developed, particularly with regard to the cinema, by a group around the magazine *Screen*, for whom the key to understanding ideology lay in Lacanian psychoanalysis.

Hall rejected the *Screen* interpretation of Althusser's theory ideology on the grounds that it was too coercive (Hall, 1980c: 161–2). Cultural studies had from the start operated with the idea of there being different possible readings of particular texts, which depended largely on the experience of the audiences. Hall wished to retain this notion of at least the relative indeterminacy of decoding. On the other hand, he remained within a framework which saw ideology as fundamentally discursive and unconscious in its operation. It was to this end that he developed the 'encoding/ decoding' model away from Althusser. An engagement with Gramsci provided a modification of the unconscious into the unconsciously held propositions of common sense which explained why the dominant decoding could work so apparently effortlessly. Volosinov provided the possibility of variant, and thus oppositional, decodings through a theory of the multi-accentuality of the sign. While these additions 'worked' in the sense

that they plugged the gaps in the model, the overall structure resulting lacked the elegant simplicity of its Althusserian parent. Its increasingly baroque structure had less and less internal stability.

The two problem areas, one involving determination and the other the positioning power of ideology, were central to the project of the book *Policing the Crisis*. This multi-authored text is in many ways an attempt to synthesize the work of the Birmingham Centre during the heroic age, and it is still an enormously impressive effort. It is, however, quite striking how little input the theoretical work of the preceding five years makes to the final text. The multiple crises facing British society are extensively catalogued, but there is no theoretical effort to show how determination in the last instance, or overdetermination, might be useful categories in the analysis of a concrete social formation. Ideology, too, although central to the book, is afforded no systematic theoretical investigation. Althusser and his idea of the 'ideological state apparatus' are invoked more or less in passing on a number of occasions, but the real centre of attention is on developing aspects of Gramsci's work on the winning of consent (Hall *et al.*, 1978: 201–17).

One might wish to make detailed criticisms of this or that aspect of the book, but the central failure is a theoretical one. Although its publication predates the final working-out of the 'encoding/decoding' model, it does not operate within that theoretical framework or any other. It is a work of many productive insights, but it does not deliver the synthesis which it promised. If it is the high point of the heroic age of cultural studies, it is also the end point. The attempt to recast cultural studies in the form of Althusserian marxism has not been achieved. In the long run, the attempt to understand a field of enquiry which had been delimited in terms of expressive humanism with the methods of structuralist marxism proved impossible to complete.

THE ROAD FROM MARX

In its classic form, then, the attempt at an Althusserian marxist cultural studies had a life of at most ten years. It did not immediately and publicly collapse, but by the time that cultural studies was experiencing internationalization, its specifically marxist element was already in serious decline. In retrospect, it is clear that the theoretical developments of the mainsteam of cultural studies in the 1980s constituted a slow movement away from any self-identification with marxism. The inexorable logic of this development was probably as invisible to the protagonists as it was to outside observers such as the present author. The main body of Hall's writings during this period appeared in a journal with the title of *Marxism Today*, and his concerns remained throughout the decade centred upon the development of a 'marxism without guarantees'.

The gradual nature of this disengagement was partly because Hall's road away from Marx lay through the writing of Laclau. In the collection of reviews and essays which formed his first book, Laclau provided a significant weakening of the rigours of the Althusserian version of marxism 'from within'. Laclau was concerned to produce a 'non-reductive' theory of ideology and the mechanisms by which it functioned in society, especially with reference to the problem of classical fascism. For Laclau, the 'correct method' in understanding ideology was:

> to accept that ideological 'elements' taken in isolation have no necessary class connotation, and that this connotation is only the result of the articulation of those elements in a concrete ideological discourse. This means that the precondition for analysing the class nature of an ideology is to conduct the inquiry through that which constitutes the distinctive unity of an ideological discourse.
>
> (Laclau, 1979: 99)

This proposition has two concrete consequences. In the first place, theoretically speaking, any 'element' could be part of any 'class ideology'. Laclau chose the example of nationalism, which he argued was part of the ideology of various and diverse social classes. Secondly, the internal ideological structure was more important for the purposes of analysis than was the relationship between a particular 'ideological discourse' and social class: this latter relationship is in fact as resultant achieved by specific features of the discursive practice itself.

It is obvious that despite considerable similarities in terms of the analysis of the nature of society, and the stress upon the internal structure of ideology, there is a different emphasis to Laclau's theory ideology compared with Althusser's. In Althusser, ideology was, essentially, uniform and without history. There are in Laclau a variety of ideologies: feudal, bourgeois, fascist, imperialist, populist, and so on. We are dealing with a much more limited notion of ideology, and one which need not be considered to be working simply at the level of the unconscious.

There remains, however, an important direct debt to Althusser in this theory of ideology in that Laclau argues that the primary mechanism by which ideologies establish their relationship with the rest of the social formation is through their ability to 'interpellate' concrete social forces: '*what constitutes the unifyng principle of an ideological discourse is the "subject" interpellated and thus constituted through this discourse*' (Laclau, 1979: 101). An ideological discourse belongs to a particular part of the social formation to the extent that it succeeds in naming, and thus 'capturing the attention of', a particular social force.

In practice, according to Laclau, the subjects so interpellated are never social classes. In his account, social class is an economic abstraction which does not exist in any concrete social reality. 'Bourgeois' and 'proletarian'

are theoretical abstractions appropriate to the analysis of a social formation. They find no concrete living representatives in the real world of human beings. It is in this world that actual political struggles are conducted. The real-world forces which constitute the elements in social struggles are 'the people' and 'the power bloc'.

These formulations provided four valuable ways of negotiating an exit from the dilemmas of Althusserian marxism. In the first place, by loosening the definition of ideology, the new framework permitted both the plurality and historicity of ideologies. The task of enquiry was therefore no longer the impossible one of demonstrating how an abstract and universal ideology was equally present in all forms of cultural life but of exploring the concrete forms and contents of different ideologies.

It was thus possible properly to integrate a reading of Gramsci into the account of ideology. Although Althusser had signalled an interest in Gramsci as someone who had addressed the question of ideology, there was a range of problems preventing any full assimilation of the latter's ideas in Althusser's system. The most important of these in this context is Gramsci's constant stress upon the shifting and provisional nature of the hegemonic order, and the way in which hegemony could be won and lost, which sits ill with a notion of a single pervasive ideology which operates in and throughout all societies. In Althusser's formulations, 'ideological struggle' was more properly thought of as a single struggle between ideology and science. In adopting Laclau's alternative version of ideology, it became possible to direct attention to the formulations of particular kinds of hegemonic ideologies.

Second, Laclau further weakened the notion that there might be a determinate relation between ideology and the social structure. In the Althusserian schema, there had always been the saving phrase of 'determination in the last instance'. As we have seen, in concrete Althusserian analyses this tended to be ritual incantation rather than an informing principle of the investigation, but it nevertheless represented a continued commitment to the principle of material determination. Theorizing the precise weight to be given to determination was always a most difficult part of the Althusserian project but it remained part of the project. It was at this point that Coward, and other equally rigorous Althusserian critics, had attacked marxist cultural studies for adhering to obsolete expressive notions of cultural practices. None of the attempts at constructing a convincing reply seemed satisfactory at either the theoretical or the empirical level. The solution proposed by Laclau represented a step away from any concern with determination.

In fact, in his earlier formulation it remained the 'elements' of any given ideological discourse which were free of class determination, while the determination of the discourse itself remained problematic. In later formulations produced with his co-thinker Chantal Mouffe, he cleared up

this remaining ambiguity by breaking radically with any notion of determination:

> Let us draw the conclusions. It is not the case that the field of the economy is a self-regulated space subject to endogenous laws; nor does there exist a constitutive principle for social agents which can be fixed in an ultimate class core; nor are class positions the necessary location of historical interests . . . even for Gramsci, the ultimate core of the hegemonic subject's identity is constituted at a point external to the space it articulates: the logic of hegemony does not unfold all its deconstructive effects on the theoretical terrain of classical Marxism. We have witnessed, however, the fall of this last redoubt of class reductionism, insofar as the very unity and homogeneity of class subjects has split into a set of precariously integrated positions which, once the thesis of the neutral character of the productive forces is abandoned, cannot be referred to any necessary point of future unification. The logic of hegemony, as a logic of articulation and contingency, has come to determine the very identity of the hegemonic subjects.
>
> (Laclau and Mouffe, 1985: 85)

Although Hall himself has expressed hesitations about following this logic through to its conclusion, there can be little doubt that the development of cultural studies in the 1980s and 1990s has accepted this account of the radical non-determinacy of ideological discourses.

Third, to the extent that there was now any relation of determination between ideology and social subject, it was through the activity of ideology that the link was made. The origins of ideologies were indeterminate, but a political ideology could, for example, constitute a given social group as part of 'the people'. In this, it did not differ radically from the implications of Althusserian ideas. The tendency of the Althusserian concern, however, had been in determinant nature of interpellation. In Laclau's version, while an ideology had the potential to determine a subject-position, this determination was merely a possibility rather than a given.

Fourth, 'class' was displaced from the privileged position which it holds in marxism, even Althusser's marxism. In Laclau's account: 'If class contradiction is the dominant contradiction at the abstract level of the mode of production, the people/power-bloc contradiction is dominant at the level of the social formation' (Laclau, 1979: 108). The really-existing 'people' always consists of elements of different classes whose unity is constituted not by their objective relationship to the means of the production but by the extent to which they subscribe to a particular discursive ideology. If this is the case, however, there is no logical reason why we should insist that the sole or dominant constitutive element of any ideology must be the interests of a social class. It could just as well be any other social division. It thus became possible to think the centrality of the

troublesome 'new' categories of gender and ethnicity in cultural studies in ways that were not possible within the marxist framework. As one, rather uncritical, representative of the newer cultural studies put it:

> The classical Marxist view of the industrial working class as the privileged agent of revolutionary historical change has been undermined and discredited from below by the emergence of numerous social movements – feminisms, black struggles, national liberation, anti-nuclear and ecological movements – that have also reshaped and redefined the sphere of politics.
>
> (Mercer, 1990: 44)

The urgent claims of these new social movements had been pressing against cultural studies for some time. One of the reasons for the dispute over the implications of Althusser which we examined above was precisely that his work was taken by some, by token of its privileging the category of the unconscious and thus of psychoanalysis, to entail a shift of attention from class to the construction of gender. In rejecting this 'strong' version of ideology, cultural studies was left without theoretical space to accommodate to the theories and practices of feminism. In adopting the formulations of Laclau, it became possible to give equal weight to each of the members of the 'holy trinity' of race, class and gender.

We can track the effects of this theoretical loosening of the constraints of Althusserian marxism if we look at the development of the three areas of work we explored above: the analysis of youth cultures, the encoding/decoding model and the analysis of the historical moment. In the development of the study of youth cultures, there have been two different trajectories. The best known of these is that so brilliantly represented by Dick Hebdige. In all of his work, the stress has always been upon 'reading the style', rather than upon style as an expression of class position. His earlier writing sat a little uneasily in the theoretical framework of *Resistance through Rituals*. His later and better known work elaborates a theory of youth cultures in which the concerns with class determination are more or less absent. One could encapsulate the emphasis which he has imparted to this field of study by claiming that he has shifted the centre of theoretical concern away from subcultures and towards lifestyles. Musical taste, rather than social situation, has come more and more to be the focus of his analysis and the defining characteristic of his subjects. The theoretical grounding for this shift has been a growing engagement with postmodernity, which is interpreted as requiring us

> to redefine the function(s) of critique. To concentrate on the problematic of affect involves a break with those forms of (interpretive, functionalist, (post)structuralist) cultural critique which are bound into the problematic of meaning. It involves a shift away from semiotics to pragmatics,

from the analysis of the putative relations between cultural practices and social formations, between 'texts' and 'readers' towards a critical engagement with those processes through which libidinal and 'information' flows are organised via networks in which 'meanings' and 'affects' circulate, form clusters, separate in a flux combining signifying and asignifying elements.

(Hebdige, 1988: 223)

The intellectual framework deployed here is one in which neither of the terms of *Resistance through Rituals* has a place. The problem of the difficulty of reconciling a theory of determination with a theory of style has been resolved by an abolition of the former. Style itself has been transformed from the meaningful articulation of a group's social self-identification into a free play of indeterminate signifiers.

The opposite movement is best identified with Paul Willis, whose response to the crisis of cultural theory is a more or less direct restatement of the earlier positions of Williams on culture:

The crucial failure and danger of most cultural analysis are that dynamic, living grounded aesthetics are transformed and transferred into ontological properties of things, object and artefacts which may represent and sustain aesthetics but which are, in fact, separate. The aesthetic effect is not *in* the text or artefact. It is part of the sensuous/emotive/cognitive creativities of human receivers, especially as they produce a stronger sense of emotional and cognitive identity as expanded capacity and power – even if only in the possibility of *future* recognitions of a similar kind.

(Willis, 1990: 24)

One must make allowance for the fact that this passage was written as an attempt to persuade the Gulbenkian Foundation of the value of popular culture, but even so it is striking how far the resources of *The Long Revolution*, and its essentially non-ideological and expressivist ideas about culture, are redeployed. In Willis's account, the variety of working-class youth subcultures is once again the expression of life situation.

The fate of the 'encoding/decoding' model is slightly different. Hall appears to have abandoned the attempt to develop this any further at the start of the 1980s. The media are barely discussed directly in *The Hard Road to Renewal*, despite the fact that they must surely have been considered central to the struggle for hegemony in contemporary society. When they are mentioned, it is simply as 'ventriloquists' for Thatcherism (Hall, 1988: 52–3). The elaboration of the decoding moment of the model was one of the most successful aspects of cultural studies during the period. In this respect, Morley's book *The 'Nationwide' Audience* was genuinely seminal in that it opened the route to the 'ethnographic' approach to the

audience. In its original form, this book was the second part of a study which also involved an attempt to produce an account of the embedded codes of the 'Nationwide' television programme. In the subsequent elaboration of this strand of analysis, the concern with the nature of the text which forms the basis for the decoding has usually been absent. Starting from the perception that there are observable differences in decoding, emphasis has shifted to the activity of the audience, which is now conceived of as a much more shifting and transitory phenomenon than it was originally. While Morley has been careful to distinguish himself from the more extreme formulations, there can be no doubt that the tendency of the work in this field over the last years has been towards the radical indeterminacy of audience readings (Morley, 1992: 23–32). In *The 'Nationwide' Audience*, and in some of his subsequent work, Morley made a serious effort to investigate how far particular decodings could be related to social position. In the writings of other prominent figures who have developed this line of thinking, most notably John Fiske, any concern with determination has completely vanished. His central concern is with the production of 'popular' readings. His account of the category of 'the people' who actually produce such readings is that 'it does not exist in objective reality'. It is better thought of 'in terms of people's felt collectivity' and one may move between different forms of 'popular formation' apparently more or less at will (Fiske, 1989: 24).

The analysis of the historical moment is the subject of Hall's only major published work during the 1980s. This was concerned with the analysis of British politics. While it represented a focus rather different than that of the immediately preceding period, it developed out of, and built upon, the work published in *Policing the Crisis*. In the essays collected as *The Hard Road to Renewal*, Hall developed the idea of the success of Thatcherism as being a consequence of the successful interpellation of at least a section of the working class by the discourse of 'popular authoritarianism'. This constituted a new hegemonic order which succeeded in presenting particular partial political strategies as the commonsense embodiment of universal truths. For Hall, the support for the British recovery of the Malvinas/Falklands Islands, was a clear illustration of the way this process worked:

> The Falkland crisis may have been unpredicted, but the way in which it has been constructed into a populist cause is not. It is the apogee of the whole arc of Thatcherite populism. By 'populism' I mean something more than the ability to secure electoral support for a political programme, a quality all politicians must possess. I mean the project, central to the politics of Thatcherism, to ground neo-liberal policies directly in an appeal to 'the people'; to root them in the essentialist categories of commonsense experience and practical moralism – and

thus to construct, not simply awaken, classes, groups and interests into a particular definition of 'the people'.

(Hall, 1988: 71)

The theoretical point of reference which Hall used to argue for this position is explicitly drawn from Laclau (Hall, 1988: 139–40). It is his notion of hegemony and of the construction of 'the people' which, with some small reservations, Hall employs throughout his work in the 1980s.

Hall developed this theoretical position in the 'official' Communist Party celebration of the one hundredth anniversary of Marx's death. He contributed a piece which has become widely known in different forms and which is there published as 'The problem of ideology: marxism without guarantees'. This was written within a framework which clearly identified itself as wishing to continue with the marxist theoretical project as a 'living body of thought' (Hall, 1983: 84). Hall again drew heavily on Laclau to argue against reductivism in the realm of ideology: 'Laclau has demonstrated definitively . . . the untenable nature of the proposition that classes, as such, are the subjects of fixed and ascribed class ideologies' (Hall, 1983: 77). On the other hand, Hall wished to continue to argue for the continuing relevance of the idea of determination. To do this, he borrowed from Raymond Williams the idea of determination as a setting of limits. In practice, however, Hall used this borrowing very sparingly. In the analysis of Thatcherism, for example, there is no attempt to incorporate changes in the class structure, the differential impact of rising real wages, tax cuts, unemployment, privatization and the spread of subsidized home ownership, or any of the other major economic planks of Conservative policies during the 1980s, into an understanding of how a particular hegemonic project might come to win consent. In a word, the material basis of Thatcher's political successes is never investigated.

AFTER MARXISM

Taken together, the implications of the above formulations are clearly to shift cultural studies away from its encounter with marxism. When Laclau and Mouffe characterized their position as 'post-marxism' with an equal stress upon each of the two elements in that portmanteau word, they were perhaps a little generous to Marx. The category of 'marxism' is an extremely broad one, and there is little point or profit in trying to decide whether someone can legitimately claim to be 'marxist' or not. If they wish to adopt the label, then we have no need to quibble. We may note, however, that there is a fairly large gap between the theoretical framework cultural studies used in its marxist phase and the one that has come to dominance in more recent years. In this respect, the 'marxist cultural studies' which has travelled so successfully around the world was one which was perhaps

carrying a dubious passport: the 'marxist' element was in crisis from the beginning and has now been more or less abandoned.

The very success of cultural studies means that it is today difficult to pin down a single strand of thought as the successor to marxist cultural studies. If in the early days there was a handful of people working more or less in isolation on similar topics, and if in the 1970s one could identify a Centre which was also the centre, today the field is so diverse that such a task is hopeless. It is, however, possible to claim that almost nobody today active in the field of cultural studies identifies themselves with the theoretical framework of what was once marxist cultural studies. In particular, the central concerns with the problem of determination and the nature of ideology have more or less disappeared. The difficulties which faced the project of marxist cultural studies have been resolved by shifting the terrain of investigation.

Hall himself modified his position considerably during the late 1980s. In his contribution to the debate over 'New Times', Hall developed a position which seems to owe rather more to Foucault than Marx:

> Of course, 'civil society' is no ideal realm of pure freedom. Its micro-worlds include the multiplication of points of power and conflict – and thus exploitation, oppression and marginalisation. More and more of our everyday lives are caught up in these forms of power, and their lines of intersection. Far from there being no resistance to the system, there has been a proliferation of new points of antagonism, new social movements of resistance organised around them – and consequently, a generalisation of 'politics' to spheres which hitherto the Left assumed to be apolitical: a politics of the family, of health, of food, of sexuality, of the body. What we lack is any overall map of how these power relations connect and of their resistances. Perhaps there isn't, in that sense, one 'power game' at all, more a network of strategies and powers and their articulations – and thus a politics which is always positional.
>
> (Hall, 1989b: 130)

The systematizing discursive formations of ideology, with their power to constitute individuals as subjects, and the concern with the extent to which it is possible to construct some kind of theory of determination have here disappeared. There has been a change not only in the theoretical reference points but in the kinds of questions which are set out as requiring investigation.

The novelty of the framework may, however, be more apparent than real. In an essay titled 'The supply of demand', first published in 1960, Stuart Hall had written about the corrosive effects of affluence on the older patterns of politics and of culture. Much of the essay is borrowed more or less directly from Williams and Hoggart, but it is remarkable in the ways in which it extends those ideas into a central focus on the impact, which

Hall very often sees as a positive impact, of the capitalist boom on the everyday life experience of the working class:

> Even if working-class prosperity is a mixed affair . . . it is *there*: the fact has bitten deep into the experience of working people. . . . There has been an absolute rise in living standards for the majority of workers, fuller wage-packets, more overtime, a gradual filling out of the home with some of the domestic consumer goods which transform it from a place of absolute drudgery. For some, the important move out of the constricting environment of the working-class slum into the more open and convenient housing estate or even the new industrial town. The scourge of TB and diseases of undernourishment no longer haunting whole regions; the Health Service to turn to if the children are ill. Above all, the sense of security – a little space at least to turn around in.
>
> (Hall, 1960b: 79)

Hall was concerned as to whether the left, by which he meant Gaitskell's Labour Party, had managed to adapt its thinking to the demands of the 'New Times'. The danger was that although there was as yet no genuine popular belief in, or enthusiasm for, the new way of life, there was the possibility that it would erode the traditional cultural and political loyalties upon which the left based itself. In the future, there could be: 'a thrusting, confident, celebration of the new capitalism on the part of the majority of people in this country' (Hall, 1960b: 77).

It is not stretching the sense of things too far to argue that in Thatcherism Hall found, twenty years after he had recognized its dangers, just such a 'celebration of the new capitalism'. In this light his recent concerns have been more a return to the themes of youth than a new and radical departure. Certainly, the language and some of the issues of relevance have changed in three decades, but the central concern with the impact of increasing wealth, changing patterns of work, increased leisure, the centrality of consumption, fragmentation of the social structure, the problematization of old identities and the fragmentary and transitory nature of their replacements, are common to the thinking of both periods. It is almost as though Hall perceived the limits of modernity and harbingers of postmodernity thirty years before their time.

CONCLUSION

All of this suggests that, in the current associated with Stuart Hall, the link between marxism and cultural studies was much more contingent and transitory than it once appeared even to its main actors. The initial formation of cultural studies was in part a rejection of the then dominant version of marxism. The later elaboration of marxist cultural studies took place through the appropriation of one particular version of marxism. It was from

the start beset by internal intellectual problems arising in part from the radical incommensurability between the project of cultural studies and the variety of marxism adopted. The productive life of this marxist cultural studies was very short: certainly less than a decade and perhaps as little as five years. As the problems within Althusserian marxism became more apparent, the move away from a strictly marxist cultural studies began. The form of its subsequent evolution represented a continual loosening of some of the categories usually thought to be characteristic of marxism. It is today definitely an historical phenomenon.

We may legitimately enquire as to the implications of the trajectory we have examined. The dominant view within the field today is probably that in shedding its marxist husk, cultural studies has empowered itself to address the real issues of contemporary cultural analysis. Whether one subscribes to that view or not depends on the answers one gives to two questions. The first is whether one believes that marxism has, after the events of 1989, any continuing claim to be considered a correct, or even a useful, way of analysing the world. A full discussion of that topic would take us well beyond the scope of this chapter. If one holds, as does the present author, that the fall of stalinism provided an opportunity to free marxism from a crippling distortion and to develop it anew, then clearly the increasing distance between cultural studies and marxism is a retrograde move.

The second question is more limited. It involves asking whether abandoning the problem of determination, which formed the substantial content of the move away from marxism, has strengthened cultural studies or not. The concern with the ways in which material life and culture were deeply interwoven was not unique and original to cultural studies. Quite apart from marxism, it was also part of the theoretical programme, if not necessarily the critical practice, of F.R. Leavis and his school. Leavis, famously, had no time at all for any kind of marxism. Nevertheless, for him and his associates, the kinds of literature and the kinds of life prevailing in a particular epoch were necessarily connected. The problem of understanding the determination of culture was the central concern of cultural studies long before the decisive encounter with marxism.

In abandoning the effort to understand this very difficult problem, cultural studies is changing the object of its enquiries in a fundamental way. It is regressing beyond Hoggart and Williams, beyond the Leavises and the British marxists, to an essentially textualist account of culture. The only thing which now seems to distinguish cultural studies from literary studies is that the former has a rather wider range of texts from which to choose. This seems to me a fundamentally regressive step.

Fortunately, the above account need not be taken as the final and definitive word upon marxism and cultural studies in general. It is, for example, possible to tell a different story, with a very different ending, by

following through the intellectual development of Raymond Williams. The development of his thought retains and even amplifies the materialist inspiration of the first phase of cultural studies and certainly provides an opening for a continuing engagement with marxism. A critical recovery of that interpretation of cultural studies would mean a new lease of life for the relationship between marxism and cultural studies.

The task of this recovery would be to complete the project of cultural studies rather than to bury it. In the first issue of *New Left Review*, rightly claimed by Stuart Hall as a key element in the formation of cultural studies, there is a record of the first meeting between Richard Hoggart and Raymond Williams. In the course of the discussion of the problems their work raised, Williams remarked:

> The most difficult bit of theory, that I think both of us have been trying to get at, is what relation there is between kinds of community, that we call working-class, and the high working-class tradition, leading to democracy, solidarity in the unions, socialism.
>
> (Hoggart and Williams, 1960: 28)

Neither Raymond Williams nor anyone else within cultural studies ever managed to resolve that 'most difficult bit of theory'. Cultural studies explored, for much of its life, the terrain of the working class community. Marxism, for its part, has been obsessively and rightly concentrated on precisely that 'high working-class tradition'. Marrying the two approaches remains an important and fruitful project.

REFERENCES

Note: the emphasis in all quotations is as in the originals.

Althusser, L. (1969) *For Marx*, (trans. B. Brewster), London: Penguin.
Anon (1958a) 'Editorial' in *Universities and Left Review*, 1 (5) (Autumn), 3.
——— (1958b) 'Editorial' in *Universities and Left Review*, 1 (4) (Summer), 3.
——— (1968) *Centre for Contemporary Cultural Studies Annual Report: 1968–9*, Birmingham: University of Birmingham.
——— (1969) *Centre for Contemporary Cultural Studies: Second Report*, Birmingham: University of Birmingham.
——— (1971) *Centre for Contemporary Cultural Studies Report: 7.1969–12.1971*, Birmingham: University of Birmingham.
Chambers, I., Clarke, J., Connell, I., Curti, L., Hall, S. and Jefferson, T. (1977/8) 'Marxism and culture' in *Screen*, 18 (4) (Winter), 109–19.
Chambers, I., Ellis, J., Green, M., Lacey, S., Rusher, R., Tolson, A. and Winship, J. (1974) *Working Papers in Cultural Studies 6*, 1–6.
Clarke, J., Hall, S., Jefferson, T. and Roberts, B. (1976) 'Subcultures, cultures and class' in Hall, S. and Jefferson, T. (eds) *Resistance Through Rituals*, Birmingham: University of Birmingham Centre for Contemporary Cultural Studies, 9–79.
Coward, R. (1977) 'Class, "culture" and the social formation' in *Screen*, 18 (1) (Spring), 75–105.

Fiske, J. (1989) *Understanding Popular Culture*, London: Unwin Hyman.

Grossberg, L. (1986) 'History, politics, postmodernism: Stuart Hall and cultural studies' in *Journal of Communication Enquiry*, 10 (2) (Summer), 61–77.

Hall, S. (1958) 'A sense of classlessness' in *Universities and Left Review*, 1 (5) (Autumn), 26–32.

—— (1960a) 'Crosland territory' in *New Left Review*, 2 (March–April), 2–4.

—— (1960b) 'The Supply of demand' in Thompson, E. (ed.) *Out of Apathy*, London: New Left Books/Stevens and Sons, 56–97.

—— (1973) *Encoding and Decoding in the Television Discourse*, Birmingham: University of Birmingham Centre for Contemporary Cultural Studies. Unnumbered stencilled paper.

—— (1980a) 'Cultural studies and the centre: some problematics and problems' in Hall, S., Hobson, D., Lowe, A. and Willis, P. (eds) *Culture, Media, Language*, London: Hutchinson, 15–47.

—— (1980b) 'Cultural studies: two paradigms' in *Media, Culture and Society*, 2 (1) (January), 57–72.

—— (1980c) 'Recent developments in theories of language and ideology: a critical note' in Hall, S., Hobson, D., Lowe, A. and Willis, P. (eds) *Culture, Media, Language*, London: Hutchinson.

—— (1983) 'The problem of ideology: marxism without guarantees' in Matthews, B. (ed.) *Marx 100 Years On*, London: Lawrence & Wishart, 57–84.

—— (1988) *The Hard Road to Renewal*, London: Verso.

—— (1989a) 'The first "New Left": life and times' in Oxford University Socialist Discussion Group (eds) *Out of Apathy: Voices of the New Left 30 Years On*, London: Verso, 11–38.

—— (1989b) 'The Meaning of New Times' in Hall, S. and Jacques, M. *New Times: The Changing Face of Politics in the 1990s*, London: Lawrence & Wishart, 116–34.

—— (1992) 'Cultural studies and its theoretical legacies' in Grossberg, L., Nelson, C. and Treichler, P. (eds) *Cultural Studies*, London: Routledge, 277–94.

Hall, S., Chricter, C., Jefferson, T., Clarke, J., Roberts, B. (1978) *Policing the Crisis: ' Mugging', the State, and Law and Order*, London: Macmillan.

Hall, S. and Whannel, P. (1964) *The Popular Arts*, London: Hutchinson.

Hebdige, D. (1988) *Hiding in the Light*, London: Routledge.

Hoggart R. (1951) *Auden: An Introductory Essay*, London: Chatto & Windus.

—— (1957) *The Uses of Literacy*, London: Penguin.

—— (1967) *Your Sunday Paper*, London: London University Press.

—— (1969) *Contemporary Cultural Studies: An Approach to the Study of Literature and Society*, Occasional Paper 6, Birmingham: University of Birmingham Centre for Contemporary Cultural Studies.

—— (1973) 'Changes in working-class life' in R. Hoggart *Speaking to Each Other Volume One: About Society*, London: Penguin.

—— (1988) *A Local Habitation*, Oxford: Oxford University Press.

Hoggart, R. and Williams, R. (1960) 'Working class attitudes' in *New Left Review*, 1 (January–February), 26–30.

Laclau, E. (1979) *Politics and Ideology in Marxist Theory*, London: Verso.

Laclau, E. and Mouffe, C. (1985) *Hegemony and Socialist Strategy*, London: Verso.

Mercer, K. (1990) 'Welcome to the jungle: identity and diversity in postmodern politics' in Rutherford, J. (ed.) *Identity: Community, Culture, Difference*, London: Lawrence & Wishart, 43–71.

Moore, T. (1968) *Claude Lévi-Strauss and the Cultural Sciences*, Occasional Paper

4, Birmingham: University of Birmingham Centre for Contemporary Cultural Studies.

Morin, E. (1969) *New Trends in the Study of Mass Communications*, Occasional Paper 7, Birmingham: University of Birmingham Centre for Contemporary Cultural Studies.

Morley, D. (1980) *The ' Nationwide' Audience*, London: British Film Institute.

—— (1992) *Television, Audiences and Cultural Studies*, London: Routledge.

O'Connor, A. (1989) *Raymond Williams: Writing, Culture, Politics*, Oxford: Basil Blackwell.

Saville, J.S. and Thompson, E.P. (1957) 'Editorial' in *New Reasoner*, 1 (1) (Summer), 2–3.

Shuttleworth, A. (1966) *Two Working Papers in Cultural Studies*, Occasional Paper 2, Birmingham: University of Birmingham Centre for Contemporary Cultural Studies.

Thompson, E.P. (1957) 'Socialism and the intellectuals' in *Universities and Left Review*, 1 (1), 31–36.

—— (1958) 'Agency and choice: a reply to criticism' in *New Reasoner* (Summer), 88–106.

—— (1959a) 'A psessay in ephology' in *New Reasoner* (Autumn), 1–8.

—— (1959b) 'The New Left' in *New Reasoner* (Summer), 1–17.

—— (1978) *The Poverty of Theory*, London: Merlin.

Walton, P. and Hall, S. (n.d.) 'Introduction' to Walton, P. and Hall, S. *Situating Marx*, London: Human Context.

Williams, R. (1958) 'Culture is ordinary' in Williams, R. (1989) *Resources of Hope*, London: New Left Books, 3–18.

—— (1961) *The Long Revolution*, London: Chatto & Windus.

—— (1963) *Culture and Society 1780–1950*, London: Penguin.

—— (1968) *May Day Manifesto 1968*, London: Penguin

—— (1979) *Politics and Letters*, London: New Left Books.

Willis, P. (1990) *Common Culture*, Milton Keynes: Open University Press.

Chapter 4

British cultural studies and the return of the 'critical' in American mass communication research
Accommodation or radical change?

Hanno Hardt

Communication and media studies in the United States throughout the 1980s have come under the influence of a body of British literature identified with the intellectual traditions of Raymond Williams, Richard Hoggart and the University of Birmingham Centre for Contemporary Cultural Studies, notably under the leadership of Stuart Hall. Indeed, the writings of the British cultural studies group constitute a significant contribution to the field of mass communication research, and they begin to represent the most decisive theoretical 'break' that has captured the attention of scholarly journals since the domination of traditional sociology in the field of communication and media studies in the United States a generation ago.

The fascination with new ideas, particularly the continuing challenge of marxism, the appeal of a European renaissance in the study of culture and society, particularly enhanced by its immediate accessibility as an English language text, and a heightened sense of criticism concerning current definitions of society as basic presuppositions for mass communication research, provide the context for the reception of British cultural studies in the realm of mass communication and communication scholarship in the United States.

Since a major problem of American thought continues to be how to mould its European heritage to fit the specific needs of American culture, the American encounter with British cultural studies may serve as a contemporary link in this intellectual tradition of re-creating social theories as an exercise in cultural exploitation, in this case, for the development of communication and mass communication studies. More specifically, this essay will explore the development of mass communication research as a problem of adapting and integrating theoretical constructs as they emerge from a continuing intellectual exchange of social

Reprinted from *Journal of Communication Inquiry*, (1986), 10(2), 117–24, abridged.

and political ideas located within the specific historical context of a marxist perspective.

There seems to be a specific interest in the exploration of ideological representations and the process of ideological struggle with and within the media, emphasizing the relationship between the media and the maintenance of social order. This perceived need for an alternative explanation of media and communication in society stresses the importance of culture and cultural expressions and has focused on the work of British cultural studies as an appropriate alternative, although there have been earlier encounters with a critical tradition in the American social sciences.

The development of social theories in the United States under the guidance of a liberal-pluralist perspective was based upon an assumption of consensual unity, and reduced complex social and political issues of power and authority to an examination (and legitimation) of the dominant social system; that is to say, the practice of normative functionalism, including the assumptions of behavioural research, surveys, and the contributions of social psychology led to the reproduction of the dominant view of society in mass communication research. Furthermore, the influence of pragmatism, rising through the social reform movement of the 1920s and supported by social research of the 1940s and 1950s, had remained a strong and persistent element in the changing climate of the 1960s and guided the expressions of the social sciences in the 1970s and 1980s. Its prevailing disposition was the result of an optimistic belief in the individual as a free and creative participant in the social and political life of the community. The promise of a place and a share in the benefits of the 'great society' for everyone continued to be reflected in theoretical issues and practical concerns and produced a vision of mass society as a community of cultures.

The field of communication and media studies remained identified with the mainstream perspective of social science research. Based upon a pragmatic model of society, it related to the values of individualism and operated on the strength of efficiency and instrumental values in its pursuit of democracy and the American dream. Thus, conditions of society were defined in terms of individuals as members of a large-scale, consensual society and their encounter with the social and cultural order.

For instance, the persistent growth of mass communication research agendas, involving conspicuous topics like children, advertising, pornography, violence, crime and the media produced a spontaneous definition and an extensive compilation of social problems. But mass communication research typically reduced its inquiry by isolating specific conditions of the environment, instead of expanding its investigation to raise questions about the role of the media in the process of cultural expressions and ideological struggles and about power among individuals, groups and political or economic institutions. Consequently, mass communication research

delved into relationships among individuals, investigated questions of social identity, and, generally speaking, raised some doubts about the stability of individuals in their social relations. At the same time, there was a marked absence, however, of investigating the structure of society, including the location of authority and the distribution of power, and a lack of articulating larger, more fundamental questions about the failure of the liberal-pluralist vision of American society, including the failure of its own theoretical foundation. Although reform minded in the sense of understanding itself as contributing to the betterment of society, mass communication research remained committed to a traditionally conservative approach to the study of social and cultural phenomena, in which instrumental values merged and identified with moral values.

The 1970s saw the emergence of a brand of social criticism strongly related to an earlier critique of American society. These expressions had ranged from the socialist writings of political economists and sociologists during the turn of the century, to populist criticism of political and economic authority by publicists and muckraking journalists in the late 1920s, and to the social criticism of social scientists since the 1950s.

However, the introduction of critical theory as a competing social (and political) theory of society constituted a significant development in American social thought. It rekindled a debate of marxism and radical criticism and signalled the beginning of substantial marxist scholarship after the Second World War. The ensuing critique of contemporary American social theory and research practice also established the intellectual leadership of British, French and German social theorists. Thus, the encounter with critical theorists provided a solid opportunity to examine form and substance of an ideological critique of society. Specifically, the cultural pessimism of Theodor Adorno and Max Horkheimer together with the political critique of Herbert Marcuse and the theoretical inquiries of Jurgen Habermas concerning the role of communication in the struggle against bureaucracies and authority, provided American social theorists with an alternative approach to the questions of power, change, and the future of society. Throughout, this body of critical writings exemplified an abiding commitment to the study of culture, including the complicity of the media industry in the ideological struggle, and to an analysis of the cultural process.

When critical theory reached the representatives of mainstream mass communication research in the 1970s, it had been a major theoretical event for over four decades, constituting a considerable body of literature which reflected the extent and quality of the modernist debate in a number of disciplines. The subsequent readings and interpretations by mass communication research remained peripheral to the field, but reveal an expressed tendency to appropriate compatible ideas. This practice of collecting and adapting theoretical propositions and practical applications for the better-

ment of society, disregarding cultural or political origins and ideological foundations, reflects an intellectual process of Americanizing ideas. It has occurred in the social sciences with the influence of European knowledge on American scholarship since the beginning of academic institutions in the United States, and is most clearly visible in American pragmatism (particularly in Dewey's instrumentalism), which seemed to acquire and apply suitable theoretical propositions according to the interests it served at the time.

Thus, to realize the potential contribution of critical theory to a critique of contemporary society, mass communication research needed to explore the rise of critical theory in the cultural and political context of Weimar Germany. Specifically, its attempts to replace the preoccupation of traditional philosophy with science and nature by shifting to an emphasis upon history and culture, and its acute awareness of the relationship between epistemology and politics, were decisive elements for such analysis. They offered the basis for an intensive examination of the critique of modern society, including a discussion of its philosophical (and political) consequences for mass communication research. Such enquiry, however, remained uncompleted, and a debate of critical theory as the foundation of a critical theory of mass communication was limited to sporadic contributions from other disciplines.

For instance, when Paul Lazarsfeld recognized the political nature of mass communication research and began to formulate his position *vis-à-vis* the reality of economic and political authority in the United States, he offered a reading of critical theory and the Frankfurt School which ignored the theoretical premises and their practical consequences (particularly as suggested in the work of Horkheimer and Adorno). Instead, he produced his own claims for critical research without leaving, theoretically or practically (politically), the traditional bourgeois context of the social science enterprise. The notion of a critical position ultimately meant a recognition of authority and a reconciliation with power; it also meant working with the necessity for change within the dominant paradigm and arguing for the convergence of existing theoretical or practical perspectives. Thus, the 'critical' research of Lazarsfeld is neither based upon a critique of society nor engaged in a questioning of authority in the populist, reformist sense of traditional social criticism.

Instead, it represents the repositioning of traditional social science research *within* the practice of what C. Wright Mills has called abstracted empiricism. The notion of 'critical' research (as opposed to administrative research) becomes a point of legitimation in the development of mass communication studies. It asserts the neutral, independent position of mass communication research in the study of society and establishes mass communication research not only as a field (and therefore, as an administrative unit within universities), but also as a relevant and important

methodological specialization of a branch of sociology, in which the priorities of the method become the determinants of social research and the source of research agendas.

In this form, the accommodation of a 'critical' position within mass communication research may have served as a convenient strategy for defusing potentially controversial (since ideologically unacceptable) and challenging threats to the authority of the sociological enterprise in mass communication studies, including public opinion research. They arose from two directions: traditional social criticism, latent in social scientific scholarship since the turn of the century, and post-Second World War marxism, vital as a theoretical force in the explanation of social changes and the historical condition in Europe.

The suggestion of 'critical' research as a socially desirable goal, within the limits of the dominant perspective of democratic practice, however, was a pseudo-oppositional argument with an appeal to a commonsense notion of criticism. It represented a successful attempt to create a false dichotomy and a confrontation of research practices without challenging their common theoretical and political premises. Subsequent endeavours of mainstream mass communication research to embrace critical theory, or appropriate certain aspects of a marxist perspective, have demonstrated a willingness to coopt such approaches, rather than to rethink the position of communication and media studies in terms of the weaknesses or failures of their underlying theory of society.

Not unlike British cultural studies a few years later, the introduction of critical theory as a European critique of contemporary society was a political challenge and a direct confrontation between liberal pluralism and marxism as competing theories of society; it also reflected the quality and intensity of an intellectual commitment to a critique of ideological domination and political power. Thus, the question of adapting cultural studies to an analysis of social and political conditions of American society is not only a commitment to the uses of history; it also requires an emphasis upon the ideological in the review of those intentions, interests and actions which intersect in the spheres of cultural, economic and political power, thus rendering a fundamental critique of the dominant model of society.

At a different level, the reception and assimilation of such distinct theoretical propositions and research practices raise a number of questions concerning the ways in which they are transformed into a problematic which can be accommodated by a rather distinct, if limiting, system of academic disciplines in the United States. Although this is an issue which has been underlying the study of communication and media practice in American universities for many years, the arrival of British cultural studies on the American academic scene has dramatized the question of disciplinary boundaries and academic compartmentalization of knowlege, including the construction and administration of appropriate social research agendas.

The arrival of British cultural studies in the research literature of American mass communication studies promised a series of immediate rewards, since the encounter of mass communication research with critical theory had remained a most difficult undertaking. There was a continuing problem with the accessibility of these ideas for the development of research, which had remained conceptually rooted in the traditional, sociological model of mass communication research. This problem was exacerbated by the atheoretical nature of mass communication studies, its relative isolation from other disciplines engaged in an exchange with critical theory, and, possibly, by an identification with a marxist critique of society, and thus with a devastating critique of the culture industry, that excluded the potential for a theoretical compromise of sorts.

The work of the Frankfurt School had offered a comprehensive modernist view of the cultural and political crisis of Western society, which found a modest and eclectic response among communication and media scholars. British cultural studies, on the other hand, has attracted considerable interest and a substantial following. The initial response may have been partly due to a sense of familiarity, albeit misleading, with the ideas of culture and media research as significant concepts in the history of American mass communication research.

In fact, mass communication studies in the United States have had a strong cultural tradition, and a cultural approach to the problems of communication and media has remained a consistent and recognized theme in the literature of the field. Also, the idea of culture and society in the context of mass communication research in the United States has European origins. It is defined through its assimilation of nineteenth century European social thought into American practice; that is to say, by the effects of American pragmatism on the development of academic disciplines and their particular social concerns.

Consequently, mass communication studies have been embedded in the social science apparatus and surfaced with the social reform movement earlier this century. They rose to academic prominence and political importance with the recognition of commercial and political propaganda as essential aspects of mass persuasion *vis-à-vis* an increasing need for the mediation of knowledge in a complex urban society. The field also shared the basic tenets of the social sciences of the time, namely the belief in a world that is knowable through the application of scientific techniques which stressed the plurality and equality of facts, through the belief in the objectivity of expert observations and the power of empirical explanations. Since mass communication was treated as a series of specific, isolated social phenomena, it resulted in a narrow understanding of communication and in a conduct of media studies without appreciation for the importance of their historical environment.

As a matter of fact, in the past the American perspective on culture had

been more closely related to a biological approach towards man and was less committed to emphasizing the differences between natural and cultural disciplines than the German tradition. This position was reflected in the struggle against the biological bias of Spencer's sociological methods which had occupied a generation of social scientists after the turn of the century and continued while the trend towards a cultural analysis of social phenomena gained ground with the coming of the Progressive era in American social history. A generation later, traditional sociology redis- covered nature, and under the influence of Talcott Parsons, embraced structural functionalism with its claim to move steadily in the direction of a theoretical system, like classical mechanics.

Throughout this time, there was hardly any disagreement over the suggestion that there can be no human nature independent of culture. The question was rather how to deal conceptually with the historical components in the examination of social and cultural processes. Indeed, there was a strong movement among the first generation of American social scientists at the beginning of the twentieth century, which reflected a sophisticated understanding and appreciation of the German historical school, including socialist writings. As exponents of a cultural-historical tradition in social science scholarship, its most prominent representatives provided academic leadership in the critique of social and political condi- tions of society with works which were a direct response to the reality of their own age. However, in their writings they sought to reach an accom- modation with existing economic structures and political power, and their solutions to the problems of modern capitalism were based upon the conviction that despite its failures, capitalism offered an appropriate con- text for the growth and success of a great society. Thus, the first encounter with the 'critical' in the social sciences, and specifically in the study of mass communication as a concern of modern sociology, reflected more accurately the tolerance for dissent within the academic establishment, and therefore within the dominant theoretical paradigm, than the emergence of an alternative, let alone marxist theory of society.

When the context of culture became a significant feature of the socio- logical enterprise, particularly with the rise of a spirit of collectivism in American thought before the First World War, its theoretical position was a reflection of European and American influences. Under the leadership of pragmatism, social theorists focused upon the idea of the social, the role of community and the process of communication. These concepts suggested (particularly to Dewey) the potential of a democratic way of life; accord- ingly, communication as a life process would eventually and undoubtedly lead to democratic practice.

Over time, however, significant differences became evident in the study of culture and society. The German approach remained within the historical, speculative and philosophically oriented realm of academic scholarship.

The American analysis of society, on the other hand, became increasingly empirical, behaviouristic and scientific in the consideration of the individual, the role of communication and the effects of the media. Mass communication research followed the route of atomistic positivism in its analysis of democratic practice. Implicit in this direction of social scientific enquiry was an assumption of shared cultural and social values across American society. Thus, the spectre of mass society would also be conceived of as holding the promise of an emancipatory movement, involving all people and suggesting a triumph of individualism in an age of technology and under bureaucratic guidance.

Throughout these developments, the cultural studies approach to mass communication in the United States depended upon a firm belief in a utopian model of society. It was based upon a vision of consensual participation as democratic practice and an understanding of the exercise of political and economic power as acts of progressive intervention in the advancement of people. Radical dissent, including marxist criticism of American society, remained outside the mainstream of mass communication research. When it arose, it belonged to the literature of social criticism rooted in rhetorical studies, literature, political economy and sociology, in particular, from where it was unable to engage the field in an extensive and prolonged debate concerning the foundations of social theory and the false optimism of social enquiries into the role and function of communication and media.

However, neither a cultural tradition in American mass communication research, nor the acquaintance with British mass communication research, particularly since the 1970s, when it had been favourably received and widely incorporated into the analysis of political communication and the study of television effects, can directly explain the success of the British cultural studies group. Instead, the prominence of these ideas in the current American mass communication literature may be the result of a growing disillusionment with contemporary liberal pluralism reflected in the social sciences and humanities together with a rising radical critique of the liberal tradition in American thought. In addition, the field of mass communication studies has benefited from a keen interest in the notions of culture and communication among other academic disciplines, which resulted in an increased reception of the relevant intellectual discourse concerning communication and the media from outside its own sphere. By now it has become obvious that the study of communication and the media is no longer the academic prerogative of one discipline, but the joint concern of several intellectual traditions.

Notably the field of literary studies with its curiosity about the process of social communication, including the role of the media, has moved freely among leading intellectual currents and created an awareness of British and Continental European thought and its contribution to the modernist and

postmodernist debates. In the meantime, mass communication research proceeded with its narrowly defined task of investigating communication and the media as autonomous social entities, demonstrating the definitive and irreconcilable difference between the practitioners of pluralist functionalism and the exponents of an ideological approach to the processes of culture and communication.

Specifically, the British cultural studies tradition emerged from an intellectual climate created and sustained by a political discourse (as represented by the *New Left Review*), which operates on the assumption that the social and economic problems of Britain cannot be solved by current conservative or liberal socialist theories; instead, marxism as a social theory is not only capable of explaining, but also of changing the conditions of British society. These debates, informed by the contributions of western European marxism, French structuralism, and the work of Louis Althusser in particular, continue to serve as the intellectual resources for alternative, political responses to the problems of British society, including the distribution of economic and political power and the role of the media.

British cultural studies belong to an intellectual tradition in which mass communication research serves a useful purpose for a particular, if limited, perspective on culture. Instead, the matrix of literature, literary criticism and marxism produces a convenient context for the questioning of cultural activities, including social communication. Such contextualization and the location of the problematic in the cultural process, specifically among cultural, political and economic phenomena, provided descriptive power and theoretical complexity to the analysis of communication and media practice. British cultural studies also appealed to the critics of mass communication research with its provocative investigations of contemporary social problems, demonstrating a sense of engagement between political practice and theoretical consideration within the public sphere. This is a qualitatively decisive difference from a system in which the nature and extent of social research depend upon the relationship between academic organizations, economic interests, and the political system. Hence, mass communication research in the United States, with its primary location within the organization of universities, encounters the practical effects of politicizing research (for instance, through the policies of funding social scientific enquiries). In seeking alternative paths, American mass communication research may find the organizational aspects of the British cultural studies perspective in a climate of political engagement equally appropriate and useful for producing its own answers to socially important and politically relevant problems.

At the same time, the enthusiasm for an alternative explanation of communication in society, if sustained, cannot rest upon the goodwill towards British cultural studies and a calculated indifference towards the dominant interpretation of the social structure. Instead, a commitment to a

critical approach, in the sense of a marxist critique of society, will lead to a number of significant changes in the definition of society, social problems and the media as well as in the organisation and execution of research projects. They are changes rooted in radical ideas, uncompromising in their demands for rethinking the theoretical basis of mass communication studies and innovative in their creation of appropriate methodologies. Since the traditional literature of communication theory and research restricts the imagination by its denial of the historical process in the presentation of mass communication phenomena, it must be replaced by a comprehensive body of knowledge, which locates the enquiry about mass communication in the realm of the ideological and explains the role of communication and the place of the media through an examination of the cultural process. As a result, disciplinary (and administrative) boundaries must be redrawn, with theoretical (and political) implications for the definition of the field, which leave no doubt that culture as a way of life directs the interpretation of mass communication in society.

There is always a chance for the return of the 'critical' as an accommodation of liberal dissent, while Marxist thought retreats again into the shadow of the dominant ideology. In any case, British cultural studies as a cultural phenomenon holds its own interpretation; its language and practice are contained in the specific historical moment, which may become accessible to American mass communication research, but it cannot be appropriated, adapted or co-opted without losing its meaning. The dilemma of American mass communication studies continues to lie in the failure to comprehend and overcome the limitations of its own intellectual history, not only by failing to address the problems of an established (and politically powerful) academic discipline with its specific theoretical and methodological requirements, but also by failing to recognize the strength of eclecticism, including the potential of radical thought.

For an extended discussion, see 'On understanding hegemony: cultural studies and the recovery of the critical' in *Critical Communication Studies: Communication, History and Theory in America*, London: Routledge, 173–216.

Chapter 5

The theory and method of articulation in cultural studies

Jennifer Daryl Slack

ARTICULATION AS THEORY AND METHOD

The concept of articulation is perhaps one of the most generative concepts in contemporary cultural studies. It is critical for understanding how cultural theorists conceptualize the world, analyse it and participate in shaping it. For some, articulation has achieved the status of theory, as in 'the theory of articulation'. Theoretically, articulation can be understood as a way of characterizing a social formation without falling into the twin traps of reductionism and essentialism. It can be seen as transforming 'cultural studies from a model of communication (production-text-consumption; encoding-decoding) to a theory of contexts' (Grossberg, 1993: 4). But articulation can also be thought of as a method used in cultural analysis. On the one hand, articulation suggests a methodological framework for understanding what a cultural study does. On the other hand, it provides strategies for undertaking a cultural study, a way of 'contextualizing' the object of one's analysis.

However, articulation works at additional levels: at the levels of the epistemological, the political and the strategic. Epistemologically, articulation is a way of thinking the structures of what we know as a play of correspondences, non-correspondences and contradictions, as fragments in the constitution of what we take to be unities. Politically, articulation is a way of foregrounding the structure and play of power that entail in relations of dominance and subordination. Strategically, articulation provides a mechanism for shaping intervention within a particular social formation, conjuncture or context.

Articulation can appear deceptively to be a simple concept – especially when one level or aspect of its work is taken in isolation. For example, it *seems* manageable if we limit our treatment of articulation to its operation as either a (or *the*) theory or method of cultural studies. But when theory and method are understood – as they have been in cultural studies – as developing in relation to changing epistemological positions and political conditions as well as providing guidance for strategic intervention, it

becomes impossible to parse out a neatly packaged theory or a clearly delineated method.

It seems timely to belabour this point, precisely because the popularity and institutionalization of cultural studies has been accompanied by a widening interest in finding out – and often finding out quickly – how to 'do' a cultural study and what it means to be a cultural theorist. The risk comes in that it has become a bit too easy to separate out articulation as *the* theory or method of cultural studies, to isolate it as having formal, eminently transferable properties. This has taken the form of scholars interested in utilizing articulation in the service of research whose theoretical, methodological, epistemological, political and strategic commitments are rather dramatically different from those of cultural theorists. Although the boundaries of cultural studies are certainly indistinct and changing, they do sometimes get unquestionably crossed.

Consequently, a certain care is in order when using the designations theory and method. However useful it may be to think of articulation in terms of theoretical and methodological valences, to do so is to take the risk that theory and method will be taken too formally. Stuart Hall recognized this in 1980 when he acknowledged that 'articulation contains the danger of a high formalism' (Hall, 1980a: 69). While he wrote this at the height of the Althusserian structuralist moment in cultural studies, when the threat of formalism was paramount, we still need to be sensitive to the warning today – even if for slightly different reasons.

'Theory' is a term that often connotes an objective, formal tool, or even a 'value-free' heuristic device. Cultural studies resists thinking in terms of the 'application' of theory in this sense, where theory is used to 'let you off the hook, providing answers which are always known in advance or endlessly deferring any answer into the field of its endless reflections and reflexivity' (Grossberg, 1992: 19). In place of that conception of theory, cultural studies works with the notion of theory as a 'detour' to help ground our engagement with what newly confronts us and to let that engagement provide the ground for retheorizing. Theory is thus a practice in a double sense: it is a formal conceptual tool as well as a practising or 'trying out' of a way of theorizing. In joining these two senses of practice, we commit to working with momentarily, temporarily 'objectified' theories, moments of 'arbitrary closure', recognizing that in the ongoing analysis of the concrete, theory must be challenged and revised. 'The only theory worth having,' Hall maintains, 'is that which you have to fight off, not that which you speak with profound fluency' (Hall, 1992: 280). Successful theorizing is not measured by exact theoretical fit but by the ability to work with our always inadequate theories to help us move understanding 'a little further on down the road'. A commitment to 'the process of theorizing' is characteristic of the project of cultural studies; it is 'the sign of a living

body of thought, capable still of engaging and grasping something of the truth about new historical realities' (Hall, 1983: 84).

'Method' similarly can suggest rigid templates or practical techniques to orchestrate research. But again, cultural studies works with a conception of method as 'practice', which suggests both techniques to be 'used as resources as well as the activity of practising or 'trying out'. In this double sense, techniques are borrowed and combined, worked with and through, and reworked. Again, the commitment is always to be able to adapt our methods as the new historical realities we engage keep also moving on down the road.

Thinking of the theory and method of articulation as practice also highlights an important political aspect of cultural studies: the recognition that the work of cultural studies involves at a variety of levels a politics within a – broadly understood – marxist framework. With and through articulation, we engage the concrete in order to change it, that is, to rearticulate it. To understand theory and method in this way shifts perspective from the acquisition or application of an epistemology to the creative process of articulating, of thinking relations and connections as how we come to know and as creating what we know. Articulation is, then, not just a thing (not just a connection) but a process of creating connections, much in the same way that hegemony is not domination but the process of creating and maintaining consensus or of co-ordinating interests.

Working with that understanding of theory and method in interrogating the role of articulation in cultural studies requires keeping in mind two general insights. First, articulation was not 'born' whole nor has it ever achieved that status. It has never been, nor should it be, delineated or used as a completely 'sewn-up' theory or method. Rather, it is a complex, unfinished phenomenon that has emerged and continues to emerge genealogically. Second, articulation has never been configured as simply one thing. The ways in which articulation has been developed, discussed and used tend to foreground and background certain theoretical, methodological, epistemological, political and strategic forces, interests and issues. As theory and method, articulation has developed unevenly within a changing configuration of those forces. It carries with it 'traces' of those forces in which it has been constituted and which it has constituted. To understand the role of articulation in cultural studies is thus to map that play of forces, in other words, to track its development genealogically.

My project here is a beginning; it is surely not a genealogy but an attempt to map some particularly profound forces and moments that contribute to a genealogical understanding of articulation.

ARTICULATION IS . . . : A MOMENT OF ARBITRARY CLOSURE

In order to begin on some common ground, I offer a few definitional statements, helpful moments of 'arbitrary closure'. Articulation is

> the form of the connection that can make a unity of two different elements, under certain conditions. It is a linkage which is not necessary, determined, absolute and essential for all time. You have to ask, under what circumstances can a connection be forged or made? The so-called 'unity' of a discourse is really the articulation of different, distinct elements which can be rearticulated in different ways because they have no necessary 'belongingness'. The 'unity' which matters is a linkage between the articulated discourse and the social forces with which it can, under certain historical conditions, but need not necessarily, be connected.
>
> (Hall, 1986b: 53)

> Articulation is the production of identity on top of differences, of unities out of fragments, of structures across practices. Articulation links this practice to that effect, this text to that meaning, this meaning to that reality, this experience to those politics. And these links are themselves articulated into larger structures, etc.
>
> (Grossberg, 1992; 54)

> The unity formed by this combination or articulation, is always, necessarily, a 'complex structure': a structure in which things are related, as much through their differences as through their similarities. This requires that the mechanisms which connect dissimilar features must be shown – since no 'necessary correspondence' or expressive homology can be assumed as given. It also means – since the combination is a structure (an articulated combination) and not a random association – that there will be structured relations between its parts, i.e., relations of dominance and subordination.
>
> (Hall, 1980d: 325)

Articulation is an 'old word' and predates cultural studies by several centuries. It has had a variety of dental, medical, biological and enunciative meanings. But in every case, the word suggests some kind of joining of parts to make a unity. Even the articulation of sounds or utterances suggests the 'clinging together' of notes (*Oxford English Dictionary*, 1971: 118). It is interesting to note that 'articulation' is *not* in Raymond Williams' *Keywords* (Williams, 1976); it was not a term in the lexicon of 'culturalism' (see Hall, 1980a for the meaning of 'culturalism'). It is in the 1970s, however, that articulation begins to be explicitly theorized. This happens as the problem of reductionism in marxism (and the related

problem of essentialism) becomes salient and the question of how the elements of the social field are joined to form unities in a non-reductionist way becomes paramount.

By the 1970s, cultural theorists were explicitly engaged in critiques of 'classical' or 'orthodox' marxism and its reliance on two related forms of reductionism: economic reductionism, which relies on a limited reading of Marx's notion of the relationship between base and superstructure; and class reductionism, which relies on a limited reading of Marx's notion of class. Briefly put, economic reductionism maintains that economic relations, thought of as a virtually static mode of production (the base) controls and produces (determines) everything else in society (the super-structure). Hence, every element in society (including changes in those elements) can be reduced to (explained by) the operations of the corresponding mode of production – and those operations alone. Class reductionism holds that all political and ideological practices, contradictions, and so on, in short all that might be conceived of as other than economic, have a necessary class belonging which is defined by the mode of production. Consequently, the discourse of a class and the existence of the corresponding class itself constitute a direct reflection of, or a necessary moment in the unfolding of the economic. (For discussions of reductionism, see especially Hall, 1977; 1980d; Laclau, 1977; Williams, 1973.)

'Culturalism', the term Hall used to describe what had been the dominant, early paradigm in cultural studies, struggled against the reduction to the economic in part by attending to the specificity of particular practices (Hall, 1980a). But culturalism lacked, as Hall put it 'an adequate way of establishing this specificity theoretically' (69). The tendency was often to fall back on versions of the reduction to the mode of production or to class. For example, Hoggart's *The Uses of Literacy* disappointedly concludes by attributing the post-war changes in English working-class culture essentially to capitalism, via the imposition of mass culture (Hoggart, 1958).

Posing reductionism as a problem had several related sources. Most notable here is that marxist theorizing had developed its own 'internal' critique of reductionism in that reductionism offered inadequate explanations of the mechanisms of domination and subordination in late capitalism. Reduction to the mode of production could not account for the shape of a social formation if it was understood to be composed of relationships among several modes of production (Hall, 1980d). It could not account for apparent disparities among the conditions of one's existence, how one lived out those conditions, and what one believed about those conditions. It could not account for the non-revolutionary culture of the working class. And finally, it could not account for the way in which factors other than class (gender, race and subculture, for example) entered into what looked like far more complex relations of dominance and subordination.

The struggle to substitute the reduction that didn't work with . . . something . . . pointed to the need to retheorize processes of determination. The work of cultural theorists in the 1970s and early 1980s, especially the work of Stuart Hall, opened up that space by drawing attention to what reductionist conceptions rendered inexplicable. It is as though a theoretical lacuna develops, a space struggling to be filled. It gets filled with terms like 'productive matrix' and 'combination of relations' (Hall, 1977), and eventually 'articulation'. The term is almost, at first, what Kuan-Hsing Chen has called 'a sign to avoid reduction' (Chen, 1994). Without having exactly theorized what articulation is and how it works, it becomes the sign that speaks of other possibilities, of other ways of theorizing the elements of a social formation and the relations that constitute it not simply as relations of correspondence (that is, as reductionist and essentialist) but also as relations of non-correspondence and contradiction, and how these relations constitute unities that instantiate relations of dominance and subordination. This process of siting the space as a terrain for theorizing accounts to some extent for the difficulties and resistance – that still exist – in pointing to what exactly articulation is. The point is that it isn't *exactly* anything.

In theorizing this space, a number of marxist theorists are drawn on: most notably Althusser (who drew on Gramsci and Marx), Gramsci (who drew on Marx) and, of course, Marx. Its principal architects have been Laclau and Hall. Without wanting to sidetrack the discussion, it is important to indicate broadly at least what in Althusser, Gramsci and Marx is drawn on in developing conceptions of articulation. In brief, from Althusser, the conception of a complex totality structured in dominance figures immensely. The totality is conceived of as made up of a relationship among levels, constituted in relations of correspondence as well as of contradiction, rather than of relations reducible to a single essential one-to-one correspondence. These levels come to be thought of as 'articulated'. One of the levels, the ideological, takes on special significance in that in it and through it those relations are represented, produced and reproduced. The process comes to be thought of as a process of articulation and re-articulation (see Hall, 1980d, 1985). From Gramsci, the notions of hegemony, articulation and ideology as common sense have been influential, through their appropriation by Althusser as well as independently. Hegemony, for Gramsci, is a process by which a hegemonic class articulates (or co-ordinates) the interests of social groups such that those groups actively 'consent' to their subordinated status. The vehicle of this subordination, its 'cement', so to speak, is ideology, which is conceived of as an articulation of disparate elements, that is, common sense, and the more coherent notion of 'higher philosophy'. Gramsci offers a way of understanding hegemony as the struggle to construct (articulate and re-articulate) common sense out of an ensemble of interests, beliefs and practices. The process of

hegemony as ideological *struggle* is used to draw attention to the relations of domination and subordination that articulation always entails (see Mouffe, 1979). From Marx is drawn the conception of a social formation as a combination of relations or levels of abstraction, within which determination must be understood as produced within specific conjunctures of the levels rather than as produced uniformly and directly by the mode of production. The conjunctures come to be seen as historically specific articulations of concrete social forces (see Hall, 1977).

AN EXPLICIT THEORY OF ARTICULATION: THE CONTRIBUTION OF ERNESTO LACLAU

Ernesto Laclau configures these elements – and others – in an especially forceful way in *Politics and Ideology in Marxist Theory* (Laclau, 1977). His work warrants special attention here for at least four reasons. First, his is the initial attempt to formulate an explicit 'theory of articulation'. Second, Hall's work on articulation takes Laclau's position as a major contribution to the theoretical ground on which and from which to engage the concrete and retheorize. Third, Laclau's reconstitution of the problematic in the discursive mode, foregrounding the role of ideology, figures significantly in a range of directions (replete with problems and possibilities) taken by articulation after Laclau's intervention. Fourth, the relative absence of Laclau in the 'histories' of cultural studies suggests some disturbing reconfigurations (can I now safely say, re-articulations?) of foregrounded and backgrounded features of articulation.

In *Politics and Ideology in Marxist Theory*, Laclau engages in the play of theorizing the concrete in terms of articulation and theorizing articulation in terms of the concrete, principally in terms of Latin American politics. Reductionism, he argues, specifically class reductionism, failed – both theoretically and politically. The world communist movement was divided, the Cold War was winding down, the masses were emergent on a world scale, and while capitalism was in the decline, it had proved to be highly adaptable. Laclau sets out to formalize marxist categories to contribute to a new socialist movement, one in which the 'proletariat must abandon any narrow class perspective and present itself as a hegemonic force to the vast masses seeking a radical political reorientation in the epoch of the world decline of capitalism' (12).

Laclau develops his theory of articulation in contestation with class reductionism. The failure of such reductionism, he argues, lies in its failure to account for the existence of actual variations in the discourse of classes. Simply put, not everyone believes what they are supposed to believe or acts in a way they are supposed to act, regardless of their class belonging. Laclau rejects the usual explanations that these aberrations are either accidents or indicative of an as yet underdeveloped mode of production

(11–12) and argues instead to replace a simple determination by the economic with a concept of articulation.

Laclau links this political rationale with an epistemological one and renders his own genealogy of articulation. He argues that a concept of articulation is embedded in the western philosophical tradition but that it requires refiguring. Using the example of Plato's allegory of the cave, in which the prisoners in the cave incorrectly link the voices they hear with the shadows on the wall, Laclau explains that

> Common sense discourse, *doxa*, is presented as a system of misleading articulations in which concepts do not appear linked by inherent logical relations, but are bound together simply by connotative or evocative links which custom and opinion have established between them. (7)

Articulations are thus the 'links between concepts' (7), and Plato's goal is to disarticulate the (misleading) links and to re-articulate their true (or necessary) links. Articulation is at this point then linked to and defined by the rationalist paradigm.

Laclau amends what he takes as this western philosophical move with the insistence that (a) there are no necessary links between concepts, a move that renders all links essentially connotative, and that (b) concepts do not necessarily have links with all others, a move that makes it impossible to construct the totality of a system having begun with one concept, as one could do in a Hegelian system (10). Consequently, the analysis of any concrete situation or phenomenon entails the exploration of complex, multiple, and theoretically abstract non-necessary links.

In his most influential argument, in the chapter 'Towards a theory of populism', Laclau theorizes articulation in relation to political practice by bringing into focus the process by which a dominant class exerts hegemony. Although, according to Laclau, no discourse has an essential class connotation, the meanings within discourse are always connotatively linked to different class interests or characters. So, for example, the discourse on nationalism can be linked to a feudal project of maintaining traditional hierarchy and order; or it can be linked to a communist project accusing capitalists of betraying a nationalist cause; or it can be linked to a bourgeois project of appealing to unity in order to neutralize class conflict, and so on (160). In any case, the class that achieves dominance is the class that is able to articulate non-class contradictions into its own discourse and thereby absorb the contents of the discourse of dominated classes (162). The link between articulation and the concept of hegemony is thus made explicit. Laclau writes that

> A class is hegemonic not so much to the extent that it is able to impose a uniform conception of the world on the rest of society, but to the extent that it can articulate different visions of the world in such a way that their potential antagonism is neutralized. (161)

Consequently, in the concept of articulation, Laclau brings into focus a non-reductionist view of class, the assertion of no-necessary correspondence among practices and the elements of ideology, the critique of common sense as contradictory ideological structures, and a commitment to analysing hegemony as a process of articulating practices in discourse.

Articulation, thus articulated, provided a way for, indeed compelled, cultural theorists to rethink the problem of determination. But in theorizing the space by highlighting the role of the discursive in the process of articulation, Laclau foregrounds a theoretical position that has an interesting – even ironic – backgrounding effect on the very politics that played such a crucial role in Laclau's work to begin with. As Hall puts it, what 'matters' in Laclau's formulation is 'the particular ways in which these [ideological] elements are organized together within the logic of different discourses' (Hall, 1980c: 174). The effect of this move, as Hall identifies it operating in Laclau and Mouffe's later work, *Hegemony and Socialist Strategy* (1985), is

> to conceptualize *all* practices as nothing but discourses, and all historical agents as discursively constituted subjectivities, to talk about positionalities but never positions, and only to look at the way concrete individuals can be interpellated in different subject positionalities.
>
> (Hall, 1986b: 56)

If what is at issue is the operation of the discursive, it is easy to leave behind any notion that anything exists outside of discourse. Struggle is reduced to struggle in discourse, where 'there is no reason why anything is or isn't potentially articulatable with anything' and society becomes 'a totally open discursive field' (Hall, 1986b: 56).

Laclau's turn from reduction, which provides a basis to articulate relations *in discourse*, thus also provides a basis to posit a radical non-correspondence among discourses and practices. In effect, Laclau's no-necessary correspondence could be and was easily used in service of 'necessary non-correspondence'. Laclau and Laclau and Mouffe certainly do not *intend* to leave behind politics, indeed to claim that would be outrageous, especially given their explicit intent to develop a 'radical democratic politics'. But among the effects of their theorizing, that possibility is brought into focus. So even though the idea of an 'articulating principle' seems meant to insist on a mechanism with which to ensure attention to the way in which discursive structures are always articulated to particular class practices (Laclau, 1977: 101–2, 160–1; Mouffe, 1979: 193–5), the clarity of its operation is never really established and its theoretical status is never secured.

In spite of the importance of Laclau's formulations, he has been excluded – as has Mouffe – from most of the popular histories of cultural studies, such as those of Brantlinger (1990), Inglis (1993), Storey (1993),

and Turner (1990). Perhaps this is because of Laclau's own ironic contribution to dislodging (or re-articulating) the concept of articulation from the political concrete – conceived of within a marxist problematic – that was the focus of the work to begin with. In effect the political is easily backgrounded in foregrounding attention to the theoretical debates focused on the play of discursive possibilities.

However, the anti-reductionist turn in cultural studies, as exemplified here by Laclau, effectively disempowered the possibility of reducing culture to class or to the mode of production and rendered it possible and necessary to re-theorize social forces such as gender, race and subculture as existing in complex – articulated – relations with one other as well as with class. (See Hall, 1980d and 1986a, on race; McRobbie, 1981, on gender and subculture.) Furthermore, when Laclau is read without losing grip on the ensemble of forces, by attributing to them something more like equal weight, without privileging the discursive, the space of articulation has greater possibilities.

Since about 1980, the proliferation of these possibilities and the excitement generated by them has certainly contributed to the astounding growth of interest in cultural studies. Here was a way to talk about the power of the discursive and its role in culture, communication, politics, economics, gender, race, class, ethnicity and technology in ways that provided progressive-minded people sophisticated understanding as well as mechanisms for strategic intervention. So at the same time that an expanding cultural studies community begins to try to clarify and 'nail down' the meaning of articulation, there is a corresponding expansion in the number of theoretically possible directions within which it begins to get thought.

ARTICULATION AS UNITY IN DIFFERENCE: THE VOICE OF STUART HALL

Stuart Hall's contributions to the development of articulation have been significant for at least four reasons. First, he resists the temptation of reduction to class, mode of production, structure, as well as to culturalism's tendency to reduce culture to 'experience'. Second, he elevates the importance of articulating discourse to other social forces, without going 'over the brink' of turning everything into discourse. Third, Hall's commitment to the strategic feature of articulation has foregrounded cultural studies' interventionist commitments. And fourth, Hall's treatment of articulation has been the most sustained and accessible. His willingness to engage different philosophical and political traditions in theorizing articulation has meant that his influence is quite widespread; and the generous manner in which he engages people and arguments provides an exceptional exemplar of articulation at work.

When Hall 'reigns in discourse' or 'tames ideology', he does so by insisting on the Althusserian recognition that no practice exists *outside* of discourse *without reducing* everything else to it. In a frequently cited quotation, he claims that

> It does not follow that because all practices are *in* ideology, or inscribed by ideology, all practices are *nothing but* ideology. There is a specificity to those practices whose principal object is to produce ideological representations. They are different from those practices which – meaningfully, intelligibly – produce other commodities. Those people who work in the media are producing, reproducing and transforming the field of ideological representation itself. They stand in a different relationship to ideology in general from others who are producing and reproducing the world of material commodities – which are, nevertheless, also inscribed by ideology. (Hall, 1985: 103–4)

By insisting on the specificity of practices in different kinds of relations to discourse, Hall contests the move that Laclau and other post-Althusserians have taken positing the absolute, rather than relative, autonomy of practices that is implied by the position that all practices are nothing but ideology (Hall, 1980a: 68).

Hall pulls articulation back from the extreme, theoretically-driven logic of 'necessary non-correspondence' (what he called the 'excesses' of theory) to insist on thinking and theorizing practices within which unities – often relatively stable unities – are also constituted. For Hall, articulation

> has the considerable advantage of enabling us to think of how specific practices articulated around contradictions which do not all arise in the same way, at the same point, in the same moment, can nevertheless be thought *together*. The structuralist paradigm thus does – if properly developed – enable us to begin really to *conceptualize* the specificity of different practices (analytically distinguished, abstracted out), without losing its grip on the ensemble which they constitute.
> (Hall, 1980a: 69)

Thinking articulation thus becomes a practice of thinking 'unity and difference', of 'difference *in* complex unity, without becoming a hostage to the privileging of difference as such' (Hall, 1985: 93).

Hall's model of strategic intervention is not then limited to a kind of theoretically-driven Derridian deconstruction of difference and the construction of discursive possibility, but a theoretically-informed practice of rearticulating relations among the social forces that constitute articulated structures in specific historical conjunctures. He maintains that

> The aim of a theoretically-informed political practice must surely be to bring about or construct the articulation between social or economic

forces and those forms of politics and ideology which might lead them in practice to intervene in history in a progressive way – an articulation which has to be *constructed* through practice precisely because it is not guaranteed by how those forces are constituted in the first place.

(Hall, 1985: 95)

In practice, this has opened the way for cultural theorists to consider the role of a range of *other* social forces both in their specificity and in discourse, interrogating the ways in which they are complexly articulated in structures of domination and subordination and considering ways that they might be re-articulated. (See for example, Slack, 1989, on the technological; Slack and Whitt, 1992, on the environmental; Grossberg, 1992 on the affective.)

REARTICULATING COMMUNICATION: MAPPING THE CONTEXT

Stuart Hall's practice of articulation can be tracked through any of a number of sites of contestation, for example, through his work on race (for example, Hall 1980d; 1986a), ethnicity (for example, Hall, 1991), the popular (for example, Hall, 1980c; 1981) and so on. The site of Hall's engagement with the concrete that I choose to track here is his critique of communication theory and the methods used to study communication. This serves as a useful example for several reasons. First, this engagement with practices of communication demonstrates the effectiveness of the resistance to thinking the elements in articulated structures as being 'potentially articulatable with anything'. Second, in the United States at least, Hall's work on communication has been particularly influential and thus a way that many people – including myself – have come initially to understand the space articulation theorizes. Third, articulation as it is developed in relation to communication comes closest to 'looking like' a theory and method. Hence it is this site where it might most easily be disarticulated from its political, epistemological and strategic traces.

The study of communication was built on the model of sender-receiver, the components of which are solidified in Laswell's definition of communication as 'who says what in which channel to whom with what effect' (Laswell, 1971). Each component has, in this model, its own isolatable intrinsic (or essential) identity. Neither the components nor the process are articulations. In considering the *process* of communication, what is sought is the mechanism whereby correspondence between the meanings encoded (the what) and the effects that meaning generates is guaranteed.

While working with a still-recognizable model of transmission, Hall's 'Encoding/decoding' (Hall, 1980b) challenges the simple assertion of intrinsic identity by insisting that the components of the process (sender,

receiver, message, meaning, etc.) are themselves articulations, without essential meanings or identities. This move compels a rethinking of the process of communication not as correspondence but as articulation. The tension between the reliance on the mainstream model of encoding/decoding and an articulated model of the communication process is palpable in 'Encoding/decoding' as well as in the work of David Morley (1980), who used the developing articulated model to analyse the relationship between the encoded and decoded meanings of television news; and they are particularly interesting in that regard.

What comes to be understood is that if each component or moment in the process of communication is itself an articulation, a relatively autonomous moment, then 'no one moment can fully guarantee the next moment with which it is articulated' (Hall, 1980b: 129). The insistence that the autonomy is only relative (drawing a link to Althusserian structuralism) rescues articulation from the brink of a 'necessary non-correspondence' and allows Hall and Morley to acknowledge that some articulations – the discursive form of the message, for example – work from more privileged – or powerful – positions (Hall, 1980b; Morley, 1981).

Hall continues to develop this notion of power and privilege and, drawing on Gramsci, argues that some articulations are particularly potent, persistent, and effective. These constitute, for Hall, 'lines of tendential force' and serve as powerful barriers to the potential for re-articulation (Hall, 1986b: 53–4). With respect to contemporary communication practices, he depicts communicative institutions, practices and relations as posing that kind of barrier. They have become a 'material force' dominating the cultural (Hall, 1989: 43).

Theorizing communication in this way suggests methodological direction and strategic implications. Interrogating any articulated structure or practice requires an examination of the ways in which the 'relatively autonomous' social, institutional, technical, economic and political forces are organized into unities that are effective and are relatively empowering or disempowering. The specificity of the domain of communication, for example, requires that we examine the way in which these forces,

> at a certain moment, yield intelligible meanings, enter the circuits of culture – the field of cultural practices – that shape the understandings and conceptions of the world of men and women in their ordinary everyday social calculations, construct them as potential social subjects, and have the effect of organizing the ways in which they come to or form consciousness of the world.
>
> (Hall, 1989: 49)

Determining when, where and how these circuits might be re-articulated is the aim of a cultural theorist's theoretically-informed political practice. The examination of and participation in communication – or any practice –

is thus an ongong process of re-articulating contexts, that is, of examining and intervening in the changing ensemble of forces (or articulations) that create and maintain identities that have real concrete effects. 'Understanding a practice involves,' as Grossberg puts it, 'theoretically and historically (re)-constructing its context' (Grossberg, 1992: 55).

Seen from this perspective, this is what a cultural study does: map the context – not in the sense of situating a phenomenon *in a context*, but in mapping a context, mapping the very identity that brings the context into focus (Slack, 1989; cf. Grossberg, 1992: 55). It is possible to claim that this is what I have done throughout this chapter, for example, in explaining how for Laclau 'the concept of articulation . . . brings into focus a non-reductionist view of class, the assertion of no-necessary correspondence,' etc. It isn't as though the context *for* the development of articulation *is these things*. Rather the articulation of these identities (in a double articulation: both as articulated identities and in an articulated relationship with one another) is brought into focus in and through the concept of articulation. To put it another way, the context is not something *out there, within which practices occur or which influence the development of practices.* Rather, *identities, practices, and effects generally, constitute the very context within which they are practices, identities or effects.*

GOING ON THEORIZING

There is certainly more to mapping a genealogy of articulation than I have offered here. More pieces or forces to be articulated might include drawing more explicit links to structural linguistics (raised by Hall, 1980d: 327) and postmodernism; foregrounding the status of the 'real' rather than the problem of reduction (as does Grossberg, 1992); considering the role of specific articulations such as those of gender, race, ethnicity, neo-colonialism; foregrounding the politics of institutionalization; and finally, considering the influence of strategic interventions practised among the ranks of the practitioners of cultural studies.

We can certainly expect that different conceptions of cultural studies and the development of cultural studies over time can and will be explained in part by changing configurations of articulation. I am particularly concerned that as cultural studies becomes more 'domesticated', that is, as it becomes a more institutionally acceptable academic practice, the 'problem' of articulation will be cast more as a theoretical, methodological and epistemological one than a political and strategic one. To some extent this is happening already. Given a dominant politics of despair and the political and economic realities of education, this is hardly a surprise; though it is discouraging. What I would hope, at least, is that by drawing attention to the ways in which the re-articulation of articulation entails changing

relations among theory, method, epistemology, politics and strategy, we might expect more of our detours through theory, not less.

Author's Note

I would like to thank Kuan-Hsing Chen, Lawrence Grossberg, David James Miller and Patricia Sotirin for helpful comments on earlier versions of this chapter and generous guidance in working out some of the issues dealt with here. Errors are, of course, my own.

REFERENCES

Brantlinger, P. (1990) *Crusoe's Footprints: Cultural Studies in Britain and America*, New York and London: Routledge.
Chen, Kuan-Hsing. (1994) Personal conversation, July.
Grossberg, L. (1992) *We Gotta Get Out of This Place: Popular Conservatism and Postmodern Culture*, New York and London: Routledge.
——— (1993) 'Cultural studies and/in new worlds', in *Critical Studies in Mass Communication* 10, 1-22.
Hall, S. (1977) 'Rethinking the "base-and-superstructure" metaphor', in J. Bloomfield (ed.) *Papers on Class, Hegemony and Party*, London: Lawrence & Wishart, 43–72.
——— (1980a) 'Cultural studies: two paradigms', in *Media, Culture and Society* 2 (1), 57–72.
——— (1980b) 'Encoding/decoding', in S. Hall, D. Hobson, A. Lowe and P. Willis (eds) *Culture, Media, Language*, London: Hutchinson, 128–40.
——— (1980c) 'Popular-democratic vs. authoritarian-populism: two ways of "taking democracy seriously"' in A. Hunt (ed.) *Marxism and Democracy*, London: Lawrence & Wishart, 157–85.
——— (1980d) 'Race, articulation and societies structured in dominance', in Unesco, *Sociological Theories: Race and Colonialism*, Paris: Unesco, 305–45.
——— (1981) 'Notes on deconstructing "the Popular"' in R. Samuel (ed.) *People's History and Socialist Theory*, London: Routledge & Kegan Paul, 227–40.
——— (1983) 'The problem of ideology: marxism without guarantees' in B. Matthews (ed.) *Marx 100 Years On*, London: Lawrence & Wishart, 57–85.
——— (1985) 'Signification, representation, ideology: Althusser and the post-structuralist debates', in *Critical Studies in Mass Communication* 2 (2), 91–114.
——— (1986a) 'Gramsci's relevance for the study of race and ethnicity', *Journal of Communication Inquiry* 10 (2), 5–27.
——— (1986b) 'On postmodernism and articulation: an interview with Stuart Hall', ed. L. Grossberg, *Journal of Communication Inquiry* 10 (2), 45–60.
——— (1989) 'Ideology and communication theory', in B. Dervin, L. Grossberg, B. J. O'Keefe and E. Wartella (eds) *Rethinking Communication*, vol. 1, *Paradigm Issues*, Newbury Park: Sage, 40–52.
——— (1991) 'Old and new identities, old and new ethnicities', in A. D. King (ed.) *Culture, Globalization and the World System*, London: Macmillan, 41–68.
——— (1992) 'Cultural studies and its theoretical legacies', in L. Grossberg, C. Nelson and P. Treichler (eds) *Cultural Studies*, New York and London: Routledge, 277–94.
Hoggart, R. (1958; 1970) *The Uses of Literacy*, New York: Oxford University Press.

Inglis, F. (1993) *Cultural Studies*, Oxford and Cambridge: Blackwell.
Laclau, E. (1977) *Politics and Ideology in Marxist Theory*, London: New Left Books.
Laclau, E. and Mouffe, C. (1985) *Hegemony and Socialist Strategy: Towards a Radical Democratic Politics*, trans. W. Moore and P. Cammack, London: Verso.
Laswell, H. D. (1971) 'The structure and function of communication in society', in W. Schramm and D. F. Roberts (eds) *The Process and Effects of Mass Communication* (rev. edn), Urbana: University of Illinois Press, 84–99.
McRobbie, A. (1981) 'Settling accounts with subcultures; a feminist critique', in T. Bennett *et al.* (eds) *Culture, Ideology and Social Process: A Reader*, London: Batsford, 113–23.
Morley, D. (1980) *The 'Nationwide' Audience*, London: British Film Institute.
— — — (1981) 'The "Nationwide" audience: a critical postscript', *Screen Education* 39, 3–14.
Mouffe, C. (1979) 'Hegemony and ideology in Gramsci', trans. D. Derome, in C. Mouffe (ed.) *Gramsci and Marxist Theory*, London, Boston and Henley: Routledge & Kegan Paul, 168–204.
Oxford English Dictionary (1971) Compact edition, Oxford: Oxford University Press.
Slack, J. D. (1989) 'Contextualizing technology', in B. Dervin *et al.* (eds) *Rethinking Communication*, vol. 2, *Paradigm Exemplars*, Newbury Park: Sage, 329–45.
Slack, J. D. and Whitt, L. A. (1992) 'Ethics and cultural studies', in L. Grossberg, C. Nelson and P. Treichler (eds) *Cultural Studies*, New York and London: Routledge, 571–91.
Slack, J. D., Miller, D. J. and Doak, J. (1993) 'The technical communicator as author: meaning, power, authority', *Journal of Business and Technical Communication* 7 (1), 12–36.
Storey, J. (1993) *An Introductory Guide to Cultural Theory and Popular Culture*, Athens: University of Georgia Press.
Turner, G. (1990) *British Cultural Studies: An Introduction*, Boston, London, Sydney and Wellington: Unwin Hyman.
Williams, R. (1973) 'Base and superstructure in marxist cultural theory', *New Left Review* 82, 3–16.
— — — (1976) *Keywords: A Vocabulary of Culture and Society*, New York: Oxford University Press.

Postmodernism and cultural studies

First encounters

Chapter 6

On postmodernism and articulation
An Interview with Stuart Hall

Edited by Lawrence Grossberg

Question: I would like to begin by asking how you would locate your interest in and relationship to the current explosion of work within what is called 'postmodernism'. Perhaps, as a way of getting into this rather convoluted set of discourses, you could comment on how you would position yourself in the debate between Habermas and Lyotard.

SH: I am interested in it for a number of reasons. First I am fascinated by the degree to which postmodernism has taken off in America – its immediate success as a concept, compared with either post-marxism or post-structuralism. 'Postmodernism' is the biggest success story going. And since it is, in essence, such a devastating story – precisely about American culture, it seems a funny thing to be so popular. It's like asking, how long can you live with the end of the world, how much of a bang can you get out of the big bang? And yet, apart from that, one has to come to terms with it. The concept poses key questions about the shape and tendency of contemporary culture. It is emerging in Europe as a central focus of debate, and there are very serious issues involved. Let me consider the specific question of the debate between Habermas and Lyotard.

Briefly, I don't really agree with either of them. I think Habermas's defence of the Enlightenment/modernist project is worthy and courageous, but I think it's not sufficiently exposed to some of the deeply contradictory tendencies in modern culture to which the postmodernist theories quite correctly draw our attention. But I think Lyotard, and Baudrillard in his celebratory mode, really have gone right through the sound barrier. They are involved, not simply in identifying new trends or tendencies, new cultural configurations, but in learning to love them. I think they collapse these two steps – analysis and prescription – into one. It's a bit like that precursor-prophet of postmodernism, Marshall McLuhan. When Marshall McLuhan first began to write about the media, he had come down from Cambridge as a committed Leavisite critic. His first book, The *Mechanical*

Reprinted from *Journal of Communication Inquiry* (1986), 10(2), 45–60.

Bride, was highly critical of the new technologies. In fact, he referred to this book as 'a civil defense against mass media fallout'. But the disillusionment soon turned into its opposite – celebration, and in his later work, he took a very different position, just lying back and letting the media roll over him; he celebrated the very things he had most bitterly attacked. I think something like that has happened among the postmodern ideologues. You can see, behind this celebration of the American age, the deep disillusionment of the left-bank Parisian literary intelligentsia. So, in relation to the still-too-integrated positions enunciated in the critical theory of Habermas, postmodernists are quite correct to talk about the erosion of the Enlightenment project, the sharp changes taking place in modernism, etc. But I think the label 'postmodernism', especially in its American appropriation (and it *is* about how the world dreams itself to be 'American') carries two additional charges: it not only points to how things are going in modern culture, but it says, first, that there is nothing else of any significance – no contradictory forces, and no counter-tendencies; and second, that these changes are terrific, and all we have to do is to reconcile ourselves to them. It is, in my view, being deployed in an essentialist and uncritical way. And it is irrevocably Euro- or western-centric in its whole episteme.

So we are caught between two unacceptable choices: Habermas's defensive position in relation to the old Enlightenment project and Lyotard's Euro-centred celebration of the postmodern collapse. To understand the reasons for this oversimplified binary choice is simple enough, if one starts back far enough. I don't think that there is any such thing as *the* modernist impulse, in the singular. Modernism itself was a decisively 'western' phenomenon. It was always composed of many different projects, which were not all integratable or homogeneous with one another; they were often, in fact, in conflict. For example, consider Adorno and Benjamin: both were theorists of the modern and in some ways, very close together in formation. They are also bitterly, deeply, opposed to one another on some key questions. Now I know that shorthand terms like 'modernism' can be useful in everyday exchanges but I don't know, analytically, what the single project was which modernism might have been. And it's very important to realize that, if modernism was never one project, then there have always been a series of different tendencies growing out of it as it has developed historically. I think this is similar to the argument behind Perry Anderson's critique of Marshall Berman's *All That Is Solid Melts into Air* in a recent *New Left Review*. While I like Berman's book very much and think that there is a rather traditionalist view of modernism built into Perry Anderson's response, I still agree with Anderson rather than Berman on the central argument about periodization. I don't think that what Berman is describing is a new epoch but rather the accentuation of certain important tendencies in the culture of the overdeveloped 'West' which, if we under-

stand the complex histories of modernism properly, have been in play in a highly uneven way since modernism emerged.

Now we come to postmodernism and what I want to know is: is post-modernism a global or a 'western' phenomenon? Is postmodernism the word we give to the rearrangement, the new configuration, which many of the elements that went into the modernist project have now assumed? Or is it, as I think the postmodernist theorists want to suggest, a new kind of absolute rupture with the past, the beginning of a new global epoch altogether? This is not merely a formal question, of where to place the break. If you are within the same epoch – the one which opens with the age of imperialism, mass democracy, mass consumption and mass culture from about 1880–1920 – you have to expect that there will be continuities and transformations as well as ruptures and breaks.

Let's take the postmodernist argument about the so-called collapse or implosion of 'the real'. Three-quarters of the human race have not yet entered the era of what we are pleased to call 'the real'. Furthermore, even within the West, ever since the development of modern mass media, and their introduction on a mass scale into cultural production, and their impact on the audiences for cultural products, we have witnessed the undermining of the absolutism of 'the real' of the great discourses of realism, and the familiar realist and rationalist guarantees, the dominance of certain types of representational form, etc. I don't mean to argue that the new discourses and relationships between these things, which is in essence what we called 'modernism', are the same in 1980 as they were in 1900. But I don't know that with 'postmodernism' we are dealing with something totally and fundamentally different from that break at the turn of the century. I don't mean to deny that we've gone through profound qualitative changes between then and now. There are, therefore, now some very perplexing features to contemporary culture that certainly tend to outrun the critical and theoretical concepts generated in the early modernist period. We have, in that sense, to constantly update our theories and to be dealing with new experiences. I also accept that these changes may constitute new subject-positions and social identities for people. But I don't think there is any such absolutely novel and unified thing as *the* postmodern condition. It's another version of that historical amnesia characteristic of American culture – the tyranny of the New.

I recognize, experientially or ideologically, what people mean when they point to this 'condition'. But I see it much more as one emergent trend or tendency amongst others – and still not fully crystallized out. For example, there is a very interesting film called *Wetherby*, written by the English playwright, David Hare, which is, formally, a very conventional film about a middle-aged woman (played by Vanessa Redgrave) who teaches in a provincial town. A student, who is in the town for reasons which are never fully explained, turns up at a dinner party she's giving on her birthday. She

thinks her friends have invited him, and they think she's invited him, so he comes in, is accepted as a guest, takes part in the conversations, and so forth. In the middle of the party there is a fleeting and unsuccessful sexual encounter with the teacher. The next day, he shows up again at her house, he sits at the table, starts conversing, and then he shoots himself. And the rest of the film is 'about' who this person is who comes from nowhere, and why does he kill himself there, and does it have any connection with any other part of her life. Now, the interesting thing about the film, and why I say it contains emergent 'postmodernist' elements, as it were, is that there is no story in the old sense. He doesn't come from anywhere; there is no whole story about him to tell. When his girlfriend turns up, she doesn't quite know why she's there either. She just came to the funeral and stays on a few days. But she doesn't want to be made into the explanation for him. So while the film has a very conventional structure, at its centre is what I would call a recognizably postmodernist experience. In some ways this note in the British cinema is qualitatively new. But it isn't *totally* different from that disintegration of whole experiences, or from that experience of the self as a whole person with an integrated history whose life makes sense from some fixed and stable position that's been 'in trouble' since at least Freud, Picasso, James Joyce, Brecht, and Surrealism.

So I would say postmodernism is the current name we give to how these old certainties began to run into trouble from the 1900s onwards. In that sense, I don't refuse some of the new things the postmodernists point to. They are extremely important, and the traditional Habermasian defence won't do. But the attempt to gather them all under a singular sign – which suggests a kind of final rupture or break with the modern era – is the point at which the operation of postmodernism becomes ideological in a very specific way. What it says is: this is the end of the world. History stops with us and there is no place to go after this. But whenever it is said that *this* is the last thing that will ever happen in history, that is the sign of the functioning, in the narrow sense, of the ideological – what Marx called the 'eternalizing' effect. Since most of the world has not yet properly entered the modern era, who is it who 'has no future left'? And how long will this 'no future' last into the future, if you'll excuse the paradox? If the Titanic is going down [A reference to the slogan, 'if you're sailing on the Titanic, go first class' – LG], how long is it going to take? If the bomb has already gone off, can it go on 'going off' forever? You can't be another century constantly confronting the end of the world. You can live this as a metaphor, suggesting that certain contemporary positions and ideas are now deeply undermined, rendered increasingly fragile as it were, by having the fact of the world's end as one of their imminent possibilities. That *is* a radically new historical fact and, I think, it has de-centred us all. In that sense love and human relationships in the postmodern period feel very different – more temporary, provisional, contingent. But what we are

looking at here is the tempering and elongation of the very same profound cultural and historical tendencies which constructed that break with 'the modern' which we call 'modernism'. And I want to be able to retain the term 'modernity' to refer to the long history – the *longue durée* – of those tendencies.

Question: One of the very distinctive features of the so-called postmodern theorists is their abandonment of issues of meaning, representation and signification, and ideology. How would you respond to this turn?

SH: There is here a very sharp polarization. I don't think it is possible to conceptualize language without meaning, whereas the postmodernists talk about the collapse or implosion of all meaning. I still talk about representation and signification, whereas Baudrillard says we are at the end of all representational and signifying practice. I still talk about ideology, whereas Foucault talks about the discursive which has no ideological dimension to it. Perhaps I am in these respects a dinosaur or a recidivist, but I find it very difficult to understand contemporary society and social practice giving up those three orienting points. I am not convinced by the theoretical arguments that have been advanced against them.

First, let's take Foucault's argument for the discursive as against the ideological. What Foucault would talk about is the setting in place, through the institutionalization of a discursive regime, of a number of competing regimes of truth and, within these regimes, the operation of power though the practices he calls normalization, regulation and surveillance. Now perhaps it's just a sleight of hand, but the combination of regime of truth plus normalization/regulation/surveillance is not all that far from the notions of dominance in ideology that I'm trying to work with. So maybe Foucault's point is really a polemical, not an analytic one, contesting one particular way of understanding those terms, within a much more linear kind of base/superstructure model. I think the movement from that old base/superstructure paradigm into the domain of the discursive is a very positive one. But, while I have learned a great deal from Foucault in this sense about the relation between knowledge and power, I don't see how you can retain the notion of 'resistance', as he does, without facing questions about the constitution of dominance in ideology. Foucault's evasion of the question is at the heart of his proto-anarchist position precisely because his resistance must be summoned up from nowhere. Nobody knows where it comes from. Fortunately, it goes on being there, always guaranteed: in so far as there is power, there is resistance. But at any one moment, when you want to know how strong the power is, and how strong the resistance is, and what is the changing balance of forces, it's impossible to assess because such a field of force is not conceptualizable in his model. Why? Because there is no way of conceptualizing the balance of power between different regimes of truth without society conceptualized,

not as a unity, but as a 'formation'. If Foucault is to prevent the regime of truth from collapsing into a synonym for the dominant ideology, he has to recognize that there are different regimes of truth in the social formation. And these are not simply 'plural' – they define an ideological field of force. There are subordinated regimes of truth which make sense, which have some plausibility, for subordinated subjects, while not being part of the dominant episteme. In other words, as soon as you begin to look at a discursive formation, not just as a single discipline but as *a formation*, you have to talk about the relations of power which structure the inter-discursivity, or the inter-textuality, of the field of knowledge. I don't much care whether you call it ideology or not. What matters is not the terminology but the conceptualization. The question of the relative power and distribution of different regimes of truth in the social formation at any one time – which have certain effects for the maintenance of power in the social order – that is what I call 'the ideological effect'. So I go on using the term 'ideology' because it forces me to continue thinking about that problem. By abandoning the term, I think that Foucault has let himself off the hook of having to re-theorize it in a more radical way: he saves for himself 'the political' with his insistence on power, but he denies himself *a politics* because he has no idea of the 'relations of force'.

Let's take Baudrillard's argument about representation and the implosion of meaning.This seems to rest upon an assumption of the sheer facticity of things: things *are* just what is seen on the surface. They don't mean or signify anything. They cannot be 'read'. We are beyond reading, language, meaning. Again I agree with Baudrillard's attempt to contest the old manifest/latent type of hermeneutic analyses; this stands in his work as the base/superstructure does in Foucault's – that which has to be contested and displaced. Above- and under-ground is not a very useful way of thinking about appearance in relation to structural forces. Perhaps I ought to admit that some of the tendencies in cultural studies did go that way: phenomenal form/real relation, despite all our qualifications, did suggest that the surface of things was only important in so far as you penetrated it to the underlying rules and codes. So Baudrillard is quite right in returning us to what there is, the facticity of life, the surface, the spectacle, etc. Politically, in England, this has come to connote a certain kind of 'realism' on the left which argues that you can't always go behind what the masses manifestly think to what they really think: you also have to recognize the validity of how they do make sense of the world. But I think Baudrillard's position has become a kind of super-realism, taken to the nth degree. It says that, in the process of recognizing the real, there is *nothing* except what is immediately there on the surface. Of course, in so-called postmodern society, we feel overwhelmed by the diversity, the plurality, of surfaces which it is possible to produce, and we have to recognize the rich techno-logical bases of modern cultural production which enable us endlessly to

simulate, reproduce, reiterate and recapitulate. But there is all the difference in the world between the assertion that there is no one, final, absolute meaning – no ultimate signified, only the endlessly sliding chain of signification, and, on the other hand, the assertion that meaning does not exist.

Benjamin reminded us quite a while ago that montage would destroy the aura of the unique and singular work of art forever. And once you destroy the aura of the singular work of art because it can be reiterated, you enter into a new era which cannot be approached in the same way, using the traditional theoretical concepts. You are going to have to operate your analysis of meaning without the solace of closure: more on the basis of the semantic raids that Benjamin proposed – to find the fragments, to decipher their assembly and see how you can make a surgical cut into them, assembling and reassembling the means and instruments of cultural production. It is this that inaugurates the modern era. But although this breaks the one, true meaning into fragments and puts one in the universe of the infinite plurality of codes, it does not destroy the process of encoding, which always entails the imposition of an arbitrary 'closure'. Indeed it actually enriches it, because we understand meaning not as a natural but as an arbitrary act – the intervention of ideology into language. Therefore, I don't agree with Baudrillard that representation is at an end because the cultural codes have become pluralized. I think we are in a period of the infinite multiplicity of codings, which is different. We have all become, historically, fantastically codable encoding agents. We are in the middle of this multiplicity of readings and discourses and that has produced new forms of self-consciousness and reflexivity. So, while the modes of cultural production and consumption have changed, qualitatively, fantastically, as the result of that expansion, it does not mean that representation itself has collapsed. Representation has become a more problematic process but it doesn't mean the end of representation. Again, it is exactly the term 'postmodernism' itself which takes you off the tension of having to recognize what is new, and of struggling to mobilize some historical understanding of how it came to be produced. Postmodernism attempts to close off the past by saying that history is finished, therefore you needn't go back to it. There is only the present, and all you can do is be with it, immersed in it.

Question: To what extent would you then describe yourself as a modernist attempting to make sense of these postmodern tendencies? To what extent can the inherent critical categories of modernism analyse the current forms and conditions of cultural production and reception? To what extent, for example, can modernism make sense of MTV?

SH: I think MTV is quite extraordinary. It takes fragmentation, the plurality of signification, to new heights. But I certainly couldn't say that

it is unintelligible. Each so-called meaningless fragment seems to me rich with connotations. It seems perfectly clear where MTV comes from: indeed, it is almost too predictable in its 'unpredictability'. Unpredictability is its meta-message. We know enough about the tendencies of mass culture for the last hundred years to recognize that MTV does not come from outer space. Don't misunderstand me. I do appreciate the genuine 'openness' of postmodernism before these new cultural trends and forces. But the extrapolations about the universe it makes from them are plainly wildly exaggerated and ideological, based on taking one's own metaphors literally, which is a stupid mistake to make. Not all of those tendencies are by any means progressive; many of them are very contradictory. For instance, modern mass phenomena like the mega-event – like Live Aid, Farm Aid, etc., or like Springsteen's current success – have many post-modern elements in them. But that doesn't mean they are to be seen as the unambiguous cultural expressions of an entirely new epoch. It seems to me that such events are, precisely, massively defined by their diversity, their contradictory plurality. Springsteen is a phenomen that can be read, with equal conviction, in at least two diametrically opposed ways. Hs audiences seem to be made up of people from 5 to 50, busily reading him in different ways. The symbols are deeply American – populist in their ambiguity: he's both in the White House and On The Road. In the 1960s, you had to be one or the other. Springsteen is somehow both at the same time. That's what I mean by fragmentation.

Now, if postmodernism wants to say that such processes of diversity and fragmentation, which modernism first tried to name, have gone much further, are technologically underpinned in new ways, and have penetrated more deeply into mass consciousness, etc., I would agree. But that does not mean that this constitutes an entirely new epoch or that we don't have any tools to comprehend the main trends in contemporary culture, so all we can do is to lie back and love it. I don't feel that those things which people are pointing to in postmodernism so entirely outrun our critical theories as to render those theories irrelevant. The problem is that it is assumed that theory consists of a series of closed paradigms. If paradigms are closed, of course, new phenomena will be quite difficult to interpret, because they depend on new historical conditions and incorporate novel discursive elements. But if we understand theorizing as an open horizon, moving within the magnetic field of some basic concepts, but constantly being applied afresh to what is genuinely original and novel in new forms of cultural practice, and recognizing the capacity of subjects to reposition themselves differently, then you needn't be so defeated. True, the great discourses of classical Reason, and of the rationalist actor or subject are much weaker in their explanatory power now than they were before. So are the great evolutionary chains of explanation predicated on some teleologi-cal, progressive historical movement. But in the era of Hi Tech, the

corporate, international economy and global communication networks, what does it mean to say – except as a metaphor exaggerated for affect – that the age of rationalism has ended. Only those who speak of 'culture' abstracted from its material, technical and economic conditions of existence could hold such a position.

I think a postmodernist would be likely to see my response as too complacent, and perhaps that's what you mean by characterizing me as a modernist. I admit to being a modernist, in the sense that I find the early stages of the modernist project – when it is breaking through, historically, aesthetically, when it is all happening at once – the moment of Braque, Picasso, Joyce, Klee, the Bauhaus, Brecht, Heartfield, Surrealism and Dada – to be one of the most fantastically exciting intellectual moments in twentieth-century history. Of course, I recognize that this movement was limited and did not directly engage with or transform the popular. How could it? How could culture, on its own, transcend the social, political and economic terrain on which it operates? Certainly, failing in its radical promise, many modernist impulses were then pulled back into more elitist formations. Williams long ago explained how emergent movements are assimilated into the dominant. This does not diminish the radical break with the epistemes of the modern which modernism represented. Since then, the engagement between modernism and the popular has been following a rapid but uneven path. This articulation – far from being completed – is only now really beginning. It's not that I don't respond positively to many elements in postmodernism, but the many separate and diverse strands, which modernism tried to hold together in one framework, have once again separated out. So there's now an aesthetic postmodernism an achitectural postmodernism, postmodernist theory, postmodernist film making, etc. Postmodern culture has become a set of disassociated specialisms. I suppose I am still very attracted by that highly contradictory point at the inception of modernism when an old paradigm is breaking up and a new one is being born. I'm drawn by the immediate intellectual excitement that is generated in the capacity to move from one thing to another, to make multiple cross-linkings, multi-accentualities, which was at the centre of the modernist project. However, while my tastes tend toward the modernist, I don't know whether I would locate myself now within the modernist theoretical project.

Question: It seems to me that the most powerful challenge to your theory of articulation – and its political implications – is Baudrillard's description of the masses as an implosive force that 'can no longer be spoken for, articulated and represented.'

SH: I think the whole collapse of the critical French intelligentsia during the Mitterrand era is inscribed in that statement. What raised my political hackles is the comfortable way in which French intellectuals now take it

upon themselves to declare when and for whom history ends, how the masses can or cannot be represented, when they are or are not a real historical force, when they can or cannot by mythically invoked in the French revolutionary tradition, etc. French intellectuals always had a tendency to use 'the masses' in the abstract to fuel or underpin their own intellectual positions. Now that the intellectuals have renounced critical thought, they feel no inhibition in renouncing it on behalf of the masses – whose destinies they have only shared abstractly. I find it ironic that the silent majority, whom the intellectuals only discovered yesterday, is fueling the postmodernist collapse. France, like all western European capitalist societies, is in deep trouble. And, against the revolutionary myths which French intellectuals kept alive for so long, what we continue to confront in such developed western industrial societies is the much more accurate – and continuing – problem of the insertion of the masses in subordinate positionalities within dominant culture practices. The longer that history has gone on, the more popular culture has been represented as inevitably corrupt, etc. It is critical intellectuals, locked into their own kind of cultural elitism, who have often succumbed to the temptation to give an account of the Other – the masses – in terms of false consciousness or the banalization of mass culture, etc. So the recognition of the masses and the mass media as significant historical elements is a useful corrective against that in postmodernism. But the politics which follows from saying that the masses are nothing but a passive reflection of the historical, economical and political forces which have gone into the construction of modern industrial mass society, seems to me historically incorrect and politically inadequate.

I would say quite the opposite. The silent majorities *do* think; if they do not speak, it may be because we have taken their speech away from them, deprived them of the means of enunciation, not because they have nothing to say. I would argue that, in spite of the fact that the popular masses have never been able to become in any complete sense the subject-authors of the cultural practices in the twentieth century, their continuing presence, as a kind of passive historical-cultural force, has constantly interrupted, limited and disrupted everythig else. It is as if the masses have kept a secret to themselves whie the intellectuals keep running around in circles trying to make out what it is, what is going on.

That is what Benjamin meant by saying that it isn't only the new means of mechanical reproduction but the historical presence of the masses which interrupts history. He didn't mean this as a guarantee that the masses are instantly going to take over the world and remake modern culture in their own image. He meant that they are now, irrevocably, on the historical stage and nothing can move any longer – including the dominant cultural industries – without taking that 'presence' into account. Nothing can be constituted as high art without recognizing, in the existing distribution of

educational practices, its relative divorce from the masses' experience. Nothing can become popular which does not negotiate the experiences, the codes, etc., of the popular masses . . .

For something to become popular entails a struggle; it is never a simple process, as Gramsci reminded us. It doesn't just happen. And that means there must be always some distance between the immediate practical consciousness or common sense of ordinary people, and what it is possible for them to become. I don't think that history is finished and the assertion that it is, which lies at the heart of postmodernism, betrays the inexcusable ethnocentrism – the Eurocentrism – of its high priests. It is their cultural dominance, in the West, across the globe, which is historically at an end. The masses are like an irritant, a point that you have to pass through. And I think that postmodernism has yet to go through that point; it has yet to actually think through and engage the question of the masses. I think Baudrillard needs to join the masses for a while, to be silent for two-thirds of a century, just to see what it feels like. So, it is precisely at the site of the question of the political possibilities of the masses that my political objections to, and contestations with, postmodernism come through most sharply.

Question: Some postmodern theorists are concerned with what they call 'articulation', for example, Deleuze and Guattari emphasize the articulation of desiring production. Could you describe your own theory of the articulation of ideology and ideological struggle?

SH: I always use the word 'articulation', though I don't know whether the meaning I attribute to it is perfectly understood. In England, the term has a nice double meaning because 'articulate' means to utter, to speak forth, to be articulate. It carries that sense of language-ing, of expressing, etc. But we also speak of an 'articulated' lorry (truck): a lorry where the front (cab) and back (trailer) can, but need not necessarily, be connected to one another The two parts are connected to each other, but through a specific linkage, that can be broken. An articulation is thus the form of the connection that *can* make a unity of two different elements, under certain conditions. It is a linkage which is not necessary, determined, absolute and essential for all time. You have to ask, under what circumstances *can* a connection be forged or made? So the so-called 'unity' of a discourse is really the articulation of different, distinct elements which can be re-articulated in different ways because they have no necessary 'belonging-ness'. The 'unity' which matters is a linkage between that articulated discourse and the social forces with which it can, under certain historical conditions, but need not necessarily, be connected. Thus, a theory of articulation is both a way of understanding how ideological elements come, under certain conditions, to cohere together within a discourse, and a way of asking how they do or do not become articulated, at specific

conjunctures, to certain political subjects. Let me put that the other way: the theory of articulation asks how an ideology discovers its subject rather than how the subject thinks the necessary and inevitable thoughts which belong to it; it enables us to think how an ideology empowers people, enabling them to begin to make some sense or intelligibility of their historical stituation, without reducing those forms of intelligibility to their socio-economic or class location or social position.

The theory of articulation, as I use it, has been developed by Ernesto Laclau, in his book *Politics and Ideology in Marxist Theory*. His argument there is that the political connotation of ideological elements has no necessary belongingess, and thus, we need to think the contingent, the non-necessary, connection between different practices – between ideology and social forces, and between different elements within ideology, and between different social groups composing a social movement, etc. He uses the notion of articulation to break with the necessetarian and reductionist logic which has dogged the classical marxist theory of ideology.

For example: Religion has no necessary political connotation. Anyone interested in the politics of contemporary culture has to recognize the continuing force in modern life of cultural forms which have a prehistory long predating that of our rational systems, and which sometimes constitute the only cultural resources which human beings have to make sense of their world. This is not to deny that, in one historical-social formation after another, religion has been bound up in particular ways, wired up very directly as the cultural and ideological underpinning of a particular structure of power. That is certainly the case, historically; and in those societies, there are powerful, immensely strong what I would call 'lines of tendential force' articulating that religious formation to political, economic and ideological structures. So that, if you move into that society, it would be idiotic to think that you could easily detach religion from its historical embeddedness and simply put it in another place. Thus, when I say the connections are 'not necessary', I don't mean religion is free-floating. It exists historically in a particular formation, anchored very directly in relation to a number of different forces. Nevertheless, it has no necessary, intrinsic, transhistorical belongingness. Its meaning – political and ideological – comes precisely from its position within a formation. It comes with what else it is articulated to. Since those articulations are not inevitable, not necessary, they can potentially be transformed, so that religion can be articulated in more than one way. I insist that, historically, it has been inserted into particular cultures in a particular way over a long period of time, and this constitutes the magnetic lines of tendency which are very difficult to disrupt. To use a geographical metaphor, to struggle around religion in that country, you need to know the ideological terrain, the lay of the land. But that's not to say, 'that's how it is, so it always will be so'. Of course, if you are going to try to break, contest or

interrupt some of these tendential historical connections, you have to know when you are moving against the grain of historical formations. If you want to move religion, to re-articulate it in another way, you are going to come across all the grooves that have articulated it already.

Nevertheless, as we look across the modern and developing worlds, we see the extraordinary diversity of the roles which religious formations have actually played. We also see the extraordinary cultural and ideological vitality which religion has given to certain popular social movements. That is to say, in particular social formations, where religion has become the *valorized* ideological domain, the domain into which all the different cultural strands are obliged to enter, no political movement in that society can become popular without negotiating the religious terrain. Social movements have to transform it, buy into it, inflect it, develop it, clarify it – but they must engage with it. You can't create a popular political movement in such social formations without getting into the religious question, because it is the arena in which this community has come to a certain kind of consciousness. This consciousness may be limited, it may not have successfully helped them to remake their history. But they have been 'languaged' by the discourse of popular religion. They have, for the first time, used religion to construct some narrative, however impoverished and impure, to connect the past and the present: where they came from with where they are and where they are going to, and why they are here . . .

In the case of the Rastafarians in Jamaica: Rasta was a funny language, borrowed from a text – the Bible – that did not belong to them; they had to turn the text upside-down, to get a meaning which fit their experience. But in turning the text upside-down they remade themselves; they positioned themselves differently as new political subjects; they reconstructed themselves as blacks in the new world: they *became* what they are. And, positioning themselves in that way, they learned to speak a new language. And they spoke it with a vengeance. They learned to speak and sing. And in so doing, they did not assume that their only cultural resources lay in the past. They did not go back and try to recover some absolutely pure 'folk culture', untouched by history, as if that would be the only way they could learn to speak. No, they made use of the modern media to broadcast their message. 'Don't tell us about tom-toms in the forest. We want to use the new means of articulation and production to make a new music, with a new message.' This is a cultural transformation. It is not something totally new. It is not something which has a straight, unbroken line of continuity from the past. It is transformation through a reorganization of the elements of a cultural practice, elements which do not in themselves have any necessary political connotations. It is not the individual elements of a discourse that have political or ideological connotations, it is the ways those elements are organized together in a new discursive formation.

Let me come to the question of social forces. This ideology, which transforms a people's consciousness and awareness of themselves and their historical situation, although it explodes culturally, does not constitute itself *directly* as a social and political force. It has its limits, as all religious forms of explanation do. But it does become articulated to a social movement, a movement of people. And it functioned so as to harness or draw to it sectors of the population who have never been inside that historical bloc before. Is it a class? In the case of the Rastafarian movement, it has at its centre the experiences, the position, the determinations of economic life in Jamaican society. It has at its heart a class formation. Is it only a class? No, it could not have become a historical or political force simply reduced to an already unified class. Indeed it never has been a unified class, with a unified ideology already in place. It is cross-cut, deeply intersected by, a variety of other determinations and ideologies. In fact, it only *becomes* a unified social force through the constitution of itself as a collective subject within a unifying ideology. It does not become a class or a unified social force until it begins to have forms of intelligibility which explain a shared collective situation. And even then, what determines the place and unity is nothing we can reduce to the terms of what we used to mean by an economic class. A variety of sectors of different social forces, in that moment, become articulated to and within this particular ideology. Therefore, it is not the case that the social forces, classes, groups, political movements, etc. are first constituted in their unity by objective economic conditions and then give rise to a unified ideology. The process is quite the reverse. One has to see the way in which a variety of different social groups enter into and constitute for a time a kind of political and social force, in part by seeing themselves reflected as a unified force in the ideology which constitutes them. The relationship between social forces and ideology is absolutely dialectical. As the ideological vision emerges, so does the group. The Rastafarians were, Marx would say, as a group in themselves, the poor. But they don't constitute a unified political force *because* they are poor. In fact, the dominant ideology makes sense of them, not as 'the poor' but as the feckless, the layabouts, the underclass. They only constitute a political force, that is, they *become* a historical force in so far as they are constituted as new political subjects.

So it is the articulation, the non-necessary link, between a social force which is making itself, and the ideology or conceptions of the world which makes intelligible the process they are going through, which begins to bring onto the historical stage a new social position and political position, a new set of social and political subjects. In that sense, I don't refuse the connection between an ideology or cultural force and a social force; indeed, I want to *insist* that the popular force of an organic ideology always depends upon the social groups that can be articulated to and by it. It is here that one must locate the articulating principle. But I want to think that

connection, not as one *necessarily* given in socio-economic structures or positions, but precisely as the result of *an articulation*.

Question: Given your obviously close connection with theories of discourse and discursive analysis – your theory of articulation seems to suggest that the elements of a social formation be thought of as operating like a language – I wonder how far you are willing to go into a kind of poststructuralist position that would argue that society itself can be analysed as a series of competing languages. I'm thinking here particularly of Laclau and Mouffe's latest book, *Hegemony and Socialist Strategy*, and I wonder how you would make out the similarities and differences between their position and your own.

SH: You are absolutely right in saying that I've gone a very long way along the route of rethinking practices as functioning discursively – i.e., like languages. That metaphor has been, I think, enormously generative for me and has powerfully penetrated my thinking. If I had to put my finger on the one thing which constitutes the theoretical revolution of our time, I think it lies in that metaphor – it's gone in a thousand different directions but it has also reorganized our theoretical universe. It is not only the discovery of the importance of the discursive, and the utility of a particular kind of analysis; it is also the metaphorically generated capacity to reconceptualize other kinds of practices as operating, in some important ways, like a language. I think, for example, it's possible to get a long way by talking about what is sometimes called the 'economic' as operating discursively. The discursive perspective has also brought into play a very important insight, namely, the whole dimension of subjectivity, particularly in the ideological domain. I think marxism and structuralism had already made a very significant break with the traditional notion of the empirical sociological subject. And probably, they had to go by way of what has been called the theory of 'a history without subjects', a language with no speakers. But that was manifestly only a stopping point on the route to something else. It's just not possible to make history without subjects in quite that absolute way. The discursive perspective has required us to think about reintroducing, reintegrating the subjective dimension in a non-holistic, non-unitary way. From this point of view, one cannot ignore Laclau and Mouffe's seminal work on the constitution of political subjects and their deconstruction of the notion that political subjectivities do flow from the integrated ego, which is also the integrated speaker, the stable subject of enunciation. The discursive metaphor is thus extraordinarily rich and has massive political consequences. For instance, it enabled cultural theorists to realize that what we call 'the self' is constituted out of and by difference, and remains contradictory, and that cultural forms are, similarly, in that way, never whole, never fully closed or 'sutured'.

The question is, can one, does one, follow that argument to the point that there is nothing to practice but its discursive aspect? I think that's what their recent book does. It is a sustained philosophical effort, really, to conceptualize *all* practices as nothing but discourses, and all historical agents as discursively constituted subjectivities, to talk about positionalities but never positions, and only to look at the way concrete individuals can be interpellated in different subject positionalities. The book is thus a bold attempt to discover what a politics of such a theory might be. All of that I think is important. I still prefer *Politics and Ideology in Marxist Theory* over *Hegemony and Socialist Strategy*. (Perhaps I ought to say in parenthesis that I do find an alarming tendency in myself to prefer people's less complete works to their later, mature and complete ones. I prefer *The Eighteenth Brumaire* to book II of *Capital*. I prefer Althusser's *For Marx* to *Reading Capital*. I like people's middle period a lot, where they have gotten over their adolescent idealism but their thought has not yet hardened into a system. And I like Laclau when he's struggling to find a way out of reductionism and beginning to reconceptualize marxist categories in the discursive mode.) But in the last book, there is no reason why anything is or isn't potentially articulatable with anything. The critique of reductionism has apparently resulted in the notion of society as a totally open discursive field.

I would put it polemically in the following form: the last book thinks that the world, social practice, is language, whereas I want to say that the social operates *like* a language. While the metaphor of language is the best way of rethinking many fundamental questions, there's a kind of slippage from acknowledging its utility and power to saying that that's really the way it is. There's a very powerful tendency which pushes people, as soon as they get to the first position, to make the theoretically logical move of going all the way. Theoretically, perhaps, they are much more consistent than I am. Logically, once you've opened the gate, it's reasonable to go through it and see what the world looks like on the other side. But I think that that often becomes its own kind of reductionism. I would say that the fully discursive position is a reductionism upward, rather than a reductionism downward, as economism was. What seems to happen is that, in the reaction against a crude materialism, the metaphor of x operates like y is reduced to $x = y$. There is a very dramatic condensation which, in its movement, reminds me of theoretical reductionism very strongly. You see it most clearly in something like the reworking of Lacanian psychoanalysis.

And at that point, I think it's theoretically wrong in fact, what is left of the old materialist in me wants to say extremely crude things like 'I'd like to make you eat your words.' Let me put this another more serious way. If you go back to the early formulations of historical materialism, what Marx always talks about is the way in which social and cultural structures overdetermine the natural ones. Marx is aware that we remain

natural beings, that we remain in nature. What he's talking about is the elaborations of social and cultural organization which complete those natural structures. Our genetic constitution is extraordinarly open-ended and is thus a necessary but not sufficient way of becoming human. What is happening, historically, is the massive complexification of the social, the overdetermination of the natural by the social and cultural. So Nature can no longer stand as the ultimate guarantee of materialism. Already in the nineteenth century, Marx polemicized against that kind of vulgar materialism but there was, and still is, a sense in which orthodox marxists think that something is ultimately only real when you can put your hands on it in Nature. We can't be materialists in that way any longer. But I do think that we are still required to think about the way in which ideological/cultural/discursive practices continue to exist within the determining lines of force of material relations, and the expropriation of nature, which is a very different question. Material conditions are the necessary but not sufficient condition of all historical practice. Of course, we need to think material conditions in their determinate discursive form, not as a fixed absolute. I think the discursive position is often in danger of losing its reference to material practice and historical conditions.

Question: There seem to be two separate questions involved in your description of that slippage. One is how politically and historically specific the analysis is, and the other is whether opening the discursive terrain necessarily takes you into reductionism. Is the slippage the result of excessive abstraction and idealization that loses touch with the political and historical limits on the ways in which particular discourses can be articulated to one another? If what is lost in making the social formation into an open field of discourse is a particular sense of historical necessity, of limits within which languages are juxtaposed with one another in a social formation, that is a much more limited kind of problem. One simple way of posing that for Laclau and Mouffe might be to say that their position doesn't have enough of a political inflection. That's not necessarily the same as saying that, because they've opened the door onto thinking of society as a discursive formation, they are necessarily pulled into reductionism.

SH: I do not think that opening the door to the discursive field necessarily takes you in that direction. It doesn't take me there. So I would prefer your first formulation. In *Politics and Ideology in Marxist Theory*, Laclau contests the *a priori* insertion of classes, for instance, into marxist analysis because there is no way to substantiate such a philosophical *a priori*. Yet he does reintroduce class as an historical determinant. Now I find it very difficult to quarrel with that. I think the question of political inflection is a very real problem with a lot of people who have taken the full discursive route. But I don't think I would advance that critique against Laclau and

Mouffe. The new book is quite striking in that it *does* try to constitute a new politics out of that position. In that sense, it's very responsible and original. It says, let's go through the discursive door but then, we still have to act politically. Their problem isn't politics but history. They have let slip the question of the historical forces which have produced the present, and which continue to function as constraints and determinations on discursive articulation.

Question: Is the difference between the two books then a matter of levels of abstraction?

SH: I think they are quite heroic, in the new book, to say that until one can express these new positions in the form of a rigorously articulated general theory, one is still too bogged down in the pragmatics of local examples, conjunctural analysis, and so on. I don't operate well at that level, but I don't want to deny the importance of what is sometimes called 'theoretical practice'. It is not an autonomous practice, as some Althusserians have tried to talk about it, but it does have its own dynamic. At many important points, *Capital* is operating precisely at that level; it is a necessary level of abstraction. So the project itself is not wrong. But in carrying it out, they do tend to slip from the requirement to recognize the constraints of existing historical formations. While they are very responsible – whether you agree with them or not – about recognizing that their position does have political consequences, when they come down to particular political conjunctures, they don't reintegrate other levels of determination into the analysis. Instead, they take the abstractions which have been developed and elaborated, in a very rigorous and conceptual way at a high philosophical level, and insert them into the here and now. You don't seem them adding, adding, adding, the different levels of determination; you see them producing the concrete philosophically, and somewhere in there is, I think, the king of analytic slippage I am talking about. That's not to say that it's theoretically impossible to develop a more adequate set of political positions within their theoretical framework, but somehow, the route they have taken allows them to avoid the pressure of doing so. The structuring force, the lines of tendency stemming from the implantation of capital, for example, simply disappears.

Question: Two other terms becoming common in cultural theory are 'post-marxism' and 'post-structuralism'. Both have, at various times, been used to describe your work. Can you describe your relation to these categories?

SH: I am a 'post-marxist' only in the sense that I recognize the necessity to move beyond orthodox marxism, beyond the notion of marxism guaranteed by the laws of history. But I still operate somewhere within what I understand to be the discursive limits of a marxist position. And I feel the same way about structuralism. My work is neither a refusal nor an apologia of

Althusser's position. I refuse certain of those positions, but Althusser certainly has had an enormous influence on my thinking, in many positive ways that I continue to acknowledge, even after he has gone out of fashion. So 'post' means, for me, going on thinking on the ground of a set of established problems, a problematic. It doesn't mean deserting that terrain but rather, using it as one's reference point. So I am, only in that sense, a post-marxist and a post-structuralist, because those are the two discourses I feel most constantly engaged with. They are central to my formation and I don't believe in the endless, trendy recyling of one fashionable theorist after another, as if you can wear new theories like T-shirts.

Question: It is clear that cultural studies is enjoying a new measure of success in the United States. I wonder how you feel about these recent successes to institutionalize and codify cultural studies?

SH: I would like to perhaps make a distinction between the two terms that you use. I am in favour of institutionalization because one needs to go through the organizational moment – the long march through the institutions – to get people together, to build some kind of collective intellectual project. But codification makes my hackles rise, even about the things I have been involved in. People talk about 'the Birmingham school' [The Centre for Contemporary Cultural Studies at the University of Birmingham] and all I can hear are the arguments we used to have in Birmingham that we never were one school; there may have been four or five but we were never able to unify it all, nor did we want to create that kind of orthodoxy. Now let me say something, perhaps controversial, about the American appropriation of all that was going on at Birmingham, and cultural studies in general, for I see some interesting presences and absences. For instance, I find it interesting that formal semiotics here rapidly became a sort of alternative interpretive methodology, whereas I don't think anybody in England ever really believed in it as a complete method. When we took on semiotics, we were taking on a methodological requirement: you had to show *why* and *how* you could say that that is what the meaning of any cultural form or practice is. That is the semiotic imperative: to demonstrate that what you were calling 'the meaning' is textually constituted. But as a formal or elaborated *methodology*, that was not what semiotics was for us. In America, taking on semiotics seemed to entail taking on the entire ideological baggage of structuralism. Similarly, I notice there is now a very rapid assimilation of the Althusserian moment into literary studies but without its marxist connotations. And I notice the same thing about Gramsci's work. Suddenly, I see Gramsci quoted everywhere. Even more troubling, I see Gramscian concepts directly substituted for some of the very things we went to Gramsci to avoid. People talk about 'hegemony' for instance as the equivalent of ideological domination. I have tried to fight against that interpretation of 'hegemony' for twenty years.

Sometimes, I hear a similar kind of easy appropriation when people start talking about cultural studies. I see it establishing itself quite rapidly on the foundations of existing academic departments, existing intellectual divisions, and disciplinary curricula. It becomes a kind of 'received knowledge', instead of having a real critical and deconstructive edge to it. But I don't know what you do about that; I don't know how you refuse success. I think that in America, cultural studies is sometimes used as just one more paradigm. You know, there are fifteen around, so this time I will say that I have a cultural studies approach. . . . I understand why that happens because, in a sense, there *is* a perspective there, despite its eclecticism and relative openness. It has always been trying to integrate itself into a perspective. That's inevitable whenever you try to get people to do research collectively because they have to collaborate while trying to answer specific questions. So there is a thrust toward codification inevitably, as the project develops and generates work. Let me put it this way: you have to be sure about a position in order to teach a class, but you have to be open-ended enough to know that you are going to change your mind by the time you teach it next week. As a strategy, that means holding enough ground to be able to think a position but always putting it in a way which has a horizon toward open-ended theorization. Maintaining that is absolutely essential for cultural studies, at least if it is to remain a critical and deconstructive project. I mean that it is always self-reflectively deconstructing itself; it is always operating on the progressive/regressive movement of the need to go on theorizing. I am not interested in Theory, I am interested in going on theorizing. And that also means that cultural studies has to be open to external influences, for example, to the rise of new social movements, to psychoanalysis, to feminism, to cultural differences. Such influences are likely to have, and must be allowed to have, a strong impact on the content, the modes of thought and the theoretical problematics being used. In that sense, cultural studies cannot possibly thrive by isolating itself in academic terms from those external influences. So in all those ways I think there are good reasons, not just personal predilections, for saying that it must remain open-ended. It is theorizing in the postmodern context, if you like, in the sense that it does not believe in the finality of a finished theoretical paradigm.

Editor's Note
This article is drawn from interview sessions with Hall conducted by S. Elizabeth Bird, Marilyn Smith, Patrick O'Brien and Kuan-Hsing Chen (on postmodernism) at the University of Iowa School of Journalism and Mass Communication in September 1985, and by Cary Nelson, Lawrence Grossberg and others (on articulation) at the University of Illinois Unit for Criticism and Interpretive Theory in August 1985. Transcriptions were made by Kuan-Hsing Chen and Michael Greer.

Chapter 7

History, politics and postmodernism
Stuart Hall and cultural studies

Lawrence Grossberg

I STUART HALL ON IDEOLOGY, HEGEMONY, AND THE SOCIAL FORMATION

Living with difference

It is both surprising and understandable that British marxist cultural studies, in the works of the Birmingham Centre for Contemporary Cultural Studies, has recently had a significant and influential impact in the United States, especially for communication scholars. (Bits and pieces of it have been appropriated before by other disciplines, such as education and sociology.) There are many reasons for the resistance in the past: the publications are dispersed and often difficult to find; the language is often explicitly defined by its links to and debates with contemporary continental philosophy and theory; and the 'position's' commitment to the ongoing and practical nature of theorizing contravenes common notions of theoretical stability in the social sciences. There are also many reasons for the sudden interest: the dissatisfaction with available theoretical paradigms and research programmes; the increasing politicization of the academy; the slow incorporation of continental philosophies into the graduate curriculum, and perhaps, most powerfully, the recent visibility of Stuart Hall in the United States. Those who have been working in this tradition for some time might, understandably, be a bit suspicious of this current interest, even as it is welcomed, for like all intellectual traditions, marxist cultural studies, even in the work of a single author like Hall, is a complex and contradictory terrain, with its own histories, debates and differences.

It is difficult to identify a single position, concern, tradition or method in Hall's work, or to assign specific arguments to a single theoretical level or 'empirical' arena. The 'multi-accentuality' of his work is magnified by his commitment to modes of collective intellectual work and authorship

Reprinted from *Journal of Communication Inquiry* (1986), 10(2), 61–77.

(1988b). His 'author-ity' extends far beyond those texts he himself has authored; he is as much a teacher and an activist as a writer. As a founding member of the New Left in England and the first editor of the influential *New Left Review*, as one of those crucially responsible for the definition and institutionalization of 'cultural studies' during his tenure at the Birmingham Centre for Contemporary Cultural Studies, and as a leading figure in the attempt to forge a new marxism – both intellectual and practical – since moving to the Open University, his work embodies an ongoing project, realized in an explicit dialogue with others and character-ized above all by a modesty and generosity, as much in his descriptions of people in concrete historical situations as in his considerations of other positions. Anyone who has had the pleasure of hearing or meeting Hall knows the special quality of his presence, a presence that combines his political and intellectual passion with the commitment to human decency that pervades all his interactions.[1]

In fact, Hall's own discursive practice exemplifies those commitments. His engagement with other writers embodies a 'critical dialogue': he simultaneously borrows and distances himself from them, struggling with their texts, re-inflecting them into his own understanding of history as an active struggle. History and theory – both enact an ongoing process of what Gramsci called 'destruction and reconstruction' or, in Hall's terms, 'de- and re-articulation' (although Hall tends to use 'articulation' when talking about cultural or signifying practices). While many increasingly acknowl-edge the need for theoretical complexity, Hall elaborates and concretizes that demand as he moves from the more abstract to the more concrete. He rarely claims that the questions he addresses are sufficient, merely that they are often ignored. He does not offer his answers as authoritative; he seeks rather to open up new fields of exploration and critical reflection, to put on the agenda of the left whatever is being kept off, to challenge that which we take for granted. His theoretical advances are offered, not as the end of a debate, but as the ongoing attempt to understand the complexity, contra-dictions and struggles within the concrete lives of human beings. Yet the model of his practice – as a writer, teacher, theoretician, cultural critic and political strategist – and the middle ground he constantly tries to occupy, can be extended beyond the debates he addresses. It is this commitment to struggle, at all levels, which constitutes the centre of his current position and the theme of his latest work.

Nevertheless, Hall does write from a particular position, defined in part by his own social and intellectual history. The latter is likely to be unfamiliar to many communications scholars. Hall works within both marxist and semiotic discourses which attempt to understand the nature of contemporary social life and the central place of communication within it. To try, in the name of generalization, to eliminate either his fundamental concern with power and historical change, or the real theoretical advances,

over a broad range of issues, accomplished in his vocabulary, would be a disservice. Moreover, it would be a distortion of Hall's work not to recognize that his position has changed, over time, in response to new theoretical and historical questions; old concepts and strategies have occasionally disappeared from his writing, but more commonly, they are reappropriated into a new theoretical formation which re-articulates not only their significance but their political challenge as well. In what follows, then, I will try to move between the abstraction and the detail, offering a map of Hall's own current strategies and struggles.

For Hall, all human practices (including communication and communication theory) are struggles to 'make history but in conditions not of our own making.' He brings this marxist maxim to bear upon at least three different, albeit related projects: (1) to offer a theory of ideology which sees communicative practices in terms of what people can and do make of them; (2) to describe the particular historical form of contemporary cultural and political struggle (hegemony); and (3) to define a 'marxism without guarantees' by rethinking the 'conjunctural' nature of society. At each of these levels, Hall connects, in complex ways, theory and writing to real social practices and struggles.

There can be no radical separation between theory, at whatever level of abstraction, and the concrete social historical context which provides both its object of study and its conditions of existence. This is not merely a political position (although it is that); it is also an epistemological one. Hall extends the marxist attempt to 'reproduce the concrete in thought' with Benjamin's comparison of the magician and the surgeon: the magician acts upon the surface of reality, the surgeon cuts into it. (It is not coincidental that Benjamin's metaphor describes the new media technology, specifically photography.) Rejecting the 'magical incantations' of the empiricist who claims to have secure access to the real (even in its marxist forms: e.g., theories of false consciousness), Hall (1980a) seeks 'concepts with which to cut into the complexity of the real, in order precisely to reveal and bring to light relationships and structures which cannot be visible to the naive naked eye,' relations of power and contradiction, of domination and struggle. Hall disclaims abstract and universal theory; rather, his epistemology derives from a reading (1974) of Marx which sees the relation between conceptual and empirical reality as a constant movement between different levels of abstraction. Hall also refuses the relativism of rationalism: although theories and descriptions are always ideological, their 'truth' is measured in the context of concrete historical struggles, their adequacy judged by the purchase they give us for understanding the complex and contradictory structure of any field of social practices, for seeing beyond the taken-for-granted to the ongoing struggles of domination and resistance.

At whatever level of abstraction, Hall's fundamental commitment is to a

structuring principle of struggle, not as an abstract possibility, but as a recognition that human activity at all levels always takes place within and over concretely 'contested terrain'. For example, against those who would reduce the politics of culture to a simple economic relation of domination, Hall (1984a) argues that

> we must not confuse the practical inability to afford the fruits of modern industry with the correct popular aspiration that modern people know how to use and master and bend to their needs and pleasures modern things . . . In part, of course, this is the product of a massively capitalised swamp advertising campaign. But more importantly, it is also a perfectly correct perception that this is where modern technology is, these are languages of calculation of the future . . . Not to recognize the dialectic in this is to fail to see where real people are . . .

By identifying the possibilities of struggle within any field, Hall occupies the middle ground between those who emphasize the determination of human life by social structures and processes, and those who, emphasizing the freedom and creativity of human activity, fail to recognize its historical limits and conditions: a middle ground in which people constantly try to bend what they are given to their own needs and desires, to win a bit of space for themselves, a bit of power over their own lives and society's future.

Hall seeks to define a non-reductionist theory of determination and social practices, of ideology, culture and politics. The concept of 'articulation' signals his attempt to rethink the dialectic of determination as struggle; it marks his movement of this marxist problematic onto the terrain of structuralist theory while simultaneously registering the limit he places upon the 'riot of deconstruction' (1985), a movement which is determined in part by his more recent non-humanist rereading (1986; cf. Hall *et al.*, 1977b) of Gramsci. Structuralism argues that the identity of a term is not pregiven, inherent in the term itself but rather, is the product of its position within a system of differences. Thus, as Hall himself has said, it was structuralism (and particularly Althusser) that taught him to 'live with difference'. For Hall, the meaning and politics of any practice is, similarly, the product of a particular structuring of the complex relations and contradictions within which it exists. 'Articulation' refers to the complex set of historical practices by which we struggle to produce identity or structural unity out of, on top of, complexity, difference, contradiction. It signals the absence of guarantees, the inability to know in advance the historical significance of particular practices. It shifts the question of determination from origins (e.g., a practice is defined by its capitalist or working-class genesis) to effects. It is the struggle to articulate particular effects in history that Hall seeks to find at every level, and in every domain of social life.

Marxism without guarantees

Although Hall is best known for his work in cultural theory and ideological analysis, the power of the concept of 'articulation' is perhaps more clearly illustrated by his 'conjunctural theory' of the social formation. Here, Hall's middle ground between 'culturalism' and '(post)structuralism' is explicitly theorized (1980a, 1983). What is the nature of society and of the structural determinations operating within it? In the 'culturalist' position, the coherence and totality of a particular social structure (and the nature of the power relations within it) are already given, defined as a series of correspondences between different levels of social experiences, cultural practices, economic and political relations. Society is an 'expressive totality' in which every practice refers back to a common origin. A chain of equivalences is constructed: for example, a particular class = particular experiences = particular political functions = particular cultural practices = particular needs and interests = a particular position in the economic relations of capital. That is, a particular social identity corresponds to particular experiences, defines a particular set of political interests, roles and actions, has its own 'authentic' cultural practices, and so on. What determines this network of correspondences, what defines and guarantees this system's existence is – whether in the first or the last instance – the economic. Culturalism is a theory of necessary correspondences in which the meaning and politics of every action are already defined, guaranteed in the end by its origin in the class struggle or by its stable place in the contradictions of capital. As a theory of power, struggle and contestation are possible only by appealing to an abstract principle of human nature: the question of agency is necessarily transformed into one of creativity; the subject is somehow determining but indeterminate.

On the other hand, in the '(post)structuralist' position, structural unity and identity are always deconstructed, leaving in their place the complexity, contradictions and fragmentation implied in difference. There are no necessary relations, no correspondences; that is guaranteed outside of any concrete struggle. What something is (including the social formation) is only its relations to what it is not, its existence in a nominalist field of particular others. Any structure or organization is to be dismantled: one can build neither theory nor struggle upon it. With any unitary nature denied, society can only be seen as a network of differences within which power operates 'microphysically' (i.e., absolutely nonhierarchically). Similarly, the identification of the historical agent with a creative subject is broken. The actor is fragmented and its intentions 'decentred' from any claim of origination/determination. Agency is nothing but the product of the individual's insertion into various and contradictory codes of social practice: the speaker is always already spoken. Thus, the social totality is dissolved into a pluralism of powers, practices, subject-positions. This is a theory of

necessary non-correspondence, in which the lack of identity and structure is guaranteed, in which there can be no organization of power (as either a system of domination structured by certain more fundamental contradictions or a coherent structure of resistance). Resistance itself is comprehensible only by appealing to an abstract principle of the unconscious or the repressed.

At this level, the concept of 'articulation' marks Hall's unwillingness to accept the necessity of either correspondence or non-correspondence, either the simple unity or the absolute complexity of the social formation. He argues that correspondences are historically produced, the site of the struggle over power. Society is, for Hall, a complex unity, always having multiple and contradictory determinations, always historically specific. This 'conjunctural' view sees the social formation as a concrete, historically produced organization – a 'structure-in-dominance' – of the different forms of social relations, practices and experiences. Each form of social practice (political, economic and cultural) has its own specificity or 'relative autonomy'; each has its own specific field of effects, particular transformations that it produces and embodies. But the effects of any concrete practice – its conjunctural identity – are always 'overdetermined' by the network of relations in which it is located. For Hall, the struggle is over how particular practices are positioned, into what structures of meaning and power, into what correspondences, they are articulated.

Hall (1983) offers a 'marxism without guarantees', a theory of 'nonecessary (non/) correspondence', in which history is the struggle to produce the relations within which particular practices have particular meanings and effects, to organize practices into larger structures, to 'inflect' particular practices and subject-positions into relations with political, economic and cultural structures of domination and resistance. Hall's marxism demands that we seek to understand the concrete practices by which such articulations are accomplished and the contradictions around which struggles are and can be organized. The theory of articulation is the assertion of struggle over necessity, struggles both to produce structures of domination and to resist them. (It is perhaps also meant to remind the left of an important lesson: 'pessimism of the intellect, optimism of the will'.)

It offers a different version of determination, a rigorously anti-reductionist model of the production of social life as a field of power. Furthermore, Hall argues that these systems of power are organized upon contradictions, not only of class and capital, but of gender and race as well; these various equally fundamental contradictions may or may not be made to correspond – this is yet another site of articulation and power. Hall's theory offers, as well, a non-essentialist theory of agency: social identities are themselves complex fields of multiple and even contradictory struggles; they are the product of the articulations of particular social positions into chains of equivalences, between experiences, interests, political struggles

and cultural forms, and between different social positions. This is a fragmented, decentred human agent, an agent who is both 'subject-ed' by power and capable of acting against those powers. It is a position of theoretical anti-humanism and political humanism, for without an articulated subject capable of acting, no resistance is possible.

Culture and ideology

These same principles and practices define Hall's (1977, 1982, 1983, 1985) contribution to the theory of culture and ideology. Culture is never merely a set of practices, technologies or messages, objects whose meaning and identity can be guaranteed by their origin or their intrinsic essences. For example, Hall (1984b) argues that

> there is no such thing as 'photography'; only a diversity of practices and historical situations in which the photographic text is produced, circulated and deployed. . . . And of course, the search for an 'essential, true original' meaning is an illusion. No such previously natural moment of true meaning, untouched by the codes and social relations of production and reading, exists.

Cultural practices are signifying practices. Following Volosinov as well as the structuralists, Hall argues that the meaning of a cultural form is not intrinsic to it; a text does not offer a transparent surface upon or through which we may discern its meaning in some non-textual origin, as if it had been deposited there, once and for all, at the moment of its origin. The meaning is not in the text itself but is the active product of the text's social articulation, of the web of connotations and codes into which it is inserted. Hall (1981) writes:

> The meaning of a cultural symbol is given in part by the social field into which it is incorporated, the practices with which it articulates and is made to resonate. What matters is not the intrinsic or historically fixed objects of culture, but the state of play in cultural relations.

The text is never isolatable; it is 'always caught in the network of the chains of signification which over-print it, inscribing it into the currency of our discourses' (1984b). We can deconstruct any text, disseminating and fragmenting its meaning into its different contexts and codes, displacing any claim it makes to 'have' a meaning. Yet, particular texts are consistently read with the same meanings, located within the same codes, as if they were written there for all to see. Thus, every sign must be and is made to mean. There is no necessary correspondence between sign and meaning; every sign is 'multiaccentual'. Culture is the struggle over meaning, a struggle that takes place over and within the sign. Culture is 'the particular

pattern of relations established through the social use of things and techniques' (1984a).

But it is not only the sign that must be made to mean, it is the world as well. For meaning does not exhaust the social world: for example, 'Class relations do not disappear because the particular historic cultural forms in which class is "lived" and experienced at a particular period, change' (1984a). Culture is the site of the struggle to define how life is lived and experienced, a struggle carried out in the discursive forms available to us. Cultural practices articulate the meanings of particular social practices and events; they define the ways we make sense of them, how they are experienced and lived. And these already interpreted social practices can be, in turn, articulated into even larger relations of domination and resistance. It is here – in the question of the relations between discourses and the realities they purport to represent – that Hall locates the question of ideology.

Ideology is articulated (constructed) in and through language but it is not equivalent to it. There is, in fact, no necessary correspondence between a text and its politics, which is always a function of its position within an ideological field of struggle, the struggle to achieve an equivalence between language and reality. Particular ideological practices are not inscribed with their politics, any more than particular social identities are inscribed with their ideologies 'on their backs'. Practices do not intrinsically belong to any political position or social identity; they must be articulated into it. The meaning and political inflection of, for example, 'democracy', 'freedom', or 'black', or of a particular media practice, technology or social relationship are not guaranteed by its origin in a particular class struture. It is always capable of being de-articulated and re-articulated; it is a site of struggle. Hall (1981) writes that

> The meaning of a cultural form and its place or position in the cultural field is not inscribed inside its form. Nor is its position fixed once and forever. This year's radical symbol or slogan will be neutralized into next year's fashion; the year after, it will be the object of a profound cultural nostalgia

or, one might add, it may be re-articulated as a symbol of opposition. Moreover, 'it depends . . . on the way concrete practices are used and implemented in concrete historical conditions, the [strength] with which certain codes are constituted as "in dominance", the relations of struggle within the social relations of representation.' It is the struggle to articulate certain codes into a position of dominance, to legitimate their claim, not only to define the meaning of cultural forms but to define the relation of that meaning (and hence, the text) to reality as one of representation, that defines the specificity of the ideological. That is, ideological practices entail a double articulation of the signifier, first to a web of connotation

(signification) and second, to real social practices and subject-positions (representation).

Ideological practices are those through which particular relations, particular chains of equivalences, are 'fixed', 'yoked together'. They construct the necessity, the naturalness, the 'reality' of particular identifications and interpretations (and of course, the simultaneous exclusion of others as fantastic, contingent, unnatural or biased). Ideology is the naturalization of a particular historical cultural articulation. What is natural can be taken for granted; it defines 'common sense'. Ideology 'yokes together' particular social practices and relations with particular structures of meaning, thus anchoring them in a structure in which their relations to social identity, political interests, etc., have already been defined and seem inevitable.

We cannot live social reality outside of the cultural forms through which we make sense of it. Ideology involves the claim of particular cultural practices to represent reality. Yet, it is not reality that is represented (and constructed); it is rather our relation to it, the ways we live and experience reality. Ideology constructs the field and structures of our experience. It is, then, a contradictory field in which we struggle to define the systems of representation through which, paraphrasing Althusser, we live the 'imaginary' relations between ourselves and our real conditons of existence (Hall, 1985). The necessity which it inscribes upon particular interpretations is grounded in the 'immediacy' of experience and in the ways we are located within it. Ideology links particular social identities with particular experiences, as if the former were the necessary source of the latter. While the individual is positioned – their identity as the author/subject of experience defined – within ideological practices, the individual is never a *tabula rasa* seduced into a simple idoeological structure. The ideological field is always marked by contradictions and struggles. Moreover, the individual is already defined by other discourses and practices. Ideologies must attempt to win subjects already spoken for into their representations by articulating various social identities into chains of equivalence which constitute and are articulated into structures of domination and resistance.

Such ideological struggles can only be read by examining the complex 'ideological structuration' of the text and its insertion into concrete historical struggles. It is here that one must locate the most significant work that Hall accomplished and sponsored while at the Centre for Contemporary Cultural Studies. For example, Hall and Jefferson (1976) offer a theory of subcultures centring on the question of style as the articulation of an alternative ideology which offers its members a 'magical' solution to the real contradictions of their social position. Similarly, the Centre's main contributions to media studies in the 1970s can be understood in the context of Hall's developing theory of ideology. In particular, Hall's analytic separation of the moments of encoding and decoding (Hall *et al.*, 1980) can be seen as one version of the struggle of articulation. In

the studies around the 'Nationwide' programme (Brunsdon and Morley, 1978; Morley, 1980), the gap between the two moments becomes evident as the authors elucidate first the semiotic structures of the programme and then, the various ways in which audience fragments interpret the programme. The particular signifying practices of the text (for example, its modes of address, its modes of representation, the ways in which it frames various 'ideological problematics') not only embody real historical choices (an 'encoded' or 'preferred' reading) but also become the active sites at which ideological struggles are waged. Of course, not only are different 'decodings' possible, but such alternative readings are themselvs inflected into different political formations and relations.

While Hall wants to argue that the ideology of a text is not guaranteed, no text is free of its encoded structures and its ideological history. Texts have

> already appeared in some place – and are therefore already inscribed or placed by that earlier positioning. They will be inscribed in the particular social relations which produced them. . . . The vast majority will already be organized within certain 'systems' of classification. Each practice, each placing, slides another layer of meaning across the frame. (1984b)

These 'traces' of past struggles do not guarantee future articulations but they do mark the ways in which the text has already been inflected. If we are to understand ideology as a contested terrain, we must not only recognize the struggle but also learn 'to read the cultural signposts and traces which history has left behind – as Gramsci says, "without an inventory"' (1984b).

Furthermore, if we are to understand ideology as a contested terrain, we must recognize that ideological struggles are never wholly autonomous; they are themselves located within, articulated with, a broader field of economic, cultural and political struggles. Thus Hall (1985b) does not totalize the claim of the ideological; he merely seeks to put it 'on the agenda' of the left's analyses of social power. He does not deny the importance of political economy or of the state (although many political economists would deny ideology its place or reduce it to one of simple domination and false consciousness) but he readily admits that he is still unable to theorize the complex articulations that exist between them. But ideology is not reducible to struggles located elsewhere; its importance cannot be dismissed by claiming that it is determined by the non-ideological. Ideological practices have their own 'relative autonomy' and they produce real effects in the social formation, even outside of their own (signifying) domain.

Hegemony

The concrete processes by which ideology enters into larger and more complex relations of power within the social formation define the point at which, most explicitly, Hall's theory attempts to understand its own historical conditions of existence. It is not only ideology that must be located within a broader context of struggle but Hall's arguments as well. His preference for 'theorizing from the concrete' makes his work a response to historically specific conditions: the emergence of new forms of cultural power. Hall extends the parameters of 'cultural studies', calling (1981) for us to look at

> the domain of cultural forms and activities as a constantly changing field
> . . . [to look] at the relations which constantly structure this field into
> dominant and subordinate formations . . . [to look] at the process by
> which these relations of dominance and subordination are articulated
> . . . [to place] at its centre the changing and uneven relations of force
> which define the field of culture – that is, the question of cultural
> struggle and its many forms . . . [to make our] main focus of attention
> . . . the relation between culture and questions of hegemony.

Hall's work increasingly draws attention to the historical fact of 'hegemonic politics', and the need to 'cut into' the processes by which a dominant cultural order is consistently preferred, despite its articulation with structures of domination and oppression. For example, he has turned his attention to the 'autonomy' of civil society (in the so-called 'democratic' nations) as a problem; how is it that the very freedom of civil and cultural institutions from direct political intervention results in the re-articulation of the already dominant structures of meaning and power? How does the appeal to 'professional codes', in the production of both news and entertainment consistently re-inscribe 'hegemonically preferred' meanings? How are people 'subject-ed' to particular definitions and practices of 'freedom'?

For Hall (1984c), the appearance of 'hegemony' is tied to the incorporation of the great majority of people into broadly based relations of cultural consumption. Of course, this required both the incorporation of culture into the sphere of market relations and the application of modern industrial techniques to cultural production. This was and remains a limited form of cultural enfranchisement for it left unchallenged the people's 'expropriation from the processes of democratization of the means of cultural production'. But it also had its real effects upon the social formation and empowered the population. Benjamin had observed that 'The adjustment of reality to the masses and of the masses to reality is a process of unlimited scope, as much for thinking as for perception.' Hall (1976) echoes and elaborates this:

Once the masses enter directly into the transformation of history, society and culture, it is not possible any longer to construct or appropriate the world as if reality issues in The World from the wholly individual person of the speaking, the uttering subject. . . . We are, as historical subjects and as speakers, 'spoken' by 'the others'. It is the end of a certain kind of western innocence, as well as the birth-point of a new set of codes.

The appearance of 'the masses' on the historical scene, especially as an agent in the scene of culture, displaces the field of cultural struggle from the expression of class conflict into a larger struggle between the people and the elite or ruling bloc. (This does not deny the continuing relevance of class contradictions but places them in relation to other contradictions: for example, race, gender, age.) As a result of this restructuring of the field of cultural relations, new forms and organizations of cultural politics emerged: this is Hall's (1986) reading of the Gramscian notion of hegemony.

Hegemony is not a universally present struggle; it is a conjunctural politics opened up by the conditions of advanced capitalism, mass communication and culture. Nor is it limited to the ideological struggle of the ruling class bloc to win the consent of the masses to its definitions of reality, although it encompasses the processes by which such a consensus might be achieved. But it also depends upon the ability of the ruling bloc (an alliance of class fractions) to secure its economic domination and establish its political power. Hegemony need not depend upon consensus nor consent to particular ideological constructions. It is a matter of containment rather than compulsion or even incorporation. Hegemony defines the limits within which we can struggle, the field of 'common sense' or 'popular consciousness'. It is the struggle to articulate the position of 'leadership' within the social formation, the attempt by the ruling bloc to win for itself the position of leadership across the entire terrain of cultural and political life. Hegemony involves the mobilization of popular support, by a particular social bloc, for the broad range of its social projects. In this way, the people assent to a particular social order, to a particular system of power, to a particular articulation of chains of equivalence by which the interests of the ruling bloc come to define the leading positions of the people. It is a struggle over 'the popular', a matter of the articulated relations, not only within civil society (which is itself more than culture) but between the state (as a condensed site of power), the economic sector and civil society.

Hall (1980) describes hegemony as the struggle between 'popular' and 'populist' articulations, where the latter points to structures which neutralize the opposition between the people and the power bloc. He has used this framework (1978, 1980b, 1988a) to describe the unique configuration,

emergence and political successes of the New Right and Thatcherism in Britain. However it is important that we do not romanticize the 'popular' (1984a):

> Since the inception of commerical capitalism and the drawing of all relations into the net of market transactions, there has been little or no 'pure' culture of the people – no wholly separate folk-realm of the authentic popular, where 'the people' existed in their pure state, outside of the corrupting influences. The people have always had to make something out of the things the system was trying to make of them.

Nor can we locate the popular outside of the struggle for hegemony in the contemporary world. For hegemony is never securely achieved, if even momentarily. But it does describe a different form of social and political struggle, what Gramsci called a 'war of positions' (as opposed to the more traditional war of manoeuvre) in which the sites and stakes of struggles over power are multiplied and dispersed throughout the social formation. Hall argues that the left must enter into this complex set of struggles, across the entire range of social and cultural life, if it is to forge its own hegemonic politics, one dedicated to making a better life for everyone. Once again, Hall enjoins us to recognize that 'people make history but in conditions not of their own making.' This is Hall's model of practice, a model of our own practices, or our struggles to understand the relations, institutions and texts which populate our communicative environment, and the processes which organize it. It is a model posed against the elitism which characterizes so much of contemporary scholarly and political practice, a model committed to respecting human beings, their lives and their possibilities.

II CULTURAL STUDIES AND THE POSTMODERN

Hall's dialectic involves the search for a middle ground which is never merely a 'desired' synthesis or reconciliation of contradictions but the recognition and embodiment of struggle at every level. The tradition of cultural studies associated with the Birmingham School has been shaped by an almost continuous series of debates and challenges (Hall 1980a; Grossberg 1983, 1984). On the one hand, it has constantly constituted itself by a critical engagement with other theoretical positions: with the humanism of the culturalists (for example, Raymond Williams and E.P. Thompson), with the structural/functionalism of the structuralists (for example, Althusser), with the anti-humanism and textualism of deconstructionists and psychoanalytic discourse theory (for example, *Screen* and certain versions of feminist theory). In each of these debates, cultural studies has moved onto the terrain in order to both learn and draw back from the differences. In each case, it has taken something from the other position,

reshaped itself, its questions (empirical as well as theoretical) and its vocabularies. But it has refused to abandon the terrain of marxism and refused to succumb to the increasingly common pessimism of the left. On the other hand, it has constituted itself by constantly anchoring its theoretical concerns in concrete historical events and political struggles. It has opened itself, however reluctantly at times, to the recognition that history constantly makes new demands upon us, presenting us with new configurations and new questions. One can simplify this history of 'anchoring points': beginning with the New Left's concern with issues of imperialism, racism and culture, continuing into questions of emerging forms of resistance, from 'the margins' (in the form of subcultures) and from feminism, and arriving at the rise of the New Right and the simultaneous 'collapse' of effective left opposition.

It is within these terms that we must consider the relationship between marxist cultural studies and postmodernism.[2] To speak metaphorically, the war of positions between them has only begun and the result will be, not a hegemonic discourse, but a different theoretical position which has negotiated the space between them through an analysis of its own historical context. After all, both cultural studies and postmodern theory are concerned with the place of cultural practices in historical formations and political struggles. But marxists are often reluctant to acknowledge the historical differences that constitute everyday life in the contemporary world, and too often ignore the taunting playfulness and affective extremism (terrorism?) of postmodernists, while postmodernists are often too willing to retreat from the theoretical and critical ground that marxism has won with notions of articulation, hegemony and struggle. Let me try, however briefly, to map some of the frontiers and struggles, and perhaps, to make some suggestions about where the victories and defeats may lie. To begin with, we need to distinguish three discursive domains which are all, too commonly, named with the single master signifier – the postmodern: culture, theory and history. Failing to recognize the difference has allowed some authors to slide from one domain to the other, as if one could confidently assume equivalences or correspondences. Of course, the distinction itself is strategic: one also needs to theorize the relations amongst three domains.

The most commonly discussed, if also the least interesting of these three domains of inquiry is that of cultural practice, for in fact, it takes us no further in our attempt to understand the contemporary social formation. Postmodern cultural texts (whether in architecture, literature, art or film) claim to be and in some respects, are significantly different from previous aesthetic and communicative formations.[3] Many critics assert that such practices entail new cutural configurations, not only within particular texts but also across different intertextual fields. The question is, of course, how one describes that formal difference and locates its effects. In that sense,

beginning with postmodern cultural texts seems to lead us right back into many of the undecidable theoretical problematics of cultural studies. For example, can we assume that a text's 'postmodernism' is inscribed upon or encoded within it? What is its relation to its social and historical context? What are its politics? How is it inserted into and articulated with the everyday lives of those living within its cultural spaces, however one draws the boundaries? What is obvious is that such cultural practices are often defined by their quite explicit opposition to particular institutional-ized definitions of modernism. Moreover, they wear their opposition on their surfaces, letting it play with if not define their identity. They construct themselves out of the detritus of the past – not only of pre-modernist culture but of modernism as well – and the 'ruins' of contemporary commercial culture. Does such a strategy represent a *radical* break in either culture or history. I think it unlikely (and certainly too easy a conclusion) but its powerful presence and popularity do suggest a series of questions that must be addressed about the possibilities of communica-tion, opposition, elitism and self-definition.

The second site at which cultural studies and postmodernism clash is that of theory itself, but the distance between the positions is not as great as it appears. They share a number of fundamental commitments. Both are anti-essentialist; that is, they accept that there are no guarantees of identity or effects outside of the determinations of particular contexts. Foucault's radical contextualism is built upon the same ground as Hall's conjunctur-alism. (And it is significant that neither camp has quite figured out how to produce a convincing local analysis.) At the same time, both sides reject the deconstructionists' dismissal of all essences or identities (whether of contexts or elements) with its emphasis on polysemy and undecidability, arguing instead that such moments of identity and difference are both historically effective and contextually determined. To deny that a structure is necessary or universal is not to deny its concrete reality. Nor does it entail that there are no connections across contexts; neither position embraces an absolute nominalism since the question of the constitution of the relevant context or level of abstraction must itself be left open. Both positions are concerned, therefore, less with questions of origin and causality than with questions of effectivity, conditions of possibility, and overdetermination. Power is located precisely in the struggle to forge links, to direct the effective identity and relations of any practice, to articulate the existence, meanings, effects and structures of practices which are not guaranteed in advance.

Thus, for example, neither position is content to simply dismantle the subject nor to see it as a simple fragmentary collection of determined subject-positions. Although both begin by problematizing the claims of a unified, stable and self-determining subject, they also recognize the histor-ical specificity and effectivity of such 'subjects'. Rather than merely

dismantle these claims, they seek to account for them and to account, as well, for the possibilities of alternative constructions of the subject (and not merely for alternative subject-positions). In both camps, it apparently does matter who is acting/speaking, and from where. Rather than a dispersed subject, they argue for what we might describe as a migratory or nomadic subject. This 'post-humanistic' subject does not exist with a unified identity (even understood as an articulated hierarchical structure of its various subject-positionings) that somehow manifests itself in every practice. Rather, it is a subject that is constantly remade, reshaped as a mobilely situated set of relations in a fluid context. The nomadic subject is amoeba-like, struggling to win some space for itself in its local situation. The subject itself has become a site of struggle, an ongoing site of articulation with its own history, determinations and effect.

Finally both positions are also committed to the same epistemological and political strategy: the truth of a theory can only be defined by its ability to intervene into, to give us a different and perhaps better ability to come to grips with, the relations that constitute its context. If neither history nor texts speak their own truth, truth has to be won; and it is, consequently, inseparable from relations of power. Similarly, the viability of a political strategy can only be defined by its engagement with local struggles against particular relations of power and domination. This means that both positions are anti-elitist. Neither seeks to speak for the masses as a ventriloquist, but rather, to make a space in which the voices of the masses can be heard. Neither seeks to define the appropriate sites of struggle, but rather, to locate and assist those struggles that have already been opened up. And neither assumes that the masses are the passively manipulated, colonized zombies of the system, but rather, the actively struggling site of a politics in, if not of, everyday life.

Nevertheless, there are significant theoretical differences between cultural studies and postmodernism. I want to argue for the former's theory of articulation and the latter's theory of 'wild realism'.[4] The failure of postmodern theory is not that it has no notion of macrostructures but rather that it has no way of theorizing the relations between different levels of abstraction, between the microphysics of power and biopolitics (Foucault) or between the child in the bubble and the simulacrum (Baudrillard). Similarly, the failure of postmodern theory is not that it denies a reality behind the surfaces of everyday life but rather that it always forgets that there are many surfaces of everyday life and that reality is produced within the relations amongst these surfaces. The factory (even in the Third World) is as much a surface of our lives as is television. Because one does not frequently move across its terrain does not mean it is not having its effects. One must remember that not all surfaces are articulated or present or even effective in the same ways – that is precisely the site of the struggle

over the real. In both instances, the lacuna in postmodernism is a theory of articulation.

On the other hand, the failure of cultural studies is not that it continues to hold to the importance of signifying and ideological practices but rather, that it always limits its sense of discursive effectivity to this plane. It fails to recognize that discourses may not only have contradictory effects within the ideological, but that those ideological effects may themselves be placed within complex networks of other sorts of effects. Consequently, the particular model of articulation falls back into a structuralism of empty spaces in which every place in the ideological web is equally weighted, equally charged so to speak. The cultural field remains a product of oddly autonomous, indeterminate struggles, an amorphous field of equal differences and hence, of equivalences. Surprisingly, in the end, this seems to leave no space for the power of either the text itself or the historical actor to excite and incite historical struggles around particular discourses. While Hall argues that the audience cannot be seen as passive cultural dopes, he cannot elaborate its positivity. Neither aspect of the relation can be understood as merely a matter of the tendential structures that have, historically, already articulated a particular discourse or subject into powerful ideological positions. The critic, distanced from the effectivity of the popular, can decide neither where nor whether to struggle over any particular discourse. More importantly, the critic cannot understand why people have chosen a particular site of struggle, or how to mobilize them around such a site.

The postmodernist's recognition of the multiple planes of effectivity, 'wild realism', allows the recognition that discursive fields are organized affectively ('mattering maps') as well as ideologically (Grossberg, 1984b). Particular sites are differentially invested with energies and intensities that define the resources which can be mobilized into forms of popular struggle. Affect points to the (relatively autonomous) production of what is normally experienced as moods and emotions by an asignifying effectivity.[5] It refers to a dimension or plane of our lives that involves the enabling distribution of energies. While it is easy to conceptualize it as the originary (causal) libidinal economy postulated by psychoanalysis, one must avoid the temptation to go beyond its existence as a plane of effectivity. Moreover, affect is not the Freudian notion of disruptive (or repressed) pulsions of pleasure breaking through the organized surfaces of power; rather, it is an articulated plane whose organization defines its own relations of power and sites of struggle. And as such, like the ideological plane, it has its own principles which constrain the possibilities of struggle. And while it is true that the most powerfully visible moments of affective formations are often located in cultural activities (for example, leisure, romance), affect is neither limited to nor isolatable within such

relations. All affective relations are shaped by the materiality (and nega-
tivity) of everyday life. That is, we should not confuse affect with the
positivity of enablement (for example, pleasure and excitement) for it
includes as well boredom and compulsion. Even the most obvious
moments of pleasure are shaped to some extent by the continuing affec-
tivity of particular institutions (for example, home, work, etc.). Finally we
cannot ignore the interdeterminations between different levels of effects:
thus, the affective power of many cultural activities depends in part on the
ideological articulations both of the activities in general (for example, of
leisure or fun) and of the specific activities in question.

 Nevertheless, the recognition of an articulated plane of affect points to
the existence of another politics, a politics of feeling . . . (good, bad or
indifferent), a politics that Benjamin had acknowledged. Again this is not
to deny that such an affective politics is constantly being articulated to
ideological, economic and state politics, but it does not follow that it can be
explained solely within the terms of such traditional political sites. Affect-
ive struggles cannot be conceptualized within the terms of theories of
resistance for their oppositional quality is constituted, not in a negative
dialectics, but by a project of or struggle over empowerment, an empower-
ment which energizes and connects specific social moments, practices and
subject-positions. Thus, if we want to understand particular cultural prac-
tices, we need to ask how they empower their audiences and how the
audiences empower the practices; that is, how the very materiality (includ-
ing ideological) of cultural practices functions within an affective economy
of everyday life. It is ironic that so much contemporary writing on popular
culture offers accounts of affectively powerful texts which are always
mired within what Benjamin called 'organizations of pessimism'. Hall
himself has recognized (1984c) the need to theorize and describe the
'sensibility of mass culture' but has, thus far, left the question unans-
wered. But without an answer, the enormous power of contemporary
culture (especially the mass media) and the investment that we make in
it cannot be adequately approached. I would suggest that this sensibility
depends in fact on the particular historical relations between ideological
and affective struggles, between resistance and empowerment, that sur-
round the mass media and contemporary social struggles. It is here, in fact,
in an understanding of 'the popular' as an affective plane, that one can find
any grounds for an 'optimism of the will' today, any space to negotiate
between utopianism and nihilism.

 The third and perhaps most important domain of postmodern work
involves the attempt to understand the specificity of the contemporary
historical formation. This is also the most controversial and certainly the
one most fraught with difficulties and dangers. Here postmodern irony and
excess operate against themselves: a theory of the collapse of the distinc-
tion between elite and popular becomes a new elitism; a theory that denies

innocent and totalized descriptions offers itself as an innocent and totalized description; a theory that denies the new in favour of bricolage, not only offers itself as new, but announces that the absence of the new is a new situation; and a theory of the impossibility of meta-narrative becomes its own meta-narrative absence. More importantly, a theory that celebrates otherness fails to acknowledge the difference between experiences, real historical tendencies and cultural discourses and meanings, as well as the complex relations that exist between them. Moreover, even within the specific domains of experience and discourse, it fails to recognize the uneven and contradictory relations that exist within and between different sites of postmodern effects: history, subjectivity, values, reality, politics. I would agree with Hall that to read history as rupture, to see the present as the site of the apocalypse (the end of the old, the beginning of the new) is a powerful ideological moment. Echoing Hall, if reality was never as real as we have constructed it, it's not quite as unreal as we imagine it; if subjectivity was never as coherent as we imagine it, it's not quite as incoherent as we fantasize it; and if power was never as simple or mono-lithic as we fantasize it (reproducing itself, requiring giants and magical subjects to change it), it's not quite as dispersed and unchallengeable as we fear.

Thus, I would argue that Baudrillard's theory of the simulacrum confuses the collapse of a particular ideology of the real for the collapse of reality; it confuses the collapse of a particular ideology of the social (articulated into public and private) with the end of the social. But that does not mean that it does not offer important insights into the changing ways in which the real is effective in the social formation and its organization of power. To the extent that Baudrillard's theory denies its own limits, it conflates the social formation with a particular set of effects, with the plane of simulation, rendering all of social reality the simple product of media causality. And in the end, that is no different than those who would reduce reality or desire or power to meaning. Contradicting itself, the position conflates ideology (in the form of the alibi or law of value) with the multiple and complex sites of power, enabling him to assume that only a refusal of any difference constitutes struggle. It conflates the multiple and fragmentary social posi-tionings of the masses with a single configuration of or on the surface of the social body. The great burden of these reductions is placed upon the concept of implosion, as both indifference (in the masses who amusedly and in fascination live the media hype) and deterrence (as a control sysem), as both an ecstatic possibility and a catastrophic inevitability. But all of this says merely that Baudrillard, for all of the postmodern speed of his writing practice, fails to adequately theorize the sites of our postmodernity; he ends up being one of its most enjoyable (if horrifying, or perhaps, because horrifying) texts rather than its most reliable analyst.

The specificity of the contemporary social formation is more complex

than simple descriptions of the simulacrum or late capitalism (commodification, bureaucratization, infotech, etc.) would suggest, although these are real events with real effects. Thus, the problem is not with the postmodernists' descriptions as such but with the rather grandiose status they assign to their descriptions. The questions of postmodernity as a historical reality, whether experiential or tendential, have to be theorized within the context of the theory of articulation and wild realism, that is, within the spaces between cultural studies and postmodernism. This has two important consequences. First, from the perspective of cultural studies, it locates the critique of postmodernism in the project of inflecting such descriptions into a less global and more consistent context of theorizing. For example, we can re-read Baudrillard's theory as a contribution to the analysis of the changing politics of representation in history. Baudrillard has described three planes of discursive effects which not only compete with and displace one another but which may be simultaneously operative and historically organized in any particular formation. Thus, rather than making a global and ontological argument, Baudrillard's theory of the simulacrum marks the local articulations (and power relations) among three planes of discursive effectivity: representation, mediation and modelling.

Second, from the perspective of postmodernism, it locates the critique of cultural studies in the project of detailing the determining displacements, gaps and in some cases, even ruptures that have become constitutive of our contemporary existence. There are powerful new historical determinations (for example, the destructability and disposability of the planet; significant redistributions of wealth, population and power; new structures of commodity production; new media of communication), ideological and affective experiences (for example, the collapse of visions of the future and of transcendental values capable of giving shape and direction to our lives; an increasing sense of justified paranoia, terror and boredom). Hall has already opened up these spaces by giving a central role to questions about the relations between the media and the masses (as it is defined in Benjamin's theory of history) and between leadership and the popular (in Gramsci's theory of hegemony). But they remain undeveloped and one must assume that this is due, in part, to the difficulty of accounting for their effectivity within the traditional marxist categories of power.

The fact remains that such 'postmodern events' appear to have an increasingly significant place in our everyday lives and that the discourses which anchor themselves in these events appear to have a powerful place in our cultural relations. Both postmodernism and cultural studies need to find ways of describing the complex contexts – the conjunctural formations – within which the possibilities of struggle are shaped, grasped and enacted.

NOTES

1 For a more complete biography of Stuart Hall, see my entry in *The Biographical Dictionary of Neo-Marxism*, Robert Gorman (ed.), Westport: Greenwood Press, 1985, 197–200.
2 There is an ongoing debate about the relationship between post-structuralism (as a theoretical and cultural practice) and postmodernism. My own assumption is that the former represents the last stages of the modernist epistemological problematic: the relationship between the subject and the forms of mediation, in which the problem of reality is constantly displaced. Postmodernism on the other hand moves from epistemology to history, from subjectivity to a recovery of the real, from mediation and universality to effectivity and contextuality. The conflation of these positions has serious consequences for the analysis of both cultural practices and historical context. It often leads one back into a politics of codes and communications, of the construction and deconstruction of boundaries, despite what may be interesting and insightful analyses of the postmodern context of contemporary life. See Donna Haraway, 'A manifesto for Cyborgs: science, technology, and socialist feminism in the 1980s', *Socialist Review* 80 (March/April) 1985, 65–107.
3 Postmodern cultural practices are often characterized as denying totality, coherence, closure, depth (both expressive and representational), meaning, teleology, narrativity, history, freedom, creativity, and hierarchy; and as celebrating discontinuity, fragmentation, rupture, materiality, surfaces, language as intervention, diversity, chance, contextuality, egalitarianism, pastiche, heterogeneity without norms, quotations without quotation marks, parodies without originals.
4 Postmodernism's lack of a theory of articulation results in the 'flatness' (albeit defined by a multiplicity of vectors and planes) of its analysis of contextual effectivity. In neither postmodernism nor cultural studies is articulation ever complete. In cultural studies, no articulation is either complete or final; no term is ever finally sewn up. This is the condition of possibility of its dialectic of struggle. In postmodernism not every element is articulated or stitched into the fabric of any particular larger structure. Ths is a crucial part of its analysis of contemporaneity. Speaking metaphorically, a theory of articulation augments vertical complexity while a theory of wild realism augments horizontal complexity.
5 Theorizing the concept of affect involves deconstructing the opposition between the rational and the irrational in order to undercut, not only the assumed irrationality of desire but also, the assumed rationality of signification and ideology. Current theories of ideology, rooted in structuralism, have too easily abandoned the insights embodied in notions of 'the structure of feeling' (Williams) and 'the texture of lived experience' (Hoggart). (I am grateful to John Clarke for his observations on this point.)

REFERENCES

Baudrillard, J. (1983) *Simulations* (trans. P. Foss, P. Patton and P. Beitchman), New York: Semiotext(e).
Benjamin, W. (1968) *Illuminations* (ed. H. Arendt), New York: Harcourt Brace & World.
Brunsdon, C. and Morley, D. (1978) *Everyday Television: 'Nationwide'*, London: British Film Institute.

Gramsci, A. (1971) *Selections from the Prison Notebooks* (Q. Hoare and G.N. Smith, eds), New York: International Publishers.
Grossberg, L. (1983) 'Cultural studies revisited and revised', in M.S. Mander (ed.) *Communications in Transition*, New York: Praeger, 39–70.
—— (1984) 'Strategies of Marxist cultural interpretation', *Critical Studies in Mass Communication* 1 (4), 392–421.
—— (1984b) '"I'd rather feel bad than not feel anything at all": rock and roll, pleasure and power', *Enclitic* 8 (1–2), 94–110.
Hall, S. (1974) 'Marx's notes on method: a "reading" of the "1857 introduction"' *Working Papers in Cultural Studies* 6, 132–70.
—— (1976) 'Introduction' to *An Eye on China* (D. Selbourne), London: Black Liberation Press.
—— (1977) 'Culture, the media and the "ideological effect"' in J. Curran *et al.* (eds) *Mass Communication and Society*, London: Edward Arnold, 315–48.
—— (1980a) 'Cultural studies: two paradigms', *Media, Culture and Society* 2, 57–72.
—— (1980b) 'Popular-democratic vs. authoritarian-populism: two ways of "taking democracy seriously"' in A. Hunt (ed.) *Marxism and Democracy*, London: Lawrence & Wishart, 157–85.
—— (1981) 'Notes on deconstructing "the popular"' in R. Samuel (ed.) *People's History and Socialist Theory*, Boston: Routledge & Kegan Paul.
—— (1982) 'The rediscovery of "ideology"; return of the repressed in media studies', in M. Gurevitch *et al.* (eds) *Culture, Society and the Media*, New York: Methuen, 56–90.
—— (1983) 'The problem of ideology: Marxism without guarantees', in B. Matthews (ed.) *Marx 100 Years On*, London: Lawrence & Wishart, 57–86.
—— (1984a) 'The culture gap', *Marxism Today* 28 (January), 18–23.
—— (1984b) 'Reconstruction work', *Ten-8* 16, 2–9.
—— (1984c) 'Mass culture', unpublished lecture delivered at the University of Wisconsin at Milwaukee.
—— (1985) 'Signification, representation, ideology: Althusser and the post-structuralist debates', *Critical Studies in Mass Communication* 2 (2), 91–114.
—— (1985b) 'Authoritarian populism: a reply to Jessop *et al.*', *New Left Review* 151, 115–24.
—— (1986) 'Gramsci's relevance to the analysis of racism and ethnicity', *Journal of Communication Inquiry* 10 (2).
—— (1988a) 'The Toad in the garden: Thatcherism amongst the theorists', in C. Nelson and L. Grossberg (eds) *Marxism and the Interpretation of Culture*, Urbana: University of Illinois Press.
—— (1988b) 'Stuart Hall: questions and answers', in C. Nelson and L. Grossberg (eds) *Marxism and the Interpretation of Culture*, Urbana: University of Illinois Press.
Hall, S. and Jefferson, T. (eds) (1976) *Resistance through Rituals*, London: Hutchinson.
Hall, S., Lumley, B. and McLennan, G. (1977b) 'Politics and ideology: Gramsci', in *On Ideology* (CCCS), London: Hutchinson.
Hall, S., Critcher, C., Jefferson, T., Clarke, J., Roberts, B. (1978) *Policing the Crisis: 'Mugging', the State and Law and Order*, London: Macmillan.
Hall, S., Hobson, D., Lowe, A. and Willis, P. (eds) (1980) *Culture, Media, Language*, London: Hutchinson.
Morley, D. (1980) *The 'Nationwide' Audience: Structure and Decoding*, London: British Film Institute.

Volosinov, V.N. (1973) *Marxism and the Philosophy of Language* (trans. L. Matejka and I.R. Titunik), New York: Seminar Press.

Author's note

An earlier version of this essay was written as a 'Background Paper' for the Annual Meeting of the International Communication Association, Honolulu, 1985. I am grateful to Stuart Hall and Jennifer Daryl Slack for the comments and advice on the first half. The second half of this paper has benefited from discussions with many people, but I would especially like to thank Kuan-Hsing Chen, Stuart Hall, Dick Hebdige and John Clarke.

Chapter 8

Postmodernism and 'the other side'

Dick Hebdige

The success of the term postmodernism – its currency and varied use within a range of critical and descriptive discourses both within the academy and outside in the broader streams of 'informed' cultural commentary – has generated its own problems. It becomes more and more difficult as the 1980s wear on to specify exactly what it is that 'postmodernism' is supposed to refer to as the term gets stretched in all directions across different debates, different disciplinary and discursive boundaries, as different factions seek to make it their own, using it to designate a plethora of incommensurable objects, tendencies, emergencies. When it becomes possible for people to describe as 'postmodern' the decor of a room, the design of a building, the diegesis of a film, the construction of a record, or a 'scratch' video, a TV commercial, or an arts documentary, or the 'inter-textual' relations between them, the layout of a page in a fashion magazine or critical journal, an anti-teleological tendency within epistemology, the attack on the 'metaphysics of presence', a general attentuation of feeling, the collective chagrin and morbid projections of a post-war generation of Baby Boomers confronting disillusioned middle age, the 'predicament' of reflexivity, a group of rhetorical tropes, a proliferation of surfaces, a new phase in commodity fetishism, a fascination for 'images', codes and styles, a process of cultural, political or existential fragmentation and/or crisis, the 'de-centring' of the subject, an 'incredulity towards meta-narratives', the replacement of unitary power axes by a pluralism of power/discourse formations, the 'implosion of meaning', the collapse of cultural hierar-chies, the dread engendered by the threat of nuclear self-destruction, the decline of the university, the functioning and effects of the new miniatur-ized technologies, broad societal and economic shifts into a 'media', 'consumer' or 'multinational' phase, a sense (depending on whom you read) of 'placelessness' or the abandonment of placelessness ('critical regionalism') or (even) a generalized substitution of spatial for temporal

Reprinted from *Journal of Communication Inquiry* (1986), 10(2), 78–98.

co-ordinates – when it becomes possible to describe all those things as 'postmodern' (or more simply, using a current abbreviation, as 'post' or 'very post') then it's clear we are in the presence of a buzzword.

This is not to claim that because it is being used to designate so much the term is meaningless (though there is a danger that the kind of blurring of categories, objects, levels which goes on with certain kinds of 'post-modernist' writing will be used to license a lot of lazy thinking: many of the (contentious) orientations and assertions of the post are already becoming submerged as unexplicated, taken for granted 'truths' in some branches of contemporary critique). Rather I would prefer to believe, as Raymond Williams indicates in *Keywords*, that the more complexly and contradictorily nuanced a word is, the more likely it is to have formed the focus for historically significant debates, to have occupied a semantic ground in which something precious and important was felt to be embedded. I take then, as my (possibly ingenuous) starting-point that the degree of semantic complexity and overload surrounding the term 'postmodernism' at the moment signals that a significant number of people with conflicting interests and opinions feel that there is something sufficiently important at stake here to be worth struggling and arguing over.

I want to use this opportunity to try to do two things, both of which will incidentally involve reflections on and responses to the interview with Stuart Hall but neither of which engage directly with the substance of what Stuart had to say. First I shall attempt to summarize in a quite schematic way some of the themes, questions and issues that gather round this term. This attempt at clarification will involve a trek across territory already familiar to many readers. It will also entail my going against the spirit of postmodernism (which tends to favour what Paul Virilio calls 'the art of the fragment') and attempting some kind of interpretive and historical overview. However, I think it's worth trying because it may help to ground what is, after all, a notoriously vertiginous concept and to offer an opening onto the debates in Europe and the States between marxism and postmodernism and more specifically between postmodernism and British cultural studies which I think frame much of what Stuart Hall had to say in the interview. I make no claims for the authority of what I have to say: the tone here will be credulous but critical. I shall merely be taking one man's route, as it were, through or round 'the Post'. Second, resorting to what I hope is a more constructive or at least more positive register, I shall seek to specify exactly what it is that I feel is at stake in these debates and to offer a few suggestions about the lessons I've learned from living through them.

STAKING OUT THE POSTS

To say 'post' is to say 'past' – hence questions of periodization are inevitably raised. There is however little agreement as to what it is we

are alleged to have surpassed, when that passage is supposed to have occurred and what effects it is supposed to have had (see, for example, Perry Anderson's (1984) closely argued objections to Marshall Berman's (1982) (extremely loose and imprecise) periodization of modernization/ modernism in *All That Is Solid Melts into Air*). Michael Newman (1986) further problematizes the apparently superseded term in postmodernism by pointing out that there are at least two artistic modernisms articulating different politico-aesthetic aspirations which remain broadly incompatible and non-synchronous. The first, which is ultimately derived from Kant, seeks to establish the absolute autonomy of art and finds its most extreme and dictatorial apologist in Clement Greenberg, the American critic who sought to 'purify' art of all 'non-essentials' by championing the cause of abstract expressionism – the style of painting most strictly confined to an exploration of the materials and two-dimensionality of paint on canvas. The second modernist tradition which Newman (1986) traces back to Hegel aspires to the heteronomous dissolution of art into life/political practice and leads through the surrealists, the constructivists, the futurists, etc., to performance artists and the conceptualists of the 1970s.

If the unity, the boundaries and the timing of modernism itself remain contentious issues, then *post*modernism seems to defy any kind of critical consensus. Not only do different writers define it differently, but a single writer can talk at different times about different 'posts'. Thus Jean-François Lyotard (1986a) has recently used the term postmodernism to refer to three separate tendencies: (1) a trend within architecture away from the Modern Movement's project 'of a last rebuilding of the whole space occupied by humanity', (2) a decay in confidence in the idea of progress and modernization ('there is a sort of sorrow in the Zeitgeist') and (3) a recognition that it is no longer appropriate to employ the metaphor of the 'avant garde' as if modern artists were soldiers fighting on the borders of knowledge and the visible, prefiguring in their art some kind of collective global future. J.G. Merquior (1986) (in a hostile critique of what he calls the 'postmodern ideology') offers a different triptych: (1) a style or mood of exhaustion of/dissatisfaction with modernism in art and literature, (2) a trend in post-structuralist philosophy and (3) a new cultural age in the West.

Furthermore the Post is differently inflected in different national contexts. It was, for instance, notable that *The Anti-Aesthetic* in the edition available in the United States arrived on the shelves beneath a suitably austere, baleful and more or less abstract (modernist?) lilac-and-black cover which echoed the Nietzschian tone of the title. However, when the same book was published in Britain it appeared as *Post Modern Culture* with a yellow cover consisting of a photograph of a postmodernist 'installation' incorporating cameras, speakers, etc., complete with comic book sound and light rays. The 'translation' of postmodernism as a set of

discourses addressed in America to a demographically dispersed, university- and gallery-centre constituency for a similar though perhaps slightly more diverse, more geographically concentrated readership in Britain (where cultural pluralism, multiculturalism, the appeal or otherwise of 'Americana', the flattening out of aesthetic and moral standards, etc., are still 'hot' issues and where there is still – despite all the factional disputes and fragmentations of the last twenty years – a sizeable, organized marxist left) involved the negotiation of different cultural-semantic background expectancies.

National differences were further highlighted during the weekend symposium at the London Institute of Contemporary Arts (ICA) in 1985 when native speakers giving papers which stressed the enabling potentialities of the new 'user-friendly' communication technologies and the gradual deregulation of the airwaves, and which celebrated popular culture-as-postmodern-bricolage-and-play were confronted with the Gallic anti-populism of Lyotard who declared a marked preference for the fine arts, idealist aesthetics and the European avant garde tradition, and demonstrated in comments made in response to the papers in the session on 'Popular Culture and Postmodernism' a deep, abiding suspicion for the blandishments and commodified simplicities of 'mass culture' (Lyotard, 1986c).

To introduce a further nexus of distinctions, Hal Foster (1983) in his Preface to *The Anti-Aesthetic* distinguishes between neo-conservative, anti-modernist and critical postmodernisms and points out that whereas some critics and practitioners seek to extend and revitalize the modernist project(s), others condemn modernist objectives and set out to remedy the imputed effects of modernism on family life, moral values, etc., whilst still others working in a spirit of ludic and/or critical pluralism endeavour to open up new discursive spaces and subject-positions outside the confines of established practices, the art market and the modernist orthodoxy. In this latter 'critical' alternative (the one favoured by Foster) postmodernism is defined as a positive critical advance which fractures through negation (1) the petrified hegemony of an earlier corpus of 'radical aesthetic' strategies and proscriptions, and/or (2) the pre-Freudian unitary subject which formed the hub of the 'progressive' wheel of modernization and which functioned in the modern period as the regulated focus for a range of scientific, literary, legal, medical and bureaucratic discourses. In this positive 'anti-aesthetic', the critical postmodernists are said to challenge the validity of the kind of global, unilinear version of artistic and economic-technological development which a term like modernism implies and to concentrate instead on what gets left out, marginalized, repressed or buried underneath that term. The selective tradition is here seen in terms of exclusion and violence. As an initial counter-move, modernism is discarded by some critical postmodernists as a Eurocentric and phallocentric category which involves a systematic preference for certain forms and voices over others.

What is recommended in its place is an inversion of the modernist hierarchy – a hierarchy which, since its inception in the eighteenth, nineteenth or early twentieth centuries (depending on your periodization) consistently places the metropolitan centre over the 'underdeveloped' periphery, western art forms over Third World ones, men's art over women's art or, alternatively, in less anatomical terms 'masculine' or 'masculinist' forms, institutions and practices over 'feminine' or 'feminist' ones. Here the word 'postmodernism' is used to cover all those strategies which set out to dismantle the power of the white, male author as a privileged source of meaning and value.

THE THREE NEGATIONS

I shall return later to some of the substantive issues addressed by 'critical postmodernism' but for the moment I should like to dwell on the constitutive role played here, indeed throughout the Post, by negation. In fact, it is a crucial one, for postmodernism as a discourse or compound of discourses is rather like Saussure's paradigm of language, in that it's a system with no positive terms. In fact, we could say it's a system predicated, as Saussure's was, on the categorical denial of the possibility of positive entities *per se*. (See for instance, Lyotard's bracketing-off, de-construction, de-molition of the concept of 'matter' in the catalogue notes for the 'Les Immatériaux' exhibition at the Pompidou Centre in 1984. More recently, Lyotard (1986b) has argued against the 'vulgar materialist' line that matter can be grasped as substance. Instead he suggests that matter should be understood as a 'series of ungraspable elements organized by abstract structures' (10).) However, a kind of rudimentary coherence begins to emerge around the question of what postmodernism negates. There are, I think, three closely linked negations which bind the compound of postmodernism together and thereby serve to distinguish it in an approximate sort of way from other adjacent 'isms' (though the links between post-structuralism and post-modernism are in places so tight that absolute distinctions become difficult if not impossible). These founding negations, all of which involve – incidentally or otherwise – an attack on marxism as a total explanatory system, can be traced back to two sources: on the one hand historically to the blocked hopes and frustrated rhetoric of the late 1960s and the student revolts (what a friend once described to me as the 'repressed trauma of 1968'), and on the other, through the philosophical tradition to Nietzsche.

1 Against totalization

An antagonism to the 'generalizing' aspirations of all those pre-Post-erous discourses which are associated with either the Enlightenment or the

western philosophical tradition – those discourses which set out to address a transcendental Subject, to define an essential human nature, to prescribe a global human destiny or to proscribe collective human goals. This abandonment of the universalist claims underwriting all previous (legitimate) forms of authority in the West involves, more specifically a rejection of Hegelianism, marxism, any philosophy of history (more 'developed' or 'linear' than, say, Nietzsche's doctrine of the Eternal Recurrence) and tends (incidentally?) towards the abandonment of all 'sociological' concepts, categories, modes of enquiry and methods. Sociology is condemned either in its positivist guises (after Adorno, Marcuse, etc.) as a manifestation of instrumental-bureaucratic rationality, or more totally (after Foucault) as a form of surveillance/control always-already complicit with existing power relations. In the latter case, no real distinctions are made between positivist/non-positivist; qualitative/quantitative; marxist/pluralist/ interpretive/functionalist, etc., socio*logies*: all are seen as strategies embedded in institutions themselves irrefragably implicated in and productive of particular configurations of power and knowledge. In place of the totalizing intellectual Foucault offers us the intellectual-as-partisan: producer of 'socio-fictions' which despite their equivocal truth status may have 'reality-effects', and the intellectual-as-facilitator-and-self-conscious-strategist (Foucault's work with prisoners' rights groups is often cited as exemplary here). All larger validity claims are regarded with suspicion. Beneath the euphemistic masks of, for instance, 'disinterested Reason', 'scientific marxism', 'objective' statistics, 'neutral' description, 'sympathetic' ethnography or 'reflexive' ethnomethodology, the Eye of the Post is likely to discern the same essential 'Bestiary of Powers' (see especially, Jean Baudrillard (1983a) and Paul Virilio (1983) for explicit denunciations of 'sociology'). There is an especially marked antipathy to sociological abstractions like 'society', 'class', 'mass', etc. (see Lyotard (1986b)). The move against universalist or value-free knowledge claims gathers momentum in the 1960s with the growth of phenomenology but reaches its apogee in the late 1960s and 1970s under pressure from 'external' demands mediated through social and political movements, rather than from epistemological debates narrowly defined within the academy. In the late 1960s the challenge comes from the acid perspectivism of the drug culture, from the post-'68 politics of subjectivity and utterance (psychoanalysis, post-structuralism) and from the fusion of the personal and the political in feminism, etc.

In Europe, the retreat from the first person plural 'we' – the characteristic mode of address of the Voice of Liberation during the heroic age of the great bourgeois revolutions – can be associated historically with the fragmentation of the radical 'centre' after 1968 (though the process of disenchantment begins in earnest after the Second World War with the revelation of the Moscow trials, and after 1956 with the invasion of

Hungary and the formation of the New Left). At the same time, during the 1950s attempts had been made, most notably by Sartre, to rescue a viable marxism and to rectify the over general conception of epochal change which marks the Hegelian philosohy of history. Sartre and Merleau-Ponty sought to relate dialectical materialism, as Peters Dews (1986) has recently put it, to 'its smallest, most phenomenologically translucent component, the praxis of the human individual' (14). However these anti-generalist tendencies are most clearly enunciated in the late 1960s with the widespread disaffection of the students from the French Communist Party and the odour of betrayal that hung over the party after the events of 1968; with the appearance of publications like Castoriadis's *History as Creation*, and with the fully fledged revival of interest – assuming the proportions of a cult in the 1970s and early 1980s – in the work of Nietzsche – a revival which can be traced back to the 'rediscovery' of Nietzsche in the late 1950s by the generation of intellectuals which included Foucault (1977) and Deleuze (1983) but which did not really take off until the post-'68 period of disenchantment. From 1968 we can date the widespread jettisoning of the belief amongst educated, 'radical' factions, not only in marxist-leninism but in any kind of power structure administered from a bureaucratically organized centre, and the suspicion of any kind of political programme formulated by an elite and disseminated through a hierarchical chain of command. This process of fragmentation and growing sensitivity to the micro-relations of power both facilitated and was facilitated by the articulation of new radical or revolutionary demands, and the formation of new collectivities, new subjectivities which could not be contained within the old paradigms, and which could neither be addressed by nor 'spoken' in the old critical, descriptive and expressive languages. Feminism, molecular and micro politics, the autonomy movement, the counterculture, the politics of sexuality, the politics of utterance (who says what, how, to whom, on whose behalf: the issue of the politics of power and discourse, the issue of discursive 'space') – all these 'movements' and 'tendencies' grew out of the cracks, the gaps and silences in the old 'radical' articulations. Given their provenance on the 'other side', as it were of the enoncé it is hardly surprising that the new politics was more or less centrally concerned with the issue of subjectivity itself.

All these fractures and the new forms which grew inside them can be understood in this context as responses to the 'crisis of representation' where the term 'representation' – understood both in its everyday sense of 'political representation' and in the sturcturalist sense of a distortive 'ideological' representation of a pre-existent real – is regarded as problematic. From this point on, all forms and processes of 'representation' are suspect. As the films of Jean-Luc Godard set out to demonstrate, no image or utterance, from political speeches to narrative films to news broadcasts to advertisements and the inert, reified images of women in pornography

was to be regarded as innocent ('In every image we must ask who speaks' [Godard]). All such representations were more or less complicit with, more or less oppositional to the 'dominant ideology'. At the same time, the self-congratulatory rhetoric of political representation as a guarantor of individual and collective freedoms managed through the orderly routines and institutions of parliamentary democracy was rejected as a sham. This of course was nothing new: such an orientation forms the basis of a much older oppositional consensus. But more than that, for the disaffected factions who lived through the events of May 1968 the idea of an individual or a political party representing, speaking for a social group, a class, a gender, a society, a collectivity let alone for some general notion of History or Progress was untenable. (What 'he' could ever speak adequately for 'her', could recognize 'her' needs, could represent 'her' interests?) What tended to happen after 1968 is that these two senses of the term 'representation' were run together around and through the notion of discourse and language as *in themselves* productive of social relations, social and sexual inequalities, through the operations of identification, differentiation and subject-positioning. In the closely related interrogation of and assault upon the idea of the (unitary) subject a similar ambiguity was there to be exploited: on the one hand the 'subject' as in classical rhetoric and grammar, the subject of the sentence, the 'I' as in 'I did it my way,' 'I changed the world', etc., the mythical 'I' implying as it does the self-conscious, self-present Cartesian subject capable of intentional, transparent communication and unmediated action on the world. On the other hand, there is the 'subjected subject': 'subject' as in subject to the crown, subjugated, owned by some higher power. In the gap between these two meanings we became subjects of ideology, subject to the Law of the Father in the Althusserian and Lacanian senses respectively: apparently free agents and yet at the same time subject to an authority which was at once symbolic and imaginary – not 'really' there but thoroughly real in its effects. The project of freeing the subject from subjection to the Subject was interpreted after 1968 by a growing and increasingly influential intellectual contingent as being most effectively accomplished through the deflection of critical and activist energies away from abstractions like the state-as-source-and-repository-of-all-oppressive-powers towards particular, localized struggles and by directing attention to the play of power on the ground as it were in particular discursive formations.

But Paris represents just one 1968. There were others, the '68, for instance, of Woodstock and the West Coast, of Haight-Ashbury, the Pranksters, the hippies, the Yippies, the Weathermen, the Panthers and the opposition to the war in Vietnam. The lunar desertscapes and dune buggies of Manson and the Angels: the space of acid: the libertarian imaginary of unlimited social and sexual licence, of unlimited existential risking. Here too the rights of pleasure, the play of desire and the silent

'discourse of the body' were being asserted against the puritanism and logocentricism of an earlier 'straighter' set of 'radical' demands and aspirations. In different ways in Paris and in San Francisco in the wake of two quite different '68s, the assertion of the claims of the particular against the general, the fragment against the (irrecoverable) whole was to lead to the apotheosis of the schizophrenic as it did more or less contemporaneously in London in the work of R.D. Laing (1967) and David Cooper (1971). While in Paris, Kristeva, Foucault, Deleuze and Guattari excavated and redeemed the buried, repressed and forbidden discourses of the mad and the marginal (Bâtaille, Artaud, Pierre Rivière), young men and women stalked around cities as far apart as Los Angeles and Liverpool wearing T-shirts decorated with a screen-printed photograph of Charles Manson staring crazed and blazing-eyed out into the world at chest level. The failed apocalyptic aspirations of '68 and the cult of the psychotic are both deeply registered in the rhetoric and style of postmodernist critique and leave as their legacy a set of priorities and interests which functions as a hidden agenda inside the Post (see below).

To end this section on a footnote, it is perhaps surprising, given the anti-generalist bias which informs and directs the manifold vectors of the Post, that thinkers such as Jean Baudrillard, Jean-François Lyotard and Fredric Jameson should retain such a panoptic focus in their work, writing often at an extremely high level of abstraction and generality of a 'post modern condition', or 'predicament', a 'dominant cultural norm', etc.

2 Against teleology

A scepticism regarding the idea of decidable origins/causes; this anti-teleological tendency is sometimes invoked explicitly against the precepts of historical materialism: 'mode of production', 'determination', and so on. The doctrine of productive causality is here replaced by less mechanical, less unidirectional and expository accounts of process and transformation such as those available within the epistemological framework provided by, for instance, 'catastrophe theory' – to take one frequently cited example. In the same kind of knight's move which marked the growth of systems theory in the 1950s, arguments and paradigms from the 'hard' sciences, from post-Newtonian physics, relativity, bio-chemistry, genetics, etc. are transposed to the broad field of 'communications' where they function as metaphors (principally, perhaps, they work – as such transpositions of scientific terms worked within modernism, for instance in futurism and cubism – as metaphors of modernity itself, as signs of the New). The anti-teleological tendency is potentially there in the Saussurian insistence on the arbitrary nature of the sign. It 'comes out' explicitly in the post-structuralist elevation of the signifier/withering away of the signified and is most pronounced in Baudrillard's order of the simulacra where

in a parodic inversion of historical materialism the model precedes and
generates the real-seeming (which in the age of miniaturized commu-
nications is all that's left of the 'real'), where use value is completely
absorbed into exchange value (in the form of sign-exchange value),
where the old base-superstructure analogy is turned upside-down so
that value is seen to be generated in the production and exchange of
insubstantials (information, image, 'communications', in speculation on,
for example, the currency and commodity future markets) rather than
from the expropriation of 'surplus value' through the direct exploitation
of an industrial proletariat employed to produce three dimensional goods
in factories. (At this point Baudrillard's characterization of a world
given over to the production of irreal or 'hyperreal' simulacra derives
a specious quasi-empirical grounding from the work of those 'post-
industrialists' (Alain Touraine, Daniel Bell, Andre Gorsz, Alvin Tof-
fler) who concentrate on the impact in the overdeveloped world of the
new communications technologies on labour power, the relations
between and compositon of the classes, industrial patterns of work,
consumption, culture, models of subjectivity, and so on.)

The rhetorical tropes which form the literary-artistic-critical means for
effacing the traces of teleology are parody, simulation, pastiche and
allegory (Newman, 1986). All these tropes tend to deny the primacy or
originary power of the 'author' as sole source of meaning, remove the
injunction placed upon the (romantic) artist to create substance out of
nothing (that is, to 'invent', be 'original') and confine the critic/artist
instead to an endless 'reworking of the antecedent' in such a way that
the purity of the text gives way to the promiscuity of the inter-text and the
distinction between originals and copies, hosts and parasites, 'creative'
texts and 'critical' ones is eroded (with the development of meta-fiction
and paracriticism). In parody, pastiche, allegory and simulation what tends
to get celebrated is the *accretion* of texts and meanings, the *proliferation* of
sources and readings rather than the isolation, and deconstruction of the
single text or utterance. None of these favoured tropes (parody, etc.) offer
the artist a way of speaking from an 'authentic' (that is [after Barthes,
Derrida and Foucault] imaginary) point of pure presence (romanticism).
Nor do they offer the critic a way of uncovering the 'real' (intended)
meaning or meanings buried in a text or a 'phenomenon' (hermeneutics).

In Jameson's autopsia, the idea of depthlessness as a marker of post-
modernism accompanied as it is by a rejection of the vocabulary of
intellectual 'penetration' and the binary structures on which post-Socratic
thought is reckoned to be based (for example, reality v. appearance, real
relations v. phenomenal forms, science v. false consciousness, conscious-
ness v. the unconscious, inside v. outside, subject v. object, etc.) can be
understood in this context as another step away from the old explanatory
models and certainties. Derridian deconstruction and grammatology further

destabilize such dualistic structures by disrupting the illusion of priority which tends to collect around one term in any binary opposition through the prepositional links which bind antinomies together (for example, *behind* consciousness, the primary unconscious; *underneath* illusory phenomenal forms, the real relations; *beyond* subjective distortions, a world of stable objects, and so on). If the 'depth model' disappears, then so, too, does the intellectual as seer, the intellectual as informed but dispassionate observer/custodian of a 'field of enquiry' armed with 'penetrating insights' and 'authoritative overviews', enemy of sophistry, artifice and superficial detail. Once such oppositions dissolve a lot of other things go too: there can be no more rectification of popular errors, no more trawling for hidden truths, no more going behind appearances or 'against the grain' of the visible and the obvious. (The anti-positivist, anti-empiricist impetus that animated critical (rather than Greenbergian) modernism, is, in other words, no longer available as a viable option.) In short, no more (Book of) Revelations. Instead what is left, to use another postmodernist key word, is a 'fascination' with mirrors, icons, surfaces. In those accounts of postmodernism produced by writers who retain a problematic, residual commitment to marxian frames of reference, this ending of critical distance and the depth model is seen to be tied to (though not, presumably, determined by) a larger historical shift into a 'post-industrial', 'consumer', 'media', 'multi-national' or 'monopoly' phase in the development of capitalism. After the prohibitions, the instrumental rationality, and the purposiveness of a production economy (and the complementary 'oppositions' and 'interruptions' of modernism), we get – or so the argument goes – the licensed promiscuity, the unconstrained imaginaries, the merger of subjects and objects, mainstreams and margins, the drift and the dreamwork which characterize life in the consumption economy of the Post. In an economy geared towards the spinning of endlessly accelerating spirals of desire, consumption allegedly imposes its own 'ecstatic' or pluralist (dis)order (Jameson's 'heterogeneity without norms'). Idolatry, the worship of Baal (commodity fetishism) replaces positivism and its döppelganger, marxism, the dominant epistemic faiths of the modern period. Adorno and Horkheimer's *Dialectic of Enlightenment* collapses as the combative strategies of modernism – negation, estrangement, 'non-identity thinking' – which were supposed to work to reveal the arbitrariness/mutability of symbolic-social orders and to form the last line of defence for the 'authentic' and 'autonomous' values of a kingdom yet to come – are either rendered invalid (obsolete: no longer offering a purchase on the contemporary condition) or are absorbed as just another set of options on a horizontal plane of meaning and value where either everything means everything else (post-structuralist polysemy) or alternatively – what amounts to the same thing – everything means nothing whatsoever (Baudrillard's 'implosion of meaning'). Ultimately these two options achieve the same effect: the

evacuation of an axis of power external to discourse itself: end of 'ideology', the cutting edge of marxist critical practice . . .

From such a set of premises it is no longer possible to speak of our collective 'alienation' from some imagined (lost or ideal) 'species being'. Without the gaps between, say, perception, experience, articulation and the real opened up by the modernist master categories of ideology and alienation, there is no space left to struggle over, to struggle from (or as we shall see below, to struggle towards). Both the Cartesian subject, capable of moral and aesthetic judgement and the routine discrimination of truth from lies, reality from fiction, and the Enlightenment subject, child of the great modern abstractions: liberty, equality, progress, fraternity, etc.: these creatures disappear (their phantasmagoric essence finally exposed) in what Lyotard dubs the postmodern 'sensorium': a new mode of being in the world constituted in part directly through exposure to the new technologies which through the computational simulation of mental, linguistic, and corporeal operations work to efface the line between mind and matter, subject and object (for example, 'cerebration' occurs at the 'interface' between, say, two computational systems (one warmblooded, the other electronic) and is no longer adequately conceptualized as a purely 'internal' process).

In a different, though related, Lacanian declension of the post, desire (which replaces reason or the class struggle as the historical constant, the motor of history) reinforces the law propelling the subject which is constituted out of a series of partitions on a doomed quest for completion and the final satisfaction of the very lack, the recognition of which through the Oedipus complex marked the 'origin' of the subject *qua* subject in the first place (because the Oedipus complex marks the entry into language/the symbolic and the symbolic already 'owns' the discursive positions which the subject now exists to occupy). Within the Lacanian scenario, that quest for completion and satisfaction is doomed because desire is nothing more than the insatiable other side of lack, and lack itself is recto to the verso of the Law. It is doubly doomed because the questing subject is itself literally nothing if not incomplete ('I think where I am not and I am not where I think' [Lacan]). It is triply doomed because this fragmented subject is an ontological 'fact' only in so far as it 'finds' itself (that is, gets positioned) in language and the symbolic which is the domain of the Law which, to complete the circle, the movement of desire can only confirm and trace out rather than contradict or overthrow, etc. Once sutured into the Jamesonian critique of consumer culture (where the 'death of the subject' is seen as an historic 'event' rather than [as from the post-structuralist perspective] as a philosophically demonstrable case valid at all times in all places), the Lacanian model of subjectivity and desire tends to consolidate the anti-utopianism which forms the last of the major postmodernist negations (see 'Against Utopia' below), though Lacanian feminists and critical

postmodernists stress the extent to which a new political front is opened up within discourse (signifying practice) itself. At this point, through a series of post-structuralist slippages and puns a kind of total 'closure of discourse' (Marcuse) tends to occur so that we are denied the prospect of any kind of 'elsewhere', any kind of 'alternative' let alone transcendence through struggle or any prospect – imminent or otherwise – of the removal of 'scarcity' through the rational deployment of global resources. At one level, what are presented in the marxist discourse as 'contradictions' which are historical (hence ultimately soluble) get transmuted in the discourse(s) of the Post into paradoxes which are eternal (hence insoluble). Thus 'desire' supersedes 'need', 'lack' problematizes the calculus of 'scarcity', and so on. The implication is that there is nowhere left outside the ceaseless (mindless) spirals of desire, no significant conflict beyond the tension (resorting here to the very different terms and emphases of Foucault) between bodies and those constraints which shape and cut against (de-fine) them as *social* bodies. Agon – the timeless (Hellenic) contest between evenly matched combatants where there can be no final victory, no irreversible outcome here replaces history – the grand (Hebraic) narrative of the struggles of the righteous against the forces of evil – a narrative composed of a succession of unique, unrepeatable moments unfolding in a linear sequence towards the final day of judgement (Armageddon, the Apocalypse, socialism: end of class struggle).

According to one strand within the postmodernist account, the implication here is that without meaningful duration and the subjective dispositions, expectancies, and orientations, which such a 'sense of an (imminent, just and proper) ending' surreptitiously imposes on us all, psychosis begins to replace neurosis as the dominant psychic norm under late capitalism. For Baudrillard (1983c) there is the autistic 'ecstasy of communication' where judgement, meaning, action are impossible, where the psychic 'scene' (space of the subject/stage for psychic 'dramas' complete with 'characters' equipped with conscious and unconscious intentions, drives, motivations, 'conflicts', etc.) is replacd by an 'obscene' and arbitrary coupling of disparate 'screens' and 'termini' where bits of information, images, televisual close-ups of nothing in particular float about in the 'hyperreal' space of the image-bloated simulacrum: a Leviathan-like lattice work of programmes, circuits, pulses which functions merely to process and recycle the 'events' produced (excreted) within itself. For Jameson (1983) there is the 'schizophrenic' consumer disintegrating into a succession of unassimilable instants, condemned through the ubiquity and instantaneousness of commodified images and information to live forever in chronos (this then this then this) without having access to the (centring) sanctuary of *kairos* (cyclical, mythical, meaningful time). For Deleuze and Guattari there is the nomad drifting across 'milles plateaux' drawn, to use their phrase, 'like a schizophrenic taking a walk' (1977) from one arbitrary point of intensity to

the next by the febrile and erratic rhythm of desire (conceived in this case against Lacan as the subversive Other to the Law not as its accomplice). In each case, a particular (end of) 'subjectivity', a particular 'subjective modality', a distinct, universal 'structure of feeling' is posited alongside the diagnostic critique of the contemporary 'condition'. Just as Marshall Berman proposes that modernization (urbanization, industrialization, mechanization) and modernism, the later answering wave of innovations in the arts together articulated a third term, the experience of modernity itself; so the prophets of the Post are suggesting that post-modernization (automation, micro-technologies, decline of manual labour and traditional work forms, consumerism, the rise of multinational media conglomerates, deregulation of the airwaves, etc.) together with postmodernism (bricolage, pastiche, allegory, the 'hyperspace' of the new architecture) are serving to articulate the experience of the Post. Whereas the experience of modernity represented an undecidable mix of anticipated freedoms and lost certainties incorporating both the terror of disintegrating social and moral bonds, of spatial and temporal horizons and the prospect of an unprecedented mastery of nature, an emancipation from the very chains of natural scarcity – whereas, in other words, modernity was always a Janus-faced affair – the experience of *post* modernity is positively schizogenic: a grotesque attenuation – possibly monstrous, occasionally joyous – of our capacity to feel and to respond. Post-modernity is modernity without the hopes and dreams which made modernity bearable. It is a hydra-headed, decentred condition in which we get dragged along from pillow to Post across a succession of reflecting surfaces drawn by the call of the wild signifier. The implication is that when time and progress stop, at the moment when the clocks wind down, we get wound up. In Nietzsche's dread eternal Now, as the world stops turning (stroke of noon, stroke of midnight), we start spinning round instead. This at least, is the implication of the end of history argument: thus – Zarathustra-like – speak the prophets of the Post. In the dystopian extrapolation of schizophrenia as the emergent psychic norm of postmodernism we can hear perhaps, the bitter echo (back-to-front and upside-down) of the two '68s: San Francisco (Jameson) and Paris (Baudrillard). The schizophrenic is no longer presented as the wounded hero/heroic victim of the modernizing process ('Who poses the greater threat to society: the fighter pilot who dropped the bomb on Hiroshima or the schizophrenic who believes the bomb is inside his body?' [R.D. Laing]). The schizophrenic is no longer implicitly regarded as the suffering guarantor of threatened freedoms and of an imperilled ontic authenticity but rather as the desperate witness/impotent victim of the failure not only of marxism but also of the inflated libertarian claims, dreams and millenarian aspirations of the two '68s.

3 Against Utopia

Running parallel to the anti-teleological impulse, and in many ways, as is indicated above, serving as the inevitable complement to it, there is a strongly marked vein of scepticism concerning any collective destination, global framework of prediction, any claims to envisage, for instance, the 'ultimate mastery of nature', the 'rational control of social forms', a 'perfect state of being', 'end of all (oppressive) powers', and so on. This anti-utopian theme is directed against all those programmes and solutions (most especially against marxism and fascism) which have recourse to a bogus scientificity, which place a high premium on centralized planning/social engineering, and which tend to rely heavily for their implementation on the maintenance of strict party discipline, a conviction of ideological certitude, and so on. The barbaric excesses (for example, Auschwitz, the Gulag) which are said to occur *automatically* when people attempt to put such solutions and programmes into action are seen to be licensed by reference to what Lyotard (1984) calls the 'grands récits' of the West: by the blind faith in progress, evolution, race struggle, class struggle, etc., which is itself a product of the deep metaphysical residue which lies at the root of western thought and culture. In other words (and here there is an explicit link with the *nouvelles philosophes* of the 1970s) all holy wars require casualties and infidels, all utopias come wrapped in barbed wire. Many commentators have remarked upon both the banality and the irrefutability of these conclusions.

The image which is often invoked as a metaphor for the decline of utopian aspirations, the refusal of 'progress' and the 'progressive' ideologies whch underpin it – an image which in a sense encompasses all three of the founding negations of postmodern thought – is Walter Benjamin's allegorical interpretation of Paul Klee's painting the *Angelus Novus*. Benjamin (1969) suggests that in this painting, the angel of history is depicted staring in horror at the 'single catastrophe' which hurls 'wreckage upon wreckage' at his feet as the storm which is blowing from Paradise propels him irresistibly 'into the future to which his back is turned' (257). 'This storm,' writes Benjamin, 'is what we call progress'. In a number of subtly and elaborately developed arguments evolved partly in the course of his protracted debate with Habermas over the nature of rationality and modernity, Lyotard (1984) has sought to clip the angel's wings by recommending that we abandon all those 'modern' sciences which legitimate themselves by reference to a meta-discourse which makes an explicit appeal to 'some grand narrative, such as the dialectics of the spirit, the hermeneutics of meaning, the emancipation of the rational or working subject, or the creation of wealth' (xxiii).

In what becomes in effect an explicit renunciation of marxism (Lyotard was a founder member of the *Socialism or Barbarism* group in the 1950s),

Lyotard returns to Kant – especially to the critique of judgement – to reflect upon the origins of modern social thought, aesthetics and the relationship between the two. He sets out to examine the philosohical underpinnings of the Enlightenment project which is defined as a twofold impetus towards universalization (reason) and social engineering (revolution), both of which find support and legitimacy in the related doctrines of progress, social plannning and historical 'necessity'. Much of Lyotard's (1986b) argument turns on an involved discussion of the distinction in Kant (following Burke) between the two orders of aesthetic experience: the beautiful and the sublime. Whereas the beautiful in Kant consists in all those views, objects, sounds from which we derive aesthetic pleasure but which can be framed, contained, harmoniously assimilated, the sublime is reserved for all those phenomena which exceed logical containment and which elicit a mixture of both pleasure and terror in the viewer (Burke mentions, for instance, the spectacle of a stormy sea or a volcano).

Lyotard argues that in so far as the various modernist literary and artistic avant gardes attempt to 'present the unpresentable' (through abstraction, alienation, defamiliarization, etc.) they remain firmly committed to an aesthetics of the sublime rather than the beautiful. For Lyotard, a properly avant garde poem or canvas takes us to this sublime point where consciousness and being bang up against their own limitations in the prospect of absolute otherness – God or infinity – in the prospect, that is, of their disappearance in death and silence. That encounter compels the spectator's, the reader's and the artist's subjectivities to be predicated for as long as it lasts in an unliveable tense: the post modern tense. Postmodernity is here defined as a condition that is also a contradiction in terms. Lyotard calls this timeless tense the future anterior: 'post' meaning 'after', 'modo' meaning 'now'. (What Lyotard calls 'post modernity' is similar to Paul de Man's (1983) a(nti)historical definition of 'modernity' as the perpetual present tense within which human beings have always lived at all times and in all places pinioned forever between a disintegrating, irrecoverable, half remembered past and an always uncertain future.) Lyotard insists on the validity and the viability of this avant garde project of the sublime and seeks to promote those artistic practices which pose the issue of the unpresentable in a gesture which has to be incessantly forgotten and repeated. Using a term from psychoanalytic theory, Lyotard calls this process 'anamnesis': the re-encounter with a trauma or former experience of intensity through a process of recollection, utterance and invocation which involves not so much a recovery of the original experience as a recapitulation of it.

What might at first seem a quite arbitrary, unnecessarily abstruse and idiosyncratic detour through eighteenth-century German idealist aesthetics actually provides Lyotard with an opportunity to flesh out his central objections to Habermas's attempts to defend and build on the Enlight-

enment inheritance, to revive what Habermas regards as the prematurely arrested project of modernity.

For Lyotard uses the notion of the sublime as a kind of metaphor for the *absolute* nature of those limitations placed on what can be said, seen, shown, presented, demonstrated, put into play, put into practice, and Lyotard implies that each encounter with the sublime in art provides us with the single salutary lesson that complexity, difficulty, opacity are always there in the same place: *beyond our grasp*. The inference here in the insistence on the palpability of human limitation is politically nuanced at those points when Lyotard talks about the disastrous consequences which have flowed from all attempts to implement the 'perfect (rational) system' or to create the 'perfect society' during what he calls the 'last two sanguinary centuries' (1986a: 6).

Habermas, publicly aligned with the Frankfurt tradition which he is concerned both to revise and to revive, has emphasized the emancipatory and utopian dimensions of art favouring an aesthetics of the beautiful. From this position, the fact that the harmonious integration of formal elements in an artwork gives us pleasure indicates that we are all drawn ineluctably by some internal logos (reason reflexively unfolding/folding back upon itself through the dispassionate contemplation of form), that we are, in other words, drawn towards the ideal resolution of conflict in the perfection of good form. Here our capacity both to produce and to appreciate the beautiful stands as a kind of 'promissory note' for the eventual emancipation of humanity. Lyotard, on the other hand, in a move which mirrors the deconstructive strategies exemplified by Derrida, takes the relatively subordinate, residual term, the 'sublime' in the binary coupling upon which 'modern' (that is, Enlightenment) aesthetics is based (the beautiful – [the sublime] where the sublime functions as that-which-is-aesthetic-but-not-beautiful) and privileges it to such an extent that the whole edifice of Enlightenment thought and achievement is (supposedly) threatened. For whereas the idea of the beautiful contains within it the promise of an ideal, as yet unrealized community (to say 'this is beautiful' is to assert the generalizability of aesthetic judgements and hence the possibility/ideal of consensus), the sublime in contrast, atomizes the community by confronting each individual with the prospect of his or her imminent and solitary demise. In Lyotard's words, with the sublime, 'everyone is alone when it comes to judging' (1986b: 11).

The sublime functions in Lyotard's work as a means of corroding the two 'materialist' faiths (positivism and marxism) which characterize the superseded modern epoch. For example, responding recently to an attack on postmodernism by the British marxist, Terry Eagleton (1985), Lyotard (1986b) made the provocative (or facetious) claim that Marx 'touches on the issue of the sublime' in the concept of the proletariat in that the proletariat is, in Kantian terms, an Idea in Reason, an idea which must

be seen as such, not as an empirically verifiable existent (the working class). The 'proletariat', in other words, according to Lyotard, cannot be incarnated and specified as this or that group or class. It is not reducible to 'experience' (Lyotard declines of course to specify how – given this distinction – marxism is to fulfil its claims to be a philosophy of praxis). Using Adorno's shorthand term to signal the litany of disasters which he sees underwritng the modern period, Lyotard (1986a) asserts that 'Auschwitz' happened because people made precisely that category error from the time of Robespierre's Terror on, seeking to identify (more commonly to identify *themselves* with) such Ideas in Reason. A succession of revolutionary vanguards and tribunals have set themselves up as the subjects and agents of historical destiny: 'I am Justice, Truth, the revolution. . . . We are the proletariat. We are the incarnation of free humanity' (Lyotard, 1986b: 11) – and have thereby sought to render themselves unaccountable to the normative framework provided by the web of 'first order narratives' in which popular thought, morality and social life is properly grounded. Those moments when men and women believed themselves to *be* Benjamin's Angel of History who 'would like to stay, awaken the dead, and make whole what has been smashed' (Benjamin, 1968: 257), moments of illusory Faustian omnipotence, and certainty are the dangerous moments of supposedly full knowledge, when people feel fully present to themselves and to their 'destiny' (the moment, say, when the class in itself becomes a class for itself). For Lyotard they are the moments of historical disaster: they inaugurate the time of 'revolutions', executions, concentration camps. In an ironic retention of Kant's separation of the spheres of morality, science and art (ironic in view of Lyotard's judgement of the Enlightenment legacy), he seeks to stake out the sublime as the legitimate province of (post)modern art and aesthetics whilst at the same time rigorously excluding as illegitimate and 'paranoid' any aspiration to 'present the unpresentable' through politics (that is, to 'change the world') or to constitute an *ontology* of the sublime (that is, 'permanent revolution', attempts to create a new moral or social order, etc.). The sublime remains 'das Unform' (Lyotard, 1986b: 11), that which is without form hence that which is monstrous and unthinkable and rather than seeking to embody universal values of truth, justice and right finding the licence for such pretensions in the great meta-narratives ('the pursuit of freedom or happiness' (10)), Lyotard recommends that we should instead think of the human project in terms of 'the infinite task of complexification' (10). ('Maybe our task is just that of complexifying the complexity we are in charge of.') This 'obscure desire towards extra sophistication' (10) effectively functions within Lyotard's most recent work as a pan-global, trans-historical imperative assuming at times an almost metaphysical status (although he does make a concession to the persistence of scarcity in the Third World in the cryptic division of humanity into two (unequal) halves one of which (that

is, ours?) is devoted to the task of complexification, the other (theirs?) to the 'terrible, ancient task of survival'(!) (1986a: 12). Lyotard may have jettisoned the socialism which formed his preferred option in the stark choice which he felt was facing the world in the 1950s (S or B) but he remains alert to the threat of barbarism which he now associates with a refusal to acknowledge and/or contribute to this eternal complexifying mission ('The claim for simplicity, in general, appears today that of the barbarian' [Lyotard, 1986a: 6]).

Lyotard offers perhaps one of the most direct, most intricately argued critiques of the utopian impetus within modern, Enlightenment and post-Enlightenment thought but there are within the Gallic version of the Post other variations on the (Nietzschean) theme of the end of the western philosophical tradition (Lyotard ends by dissolving dialectics into para-doxology, and language games). In some ways, those discourses from Foucault to Derrida, from the Barthes of the *Tel Quel* phase to the Jacques Lacan of the *Ecrits* might be said to be posited following Nietzsche on the No Man's land (the gender here *is* marked!) staked out between the two meanings of the word 'subject' mentioned earlier (see 'Against totaliza-tion', above) – a No Man's land which is just that: a land owned by nobody in the space between the enoncé and the enunciation where questions of agency, cause, intention, authorship, history become irrelevant. All those questions dissolve into a sublime, asocial Now which is differently dimen-sionalized in different accounts. For Derrida in grammatology that space is called 'aporia' – the unpassable path – the moment when the self-contradictory nature of human discourse stands exposed. For Foucault, it is the endless recursive spirals of power and knowledge: the total, timeless space he creates around the hellish figure of the Panopticon: the viewing tower at the centre of the prison yard – the *'voir'* in *savoir/pouvoir*, the looking in knowing. For *Tel Quel* it is the moment of what Julia Kristeva calls 'signifiance': the unravelling of the subject in the pleasure of the text, the point where the subject disintegrates, moved beyond words by the materiality, productivity and slippage of the signifier over the signified. And for Lacan, it is the Real – that which remains unsayable and hence unbearable – the (boundless, inconceivable) space outside language and the Law, beyond the boundaries of the Imaginary register: the Real being the realm of the promise/threat of our eventual (unthinkable) disintegration, our absorption into flux. The sublime is here installed in each case as the place of epiphany and terror, the place of the ineffable which stands over and against all human endeavour, including the project of intellectual totalization itself. Lacan's Real, Foucault's power-knowledge spirals, Kristeva's signifiance, Derrida's aporia, Barthes' text of bliss: all are equivalent, in some senses reducible to Lyotard's category of the sub-lime. This elevation of the sublime (which has its more literal (or crass) quasi-empirical corollary in the cult of schizophrenia (see above) – the cult,

that is, of dread, of the sublime mode of being in the world) could be interpreted as an extension of the aspiration towards the ineffable which has impelled the European avant garde at least since the Symbolists and Decadents and probably since the inception in the 1840s of metropolitan literary and artistic modernism with the 'anti-bourgeois' refusals of Baudelaire. It implies a withdrawal from the immediately given ground of sociality by problematizing language as tool and language as communicative medium, by substituting models of signification, discourse and decentred subjectivity for these older humanist paradigms and by emphasizing the *im*possibility (of 'communication', transcendence, dialectic, the determination of origins and outcomes, the fixing or stabilization of values and meanings, etc.). The moment which is privileged is the solitary confrontation with the irreducible fact of limitation, Otherness, 'differance', with the question variously of the loss of mastery, 'death in life' (Lyotard), of the 'frequent little deaths' or 'picknoleptic interruptions' of consciousness by the unconscious (Virilio), and so on.

The conversion of asociality into an absolute value can accommodate a variety of more or less resigned postures: scepticism (Derrida), stoicism (Lyotard, Lacan, Foucault), libertarian anarchism/mysticism (Kristeva), hedonism (Barthes), cynicism/nihilism (Baudrillard). However such a privileging of the sublime tends to militate against the identification of larger (collective) interests (the ism's of the modern epoch, such as marxism, liberalism, and so on). It does this by undermining or dismissing as simplistic/'barbaric' what Richard Rorty has called 'our untheoretical sense of social solidarity' (1984: 41), and by bankrupting the liberal investment in the belief in the capacity of human beings to empathize with one another, to reconcile opposing 'viewpoints', to seek the fight-free integration of conflicting interest groups. There is no room in the split opened up in the subject by the Post for the cultivation of 'consensus' or for the growth and maintenance of a 'communicative community', no feasible ascent towards an 'ideal speech situation' (Habermas). The stress on the asocial further erodes the sense of destination and purposive struggle supplied by the 'optimistic will' (Gramsci), and the theoretical means to recover (emancipate) a 'reality' obscured by something called 'ideology' (created by power) in the name of something called 'validity' (not created by power) (Rorty, 1984: 41) (Habermas again). The stress on the impossible tends in other words, to seriously limit the scope and definition of the political (where politics is defined as the 'art of the possible'). A series of elisions tends to prescribe a definite route here (though it is a route taken by more disciples than master-mistresses). First there is the absolute conflation of a number of relatively distinct structures, paradigms, tendencies: the emergence of industrial-military complexes, the Enlightenment aspiration to liberate humanity, the bourgeoisie, the rise of the modern 'scientific' episteme, the bureaucratic nation-state and 'Auschwitz'. Next these dis-

crete and non-synchronous historical developments are traced back to the model of the subject secreted at the origins of western thought and culture in transcendental philosophy. Finally an ending is declared to the 'tradition' thus established and the equation is made between this ending (the end of philosophy) and the ending of history itself.

As Rorty has pointed out – and these concluding remarks on antiutopianism are a précis of Rorty's arguments – such a trajectory overestimates the wider historical importance of the philosophical tradition and especially overestimates the extent to which modern social, economic and political structures were underwritten by models of subjectivity 'originating' in the context of philosophical debates on the nature of consciousness, perception, alienation, freedom, language, etc. In this way, the Post tends to reproduce back to front as it were like a photographic negative, the mistake which Habermas himself makes of linking the story of modern post-Kantian philosophy and rationalism too closely to that other modern story: the rise of industrialized democractic societies. Rorty suggests that the second story has more to do with pressures and social movements external to the academy, that the idea(l) of the 'communicative community' has been established through 'things like the formation of trade unions, the meritocratization of education, the expansion of the franchise, and cheap newspapers' rather than through the abstract discussion of epistemology, that religion declines in influence not because of Nietzsche, Darwin, positivism or whatever but because 'one's sense of relation to a power beyond the community becomes less important as you see yourself as part of a body of public opinion, capable of making a difference to the public fate' (Rorty, 1984: 38). Viewed in this light, the history of philosophy from, say, Descartes to Nietzsche is seen as a 'distraction from the history of concrete social engineering which made the contemporary North Atlantic culture what it is now (with all its faults and virtues)' and Rorty concludes by sketching the outlines of an alternative philosophical canon in which the 'greatness' of a 'Great Mind' would be measured less by reference to her/his contribution to the dialectics of the 'Great Debates', and by the epistemological complexity of the arguments put forward than by his/her sensitivity to 'new social and religious and institutional possibilities' – a prescient and strategic orientation which renders questions of 'grounding' and 'legitimation' irrelevant. Within such a transformed knowledge-practice field, the function of analysis would be neither to unmask ideology, to assist the forward march of Reason nor to trace out the eternal perimeters of sociality, knowledge and the sayable but rather, following Foucault, to explain 'who was currently getting and using power and for what purposes and then (unlike Foucault) to suggest how some other people might get it and use it for other purposes' (Rorty, 1984: 42).

GRAMSCI AND ARTICULATION

Such an orientation would seem to require that same combination of qualities, that same mix of conjunctural analysis and strategic intervention which typifies the Gramscian approach – (especially as developed by people like Stuart Hall and Ernesto Laclau and Chantal Mouffe (1985), [albeit, as Hall himself points out, along rather different lines]) – where a 'war of position' is waged between conflicting alliances of 'dominant' and 'subaltern' class fractions over and within a heterogenous range of sites which are themselves shaped by a complex play of discursive and extra-discursive factors and forces. But what distinguishes the Gramscian approach is the way in which it requires us to negotiate and engage with the multiple axes of both power and the popular and to acknowledge the ways in which these two axes are 'mutually articulated' through a range of populist discourses which centre by and large precisely on those pre-Post-erous 'modern' categories: the 'nation', 'roots', the 'national past', 'heritage', 'the rights of the individual' (variously) 'to life and liberty', 'to work', 'to own property', 'to expect a better future for his or her children', the right 'to *be* an individual': the 'right to choose'. To engage with the popular as constructed and as lived – to negotiate this bumpy and intract-able terrain – we are forced at once to desert the perfection of a purely theoretical analysis, of a 'negative dialectic' (Adorno) in favour of a more 'sensuous (and strategic) logic' (Gramsci) – a logic attuned to the living textures of popular culture, to the ebb and flow of popular debate.

In this shift in the critical focus, the meaning of the phrase 'legitimation crisis' is inflected right away from problems of epistemology directly on to the political, as our attention is drawn to the *processes* whereby particular power blocs seek to impose their moral leadership on the masses and to legitimate their authority through the construction (rather than the realiza-tion) of consensus. The Gramscian model demands that we grasp these processes not because we want to expose them or to understand them in the abstract but because we want to *use* them *effectively* to contest that authority and leadership by offering arguments and alternatives that are not only 'correct' ('right on') but convincing and convincingly presented, arguments that capture the popular imagination, that engage directly with the issues, problems, anxieties, dreams and hopes of real (actually existing) men and women: arguments, in other words, that take the popular (and hence the populace) seriously *on its own terms*.

At the same time, the Gramscian line is identified, at least in Britain, with a commitment to flexible strategies, to responsive, accountable power structures, with commitment to decentralization and local democracy. It is associated with a challenge to the workerism and masculinism of the old Labour left, a move away from the dogmatism which can still plague the fringe parties, with a sensitivity to local and regional issues, with an

alertness, too, to race and gender as well as class as significant axes of power. It is associated with a commitment to 'advance along multiple fronts', with the kinds of radical policy implemented by those progressive enclaves within the local state (for example, sponsorship for feminist, gay rights, ethnic minority; citizens' rights; health care and support groups; police monitoring committees; small, alternative presses; alternative arts programmes; cheap public transport; expanded public information services and issue oriented 'consciousness raising' (e.g., anti-nuclear power) publicity campaigns; popular festivals, etc.) – policies which so provoked the Thatcher administration that in 1986–7 they dismantled the system of local municipal government in the big urban centres run throughout the 1980s by Labour administrations (leaving London as the only major western European capital without its own elected council).

The commitment on the one hand to local radicalism, to a menu of bold, experimental policies for the inner city and on the other, the critique of Thatcherite 'authoritarian populism' (Hall, 1980a) and the resolve to engage for instance on the traditional rightist ground of 'national-popular' discourses represent perhaps the two dominant and potentially opposed tendencies which derive in part from debates amongst the British left on the relatively recently translated work of Gramsci (1985). However, while the first tendency clearly resonates with many of the (more positive) themes of the Post ('68) debates, the stress on populism seems to run directly counter to the drift of the Post. For the popular exists solely in and through the problematic 'we' – the denigrated mode of address, the obsolescent shifter. This 'we' is the imaginary community which remains unspeakable within the Post – literally unspeakable in Baudrillard who presents the myth of the masses as a 'black hole' drawing all meaning to its non-existent centre (1983a). In Gramsci, of course, the 'we' is neither 'fatal' in the Baudrillardian sense, nor given, pre-existent, 'out there' in the pre-Post-erous sense. Instead it is itself the site of struggle. The 'we' in Gramsci has to be *made* and remade, actively articulated in the double sense that Stuart Hall refers to in the interview: both 'spoken', 'uttered' and 'linked with', 'combined'. It has to be at once 'positioned' *and* brought into being. The term 'articulation' is thus a key bridging concept between two distinct paradigms or problematics. It bridges the 'structuralist' and the 'culturalist' paradigms which Hall (1980b) has identified and since the late 1960s sought to integrate in that it both acknowledges the constitutive role played by (ideological!) discourses in the shaping of (historical) subjectivities and at the same time it insists that there is somewhere outside 'discourse' (a world where groups and classes differentiated by conflicting interests, cultures, goals, aspirations; by the positions they occupy in various hierarchies are working in and on dynamic [changing] power structures) – a world which has in turn *to be linked with*, shaped, acted upon, struggled over, intervened in: changed.

In other words, the concept of 'articulation' itself articulates the two paradigms by linking together and expressing the double emphasis which characterizes Gramscian cultural studies. It performs the same metonymic function, is as homologous to and as exemplary of Stuart Hall's project as 'differance' is to Derrida's (where the term 'differance' simultaneously connotes and itself *enacts* the double process of differing and deferring meaning which Derrida sees as language's essential operation). The reliance on the concept of articulation suggests that the 'social' in Gramsci is neither a 'beautiful' dream nor a dangerous abstraction, neither a contract made and remade on the ground as it were, by the members of a 'communicative community' (Habermas) nor an empirically non-existent 'Idea in Reason' which bears no relation whatsoever to experience (Lyotard). It is instead a continually shifting, mediated relation between groups and classes, a structured field and a set of lived relations in which complex ideological formations composed of elements derived from diverse sources have to be actively combined, dismantled, bricolaged so that new politically effective alliances can be secured between different fractional groupings which can themselves no longer be returned to static, homogenous classes. In other words, we can't collapse the social into speech act theory or subsume its contradictory dynamics underneath the impossible quest for universal validity claims. At the same time, rather than dispensing with the 'claim for simplicity' by equating it with barbarism, we might do better to begin by distinguishing a claim from a demand, and by acknowledging that a *demand* for simplicity exists, that such a demand has to be negotiated, that it is neither essentially noble nor barbaric, that it is, however, *complexly articulated* with different ideological fragments and social forces in the form of a range of competing populisms.

It would be foolish to present a polar opposition between the Gramscian lines(s) and the (heterogeneous) Posts. There is too much shared historical and intellectual ground for such a partition to serve any valid purpose. It was, after all, the generation of marxist intellectuals who lived through '68 and who took the events in Paris and the West Coast seriously who turned in the 1970s to Gramsci. In addition, there are clear cross-Channel links between the two sets of concerns and emphases, for instance, in the work of Michel Pêcheux (1982) on 'interdiscourse'. The retention of the old marxist terms should not be allowed to obscure the extent to which many of these terms have been transformed – wrenched away from the 'scientific' mooring constructed in the Althusserian phase. What looks at first glance a lot like the old 'rationalist' dualism ('Left' v. 'Right', etc.); the old 'modernizing' teleology ('progressive', 'reactionary', 'emergent', 'residual', etc.); a typically 'modernist' penchant for military metaphors ('dominant' and 'subaltern classes', etc.); an unreconstructed 'modernist' epistemology ('ideology', for instance, rather than 'discourse') looks

different closer to. From the perspectives heavily influenced by the Gramscian approach, nothing is anchored to the 'grands récits', to master narratives, to stable (positive) identities, to fixed and certain meanings: all social and semantic relations are contestable hence mutable: everything appears to be in flux: there are no predictable outcomes. Though classes still exist, there is no guaranteed dynamic to class struggle and no 'class belonging': there are no solid homes to return to, no places reserved in advance for the righteous. No one 'owns' an 'ideology' because ideologies are themselves in process: in a state of constant formation and reformation. In the same way, the concept of hegemony remains distinct from the Frankfurt model of a 'total closure of discourse' (Marcuse) and from the ascription of total class domination which is implied in the Althusserian model of a contradictory social formation held in check eternally (at least until 'the last (ruptural) instance') by the work of the RSAs and the ISAs. Instead hegemony is a precarious, 'moving equilibrium' (Gramsci) achieved through the orchestration of conflicting and competing forces by more or less unstable, more or less temporary alliances of class fractions.

Within this model, there is no 'science' to be opposed to the monolith of ideology, only prescience: an alertness to possibility and emergence – that and the always imperfect, risky, undecidable 'science' of strategy. There are only competing ideolog*ies* themselves unstable constellations liable to collapse at any moment into their component parts. These parts in turn can be recombined with other elements from other ideological formations to form fragile unities which in turn act to interpellate and bond together new imaginary communities, to forge fresh alliances between disparate social groups (see, for instance, Hall (1980a, 1985) and others (Jessop *et al.*, 1984) on 'national popular' discourses).

But it would be equally foolish to deny that there are crucial differences between the two sets of orientations. A marxism of whatever kind could never move back from or go beyond 'modernity' in the very general terms in which it is defined within the Post, which is not to say that marxism is necessarily bound to a 'dynamic' and destructive model of technological 'advance' (see Bahro (1984) on the possibility of eco-marxism: a union of 'greens' and 'reds'). However it should be said that the kind of marxism Stuart Hall proposes bears little or no relation to the caricatured, teleological *religion* of marxism which – legitimately in my view – is pilloried by the Post. A marxism without guarantees is a marxism which has suffered a sea change. It is a marxism which has 'gone under' in a succession of tempests that include the smoke and fire of 1968 and the shrinkage of imaginative horizons in the monetarist 'new realism' of the 1980s and yet it is a marxism that has survived, returning perhaps a little lighter on its feet, (staggering at first), a marxism more prone perhaps to listen, learn, adapt and to appreciate, for instance, that words like 'emergency' and 'struggle'

don't just mean fight, conflict, war and death but birthing, the prospect of new life emerging: a struggling to the light . . .

REFERENCES

Anderson, P. (1984) 'Modernity and revolution', *New Left Review* 144, 96–113.
Appignanensi, L. and Bennington, G. (eds) (1986) *Postmodernism: ICA Documents 4*, London: Institute of Contemporary Arts.
Bahro, R. (1984) *From Red to Green*, Lodon: New Left Books.
Barthes, R. (1977) *Image, Music, Text* (trans. S. Heath), New York: Hill & Wang.
Baudrillard, J. (1983a) *In the Shadow of the Silent Majorities* (trans. P. Foss), New York: Semiotext(e).
——— (1983b) *Simulations*, New York: Semiotext(e).
——— (1983c) 'The ecstasy of communication', in H. Foster (ed.) *The Anti-Aesthetic*, Port Townsend (Washingston): Bay Press 126–34.
Benjamin, W. (1969) *Illuminations*, H. Arendt (ed.) New York: Schocken.
Berman, M. (1982) *All That Is Solid Melts into Air*, New York: Simon & Schuster.
——— (1984) 'Signs in the street', *New Left Review* 144.
Cooper, D. (1971) *Psychiatry and Anti-psychiatry*, New York: Ballantine.
Deleuze, G. (1983) *Nietzsche and Philosophy* (trans. H. Tomlinson), London: Athlone Press. (Originally published in 1962.)
Deleuze, G. and Guattari, F. (1977) *Anti-Oedipus: Capitalism and Schizophrenia*, New York: Viking Press.
De Man, P. (1983) *Blindness and Insight*, Minneapolis: University of Minnesota Press.
Derrida, J. (1980) *Writing and Differance* (trans. A. Bass), Chicago: University of Chicago Press.
Dews, P. (1986) 'From post-structuralism to postmodernity: Habermas's counter-perspective', in L. Appignanensi and G. Bennington (eds), *Postmodernism: ICA Documents 4*, 12–16.
Eagleton, T. (1985) 'Capitalism, modernism and postmodernism', *New Left Review* 152, 60–73.
Foster, H. (ed.) (1983) *The Anti-Aesthetic*, Port Townsend (Washington): Bay Press.
Foucault, M. (1977) *Language, Counter-memory, Practice*, D. F. Bouchard (ed.), Ithaca: Cornell University Press.
Gramsci, A. (1985) *Selections from Cultural Writings*, D. Forgacs and G. Nowell-Smith (eds), Cambridge: Harvard University Press.
Hall, S. (1980a) 'Popular-democratic vs. authoritarian populism', in A. Hunt (ed.) *Marxism and Democracy*, London: Lawrence & Wishart, 157–85.
——— (1980b) 'Cultural studies: two paradigms', *Media, Culture and Society* 2, 57–72.
——— (1985) 'Authoritarian populism: a response to Jessop *et al.*', *New Left Review* 151, 115–24.
Hall, S. and Jacques, M. (eds) (1983) *The Politics of Thatcherism*, London: Lawrence & Wishart.
Harvey, S. (1978) *May '68 and Film Culture*, London: British Film Institute.
Jameson, F. (1983) 'Postmodernism and consumer society' in H. Foster (ed.) *The Anti-Aesthetic*, 111–25.
——— (1984) 'Postmodernism, or the cultural logic of late capitalism', *New Left Review* 146.

Jessop, B. *et al.* (1984) 'Authoritarian populism, two nations, and Thatcherism', *New Left Review* 147, 32–60.

Kuhn, A. (1982) *Women's Pictures: Feminism and Cinema*, London: Routledge & Kegan Paul.

Laclau, E. and Mouffe, C. (1985) *Hegemony and Socialist Strategy*, London: Verso.

Laing, R. D. (1967) *The Politics of Experience*, New York: Ballantine.

Lyotard, J-F. (1984) *The Postmodern Condition: A Report on Knowledge* (trans. G. Bennington and B. Massumi), Minneapolis: University of Minnesota Press.

——— (1986a) 'Defining the postmodern', in Appignanensi and Bennington (eds), *ICA Documents 4*, 6–7.

——— (1986b) 'Complexity and the sublime', in Appignanensi and Bennington (eds), *ICA Documents 4*, 10–12.

——— (1986c) 'Reflections on popular culture' in L. Appignanensi and G. Bennington (eds), *ICA Documents 4*, 58.

Merquior, J. G. (1986) 'Spider and bee: toward a critique of postmodern ideology', in Appignanensi and Bennington (eds), *ICA Documents 4*, 16–18.

Newman, M. (1986) 'Revising modernism, representing postmodernism: critical discourse of the visual arts' in Appignanensi and Bennington (eds), *ICA Documents 4*, 32–51.

Pêcheux, M. (1982) *Language, Semantics and Ideology* (trans. Nagpal), New York: St Martin's Press.

Rorty, R. (1984) 'Habermas and Lyotard on postmodernity', *Praxis International* 4(1), 32–44.

Virilio, P. (1983) *Pure War*, New York: Semiotext(e).

Editor's note

A version of this article appeared in Dick Hebdige's book *Hiding in the Light: On Images and Things*, London: Routledge (1988).

Chapter 9

Waiting on the end of the world?

Iain Chambers

If the 1960s can be characterized as being the decade of 'pop', with the theoretical recognition of pop art, pop music and popular culture, then the 1980s might be considered the decade of 'Post': postmodernism, post-structuralism, post-marxism, post-feminism. Read in this key, pop was among the final gestures of modernism. As the closing curtain-call of the attempt to transform the icons and tastes of popular culture into art, to close the gap and æstheticize the everyday, it effectively signalled the termination of a lengthy European debate on 'culture and society'.[1] By the 1960s the once religious distinction between these categories was being continually breached by the speed and success of such secular, cheap, commercial cultural languages as cinema, television, pop music, fashion and associated urban styles. 'It's not really pop art. It's just regular . . . it's the way we are . . . pop life', said Kenny Scharf. Of course, in moving from that moment to this, from pop to post, it is easy to exaggerate and inflate change and become a ventriloquist of stylistic circumstances; but there is, nevertheless, a complex shift in gravity, a decidedly altered state and feel to the present that was neither felt nor anticipated twenty or thirty years ago. The overall constellation of thought, critical work, artistic production and everyday life has decisively shifted and acquired new bearings in the universe of our histories.

In a readily caricatured distinction, postmodernism apparently takes us through pop to a beyond in which the media-induced sign invasion of the world now spells the death of the referent. Modernism, meanwhile, continues to stand for the epistemological wager that a sign can be exchanged for meaning, that the image is only 'reality' at one remove. The point, however, may well be not to resolve this question philosophically but rather to explore the different possibilities that it brings together. In other words, rather than come down on the side of the 'real' or the 'simulacrum', it might be better to force these respective concerns into a fruitful friction and there to work the crisis that their meeting elicits.

So, I have no intention of defending some hypothetical postmodernist

project – surely far too strong and homogeneous an idea to be 'postmo-
dernist'? – but prefer instead to circulate among the perspectives, proposals
and possibilities that the debate over modernity and postmodernity has
uncovered. I would like to think that the 'noise' that has been generated,
the spaces that have been opened up between the signs, and the subsequent
disturbance in discursive regimes, betray an unsuspected 'truth' about the
contemporary critical condition. This truth may perhaps help us better to
experience and engage in what Stuart calls a more adequate account.

Naturally, any idea of 'adequacy' invokes the testing of previous limits.
Working over previous ground does, almost inevitably, involve moving
beyond previous referent points; which, it must be emphasized, is not the
same as eradicating them. Postmodernism, whatever the variant chosen,
clearly invokes an attempt (and a temptation) to move beyond earlier points
of reference, although not necessarily in an obviously linear nor scorched-
earth fashion.

It is certainly imprecise and perhaps a little ungenerous to suggest that
postmodernity merely entertains the idea of the 'end of the world'. More
suggestively, and more accurately, it can be read to suggest the potential
ending of *a* world: a world of European, enlightened rationalism and its
metaphysical and positivist variants. In a sophisticated account à la Derrida
this would be to give shape through modernism to the end of modernism. In
a more immediate language it would be to contest a world that is white,
male and Eurocentric, and which believes its rationalizations to be the
highest form of reason.

This particular world is indeed increasingly cracking apart as both
internal and external forms of history, knowledge and power multiply.
Old meanings do indeed find themselves meaning-less. There is a new
complexity that can be received either as an extension of sense or as the
manifesto of its eventual dissipation. In certain areas of a heterogeneous
postmodern constituency there is the welcomed registration of this
expanded condition. Elsewhere, it has led to an altogether darker vision,
particularly when concentrated in the acerbic prose of Jean Baudrillard's
negative reports from the semantic edges of the contemporary universe.

However, notwithstanding its exasperating cybernese style it is possible
to discern in the sheen of Baudrillard's breathless prose the unmistakable
echoes of a critical configuration that resonates with Lukács, the Frankfurt
School, the Situationists and the vocabulary of alienated consciousness.
Pushed to its logical limit, the commodification of the world – the 'hyper-
reality' of a totally alienated social existence – comes to its final steady-
state in the simulacrum: use values are obliterated in an incessant exchange
of signs that bear 'no relation to any reality whatever'. We thus now find
ourselves in the next logical step after alienation – the obscene transparency
of the post-spectacle:

so long as there is alienation, there is spectacle, action, scene. . . .
Obscenity begins precisely where there is no more spectacle, no more
scene, when all becomes transparent and immediate visibility, when
everything is exposed to the harsh and inexorable light of information
and communication.[2]

The concentrated vehemence in these sort of pronouncements by Baudril-
lard, who is often considered to be the totemic source of the postmodern
malaise, perhaps symptomatically reveals his vicinity to his anguished
accusers. Seeking to preserve the project of modernity, they cannot for-
give him for cynically betraying the faculty that permits him to speak. By
carrying to the extreme, where reason runs riot, the logic of alienated
consciousness, he has unavoidably exposed the Other, the repressed, the
unconscious, side of the occidental *ratio* in a parodic rhapsody.[3]

In a world that is seemingly running down, that every day is choked with
signs producing less and less sense, Baudrillard's phlegmatic philosophy
offers a bleak dirge for the loss of meaning, for the withering away of
stable, semantic guarantees, the referents, that have been nullified in the
empty space between the signs. Baudrillard's voice here becomes that of a
latter-day *flâneur* in a dying universe, casting the concentrated light of his
melancholic reason on the semiotic entropy of a world lost in space. This
does not represent a passive acceptance of the present so much as the
logical extension of a negative rationalism: an excess that spills over and
sabotages the limits of the previously 'rational'. We can choose to read it as
the inadvertent acknowledgement that a certain critical 'distance', author-
ity and truth is being ineluctably swept away in the enveloping and
apparently indifferent movement of the modern world. This is what Bau-
drillard himself likes to call the 'historical collapse' in which everything
becomes ecstatic and ex-centric, without referent or centre.

But the rhetorical flourish of the 'collapse of the real' is ultimately a
deeply ambiguous assertion. What is undoubtedly collapsing is an earlier
confidence in assigning an unequivocal sense of the 'real' conceived of in
terms of a rationalist paradigm that produces a complete and potentially
exhaustive sense of knowledge. Knowledge, and the realities it speaks for,
becomes altogether more complex. The rationalist plane is supplemented
by more complex epistemological figures and a series of ontological
openings that call for a radical revision of history, culture and politics.
As Edward Said insists, any rationalist codification – the 'knowledge' that
constitutes the field of 'Orientalism', for instance – is at the same time a
codification of the historical powers invested in the paradigm and in their
underlying relation to the 'real': Eurocentrism, imperialism and racism, for
example.[4] Such a breach in 'reality' can therefore be fruitfully exposed and
explored in order to deviate and unpack the languages that previously
blocked our passage to the recognition of other realities. At this point

the 'collapse of the real' need not necessarily cast us into a mournful solipsism, for it can also lead us out of the hall of mirrors peopled with Eurocentric reflections towards the disruption of previous enclosures and the reception of a wider horizon.

The idea of a neat (epistemological) break between modernism and postmodernism is, of course, the figment of an apocalyptic imagination. Many tendencies that today are nominated in the postmodern condition – from the languages of pastiche and collage to the interruption and æsthetics of shock and alterity – were clearly also central to modernism. To argue in this manner, with a commitment to a linear perception of change and 'progress' would surely be at odds with a postmodernist critique. It might be better to think rather in terms of a shift in the constellation. The same languages, the same tendencies and techniques, acquire a different configuration when viewed from another perspective. The stars do not disappear, but the constellation changes shape. The power of illumination cast by individual planets and suns sometimes wanes, elsewhere increases. They remain, the universe *is there*, but the knowledge we have of it is neither obvious nor merely accumulative.

To search for a precise 'break' is futile. Nevertheless, among the preliminary moments that undoubtedly made a major internal contribution to shifting the axes of the critical constellation that we in the West have inherited are the decades around 1900. That is when in Europe the naive factuality of realism was deliberately sabotaged as language and representation broke down and the avant-gardes emerged to tour their ruins: in the visual arts, in writing, in music, in theatre. The discourse on and of psychoanalysis that emerged in those years was perhaps the sharpest recognition of a reality in which the apparent and rationally received is always shadowed by an 'other', by an unconscious that haunts the etymological marriage of criticism with crisis, with semantic breakdown and the limits of meaning. To this disruptive process is to be added the growing intrusion of the previously ignored pleasures, possibilities and provocation of urban popular culture as the present century advances: 'the advent of that new era designated in *Finnegans Wake* by the letters HCE: Here Comes Everybody'.[5]

Until quite recently popular culture has lacked a 'serious' discourse. It was invariably disassociated from intellectual life, usually considered its demonic antithesis, and so was completely underrepresented in theory, except by negation; in other words, it was not 'culture'. But the experiences of the modern city and the languages of popular music, cinema and television, together with the metropolitan cycles of fashion and style, produced subjects who appropriated and transformed the world they inhabited without the approval of institutional mandarins. This divided sense of culture – as a minimum, 'ours' and 'theirs' – deepened to the point of crisis the longstanding historical distinction between the 'popular'

and the 'cultivated'. For there were now whole cityscapes, soundscapes, visualscapes and pleasurescapes, whole 'worlds', existing quite oblivious of the canons of 'art', 'culture' and 'good taste'. In the obvious challenge to earlier assumptions over the 'knowledge' and 'meaning' of culture, the provocation of modern, mass culture acquired a fundamental political resonance as the 'culture and society' debate slowly came to be democratized.

The 'masses' Stuart refers to have become individual historical subjects, at least in western capitalist societies, not so much through the representative organs of parliamentary democracy (a fairly limited institution, especially in Britain), but through the diverse modalities of urban popular culture. It is there that the greatest exercise in the powers of individual and local choice and taste has been realized, effectively remaking the field of culture in a far more extensive fashion than the presence of the 'masses' in the more restricted field of politics has so far achieved. To adopt this perspective is to raise questions about the understanding of power and politics in the everyday world. Perhaps the particular histories of culture and politics in Britain, and elsewhere in the West, suggest that it is not a more political culture that is needed but rather a culture that interrupts and interrogates the existing codification of the 'political'. This would be to reiterate and reinforce the Gramscian proposition that it is 'civil society' that makes 'political society' possible.

Those areas traditionally most excluded from the 'political' – identifications secured in gender, race, sexuality, the familial, but also in the psychic and the poetic (in sum, what was once consigned to the anonymous world of the 'private') – provide the languages in which daily sense is usually secured and where eventually more extensive communal and social meanings (politics) take shape. It has been in these areas, in the 'microphysics of power', that political discourse has experienced its most significant interrogations and innovations over the last thirty years: black power, feminism, gay liberation, ecology. Meanwhile, the 'real world' of institutional politics does indeed often seem to be a mere simulacrum: untouched and uncontrolled by sentiments and sensibilities that originate elsewhere, an empty sign-play that constitutes 'government'. The effects are felt, are real enough – in Europe the systematic tendency towards dismantling the welfare state; in Britain a major war waged in the South Atlantic in the name of national sovereignty – but the machinery remains distant and opaque, the language rarely rising above the semantics of slogans. This is the other side of democracy, your abstract involvement (representation) is disinvested of real involvement (power). Most of us do indeed experience institutional politics as a simulacrum of power, not as an intervention in the 'real'.

A crisis in the languages of representation, both in culture and politics, fundamentally involves a crisis in the legitimation of knowledge and power. The productive tensions in this crisis have many histories and follow diverse tempos. They do not really acquire wider, effective contact

and shape until the 1950s and 1960s. Perhaps this is only finally caught up with and acknowledged (?) by some intellectuals in Anglo-American contexts in the 1970s when the term 'postmodernism' begins to make the rounds in architecture and the visual arts, often crossing and sometimes colluding with subsequent interrogations emerging from 'cultural studies', and then even more extensively in continental western Europe in the wake of the 'crisis of marxism' in the 1980s.

This shift, which is certainly not unified, can nevertheless be traced in critical, historical, political and æsthetic terms. It is most marked by a movement away from an idealized, theoretical production that reveals the 'real relations' and political agendas of a culture and world rendered transparent by critique. That comforting clarity has largely been forsaken for an engagement with the experiential and contingent meanings (which, of course, are not without their own abstract, theorizing moment) involved in inhabiting the opaque complexities of inherited, and unresolved, histories. At this point, in the 'critique of the critique' (Nietzsche), we enter the zone of the post-ideological, not because ideologies have somehow magically evaporated, but because the need to step beyond the earlier securities of ideological critique is now explicitly evoked. What was once considered to be the point of critical arrival – the revelation of the critique – has become the point of departure in an altogether more uncertain journey as thought abandons its own ideological stance, its 'critical distance', and is displaced from an exterior and universal point of view to a more modest but involved sense in its own prosaic practices and politics.

So, there is no clean break or sharp rupture but rather a widening sense of attempts to break through, break up and rewrite languages that are straining under the load of the present. At this point, postmodernism, like any –ism, is not, of course, the answer. But its disruptive presence, which is certainly both theoretical, irreverent and sometimes simply modish, has produced a space in the West in which to explicitly evaluate the adequacy of our accounts. Its nihilist strain has provided the opportunity to break with the silent authority of certain inheritances and to more self-consciously address the conditions of contemporary critical work. This, however, is not to say that the past is merely abandoned, rather it comes to be reworked and re-sited from another vantage point: its traces are not merely accumulative, they are also polidimensional and re-scriptable. Put in other terms, the world we inherit and inhabit can still be transformed.

Postscript: the breath of language

Japanese: . . . the temptation is great to rely on European ways of representation and their concepts.
Inquirer: That temptation is reinforced by a process which I would call the complete Europeanization of the earth and of man.

Martin Heidegger[6]

The previous sentiments were formulated some time ago. To return to them today, however, is still to return to a crisis in the languages of criticism, now increasingly concentrated in the earlier claims of the West to represent the rest. Once more there is both a shift and an accentuation. For it is again to take up those journeys into language that have simultaneously located there, in language itself, the essence of the West and its crisis. This is encountered in the celebrated Nietzschean transvaluation of all values, in the Heideggerean recovery of 'being', as well as, in an altogether more resigned register, in the gloomy announcement of the exhaustion of occidental energies. But before we take sides on this point, and thereby blithely accept the story of the unwinding of the springs of western metaphysics, perhaps we need to dwell a little longer among the questions that this event, whether real or imagined, foregrounds. If the West is undone, what forces and what circumstances have led to the dispersal of its power? And what if the West has, in a strange, asymmetrical manner, also become the 'world', what does this mean? For if the West is in decline there have also unmistakably emerged from its shadows others who speak its languages while simultaneously signalling their provenance elsewhere: both in but not completely of the West, as C. L. R. James and Paul Gilroy point out. These voices, along with those who have been historically defined as its internal Other, called upon to represent the obscured and denied side of occidental reason that resides in being a woman, a Jew, apparently flaunt a disturbing excess. In this complex rendez-vous within the languages of the West there emerges a supplement that becomes irreducible to the imperious unity that its languages were once presumed to embody.

Such a transvaluation of language might persuade us then to think not so much in terms of absolute rupture, contrastive division, breakdown and overthrow, but rather in terms of radical reconfigurations, rewritings and re-routings that lead to sharp, frequently dramatic, alterations in accent, tone, cultural sense and the political accounting of time. In this act of dispersal the European subject is potentially displaced within the languages s/he is accustomed to employ. This may not mark the end of the 'real' but perhaps inaugurates the termination of the epistemological pretensions that once elevated western 'realism' – whether in the camera lens, the anthropological notebook, or literary, historical and sociological narratives – to the role of providing a privileged access to truth. Glossing Nietzsche, Michel Foucault once pointed out that it is not error, illusion, alienated consciousness or ideology but the question of truth itself that is the central political question that carries the name of the West. Put in these terms, this represents a challenge to an institutional and psychic disposition which, even after Nietzsche, after Freud, continues to insist on a 'natural', or 'commonsensical', set of distinctions between 'fact' and 'fantasy', between what 'actually happened' and what is 'constructed' or construed. The exposure of such pretensions, and the silent arrogance of its

underlying positivism, perhaps better reveals the deeper stakes involved in the diverse political regimes of truth that are being contested along contemporary critical divides. Here we are forced to focus sharply on the disposition of truth that grounds and disciplines the vaguer critical gesturing towards discussion of 'totalities', 'cognitive mappings', 'master narratives' and 'epistemes'. For to contest the truth of 'realism' is to confute the idea that it offers a transparent window which immediately reveals the world to my inquisitive gaze. It suggests that what I see is ultimately what I desire and have been taught to see: the reflection of my gaze, the embodiment of my presence.

To delimit and locate the narcissism of this aggrandizing gesture, the optic and vocal empires, the physical appropriation of the world, that laid up 'knowledge' in this manner, means to query the inherited grammar of an epistemology that presumes that the world commences with me, the subject, and then proceeds outwards nominating and collating reality 'in an exploratory, necessarily exploitative way'.[7] This is to assume that I, the subject, always come before language, before history. Such a 'grammatical fallacy' (Nietzsche) fails to entertain the possibility that the subject comes after language, in its wake, listening to the call of its possibilities. 'What we speak of, language, is always ahead of us.'[8] In the latter, anterior, sense of history and language there lie the seeds of disruption. My coming after language drastically removes the foundations for the accepted scenario of linear time. The accumulation of objects by the individual subject that contributes directly to the cultural capital of 'progress' is disrupted. In displacing the presumed autonomy of the subject and its assumed teleology of historical agency and political will, in this dispersal of the concepts with which we have been taught to conceive of historical, political and cultural 'reality', not only is the confident liberal agenda of rational consensus disrupted but also the very language of European identification undermined.

To abandon the confident appropriation of meaning and representation, and to acknowledge that the languages of nomination are neither neutral nor transparent, can be particularly hard for the pragmatic formation of Anglo-American empiricism to digest. That opening within the West historically and culturally lies elsewhere. In the distinction between modern analytical philosophy, with its insistence on the underlying logic of language, and post-Nietzschean meditations on the metaphysical opaqueness of 'language as being and being as language' (Heidegger) there exists a gap through which much of postwar critical European thought has travelled.[9] Viewed from the other side of the Channel, and of the Atlantic, faith in the ultimate transparency of language can be considered to mark a refusal to investigate our being in the very constitution of being (language). To cling to the logic of linguistics and abhor ambiguity is to ignore the shadows, the unknown paths and openings in language,

sometimes also the space of terror, in order to relentlessly reduce the world to an illusory semantic unity. The instance of alterity, and the potential ethical opening it installs in the languages of our being, is here nullified in the closed economy of a unilateral and universal reason.

But lest this opening appears as yet one more recuperation of the West, the final gesture drawn from the energies of its dissipation, where and how we move in this gap, this interval, where we go is not solely dependent upon this rent in occidental thought as though such an 'origin' could claim language, and the critical disposition of being, as its property. For this is only one 'cut', one 'version', itself perhaps only a displaced disruption of a diverse 'wordling of the world' (Heidegger) in which the injections of feminism, the histories of ethnic positionalities and the interruptions of postcoloniality have become the insistent markers of a diverse and differential inhabitation of such languages. In particular, the shift from 'Third World' criticism to 'postcoloniality' invokes an explicit critique of the spatial metaphors and the temporal axis employed in 'First World' discourses. Whereas the former designation was intended to signal both spatial and temporal distance – 'out there' and 'back there' – the postcolonial perspective insists, in both spatial and temporal terms, that the 'other' world is 'in here'. That heterogeneous other world, with all its particular differences and distinctions, is *integral* to what the West refers to as 'modernity' and 'progress'; it contributes directly in its labour and being exploited, certainly, but also in its modalities and æsthetics, in its immediacy and presence, to constituting the languages and possibilities of the West and their distillation into the world. Clearly, this is not to claim and defend the 'Third World' as a separate or autonomous reality, but is rather to attempt the more ambitious and decisive task of rewriting the hegemonic accounting of time (history), and its spatial distribution of knowledge (power), that previously produced and positioned the 'Third World' as a necessary effect of its languages.

What can be registered at this point, as we negotiate our diverse ways in these languages, is that resisting and rewriting them can no longer appeal to the securities of stable truth or fixed identity. These, too, are among the interrupted and discontinued narratives of the West. The desire for the transparent logic of a radically alternative ontology, even when voiced in the name of the previously excluded, defeated and marginalized, is a chimera that can only provide the consolatory comfort of an ineffectual political 'correctness'. To repudiate the illusory resolution of a ready-made truth, and the appealing purity of transforming the once negative into a positive counter-image, is to refuse the proposal of reducing the world to a single centre of meaning and authority, whether 'ours' or 'theirs', black or white. It is to attempt to learn to live without the edicts of a prescribed homeland and to dwell in the traumatic region of *Unheimlich* (Freud, Heidegger).

Denied the possibility of returning home to a unique house of truth we are made painfully aware that there is no escape from the histories and powers that disrupt and perturb such a desire. There is no exit, no cure. Our only 'choice is not to sublimate and not to negate the condition of precariousness and crisis but to know it.'[10] This promotes the disquieting disturbance of a perpetual interrogation that destabilizes us all. Re-citing and re-siting our critical traditions and inheritances in the languages of historical configuration, beyond the silent dream of pure alterity or the theoretical redemption of an absolute truth, we are forced to speak and reveal ourselves in a world that does not always and necessarily respect the scriptural authority of the Word or of the West. Our histories become vulnerable (Gayatri Chakravorty Spivak). In the passage from the visual acknowledgement of the other's face to the other's voice, from my gaze to the other's locution, from the categorizing power of my look to the disturbing intonation of the stranger's body, I pass from a politics of sight to one of listening in which what I hear exceeds the idea of the other in me.[11] Here, trying to decipher the opaque, the cartographer's pen splutters into a smudge and my reading is disabled. Here I sometimes catch in the silence of language the breath of a body that is not my own. The text, language, the world, is punctuated by this opening, is now lacerated by voices, bodies and narratives that a previously unsuspecting reason can no longer dispose of.

NOTES

1 See the two classic volumes by Raymond Williams: *Culture and Society*, Harmondsworth: Penguin, 1961, and *The Long Revolution*, Harmondsworth: Penguin, 1965.
2 Jean Baudrillard, 'The Ecstasy of Communication' in H. Foster (ed.), *The Anti-Aesthetic*, Port Townsend: Bay Press, 1983.
3 This potential had of course already been starkly brought home by Max Horkheimer and Theodor Adorno in their *Dialectic of Enlightenment*, New York: Herder & Herder, 1972.
4 Edward Said, *Orientalism*, New York: Pantheon, 1978.
5 Norman O. Brown, 'Dionysus in 1990', in Norman O. Brown, *Apocalypse and/or Metamorphosis*, Berkeley and Oxford: University of California, 1991, 190.
6 Martin Heidegger, 'A dialogue on language', in Martin Heidegger, *On The Way To Language*, New York: Harper & Row, 1982, 15 (originated in 1953/4 on the occasion of a visit by Professor Tezuka of the Imperial University, Tokyo, ibid., 199.)
7 George Steiner, *Heidegger*, London: Fontana, 1992, 32.
8 Martin Heidegger, 'The nature of language', in Martin Heidegger, *On The Way To Language*, New York: Harper & Row, 1982, 75.
9 Much of this has been relayed through Parisian circles. Yet, outside France, the centrality of Nietzsche and Heidegger in post-war French thought is rarely considered. It encompasses, beyond the more obvious case of Sartre's existentialism, Lacan, Bataille, Blanchot, Althusser, Foucault, Derrida, Irigaray,

Cixous, de Certeau; in other words, a series of overlapping critical constellations that have induced the most profound internal revision of western discourses over the last three decades. However, and this seems hardly incidental at this point, Gayatri Spivak's important 'Translator's preface' to the English language edition of Jacques Derrida's *Of Grammatology*, Baltimore: Johns Hopkins Press, 1977, is also steeped in Heideggerean language.

10 Franco Rella, *Il mito dell'altro*, Milano: Feltrinelli, 1978.

11 '. . . we name this calling into question of my spontaneity by the presence of the other ethics.' Emmanuel Lévinas, *Totality and Infinity*, Pittsburg: Duquesne University Press.

Chapter 10

Opening the Hallway
Some remarks on the fertility of Stuart Hall's contribution to critical theory

John Fiske

If we had to characterize Stuart Hall's contribution to the development of cultural studies in one word, that word would be 'open'. His work typically opens up what had seemed to be closed off; his project is always open-ended, always in progress and thus always open to the contributions of others; he constantly opens doors through which people may pass and meet, sometimes surprisingly as when he brings Lévi-Strauss through one, Gramsci through another and shows that the conversation between them is richer than the monologues in their own rooms. And his political energies never deviate from his aim of opening up the strategies of the power bloc to critical inspection, and opening up the democratic processes to those who would use them to advance democracy.

Though scrupulously situating his work within a marxist tradition, he is in constant and productive disagreement with the rigidly determinist and reductionist strands within it. He brings Laclau into conversation with Althusser and demonstrates that the way that contributors to *Screen* developed Althusser's theory of ideology into a closed and totalizing system was tactical and not necessary: indeed, the concept of the 'not necessary' is one that he uses often and productively to open up mechanically deterministic accounts of the overdetermining structural relations that Althusser describes so convincingly. By showing that the structural pressure exerted by these relations is not the same as necessary determination, Hall opens up the closed system of *Screen*'s Althusserianism and finds spaces for engagement that its totalizing tendency denies: he shows that the relations that are formed are the result of social agency in historically contingent conditions, and that social agency can be exerted by formations of the people as well as by those of the power bloc. He detaches ideology from any necessary exclusive articulation with the interests of the dominant classes and shows that subordinate social groups can, and do, produce

This article is based on ideas initially developed in John Fiske and Jon Watts' 'An articulating culture: Hall, meaning and power', in the 1986 *Journal of Communication Inquiry*'s *Special Issue* on Stuart Hall.

ideologies that function for them as does Ideology-with-a-capital for the power bloc. Ideology for him is simultaneously a strategy of domination and a terrain of struggle.

His double use of the concept of articulation (both 'speaking' [sense 1] and 'linking' [sense 2]) is central in his theorizing, and one of its most enabling uses is to bring Gramsci and Volosinov into conversation with Althusser, Saussure and Lévi-Strauss. He develops Volosinov's theory of 'accent' to argue that the contingent conditions in which language is spoken (or articulated–1), form the speaker's point of entry into a parti- cular set of social relations (or articulation–2). Giving language an accent is articulating it fully, and until it is accented/articulated language, like other deep cultural structures, is another closed and totalizing system. Accenting it, therefore, makes it historically contingent and opens it up as a terrain of struggle. The struggle for meaning, which Hall insists is integral to the social struggle at large, can only take place in historically specific conditions, and Hall never allows us to forget that these conditions of struggle are determined (in his opened sense of the word) by the historically transcendent structures theorized by Althusser, Lévi-Strauss and Saussure. Language was central in the thinking of all these structural- ists: for Saussure it was the defining and universal human attribute, for Lévi-Strauss it formed the model for all cultural systems, and for Althusser, as for Lacan, language was the structuring principle of ideology and the unconscious. Hall found in their insistence that one cannot understand social experience without a thorough understanding of language a way to correct what he saw as an undervaluation of the importance of language and representation in traditional marxism, particularly in its insistence on the primacy of economic relations. His theory of articulation brings together social and economic relations, historical conditions, and language in a way that has opened up some of the richest strands of work in cultural studies.

Hall found fertile soil in which to propagate his theories in the work of Gramsci. Indeed, the theory of articulation may be seen as a direct descendent of Gramsci's argument that the elaborated societies of capital- ism required political struggles to be fought by bloc formation rather than by structurally determined class relations. A bloc is an alliance of social forces formed to promote common social interests as they can be brought together in particular historical conditions. Like articulation, bloc forma- tion requires active and intentional political work, and, like articulation also, it occurs within determining conditions but its labour can transform, if only slightly, those conditions within which it works. Articulation describes a form of semiotic activism that continues the more directly political activism of bloc formation. Both Gramsci and Hall insist on the centrality of economic or class relations in any critical analysis of the socio-cultural world, but insisting on their importance does not, in either

thinker, mean granting them the position of prime determinant. Hall and Gramsci both recognize that economic conditions cannot be divorced from cultural conditions and that class struggles must, therefore, involve cultural struggles, not as secondary, but as integral.

For Hall, then, representation (which he saw as the key form of cultural labour) was real. There was no essential social reality that was then represented: reality could not take an essential precedence over representation, for representation was itself a necessary means of securing reality. To the extent that representations are real in their effects, they produce what passes for real in any particular conditions. Social reality and representation are mutually constitutive, and the relations between them are necessarily political. The labour of representation, the work of making things mean, is as real a form of labour and as necessary to capitalism as that performed on the factory floor.

Though Hall is deeply suspicious of postmodernism, particularly and justifiably of the ease with which the political and the socially specific can be evacuated from its concerns, there is an irony to his anxiety, for, of all the critical theorists working within the (broadly conceived) marxist tradition, Hall is the one whose work translates most readily into postmodern conditions. His opening up of closed systems of determination adapts to the fluidity that postmodernism claims to itself, but Hall's insistence that the structures still operate, if less predictably, prevents the slippage into postmodern indeterminacy: his theory of articulation resonates with the Derridean refusal to allow meaning any fixity, but his insistence that meanings *are* made, *are* held in place and *are* used in particular if temporary conditions prevents any slippage into the political desert of meanings in infinite deferral: his refusal of any essential precedence of the real over the representation prefigures the postmodern collapse of systems of categorization and hierarchization, yet Hall refuses to allow the absence of essential hierarchies to entail the absence of contingent ones: His argument that representations are real is similar in some ways to Baudrillard's notion of the simulacrum, yet his insistence on the social reality of which the representations are part avoids the total loss of the real and the consequent evasion of the problem of how perceived phenomena can be articulated into a sense of reality that has real effects in a way that simulacra do not — and these reality effects, of course, are the site of the political, so their absence in the theory of the simulacrum accounts for its potential depoliticization.

While Hall may be over-critical of postmodernism, his criticism does not stem from a reactionary rejection of it, but from a desire to warn that its excesses do allow some of its practitioners to lose the dimension of critical analysis and thus of political potential. This warning is well founded. But Hall is well aware that there is a 'reality' to the conditions

that postmodernism identifies as its own, and he is well aware that critical theory needs to engage with them.

Postmodernism, he says, is the current name given to the problems raised with the 'disintegration of whole experiences' which began in the 1920s. In accusing postmodernism of attempting to 'gather them all under a single sign', a sign which says 'this is the end of the world', Hall uses allegory: 'If the *Titanic* is going down, how long is it going to take? If the bomb has gone off, it can't go on going off forever.' The allusion to disaster is ideologically significant, but more telling is the suggestion that the discursive suspension of closure-as-meaning in the face of the ultimate closure is, *ipso facto*, the suspension of meaning as anything other than metaphor.

If the *Titanic* is going down, the question 'How long is it going to take? ' becomes less immediately demanding than 'What shall we do in the meantime? ' Meaning is less urgent than experience and pleasure – a notion that Hall rarely manages to take on board (to continue the metaphor) in his theory. For Hall, the struggle for meaning is too important, too inherently serious, to be adequately explained by a theory of pleasure.

This concept of pleasure as deceptive and culpable is too Althusserian, too unproblematic. If postmodern love and human relationships are as profoundly different as Hall suggests – although he doesn't say where the difference lies – then one question begged asks about the failure of ideological approaches to examine meanings of pleasure rather than to see it only as escape from or evasion of narrative closure and denial of consequences. Dominance exists as epistemology not simply as power.

Pleasure-as-resistance and/or -refusal is no less proscribed by an articulating politics of meaning than are more 'rational' regimes. This might be illustrated if we take a look at Hall's comments on Baudrillard. He assumes that Baudrillard is suggesting that there is a 'shared facticity of things, things are just what we seem on the surface'. However, this seems to be something of a forced reading: Baudrillard (1983) writes in his article 'Implosion of meaning in the media' that: 'Information devours its own contents. It devours communication and the social for two reasons. Instead of communication it exhausts itself in the act of staging the communication. Instead of producing meaning it exhausts itself in the staging of meaning' (1). This is very different from saying that meaning simply resides on the surface. Rather Baudrillard is suggesting that the surface is where meaning is performed as process, not produced as product. Baudrillard's denial of any deep structure that organizes reality certainly puts him on the other side of the street from Hall, but his notion that meanings exist only in their performance or staging may not be as politically vacuous as Hall implies: it may well be that ideological processes, as processes of information or processes of explanation or revelation, have become precisely this sort of vehicle for meaning. In which case pleasure

can be seen as part of the resistance of the masses that Baudrillard talks about and that Hall seems to have avoided in Baudrillard's work. Baudrillard (1983) suggests that this resistance is 'equivalent to sending back to the system its own logic by doubling it to reflecting like a mirror meaning without absorbing it'. It may well be that pleasure is one of the resistances of the masses and that part of the function of this pleasure is an attempt to disrupt or refuse the seemingly necessary relations of power that ideology requires for the distribution and transferral of meaning within social structures.

Hall seems to find the work of Foucault more problematic than that of any other postmodernist, probably because he thinks it is the most significant and most serious. On the face of it Hall and Foucault appear to have much in common – their politicized and critically engaged studies of how the defining and controlling social forces of capitalism operate in particular historical conditions; their deeply felt conviction that Western modernity has produced societies that are fundamentally alienating and inhumane; and their assumption that the *raison d'être* of socio-cultural analysis is to intervene in the object of its study.

Hall is suspicious that Foucault's emphasis on the dispersed technologies of power denies the value of any systematic analysis of power as a structuring principle: He is worried that Foucault's disconnection of power from *any* class belongingness has taken too far his own and Laclau's notion of no necessary class belongingness. He is worried, too, that Foucault's shift of the focal point of critical analysis away from ideology and consciousness to power and the body risks throwing out the healthy and useful politics of meaning along with the dirty bath-water of a 'grand narrative' theory of ideology. Certainly, Foucault does not find the concept of ideology necessary to his account of the micro-techologies by which power produces the docile body, and by which, through disciplining individuated bodies, it reaches to the heart of the social body. But the ultimate object of Foucault's theory and analytical method may not be that far distanced from Hall's. For Foucault the normalization of the body and its ways of behaving is necessarily part of the normalization of the mind and its ways of knowing/believing. Foucault's theory of the power of discourse to produce truth is operating in the same arena as Hall's theory of the work of representation to produce reality. The key theoretical difference between them may be summarized as that between structuralism and post-structuralism.

Although Hall's work has thoroughly loosened up the overdetermining relations among the structuring forces of capitalism, it has not displaced them. He sees clear structural connections between the class interests that inform, say, the work of representation in the media and the class interests that control the economy, and for him, ideology can only be understood in terms of these, and other, social relations: for him ideology is structural.

His account of representation is deeply informed by structural linguistics, particularly through the work of Lévi-Strauss and Barthes, and this theory always accords a determining pressure to the linguistic structure or *langue*: to some extent, the way in which *langue* is structured always determines what can be said, and the way in which it is structured is overdetermined by its relations with the way the economy is structured, the way political life is structured and so on. The constant echoes of the organizing regularities that interconnect systems of representation with systems of politics, of education, of law and order and, of course, the economy are what give Hall's work a footing in the structuralist enterprise (albeit, as we have argued, he seems always poised to step out of it into the post-structuralist one).

Foucault's theory of discourse, however, focuses on what is said, publicly and powerfully, in particular social conditions rather than on the structural regularities that enable it to be spoken. The power to put certain meanings into public discourse and to repress others is, for Foucault, a social technology parallel to the power to produce certain bodily behaviours as normal and to repress or abnormalize others. Dispersed though they are, the micro-technologies of power are not haphazard. Foucault's focus on their sites of operation rather than on their systematic interrelations gives priority to an empirical materiality over a theorized abstraction: these multiple technologies do work finally as an overarching regime of power, but the regime can be experienced only in the concreteness of its multifarious, widely dispersed and very particular applications. For Foucault, discourse is as material and as power-effective as incarceration or surgery. The way that Foucault theorizes the operation of power through discourse to discipline speech, meanings and behaviour does not, in the last resort, seem too far removed from Hall's theory of representation.

It is, however, directly opposed to the high structuralism of Althusserianism and Lacanianism. Foucault's object of study has a materiality and a concreteness (what *is* said, power that *is* applied, the *techniques* of application) that directly contradicts high structuralism's argument that the ultimate reality consists of the deep structuring relations that transcend the immediate conditions in which they operate: high structuralism's object of study, then is accessible only through macro-theoretical rather than empirical methodology. Hall's constant return to concrete political and social conditions, his insistence that the real effects of ideology and of representation are material, historically specific and available for empirical analysis would appear to have to have affinities with more of Foucault's work than he is prepared to recognize. This, of course, is the Gramscian or 'culturalist' side of Hall rather than the structuralist one.

Hall's suspicion of Foucault is uncharacteristic. What we would have expected as more in character with his work in general, would be to see Hall opening up a dialogue between Gramsci and Foucault, in which, for

instance, Gramsci's concept of the 'power bloc' might serve to reconnect Foucault's abstracted theory of power not to a class but to an alliance of social interests, and in which Foucault's centrality of the body as a site of power and resistance might compensate for Gramsci's (historically contingent) failure to consider social relations where the winning of consent has never been an issue, such as those of slavery.

There is a further point that underlies Hall's suspicion of postmodernism. This is his feeling that it is a simplistic model that evades engaging with the complexities and contradictions of a late capitalist society. By denying meaning, by denying ideology it denies the unequal distribution of power in society, the perception of which has always been an informing perspective in Hall's work. Entailed by this is the notion that meanings not only exist, but are full of the same contradictory and contesting forces as the society which produces, circulates and consumes them.

His theory of articulation precisely addresses this sense of complexity. It is a sophistication of his earlier 'preferred reading' theory which insisted on the reader's ability to contest and modify meanings promoted by the dominant ideology: this contestation was socially determined so that the relationship of the reader to the text reproduced the relationship of his/her social location to the dominant ideology. The theory of articulation takes this a stage further by denying a monosemic view of the dominant ideology – ideology does not say the same things to the same people at the same time. Rather it works through cultural forms whose meanings and political effectivity are determined by how they are articulated with other forms. So when MTV is articulated with the music industry its meanings are those of advertising, and a rock video is a more or less effective commercial for the record or group it is promoting. But when it is articulated (linked) with the politics of pleasure it can articulate (speak) resistances to, and evasions of, the capitalist social machine. As MTV is articulated (linked) differently to other cultural formations of capitalism, so the capitalism inscribed in it and the effectivity of its inscription, is differently articulated (spoken). As the viewer's social relations contradict those of the producers, so his/her articulations (linkages and speech) of MTV will contradict the capitalist ideology.

But Hall is careful to argue that an oppositional articulation of a cultural form has no necessary connection with radical politics. A change in cultural form (for example, MTV) or a change in social forces (for example, Rastafarianism) need not produce changes in the political system because their cultural domains are not necessarily articulated with that of politics. A rock subculture or a black subculture may not find direct political action necessary to their subcultural experience. But, on the other hand, they may: political action is always possible, though never necessary. Articulation does not just happen as a structural effect: it is a process of struggle that requires active, intentional and directed engagement.

It is by discursive practices such as the politics of meaning that social differences are kept alive and well, and through which they are able to exert constant resistances (however varied in degree and kind) to the equally constant attempts of the dominant to make their social power as effective as possible. And this points to a profound difference between Hall and Baudrillard, for Hall *respects* those social groups that Baudrillard lumps dismissively under the term 'the masses'. Hall respects the cultural resistance of the disempowered and subordinated. Despite more than a century of economic, political and ideological domination, they are still active and kicking: they still make it difficult for hegemony to work, they still maintain an uncomfortable and unaccommodating variety of social identities despite the powerful political and economic attempts to homogenize them. For Hall, the people are not a passive, silent mass. Their power to contest meanings enables them to produce cultural formations through which they can speak and circulate their meanings. Hall's account of Rastafarian culture is a clear example of articulation in both senses of the word. This ability of the subordinate to re-articulate themselves as their material conditions change and as their meanings of those conditions change is evidence of the vitality and resilience that Hall respects so deeply.

But this ability to articulate a subcultural identity exists only within and against hegemonic forces. Hall recognizes clearly that discursive resources are as inequitably distributed as economic resources, and that the subordinate arc limited to devalued and disempowered discursive formations – they rarely speak in literature, in film, on television. But they do speak, they do make their own meanings, for their own identities: The discourse of the repressed is never *as* repressed as Foucault implies.

And the role of an 'opened up' ideology is crucial to these struggles. What Hall calls an 'organic ideology', that is one arising from the shared material conditions of various formations of the people, can act to unify them and construct for them something approaching a class identity, a class consciousness. This organic ideology unifies by providing forms of intelligibility which explain the collective situation of different social groups: an organic ideology, then, empowers the subordinate. Feminism is a clear and potent example of an organic ideology working to unify and empower. (Incidentally, the comparative lack of acknowledgement of feminism in Hall's work is both surprising and unfortunate.) The notion of an ideology empowering the subordinate rather than the dominant may seem, on the face of it, a surprising one but it is a vital part of Hall's respect for the subordinate, for their power to resist the dominant, and to maintain awkward social contradictions.

Hall constantly emphasizes the contradictions in society, the contradictions in meanings, the contradictions in ideologies and the contradictions in subjectivities; and those pervasive, structural contradictions are both the

seeds and the fruit of resistance. But all these contradictory, competing cultural forces are not a sort of free-floating liberal pluralism, nor do they exist merely at the postmodern level of fragmented signifiers, but they are deeply inscribed in the material conditions of existence in capitalist societies and in the power relations that structure those conditions. Meanings underpin or undermine any given social order, but they cannot exist independent of it. The people are neither cultural dupes nor silenced victims, but are vital, resilient, varied, contradictory, and, as a source of constant contestations of dominance, are a vital social resource, the only one that can fuel social change. The politics of Hall's work is to recover, understand and legitimate these popular forces and in so doing to redefine and revalidate the social role of the intellectual.

REFERENCE

Baudrillard, J. (1983). *In the Shadow of the Silent Majorities . . . or the End of the Social and Other Essays*, (trans. P. Foss), New York: Semiotext(e).

Part III

New Times, transformations and transgressions

Chapter 11

The meaning of New Times

Stuart Hall

How new are these 'New Times'? Are they the dawn of a New Age or only the whisper of an old one? What is 'new' about them? How do we assess their contradictory tendencies – are they progressive or regressive? These are some of the questions which the ambiguous discourse of 'New Times' poses. They are worth asking, not because 'New Times' represents a definitive set of answers to them or even a clear way of resolving the ambiguities inherent in the idea, but because they stimulate the left to open a debate about how society is changing and to offer new descriptions and analyses of the social conditions it seeks to transcend and transform. If it succeeds in this, but accomplishes nothing else the metaphor of 'New Times' will have done its work.

As the questions suggest, there is considerable ambiguity as to what the phrase 'New Times' really means. It seems to be connected with the ascendancy of the New Right in Britain, the United States and some parts of Europe over the past decade. But what precisely is the connection? For example, are 'New Times' a product of 'the Thatcher revolution'? Was Thatcherism really so decisive and fundamental? And, if so, does that mean that the left has no alternative but to adapt to the changed terrain and agenda of politics, post-Thatcherism, if it is to survive? This is a very negative interpretation of 'New Times': and it is easy to see why those who read 'New Times' in this way regard the whole thing as a smokescreen for some seismic shift of gravity by the left towards the right.

There is, however, a different reading. This suggests that Thatcherism itself was, in part, produced by 'New Times'. On this interpretation, 'New Times' refers to social, economic, political and cultural changes of a deeper kind now taking place in western capitalist societies. These changes, it is suggested, form the necessary shaping context, the material and cultural conditions of existence, for *any* political strategy, whether of the right the or left. From this position, Thatcherism represents, in fact, in its own way,

Reprinted from Stuart Hall and Martin Jacques (eds) *New Times*, London: Lawrence & Wishart, 116–33.

an attempt (only partially successful) to harness and bend to its political project circumstances which were not of its making, which have a much longer history and trajectory, and which do not necessarily have a 'New Right' political agenda inscribed in them. Much turns on which version of 'New Times' one subscribes to.

If we take the 'New Times' idea apart, we find that it is an attempt to capture, within the confines of a single metaphor, a number of different facets of social change, none of which has any necessary connection with the other. In the current debates, a variety of different terms jostle with one another for pride of place, in the attempt to describe these different dimensions of change. They include 'post-industrial', 'post-Fordist', 'revolution of the subject', 'postmodernism'. None of these is wholly satisfactory. Each expresses a clearer sense of what we are leaving behind ('post' everything?) than of where we are heading. Each, however, signifies something important about the 'New Times' debate.

'Post-industrial' writers, like Alain Touraine and André Gorz start from shifts in the technical organization of industrial capitalist production, with its 'classic' economies of scale, integrated labour processes, advanced division of labour and industrial class conflicts. They foresee an increasing shift to new productive regimes – with inevitable consequences for social structure and politics. Thus Touraine has written of the replacement of older forms of class struggle by the new social movements; and Gorz's most provocative title is *Farewell to the Working Class*. In these forms, 'New Times' touches debates which have already seriously divided the left. There is certainly an important point about the shifting social and technical landscapes of modern industrial production regimes being made in some of these arguments, though they are open to the criticism that they fall for a sort of technological determinism.

'Post-Fordism' is a broader term, suggesting a whole new epoch distinct from the era of mass production, with its standardized products, concentrations of capital and its 'Taylorist' forms of work organization and discipline. The debate still rages as to whether 'post-Fordism' actually exists, and if it does, what exactly it is and how extensive it is, either within any single economy or across the advanced industrial economies of the West as a whole. Nevertheless, most commentators would agree that the term covers at least some of the following characteristics of change. A shift is taking place to new 'information technologies' from the chemical and electronic-based technologies which drove the 'second' industrial revolution from the turn of the century onwards – the one which signalled the advance of the American, German and Japanese economies to a leading position, and the relative 'backwardness' and incipient decline of the British economy. Second, there is a shift towards a more flexible specialized and decentralized form of labour process and work organization, and, as a consequence, a decline of the old manufacturing base (and the regions

and cultures associated with it) and the growth of the 'sunrise', computer-based, hi-tech industries and their regions. Third, there is the hiving-off or a contracting-out of functions and services hitherto provided 'in house' on a corporate basis. Fourth, there is a leading role for consumption, reflected in such things as greater emphasis on choice and product differentiation, on marketing, packaging and design, on the 'targeting' of consumers by lifestyle, taste and culture rather than by the Registrar General's categories of social class.

Fifth, there has been a decline in the proportion of the skilled, male, manual working class and the corresponding rise of the service and white-collar classes. In the domain of paid work itself, there is more flexi-time and part-time working, coupled with the 'feminization' and 'ethnicization' of the workforce. Sixth, there is an economy dominated by the multinationals, with their new international division of labour and their greater autonomy of nation-state control. Seventh, there is the 'globalization' of the new financial markets. Finally, there is the emergence of new patterns of social divisions – especially those between 'public' and 'private' sectors and between the two-thirds who have rising expectations and the 'new poor' and underclasses of the one-third that is left behind on every significant dimension of social opportunity.

It is clear that 'post-Fordism', though having a significant reference to questions of economic organization and structure, has a much broader social and cultural significance. Thus, for example, it also signals greater social fragmentation and pluralism, the weakening of older collective solidarities and block identities and the emergence of new identities as well as the maximization of individual choices through personal consumption, as equally significant dimensions of the shift towards 'post-Fordism'.

Some critics have suggested that 'post-Fordism' as a concept marks a return to the old, discredited base-superstructure or economic-determinist model according to which the economy determines everything and all other aspects can be 'read off' as simply reflecting that 'base'. However, the metaphor of 'post-Fordism' does not necessarily carry any such implication. Indeed, it is modelled on Gramsci's earlier use of the term, 'Fordism', at the turn of the century to connote a whole shift in capitalist civilization (which Gramsci certainly did not reduce to a mere phenomenon of the economic base). 'Post-Fordism' should also be read in a much broader way. Indeed, it could just as easily be taken in the opposite way – as signalling the *constitutive* role which social and cultural relations play in relation to any economic system. Post-Fordism as I understand it is not committed to any prior determining position for the economy. But it does insist – as all but the most extreme discourse theorists and culturalists must recognize – that shifts of this order in economic life must be taken seriously in any analysis of our present circumstances.

A recent writer on the subject of contemporary cultural change, Marshall

Berman, notes that 'modern environments and experiences cut across all boundaries of geography and ethnicity, of class and nationality, of religion and ideology' – not destroying them entirely, but weakening and subverting them, eroding the lines of continuity which hitherto stabilized our social identities.

THE RETURN OF THE SUBJECT

One boundary which 'New Times' has certainly displaced is that between the 'objective' and 'subjective' dimensions of change. This is the so-called 'revolution of the subject' aspect. The individual subject has become more important, as collective social subjects – like that of class or nation or ethnic group – become more segmented and 'pluralized'. As social theorists have become more concerned with how ideologies actually function, and how political mobilization really takes place in complex societies, so they have been obliged to take the *'subject'* of these processes more seriously. As Gramsci remarked about ideologies, 'To the extent that ideologies are historically necessary they have a validity which is "psychological" ' (*Prison Notebooks*, 1971: 377). At the same time, our models of 'the subject' have altered. We can no longer conceive of 'the individual' in terms of a whole, centred, stable and completed Ego or autonomous, rational 'self'. The 'self' is conceptualized as more fragmented and incomplete, composed of multiple 'selves' or identities in relation to the different social worlds we inhabit, something with a history, 'produced', in process. The 'subject' is differently placed or *positioned* by different discourses and practices.

This is novel conceptual or theoretical terrain. But these vicissitudes of 'the subject' also have their own histories which are key episodes in the passage to 'New Times'. They include the cultural revolution of the 1960s; '1968' itself, with its strong sense of politics as 'theatre' and its talk of 'will' and 'consciousness'; feminism, with its insistence that 'the personal is political'; the renewed interest in psychoanalysis, with its rediscovery of the unconscious roots of subjectivity; the theoretical revolutions of the 1960s and 1970s – semiotics, structuralism, 'post-structuralism' – with their concern for language, discourse and representation.

This 'return of the subjective' aspect suggests that we cannot settle for a language in which to describe 'New Times' which respects the old distinction between the objective and subjective dimensions of change. 'New Times' are both 'out there', changing our conditions of life, and 'in here', working on us. In part, it is *us* who are being 're-made'. But such a conceptual shift presents particular problems for the left. The conventional culture and discourses of the left, with its stress on 'objective contradictions', 'impersonal structures' and processes that work 'behind men's (*sic*)

backs', have disabled us from confronting the subjective dimension in politics in any very coherent way.

In part, the difficulty lies in the very words and concepts we use. For a long time, being a socialist was synonymous with the ability to translate everything into the language of 'structures'. But it is not only a question of language. In part, the difficulty lies in the fact that men so often provide the categories within which *everybody* experiences things, even on the left. Men have always found the spectacle of the 'return' of the subjective dimension deeply unnerving. The problem is also theoretical. Classical marxism depended on an assumed correspondence between 'the economic' and 'the political': one could read off political attitudes and objective social interests and motivations from economic class position. For a long time, these correspondences held the theoretical analyses and perspectives of the left in place. However, any simple correspondence between 'the political' and 'the economic' is exactly what has now disintegrated – practically and theoretically. This has had the effect of throwing the language of politics more over to the cultural side of the equation.

'Postmodernism' is the preferred term which signals this more *cultural* character of 'New Times'. 'Modernism', it argues, which dominated the art and architecture, the cultural imagination, of the early decades of the twentieth century, and came to represent the look and experience of 'modernity' itself, is at an end. It has declined into the International Style characteristics of the freeway, the wall-of-glass skyscraper and international airports. Modernism's revolutionary impulse – which could be seen in surrealism, Dada, constructivism, the move to an abstract and non-figurative visual culture – has been tamed and contained by the museum. It has become the preserve of an avant-garde elite, betraying its revolutionary and 'populist' impulses.

'Postmodernism', by contrast, celebrates the penetration of aesthetics into everyday life and the ascendancy of popular culture over the High Arts. Theorists like Fredric Jameson and Jean-François Lyotard agree on many of the characteristics of 'the postmodern condition'. They remark on the dominance of image, appearance, surface-effect over depth (was Ronald Reagan a president or just a B-movie actor, real or cardboard cut-out, alive or Spitting Image?). They point to the blurring of image and reality in our media-saturated world (is the Contra war real or only happening on TV?). They note the preference for parody, nostalgia, kitsch and pastiche – the continual re-working and quotation of past styles – over more positive modes of artistic representation, like realism or naturalism. They note, also, a preference for the popular and the decorative over the brutalist or the functional in architecture and design. 'Postmodernism' also has a more philosophical aspect. Lyotard, Baudrillard and Derrida cite the erasure of a strong sense of history, the slippage of hitherto stable meanings, the proliferation of difference, and the end of what Lyotard calls the

'grand narratives' of progress, development, Enlightenment, rationality, and truth which, until recently, were the foundations of western philosophy and politics.

Jameson, however, argues very persuasively that postmodernism is also 'the new cultural logic of capital' – 'the purest form of capital yet to have emerged, a prodigious expansion into hitherto uncommodified areas' (Jameson, 1984: 78). His formulations remind us that the changing cultural dynamic we are trying to characterize is clearly connected with the revolutionary energy of modern capital – capital *after* what we used to call its 'highest stages' (imperialism, organized or corporate capitalism), even *later* than 'late capitalism'.

'Post-industrialism', 'post-Fordism', 'postmodernism' are all different ways of trying to characterize or explain this dramatic, even brutal, resumption of the link between modernity and capitalism. Some theorists argue that, though Marx may have been wrong in his predictions about class as the motor of revolution, he was right – with a vengeance – about capital. Its 'global' expansion continues, with renewed energy in the 1980s, to transform everything in its wake, subordinating every society and social relationship to the law of commodification and exchange value. Others argue that, with the failures of the stalinist and social-democratic alternatives, and the transformations and upheavals now taking place throughout the communist world, capital has acquired a new lease of life.

Some economists argue that we are simply in the early, up-beat half of the new Kondratiev 'long wave' of capitalist expansion (after which the inevitable downturn or recession will follow). The American social critic whom we quoted earlier, Marshall Berman, relates 'New Times' to 'the ever-expanding drastically fluctuating capitalist world markets' (Berman, 1983: 16). Others, with their eye more firmly fixed on the limits and uneven development of capital on a global scale, emphasize more the ceaseless rhythm of the international division of labour, redistributing poverty and wealth, dependency and overdevelopment in new ways across the face of the earth. One casualty of this process is the old idea of some homogeneous 'Third World'. Nowadays, Formosa and Taiwan are integrated into the advanced capitalist economies, as Hong Kong is with the new financial markets. Ethiopia or the Sudan or Bangladesh, on the other hand, belong to a different 'world' altogether. It is the new forms and dynamic of capital as a global force which is marking out these new divisions across the globe.

However, it seems to be the case that, whichever explanation we finally settle for, the really startling fact is that *these* New Times clearly belong to a time-zone marked by the march of capital simultaneously across the globe and through the Maginot Lines of our subjectivities.

The title of Berman's book *All That Is Solid Melts into Air* – a quotation from the *Communist Manifesto* – reminds us that Marx was one of the

earliest people to grasp the revolutionary connection between capitalism and modernity. In the *Manifesto*, he spoke of the 'constant revolutionizing of production, uninterrupted disturbance of all social relations, everlasting uncertainty and agitation' which distinguished 'the bourgeois epoch from all earlier times'. 'All fixed, fast-frozen relationships, with their train of venerable ideas and opinions, are swept away, all new-formed ones become obsolete before they can ossify. All that is Solid Melts into Air.'

Indeed, as Berman points out, Marx considered the revolution of modern industry and production the necessary precondition for that Promethean or Romantic conception of the social individual which towers over his early writings, with its prospect of the many-sided development of human capacities. In this context, it was not the commodities which the bourgeoisie created which impressed Marx, so much as 'the processes, the powers, the expressions of human life and energy; men (*sic*) working, moving, cultivating, communicating, organizing and reorganizing nature and themselves' (Berman: 93). Of course, Marx also understood the one-sided and distorted character of the modernity and type of modern individual produced by this development – how the forms of bourgeois appropriation destroyed the human possibilities it created. But he did not, on this count, refuse it. What he argued was that *only socialism* could complete the revolution of modernity which capitalism had initiated. As Berman puts it, he hoped 'to heal the wounds of modernity through a fuller and deeper modernity'.

Now here exactly is the rub about 'New Times' for the left. The 'promise' of modernity has become, at the end of the twentieth century, considerably more ambiguous, its links with socialism and the left much more tenuous. We have become more aware of the double-edged and problematic character of modernity: what Theodore Adorno called the 'negative dialectic' of enlightenment. Of course, to be 'modern' has *always* meant

> to live a life of paradox and contradiction . . . alive to new possibilities for experience and adventure, frightened by the nihilistic depths to which so many modern adventures lead (e.g. the line from Nietzsche and Wagner to the death camps), longing to create and hold onto something real even as everything melts.

Some theorists argue – the German philosopher, Jurgen Habermas is one – that this is too pessimistic a reading of 'Enlightenment' and that the project of modernity is not yet completed. But it is difficult to deny that, at the end of the twentieth century, the paradoxes of modernity seem even more extreme. 'Modernity' has acquired a relentlessly uneven and contradictory character: material abundance here, producing poverty and immiseration there; greater diversity and choice – but often at the cost of commodification, fragmentation and isolation. More opportunities for participation – but only at the expense of subordinating oneself to the

laws of the market. Novelty and innovation – but driven by what often appear to be false needs. The rich 'West' – and the famine-stricken South. Forms of 'development' which destroy faster than they create. The city – privileged scenario of the modern experience for Baudelaire or Walter Benjamin – transformed into the anonymous city, the sprawling city, the inner city, the abandoned city . . .

These stark paradoxes project uncertainty into any secure judgement or assessment of the trends and tendencies of New Times especially on the left. Are New Times to be welcomed for the new possibilities they open? Or rejected for the threat of horrendous disasters (the ecological ones are uppermost in our minds just now) and final closures which they bring in their wake? Terry Eagleton has recently posed the dilemma in comparable terms, when discussing the:

> true aporia, impasse or undecidability of a transitional epoch, struggling out as it is from beneath an increasingly clapped-out, discreditable, historically superannuated ideology of Autonomous Man, (first cousin to Socialist Man) with no very clear sense as yet of which path out from this pile of ruins is likely to lead us towards an enriched human life and which to the unthinkable terminus of some fashionable new irrationalist barbarism.
>
> (Eagleton, 1987: 47)

We seem especially on the left, permanently impaled on the horns of these extreme and irreconcilable alternatives.

It is imperative for the left to get past this impossible impasse, these irreconcilable either/ors. There are few better (though many more fashionable) places to begin than with Gramsci's 'Americanism and Fordism' essay, which is of seminal importance for this debate, even if it is also a strangely broken and 'unfinished' text. 'Americanism and Fordism' represented a very similar effort, much earlier in the century, to describe and assess the dangers and possibilities for the left of the birth of that epoch – 'Fordism' – which we are just supposed to be leaving. Gramsci was conducting this exercise in very similar political circumstances for the left – retreat and retrenchment of the working-class movement, ascendancy of fascism, new surge of capital 'with its intensified economic exploitation and authoritarian cultural expression'.

If we take our bearings from 'Americanism and Fordism' we are obliged to note that Gramsci's 'catalogue of . . . most important or interesting problems' relevant to deciding 'whether Americanism can constitute a new historical epoch' begins with 'a new mechanism of accumulation and distribution of finance capital based directly on industrial production'. But his characterization of 'Fordism' also includes a range of other social and cultural phenomena which are discussed in the essay: the rationalization of the demographic composition of Europe; the balance

between endogamous and exogamous change; the phenomenon of mass consumption and 'high wages'; 'psychoanalysis and its enormous diffusion since the war'; the increased 'moral coercion' exercised by the state; artistic and intellectual movements associated with 'Modernism'; what Gramsci calls the contrast between 'super-city' and 'super-country'; feminism, masculinism and 'the question of sex'. Who, on the left, now has the confidence to address the problems and promise of New Times with a matching comprehensiveness and range? The sad fact is that a list of 'new questions' like that are most likely to engender a response of derision and sectarian back-biting at most meetings of the organized political left today – coupled with the usual cries of 'sell-out'!

This lack of intellectual boldness on the left is certainly, in part, attributable to the fact that the contradictory forces associated with New Times are just now, and have been for some time, firmly in the keeping and under the tutelage of the right. The right has imprinted them with the apparent inevitability of its own political project. However, as we argued earlier, this may have obscured the fact that what is going on is not the unrolling of a singular, unilinear logic in which the ascendancy of capital, the hegemony of the New Right and the march of commodification are indissolubly locked together. These may be *different* processes, with different time-scales, which the dominance of the right in the 1980s has somehow rendered natural and inevitable.

One of the lessons of New Times is that history does not consist of what Benedict Anderson calls 'empty, homogeneous time', but of processes with different time-scales and trajectories. They may be convened in the same conjuncture. But historic conjunctures of this kind remain complex, not simple: not in any simple sense 'determined' but *over-determined* (that is, the result of a fusion or merging of different processes and contradictions which nevertheless retain their own effectivity, 'the specific modalities of their actions' – (Althusser, 'Contradiction and over-determination'). That is really what a 'new conjuncture' means, as Gramsci clearly showed. The histories and time-scales of Thatcherism and of New Times have certainly overlapped. Nevertheless, they may belong to different temporalities. Political time, the time of regimes and elections, is short: 'a week is a long time in politics.' Economic time, sociological time, so to speak, has a longer *durée*. Cultural time is even slower, more glacial. This does not detract from the significance of Thatcherism and the scale of its political intervention, about which we have been writing. There is nothing slow, glacial or 'passive' about the Thatcherite revolution, which seems by contrast brutally abrupt, concise and condensed.

Nevertheless, from the perspective of the longer *durée* of new times, Thatcherism's project can be understood as operating on the ground of longer, deeper, more profound movements of change which *appear* to be going its way, but of which, in reality, it has been only occasionally, and

fleetingly, in command over the past decade. We can see Thatcherism as, in fact, an attempt to hegemonize these deeper tendencies within its project of 'regressive modernization', to appropriate them to a reactionary political agenda and to harness to them the interests and fortunes of specific and limited social interests. Once we have opened up this gap, analytically, between Thatcherism and New Times, it *may* become possible to resume or re-stage the broken dialogue between socialism and modernity.

Consider another question with which people on the left perpetually tease and puzzle one another: what kind of 'transition' are we talking about and how total or how complete is it? This way of posing the question implies an all-or-nothing answer. Either it *is* a New Epoch, or nothing at all has changed. But that is not the only alternative. We are certainly not debating an *epochal* shift, of the order of the famous transition from feudalism to capitalism. But we have had other transitions from one regime of accumulation to another, within capitalism, whose impact has been extraordinarily wide-ranging. Think, for example, of the transition which Marx writes about between absolute and relative surplus value; or from machinofacture to 'modern industry'; or the one which preoccupied Lenin and others at the turn of the century and about which Gramsci was writing in 'Americanism and Fordism'. The transition which New Times references is of the latter order of things.

As to how complete it is: this stand-and-deliver way of assessing things may itself be the product of an earlier type of totalizing logic which is beginning to be superseded. In a permanently Transitional Age we must *expect* unevenness, contradictory outcomes, disjunctures, delays, contingencies, uncompleted projects overlapping emergent ones. We know that Marx's *Capital* stands at the beginning, not the completion, of the expansion of the capitalist 'world market'; and that earlier transitions (such as that from household to factory production) all turned out, on inspection, to be more protracted and incomplete than the theory suggested.

We have to make assessments, not from the completed base, but from the 'leading edge' of change. The food industry, which has just arrived at the point where it can guarantee worldwide the standardization of the size, shape and composition of every hamburger and every potato (*sic*) chip in a Macdonald's Big Mac from Tokyo to Harare, is clearly just entering its 'Fordist' apogee. However, its labour force and highly mobile, 'flexible' and deskilled work patterns approximate more to some post-Fordist patterns. Motor cars, from which the age of Fordism derived its name, with its multiple variations on every model and market specialization (like the fashion and software industries) is, in some areas at least, on the move towards a more post-Fordist form. The question should always be, where is the 'leading edge' and in what direction is it pointing.

THE CULTURAL DIMENSION

Another major requirement for trying to think through the complexities and ambiguities of New Times is simply to open our minds to the deeply *cultural* character of the revolution of our times. If 'post-Fordism' exists, then it is as much a description of cultural as of economic change. Indeed, that distinction is now quite useless. Culture has ceased (if ever it was – which I doubt) to be a decorative addendum to the 'hard world' of production and things, the icing on the cake of the material world. The word is now as 'material' as the world. Through design, technology and styling, 'aesthetics' has already penetrated the world of modern production. Through marketing, layout and style, the 'image' provides the mode of representation and fictional narrativization of the body on which so much of modern consumption depends. Modern culture is relentlessly material in its practices and modes of production. And the material world of commodities and technologies is profoundly cultural. Young people, black and white, who can't even spell 'postmodernism' but have grown up in the age of computer technology, rock-video and electronic music, already inhabit such a universe in their heads.

Is this merely the culture of commodified consumption? Are these necessarily Trivial Pursuits? (Or, to bring it right home, a trendy 'designer addiction' to the detritus of capitalism which serious left magazines like *Marxism Today* should renounce – or even better denounce – forever?) Yes, much – perhaps, even most – of the time. But underlying that, have we missed the opening up of the individual to the transforming rhythms and forces of modern *material* life? Have we become bewitched by who, in the short run, reaps the profit from these transactions (there are vast amounts of it being made), and missed the democratization of culture which is *also* potentially part of their hidden agenda? Can a socialism of the twenty-first century revive, or even survive, which is wholly cut off from the landscapes of popular pleasures, however contradictory and 'commodified' a terrain they represent? Are we thinking dialectically enough?

One strategy for getting at the more cultural and subjective dimensions of New Times would be to start from the objective characteristics of post-Fordism and simply turn them inside out. Take the new technologies. They not only introduce new skills and practices. They also require new ways of thinking. Technology, which used to be 'hard-nosed' is now 'soft'. And it no longer operates along one, singular line or path of development. Modern technology, far from having a fixed path, is open to constant renegotiation and re-articulation. 'Planning', in this new technological environment, has less to do with absolute predictability and everything to do with instituting a 'regime' out of which a plurality of outcomes will emerge. One, so to

speak, plans for contingency. This mode of thinking signals the end of a certain kind of deterministic rationality.

Or consider the proliferation of models and styles, the increased product differentiation, which characterizes 'post-Fordist' production. We can see mirrored there wider processes of cultural diversity and differentiation, related to the multiplication of social worlds and social 'logics' typical of modern life in the West.

There has been an enormous expansion of 'civil society', related to the diversification of social worlds in which men and women now operate. At present, most people only relate to these worlds through the medium of consumption. But, increasingly we are coming to understand that to maintain these worlds at an advanced level requires forms of collective consumption far beyond the restricted logic of the market. Furthermore, each of these worlds also has its own codes of behaviour, its 'scenes' and 'economies' and (don't knock it) its 'pleasures'. These already allow those individuals who have some access to them some space in which to reassert a measure of choice and control over everyday life, and to 'play' with its more expressive dimensions. This 'pluralization' of social life expands the positionalities and identities available to ordinary people (at least in the industrialized world) in their everyday working, social, familial and sexual lives. Such opportunities need to be more, not less, widely available across the globe, and in ways not limited by private appropriation.

This shift of time and activity towards 'civil society' has implications for our thinking about the individual's rights and responsibilities, about new forms of citizenship and about ways of ordering and regulating society other than through the all-encompassing state. They imply a 'socialism' committed to, rather than scared of, diversity and difference.

Of course, 'civil society' is no ideal realm of pure freedom. Its microworlds include the multiplication of points of power and conflict – and thus exploitation, oppression and marginalization. More and more of our everyday lives are caught up in these forms of power, and their lines of intersection. Far from there being no resistance to the system, there has been a proliferation of new points of antagonism, new social movements of resistance organized around them – and, consequently, a generalization of 'politics' to spheres which hitherto the left assumed to be apolitical: a politics of the family, of health, of food, of sexuality, of the body. What we lack is any overall map of how these power relations connect and of their resistances. Perhaps there isn't, in that sense, one 'power game' at all, more a network of strategies and powers and their articulations – and thus a politics which is always positional.

One of these critical 'new' sites of politics is the arena of social reproduction. On the left, we know about the reproduction of labour power. But what do we really know – outside of feminism – about ideological, cultural, sexual reproduction? One of the characteristics of

this area of 'reproduction' is that it is both material and symbolic, since we are reproducing not only the cells of the body but also the categories of the culture. Even consumption, in some ways the privileged terrain of reproduction, is no less symbolic for being material. We need not go so far as Baudrillard (1977: 62), as to say 'the object is nothing' in order to recognize that, in the modern world, objects are also signs, and we relate to the world of things in both an instrumental and a symbolic mode. In a world tyrannized by scarcity, men and women nevertheless express in their practical lives not only what they need for material existence but some sense of their symbolic place in the world, of who they are, their identities. One should not miss this drive to take part or 'come on' in the theatre of the social – even if, as things stand, the only stage provided is within what the Situationists, in 1968, used to call the 'fetishized spectacle of the commodity'.

Of course, the preoccupation with consumption and style may appear trivial – though more so to men, who tend to have themselves 'reproduced', so as to say, at arm's length from the grubby processes of shopping and buying and getting and spending and therefore take it less seriously than women, for whom it was destiny, life's 'work'. But the fact is that greater and greater numbers of people (men *and* women) – with however little money – play the game of using things to signify who they are. Everybody, including people in very poor societies whom we in the West frequently speak about as if they inhabit a world *outside* of culture, knows that today's 'goods' double up as social signs and produce meanings as well as energy. There is no clear evidence that, in an alternative socialist economy, our propensity to 'code' things according to systems of meaning, which is an essential feature of our sociality, would *necessarily* cease – or, indeed, should.

A socialism built on any simple notion of a 'return to nature' is finished. We are all irrevocably in the 'secondary universes' where culture predominates over nature. And culture, increasingly, distances us from invoking the simple, transparent ground of 'material interests' as a way of settling any argument. The environmental crisis, which is a result of the profound imbalance between nature and culture induced by the relentless drive to subordinate everything to the drive for profitability and capital accumulation cannot be resolved by any simple 'return' to nature. It can only be resolved by a more human – that is, socially responsible and communally responsive – way of *cultivating* the natural world of finite resources on which we all now depend. The notion that 'the market' can resolve such questions is patently – in the light of present experience – absurd and untenable.

This recognition of the expanded cultural and subjective ground on which any socialism of the twenty-first century must stand, relates, in a significant way, to feminism, or better still, what we might call 'the

feminization of the social'. We should distinguish this from the simplistic version of 'the future is female', espoused by some tendencies within the women's movement, but recently subject to Lynne Segal's persuasive critique. It arises from the remarkable – and irreversible – transformation in the position of women in modern life as a consequence not only of shifts in conceptions of work and exploitation, the gendered recomposition of the workforce and the greater control over fertility and reproduction, but also the rebirth of modern feminism itself.

Feminism and the social movements around sexual politics have thus had an unsettling effect on everything once thought of as 'settled' in the theoretical universe of the left. And nowhere more dramatically than in their power to decentre the characteristic conversations of the left by bringing on to the political agenda the question of sexuality. This is more than simply the question of the left being 'nice' to women or lesbians or gay men or beginning to address their forms of oppression and exclusion. It has to do with the revolution in thinking which follows in the wake of the recognition that *all* social practices and forms of domination – including the politics of the left – are always inscribed in and to some extent secured by sexual identity and positioning. If we don't attend to how gendered identities are formed and transformed and how they are deployed politically, we simply do not have a language of sufficient explanatory power at our command with which to understand the institutionalization of power in our society and the secret sources of our resistances to change. After another of those meetings of the left where the question of sexuality has cut through like an electric current which nobody knows how to plug into, one is tempted to say *especially* the resistances to change *on the left*.

Thatcherism was certainly fully aware of this implication of gender and identity in politics. It has powerfully organized itself around particular forms of patriarchy and cultural or national identity. Its defence of 'Englishness', of that way of 'being British' or of the English feeling 'Great again', is a key to some of the unexpected sources of Thatcherisms popularity. Cultural racism has been one of its most powerful, enduring, effective – and least remarked – sources of strength. For that very reason, 'Englishness', as a privileged and restrictive cultural identity, is becoming a site of contestation for those many marginalized ethnic and racial groups in the society who feel excluded by it and who hold to a different form of racial and ethnic identification and insist on cultural diversity as a goal of society in New Times.

The left should not be afraid of this surprising return of ethnicity. Though ethnicity continues to be, in many places, a surprisingly resilient and powerfully reactionary force, the *new* forms of ethnicity are articulated, politically, in a different direction. By 'ethnicity' we mean the astonishing return to the political agenda of all those points of attachment

which give the individual some sense of 'place' and position in the world, whether these be in relation to particular communities, localities, territories, languages, religions or cultures. These days, black writers and filmmakers refuse to be restricted to only addressing black subjects. But they insist that others recognize that what they have to say comes out of particular histories and cultures and that everyone speaks from positions within the global distribution of power. Because these positions change and alter, there is always an engagement with politics as a 'war of position'.

This insistence on 'positioning' provides people with co-ordinates, which are specially important in face of the enormous globalization and transnational character of many of the processes which now shape their lives. The New Times seem to have gone 'global' and 'local' at the same moment. And the question of ethnicity reminds us that everybody comes from some place – even if it is only an 'imagined community' – and needs some sense of identification and belonging. A politics which neglects that moment of identity and identification– without, of course, thinking of it as something permanent, fixed or essential – is not likely to be able to command the New Times.

Could there be New Times without new subjects? Could the world be transformed while its subjects stay exactly the same? Have the forces remaking the modern world left the subjects of that process untouched? Is change possible while *we* remain untransformed? It was always unlikely and is certainly an untenable proposition now. This is another one of those many 'fixed and fast-frozen relationships, venerable ideas and opinions' which, as Marx accurately predicted, New Times are quietly melting into thin air.

REFERENCES

Baudrillard, J. (1977) *The Mirror of Production*, New York: Telos.
Berman, M. (1983) *All That Is Solid Melts into Air*, New York: Simon & Schuster.
Eagleton, T. (1987) 'Identity', in L. Appignanensi (ed.) *The Real Me: Postmodernism and the Question of Identity*, London: Institute of Contemporary Arts.
Gramsci, A. (1971) *The Prison Notebooks*, London: Lawrence & Wishart.
Jameson, F. (1984) 'The cultural logic of Capital', *New Left Review* 146 (July/August).

Chapter 12

Looking back at New Times and its critics

Angela McRobbie

THE NEW TIMES PROJECT

Looking back at *New Times: The Changing Face of Politics in the 1990s*, edited by Stuart Hall and Martin Jacques (Hall and Jacques, 1989, referred to henceforward as New Times), it is a volume which can be read as doing a number of things at once. The voice is tentative for the simple reason that on the one hand what is being broached is the kind of orthodox left thinking which settled into a fairly defensive mode as the years of the Thatcher government passed by, inexorably, it seemed. On the other hand what is also happening is that a whole new set of social relations are coming into being, some of which are the direct offshoot of Thatcher, others which are connected but which are more closely tied to emergent global patterns of economic life. Then there are also changes which are happening in culture and in politics which are broadly oppositional, and it is the task which the New Times work sets itself, to make sense of these multiple movements by trying to keep hold of them, analytically, all at the one time. The cautious tone is also underpinned by a hint of hopefulness. There is an optimism in the phrase New Times. Without this it would be more of the same old Hard Times which we were all getting used to.

It was hardly euphoric, but it was this upbeat, more positive tone which caused some critics from the left to see New Times as virtually collusive with the bubble of economic and consumer confidence of the mid-1980s so carefully stage-managed by the Conservatives. All the more reason, a few years on, and once the bubble has well and truly burst, for them to deride the New Times writers for falling under 'her' spell. Granted, with the post-industrial economy rapidly giving way to a post-employment economy, and with there being more thrift shops on the high street than designer boutiques, it may well be that the idea of New Times as marking a moment of economic and cultural opportunity for the left has somewhat faded. *Marxism Today*, the journal which announced 'New Times' as a political concept for the left, and which also printed many of the articles included in the Hall and Jacques collection, has since disappeared. *DEMOS*, the

research and lobbying 'think tank' which sought to take its place is, with representatives intentionally drawn from right across the political spectrum, from right to left, much less successful in maintaining the broad church project which *Marxism Today* represented. That project was not a political aim but a publishing idea, one which was novel for the left, and surprisingly invigorating in the contributions and interviews it carried with leading, if sometimes maverick Tories. In contrast *DEMOS* seems like a rather stuffy gentleman's club whose doors are shut to those who do not want to sit down to high table with the 'radical right'.

The reading of the New Times volume, and the commentary on its critics which follows, focus on those contributions which belong more immediately to the field of cultural studies. This requires selection, and a number of important issues unfortunately must be left out; the whole question of the new Europe for example, and with it the crisis of communism and the decline of the party. Neither is it my intention to present this chapter as a detailed review of the whole New Times work. The aim is instead to address what now appear as the agenda-setting issues found in this volume, and to show how a handful of critics have wrongly conflated these questions with a quite separate and more problematic strand which has emerged in the new cultural studies. This conflation has then allowed these critics to denounce New Times for pursuing an apolitical and 'celebratory' mode. The politics, the practice and the jostling for position inherent in these various critiques will also be considered.

The direction of the chapter is as follows. First there is a consideration of the main themes and questions raised in New Times. A brief summary follows of those writers who have challenged the particular configuration of social forces which the New Times writers designate as 'post-Fordist'. This will then entail an assessment of where *both* New Times and cultural studies stand in relation to thinking about the connections between the various levels (in particular the political and the economic) which constitute the recognizably social field which we currently inhabit. In the second part of the chapter I will look at those writers who have recently felt compelled to take cultural studies to task and who have done this directly or indirectly through the New Times work. Of course some of these contributions are more useful than others. Most represent an opportunity to lay some claim to the field of cultural analysis which for a whole number of reasons has found itself unexpectedly undergoing a process of expansion and rapid institutionalization. The main protagonists here are McGuigan (1992), Frith and Savage (1992), and Christopher Norris (1992). The argument here is not against the expansion of cultural studies, nor against its institutionalization. Instead it will be suggested that just as New Times found itself positioned at a crossroads, in a moment of political, intellectual and social change and transformation, so also was this a moment in which cultural studies

was emerging from the shadows and the margins of academic life, and because several of the New Times writers, most notably Stuart Hall, were inextricably linked with both fields, the scathing criticisms of New Times were then also applied to its sister discipline, cultural studies. But there was also something else going on which is worth noting. A few figures from a new generation of cultural studies graduates were getting jobs which in the past would have been reserved for those with Oxford Firsts. Positioned inside arts programming in the BBC or Channel 4 cultural studies ideas suddenly received a new kind of outlet in slots like *The Late Show* (BBC2); *Wall to Wall* (Channel 4) and in the *Guardian* newspaper. The popularization of cultural studies has ironically perhaps produced the greatest storm of criticism from two writers who have themselves, more than most, moved between 'popular' journalism (i.e. rock criticism) and academic writing. Later I will comment on Frith and Savage's attack on both 'cultural populism' and the popularization of cultural studies. I will suggest that the claim of populism is misplaced and the aim of keeping cultural studies pure and its hands clean and out of reach of the predatory, slick prose-style of the likes of Julie Burchill and Toby Young of the *Modern Review* unrealistic and unnecessarily protective.

To return to New Times, it was a vulnerable target because the articles were written in a deliberately journalistic, accessible and, to some extent, provocative tone. However this stepping outside of the academy and bringing into the world of politics, both a new set of concepts for understanding social change, and simultaneously a strong defence of the 'politics of theory', as Stuart Hall has put it, remains, in my mind, an important task. It is all the more curious, then, that Simon Frith and Jon Savage – both figures who, as I have just indicated, have themselves moved between higher education and popular journalism – should take such exception to those strands in this kind of popularizing of new ideas by virtually placing New Times, in its so-called embracing of 'cultural populism', alongside the neo-right magazine *Modern Review* owned and overseen by Julie Burchill. Of course as the several critics of the New Times work have suggested (myself included), there were a number of issues which were either ignored or else pushed to the side. There was the downside of consumption, for example, through its connection with domestic labour and social reproduction, often for women hard and unrewarding activity. There were also the more limited pleasures of shopping 'when every penny counts'. In 'New Times in cultural studies' I argued that there was a tendency in this work to extol the shared enjoyment of aspects of consumption at the expense of the high cost of living and the way in which so many are excluded from these enjoyments (McRobbie, 1991). This point was not made, as McGuigan implies, in an accusatory tone of puritanical and political condemnation. It was more of a gentle rejoinder. More significant was the absence of what I will here label the nexus of the 'institutional–experiential–empirical'. I will

return to this in the conclusion, where it will also be my intention to add a more feminist voice to this debate, as it winds its way through what are now emerging as different 'schools' of cultural studies. I will do this by touching once again on pleasure and enjoyment and in returning to these I will also suggest that serious attention to the place and meaning of these experiences need not lead to the celebratory extremes which some have claimed them to do. Just as there is a place for the politics of theory so must there be a place for the politics of pleasure, and this, in some ways is where New Times started.

TRANSITIONS AND TRANSFORMATIONS

The three articles which are pivotal to the New Times reader and which have since been taken to represent its project are the 'Introduction' by Hall and Jacques, Stuart Hall's 'The meaning of New Times' and the an-onymous 'The New Times'. Alongside these, and echoing many of the ideas raised there, are the two chapters by Robin Murray which focus on the meaning of post-Fordism, Dick Hebdige's seminal 'After the masses' and Frank Mort's equally important 'The politics of consumption'. Finally there is Bea Campbell's 'New Times towns'. In each of these a language of shift, transition and transformation is used to signal something of the scale of the changes which have necessitated a corresponding shift in critical and theoretical vocabulary. While these chapters will form the focus of the commentary that follows, it is worth reminding the reader of the prescience of the volume as a whole. The titles of the various sections show clearly what is on the new agenda, and it is significant that it is these same issues, in particular 'Identity and individual' and 'Globalization and localization', which have gone on to become such landmark terms in cultural studies in the 1990s.

Very early the main New Times pieces establish a new framework for understanding the social in terms of 'diversity, differentiation and fragmentation, rather than homogeneity, standardization and the econ-omics and organizations of scale which characterized modern mass society' (11). The authors are, however, anxious to assert that this does not precipitate a new orthodoxy nor does it mark a clean break. There exists at any moment in time many examples of different modes of production, from Fordism to post-Fordism, from sweat shop to hi-tech cottage industry. If there has been a definitive shift in production to post-Fordism, then this neither exists in a pure form nor does its existence eliminate at a stroke the continuation in some sectors, of the older forms of mass production.

The main point seems to be the occurrence of shifts right across those levels which constitute the social as we know it, shifts which apparently follow their own distinctive logics, and which are only at critical political

moments revealed as clearly connected to each other. Thus there is the move towards forms of industrial production which employ new ways of making goods and commodities which differ sharply from the old assembly lines of mass production. These in turn serve more differentiated markets with high-quality goods which are sold in 'niche marketed' outlets or through segmented retailing strategies. In addition a good deal more attention is paid to the selling environment. Shopping becomes an even more heightened social activity, one which is designed to enhance or highlight the particular or nuanced meanings of the products, for example, through the spatial arrangement in new supermarkets. Shopping environments connect with the broader space of the city or the new town or the out-of-town hypermarkets which in turn produce new experiences of space, geography and region.

The shop or supermarket, as designed environment, is integral to the growth of consumption in the 1980s which through the currency of the 'gold cards' brought an abundance of new goods to an eager population of consumers. Frank Mort points to the way in which 'lifestyle' carried a distinctively populist ring about it during the Thatcher years, offering, it seemed, a consumerist endorsement of emergent identities such as that of the 'new man' or the 'career woman' or even the 'gay couple'. In advertising copy these found their equivalent in yuppies, buppies, dinkies, etc. In the New Times writing there is a recognition of the break-up of the older points of collective identification especially that of social class and the re-formation of identity around other chosen sites of 'belonging'. So for a moment there appears to be a convergence of thinking between the advertising agencies and the New Times writers. This is where, for the rest of the left, the betrayal begins, the slide into accepting as a *fait accompli* the 'end of class'. Such an accusation assumes a shift of allegiances from class to these consumer-led identities, but it is too easy to map the flowering of a more pluralist, social movement-based politics, with the neo-conservative language of Mrs Thatcher and her celebration of the 'freedom of the market', the 'right to choose', and the 'value of enterprise'. This is a way of avoiding much more awkward theoretical questions such as the nature of the political relationships which can or do exist between emergent social identities. Instead of facing up to the challenge of their possible 'radical incommensurability', much of the left prefers instead to rely on the assumed centrality of class, as providing a kind of underpinning for the politics of race or sexuality.

There is another issue of how, if identities such as those described by Mort are to be taken seriously, they are to be understood in terms of the market. What is the market and what role does it play? It is after all here that Mort sees the critical shifts in working class masculinity occurring, as 'lads' come to perceive themselves in the Emporio Armani as actively gendered rather than just neutrally male. The question of the relationship

between the centrality of the 'market' as an abstract but crucial category in the shift to post-Fordism and the participative pleasures discovered in the marketplace by 'the people' is not wholly answered by the New Times writers. It is a question to which the final section of this chapter will return, the suggestion being that this intersection produces what cultural studies in the past labelled 'popular culture'. It is significant that it has been precisely this meeting-point, this sometimes smooth but often clumsy and unexpected collision place of capitalist commerce with popular desires, that has given rise to the angriest denunciations by those who interpret the 'New Timers' as somehow simply celebrating the market ('sales and styles' as Frith and Savage put it) and of attributing to it an empowering capacity through providing consumers with the possibility of finding meanings which allow them to have more control over areas of their lives.

But looking back, it seems both important and necessary to raise the question, as Dick Hebdige did at the end of 'After the masses', of how commercial and global televisual events like BandAid could, as entertainment, simultaneously produce a desire on the part of viewers at home and in front of the TV, to be actively engaged in a bigger political issue, one which as it happens the left could hardly disavow as important. Likewise Frank Mort concludes his article by insisting that shopping, with the new eco-politics of food production, and car culture with its politics of pollution are

> localized points where consuming meshes with social demands and aspirations in new ways. What they underline is that consumption is not ultimately about individualism *versus* collectivism, but about articulating the two in a new relation which can form the basis of a future common sense.
>
> (Mort, 1989: 172)

And finally Stuart Hall continues in this mode of thinking by suggesting that while it is through the increasingly differentiated market and the 'medium of consumption' at present that many people experience something of the pleasures of difference and cultural diversity, 'This pluralization of social life expands the positionalities and identities available to ordinary people. . . . Such opportunities need to be more, not less, widely available across the globe, and in ways not limited by private appropriation' (Hall, 1988: 129). This is to grant a legitimacy to the experiences currently found within the orbit of the market on the basis that the private sphere is of course circumscribed through access and ability to pay, and that a more socialized provision would allow greater expression of these collective desires.

What these examples also show is how a discussion which begins by

defining itself within the framework of economics and production finds itself very quickly dealing with questions of culture. As Stuart Hall notes,

> Culture has ceased (if ever it was – which I doubt) to be a decorative addendum to the 'hard world' of production and things, the icing on the cake of the material world. . . . Modern culture is relentlessly material in its practices and modes of production. And the material world of commodities and technologies is profoundly cultural.
>
> (Hall, 1988: 128)

Hall then suggests that the new technologies make demands on their users or consumers which in turn require the mastery of new cultural capacities. While the sheer unpredictability of the new technologies does away with 'deterministic rationality', there is still a tendency in this mode of analysis to slip into a model which, though far from the old language of the marxist base-superstructure metaphor, evokes a sense that cultural and social changes emerge, however unevenly, out of the changes in the economy. It is the economy which takes the lead. This makes absolute sense as a counterpoint to the Thatcherist 'sovereignty of the market' model, and to the neo-right's free-floating notion of demand, both of which imply that it is the people who take the lead. It also re-introduces to cultural studies the importance of the place occupied by economic processes, something which Meaghan Morris has recently suggested is acknowledged in cultural studies as being important but as somehow already dealt with by the political economists of the media. Morris argues for greater consideration to be given to the re-integration of the economics of culture than a reworked version of the old base-superstructure model allows,

> in an era of de-industrialisation and increasing integration of markets and circuits alike, the problem of theorising relations between production and consumption (or thinking 'production' at all) is considerably more complex than is allowed by a reduction of effort to so to anachronistic terms.
>
> (quoted in Goodwin, 1993: 21)

What Morris is suggesting here is that the whole idea of production and consumption being stable and somehow fixed processes needs to be revised. Nixon has also expressed concern that as long as phrases like these are used in cultural analysis there will be a tendency to think of production as economic and therefore 'bottom line' and consumption as cultural. This produces a further tendency which he also detects in the New Times work to continue in the mould of seeing this kind of economics of production (albeit in post-Fordist terms) as the 'motor of change' and at the same time in the desire to keep hold of the various levels which also come into play in these New Times and particularly in consumption, to 'overplay the coherence of the shifts which are being pinpointed' (Nixon, 1994a). I

also find useful Nixon's alternative, that the economic is frequently constructed in culturally-informed discourse. His detailed example is the professional knowledge of magazine editors and advertisers brought into play as they consider the production of a new commodity, for example, a man's magazine. The discourse which results in an economy (investment capital, etc.) and in a new commodity being put into production (in this case a magazine) relies extensively on cultural knowledge drawn from the observable world of social trends, tastes and lifestyles. Equally important to Nixon's argument is that different knowledges are here posed against each other so that what is a question of economics and profit is constructed and carried out in the language of culture.

> My contention is that this negotiation occurs, not because the 'cultural' components of the magazines are somehow 'relatively autonomous' from their economic kernel, but because the economic determinants on the magazines have specific conditions of existence that are discursive; that is, they are produced by specific discursive practices.
>
> (Nixon, 1993: 490)

What all of this shows is that questions of the economy are back on the agenda of cultural theory after what some might see as too long an absence, and with this reappearance come the equally important experiences of work and employment. What is more problematic from Nixon's viewpoint is the way in which these 'big issues' still seem to have the power to re-insert themselves magisterially, and fairly automatically re-inscribe themselves in bottom-line positions. In New Times, he argues, they still take the lead. This kind of criticism casts some theoretical doubt over, for example, Robin Murray's contributions which focus on how the emergent world economy is marking the end of the old Keynesian order. This has become outmoded by the growth of international capital, the crisis of unemployment, the skills mismatch produced by the development of new technology and the crisis of profitability brought about by 'market saturation'. Post-Fordism and flexible specialization then step in as part of a grand process of capital restructuring. New technology and new markets offer the promise of recovery, and according to some of the commentators on post-Fordism, particularly those who have been associated with the French and Italian 'Regulation School', they also 'hand back to labour some of the creativity of work which Fordism has eliminated' (Sabel, quoted in Pollert, 1988).

If he sees Murray as assuming these to be primary processes, the question which Nixon does not address is whether we can indeed talk about economic processes at all in this broad way without succumbing to a kind of post-Fordist fundamentalism. The value of thinking through these shifts, in the space opened up by New Times, *in conjunction with* those of retail, shopping, and popular culture, seems to me to outstrip the dangers of

crude reductionism. Post-Fordism is not here a *deus ex machina*, more a set of emergent social and economic and cultural relationships. It is not so determinist in New Times as it is for writers like Touraine and Gorz, nor does it promise a utopia of craft and creativity which some of the Regulation School writers go so far as suggesting. So perhaps the question is one of specifying both the degree of determination and that of containment, so that the range of contingent and historically specific social processes is held together for the purposes of the particular analysis. Thus even if the economic is pre-written in a script drafted by cultural practitioners, as Nixon would argue, can we not still see it actively shaping some of the social practices of work and leisure which we all participate in?

The New Times writers also play the more modest role of intermediary. They are translating from a wide range of writing and condensing this to short pieces for New Times readers. They draw attention to the Japanese team-based work practices and to the more participative role which workers find themselves playing in the new factories organized to combat worker alienation, and increase productivity through making better use of the mental as well as the manual capacities of the entire workforce. These 'core' producers can in turn expect some privileges and a greater degree of job security than those existing in the periphery, where post-Fordism subcontracts its less directly profitable work. This is carried out at lower human or technological cost to the main manufacturers, by workers on the fringes of the economy, in workshops, or indeed in homework or outwork. Robin Murray points to the Benetton model where, in a company with hundreds of global outlets, the core workers number no more than 1500. Instead there is a vast international network of franchises in the retail operation, a whole chain of subcontractors serving the Italian centre of operations, where there is also an industrial core using the most advanced dye technology, and a team of highly qualified creative professionals including designers, publicists and photographers (particularly Oliver Toscani, who recently produced the deliberately controversial billboard campaign which resulted in immense publicity and in many cases outright bans). The role of these cultural intermediaries in styling, designing and promoting the product is as vital to its production as the actual process of manufacture.

The New Times writers maintain some degree of distance from these developments, neither welcoming them, nor dismissing them as marking simply an escalation in class conflict through the deployment of new technology and 'ideology' to produce an intensification of labour (which is how they are seen by some of the contributors to the journal *Capital and Class*, notably Pollert and Clarke). They do, however, present to readers a clear account of that trajectory of analysis which winds its way through the French post-industrial writers (Touraine, Gorz) whose technological determinism allow them to anticipate the decline of class, the coming of a

leisure society and the growth, perhaps, of social movement politics. Stuart Hall asks 'Are the New Times to be welcomed for the new possibilities they open? Or rejected for the threat of horrendous disasters . . . and final closures which they bring in their wake?' (Hall: 124). He then goes on to argue that the left must work its way out of 'extreme and irreconcilable alternatives' (125). Hall proposes approaching the question of an epochal shift through the kind of dense and layered analysis which Gramsci developed in his account of 'Americanism and Fordism'. That is, a convincing analysis must somehow be able to embrace the range and the scale of changes as they seep from the public world of politics and production down into the most private and intimate of our everyday experiences. Or is it, as some might ask, the other way round, must 'politics' and 'production' be so primary? That presumably depends on how both terms are defined. Feminism has shown intimacy to be as productive of political sensibilities as any other moment in the circuit of social experience.

Finally Hall makes the important point that the arrival of new goods in shiny wrapping-paper is not simply a symbol of the advantage of living in the 'prosperous West', 'Everybody, including people in very poor societies whom we in the West frequently speak about as though they inhabit a world outside culture, knows that today's "goods" double up as social signs and produce meanings as well as energy' (Hall: 131).

NEW TIMES AND ITS CRITICS

New Times marked a controversial turning-point for the left and for those concerned with the politics of culture. From a cultural studies perspective it was important that by drawing on the work of the Regulation School theorists New Times engaged with work, leisure, employment and with the economy, as well as with questions of the globalized mass media and with new cultural identities. Identity was also associated with the more theoretical strand marked out by the term subjectivity which appears in New Times as the 'return of the subject'. This is an axiomatic point because it indicates the decisive turn away from the Althusserian assumption of people being the subject of ideology, to a more active account of new subjectivities emerging precisely from the different constellation of social, cultural and economic forces. If we are in part constructed as subjects through the particular layering of historical discourses which we inhabit, then new kinds of sensibilities begin to be clearly discernible. To anybody interested in the sociology of youth or in youth subcultures this is immediately obvious because of the strong symbolic coding which accompanies these 'different, youthful, subjectivities' (McRobbie, 1994). But for the mainstream left, the very question of subjectivity is difficult to swallow because of its particular theoretical legacy through Lacanian psychoanalysis and then through the later work of Foucault where the subject

shows itself able to construct itself through 'technologies of the self' (Foucault, 1988). The sheer eclecticism of New Times, as well as the attempt to use theory to construct a political practice which takes into account difference and which actively recognizes the autonomous dynamics of the social movements and the new politics of sexuality, ethnicity, ecology (and indeed kind of pressure-group politics and even the politics of charity), raises the question of a pluralism which is not merely a rerun of classical liberal pluralism but something rather different.

Much of this was heresy to others on the left including the academic left. From *New Left Review* to *Capital and Class*, from the *New Socialist* to the *New Statesman*, from *New Formations* to *Feminist Review*, 'New Times' was either denounced for its disavowal of politics altogether, or for its virtual embracing of the language of Thatcherism (and more recently Majorism) as a desperate attempt to tune into what it was that made Thatcher click with ordinary people in the hope that if her lessons could be learnt then the left might be able to construct for itself a more electable platform. (McGuigan characterizes Stuart Hall's question baldly as 'Why did Thatcherism become so popular?' [McGuigan, 1992].) There was a more muted response from Mike Rustin (also published in New Times), who argued that the project of change and transformation being described by the New Times writers was indeed part of the absolute logic of Thatcher's radical restructuring of the whole fabric of British society. At the same time 'Thatcherism may be understood as a strategy of post-Fordism initiated from the perspective of the Right' (Rustin, 1989: 319). Rustin therefore secures the New Times analysis to a more familiar political anchor. He is saying that market forces, enterprise culture and the whole programme of privatization are what have effected the other shifts at the level of culture and everyday life. This is a somewhat nuanced account of New Times and it chooses to all but ignore the political challenge it begins to pose to old 'New Left' thinking. Instead it is seen purely as a new complicity: 'The positive emphases given to modernisation, consumption and individualism are instances of the tacit accommodation to the values of resurgent capitalism' (313).

The various writers closely linked with the journal *Capital and Class* are even more scathing in their condemnation of New Times. In a string of articles published over a period of five years they take the kind of writing found in the New Times collection to task for its capitulation to the rhetoric of the right and for its abandonment of a left programme in favour of an alliance-based politics of accommodation with capital, on the excuse that flexible specialization is somehow progressive. Anna Pollert's 'Dismantling flexibility' makes a number of points (Pollert, 1988). Post-Fordism is much less extensive as a new practice of production than the New Timers suggest. Where it does exist it offers secure jobs only to a small minority of highly skilled middle-aged men. 'The quality craft work that Sabel

discovers is work for middle aged Emilian men' writes Pollert on the economic miracle of the so-called 'third Italy'. And it relies, she continues, on the insecurity of those forced onto the periphery to play the role of buffer against the instabilities of the marketplace. More than this, the shift to post-Fordism represents a long-term strategy developed on the part of capital to circumscribe and sidestep the established strength and radicalism of the workers. Pollert also argues that where labour has co-operated and has won some concessions, such as participation in decision-making, these have also been the result of long years of struggle. And within the post-Fordist factories the establishment of work teams and the introduction of flexibility in the working day have to be set alongside the disappearance of space for autonomy and resistance. There is no longer the possibility of shopfloor culture where an integrated and less overtly hier-archical workforce watch each other in the workshop, and over the dinner table. And the consequences of post-Fordism for those excluded from the secure jobs is to consolidate the casualization of work for the rest and in the longer term to create a more divisive society, one with a real rather than simply an imagined underclass. Post-Fordism in its more alluring guise is, according to Pollert, nothing more than an 'ideology' which conceals the radical restructuring which capital has found it necessary to undertake as the older post-war economic and social settlement fails to produce the profit levels necessary to shield off international competition. As she puts it, 'the "discovery" of the flexible workforce is part of an ideological offensive which celebrates pliability and casualisation, *and makes them seem inevitable*'. She continues to argue that this is nothing more than telling people 'how to live with insecurity and unemployment and learn to love it' (72).

In Simon Clarke's response to New Times this argument is extended to include a strong critique of the emphasis on the market. He sees the seriousness with which the New Timers take the market as either a theoretical flaw or else as a sign of capitulation to the language of Thatcherism and thus an abandonment of socialism or indeed marxism.

Clarke and Pollert refuse to engage with Hall's earlier reformulation of the social meaning of the market. In *The Hard Road to Renewal* he argues that 'the left has never understood the capacity of the market to become identified in the minds of the mass or ordinary people, not as fair and decent and socially responsible (it never was), but as an expansive popular system' (Hall, 1988: 215, quoted in McGuigan, 1992: 38). In this way the market is opened up theoretically to incorporate some of the active cultural concerns of those who participate. Contrary to this position, for Clarke and Pollert the market remains nothing other than the outcome of the process of accumulation. The market is ideological in that it suggests a field of choice and expression but in reality it is a determined space, the point at which the rate of profit is managed, often through a complex set of controls and manoeuvrings involving the state in the form of subsidies, investments and

'welfare', all of which are means of ensuring the sustainability of profits for capital. Clarke's argument is that post-Fordism represents little more than a strategy developed from within capital for dealing with the falling rate of profit which the old interventionist state can no longer prop up. It is the threat to profits which requires capital to reorganize itself along the lines of flexible specialization.

In fact, between these writers there is less disagreement on post-Fordism emerging from the crisis of capital following the break-up of the old postwar settlement than they themselves seem to imagine. It is more a question of the political analysis which follows. Needless to say there is no mention of the word 'culture' in the *Capital and Class* writing. The nearest Clarke comes to engaging with what people might look for or find in the commodities of consumer capitalism lies in a fleeting reference to the old postwar settlement responding to 'rising working-class aspirations'. My point is precisely that the refusal to unpack the world of meanings in the idea of 'rising aspirations' is a much greater flaw in the otherwise sophisticated arguments of both Pollert and Clarke than the difficult and sometimes uncertain attempts by the New Times writers to revise orthodox left thinking on the market, to bring the economy back into cultural theory and at the same time to engage with the 'politics of theory', all in the space of an accessible and deliberately open-ended dialogue.

The *Capital and Class* position in contrast means being left with capital lurching from one crisis to another but always with a set of strategies tucked up its sleeve for further exploiting the working class and also for pre-empting any possibility of class politics. It is here that ideology comes into play. It manipulates and controls the working classes, end of story. (*Capital and Class* have little to say about women or black people and even less to say about cultural or identity-based politics.) This is in my mind a deeply anachronistic model. While no single account can hope to embrace the entire sweep of social changes which leave their mark across the whole landscape of everyday life, the real value of the New Times writers is that they recognize the importance of understanding social change. Thus they take the emergence of new forms of work and new kinds of workers seriously. This is the first account for example to acknowledge the existence of substantial numbers of 'design professionals' whose job it is to decide the 'economies of scope' rather than scale and who develop an 'anthropology of consumption' as they attempt to get to the heart of what people seem to want.

To writers like Pollert and Clarke such workers would be seen as either so small in number to be insignificant or else to be mere instruments of the big multinational companies who employ them to fend off competition by providing 'added value' in the form of design or unnecessary packaging of their commodities. In this respect they are mistaken. Any analysis of work which does not attempt to come to grips with the dramatic transformations

which have created huge numbers of self-employed units or small busi-
nesses across the spectrum of class, gender and ethnicity, is simply not
alert to the realities of working life in Britain today. To ignore these
fields of economic activity (for example, the production of culture and
the image industries) is to see only a void or a vacuum in that space
opened up by the decline of heavy industry. This is not the place to
engage in a debate about the sustainability of self-employment or semi-
employment in Majorist (and post-Thatcherist) Britain but it is important
to signal that these are patterns which are establishing themselves among
young and not so young workers with astonishing rapidity. John Urry in
the New Times reader says 'There have been a number of inter-related
changes in Britain; sizeable increases in the number of self-employed
people; the growth in the size of the secondary labour force so that one
third of the labour force now consists of part-time temporary and home
workers . . .'. As shown in my own work on British fashion designers, to
have one's 'own label' is simultaneously an overwhelming desire on the
part of the many fashion graduates leaving art school each year and also a
realistic response to the alternative of unemployment (McRobbie, forth-
coming). It is also a dream made possible by the Enterprise Allowance
Scheme which provides £40 a week to help young 'entrepreneurs' to
move from unemployment into self-employment. However, there is much
more to enterprise culture than simply numbers of young people on the
EAS. This 'choice' rarely coincides with an approval for Mrs Thatcher's
idea of enterprise; it is an altogether more complex and even a more
radical response. These young workers come closer to what Sean Nixon,
talking about the people who launched *The Face* magazine in the early
1980s, describes as 'committed entrepreneurs' (Nixon, 1993). So, just as
there is more to the market than the manipulation of needs, so also is
there more to new work than the intensification of labour. It is in both
these spaces that lived culture, social agents, and the category of experi-
ence and desire come into play. All of these remain, however, resolutely
outwith the vocabulary of the *Capital and Class* journal. Without theoriz-
ing what they mean by it, to these writers this is all 'ideology'.

THE PROBLEM OF IDEOLOGY

In one rather narrow respect the *Capital and Class* theorists present a
convincing analysis of what it is that capital is doing as it shifts into a
mode which is less centralized, less homogenized and more highly com-
puterized, thus dispensing with substantial sectors of the workforce on the
way. This is, they argue, managed through the successful deployment of a
huge ideological offensive which was held together in Britain through the
figure of Thatcher and through the ideas which came to be associated with
Thatcherism. In this way the class struggle continues unabated as the

workforce is beaten from pillar to post. The problem is, however, that there is little talk of the workers and the struggles they are engaged in throughout the *Capital and Class* writing. There is a large silence here. And the only assumption that can be drawn is that in the light of this offensive the working classes have been, temporarily perhaps, quietened. But this silence also means that the analysis itself is weakened because we have absolutely no sense of what this totalizing model of economic restructuring and ideological attack comes up against, or of what it encounters in its journey from factory floor, to dole office, to home, street and family.

In short there is no sense of what the social field itself looks like, how it is occupied, what forms of social and cultural activity accompany changes in the workplace. The only conclusion that can be drawn is that the working class in whatever form it continues to exist (and this is also a question not raised by the *Capital and Class* writers) is won over by ideology, it is in effect made passive, it is the victim of capital. It is precisely against this kind of manipulation thesis that New Times writers make a clear attempt to rethink ideology. From their point of view the lofty correctness of the left in relation to how the masses are simply duped, tricked or conned by the gloss and the glow of Thatcherism has a tinge of arrogance and elitism. In what is perhaps an urgent piece of pleading Hall asks that the left stops for a moment and thinks about what it is that makes the language of the new radical right sufficiently attractive to the electorate to keep the Conservatives in government for so long that the idea of Labour in office is now a hazy memory.

This is to return to those aspects of ordinary everyday life which connect people to the ideas of the right rather than those of the left, it is to show how questions of choice, how the 'right to buy', how the address to parents, and to citizens, had a resonance which the left were not able to match, even when they were able to demonstrate the shallowness and the dishonesty of many of these 'promises'. Partly of course this had to do with the simultaneous negating of all ideas associated with the left which the Thatcher government also embarked upon and maintained through the heady days of gold cards and huge mortgages. It is ironic to say the least that Stuart Hall's account in *Policing the Crisis* (Hall *et al.*, 1978) of the management of consent undertaken by the radical right, and the way in which that entailed the total discrediting of the ideas associated with the radical left from the late 1960s onwards, still leaves him open to scorn for adopting what is described as a 'new realist' or accommodationist position today. It is as though 'letting the people in' to the field of analysis rocks the boat of left consensus. The people are too difficult in their diversity, too unpredictable in their tastes, too likely to stray from the path of class politics, that it is better and perhaps safer to run the risk of being seen as elitist and have them safely suffering from either 'false consciousness' or ideological seduction.

Part of the New Times project was therefore to write into the analysis of the field of social and cultural life, not just the noticeable changes on the landscape of new towns and new shopping-centres and theme parks and heritage museums, but also the experience of these phenomena. As men of the left this perhaps did not come too easy and the suggestion of a personal voice in the account of walking round IKEA sometimes struck an awkward note. What is more, for feminists who had for some time been arguing for the inclusion of the category of experience in political analysis and in theory and who had with some difficulty also striven to find the right kind of voice, this new evocation of experience was maybe a little overdue. But that did not mean it was not welcome, the alternative assumption being that the austere writers of *Capital and Class* could not consider stooping so low as to express some degree of enjoyment in taking a stroll down South Molton Street or through Covent Garden. Or else, as Frith and Savage do, remove themselves from such a discourse except when they write journal-istically as 'rock critics' in which case they 'come out' as fans. Otherwise they see the current interest in popular culture as 'a method of uncritical celebration' or more aggressively they see in 'Contemporary cultural studies' cheerful populism' academics with 'new found respect for sales figures' (Frith and Savage, 1992: 107).

My own critique of New Times was certainly not made in this rather spiteful spirit. It was more of a reminder that for women a good deal of the construction of femininity, ideology or not, has focused round consump-tion, from the smallest item of beauty product to the perfect pair of shoes. Feminist theory has for many years grappled with the question of pleasure and complicity in the ideology of femininity and most importantly has shown women not to be simply taken in by consumer culture but to be engaged in everyday life neither as dupes nor simply and unproblemati-cally as feminists and socialists waiting patiently for the great day when their sisters denounce Clinique or Next or Donna Karan and channel their efforts into something different and better.

What might have weakened the case of the New Times writers is that, while open to the question of experience, there were few spoken voices of ordinary people in the book as a whole. Not that the full-blown presence of the category of experience would have been unproblematic. How such 'voices' would have found their way into this kind of analysis raises many more questions than can be realistically dealt with here. David Morley's recent review of the current debate in cultural studies on ethno-graphy, and on recording, documenting and analysing the accounts of 'other people(s)' is useful in that it reminds us of the inevitability and indeed the necessity of authorial mediation in such work (Morley, forth-coming). In the case of New Times and in relation to the earlier comment made here about the importance of developing a nexus of institutional, ethnographic and empirical work, the obvious question is how and why?

There is a tendency, when the question of experience is raised in this way, for it to act as a kind of touchstone of truth or authenticity; it becomes a point of reference against which all the other work can be judged. Only through a re-conceptualization of the category of experience, and with this a good deal of new thinking on how to use experience fruitfully whether in an ethnographic context or not, can we move towards a more integrative mode of analysis which overcomes this idea that 'ordinary people' and 'lived reality' are out there and somehow not in here. In fact the real attempt in the position pieces in New Times to articulate the shared enjoyments and small pleasures of everyday life mark one way of 'identifying' oneself as part of that community of ordinary people, without shifting too decisively into the language of personal experience or autobiography. However this kind of 'mention' remains very much an undercurrent. It leaves unresolved how spoken voices might be brought back into the distinctive kind of work which New Times represents. (This is a slightly different question from that of the status of 'ethnography' in, let us say, television audience studies. For a much fuller account of this debate see, again, Morley's paper.)

Only in Bea Campbell's analysis of three new towns as viewed from the perspective of some of their female inhabitants, is there any sense of the lived, dense, textured quality of experience. Work like this, drawn up into a much fuller study, would indeed accomplish the move towards the kind of empirical and experiential 'realities', the absence of which I argued earlier left cultural theory open to attack for an overemphasis on representations, texts and meaning which in turn had produced an unproductive counter-development in the looking towards so-called active readers and subversive audiences. This kind of 'new ethnography' can be found substantially in recent American cultural studies. If one of the problems with pure textuality was the tendency to lose track of wider social and political realities, then exactly the same criticism can be made of ethnographic work which finds no reason to connect the now hyperactive textual experiences of the 'sample' to the wider social and historical relations in which these experiences come to be expressed. The politics is sufficiently revealed in the activity. This is unsatisfactory even from the most basic sociological point of view. Putting to one side for the moment the 'new' cultural studies which embraces this 'power to the audience' approach, what it does nonetheless raise as a critical question is precisely on what grounds experiential, ethnographic material can exist within the kind of connective cultural studies work which is the complement to the more immediately political project of New Times.

If the key issue for New Times remains, however, that of how to make sense of social phenomena without unduly relying on ideology, then writers like Morley, whose sociological sense disallows attributing to the audience the enormous powers of opposition which this new cultural

studies work permits, have also played an important role in disputing the totalizing power of ideology. Here attention is paid to the significant slippages which occur in the spaces which intervene in the passage of reading, watching or consuming. McGuigan, Frith and others conflate the careful attention to the interactive surface of texts with experience seen in the work of Morley (1992) and Ang (1991) with the more ambitious claims of others to find resistance in the act of turning the television on. The two terms of abuse from McGuigan *et al.* that keep reappearing are 'fashionable' and 'celebration'. I will return to the charge of being 'fashionable' later. For now McGuigan sees in Hall's New Times work and in all the authors cited above (in addition to myself) a kind of 'cultural populism'. By this he means a stretching out on the part of the theorist to understand that the popular pleasures experienced by ordinary people in the space of leisure or consumption or indeed in 'family life', can contain elements untarnished by or unanticipated by capital or even provided by capital but at least reworked by the consumer in the practice of consumption. McGuigan mistakenly interprets Stuart Hall as pursuing this kind of analysis even further. He claims Hall sees ordinary people as 'active pleasure-seekers' and 'trusts in the good sense of their judgement' (McGuigan, 1992: 38).

This suggestion, discounting for a moment the scale of misrepresentation here of Hall's writing, allows McGuigan and others, in particular Frith and Savage, to argue that cultural studies has abandoned all commitment to understanding relations of power and powerlessness, dominance and subordination as they are expressed in culture. For them the New Times writing is the ultimate example of recantation. The simple existence of clear signs of opposition and resistance in the heartland of consumer culture means that politics is happening anyway. This, argue Frith and Savage, allows New Times to feel obliged to do no more than mention it and otherwise sit back and enjoy the sound of the tills ringing up more sales. Frith and Savage are even more aggressive than McGuigan in their account of this new kind of cultural studies, as the title of their polemic suggests. 'The pearls and the swine' sets a new and unwelcome standard in male intellectual-left combat. In the light of such antagonism let us stand back for a moment and absorb and reflect on the charges now being laid at the doorstep not just of New Times but of the whole field of cultural studies.

WHAT IS AT STAKE?

First I would suggest that in all emergent theoretical position-taking there are margins of provocation, there is an imaginative (perhaps too highly imaginative) staking out of new terrains. If that counts as being too 'fashionable' as McGuigan puts it, then it might be worth reminding that writer that the trivial pursuits which count for him as too fashionable, and

thus lacking in substance, are precisely what cultural studies insisted on taking seriously in the first place. If this is too much for the critics then why do they too spend so much time on cultural studies itself? Are they somehow in possession of the real political agenda? If so, it might be useful to have an opportunity to look at it. Meanwhile the profound distrust of fashion and the charge laid against these writers as being merely fashionable, betrays the voice of the male critic for whom fashion is disquieting, uncomfortable, and thus best regarded as superficial and unimportant.

The same kind of dismissive (bordering on contemptuous) tone creeps into the language of another recent critic of cultural studies in what in this case is a defence of political economy. Writing against what he perceives as an excessive concern for cultural politics in black writing Garnham (1995) argues 'it is hard to argue that much dent will be made in domination if black is recognised as beautiful but nothing is done about processes of economic development . . . and exclusions from and marginalisation in labour markets.' The same goes, he continues for gender. As though all that has emerged from the extensive writing on race and ethnicity in cultural studies by Stuart Hall, Kobena Mercer and Paul Gilroy, can be condensed into the idea that 'black is beautiful'. The scale of this reductionism is as revealing as it is extraordinary.

There is a world of difference between the few wilder voices who see self-expression and resistance residing in the actions of those who loiter in shopping malls (something for which Garnham also holds me responsible) and those who insist that we listen to how people interpret and make sense of their own experience. And that this experience points to something quite different from happy capitulation to New Right rhetoric is also interesting and important. But even where it does articulate a solid embracing of neo-conservative values, that too is something which has to be addressed. It goes some way in helping us to understand precisely what made Thatcherism so popular. Phil Cohen's recent and exhaustive work on the 'popular' racism of white working-class children and young people in South-east London is an excellent example of work of this sort (Cohen, 1992).

Christopher Norris is as critical in his response to New Times as McGuigan, Frith and Savage are to 'cultural populism'. In his reading of Stuart Hall's apparent shift to the outer reaches of apolitical postmodernism (!) he inadvertently, at least from the point of view of this discussion, hits the nail on the head when he says 'What Hall cannot countenance is any hint of a return to notions like "ideology" or "false consciousness", terms that might provide the beginning of an answer to the questions posed by his article' (Norris, 1992: 5). The challenge which New Times represents is exactly how to understand agency without relying on either ideology or false consciousness.

The difficulty in doing this is, as I suggested in 'New Times in cultural

studies' (McRobbie, 1991), also one of how to approach so vast a field as 'the social' or indeed the category of experience without a more reduced and more refined object of enquiry, and without seeing such a project as a kind of return, or even a retreat, to 'the local' or the 'micrological' (Morley, forthcoming). Nor is it a question of defending empiricism or ethnography or indeed institutional research as good things in themselves. It is more a matter of turning attention to the daily practices of institutions, the ways of making sense which exist inside these structures and which have some effect on how they operate. To conclude, and to continue in this track, I will make some observations and raise some suggestions about why the New Times project seems still valuable and why the cultural studies strand in it indicates an area of academic work which it is important to defend.

In a sense it is, as usual, unfortunate that so heated a debate on the left should produce such high levels of hostility. While ideology in its tight version, that is as a distinctive 'unity', might no longer be such a useful way of understanding the flows and crossovers and inter-textual connections which have become such a noticeable feature of the global culture of mass communications today (and ideology always seemed to work best when it was applied to the mass media), this does not mean, as Andrew Goodwin, using ideology in the more forceful sense, has usefully reminded us, that there is no such thing as market manipulation.

> One does not however have to agree that manipulation is always successful, or believe that it cannot be subverted or resisted, to see that it is attempted, routinely. Thus, in coming to terms with the construction of star images in music television it is impossible to avoid the conclusion that theories of manipulation should not be abandoned altogether.
> (Goodwin, 1993: 105)

The argument is not therefore that institutional analysis of the sort being recommended here abandons the role ideology might play in the process of marketing new products, for example. It is more that attention must be drawn to the various levels of activity and the relations of power played out in the decision-making processes which produce the marketing campaign and the product itself. This allows us to open up what otherwise remains in political economy a fairly closed and monolithic notion of large organizations and of huge multinational complexes, particularly in the field of mass communications. Letting the people who work in them into the picture not only allows lived social relations to reappear in cultural studies, it also gives to 'the politics of theory' a sharper sense of how these organizations actually work. The political value of this kind of project is more clearly indicated in New Times than elsewhere. For example, there is room in New Times for reconsidering the new politics of work. This would involve taking more seriously the kinds of employment which in the past might have been seen as having little intrinsic interest to the left because of their

'petit-bourgeois' connotations. But working with design students who with few exceptions moved into either self-employment (as graphic designers, fashion designers, advertising copy-artists) or else into working for small design studios employing a handful of freelancers, was enough to convince me that this sort of work was increasingly at the very heart of the new production processes. These were not highly paid middle-class professionals. They were inevitably doing real donkey work for the new culture industries (mock-ups for brochures, brochure-writing, corporate video production, 'styling' for cookbook photography, etc.). Such young workers aimed high but were realistically reconciled to keeping their heads above water financially. The left needs to know precisely about the politics of work in this new kind of sector. It is completely possible to be 'fashionable', to embrace an ethos of 'expressive individualism' in work and indeed to seek great pleasure and satisfaction in creative work of this sort, and *also* to adhere to socialist values of equality, social justice, economic redistribution, the value of the public sector, anti-sexism, anti-racism, etc. If this is partly what was meant by 'designer socialism' then at least it was an analysis which took seriously where many thousands of young people (black and white, working class and middle class, female and male) were at and wanted to be, where they not just wanted to work but chose to work, not for huge financial gain but for the power of being able to redefine the working day, to bring together work and leisure, and to integrate their own often radical or, to quote Nixon again, 'committed' ideas into a kind of craft entrepreneurialism. This sector shows itself to be rising in number and poses therefore a real challenge to how we think about work and the politics of the composition of the workforce. Donzelot and others have poured scorn on those who have seen in post-Fordism the possibility of 'pleasure in work', preferring to interpret such promises as entirely 'discursive' and therefore as part of the new managerial reorganization of the experience of work. To encourage pleasure in work is to create a new more enthusiastic kind of worker who willingly gives his or her everything in the expectation of having this creative commitment rewarded (Donzelot, 1991). This utopia is a 'shelter for the reign of imagination, extraverting the subject towards a world of possibilities that exhaust imagination' (276). But we could just as well re-inflect Foucault in another direction to recognize that the 'stylistics of existence' and the 'technologies of the self' manifest in this kind of choice of existence, far from signalling a retreat into narcissism, excessive self-regard or 'blind ambition', are in fact founded on real understanding of how changed the world of work is (Foucault, 1988). In this sense there is a kind of pre-emptive opportunism in opting for the cultural or creative economy, one which is also protective, realistic and potentially rewarding. We cannot automatically read from this cultural response, accommodationism or a retreat into Thatcherite-influenced 'expressive individualism' as some have

labelled it. Nor is it necessarily incompatible with the pursuit of what Laclau labels 'radical social democracy'.

A good deal seems to be at stake in the intensification of debate and even antagonism which has developed around the question of cultural studies, its so-called populist project and the kind of politics found in New Times. This stems partly from the popularity of cultural studies among students (and in this sense market forces increasingly matter in the funding of higher education). The hostility also is focused on the journalistic versions of New Times and cultural studies now found in magazines, newspapers and on the occasional television programme. It is as though the popularity of the subject forces those who would otherwise prefer to ignore it and continue with what they perceive as more conventional and rigorous programmes of study in fact to stake some claim to the field and in so doing redefine it again in the direction of some more manageable body of knowledge. There is nothing unusual or surprising about this since it is quite apparent that what emerged as cultural studies in the first place was always an open-ended and potentially redefinable field. To try to protect cultural studies from either the 'contamination' of the culture industries (the *Modern Review*, for example) or from the neo-colonialism of the old disciplines which feel themselves slipping from the centre of intellectual life, and therefore willing to redefine themselves as cultural studies too, would be a pointless task. There are also more immediate political issues to engage with than the charge that New Times is synonymous with a simple celebration of consumer culture. And yet it is because there is more at stake in these claims than the simple attack on New Times suggests, that makes it important to indicate just how mistaken it is for critics to dismiss the necessity of the pleasures which happen to come to us in the commodity form, as a cultural lifeline, a way of allowing rather than disallowing critique and analysis and understanding. This is not the same as saying that Snoop Doggy Dog sustains us in our privatized existence. Nor does it mean we applaud the mentality of gangsta rap because we like the music. The real point seems to be that as more 'subaltern' peoples (including young semi-employed people, black people, women) lay a claim to culture in diverse ways, in music, in politics and in theory, in images, in language, in pulp romance, in 'lesbian detective fiction', and as more people want to talk about culture at home, in the classroom, or even in the field of politics, and do so articulately and with increasing confidence, the old guard of cultural legislators including those from the left feel called upon to pull things into line, to impose some degree of order on a situation which they feel is sliding beyond their control. Hence the antagonism, hence the talk of 'skewering' the postmodernists for playing the commodities game (Frith and Savage, 1992). Gilroy's brief comments on records and on record sleeves stand as a useful and poignant counterpoint to such academic posturing.

'Consumption' is a vague word that trips far too easily off the dismissive tongue. People *use* these images and the music that they enclose for a variety of reasons. For the black user of these images and products, multivariant processes of 'consumption' may express the need to belong, the desire to make the beauty of blackness intelligible and somehow to fix that beauty and the pleasures it creates so that they achieve . . . at least a longevity that retrieves them from the world of . . . racial dispossession. However trivial the black music record sleeve may seem to the outsider, it points to a fund of aesthetic and philosophical folk knowledge which the record as a commodity has been made to contain *in addition* to its reified pleasures.

(Gilroy, 1993: 256)

REFERENCES

Ang, I. (1991) *Desperately Seeking the Audience*, Routledge.
Campbell, B. (1989) 'New Times towns', in S. Hall and M. Jacques (eds) *New Times: The Changing Face of Politics in the 1990s*, Lawrence & Wishart, 279–303.
Clarke, S. (1990) 'Overaccumulation, class struggle and the regulation approach', *Capital and Class* 42 (Winter), 59–93.
Cohen, P. (1992) '"It's racism what dunnit": hidden narratives in theories of racism' in J. Donald and A. Rattansi (eds) *'Race' Culture and Difference* Sage, 62–104.
Donzelot, J. 'Pleasure in work', in G. Burchell, C. Gordon and P. Miller (eds) (1991), Harvester Wheatsheaf, 251–81.
Foucault, M. (1988) *Technologies of the Self*, L.H. Martin, H. Gutman, P.H. Hutton (eds), Tavistock.
Frith, S. and Savage, J. (1992) 'Pearls and swine: the intellectuals and the mass media', *New Left Review* 198, 107–16.
Garnham, N. (1995) 'Political economy and cultural studies: reconciliation or divorce?', *Critical Studies in Mass Communications*, March, 62–71.
Gilroy, P. (1993) *Small Acts: Thoughts on the Politics of Black Cultures*, Serpents Tail.
Goodwin, A. (1993) *Dancing in the Distraction Factory: Music Television and Popular Culture*, Routledge.
Hall, S. (1988) *The Hard Road to Renewal*, Verso.
Hall, S., Critcher, C., Jefferson, T., Clarke, J. and Roberts, B. (1978) *Policing the Crisis: 'Mugging', the State and Law and Order*, Macmillan.
Hall, S. and Jacques, M., (eds) (1989) *New Times: The Changing Face of Politics in the 1990s*, Lawrence & Wishart.
Hebdige, D. (1989) 'After the masses', in Hall and Jacques (eds), as above, 76–94.
McGuigan, J. (1992) *Cultural Populism*, Routledge.
McRobbie, A. (1991) 'New Times in cultural studies', *New Formations* 13, Routledge, 1–18.
———— (1994) 'Different, youthful subjectivities: towards a cultural sociology of youth', in *Postmodernism and Popular Culture*, Routledge.
———— (forthcoming) *Fashion and the Image Industries*, Routledge.
Morley, D. (1992) *Television, Audiences and Cultural Studies*, Routledge.

———— (forthcoming) 'Theoretical orthodoxies': textualism, constructivism and the 'new ethnography', in M. Ferguson and P. Golding (eds) *Beyond Cultural Studies*, Sage.

Morris, M. (1988) 'Banality in cultural studies', *Block* 14.

Mort, F. (1989) 'The politics of consumption', in Hall and Jacques, 160–73.

Murray, R. (1989) 'Fordism and post-Fordism' and 'Benetton Britain', both in Hall and Jacques, 38–54.

Nixon, S. (1993) 'Looking for the Holy Grail: publishing and advertising strategies and contemporary men's Magazines', *Cultural Studies* 7(3), 466–92.

Norris, C. (1992) 'Old themes for New Times', *New Formations* 18, 1–25.

Pollert, A. (1988) 'Dismantling flexibility', *Capital and Class* 34 (Spring), 42–72.

Radway, J. (1988) 'Reception study', *Cultural Studies* 2(3), 359–76.

Rustin, M. (1989) 'The trouble with New Times', in Hall and Jacques, 303–21.

Urry, J. (1989) 'The end of organised capitalism', in Hall and Jacques, 76–94.

Cultural studies and its theoretical legacies

Stuart Hall

My title, 'Cultural studies and its theoretical legacies', suggests a look back to the past, to consult and think about the Now and the Future of cultural studies by way of a retrospective glance. It does seem necessary to do some genealogical and archaeological work on the archive. Now the question of the archives is extremely difficult for me because, where cultural studies is concerned, I sometimes feel like a *tableau vivant*, a spirit of the past resurrected, laying claim to the authority of an origin. After all, didn't cultural studies emerge somewhere at that moment when I first met Raymond Williams, or in the glance I exchanged with Richard Hoggart? In that moment, cultural studies was born; it emerged full grown from the head! I do want to talk about the past, but definitely not in that way. I don't want to talk about British cultural studies (which is in any case a pretty awkward signifier for me) in a patriarchal way, as the keeper of the conscience of cultural studies, hoping to police you back into line with what it really was if only you knew. That is to say, I want to absolve myself of the many burdens of representation which people carry around – I carry around at least three: I'm expected to speak for the entire black race on all questions theoretical, critical, etc., and sometimes for British politics, as well as for cultural studies. This is what is known as the black person's burden, and I would like to absolve myself of it at this moment.

That means, paradoxically, speaking autobiographically. Autobiography is usually thought of as seizing the authority of authenticity. But in order not to be authoritative, I've got to speak autobiographically. I'm going to tell you about my own take on certain theoretical legacies and moments in cultural studies, not because it is the truth or the only way of telling the history. I myself have told it many other ways before; and I intend to tell it in a different way later. But just at this moment, for this conjecture, I want to take a position in relation to the 'grand narrative' of cultural studies for the purposes of opening up some reflections on cultural studies as a

Reprinted from L. Grossberg *et al.* (eds), *Cultural Studies*, London: Routledge, 1992, 277–86.

practice, on our institutional position, and on its project. I want to do that by referring to some theoretical legacies or theoretical moments, but in a very particular way. This is not a commentary on the success or effectiveness of different theoretical positions in cultural studies (that is for some other occasion). It is an attempt to say something about what certain theoretical moments in cultural studies have been like for me, and from that position, to take some bearings about the general question of the politics of theory.

Cultural studies is a discursive formation, in Foucault's sense. It has no simple origins, though some of us were present at some point when it first named itself in that way. Much of the work out of which it grew, in my own experience, was already present in the work of other people. Raymond Williams has made the same point, charting the roots of cultural studies in the early adult education movement in his essay on 'The future of cultural studies' (1989). 'The relation between a project and a formation is always decisive', he says, because they are 'different ways of materializing . . . then of describing a common disposition of energy and direction'. Cultural studies has multiple discourses; it has a number of different histories. It is a whole set of formations; it has its own different conjunctures and moments in the past. It included many different kinds of work. I want to insist on that! It always was a set of unstable formations. It was 'centred' only in quotation marks, in a particular kind of way which I want to define in a moment. It had many trajectories; many people had and have different trajectories through it; it was constructed by a number of different methodologies and theoretical positions, all of them in contention. Theoretical work in the Centre for Contemporary Cultural Studies was more appropriately called theoretical noise. It was accompanied by a great deal of bad feeling, argument, unstable anxieties, and angry silences.

Now, does it follow that cultural studies is not a policed disciplinary area? That it is whatever people do, if they choose to call or locate themselves within the project and practice of cultural studies? I am not happy with that formulation either. Although cultural studies as a project is open-ended, it can't be simply pluralist in that way. Yes, it refuses to be a master discourse or a meta-discourse of any kind. Yes, it is a project that is always open to that which it doesn't yet know, to that which it can't yet name. But it does have some will to connect; it does have some stake in the choices it makes. It does matter whether cultural studies is this or that. It can't be just any old thing which chooses to march under a particular banner. It is a serious enterprise, or project, and that is inscribed in what is sometimes called the 'political' aspect of cultural studies. Not that there's one politics already inscribed in it. But there is something *at stake* in cultural studies, in a way that I think, and hope, is not exactly true of many other very important intellectual and critical practices. Here one registers the tension between a refusal to close the field, to police it and,

at the same time, a determination to stake out some positions within it and argue for them. That is the tension – the dialogic approach to theory – that I want to try to speak to in a number of different ways in the course of this paper. I don't believe knowledge is closed, but I do believe that politics is impossible without what I have called 'the arbitrary closure'; without what Homi Bhabha called social agency as an arbitrary closure. That is to say, I don't understand a practice which aims to make a difference in the world, which doesn't have some points of difference or distinction which it has to stake out, which really matter. It is a question of positionalities. Now, it is true that those positionalities are never final, they're never absolute. They can't be translated intact from one conjuncture to another; they cannot be depended on to remain in the same place. I want to go back to that moment of 'staking out a wager' in cultural studies, to those moments in which the positions began to matter.

This is a way of opening the question of the 'wordliness' of cultural studies, to borrow a term from Edward Said. I am not dwelling on the secular connotations of the metaphor of worldliness here, but on the worldliness of cultural studies. I'm dwelling on the 'dirtiness' of it: the dirtiness of the semiotic game, if I can put it that way. I'm trying to return the project of cultural studies from the clean air of meaning and textuality and theory to the something nasty down below. This involves the difficult exercise of examining some of the key theoretical turns or moments in cultural studies.

The first trace that I want to deconstruct has to do with a view of British cultural studies which often distinguishes it by the fact that, at a certain moment, it became a marxist critical practice. What exactly does that assignation of cultural studies as a marxist critical theory mean? How can we think cultural studies at that moment? What moment is it we are speaking of? What does that mean for the theoretical legacies, traces, and after-effects which marxism continues to have in cultural studies? There are a number of ways of telling that history, and let me remind you that I'm not proposing this as the only story. But I do want to set it up in what I think may be a slightly surprising way to you.

I entered cultural studies from the New Left, and the New Left always regarded marxism as a problem, as trouble, as danger, not as a solution. Why? It had nothing to do with theoretical questions as such or in isolation. It had to do with the fact that my own (and its own) political formation occurred in a moment historically very much like the one we are in now – which I am astonished that so few people have addressed – the moment of the disintegration of a certain kind of marxism. In fact, the first British New Left emerged in 1956 at the moment of the disintegration of an entire historical/political project. In that sense I came into marxism backwards: against the Soviet tanks in Budapest, as it were. What I mean by that is certainly not that I wasn't profoundly, and that cultural studies then wasn't

from the beginning, profoundly influenced by the questions that marxism as a theoretical project put on the agenda: the power, the global reach and history-making capacities of capital; the question of class; the complex relationships between power, which is an easier term to establish in the discourses of culture than exploitation, and exploitation; the question of a general theory which could, in a critical way, connect together in a critical reflection different domains of life, politics and theory, theory and practice, economic, political, ideological questions, and so on; the notion of critical knowledge itself and the production of critical knowledge as a practice. These important, central questions are what one meant by working within shouting distance of marxism, working on marxism, working against marxism, working with it, working to try to develop marxism.

There never was a prior moment when cultural studies and marxism represented a perfect theoretical fit. From the beginning (to use this way of speaking for a moment) there was always-already the question of the great inadequacies, theoretically and politically, the resounding silences, the great evasions of marxism – the things that Marx did not talk about or seem to understand which were our privileged object of study: culture, ideology, language, the symbolic. These were always-already, instead, the things which had imprisoned marxism as a mode of thought, as an activity of critical practice – its orthodoxy, its doctrinal character, its determinism, its reductionism, its immutable law of history, its status as a meta-narrative. That is to say, the encounter between British cultural studies and marxism has first to be understood as the engagement with a problem – not a theory, not even a problematic. It begins, and develops through the critique of a certain reductionism and economism, which I think is not extrinsic but intrinsic to marxism; a contestation with the model of base and super-structure, through which sophisticated and vulgar marxism alike had tried to think the relationships between society, economy, and culture. It was located and sited in a necessary and prolonged and as yet unending contestation with the question of false consciousness. In my own case, it required a not-yet-completed contestation with the profound Eurocentrism of marxist theory. I want to make this very precise. It is not just a matter of where Marx happened to be born, and of what he talked about, but of the model at the centre of the most developed parts of marxist theory, which suggested that capitalism evolved organically from within its own trans-formations. Whereas I came from a society where the profound integument of capitalist society, economy, and culture had been imposed by conquest and colonization. This is a theoretical, not a vulgar critique. I don't blame Marx because of where he was born; I'm questioning the theory for the model around which it is articulated: its Eurocentrism.

I want to suggest a different metaphor for theoretical work: the metaphor of struggle, of wrestling with the angels. The only theory worth having is that which you have to fight off, not that which you speak with profound

fluency. I mean to say something later about the astonishing theoretical fluency of cultural studies now. But my own experience of theory – and marxism is certainly a case in point – is of wrestling with the angels – a metaphor you can take as literally as you like. I remember wrestling with Althusser. I remember looking at the idea of 'theoretical practice' in *Reading Capital* and thinking, 'I've gone as far in this book as it is proper to go'. I felt, I will not give an inch to this profound misreading, this super-structuralist mistranslation, of classical marxism, unless he beats me down, unless he defeats me in the spirit. He'll have to march over me to convince me. I warred with him, to the death. A long, rambling piece wrote (Hall, 1974) on Marx's 1857 'Introduction' to *The Grundrisse*, in which I tried to stake out the difference between structuralism in Marx's epistemology and Althusser's, was only the tip of the iceberg of this long engagement. And that is not simply a personal question. In the Centre for Contemporary Cultural Studies, for five or six years, long after the anti-theoreticism or resistance to theory of cultural studies had been overcome, and we decided, in a very un-British way, we had to take the plunge into theory, we walked right around the entire circumference of European thought, in order not to be, in any simple capitulation to the *zeitgeist*, marxists. We read German idealism, we read Weber upside down, we read Hegelian idealism, we read idealistic art criticism. (I've written about this in the article called 'The hinterland of science: sociology of knowledge' [1980a] as well as in 'Cultural studies and the centre: some problems and problematics' [1980b].)

So the notion that marxism and cultural studies slipped into place, recognized an immediate affinity, joined hands in some teleological or Hegelian moment of synthesis, and there was the founding moment of cultural studies, is entirely mistaken. It couldn't have been more different from that. And when, eventually, in the 1970s, British cultural studies did advance – in many different ways, it must be said – within the problematic of marxism, you should hear the term problematic in a genuine way, not just in a formalist-theoretical way: as a problem; as much about struggling against the constraints and limits of that model as about the necessary questions it required us to address. And when, in the end, in my own work, I tried to learn from and work with the theoretical gains of Gramsci, it was only because certain strategies of evasion had forced Gramsci's work, in a number of different ways, to respond to what I can only call (here's another metaphor for theoretical work) the conundrums of theory, the things which marxist theory couldn't answer, the things about the modern world which Gramsci discovered remained unresolved within the theoretical framework of grand theory – marxism – in which he continued to work. At a certain point, the questions I still wanted to address in short were inaccessible to me except via a detour through Gramsci. Not because Gramsci resolved them but because he at least

addressed many of them. I don't want to go through what it is I personally think cultural studies in the British context, in a certain period, learned from Gramsci: immense amounts about the nature of culture itself, about the discipline of the conjunctural, about the importance of historical specificity, about the enormously productive metaphor of hegemony, about the way in which one can think questions of class relations only by using the displaced notion of ensemble and blocs. These are the particular gains of the 'detour' via Gramsci, but I'm not trying to talk about that. I want to say, in this context, about Gramsci, that while Gramsci belonged and belongs to the problematic of marxism, his importance for this moment of British cultural studies is precisely the degree to which he radically *displaced* some of the inheritances of marxism in cultural studies. The radical character of Gramsci's 'displacement' of marxism has not yet been understood and probably won't ever be reckoned with, now we are entering the era of post-marxism. Such is the nature of the movement of history and of intellectual fashion. But Gramsci also did something else for cultural studies, and I want to say a little bit about that because it refers to what I call the need to reflect on our institutional position, and our intellectual practice.

I tried on many occasions, and other people in British cultural studies and at the Centre especially have tried, to describe what it is we thought we were doing with the kind of intellectual work we set in place in the Centre. I have to confess that, though I've read many, more elaborated and sophisticated accounts, Gramsci's account still seems to me to come closest to expressing what it is I think we were trying to do. Admittedly, there's a problem about his phrase 'the production of organic intellectuals'. But there is no doubt in my mind that we were trying to find an institutional practice in cultural studies that might produce an organic intellectual. We didn't know previously what that would mean, in the context of Britain in the 1970s, and we weren't sure we would recognize him or her if we managed to produce it. The problem about the concept of an organic intellectual is that it appears to align intellectuals with an emerging historic movement and we couldn't tell then, and can hardly tell now, where that emerging historical movement was to be found. We were organic intellectuals without any organic point of reference; organic intellectuals with a nostalgia or will or hope (to use Gramsci's phrase from another context) that at some point we would be prepared in intellectual work for that kind of relationship, if such a conjuncture ever appeared. More truthfully, we were prepared to imagine or model or simulate such a relationship in its absence: 'pessimism of the intellect, optimism of the will'.

But I think it is very important that Gramsci's thinking around these questions certainly captures part of what we were about. Because a second aspect of Gramsci's definition of intellectual work, which I think has

always been lodged somewhere close to the notion of cultural studies as a project, has been his requirement that the 'organic intellectual' must work on two fronts at one and the same time. On the one hand, we had to be at the very forefront of intellectual theoretical work because, as Gramsci says, it is the job of the organic intellectual to know more than the traditional intellectuals do: really know, not just pretend to know, not just to have the facility of knowledge, but to know deeply and profoundly. So often knowledge for marxism is pure recognition – the production again of what we have always known! If you are in the game of hegemony you have to be smarter than 'them'. Hence, there are no theoretical limits from which cultural studies can turn back. But the second aspect is just as crucial: that the organic intellectual cannot absolve himself or herself from the responsibility of transmitting those ideas, that knowledge, through the intellectual function, to those who do not belong, professionally, in the intellectual class. And unless those two fronts are operating at the same time, or at least unless those two ambitions are part of the project of cultural studies, you can get enormous theoretical advance without any engagement at the level of the political project.

I'm extremely anxious that you should not decode what I'm saying as an anti-theoretical discourse. It is not anti-theory, but it does have something to do with the conditions and problems of developing intellectual and theoretical work as a political practice. It is an extremely difficult road, not resolving the tensions between those two requirements, but living with them. Gramsci never asked us to resolve them, but he gave us a practical example of how to live with them. We never produced organic intellectuals (would that we had) at the Centre. We never connected with that rising historic movement; it was a metaphoric exercise. Nevertheless, metaphors are serious things. They affect one's practice. I'm trying to redescribe cultural studies as theoretical work which must go on and on living with that tension.

I want to look at two other theoretical moments in cultural studies which interrupted the already-interrupted history of its formation. Some of these developments came as it were from outer space: they were not at all generated from the inside, they were not part of an inner-unfolding general theory of culture. Again and again, the so-called unfolding of cultural studies was interrupted by a break, by real ruptures, by exterior forces; the interruption, as it were, of new ideas, which decentred what looked like the accumulating practice of the work. There's another metaphor for theoretical work: theoretical work as interruption.

There were at least two interruptions in the work of the Centre for Contemporary Cultural Studies: The first around feminism, and the second around questions of race. This is not an attempt to sum up the theoretical and political advances and consequences for British cultural studies of the feminist intervention; that is for another time, another place. But I don't

want, either, to invoke that moment in an open-ended and casual way. For cultural studies (in addition to many other theoretical projects), the intervention of feminism was specific and decisive. It was ruptural. It reorganized the field in quite concrete ways. First, the opening of the question of the personal as political, and its consequences for changing the object of study in cultural studies, was completely revolutionary in a theoretical and practical way. Second, the radical expansion of the notion of power, which had hitherto been very much developed within the framework of the notion of the public, the public domain, with the effect that we could not use the term power – so key to the earlier problematic of hegemony – in the same way. Third, the centrality of questions of gender and sexuality to the understanding of power itself. Fourth, the opening of many of the questions that we thought we had abolished around the dangerous area of the subjective and the subject, which lodged those questions at the centre of cultural studies as a theoretical practice. Fifth, 'the re-opening' of the closed frontier between social theory and the theory of the unconscious – psychoanalysis. It's hard to describe the import of the opening of that new continent in cultural studies, marked out by the relationship – or rather, what Jacqueline Rose has called the as yet 'unsettled relations' – between feminism, psychoanalysis and cultural studies, or indeed how it was accomplished.

We know it was, but it's not known generally how and where feminism first broke in. I use the metaphor deliberately: As the thief in the night, it broke in; interrupted, made an unseemly noise, seized the time, crapped on the table of cultural studies. The title of the volume in which this dawn-raid was first accomplished – *Women Take Issue* – is instructive: for they 'took issue' in both senses – took over that year's book and initiated a quarrel. But I want to tell you something else about it. Because of the growing importance of feminist work and the early beginnings of the feminist movement outside in the very early 1970s, many of us in the Centre – mainly, of course, men – thought it was time there was good feminist work in cultural studies. And we indeed tried to buy it in, to import it, to attract good feminist scholars. As you might expect, many of the women in cultural studies weren't terribly interested in this benign project. We were opening the door to feminist studies, being good, transformed men. And yet, when it broke in through the window, every single unsuspected resistance rose to the surface – fully installed patriarchal power, which believed it had disavowed itself. There are no leaders here, we used to say; we are all graduate students and members of staff together, learning how to practice cultural studies. You can decide whatever you want to decide, etc. And yet, when it came to the question of the reading list Now that's where I really discovered about the gendered nature of power. Long, long after I was able to pronounce the words, I encountered the reality of Foucault's profound insight into the individual reciprocity of knowledge

and power. Talking about giving up power is a radically different experience from being silenced. That is another way of thinking, and another metaphor for theory: the way feminism broke, and broke into, cultural studies.

Then there is the question of race in cultural studies. I've talked about the important 'extrinsic' sources of the formation of cultural studies – for example, in what I called the moment of the New Left, and its original quarrel with marxism – out of which cultural studies grew. And yet, of course, that was a profoundly English or British moment. Actually getting cultural studies to put on its own agenda the critical questions of race, the politics of race, the resistance to racism, the critical questions of cultural politics, was itself a profound theoretical struggle, a struggle of which *Policing the Crisis*, was, curiously, the first and very late example. It represented a decisive turn in my own theoretical and intellectual work, as well as in that of the Centre. Again, it was only accomplished as the result of a long, and sometimes bitter – certainly bitterly contested – internal struggle against a resounding but unconscious silence. A struggle which continued in what has since come to be known, but only in the rewritten history, as one of the great seminal books of the Centre for Cultural Studies, *The Empire Strikes Back*. In actuality, Paul Gilroy and the group of people who produced the book found it extremely difficult to create the necessary theoretical and political space in the Centre in which to work on the project.

I want to hold to the notion, implicit in both these examples, that movements provoke theoretical moments. And historical conjunctures insist on theories: they are real moments in the evolution of theory. But here I have to stop and retrace my steps. Because I think you could hear, once again, in what I'm saying a kind of invocation of a simple-minded anti-theoretical populism, which does not respect and acknowledge the crucial importance, at each point in the moves I'm trying to renarrativize, of what I would call the necessary delay or detour through theory. I want to talk about that 'necessary detour' for a moment. What decentred and dislocated the settled path of the Centre for Contemporary Cultural Studies certainly, and British cultural studies to some extent in general, is what is sometimes called 'the linguistic turn': the discovery of discursivity, of textuality. There are casualties in the Centre around those names as well. They were wrestled with, in exactly the same way I've tried to describe earlier. But the gains which were made through an engagement with them are crucially important in understanding how theory came to be advanced in that work. And yet, in my view, such theoretical 'gains' can never be a self-sufficient moment.

Again, there is no space here to do more than begin to list the theoretical advances which were made by the encounters with structuralist, semiotic, and post-structuralist work: the crucial importance of language and of the

linguistic metaphor to *any* study of culture; the expansion of the notion of text and textuality, both as a source of meaning, and as that which escapes and postpones meaning; the recognition of the heterogeneity, of the multiplicity, of meanings, of the struggle to close arbitrarily the infinite semiosis beyond meaning; the acknowledgment of textuality and cultural power, of representation itself, as a site of power and regulation; of the symbolic as a source of identity. These are enormous theoretical advances, though of course, it had always attended to questions of language (Raymond Williams's work, long before the semiotic revolution, is central there). Nevertheless, the refiguring of theory, made as a result of having to think questions of culture through the metaphors of language and textuality, represents a point beyond which cultural studies must now always necessarily locate itself. The metaphor of the discursive, of textuality, instantiates a necessary delay, a displacement, which I think is *always* implied in the concept of culture. If you work on culture, or if you've tried to work on some other really important things and you find yourself driven back to culture, if culture happens to be what seizes hold of your soul, you have to recognize that you will always be working in an area of displacement. There's always something decentred about the medium of culture, about language, textuality, and signification, which always escapes and evades the attempt to link it, directly and immediately, with other structures. And yet, at the same time, the shadow, the imprint, the trace, of those other formations, of the intertextuality of texts in their institutional positions, of texts as sources of power, of textuality as a site of representation and resistance, all of those questions can never be erased from cultural studies.

The question is what happens when a field, which I've been trying to describe in a very punctuated, dispersed, and interrupted way, as constantly changing directions, and which is defined as a political project, tries to develop itself as some kind of coherent theoretical intervention? Or, to put the same question in reverse, what happens when an academic and theoretical enterprise tries to engage in pedagogies which enlist the active engagement of individuals and groups, tries to make a difference in the institutional world in which it is located? These are extremely difficult issues to resolve, because what is asked of us is to say 'yes' and 'no' at one and the same time. It asks us to assume that culture will always work through its textualities – and at the same time that textuality is never enough. But never enough of what? Never enough for what? That is an extremely difficult question to answer because, philosophically, it has always been impossible in the theoretical field of cultural studies – whether it is conceived either in terms of texts and contexts, of intertextuality, or of the historical formations in which cultural practices are lodged – to get anything like an adequate theoretical account of culture's relations and its effects. Nevertheless I want to insist that until and unless cultural studies learns to live with this tension, a tension that all textual

practices must assume – a tension which Said describes as the study of the text in its affiliations with 'institutions, offices, agencies, classes, academies, corporations, groups, ideologically defined parties and professions, nations, races, and genders' – it will have renounced its 'worldly' vocation. That is to say, unless and until one respects the necessary displacement of culture, and yet is always irritated by its failure to reconcile itself with other questions that matter, with other questions that cannot and can never be fully covered by critical textuality in its elaborations, cultural studies as a project, an intervention, remains incomplete. If you lose hold of the tension, you can do extremely fine intellectual work, but you will have lost intellectual practice as a politics. I offer this to you, not because that's what cultural studies ought to be, or because that's what the Centre managed to do well, but simply because I think that, overall, is what defines cultural studies as a project. Both in the British and the American context, cultural studies has drawn the attention itself, not just because of its sometimes dazzling internal theoretical development, but because it holds theoretical and political questions in an ever irresolvable but permanent tension. It constantly allows the one to irritate, bother and disturb the other, without insisting on some final theoretical closure.

I've been talking very much in terms of a previous history. But I have been reminded of this tension very forcefully in the discussions on AIDS. AIDS is one of the questions which urgently brings before us our marginality as critical intellectuals in making real effects in the world. And yet it has often been represented for us in contradictory ways. Against the urgency of people dying in the streets, what in God's name is the point of cultural studies? What is the point of the study of representations, if there is no response to the question of what you say to someone who wants to know if they should take a drug and if that means they'll die two days later or a few months earlier? At that point, I think anybody who is into cultural studies seriously as an intellectual practice, must feel, on their pulse, its ephemerality, its insubstantiality, how little it registers, how little we've been able to change anything or get anybody to do anything. If you don't feel that as one tension in the work that you are doing, theory has let you off the hook. On the other hand, in the end, I don't agree with the way in which the dilemma is often posed for us, for it is indeed a more complex and displaced question than just people dying out there. The question of AIDS is an extremely important terrain of struggle and contestation. In addition to the people we know who are dying, or have died, or will, there are the many people dying who are never spoken of. How could we say that the question of AIDS is not also a question of who gets represented and who does not? AIDS is the site at which the advance of sexual politics is being rolled back. It's a site at which not only people will die, but desire and pleasure will also die if certain metaphors do not survive, or survive in the wrong way. Unless we operate in this tension, we don't know what

cultural studies can do, can't, can never do; but also, what it has to do, what it alone has a privileged capacity to do. It has to analyse certain things about the constitutive and political nature of representation itself, about its complexities, about the effects of language, about textuality as a site of life and death. Those are the things cultural studies can address.

I've used that example, not because it's a perfect example, but because it's a specific example, because it has a concrete meaning, because it challenges us in its complexity, and in so doing has things to teach us about the future of serious theoretical work. It preserves the essential nature of intellectual work and critical reflection, the irreducibility of the insights which theory can bring to political practice, insights which cannot be arrived at in any other way. And at the same time, it rivets us to the necessary modesty of theory, the necessary modesty of cultural studies as an intellectual project.

I want to end in two ways. First I want to address the problem of the institutionalization of these two constructions: British cultural studies and American cultural studies. And then, drawing on the metaphors about theoretical work which I tried to launch (not I hope by claiming authority or authenticity but in what inevitably has to be a polemical, positional, political way), to say something about how the field of cultural studies has to be defined.

I don't know what to say about American cultural studies. I am completely dumbfounded by it. I think of the struggles to get cultural studies into the institution in the British context, to squeeze three or four jobs for anybody under some heavy disguise, compared with the rapid institutionalization which is going on in the United States. The comparison is not only valid for cultural studies. If you think of the important work which has been done in feminist history or theory in Britain and ask how many of those women have ever had full-time academic jobs in their lives or are likely to, you get a sense of what marginality is really about. So the enormous explosion of cultural studies in the United States, its rapid professionalization and institutionalization, is not a moment which any of us who tried to set up a marginalized Centre in a university like Birmingham could, in any simple way, regret. And yet I have to say, in the strongest sense, that it reminds me of the ways in which, in Britain, we are always aware of institutionalization as a moment of profound danger. Now, I've been saying that dangers are not places you run away from but places that you go towards. So I simply want you to know that my own feeling is that the explosion of cultural studies along with other forms of critical theory in the academy represents a moment of extraordinarily profound danger. Why? Well, it would be excessively vulgar to talk about such things as how many jobs there are, how much money there is around, and how much pressure that puts on people to do what they think of as critical political work and intellectual work of a critical kind, while also

looking over their shoulders at the promotions stakes and the publication stakes, and so on. Let me instead return to the point that I made before: my astonishment at what I called the theoretical fluency of cultural studies in the United States.

Now, the question of theoretical fluency is a difficult and provoking metaphor, and I want only to say one word about it. Some time ago, looking at what one can only call the deconstructive deluge (as opposed to deconstructive turn) which had overtaken American literary studies, in its formalist mode, I tried to distinguish the extremely important theoretical and intellectual work which it had made possible in cultural studies from a mere repetition, a sort of mimicry or deconstructive ventriloquism which sometimes passes as a serious intellectual exercise. My fear at that moment was that if cultural studies gained an equivalent institutionalization in the American context, it would, in rather the same way, formalize out of existence the critical questions of power, history, and politics. Paradoxically, what I mean by theoretical fluency is exactly the reverse. There is no moment now, in American cultural studies, where we are *not* able, extensively and without end, to theorize power – politics, race, class and gender, subjugation, domination, exclusion, marginality, Otherness, etc. There is hardly anything in cultural studies which isn't so theorized. And yet, there is the nagging doubt that this overwhelming textualization of cultural studies' own discourses somehow constitutes power and politics as exclusively matters of language and textuality itself. Now, this is not to say that I don't think that questions of power and the political have to be and are always lodged within representations, that they are always discursive questions. Nevertheless, there are ways of constituting power as an easy floating signifier which just leaves the crude exercise and connections of power and culture altogether emptied of any signification. That is what I take to be the moment of danger in the institutionalization of cultural studies in this highly rarified and enormously elaborated and well-funded professional world of American academic life. It has nothing whatever to do with cultural studies making itself more like British cultural studies, which is, I think, an entirely false and empty cause to try to propound. I have specifically tried not to speak of the past in an attempt to police the present and the future. But I do want to extract, finally, from the narrative I have constructed of the past some guidelines for my own work and perhaps for some of yours.

I come back to the deadly seriousness of intellectual work. It is a deadly serious matter. I come back to the critical distinctions between intellectual work and academic work: they overlap, they abut with one another, they feed off one another, the one provides you with the means to do the other. But they are not the same thing. I come back to the difficulty of instituting a genuine cultural and critical practice, which is intended to produce some kind of organic intellectual political work, which does not try to inscribe

itself in the overarching meta-narrative of achieved knowledges, within the institutions. I come back to theory and politics, the politics of theory. Not theory as the will to truth, but theory as a set of contested, localized, conjunctural knowledges, which have to be debated in a dialogical way. But also as a practice which always thinks about its intervention in a world in which it would make some difference, in which it would have some effect. Finally, a practice which understands the need for intellectual modesty. I do think there is all the difference in the world between understanding the politics of intellectual work and substituting intellectual work for politics.

REFERENCES

Centre for Contemporary Cultural Studies (1982) *The Empire Strikes Back*, London: Hutchinson.

Hall, S. (1974) 'Marx's notes on method: a reading of the 1857 Introduction', Working Papers in Cultural Studies 6, 132–71.

——— (1980a) 'The hinterland of science', in Centre for Contemporary Cultural Studies, *On Ideology*, London: Hutchinson.

——— (1980b) 'Cultural studies: some problematics and problems', in S. Hall *et al.* (eds), *Culture, Media, Language*, London: Hutchinson/CCCS, 15–47.

Hall, S., Critcher, C., Jefferson, T., Clarke, J. and Roberts, B. (1978) *Policing the Crisis: 'Mugging', the State and Law and Order*, London: Hutchinson.

Williams, R. (1989) *The Politics of Modernism*, London: Verso.

Women's Studies Group, CCCS (1978) *Women Take Issue*, London: Hutchinson.

Chapter 14

A thief in the night
Stories of feminism in the 1970s at CCCS

Charlotte Brunsdon

I

It was a truth acknowledged by all women studying at the Centre for Contemporary Cultural Studies at Birmingham University in the 1970s that no woman there had ever completed a PhD.[1] Nor was likely to, we muttered, if the chosen topic left the domain of the public, the state and the male working class – the boyzone. And it wasn't that no women were recruited to do graduate work. Women's magazines, girls' subcultures, romantic love, girls' comics and the culture of working-class women were some of the topics for which postgraduates were recruited. Although research was done in these areas, what seems, in memory, much more of the time was spent trying to work out what feminist intellectual work would be, and how it related to the endeavours understood as cultural studies. It is to the mapping of this tricky and unresolved set of relations that I want to turn here, with particular reference to the account given by Stuart Hall at the 1990 Illinois conference (Hall, 1992, reprinted pp. 262–75, this volume).

II

Stuart Hall, in his reflections on his involvement with cultural studies as it developed in Birmingham, has always been very scrupulous about not wanting to claim founding West Midlands origins for what now appears to be an institutionalized or semi-institutionalized area of study in the international anglophone academy. Invited to speak or write partly because of his Birmingham-ness, he has consistently responded through narratives of displacement and transformation, moving the account from 'What we did and thought in Birmingham' to analyses of the political and intellectual conditions of particular practices, while always paying attention to the space and place of the current account – the conjunctural now. Only the English Tourist Board really tries to make people believe that Birmingham is the Heart of England.

While eschewing these guarantees of origin and authenticity, Hall has, however, always also insisted on the importance – the intellectual and political responsibility – of making distinctions between positions and approaches, and arguing for some in preference to others. That is, for example, Hall has consistently argued that the marginal and displaced position cultural studies research has in relation to many more established disciplines, such as English, history and sociology, does not mean that research which is not 'in' another discipline somehow *is* cultural studies. If the early cultural studies work at Birmingham was partly constituted through the interrogation of disciplinary boundaries and fields – 'why can't you ask serious questions about the western film genre/brass bands/ the history of miners' libraries?' – the logic is not that cultural studies is the study of anything that doesn't fit. As he put it in 1992, 'It does matter whether cultural studies is this or that' (Hall, 1992: 278). In the under-funded 1980s expansion of higher education in Britain there have been very particular resonances of these arguments as degree courses modularize and the combinations of 'this and that' which students choose have in many institutions been seen as most appropriately labelled 'cultural studies'. Similarly, in the United States, the disassembling and reassembling of media-related degree programmes by cost-cutting administrators has been sometimes justified in the name of 'cultural studies'. The British Council, too, now funds the study of a national subject, British cultural studies. This institutional proliferation of administratively conceived cul-tural studies raises difficult issues for scholars who are perhaps more familiar more comfortable even – with institutional marginality, but these are not here my main concern.

In these accounts of cultural studies at Birmingham which Stuart Hall is repeatedly called on to offer, he always insists on another element. This is not about the positions being argued, but about the arguing of positions. The very process of contesting whether cultural studies is this or that. In the *October* article he wrote:

> My own memories of Birmingham are mainly of rows, debates, argu-
> ments, of people walking out of rooms. It was always in a critical
> relation to the very theoretical paradigms out of which it grew and to
> the concrete studies and practices it was attempting to transform. So, in
> that sense, cultural studies is not one thing; it has never been one thing.
> (Hall, 1990: 11)

In the collection from the 1990 Illinois conference:

> It had many trajectories; many people had and have different trajectories
> through it; it was constructed by a number of different methodologies
> and theoretical positions, all of them in contention. Theoretical work at
> the Centre for Contemporary Cultural Studies was more appropriately

called theoretical noise. It was accompanied by a great deal of bad
feeling, argument, unstable anxieties and angry silences.

(Hall: 1992: 278)

Both these passages point to the contested plurality of the 'this' of cultural
studies. Once again, Stuart refuses a singular theoretical position or origin,
even as he does invoke a particular place and period. And it is on this
personal memory that I want to focus – not to wrest it from Stuart's
scrupulous avoidance of claiming himself as source – but because it offers
an insight into something which often seems to be missing in the current
theorizations of cultural studies as this or that. In his evocation of slammed
doors and angry silences, Stuart reminds us of the materiality of political
and theoretical disagreements. Real people with passionate investments in
different positions sometimes unable to compromise or reconcile them-
selves to the winning or losing of particular arguments. People so cross
with each other that they can't bring themselves to speak. Rows – to name a
few – over political activism, attitudes to working-class culture, marxism,
psychoanalysis, structuralism, feminism, anti-racism. Rows which were
sometimes so impassioned because the substance of the disagreement
threatened the site and form of it; or because the participants were grap-
pling with the intellectual implications of emergent identity politics. That
is, if someone argued that the notion of 'theoretical practice' was merely
self-legitimatory in the face of growing unemployment in the Midlands in
1970s Britain, the argument contained an attack on the very institution in
which it was being made. Similarly, if the argument was that dominant
discourses – even oppositional ones – systematically exclude certain
categories of persons, then there was/is a crisis about how discussion can
proceed further.

I want to briefly recall one of these rows, that about feminism in the mid-
1970s, which Stuart has called one of the two 'interruptions' in the work of
the Centre for Contemporary Cultural Studies. The second interruption he
describes as the mobilization round questions of race in the late 1970s,
issuing, initially, in *The Empire Strikes Back* (CCCS, 1982). Of course,
there was not just one row about feminism, and the people engaged in
argument round this topic were not constant – postgraduates came and went
and dispute flared and died down over different sites over several years.
The 1974 'Images of women' stencilled paper by Helen Butcher, Rosalind
Coward, Marcella Evaristi, Jenny Garber, Rachel Harrison and Janice
Winship; the article by Jenny Garber and Angela McRobbie on 'Girls
and subcultures' in the 1975 Working Papers in Cultural Studies,
'Resistance through rituals' and the 1978 journal *Women Take Issue* all
mark different contestations of this field. Nor do I want to claim that how
I choose to tell this story is authoritative. But at the moment, one of the
only accounts is that by Stuart himself, when, in a profoundly shocking

description – particularly from a former Henry James scholar – he describes 'how and where feminism first broke in'. He says, 'As the thief in the night, it broke in; interrupted, made an unseemly noise, seized the time, crapped on the table of cultural studies' (Hall, 1992; 282). This is a description made in 1990 to the Illinois conference. I know of no other explicit accounts, except for the 'Introduction' to the volume, *Women Take Issue*, which Stuart nominates as a key site in his story. It can be suggested though, that these arguments are also witnessed in the acknowledgements – and sometimes the lack of acknowledgement – of the articles and books published during the 1980s by some of those concerned: Lucy Bland (1983), Rosalind Coward (1983), Dorothy Hobson (1982), Angela McRobbie (1991), Frank Mort (1987), Chris Weedon (1987) and Janice Winship (1987) – and this is not an exhaustive list. So if there is a first phase of the encounter between feminism and CCCS, beginning perhaps in 1973–4, I would suggest that its final text is the 1981 McRobbie and McCabe collection, *Feminism for Girls*, which, in its use of both 'feminism' and 'girls' suggests some distance from the 1970s. This book also marks the end of the first phase with its much stronger sense of problems with the category 'woman' and of difference between women.[2] It thus maps the challenging of second-wave feminism's ethnocentrism, with the article by Valerie Amos and Pratibha Parmar, 'Resistances and responses: the experience of black girls in Britain', a challenge continued in the 1982 book, *The Empire Strikes Back* with articles by Parmar and Hazel Carby. Interruptions interrupted.

I don't read Stuart's account as told in self-justification. Indeed, in the context of the Illinois conference, describing feminism in this way would have been strategically peculiar had this been his intention. I see it rather as a contribution to a continuing project for, if I can say this without sounding grandiose, social change. Stuart writes about the gap between intentions – to encourage feminist work in cultural studies – and the unpredictable consequences of the resulting challenges to the *status quo*. He tries to tell a story about the materiality and particularity of power – the way it is inscribed in reading lists and psyches as well as theoretical paradigms. That is, he reminds us that what we might consider theoretically and politically desirable can be very difficult to handle. This lands us in the marshy ground between the clearly defined contours of what was then called, in Britain, the 'right on' (inflected, in a different hegemony, as the politically correct) and the dizzying contemporary theoretical formulations of both subject and social in a postmodern age. It is a story about the difficult processes, in a particular instance, of coming to terms with ideas which are now part of the common sense of cultural studies. Who, in cultural studies, does not pay at least token attention to gender now? And it is partly this shift that makes the story tellable, but also makes comprehensible the choice to describe feminism as 'crapping on the table

of cultural studies'. This description of what it felt like, in some positions, when feminism erupted in CCCS comes after a theoretical discussion of what Stuart argues to be the gains for cultural studies. So something else is being said – not just about theoretical/political argument, but about the traumatic processes of these arguments, even when everybody involved thinks they start on the same side. This choice of verb proposes to both evoke the scandal of feminism in the 1970s – to remind a theoretically sophisticated 1990s audience that the second-wave women's movement (with its many problems) was once potent in its disruptive challenge in the name of 'women' – while also registering the sense of betrayal and rejection felt by those who understood themselves as sympathetic to this feminist project.

When I first read this account, I immediately wanted to unread it. To deny it, to skip over it, to not know – to not acknowledge the aggression therein. Not so much to deny that feminists at CCCS in the 1970s had made a strong challenge to cultural studies as it was constituted then and there, but to deny that it had happened the way here described. To have my feminist cake and eat it – to have drafted discussion documents, contributed to presentations and made arguments that attacked 'men at the centre', but not to have contributed to feelings of betrayal and rejection. Now there is obviously material here for analysis of fantasies and fathers, but what I want to do is sketch out some other elements of an account to lie alongside Stuart's, to contribute to a thicker description of a time and topic of conflict. The point of doing this, when the gender agenda is much more taken for granted, is to insist on the great difficulty of even minute changes in practice, to mess up the fluency and ease with which what we might call international theoretical cultural studies constructs itself as always-already politically chic.

III

The fact that we believed that no woman completed a PhD at CCCS Birmingham in the 1970s has to be placed alongside the generally rather relaxed attitude to PhD completion in the humanities in Britain in this period. No woman did until 1977 – but quite a lot of men didn't either.[3] And not only at Birmingham. So in a way, it is a misleading sign. But it had an iconic quality to us – it defined something of how women at CCCS understood our place and prospects.

Three factors peculiar to research at CCCS combined to make completion less likely for everyone. Firstly, there was the stress on collective work and the organization of research through shared-interest sub-groups. Although theoretically, this could have been a rather efficient way of conducting research, with several group members writing theses from a shared programme of work, in practice the sub-groups often involved

people in work marginally related to – and often seductively different from – their original thesis topics. Groups tended to have an organic life cycle, so it also mattered when particular individuals joined as the core intellectual project of each group was often defined in the early stages. Secondly, many of the people working at CCCS understood themselves to be particularly privileged to be able to do politically engaged intellectual work full time, and in consequence, to have some kind of mandated responsibility to those less so. This mandate was understood very differently by different groups and individuals, but generally involved some notion of making research 'available', 'accessible' or 'useful'.[4] Thus publication of work in progress for what was perceived as a general good took precedence over 'individualistic' writing-up. The other facet of Birmingham work which flows from the notion of the mandate, but which has tended to remain local and national, not contributing to the international image of Birmingham as a theoretical hotspot, was research into social policy. Sub-group research led many students to committed interventions and subsequent careers in various kinds of local government, social policy and social administration.

It is thus only the final factor inhibiting completion that can be seen as conventionally academic. This was the question of the shaping and transforming the inter- and cross-disciplinary intellectual projects of cultural studies into a conventional academic genre, the thesis. To what extent did each project have to define its fields and terms *ab initio*? A question posed by Stuart Hall among others, of what a cultural studies bibliography would look like? Or what indeed would a cultural studies PhD look like in the 1970s? What room would there be for the presentation of research after the mapping of an interdisciplinary field and the theoretical introduction?[5]

So among the reasons why so few people finished PhDs at CCCS – although they did finish other things like articles and journals and even books – were the political and social attractions of collective work, and the understanding of intellectual labour as being *for* something other than a qualification. The fact that in the 1970s PhDs were genuinely not regarded as the most important product of the intellectual work of the period at CCCS perhaps obscured the tremendous difficulty that would have attended the writing-up of many of the projects of the time. Nearly all were very ambitious, not only in their collectivity, but theoretically and politically – addressing for example, the development of public education in Britain; policing, 'mugging' and the current theorization of the state; understandings of patriarchy; language and subjectivity. That said, I think it arguable that each of these factors had particular resonances for women. The lure of the social obligations of group work should not be underestimated when thinking about the complicated relations of femininity and feminism. Or to put this another way, a group was a much easier place to negotiate the position of a gendered intellectual. But there was also

the issue of whether feminists could and should *be* intellectuals. And here it should be remembered that 'feminism' and 'feminist' were not the terms within which second-wave feminism understood itself. Instead, the late 1960s had spawned the 'Women's Liberation Movement'. It was as 'women', not 'feminists' that the early political and intellectual mobilizations were conducted. If there was generally an issue of a mandate for many people at Cultural Studies, for feminists there was the particular burden of the aggressive anti-intellectualism of much of the women's movement. Were language, the academy and the western intellectual tradition male? Was it collusion to even be in the institution?

If it was difficult to imagine what a cultural studies bibliography would be, it seemed almost impossible to imagine what a feminist cultural studies bibliography would be. Did it have to include all feminist books of the period – there weren't very many, and our reading was voraciously cross-disciplinary? To what extent did it have to engage with the CCCS dominant Althusserian, then Gramscian, interpretation of Marxism? Did we have to justify attention to women through a theorization of domestic labour and the reproduction of the social relations of production? At what level of theory could one defend a concept like 'women's oppression'? What order of concept was 'patriarchy'? And did we have to do it all ourselves – a double shift of intellectual work – while the boys carried on with the state, the conscious and the public? Were there going to be two spheres of cultural studies – 'ordinary' (as before, uninterrupted) and a feminine/feminist sphere?

CCCS Women's Studies Group in the 1970s provided a strange meeting-place for people on very different journeys. For women interested in research on aspects of conventional feminine culture; people concerned with the theorization of subjectivity, sexuality and gender; people with more activist commitments; people who were perhaps directed to the group because they were women – and those who just found it the most congenial group. I think it could be argued that it was one of the bridgeheads into CCCS of the new social movements of the late 1960s and the 1970s, of the 'new' identities and identity politics. If thought like that – and the metaphor is only fleetingly useful – then more established groups at CCCS fulfilled the role of the old boys, occupying a terrain conceptualized mainly in terms of social class. It was from the Women's Studies Group, started in October 1974, that there came the nucleus of what then became the journal group which produced *Women Take Issue* in 1978, and this history is told in the introduction to that book. However it was also from this group that there came, in 1976, the proposal to set up a closed women-only group. This proposal – which was strongly contested – was made at the end-of-year presentation made by the Women's Studies Group to the rest of Cultural Studies. It was clearly informed by the practices of the Women's

Liberation Movement and what we would now call identity politics. An extract may convey the flavour of the occasion:

> I want to raise a series of problems about the Women's Studies Group, and by implication, some questions about the position of women in the Centre as a whole. We appreciate that people may consider it inappropriate to raise these questions at the beginning of a presentation, and we are doing so partly on a captive audience principle, but that is because it seems the only way to have this discussion generally in the Centre, and not individually in the pub. We also think that these questions have affected not just our work, but that of the Centre as a whole, which makes this an eminently suitable context. That is, we do appreciate that the Women's Studies Group exists within an academic institution, and is made up of people engaged in academic work.
>
> . . . It seems undeniable that the group does have a supportive function for its members in relation to the Centre. We do talk about our difficulties as *women* in the Centre, and we did discuss specific sexist incidents in other subgroups, and also occasionally ways of trying to deal with what I regard as a peculiarly oppressive form of sexism, in which people individually agree that 'women are oppressed', but where there is no collective effort to do anything about it, or even to examine how it operates in practice.
>
> . . . The next problem is that of the hiving-off of the 'the Woman question' to the Women's Studies Group . . . it is only through an understanding of the nature of the issues raised by the 'woman question' that hiving-off becomes an impossibility. The notion of a women's studies group which is 'filling in the gaps' in an already existing analysis, and which has a kind of 'what about women?' public presence become absurd. It is necessary to *all* the intellectual work being done at the Centre that the women's movement, and the Women's Studies Group as part of that movement, defines its own problematic.
>
> (C. B. for Women's Studies Group presentation, June 1976)

We won the right to meet as a closed women's group. Stuart made a late and conclusive contribution to the discussion when he suggested that if there were any other black people at CCCS, they'd caucus too. I don't think though, looking back at *Women Take Issue*, that we made enormous progress in defining a feminist problematic. We remained too caught up in the dialogue with the particular kind of marxism dominant in CCCS at the time – in self-justification. The most successful chapters seem those which anticipate future reports of empirical investigation, rather than the attempts to theorize women's subordination at a general level. In some ways, the 'Introduction', the story of how the book came into being, has become rather more interesting as the historicity of its concerns have become more evident. Read symptomatically, alongside the other

Working Papers in Cultural Studies and Hutchinson books, *Women Take Issue* does suggest both separate spheres and a feminist double shift. There is very little overlap, at this stage, with other CCCS productions. The book is also characterized by a profoundly unstable address – it's not clear – I don't think we were clear – to whom it was addressed. To CCCS? To the Women's Liberation Movement? To the left? To 'ordinary women'?

But there have been other books since, and it is because of those that I can write this, and Stuart can give the account he did of feminism at Birmingham. We understood ourselves to be engaging in the argument about whether cultural studies was this or that. These arguments are necessary. Perhaps it is true that sometimes, only door-slamming creates the silence in which to be heard. I'm not sure. But now it seems even more important to argue these differences as differences of position, rather than identity, however overwhelming that sense of informing identity can be. Or to turn this round, and say, whatever one's espousal of hybridity, living out difference and unliving the customary power relations of those differences, can, in practice, be very difficult.

So perhaps, reflecting on these stories, I am making an apparently contradictory argument. On the one hand, to insist, against the emphasis of some current theorizations of subjectivity, on the humanity of the individuals who occupy and argue particular positions. However sophisticated our theorizations of fragmented subjectivities, people are enraged, hurt and unforgivingly upset by some political theoretical arguments. Perhaps most particularly so when issues of identity – however invoked – are involved. When there is no equality of status, no accustomed familiar disagreement, no – to be culturally specific – having a drink together afterwards to accommodate principled disagreement. Secondly, though, to argue that the historical debt that cultural studies owes to identity politics is just that, a debt, if a significant one – and that arguments that take the constructions of participants' identity as both a starting-point and a conclusion can only lead to rows – theoretical noise. It is in these contexts – and the necessity to continue arguing over the this and that of cultural studies – that I think we can most usefully understand the call for 'courtesy' towards each other with which Stuart responds in discussion of the Illinois presentation I have concentrated on here.

Now it may seem that these positions are contradictory – I think not – but maybe this attempt to occupy a position that almost isn't there is something that I learnt in Birmingham.

NOTES

1 Birmingham University computerized its records in 1984. The university only holds records of those who actually graduated in the 1970s – that is, for our purposes, those who did complete PhDs – and those who have extended their

registration since 1984. The Centre for Contemporary Cultural Studies merged with the Sociology Department in 1987 to become the Department of Cultural Studies. Administratively, with this move, Cultural Studies moved from the Faculty of Arts to the Faculty of Social Studies/Sciences. Records of those who registered for PhDs but did not complete or move into extension have not been preserved over this move. All references in this article are thus derived from scrutiny of the records of degree congregations from 1970 to 1984 and the 1984 computerization. Although Hazel Downing was regarded as the first woman with a registration at CCCS to complete a PhD (1981) in the period of the existence of the Women's Studies Group, in fact the degree congregation records reveal that Margaret Marshment was awarded a PhD in 1977.

My thanks to Ann Gray for her help in extracting this information.

2 If McRobbie and McCabe (1981) marks the end of the first phase of the encounter between feminism and CCCS, then Franklin, Lury and Stacey (1991) marks something more than the second, which I think is represented by individual books such as Hobson (1981), Coward (1983), Brunsdon (1986), Carby (1987), McRobbie (1991), Mort (1987), Winship (1987) and Weedon (1987). Trying to tell the story as an institutional one becomes foolish after a certain point, though.

3 Code '(3)' of Birmingham University graduate student records signifies 'Written off after lapse of time'. Coded as such with entry between 1972 and 1975 are: Winship, Rusher, Ellis, Clarke, Coward, Daniels, Evaristi, Garber, Greaves, Jefferson, Mansfield, Mellor, McDonough, Brook, Grant, Jeffery, Nice and Schwarz. Most of these names will be familiar to those working in the academic field of cultural studies or in British social policy. Some who did complete were Richard Dyer and Paul Willis (in 1972), Stuart Laing (1973), Ian Connell (1976) and Steve Burniston (1979). Hazel Carby and Chris Weedon both completed in 1984, which gives a total of four women.

4 Denise Riley (1991) describes the parallel flourishing of extra-academic auto-didactic socialist and feminist groups in the 1970s.

5 Many dissertations submitted as MAs – for example, Hebdige, McRobbie and Hobson – were in fact very substantial pieces of work and retrospectively perhaps their originality and achievement was under-recognized. One could hypothesize that it was particularly important that cultural studies shouldn't appear easy in this early period of institutional existence.

REFERENCES

Amos, V. and Parmar, P. (1981) 'Resistances and responses: the experiences of black girls in Britain', in McRobbie and McCabe (eds) *Feminism for Girls*, London: Routledge, 129–48.

Bland, L. (1983) 'Purity, motherhood, pleasure or threat', in Cartledge, S. and Ryan, J. (eds) *Sex and Love*, London: Women's Press, 8–29.

Butcher, H., Coward, R., Evaristi, M., Garber, J., Harrison, R. and Winship, J. (1974) 'Images of women in the media', Stencilled Occasional Paper 34, Birmingham: Centre for Contemporary Cultural Studies.

Brunsdon, C. (ed.) (1986) *Films for Women*, London: British Film Institute.

Carby, H. (1982) 'White woman listen: black feminism and the boundaries of sisterhood', in Centre for Contemporary Cultural Studies, *The Empire Strikes Back*, London: Hutchinson, 212–35.

———— (1987) *Reconstructing Womanhood*, Oxford: Oxford University Press.

Centre for Contemporary Cultural Studies (1982) *The Empire Strikes Back*, London: Hutchinson.

Coward, R. (1983) *Patriarchal Precedents*, London: Routledge & Kegan Paul.

Franklin, S., Lury, C. and Stacey, J. (eds) (1991) *Off-Centre: Feminism and Cultural Studies*, London: Harper Collins.

Garber, J. and McRobbie, A. (1975) 'Girls and subcultures: an exploration', Working Papers in Cultural Studies 7–8, 'Resistance through rituals', 209–22.

Hall, S. (1990) 'The emergence of cultural studies and the crisis in the humanities', *October* 53, 11–23.

———— (1992) 'Cultural studies and its theoretical legacies' in L. Grossberg, C. Nelson and P. Treichler, (eds) *Cultural Studies*, New York: Routledge.

Hall, S., Critcher, C., Jefferson, T., Clarke, J. and Roberts, B. (1978) *Policing the Crisis: 'Mugging', the State and Law and Order*, London and Basingstoke: Macmillan.

Hobson, D. (1982) *'Crossroads': The Drama of a Soap Opera*, London: Methuen.

McRobbie, A. (1991) *Feminism and Youth Culture*, Basingstoke: Macmillan.

McRobbie, A. and McCabe, T. (eds) (1981) *Feminism for Girls*, London: Routledge & Kegan Paul.

Mort, F. (1987) *Dangerous Sexualities*, London: Routledge & Kegan Paul.

Parmar, P. (1982) 'Gender, race and class: Asian women in resistance', in Centre for Contemporary Cultural Studies, *The Empire Strikes Back*, London: Hutchinson, 236–75.

Riley, D. (1991) 'A short history of some preoccupations', in J. Butler, and J.W. Scott, (eds) *Feminists Theorize the Political*, New York: Routledge, 121–8.

Weedon, C. (1987) *Feminist Practice and Post-structuralist Theory*, Oxford: Basil Blackwell.

Winship, J. (1987) *Inside Women's Magazines*, London: Pandora.

Women's Studies Group, CCCS (1978) *Women Take Issue*, London: Hutchinson.

Chapter 15

For Allon White
Metaphors of transformation

Stuart Hall

Transgression. Perhaps one day it will seem as decisive for our culture, as much part of its soil, as the experience of contradiction was at an earlier time for dialectical thought. Transgression does not seek to oppose one thing to another . . . it does not transform the other side of the mirror . . . into a glittering expanse . . . its role is to measure the excessive distance that it opens at the heart of the limit and to trace the flashing line that causes the limit to arise.

<div align="right">(M. Foucault, 'Preface to Transgression', in Language,
Counter-Memory, Practice)</div>

There are many different kinds of metaphors in which our thinking about cultural change takes place. These metaphors themselves change. Those which grip our imagination, and, for a time, govern our thinking about scenarios and possibilities of cultural transformation, give way to new metaphors, which make us think about these difficult questions in new terms. This essay is about one such shift which has occurred in critical theorizing in recent years.

Metaphors of transformation must do at least two things. They allow us to imagine what it would be like when prevailing cultural values are challenged and transformed, the old social hierarchies are overthrown, old standards and norms disappear or are consumed in the 'festival of revolution', and new meanings and values, social and cultural configurations, begin to appear. However, such metaphors must also have analytic value. They must somehow provide ways of thinking about the relation between the social and symbolic domains in this process of transformation. This question of how to 'think', in a non-reductionist way, the relations between 'the social' and 'the symbolic', remains the paradigm question in cultural theory – at least in all those cultural theories (and theorists) which have not settled for an elegant but empty formalism.

Text of a Memorial Lecture given at the University of Sussex. Reprinted from A. White, *Carnival, Hysteria and Writing*, Oxford: Clarendon Press, 1993.

Classic metaphors of transformation are modelled on the 'revolutionary moment'. Terms like 'the festival of revolution' belong to that family of metaphors which has been so significant, historically, for the radical imaginary. These metaphors conceptualize the social and the symbolic or the cultural as stitched together in a relationship of rough correspondence; so that, when the social hierarchies are overthrown, a reversal of cultural values and symbols is certain sooner or later to follow. 'The ideas of the ruling class are in every epoch the ruling ideas,' Marx wrote, in a now famous (even, perhaps, infamous) passage: 'i.e. the class which is the ruling *material* force of society is at the same time its ruling *intellectual* force.' Transformation here is characteristically 'thought' in terms of reversal and substitution. When the class which 'has nothing to lose but its chains' overthrows the class 'which monopolizes the means of material and mental life', it also overthrows and substitutes alternative ideas and values in a riot of cultural transvaluation. This is the image of 'the world turned upside-down', of Trotsky's 'their morals and ours', of the mutually exclusive 'world-views' of opposing class cultures so theatrically counterposed in critics like Lukács and Goldmann, which has governed the classic metaphors of transformation. These formulations startle us now with their brutal simplicities and truncated correspondences. And yet, until recently, wherever social and symbolic or cultural transformations were thought or imagined together, it was in terms which continued to be shadowed by that metaphor.

It no longer commands assent. Cultural theory has moved decisively beyond such dramatic simplifications and binary reversals. The question is, what alternative metaphors do we have for imagining a cultural politics? Once the simplistic terms of the classic metaphors of transformation have been abandoned, do we also abandon the question of the relationship between the social and the symbolic, the 'play' between power and culture? One of the most challenging recent texts to address this question, in the wake of and fully conversant with recent critical and theoretical developments, is *The Politics and Poetics of Transgression* by Peter Stallybrass and Allon White.[1] This arresting and original book explores the persistence of the 'mapping' of cultural and social domains in Europe into the symbolic categories of 'the high' and 'the low'. The book contains a richly developed argument about how 'the carnivalesque forces, which were suppressed by bourgeois elites in their protracted withdrawal from popular culture, re-emerged in displaced and distorted form as objects of phobic disgust and repressed desire in both literature and psychopathology'; and how, 'with the emergence of a distinctively bourgeois, sanitized conception of the self in post-Renaissance European culture, various social domains were constructed as "low" and "disgusting" '.[2] I was, in fact, in the middle of rereading the volume and wondering why it had not been

recognized for the 'landmark text' it is in cultural studies, when I learned of the untimely death of one of its authors, Allon White.

There are many colleagues and friends who knew Allon White more intimately or worked more closely with him than I did, and who are therefore in a much better position to speak of the quality and significance of his intellectual contribution. However, I had the pleasure and privilege to know him at an early, formative moment in his career. After his first degree in the English Department at Birmingham, he spent some time at the Centre for Cultural Studies before going on to do his PhD at Cambridge, and it was during this period at the Centre that I really got to know him. He was interested in the Hegelian dialectic, especially the famous master–slave passages in the *Phenomenology*, and I helped to supervise his MA – that is, in so far as anyone 'supervised' him. None of us were proper Hegel scholars; he had a very clear idea of what exactly he wanted to find out and he had already developed that deceptively genial but purposeful single-mindedness which I subsequently realized characterized his work. I first learned then to admire and respect his generous, branching intelligence, his rich sense of humour, the breadth of his reading, the subtlety of his critical sensibility, and his passionate intellectual curiosity.

On the last occasion that we met, he had just recovered from another bout of illness. However, he seemed particularly well – exuberant, full of hope, brimming over with ideas. His energy dispensed a 'carnivalesque' atmosphere around the table where – in true Rabelaisian fashion – a number of his friends were having a meal together. We talked of many things, including Mikhail Bakhtin's work, which had had such a profound influence on him. When I was invited to give the first Allon White Memorial Lecture organized at Sussex University, I wanted somehow to bring together around the figure of 'carnival' these two moments in his intellectual career – his engagement with cultural studies and his rich and complex relationship to Bakhtin's work – and to reflect on some surprising and unremarked connections between them.

Bakhtin is usually assumed to have had a more profound impact on literary theory than on cultural studies and in terms of direct influence, this judgement is probably correct. However, the relationship between them with respect to Bakhtin may be closer than many people imagine. In any case, I was less concerned with tracing direct theoretical influences and more interested in 'elective affinities' – specifically, in identifying a certain theoretical shift which occurs at about the same time in a number of different but related fields of work; and where, in retrospect, the work of Bakhtin – or rather, the way Bakhtin's work was variously appropriated and reworked – proved to be of decisive value. Reading again *The Politics and Poetics of Transgression*, by Allon White and his friend, interlocutor, and companion-at-arms, Peter Stallybrass, and thinking about the critical dialogue which the authors conduct in that book with Freud and Bakhtin

about 'metaphors of transformation' and the interplay between limits and transgressions in cultural processes, a number of interesting convergences between developments in cultural theory occurring in apparently disparate domains of study at more or less the same time began to suggest themselves. The occasion of the first Allon White Memorial Lecture seemed an appropriate opportunity to reflect on them. (This text is a résumé of the talk which I gave on that occasion.)

Stallybrass and White's book takes its point of departure from Curtius's observation, in *European Literature and the Middle Ages*,[3] that the social division of citizens according to tax bands based on property calculations provided the basis for classifying the prestige and rank of literary authors and their works.

> The ranking of literary genres or authors in a hierarchy analogous to social classes is a particularly clear example of a much broader and more complex cultural process, whereby the human body, psychic forms, geographical space and the social formation all are constructed within interrelating and dependent hierarchies of high and low.[4]

This 'modelling' of the social and the cultural together according to classifications of 'high' and 'low' runs through many permutations between the moment when Curtius first observes it in late classical times and the present; but it is certainly still an active element in twentieth-century debates about the threats to civilization and 'minority culture' from the debased influences of a commercialized mass culture, which fixated the Leavises and *Scrutiny*, and in the parallel debate about 'mass culture' between the Frankfurt School and their meliorist American critics.[5] Indeed, a variant of it is still alive and well in the pages of the *New York Review of Books*, the *London Review of Books*, and elsewhere in the so-called debate about 'multiculturalism' and canon formation.

What Stallybrass and White register is the process by which this practice of cultural classification is constantly transcoded across a variety of different domains. The nub of their argument is that

> cultural categories of high and low, social and aesthetic . . . but also those of the physical body and geographical space are never entirely separable. The ranking of literary genres or authors in a hierarchy analogous to social classes is a particularly clear example of a much broader and more complex process whereby the human body, psychic forms, geographical space and the social formation are all constructed within interrelating and interdependent hierarchies of high and low. This book is an attempt to map some of these interlinked hierarchies. More particularly it attends to both the formation of those hierarchies and to the process through which the low troubles the high.[6]

Stallybrass and White's notion of 'transgression' is grounded in Bakhtin's idea of 'carnival'. 'Everywhere in literary and cultural studies today, we

see "carnival" emerging as a model, as an ideal and as an analytic category.'[7] Carnival is a metaphor for the temporary licensed suspension and reversal of order, the time when the low shall be high and the high, low, the moment of upturning, of 'the world turned upside-down'. The study of Rabelais led Bakhtin to consider the existence of a whole alternative domain and aesthetic of 'the popular'. Based on studies of the importance of fairs, festivals, *mardi gras*, and other forms of popular festivity, Bakhtin uses 'carnival' to signal all those forms, tropes and effects in which the symbolic categories of hierarchy and value are inverted. The 'carnivalesque' includes the language of the market-place – curses, profanities, oaths, colloquialisms which disrupt the privileged order of polite utterance – rituals, games and performances, in which the genital zones, the 'material bodily lower strata', and all that belongs to them are exalted and the formal, polite forms of conduct and discourse dethroned; popular festive forms in which, for example, king or slave-holder is set aside and the fool or slave temporarily 'rules', and other occasions when the grotesque image of the body and its functions subvert the models of decorous behaviour and classical ideals.

Bakhtin's 'popular' is characterized by the practices and tropes of 'oxymoronic combination' – 'doubling' in language, things wrong-side up or inside-out, the bride 'weeping for laughter and laughing for tears', verbal plays and absurdities – which exploit what Bakhtin sees as the intrinsic reversibility of all symbolic order. Writing about what he calls 'unpublicized speech' and other games of conscious illogicality, Bakhtin notes that:

> It is as if words had been released from the shackles of sense, to enjoy a play period of complete freedom and establish unusual relationships among themselves. True, no new consistent links are formed in most cases, but the brief coexistence of these words, expressions and objects outside the usual logical conditions discloses their inherent ambivalence. Their multiple meanings and potentialities that would not manifest themselves in normal conditions are revealed.[8]

For Bakhtin, this upturning of the symbolic order gives access to the realm of the popular – the 'below', the 'under-world', and the 'march of the uncrowned gods'. The carnivalesque also represents a connection with new sources of energy, life, and vitality – birth, copulation, abundance, fertility, excess. Indeed, it is this sense of the overflowing of libidinal energy associated with the moment of 'carnival' which makes it such a potent metaphor of social and symbolic transformation.

Fredric Jameson, in *The Political Unconscious*, notes the co-existence of two versions of the metaphors of transformation:

> the image of the triumph of the collectivity and that of the liberation of the 'soul' or 'spiritual body'; between a Saint-Simonian vision of social

and collective engineering and a Fourieresque Utopia of libidinal grat-
ification; between a 1920s leninist formulation of communism as 'the
Soviets plus electrification' and some more properly Marcusean 1960s
celebration of an instinctual 'body politic'.[9]

Bakhtin clearly belongs to the latter camp. Jameson, characteristically,
establishes a priority between these two versions: 'the program of libidinal
revolution is political only to the degree that it is itself a figure for social
revolution.' So that, when he comes to discuss Bakhtin directly, Jameson
argues that the marxist hermeneutic – 'which will . . . be defended as
something like an ultimate *semantic* precondition for the intelligibility of
literary and cultural texts' – takes precedence over the 'carnivalesque': the
latter is made a 'local' instance of the former and Bakhtin's 'dialogic' is
assimilated to and within the classic terms of the Hegelian dialectic and
contradiction.[10]

 In fact, what is striking and original about Bakhtin's 'carnivalesque' as a
metaphor of cultural and symbolic transformation is that it is *not* simply a
metaphor of inversion – setting the 'low' in the place of the 'high', while
preserving the binary structure of the division between them. In Bakhtin's
'carnival', it is precisely the purity of this binary distinction which is
transgressed. The low invades the high, blurring the hierarchical imposi-
tion of order; creating, not simply the triumph of one aesthetic over
another, but those impure and hybrid forms of the 'grotesque'; revealing
the interdependency of the low on the high and *vice versa*, the inextricably
mixed and ambivalent nature of all cultural life, the reversibility of cultural
forms, symbols, language and meaning; and exposing the arbitrary exercise
of cultural power, simplification, and exclusion which are the mechanisms
upon which the construction of every limit, tradition and canonical forma-
tion, and the operation of every hierarchical principle of cultural closure, is
founded.

 This seems to me to be the critical shift in the 'metaphors of transforma-
tion' which Stallybrass and White expand and develop in their book. As
they make clear, their principal theme is 'the contradictory nature of
symbolic hierarchies'. The low is thus no longer the mirror-image subject
of the high, waiting in the wings to substitute it, as in the classic metaphors
of revolution, but another related but different figure, which has haunted
and shadowed that paradigmatic metaphor: the low as 'the site of conflict-
ing desires and mutually incompatible representation'.

 Again and again we find a striking ambivalence to the representations of
 the lower strata (of the body, of literature, of society, of place) in which
 they are both reviled and desired. Repugnance and fascination are the
 twin poles of the process in which a *political* imperative to reject and
 eliminate the debasing 'low' conflicts powerfully and unpredictably
 with a desire for the other.[11]

Here, far from the alternation and subordination between the two types of metaphor which Jameson sets up, we find what Jameson calls the 'metaphysic of desire' and transgression invading, subverting, and complexifying irretrievably the binary terms of the more classic forms of the metaphor.

What struck me forcibly in rereading *The Politics and Poetics of Transgression* is that this process of shifting between two related but increasingly different metaphors of transformation is not merely 'local' interpretive insight by the two authors, but symptomatic of a major transition in our cultural and political life, as well as in critical theoretical work in recent decades. It is here that certain 'elective affinities' with work in cultural theory at the Centre for Cultural Studies in the 1970s began to suggest themselves.

By way of illustration, we can take three examples: the first from the cultural debates which belong to the 'founding moment' (*sic*) of cultural studies; the second from work on youth subcultures and the popular; the third from the analysis of ideological discourse.

It is not often recalled that cultural studies 'began' at Birmingham with an interrogation of the high/low categories of the cultural debate. It inherited these terms in part from the Leavisite preoccupation with the disappearance of a 'living' organic popular culture in the eighteenth century and its replacement by a debased 'mass civilization' offering a serious threat to 'minority culture'; in part from the debate about 'mass culture' between conservative and demotic cultural critics, which is where so-called 'media studies' began.[12] In fact, cultural studies defined itself critically in relation to the terms of both these debates. It rejected the essentially elitist cultural programme in which the *Scrutiny* critique was grounded; and it rejected the either/ors of the 'mass culture' debate.[13] It sought to disentangle the question of the intrinsic literary and cultural value of particular texts from the practice of cultural classification – an elementary distinction which, regrettably, highly sophisticated contributors to the current 'canon' debate seem incapable of making. (Sociology often deserves its bad name; but a little sociological sophistication would not go amiss here and there.)

Raymond Williams' analysis of the operation of the 'selective tradition' and his later deconstruction of 'literature' into modes of writing took on a subversive charge in the context of the same debate.[14] For others of us, it was the category of 'the popular' which effectively cut the Gordian knot – not through an uncritically populist celebration, which has been common in some circles, but because of the way it disturbed the settled contours and – precisely – transgressed the boundaries of cultural classification. Since the rise of modernism, and even more in the era of 'postmodernism', it is impossible to keep the high and the low carefully segregated into their proper places in the classifying scheme. We tried to find a way out of the

binary fix by rethinking 'the popular', not in terms of fixed qualities or a given content, but *relationally* – as those forms and practices which are excluded from, and opposed to, the 'valued', the canon, through the operation of symbolic practices of exclusion and closure.[15]

In 1975, the Centre published a volume of essays on 'Youth Subcultures in Post-war Britain'. Though this volume became quite influential in the field, setting in motion a number of further studies, it represented a very crude beginning and it is cited here not to rescue it from comparative obscurity but because of what it tells us about how ideas of transgression, symbolic reversal, and cultural contestation were being reconceptualized.

The book was entitled *Resistance through Rituals*: the use of the two terms in its title was deliberate.[16] 'Resistance' signalled those forms of disaffiliation (like the new social movements associated with youth) which were in some sense challenges to and negotiations of the dominant order but which could not be assimilated to the traditional categories of revolutionary class struggle. 'Rituals' pointed to the symbolic dimension of these movements – the stylization of social actions, the 'play' of signs and symbols, the 'playing out' of resistance and repetition in the theatres of everyday life, the 'bricoleur effect', as fragments and emblems were dissociated from one cultural discourse and reassembled in another. It also hinted at an answer to the question, posed by many conventional social critics, whether there were built-in limits to all such forms of resistance – because of their gestural quality, their dissociation from the classic agencies of social transformation, their status – as it was put in the language of the time – as 'magical solutions'. This is a serious question – Bakhtin himself acknowledged that 'no consistent links are formed in most cases' – but this way of putting it also reflected the lingering presence of the belief that the symbolic could not be anything but a second-order, dependent category.

In the context of this discussion, what seems most significant now is the way *Resistance through Rituals* actively distanced itself from the classical metaphors of 'revolutionary struggle' and the reform/revolution antinomies by offering in their place an *expanded* definition of social rupture. In place of the simple binaries of 'the class struggle', it substituted the Gramscian notion of 'repertoires of resistance' which, it insisted, were always conjuncturally defined and historically specific. It attempted to ground these repertoires, not directly in the either/ors of classical class conflict but in an analysis of the 'balance in the relations of forces' developed by Gramsci in his analysis of hegemonic struggle.

> Negotiation, resistance, struggle: the relations between a subordinate and a dominant cultural formation, wherever they fall in this spectrum, are always intensely active, always oppositional in a structural sense

(even when this 'opposition' is latent, or experienced simply as the normal state of affairs . . .). Their outcome is not given but made. The subordinate class brings to this 'theatre of struggle' a repertoire of strategies and responses – ways of coping as well as ways of resisting. Each 'strategy' in the repertoire mobilizes certain material, social [and symbolic] elements: it constructs these into the supports for the different ways the class lives, [negotiates,] and resists its continuing subordination. Not all the strategies are of equal weight; not all are potentially counter-hegemonic.[17]

This is a very early stage in the formulation of this problem, and the traces of a kind of 'class reductionism' are still to be found in it.[18] But its interest lies in the way notions of a variety of forms of resistance replace the primacy of 'the class struggle'; in the movement towards a less determinist, more conjunctural way of understanding the 'repertoires of resistance' and the centrality it gave to the symbolic dimension. Gramsci is the most significant theoretical influence on these formulations. It was his concept of the 'national-popular' as a terrain of cultural and hegemonic struggle 'relatively autonomous' at least of other types of social struggle which helped us to displace the traces of reductionism in the argument.

The third example is from the analysis of ideological discourse. A great deal of attention was given in the 1970s at the Centre for Cultural Studies to trying to rethink and rework the conceptual categories of ideology, its mechanisms, and mappings in a number of different areas. This work was conducted within a specific conceptual space, defined by a number of theoretical axes: first, by the radical absence of an adequate theory or conceptualization of language and the ideological in Marx's writing and, particularly, the need to transcend the 'base–superstructure' metaphor; second, in relation to the attempts in what we can broadly define as the 'Althusserian School', to supply the absent theoretical framework; third, face to face with the new theories of language and the semiotic which had begun to transorm the ground of cultural theory; fourth, the inadequacies of available theorizations for thinking together, in any convincing or concrete way, the relations between the 'social' and the 'symbolic'.[19]

Gramsci was important here too. But the key text undoubtedly was *Marxism and the Philosophy of Language*, by V. N. Volosinov, which the Seminar Press published in English in 1973 and which had a decisive and far-reaching impact on our work.[20] First, it established the definitively discursive character of ideology. 'The domain of ideology coincides with the domain of signs', Volosinov wrote. 'They equate with one another. Whenever a sign is present, ideology is present too. Every ideological process possesses semiotic value.'

Second, it marked the decisive breaking of the correspondence between classes and the idea of separate, autonomous, and self-sufficient 'class

languages', ideological universes, or, to use Lukácsian language 'world-views'.

> Class does not coincide with the sign-community, i.e. with the community which is the totality of users of the same sets of signs and ideological communication. Thus various classes will use the same language. As a result, differently oriented accents intersect in every ideological sign. Sign becomes the arena of class struggle.[21]

Third, it advanced the key argument that, since different accents coincide within the same sign, the struggle over meaning did not take the form of substituting one, self-sufficient class language for another, but of the disarticulation and rearticulation of different ideological accentings within the same sign. It followed that meaning cannot be finally fixed, that every ideological sign, as Volosinov put it, is 'multi-accentual'; and consequently that this continuous discursive 'play' or shifting of meaning within language was the condition of possibility of ideological contestation. 'A sign that has been withdrawn from the pressure of the social struggle inevitably loses force, degenerating into allegory and becoming the object, not of a live social intelligibility, but of a mere philological comprehension.[22] Another way of putting it would be to acknowledge the infinite reversibility of the 'logics' of ideological discourse, which are so much more governed by the 'laws' of displacement and condensation of Freud's dream-work than of Enlightenment reason. 'The living ideological sign is Janus-faced'; and this 'inner dialect quality of the sign' is present in the 'ordinary conditions of life' but particularly relevant 'in times of social crisis and revolutionary change'.[23]

Fourth, *Marxism and the Philosophy of Language* made us see with clarity that what an ideology 'does', so to speak, is not to impose an already formed class perspective on another, less powerful one, but rather to intervene on the dialogic fluidity of language, to effect the 'cut' of ideology across language's infinite semiotic 'play', to define the limits and regulative order of a 'discursive formation' in order to attempt, arbitrarily, to fix the flow of language, to stabilize, freeze, suture language to a univocal meaning.

> The very same thing that makes the ideological sign vital and mutable is also however that which makes it a refracting and distorting medium. The ruling class strives to impart a superclass, eternal character to the ideological sign, to extinguish or drive inward the struggle between social value judgements which occurs in it, to make the sign uniaccentual.[24]

In Volosinov's view, every linguistic formation consists, in fact, of 'genre, register, sociolect, dialect, and the mutual interanimation of these forms', to use Allon White's phrase.

Marxism and the Philosophy of Language therefore played a critical role in the general theoretical shift from any lingering flirtation with even a modified version of the 'base–superstructure' metaphor to a fully discourse-and-power conception of the ideological.[25] And yet, there was something of great significance about that text which we did *not* understand at the time. In fact, these important formulations about the multiaccentuality of the ideological sign and the struggle to contest and shift meanings – of meaning as the symbolic stake in all social antagonism – belonged to and derived their theoretical and metaphorical power from a wider philosophical context. Volosinov's prescriptions, which we tended to read rather 'technically', required to be 'read' inter-textually – in the context of a broader model or set of metaphors about social change: specifically in relation to Bakhtin's *dialogic principle* and the great themes of 'the carnival'. Volosinov's account counterposed the exercise of cultural power through the imposition of the norm in an attempt to freeze and fix meaning in language to the constant eruption of new meanings, the fluidity of heteroglossia, and the way meaning's inherent instability and heterogeneity dislocated and displaced language's apparently 'finished' character. But this account mirrored, in miniature, Bakhtin's 'carnival', with its image of the medieval cosmology of the world, ordered into top and bottom, higher and lower, along the vertical line – 'the surprisingly consistent vertical character which projects everything upwards and out of time's movement' – and of the way this comes to be countered by the 'downward' thrust of the popular, the encroachment of the 'world's horizontal', which not only puts another time and space in play, but relativizes that which represented itself as absolute and complete.

The reason we missed these deeper metaphoric reverberations of Volosinov's textual argument is that, though we knew that Volosinov had been a member of the Bakhtin circle, we did not at that time fully appreciate the complexity of the problem, as yet not satisfactorily resolved, of who the 'real' author of *Marxism and the Philosophy of Language* actually was. Was the text written by Volosinov, who was a gifted linguist, fully capable of writing such a work? Or was it jointly authored by Bakhtin and Volosinov? Or – as many now believe – was it Bakhtin's text published under Volosinov's name or Bakhtin's text added to and emended by Volosinov? Critics are now familiar with this complex story of the disputed texts of Bakhtin's; of the circle of brilliant intellectuals in Russia in the 1920s who closely collaborated, argued, and debated these literary, linguistic, and philosophical questions in an intense period of dialogue discussion over many years.[26]

Indeed the irony did not end there. For Bakhtin had a brother, Nikolai, who had been Mikhail's *alter ego* in their early lives, with whom he shared not only many common ideas but an intense personal relationship – 'the same enmity will touch two different souls, my enemy and brother' – and

who was separated from him during the Revolution. Nikolai had not only become a member of the Wittgenstein circle in Cambridge, but taught for many years at Birmingham University (1939–50). He had been attracted to the university by his friendship with two former Cambridge associates now teaching there – George Thompson, the Professor of Classics, and the Professor of German, Roy Pascal, who was *intr alia* a firm friend, ally and supporter of the Centre for Cultural Studies – and was later to found the university's Linguistics Department.[27]

In their book *Mikhail Bakhtin*, Clark and Holquist are firmly of the view that Bakhtin was the author of both *Marxism and the Philosophy of Language* and *Freudianism: A Critical Sketch*, hitherto also attributed to Volosinov; and this was confirmed by many members of the circle, including Bakhtin's widow. However, as is now well known, Bakhtin refused to sign the document which was prepared, at his request, in 1975, to clarify the question of authorship, and as his manuscripts and papers have all been destroyed, the issue is unlikely ever to be finally resolved.[28]

This 'mystery' about authorship has its deeply serious side, for it has to be placed in the context of the threat to unorthodox intellectual work, as the stalinist gloom gathered, and Bakhtin's retreat into anonymity, culminating in his arrest and exile for religious activities. But, as is always the case with Bakhtin, this tragic aspect is 'doubled' by its parodic, carnivalesque aspect; for it has also to be understood in the context of the love of pranks, games, verbal wit, ingenuity and play amongst the Bakhtin circle and of the principles and theories of 'the dialogic' and heteroglossia which governed both the philosophical speculations and the intellectual exchanges of its members. According to the dialogic principle, the self is constituted only through its relationship to the other, all understanding is dialogic in nature, 'meaning belongs to a word in its position between speakers', and agreement between collaborators in the dialogic relationship is defined as 'co-voicing'. Bakhtin had meditated on the 'question of authorship', the shifting relations between I and other, reported speech, and the politics of quotation in as early a text as the unfinished *Architectonics of Answerability*, and they continued to be themes of his later work. Dialogism, as Clark and Holquist observe, 'celebrates alter eity. . . .'As the world needs my altereity to give it meaning, I need the authority of others to define, or author, my self.'[29] In retrospect, it would have been very surprising if questions of who 'owned' which ideas in *Marxism and the Philosophy of Language* turned out to be a simple matter amongst Bakhtin and his co-voicers.

Lacking the principle of the dialogic in its fullness, we tended to appropriate 'Volosinov' more narrowly – to supply the basis for rethinking the relations between language and social transformation in a non-reductionist way. We thought of this exercise as, in some way, a recovery

of a 'dialectical' perspective. As we have noted, this is also the context in which Fredric Jameson appropriates and inflects Bakhtin in his development of a marxist hermeneutics in *The Political Unconscious*. In retrospect, this significantly underplays what is happening in the shift of metaphors from 'the dialectic of class antagonism' to the 'dialogic of multi-accentuality'. These two logics are not mutually exclusive. But nor are they subsumable into or substitutable for one another in this way. Where, classically, the terms of the dialectic grounds the complex supersession of different social forces, providing it with its governing logic, its meta-narrative, the dialogic emphasizes the shifting terms of antagonism, the intersection of different 'accentings' in the same discursive terrain, rather than the dialectical 'parting of the ways'. It rigorously exposes the absence of a guaranteed logic or 'law' to the play of meaning, the endlessly shifting positionalities of the places of enunciation, as contrasted with the 'given' positions of class antagonism, classically conceived. The notion of articulation/disarticulation interrupts the Manichaeism or the binary fixity of the logic of class struggle, in its classic conception, as the archetypal figure of transformation. The dialogic intrudes the idea of reversibility, of historic shifts which bear the traces of the past indelibly inscribed into the future, of the rupture of novelty which is also and always caught up in the return of the archaic.

One is reminded here of Gramsci's rethinking of the nature of the revolutionary moment in its generic form in the light of the experience of Caesarism. *A* does not defeat *B* or *B* defeat *A*, with each having the self-sufficient character of 'a generically progressive and generically reactionary force'. Instead, both are caught up, in modern times, in what Gramsci calls the 'dialectic (of) revolution/restoration'.[30] Here destruction has to be conceived, not mechanically but as an active process: 'destruction/reconstruction'. These oxymoronic foundations, which capture the dialogic relationship between antagonistic forces, prefigure Gramsci's historic transition from a 'war of manœuvre' to a 'war of position' – another important shift of the metaphors of transformation which had its impact on critical theorizing at the same moment and which was pointing in the same direction.

It is difficult to capture – except 'metaphorically' – what this shift of the metaphors of transformation consists of. It is certainly not the simple rejection of one type of metaphor and the substitution of another, 'better' (that is, more theoretically correct) one. It is more a question of being caught on the meridian between two variants of the same idea; of being suspended between the metaphors – of leaving one without being able to transcend it, and of moving towards the other without being fully able to encompass it. What the so-called shift to the 'dialogic' seems to involve is the 'spatialization' of moments of conflict and antagonism which have hitherto been captured by metaphors of condensation. The dialogic has

given up on any pure idea of transcendence. Rather, it suggests that, within every moment of reversal, there is always the surreptitious return of the trace of the past; within any rupture are the surprising effects of reduplication, repetition, and ambivalence. The insertion of ambivalence and ambiguity into the 'space' of the condensed metaphors of reversal and transcendence is, I believe, the guiding thread to the incomplete displacements which seem to be in progress in this movement within the metaphorical discourse. Certainly, the 'dialogic' does not refuse the idea of antagonism. But it obliges us always to think of antagonism as more or less than a 'pure' moment; to redefine the 'carnivalesque' in terms of an economy of excess, surplus and supplementarity, on the one hand, or of underdetermination, absence and lack, on the other. None of the metaphors of transformation, which contain elements of 'the festival of the oppressed', of 'the world turned upside-down' within them, when rephrased within the perspective of the 'dialogic', can produce a fully adequate representation of the poles of the antagonism they are attempting to encompass or represent. There is always something not accounted for, or left over. Like the symptoms and representations of psychic life, they are destined to be either over- or underdetermined. The reference to the model of 'the symptom' is not casual. The argument here has been advanced mainly in relation to Bakhtin. But in Stallybrass and White's book, as so often elsewhere, the figure of Freud and the discourse of psychoanalysis have proved to be equally decisive elements in bringing about the shift.

These were some of the inchoately expressed and formulated ideas which began, slowly and unevenly, to transform the theoretical terms and the shaping metaphors of work in cultural studies during the 1970s. *The Politics and Poetics of Transgression*, definitively a book of the 1980s, is several theoretical turns beyond these halting movements. But it seems to me a turn of the same screw. The parallels and 'elective affinities' come through strongly as soon as one examines how Stallybrass and White set out to rework and expand Bakhtin. What is particularly striking is their capacity to work *with* and at the same time to work *on* Bakhtin's 'carnival' metaphor, genuinely inhabiting its richly connotative possibilities, taking seriously the critiques advanced against it (its binaryism, its 'utopian populism') while at the same time transforming it. This is exemplary theoretical work, which needs to be sharply contrasted with the many examples we have of current theoretical work, which mainly consists of ventriloquizing 'their masters' voices'. As a result, the authors seem to be justified in arguing that 'It is only by completely shifting the grounds of the debate, by transforming the "problematic" of carnival' that 'carnival' can be shown to be simply 'one instance of a generalized economy of transgression and of the recoding of high/low relations across the whole social structure'.[31] It is precisely their success in building upon the work of Bakhtin but attempting to avoid the limitations identified in his work

which provides us with the measure of the significance of the 'intervention in the current surge of Bakhtin inspired studies' which *The Politics and Poetics of Transgression* represents.

Typically, the critiques of the binary-and-inversion structure of the classic metaphors of transformation have been followed by ditching them in favour of more lateral or horizontal metaphors – a movement now so fashionable in critical theory as almost to have acquired the status of the banal. This is certainly the fate which has befallen the so-called high/low distinction in the debate about popular culture. Colin McCabe, for example, is certainly correct in his polemical essay 'Defining popular culture' to draw attention to the importance of 'the complex ways in which traditions and technologies combine to produce audiences' and to argue that 'this figuring of different audiences' radically cuts across and disrupts the positions of the champions of high art and popular culture alike.[32] He is certainly right to note the way Gramsci's idea of 'the national popular', which did so much to transform the debate about 'the popular' in the 1970s, transcends the class-against-class ways of reading culture which, as he says, debilitated the European left. He may indeed have a point in saying that nevertheless Gramsci remains in some way imprisoned by the Hegelian–Marxist theory of culture from which he is trying to escape. McCabe may also be right in dismissing the alternative (which I advanced in 'Deconstructing "the Popular" '), where, according to McCabe, 'the social is theorized as overlapping terrains of struggle and popular culture is simply a way of specifying areas of resistance to dominant ideological forms'.[33] This, he says, 'through however many million mediations' reproduces the very weakness of the position whose problems it is striving to repair.[34]

The only alternative, it seems, is simply to abandon it. 'What seems positive to me in the commitment to popular culture', he argues, 'is that element which is determined to break with any and all of the formulations which depend on a high/low, elite/mass distinction.[35] John Caughie, who adds to McCabe's argument such important considerations as 'the discrimination of pleasure and an understanding of the enormous machineries of desire which are caught up in the circulation of the popular', comes to the same conclusion in a later essay in the same volume.[36]

One can only respond that it depends on what you mean by abandoning it. Putting it 'under erasure', as Derrida would say, yes. Abandoning it altogether, no. Certainly the high/low distinction is not – has never been – tenable in the naturalistic, transhistorical terms in which it has been advanced. But if the proposition is that by 'abandoning it' one will have transcended the problem to which it referred – Stallybrass and White's persistent tendency for European culture to map 'the human body, psychic forms, geographical space and the social formation . . . within interrelating

and interdependent hierarchies of high and low' – then one must doubt the strategy.

Stallybrass and White, at any rate, do *not* move in that way. Rather, they take the processes of ranking and classification which these axes of high and low represent as fundamental cultural processes, critical within European culture for the constitution of the identity of any cultural domain. The concepts of ambivalence, hybridity, interdependence, which, we have argued, began to disrupt and transgress the stability of the hierarchical binary ordering of the cultural field into high and low, *do not destroy the force of the operation of the hierarchical principle in culture*, any more, it may be said, than the fact that 'race' is not a valid scientific category that 'in any way undermines its symbolic and social effectuality'.[37] High and low may not have the canonical status claimed for them; but they remain fundamental to the way cultural practices are organized and regulated. What 'displacing them' means is not abandoning them but shifting the focus of theoretical attention from the categories 'in themselves' as repositories of cultural value to the process of cultural classification itself. It reveals these cultural hierarchies as *necessarily arbitrary* – as an attempt, transcoded from one domain to another, to fix, stabilize and regulate a 'culture' in hierarchical ascending order, using all the metaphorical force of the 'above' and the 'below'.

The classification of cultural domains into the self-sufficient and apparently transcendental distinctions of high and low is revealed, by the operation of the carnivalesque, and by the transgressions of pleasure, play, and desire, as an exercise in cultural regulation, designed to make cultural practices into a *formation* which can then be sustained in a binary form by strategies of cultural power. The fact that the cultural field cannot be stabilized in this way does not prevent the exercise in boundary construction being attempted again, in another place, for another time. Cultural practices are never outside the play of power. And one way in which power operates in the apparently decentred sphere of culture is through the struggle to harness it, to superimpose on it, to regulate and enclose its diverse and transgressive forms and energies, within the structure and logic of a normative or canonical binary. This cultural operation, as I tried to argue elsewhere,[38] is always in some way linked – and continues, even in our more diversified postmodern culture, to be linked – with the mechanisms of cultural hegemony.[39] One would have to be extremely naive to believe that the current controversies around 'multiculturalism' and the canon – contemporary form of the high/low cultural debate – is a disinterested conversation between scholars, unrelated to questions of cultural authority or to containing the transgressive danger of social, ethnic, gendered, and sexual hybridity.

This argument is advanced with great clarity in Stallybrass and White's conclusion:

We have had cause throughout this book to reflect on an unnoticed slide between two quite distinct kinds of 'grotesque', the grotesque of the 'Other' of the defining group or self, and the grotesque as a boundary phenomenon of hybridization or inmixing, in which self and other become enmeshed in an inclusive, heterogeneous, dangerously unstable zone. What starts as a *simple* repulsion or rejection of symbolic matter foreign to the self inaugurates a process of introjection and negation which is always *complex* in its effects. In order to fathom this complexity, this inner dynamic of the boundary constructions necessary to collective identity, we have to avoid conflating the two different forms of the grotesque. If the two are confused, it becomes impossible to see that a fundamental mechanism of identity formation *produces* the second, hybrid grotesque at the level of the political unconscious by the very struggle to exclude the first The point is that the *exclusion* necessary to the formation of social identity at level one is simultaneously a *production* at the level of the Imaginary, and a production, what is more, of a complex hybrid fantasy emerging out of the very attempt to demarcate boundaries, to unite and purify the social collectivity The general processes of classification which bear most closely upon the identity of the collectivity are indissociable from the heterodox symbolic of the Imaginary. The unconscious is to this extent *necessarily* a political unconscious as Jameson avers, for the exclusion of other social groups and classes in the struggle to achieve categorical self-identity appears as a special dialogism, an agon of voices – sometimes even an *argument* – within the shared Imaginary of the class in question. The very drive to achieve a singularity of collective identity is simultaneously productive of unconscious heterogeneity, with its variety of hybrid figures, competing sovereignties and exorbitant demands.[40]

What is socially peripheral may be symbolically central.[41] The movement from simple binary metaphors of cultural and symbolic transformation to the more complex figures described above represents an absolutely fundamental 'turn' in cultural theory, mappable in a number of different fields. *The Politics and Poetics of Transgression* represents an exemplary instance of this general movement; and the contribution which Allon White was able to make to it, in the tragically brief period of his working and writing life, is only just beginning, retrospectively, to be properly understood.

NOTES

1 Peter Stallybrass and Allon White (1988) *The Politics and Poetics of Transgression* (London).
2 Ibid, back cover.
3 E.R. Curtius (1979) *European Literature and the Middle Ages* (London).

4 Ibid., 2.
5 See, for example, F. R. Leavis, *Mass Civilization Minority Culture*, reprinted as appendix 3 to *Education and the University* (London, 1948); Q. D. Leavis, *Fiction and the Reading Public* (London, 1932) and F. R. Leavis and Denys Thompson, *Culture and Environment* (London, 1933). For the 'mass culture' debate, see T. W. Adorno, 'Television and the Patterns of Mass Culture', Dwight MacDonald, 'A theory of mass culture', and Irving Howe, 'Notes on mass culture', all in B. Rosenberg and D. White (eds), *Mass Culture* (Glencoe, Ill., 1956).
6 Stallybrass and White, *The Politics and Poetics of Transgression*, 2–3.
7 Ibid., 6.
8 Mikhail Bakhtin, *Rabelais and his World* (Bloomington, Ind., 1984), 423.
9 Fredric Jameson, *The Political Unconscious* (London, 1981), 73.
10 Ibid., 75.
11 Stallybrass and White, *The Politics and Poetics of Transgression*, 5.
12 For a summary which locates the origins of media studies in the 'mass culture' debate, see Leon Bramson, *The Political Context of Sociology* (Princeton, NJ, 1961), ch. 6.
13 For an early attempt to break out of this binary fix, see S. Hall and P. Whannel, *The Popular Arts* (London, 1964).
14 See *inter alia*, Raymond Williams, 'The analysis of culture', in *The Long Revolution* (Harmondsworth, 1965); and *Marxism and Literature* (Oxford, 1977).
15 This is the position I advanced in 'Notes on deconstructing ''the Popular'' ', in Raphael Samuel (ed.), *People's History and Social Theory* (London, 1981). What is meant by a 'relational' approach to this process of cultural classification is best suggested by an example. In the eighteenth century, the novel was regarded as a 'low' and vulgar form. In the twentieth century, the eighteenth century novel has become a touchstone of 'serious' literature. Nevertheless, new novels continue to be ranked according to some implicit high/low, serious/popular generic distinction. The contents of the categories have changed, but the practice of mapping literature within a 'system of differences' remains. What matters is how 'high' is defined, at any historical moment, in relation to 'low', not these categories as fixed, with respect to either their contents or their transcendental cultural value. The point is rudimentary with respect to such studies of 'symbolic classification' as Levi-Strauss' *Mythologies: The Origin of Table Manners* (New York, 1978), Mary Douglas *Purity and Danger* (London, 1966), and V. W. Turner's *The Ritual Process* (Ithaca, NY, 1977), all referred to in Stallybrass and White, *The Politics and Poetics of Transgression*.
16 S. Hall and T. Jefferson (eds), *Resistance through Rituals* (London, 1976).
17 *Resistance through Rituals*, 44.
18 Rosalind Coward, elaborated this charge of 'class reductionism' in 'Class, "culture" and the social formation', in *Screen*, 18(1) (Spring 1977); see also, the reply by I. Chambers, J. Clarke, John Clarke, Ian Connell, Lidia Curti, Stuart Hall and Tony Jefferson, 'Marxism and culture', *Screen*, 18(4) (Winter 1977–8).
19 For an account of the work in this area during this period, see S. Hall, D. Hobson, A. Lowe and P. Willis (eds), *Culture, Media, Language* (London, 1980).
20 V. N. Volosinov, *Marxism and the Philosophy of Language* (New York, 1973).
21 *Marxism and the Philosophy of Language*, 10, 23.
22 Ibid., 23.

23 Ibid.
24 Ibid.
25 This is acknowledged in, for example, S. Hall, 'The problem of ideology: Marxism without guarantees', in Betty Matthews (ed.), *Marx: A Hundred Years On* (London, 1983).
26 See the account of the Bakhtin circle in K. Clark and M. Holquist, *Mikhail Bakhtin* (Cambridge, Mass., 1984).
27 See the introduction by A. Duncan Jones to N. Bakhtin's *Lectures and Essays* (Birmingham, 1963). The Birmingham connection is fully described in Clark and Holquist, *Mikhail Bakhtin*. It, and the existence of a Bakhtin archive in the university library, were first brought to my notice by Professor Peter Davidson. For the relationship between these different figures in the Wittgenstein circle, see T. Eagleton, 'Wittgenstein's friends', in *Against the Grain* (London, 1986).
28 See Clark and Holquist, *Mikhail Bakhtin*, ch. 10.
29 *Mikhail Bakhtin*, 65.
30 A. Gramsci, 'State and civil society', in *The Prison Notebooks* (London, 1971), 219 ff.
31 Stallybrass and White, *The Politics and Poetics of Transgression*, 19.
32 Colin McCabe, 'Defining popular culture', in McCabe (ed.), *High Theory/Low Culture* (Manchester, 1986), 8.
33 *High Theory/Low Culture*, 4.
34 Ibid. However, 'Deconstructing "the Popular" ' is not an essay about and does not use the concept of 'mediations'.
35 'Deconstructing "the Popular" ', 8.
36 John Caughie, 'Popular culture: notes and revisions', in McCabe (ed.), *High Theory/Low Culture*.
37 Introduction to J. Donald and A. Rattansi (eds.), 'Race', in *Culture and Difference* (London, 1992), 3.
38 Deconstructing "the Popular" '.
39 The argument in S. Hall, 'Deconstructing "the Popular" ', is that to see the classification of culture into 'high/low' as related to the struggle over hegemony does not require either fetishizing the content of each category or a class correspondence way of reading the relationship between the social and the symbolic.
40 Stallybrass and White, *The Politics and Poetics of Transgressions*, 193–4.
41 Ibid., 23; quoted from B. Babcock, *The Reversible World* (Ithaca, NY, 1978), 32.

Part IV

Critical postmodernism, cultural imperialism and postcolonial theory

Chapter 16

Post-marxism
Between/beyond critical postmodernism and cultural studies

Kuan-Hsing Chen

COLLAPSING EFFECTS

Current debates on post-marxism have centred around the works of Ernesto Laclau and Chantal Mouffe.[1] The sharp antagonism between different positions has not made the platform of debate a very productive one. Here, I would like to shift the ground of analysis by confronting another round of debate, this time more productive, yet largely ignored: when marxist cultural studies declared war against postmodernism.[2] My strategy here is to frame this debate *within* the terrain of post-marxism; conversely, it is only within the context of this debate that a wider post-marxist spectrum can be established and diverse politico-theoretical concerns specified.

Before entering into the debate, let me point out that the version of postmodernism discussed here *is* different from what I shall call 'dominant' ones. Elsewhere, through the post-1968 works of Michel Foucault, Gilles Deleuze, Felix Guattari and Jean Baudrillard, a 'critical' postmodernism has been proposed (Chen, 1988). This critical postmodernism distances itself from a dominant 'aesthetic' criticism which privileges art works as its central site of analysis (Lyotard, 1984); it departs from a philosophical criticism which locates itself within the history of philosophy (Habermas, 1987); it supersedes a cultural criticism which centres on the elite sectors of cultural lives (Huyssen, 1986); it diverges from a social criticism which reduces the ('postmodern') social world to a reflection of the ('late capitalist') economic mode of production (Jameson, 1983, 1984); it differs from a 'moral' criticism which calls for a return to a ('post-pragmatist') ('bourgeois') social solidarity (Rorty, 1984); and it also breaks away from a popular culture criticism which focuses on the unravelling of new cultural texts. Instead, what may be termed an alternative 'critical postmodernism' attempts to articulate the dynamics between history, theory and cultural politics, and to stress the critical location of mass

Reprinted from *Media, Culture and Society* (1991), 13(1), 35–51.

media within the strategic field of postmodernity. Because cultural studies has taken issue with the theoretical works of Foucault, Deleuze and Guattari and Baudrillard (as central referent points of postmodernism), there seems to be a common ground for pursuing a critical dialogue. The 'identities' of both cultural studies and postmodernism can perhaps be more clearly elucidated through a converging of their 'differences'; their internal limits and problems will likewise be in sharper relief.

In order to avoid the 'sliding' tendency of postmodernism, which conflates levels of abstraction, this chapter will proceed along three axes: history, cultural politics and mass media. These distinctions are strategic. As we proceed, it will become clear that one axis immediately implies, is entangled with and connected to others. Having worked through central issues involved in the debate and defended certain viable positions of postmodernism in response to cultural studies' challenges, I will then consider the possibility of negotiating a space 'in-between' in order to forge political alliances. Finally, I wish to pinpoint problematic assumptions of postmodernism, to urge the necessity of confronting long neglected issues, and to move beyond the limits of both postmodernism and cultural studies. In effect, the convergence of these two discursive domains will result in a 'cut 'n' mix' (Hebdige, 1987a), or more precisely, a 'collapsing effect', thereby constituting a new critical space, crossing over and eliminating the boundaries and identities of both. I shall call this critical zone 'post-marxist cultural studies'. Moving toward a postmodern cultural studies within the space of post-marxism is the central motive of this paper.

HISTORY: IS THERE SUCH A THING CALLED POSTMODERNITY?

In the interview, 'On postmodernism and articulation' Hall (1986: 46) asks critical questions:

> Is postmodernism the word we give to the rearrangement, the new configuration, which many of the elements that went into the modernist project have now assumed? Or is it . . . a new kind of absolute rupture with the past, the beginning of a new global epoch altogether?

In response to Hall's question, I will argue that postmodernity denotes a 'rearrangement' and a 'new configuration' which have exceeded the boundaries of modernity. Although it is not an *absolute* rupture, one has to realize, with Gramsci (as Hall himself does), that no historical era is ever absolute; that 'Stone Age' elements remain, albeit entering new relations with other internal elements. In my view, what the term 'postmodernity' designates is precisely how the relations among internal elements in the current conditions of existence have been rearranged to the extent of constituting a new historical formation. Of course, to what extent it *is*

and according to what 'criteria' one may define a new era, remain arguable. Nonetheless, the perplexities of contemporary culture have produced new structural transmutations which, as Hall (1986: 47) states, though with reservations, 'tend to outrun the critical and theoretical concepts generated in the early modernist period'. In agreement with Hall, I too doubt that 'there is any such absolutely novel and unified thing as *the* postmodern condition' (Hall, 1986: 47). If there is such a thing called a postmodern condition, it can only be plural, disunified, multiple and contradictory.

In this sense, both postmodernism and cultural studies emphasize *relative* continuity and rupture; both positions are against historical necessity and for historical contingency. Both oppose the linearity and unity of an evolutionary historicism. Both stress the plurality of origins and that of trajectories of movements. Both attempt to do 'ascending analysis' to write popular history, that is, to bring the repressed voices of history back into the historical agenda. And, most importantly, both see 'history' as the (discursively articulated) records or archives of war between the dominant and the dominated of various kinds.

The immediate markable differences between these two discourses is that postmodernism has begun to locate the courses of historical configurations, which are largely ignored on the side of cultural studies. Through different axes (relations of power, systems of representation, the flow of desire), postmodernism has attempted to chart the moving trajectories of new social formations. This is, however, not to deny that cultural studies' analysis is always historical in nature. Perhaps the divergence lies in a fundamental contention: Hall does not believe in the arrival of a new historical era, and thus there is no need to do such large-scale (re)analyses, which, however, may be seen as the starting-point for postmodernism.

Hall (1986: 50) argues that: 'Postmodernism attempts to close off the past by saying that history is finished, therefore you needn't go back to it', and that it signals 'the end of the world. History stops with us and there is no place to go after this' (1986: 47). These charges against postmodernism are unfounded. The historical works of postmodernism precisely deal with reconstituting the past as a field of struggle. With Baudrillard (1987), one might argue that postmodernity denotes excursion into post-history in the sense that *that specific* western monolithic thing called History is over and done with. As Iain Chambers (1986: 100) suggests: 'postmodernism . . . does suggest the end of *a* world; a world of Englightened rationalism and its metaphysical and positivist variants . . . a world that is white, male and Euro-centric.' And one might add: what is finished is the 'official', universal, unified, racist, sexist, imperialist History; from this point on, *that* History is finished. Thus, 'the end of History' means the beginning of histories: the history of women's struggle, the history of youth culture,

the history of prisons, the history of madness, the history of the working class, the history of minorities and the history of the Third World.

In short, on the level of histories, post-marxism has to continue this 'ascending' historical project, to write *in*, and from the point of view of minor discourses, to (re)inscribe forces of antagonism and resistance, to affirm differences while forging possible strategic alliances. More radically, post-marxist cultural studies ought perhaps sometimes even to *become silent*, or alternatively, by using already occupied social positions, to open up spaces, so that minor discourses may speak (or not) and be heard.[3]

CULTURAL POLITICS: WHAT IS POLITICS ANYWAY?

On the level of cultural politics, what postmodernism and cultural studies share most is the attempt to decentre or decentralize politics and re-centre 'culture'. But this does not mean that politics has gone. Quite the contrary, in both positions, culture is pervasively politicized on every front and every ground, hence a cultural politics. Both discourses conceive of cultural practices as collective; cultural politics is empowering and endangering, oppositional and hegemonic; culture is neither the 'authentic' practice of the 'people' nor simply a means of 'manipulation' by capitalism, but the site of active local struggle, everyday and anywhere. Both positions recognize that contemporary power networks can and do no longer work solely through an imposition from 'above'; rather it operates 'on the ground' and can only establish its hegemonic dominance through linking with local struggles. Both positions are convinced that the current networks of power cannot be reconstructed without negotiating the space of the masses. Both sides realize that, to win the battle, one can no longer wait, one has to fight here and now.

The clash between the two positions is perhaps a matter of emphasis: cultural studies emphasizes that cultural politics operates through the domains of representation, signification and ideology,[4] while postmodernism underscores the terrains of the production of signs (as the real or the hyper-real), asignifying process and discursive and non-discursive practices – the space of the micropolitics of power (Foucault, 1979b), desire (Deleuze and Guattari, 1977) and the symbolic (Baudrillard, 1981).

Let me first respond to Hall's critique of what he sees as Foucault's overemphasis on the discursive, the latter's abandonment of the ideological and his notion of power. As Hall has argued, Foucault fails to realize the complexity of contemporary theories of ideology as these are reworked through Gramsci and Althusser. Abandoning the notion of the ideological and displacing it with 'the discursive', Foucault runs the risk of 'neutralizing' the discursive, or to use Hall's (1986: 49) words, of 'let[ting] himself off the hook' of the ideological. For ideological forces, whether in the form

of discursive or extradiscursive practices, are actively working in the concrete social field. These points are all well taken.

Yet, it is highly problematic for Hall (1986: 49) to say that, by abandoning the term 'ideology', Foucault 'saves for himself "the political" with his insistence on power, but denies himself *a politics* because he has no idea of the "relations of force" '. First, Hall is perhaps right in claiming that Foucault does not have *a politics*, but he has many: the Foucaultian local struggles are aimed at every corner of the social field. Second, according to my reading, if there is a definition of power in Foucault, it is nothing if not 'the relations of force'. As Foucault (1979b: 92) succinctly puts it: 'It seems to me that power must be understood in the first instance as the multiplicity of force relations immanent in the sphere in which they operate and which constitute their own organization'. Thus, Foucault's politics is precisely to analyze the constellation of the relations of forces.

Hall (1986: 48) goes on to label Foucault's as a 'proto-anarchist position because his resistance must be summoned up from no-where', in view of his 'evasion of the question' of ideology. In Foucault, Hall argues, 'Nobody knows where it [resistance] comes from. Fortunately it goes on being there, always guaranteed: insofar as there is power, there is resistance.' In fact, this attack reveals more of Hall's own problematical concept of power grounded as it is in traditional marxist categories of power. For Foucault defines power as the *relation* of (confrontational) forces, always multiple and multidirectional. More importantly, resistance constitutes only partial forms of power relations. Resistance is in no way guaranteed to 'win', but it designates the forces against the dominant; in this sense, resistance does not come from 'no-where' but from everywhere. Whether resistance can be 'summoned up' to a larger alliance and more global type of struggle, which Hall apparently wants Foucault to address, is a different question. Thus, Hall's reading of Foucault's theory does not take it on its own terms. Second, embedded in Hall's assumption is the notion that power (that is to say domination) is in (binary) opposition to resistance, whereas Foucault has pointed out emphatically that power as such does not exist: what exists is always and specifically a power relation insofar as both resistance and domination are interconnected forms of power, among others; the opposition between them is never necessary but conditional and contingent (Foucault, 1979b: 94). In this reformulation of power, Foucault seeks precisely to avoid a dangerous entrapment: to place resistance in binary opposition to domination is to effect a reproduction of the dominant, of the binary logic set up by the 'strong' party; unless the resisting forces are strong enough to explode the logic itself, it will infinitely reproduce the original dominance. Thus, Hall's reading of Foucault is not so much incorrect as unproductive: it misses Foucault's formulation in accounting for the non-discursive (non-ideological) forms of power, and it fails to understand that, indeed, with Foucault, 'there are

different regimes of truth in the social formation' (Hall, 1986: 48), of which the ideological is only one. In not recognizing these points, Hall has 'let himself off the hook' of having to theorize the ideological without the asignifying and non-representational dimensions. (One can perhaps understand Hall's 'binarism' as a strategic articulation of social antagonisms. But, the oppositions between women and men, working class and capitalists, blacks and white, or the third worlds and 'first' world, can no longer be understood as 'ontological' givens, but are rather articulated political effects of present social contradictions.)

If postmodernism has emphasized non-ideological domains, then this is precisely where cultural studies ought to come in. As Grossberg (1986: 72–3) has noted, ideological effects have to be connected to other types of effects, whereas overemphasis on the line of the ideological has made cultural studies unwilling to connect with other planes of effects. These 'other sorts of effects' are what Grossberg calls the affective dimension of life, what Baudrillard (1986) calls the other side of the real, what Foucault (1987) calls 'the outside', and Deleuze and Guattari (1987) call 'micropolitics'.

Although Fiske and Watts (1986) correctly insist on the urgency for a 'politics of pleasure', their Barthesian impulse fails to articulate useful analytical tools and fails to recognize Guattari's (1977) warnings that pleasure (*jouissance*) as an individuated effect lacks the possibility of collective politics. The 'rationalism' of cultural studies has been single-handedly supplemented by Grossberg's works on the 'affective economy'. In noticing a missing dimension in cultural studies, Grossberg (1984: 101) recognizes the importance of making a 'distinction between affect and pleasure'. Grossberg's 'affective economy' quite accurately points to a critical space which 'involves the enabling distribution of energies', or a plane of 'an asignifying effectivity' (Grossberg, 1986: 73). He further recognizes that 'like the ideological plane', the affective space 'has its own principles which constrain [and enable] the possibilities of struggle' (Grossberg, 1986: 73). Given his insertion of a much needed dimension into cultural studies, there are, nevertheless, problems in his formulation. His theorizing practices revolve *around* the space of the affective, describing the shapes of the terrain, making connections with other planes such as the ideological, the economic and the political. He has yet to pinpoint the working 'principles', or what I would call the *inner* logics of the affective. He is able to answer the questions 'where is this [affective] enconomy produced? And what are its effects?' (Grossberg, 1984: 103), yet does not address more immanent questions – how and through what process is the affective economy able to operate? And what are its internal dynamics? The affective economy becomes a shell without trajectories. Consequently, Grossberg is not able to historicize the affective structure. He is able to pinpoint the visible configurations of styles, of body, of youth, without

theorizing the changes of more invisible inner currents. Do these inner currents always stay the same, even when styles or surrounding social conditions have become different?

Here, then, is what and where cultural studies can take off from postmodernism. Power as relations of forces, the immanent logics of desiring production and the effects of symbolic seduction and fascination may precisely articulate and historicize such inner mechanisms of the affective economy, and de-rationalize 'reason' as well as de-irrationalize 'emotion'. With Foucault (1980), one has to realize that just as domination is always present, resistance is always possible. With Deleuze and Guattari (1977), one has to learn there is always a danger of sliding from 'schizophrenia' to 'paranoia', from democracy to fascism. With Baudrillard (1983a, 1988), one has to be sensitive to the changing historical conditions which shift the dominant (affective) logic of (hot) seduction to that of (cold) fascination, from interface confrontation to media absorption, from the mood of explosion (of a rock concert) to implosion (of MTV). Whether the economies of power, desire and the symbolic are 'correct' is perhaps a different question; these analytical tools offer an entering sluice for rethinking cultural politics. The weakness of micropolitical economy is that it remains abstract and its obscure languages produce the effect of an anti-elitist elitism: 'technical' terms cannot be understood *outside* the 'critical circle'. (But doesn't one badly need new languages to address historically neglected domains?) What postmodernism has to learn from cultural studies is to *localize* the inner logics of the affective, or to 'sociologize' the working logics within specific groups. Micropolitical struggle cannot afford to assume that similar effects exist in different social groups if postmodern politics is to preserve differences. In underlining the 'fluid' nature of micropolitics, postmodernism ought not to abandon but rather ought to incorporate specific, local politics of gender, race and class.

To end this section, I would suggest that the ideological and the discursive, signifying and asignifying, representational and the affective, are not mutually exclusive categories. To avoid the political mistakes of 'either/or', a postmodern cultural studies has to recognize, on one level, the real effect of the discursive, the non-signifying and simulation, and on another level, the continual existence of ideological and signifying practices and representation. The questions become: where is the point of contact, what are the effects produced by one side on another? Do they cancel out or reinforce or remain indifferent to each other? These are the questions of cultural politics that post-marxism must begin to address.

MASS MEDIA; THE BAUDRILLARD CLASH

The importance of mass media as a site for struggle for both postmodernism and cultural studies provides the final axis for my essay. The dispute

resides mostly in the work of Baudrillard, notably on the questions of simulation, the status of the hyper-real and the masses. In what follows, I will use Baudrillard's work as a bargaining site to negotiate its validity and pinpoint its inadequacies.

The current 'Baudrillard clash' has triggered both antagonism and excitement. A common tendency of the responses is either a total rejection or an uncritical embracing. The strange thing is that neither side can entirely deny there is *something* at stake. What this something is, is still largely unclear. Hebdige (1987b: 70) thus expresses this 'ambivalence': 'I realize the pertinence of what he [Baudrillard] is saying. But I also have my suspicions that the kind of will motivating his work seems to be poisonous'. These very doubts define perhaps the possibility of negotiating a space, an in-between ground. Beyond the logic of either/or, we can start to limit the levels and specificities, to slow down the speed, to mark out the critical zone where Baudrillard's movement goes too far, too fast.

The most debatable issue is Baudrillard's theory of simulacrum – the central area of cultural studies' contestation. Because of his 'inflation' of the simulation effect, Baudrillard has been accused with the following names and/or positions: he is an 'essentialist' (Hall, 1986: 46), a Frankfurt School follower with an even 'darker vision' (Chambers, 1986: 100); his work has produced 'cynicism/nihilism' and 'fatalism' (Hebige, 1986: 92, 95); he is too 'pessimistic' (McRobbie, 1986: 110). The problem with such accusations is that it reinstates an 'essentialism' of the author and his text; whereas no attempt is made to actively appropriate the theory (not his), or whatever may be useful of it, for different, other usages.

Grossberg's (1986: 74) critique does go beyond the naming game: 'Baudrillard's theory of the simulacrum . . . conflates the social formation with a particular set of effects, with the plane of simulation, rendering all of social reality the simple product of media causality.' This, then, is where Baudrillard's media imperialism unfolds. But that certainly does not mean that there is no such thing as the simulation effect. We should therefore limit his level of argument to one plane of effect, to de-essentialize his discourse, to recognize simulation as part of the real without reducing it to the *only* effect operating in the social world. As McRobbie (1986: 115) puts it. 'There *is* no going back. For populations transfixed on images which are themselves a reality', what we have to do is to theorize the 'images', 'texts' and 'signs' as themselves part of the real rather than as representations of the real. The incorporation of simulation into the real serves to avoid the unnecessary trap of truth and falsity, as well as the 'crisis of representation'. Only thus can cultural analysis come closer to the lives of the populace.

Let me come to the question of what Hall (1986: 49) calls postmodernism's assertion of 'the sheer facticity of things: things *are just* on the surface.' The assertion that 'things are just on the surface', as a

postmodernist tenet, has been profoundly misunderstood. Foucault's (1986) denial of hermeneutic depth is a rejection of the *essential* layer of an artifact (be it a historical event, or a cultural sign) which is seen as determining its final meaning; that is, there are always multiple layers or surfaces to be accounted for, none of which have the final say. Similarly, Baudrillard's (1988) notion of 'obscenity' points to the contemporary tendency in the media to render things visible, to strip away 'private' secrecy; but this does not mean *everything* is on the surface. Further, 'on the surface' does not mean visibility: desire, the symbolic and power are precisely not something that can be seen, but rather, that work, effectively, on the social and physical body. There are, therefore, two ways to read 'everything is on the surface': (1) since the collapse of 'the depth model', no privileged level, layer or surface can assume the final 'truth' any longer; (2) historically, what had been invisible depth, secrecy or interiority can now be 'brought to the surface'. Taking 'surface' thus, I would suggest that Foucault's (1970a) analysis of different surfaces of prison technology, Deleuze and Guattari's (1977) 'Body without organs' (as the surfaces of inscription and circulation of capital and desire) and Baudrillard's (1983a) genealogical traces of the multiple trajectories of the simulation machines have all sought to address reality as produced within the relations amongst these surfaces after the historical collapse of 'the depth', or depth as the final determinant.

On the question of the subject, both positions hold that 'a unified, stable and self-determining subject' no longer exists (Grossberg, 1986: 72). Instead, cultural studies' multiple subject-positions and postmodernism's nomadic-schizo subject are always in fluid transformation, when moving from one context to another – 'The subject itself has become a site of struggle,' as Grossberg (1986: 72) puts it. Nevertheless, cultural studies, in its concrete analyses, always privileges 'one' moment of subject-positioning. For instance, influenced by film theory and traditional communication research, cultural studies will speak of the 'audience' (the spectator) in front of a TV programme – the subject is positioned by the camera angle and inserted into a textually constructed context. Falling into a traditional model of communication, cultural studies fail to see that the 'moment' itself (for example, watching TV) can always be multiplied; that is, an audience is not simply a reading subject, s/he can always 'work out', cook or fall asleep at the same time; and the textual context can also be plural. Further, when s/he reads 'intensely', the subject can flow into the hyper-spatial apparatus and disappear from the 'local' context. To use the term 'audience' thus implies an extraction of particular instance out of a larger social context; a bit like doing social science experimental research on a higher level of abstraction. (Yes, but how would or could one analyse otherwise than through abstracting and abstraction, whence the need perhaps not only to stop making sense, but to stop analysing?) In effect,

cultural studies' 'audience' research, its theory of encoding/decoding and its theory of preferred reading/actual reading largely reproduce the modernist communication model of transcendence. I do not dismiss this model for its modernism, but the model itself cannot adequately account for the complex flow of social forces and its various conditions of possibility. On the other hand, the postmodern schizo subject has recognized the fragmented and segmented flow without attempting to extract the privileged moment for analysis. In Baudrillard's works, the emphasis on spatial operation addresses the inter-textual positionings of the subject; it always upholds multiple positions at each 'moment'. In fact, what postmodern cultural studies must analyse is not simply the location of the subject within the webs composed of multiple, intersected lines; it is also the unextractable *relations* (the lines on which partial subject-points are inscribed) which form the complex social networks.

Finally, I want to turn to the most critical issue: the masses. Deleuze and Guattari (1987), and Baudrillard (1983b) have attempted to theorize the masses as a spatial and functional concept, and as molecular flow, to displace 'empiricist' individuals and the composition of atomized units. Further, they stress the internal, non-separable linkage between the masses and the media to pinpoint certain working logics, strategies and effects within this hyperspace: absorption, neutralization, indifference, refusal or the black hole, and the critical implication of these effects in confrontation with dominant social powers. Admittedly, the postmodern reformulation remains abstract and does not clarify the 'differences' between social groups or spaces. But, this reformulation has gone beyond existing understandings of the masses (as a political imaginary, as cultural dupes or as an empty referent), and provides an entering point for further elaborations or challenges.

In attacking Baudrillard's notion of the masses, Fiske and Watts (1986: 106) make a moral claim: Baudrillard does not 'respect' social groups and 'lumps [these] dismissively under the term "the masses"'. If 'the people' or 'the popular' would make the analysis more 'respectable' and less 'dismissive', so be it. (Might not 'the people' and/or 'the popular' sound more respectful but be no less dismissive and homogenizing?) Hall's (1986: 52) argument is more specific: in Baudrillard, 'the masses and the mass media are nothing but a passive reflection of the historical, economic and political forces'. But I would argue that in Baudrillard, the masses are neither passive, nor active, nor a pure reflection, but functional. Hall (1986: 52) goes on to argue that 'postmodernism has yet to go through that point [the massses]; it has yet to actually think through and engage the question of the masses'. Deleuze and Guattari's 'molecular mass' and Baudrillard's 'critical' mass precisely address this crucial question. But when Baudrillard responds, as it were, to the call to think through, to theorize and to conceptualize the masses in micropolitical terms, Hall (1986: 52) again

charges him with 'renouncing' critical thought 'on behalf of the masses' and 'us[ing] "the masses" in the abstract to fuel or underpin [his] own intellectual positions.' The question at stake is, rather: is it illegitimate to talk *about*, to study, to theorize the people, the popular, the masses, because as soon as one talks about them, one runs the risk of representing' or speaking/writing 'on behalf of the masses' ? In my view, to theorize the masses or to study the working class is different from speaking for them. (But ultimately, is it different enough? Might it not be a speaking *with*, a falling silent in order to listen to? Otherwise, how can one even begin to understand the particularities of popular forces?) Although Baudrillard's rhetoric does give rise to such a doubt and he should probably plead guilty to it, his formulations cannot, should not, so easily be dismissed.

In fact, both Hall and Baudrillard begin with Benjamin's observation of the masses as an emerging disruptive, historical force, as the subject of history. Hall however has not gone much beyond recognizing the power of the masses. On the other hand, Baudrillard is able to carry further the concept of the masses and elaborate 'its positivity'. Baudrillard's functional concept of the masses is non-existent in cultural studies; in the latter, the mass becomes either an imaginary (political) referent or a concrete individual. To conceptualize the masses as internal to the media and as moving spaces is a vantage point established by postmodernism. The problem, however, with conceptualizing the masses as a critical hyperspace does seem to do away with sociologism; it gives up sociological determination, although recognizes internal differences; but it cannot unite these differences into concrete struggles.

Following Hebdige (1986: 94), post-marxism must pursue the politics of the 'popular': to produce what Foucault calls strategic analyses in order to grasp fully the detailed textures of popular desire, ideology and concerns. Post-marxism must not only maintain structural analysis, both molar and molecular, of the relations within social networks, but also reclaim the insight of phenomenology, to 'experience' popular experiences, to forge strategic connection, to constuct lines of flight.

FOR A POLITICAL SYNCHRONIZER

From the above, it seems that the (theoretical) differences and (political) contradictions between postmodernism and cultural studies are not as ineradicable as one might assume. It is always a difference in emphasis, and a concomitant neglect of certain domains. As a provisional conclusion, I would argue that it is cultural studies' refusal to 'abandon the terrain of marxism' (Grossberg, 1986: 70), or more precisely, the 'name' (as if it were a matter of essentials) of marxism, that separates the two discursive formations. But when one looks closer, or from another angle, the 'post-

marxism' of cultural studies is not so different from the 'post-marxism' of postmodernism. As Hall puts it,

> I am a 'post-marxist' only in the sense that I recognize the necessity to move beyond orthodox marxism, beyond the notion of marxism guaranteed by the laws of history. But I still operate somewhere within what I understand to be the *discursive limits* of a marxist position. . . . So 'post' means, for me, going on thinking on the ground of a set of *established problems*, a problematic. It doesn't mean deserting that terrain but rather, using it as one's *reference point*.
>
> (Hall, 1986: 58; emphasis added)

If post-marxism can be understood as (1) the movement 'beyond orthodox marxism', (2) as the attempt 'beyond the notion of marxism guaranteed by the laws of history', and (3) as the persistent usage of marxism 'as one's reference point', then I do not see any *essential* difference, since these three problematics are precisely what postmodernism is engaged with. Perhaps the 'name' of marxism does make a difference (to the extent that holding on to it claims and authorizes one's patri-lineage, affiliations and right to write and speak). However, (1) if both cultural studies and postmodernism agree on the necessity to fashion strategic alliances, or to 'advance along multiple fronts' (Hebdige, 1986: 94); (2) if the political concerns of both positions are similar if not the same (that is, domination, against capitalism, against racism, sexism and the exploitation of labour, in short, against the social status quo), no matter whether they share an *ultimate*, 'positive' goal (socialism? – a term which both positions no longer know how to define in its specificities); (3) if both positions try to stand *with* (rather than speak *for* or even *about*, and thereby impose on) the local oppressed groups, to open a space *for them to speak for themselves* (and withstand the will to encroach upon this space for the sake of better understanding them), to bring these 'minor' voices back into the present moment, as well as history; and (4) if both seek to intervene in existing social fields and engage in concrete struggles; then, cultural studies and critical postmodernism might begin to truly effect a collapse of academic disciplines and theoretical factions, and to constitute a new theoretical-political terrain (under the new name of post-marxism?). (This is not to deny the differences within post-marxism, but to activate these differences for productive usages.)

If our purpose is to herald a postmodern cultural studies which will move beyond the limits of both postmodernism and cultural studies, then 'it would be foolish to present a polar opposition between the Gramscian line(s) [of cultural studies] and the (heterogeneous) Posts [of post-modernisms] . . . there are clear cross-Channel links between the two sets of concerns and emphases' (Hebdige, 1986: 96). 'Toward' a postmodern cultural studies seeks then to effect a critical collage of postmodernism

and cultural studies, to construct a 'political synchronizer' which will move toward a marxism or post-marxism or a post(modern)-marxism of the 1990s. This is (and there is no better way of saying it)

a marxism that has survived, returning perhaps a little lighter on its feet, (staggering at first), a marxism more prone perhaps to listen, learn, adapt and to appreciate, for instance, that words like 'emergency' and 'struggle' don't just mean fight, conflict, war and death but birthing, the prospect of new life emerging: a struggling to the light.

(Hebdige, 1986: 97)

Turning to 'the dark' side of the present is the ineluctable direction where 'the light' of a 're-articulated' post-marxism of the future may be seen.

A PERMANENT (LOCAL) STRUGGLE

The irony, and perhaps the failure, of a critical postmodernism resides in its political double bind. On the one hand, it calls for a movement toward the local, the specific, the oppressed. On the other hand, it continuously operates at the level of the global, the abstract and the general. (Yes, this chapter as well, sadly.) The local, the specific and the oppressed thus appear to be peripheral in the postmodern spectrum. It is perhaps at this final moment that a dismantling of hidden ideologies and problematic assumptions may begin.

The ideology of the new, or what Hall (1986: 47) calls the 'tyranny of the New', of the emergent, always runs the risk of diminishing potential political forces, no matter how archaic they might be. As Deleuze and Guattari (1977: 257) put it, 'archaisms have a perfectly current function . . . they represent social and potentially political forces'. The symptomatic assumption, that the formation of postmodernity (as a traversing configuration) has unequivocally taken place, whence the calling everything into question, is now to be challenged. Although it is possible to identify differences, changing formations and new constellations, this somewhat positivistic strategy, which concentrates on identifying 'new' tendencies, fails to emphasize those problems which are as 'real', as 'bad' in both modernity and postmodernity, despite their having put on a new coat and entered into new relations. Totalitarian fascism did not go with the end of the Second World War. In fact, it infiltrates our bodies, our minds, not simply in the world behind the (already torn down) 'iron curtain', but also in the so-called western democratic countries. How does the United States support the totalitarian regimes throughout the world? Why do people support Ronald Reagan, Oliver North, George Bush, Maggie Thatcher? Moreover, although class relations in the 'West' become more and more complex, this does not mean that they no longer exist. The living conditions of blacks and poor whites are worse and worse: they have moved

from a 'lower' class to an 'under' class (West, 1987). In the Third World
countries, no one can deny that local class differences are an essential line
of struggle. Poverty and the unequal distribution of wealth have intensified,
explosively.

Hall (1986: 46) has indicated another problem inherent in postmodern-
ism: 'the label "postmodernism", especially its American appropriation
(and it *is* about how the world dreams itself to be "American") . . . is
irrevocably Euro- or western-centric in its whole episteme'. Indeed, post-
modernism has focused on America as the dominant (imaged and imag-
ined) referent point of analysis, and has been thus in complicity with the
American 'Empire', with hegemonic First World academic criticism and
modes of analyses, despite 'critical encounters'; postmodernism ignores
the rest of the world, despite the avowed suspicions of 'global' analysis.

Hall has also quite correctly asked: 'Is postmodernism a global or a
"western" phenomenon?' (1986: 46). In my view, it is definitely a 'local',
western phenomenon. The attempt to globalize and the failure to localize
postmodernism have taken Jameson into a 'critical' imperialism (Chen,
1989). A resistance to universality, however, is not equivalent to the
contention that western postmodernity has no connection with and pro-
duces no effects on 'non-western' societies or vice versa. If 'late' capital-
ism is part of the 'postmodern project', can one eliminate its impact on the
other 'half' of the globe (if one might still call this other half the 'socialist
project') by arguing that it is a 'local' phenomenon? The fact is that the
international structure of capitalism has escalated and has put most
'developing' countries in permanent poverty. From a local point of view
somewhere between 'first' and 'third', it is within the geographical site of
the 'underdeveloped' or 'developing' territories that the evils of capitalist
exploitation are most nakedly revealed. The direct exploitation of the
labour forces has moved from the West into the Third World countries.

Further, on political and cultural levels, does not Reagan or Bush's
'postmodern' world policy *determine* the United States' 'post-colonies',
such as Taiwan's, cultural and political discrimination against Palestine
and the Palestinians? To be sure, the cultural imperialism thesis is both
valid and problematic. It is problematic if one understands the thesis in the
sense that American imperialism is able to *mechanically* impose its ideo-
logical content on Third World countries without any resistance: watching
Dallas would therefore amount to an unquestioning acceptance of bour-
geois capitalist ideology. Historically, this is obviously an invalid argu-
ment. People in the Third World do watch *Dallas*, but in their specific
ways, framed and in accordance to local history and politics. But, at the
same time, that the 'imageries' (traces of American life) whereby ideolo-
gical articulation is conducted are pervasively imperializing is unquestion-
able. That is, it is not so much an ideological content but its form which
seems to follow an American trend: TV culture, blue jeans, punk style or

yuppie ways of life (Taiwan has translated, and sectors of the people live by, *The Yuppie Handbook*). I am not suggesting that 'quoting' American (and now, increasingly Japanese) emblems may not constitute oppositional forces in relation to local dominant culture. But at the same time one has to ask *why* that citation is American (or Japanese), not Nicaraguan. Thus, the thesis of cultural imperialism has to be transformed with an emphasis not only on the ideological but the simulation of ways of life, as a much more subtle form of articulation.

One simply cannot deny that struggle and resistance still go on throughout the world, no matter how archaic the form they might take, for no one has the right to deny the vitality of the local struggles of oppressed peoples (Hebdige, 1986: 73). Turning to the local and the oppressed is the political choice which post-marxism must finally make. *A permanent (local) struggle* against the dominant conjoins (conjures up) and *collapses* the differences between the modern and the postmodern. It is here that postmodernism ends itself and a politically charged postmodern cultural studies of a post-marxist sort has yet to begin.

NOTES

Comments on earlier versions of this paper by Hanno Hardt, Larry Grossberg, Ien Ang, Jennifer Slack, Edward Chien, John Fiske and Ann Kaplan are gratefully acknowledged. I especially note and thank Naifei Ding for her voice from the outside and recurring, disruptive bits and pieces. A longer and more complete version of this paper has been published under the same title in *Taiwan: A Radical Quarterly in Social Studies*, 12, 1992, 85–115.

1 See Laclau (1977) and Laclau and Mouffe (1985). The major site of debate has taken place in *New Left Review*.
2 That this battle has largely been ignored might have things to do with the 'minor' site (the 'marginal' status of the journal) on which the debate was first initiated. In the *Journal of Communiation Inquiry* 10(2), 1986, a special issue devoted to Stuart Hall, the battle was first initiated. In the interview with Hall and responding essays by Grossberg, Hebdige, Chambers, Fiske and Watts, McRobbie and Hardt, disrupting forces of postmodernism are sympathetically recognized, but hidden political dangers are critically contested by these practitioners of cultural criticism. My discussion will not be limited to these essays, but will use them as a central line of organizing the debate.
3 It is perhaps only with the becoming silent of 'major' discourses (dominant and/ or critical) that the 'minor noises' can be finally heard and listened to. Whence the realization of this very project's complicity and affiliations, which 'authorize' its critique while at the same time defining its limited and limiting tactics.
4 Colin Sparks (1989) has lucidly traced the formation of cultural studies in the British social and intellectual history, which explains how these concerns became the focus of analysis.

REFERENCES

Baudrillard, J. (1981) 'Beyond the unconcsious: the symbolic', *Discourse* 3: 60–87.

—— (1983a) *Simulation*, New York: Semiotext(e).

—— (1983b) *In the Shadow of Silent Majorities*, New York: Semiotext(e).

—— (1986) 'L'amérique comme fiction', *Art Press* 103: 40–2.

—— (1987) 'The Year 2000 has already happened', in A. Kroker and M. Kroker (eds), *Body Invaders: Panis Sex in America*, Montreal: New World Perspectives, 35–44.

—— (1988) *The Ecstacy of Communication*, New York: Semiotext(e).

Chambers, I. (1986) 'Waiting on the end of the world?', *Journal of Communication Inquiry* 10(2)): 99–103.

Chen, K. H. (1988) 'History, theory and cultural politics: towards a minor discourse of mass-media and postmodernity', unpublished dissertation, University of Iowa.

—— (1989) 'Deterritorializing "critical" studies in "mass" communication' *Journal of Communication Inquiry* 13(2): 43–61.

Deleuze, G. and Guattari, F. (1977) *Anti-Oedipus: Capitalism and Schizophrenia*, New York: Viking Press.

—— (1987) *A Thousand Plateaux: Capitalism and Schizophrenia*, Minneapolis: University of Minnesota Press.

Fiske, J. and Watts, J. (1986) 'An articulating culture: Hall, meaning and power', *Journal of Communication Inquiry* 10(2): 104–7.

Foucault, M. (1979a) *Discipline and Punish: The Birth of the Prison*, New York: Vintage.

—— (1979b) *History of Sexuality*, Vol. 1, *An Introduction*, London: Penguin.

—— (1980) *Power/Knowledge*, New York: Pantheon.

—— (1986) 'Nietzsche, Freud, Marx', *Critical Text* 3(2): 1–5.

—— (1987) *Maurice Blanchot: The Thought from Outside*, New York: Zone Books.

Grossberg, L. (1984) ' "I'd rather feel bad than not feel anything at all" (rock and roll: pleasure and power) ', *Enclitic* 8: 94–111.

—— (1986) 'History, politics and postmodernism: Stuart Hall and cultural studies', *Journal of Communication Inquiry* 10(2): 61–77.

Guattari, F. (1977) 'Everybody wants to be a fascist', *Semiotext(e)* 2(3): 62–71.

Habermas, J. (1987) *The Philosophical Discourse of Modernity*, Cambridge, MA: MIT Press.

Hall, S. (1986) 'On postmodernism and articulation: an interview with Stuart Hall', *Journal of Communication Inquiry* 10(2): 45–60.

Hebdige, D. (1986) 'Postmodernism and "the other side" ', *Journal of Communication Inquiry* 10(2): 78–98.

—— (1987a) *Cut 'n' Mix: Culture, Identity and Caribbean Music*, London: Comedia.

—— (1987b) 'Hiding in the light: exended club mix with Dick Hebdige', *Art & Text* 26: 67–78.

Huyssen, A. (1986) *After the Great Divide: Modernism, Mass Culture, Postmodernism*, Bloomington: Indiana University Press.

Jameson, F. (1983) 'Postmodernism and consumer society', in H. Foster (ed.). *The Anti-Aesthetic*, Port Townsend Bay Press, 111–25.

—— (1984) 'Postmodernism, or the cultural logic of late capitalism', *New Left Review* 146: 53–92.

Laclau, E. (1977) *Politics and Ideology in Marxist Theory*, London: Verso.

Laclau, E. and Mouffe, C. (1985) *Hegemony and Socialist Strategy*, London: Verso.

Lyotard, J. F. (1984) 'Philosophy and painting in the age of their experimentation: contribution to an idea of postmodernity', *Camera Obscura* 12: 111–25.

McRobbie (1986) 'Postmodernism and popular culture', *Journal of Communication Inquiry* 10(2): 108–16.

Rorty, R. (1984) 'Habermas and Lyotard on postmodernity', *Praxis International* 4: 32–44.

Sparks, C. (1989) 'Experience, ideology and articulation: Stuart Hall and the development of culture', *Journal of Communication Inquiry* 13(2): 79–87.

West, C. (1987) 'Interview with Cornell West', *Flash Art* 133: 51–5.

EurAm, modernity, reason and alterity

or, postmodernism, the highest stage of cultural imperialism?

David Morley

INTRODUCTION

Kuan-Hsing Chen and I have offered our evaluative comments on Stuart Hall's work in the Introduction, and in the previous chapter Chen has offered a more detailed commentary on the relation of Hall's work to contemporary debates about postmodernism and postcolonialism. In this chapter, rather than addressing Hall's work directly, I offer a series of arguments which emerge from, and respond to some of these recent debates.

I begin, in postmodern style, with a pastiche of quotations from, at first sight, somewhat disparate sources:

> These [outlying possessions of ours] are hardly to be looked upon as countries . . . but more properly as outlying agricultural or manufacturing estates belonging to a larger community. Our West Indies colonies, for example, cannot be regarded as countries with a productive capital of their own . . . [but are rather] the place where England finds it convenient to carry on the production of sugar, coffee and a few other tropical commodities.
>
> (John Stuart Mill, quoted in Said, 1994: 69)

> Instead of the individual monopoly of Great Britain, we see a few imperialist powers contending for the right to share in this monopoly, and this struggle is characteristic of the whole period of the early twentieth century.
>
> (V.I. Lenin, 1917; quoted from Lenin, 1970: 104)

> OK, you Limey has-been, I'm gonna give it to you country-simple. You have been taken over, like a banana republic. Your royal family is nothing but a holograph projected by the CIA.
>
> (William Burroughs, 1983)

> Good evening, fine people. Welcome to humble show. We were just bought by Sony.
> (Johnny Carson, introducing his US TV talk show 5.10.89; quoted from Wark, 1991: 43)

Hollywood is a place you can't geographically define. We don't know where it is.

(John Wayne, quoted from Aksoy and Robins, 1992: 1).

These quotations, concerning questions of imperialism and culture, are designed to offer, if in a telegraphic manner, an indication of my concerns in this chapter. If those concerns are ultimately with contemporary debates about postmodernism, I also want to suggest that it may be helpful both to 'historicize' and to 'spatialize' these debates. Hence my quotations reference a series of temporal and spatial transitions and transformations in the nature and structure of imperialism: temporally, from one centre of imperial power to another (from Britain, to the United States, to Japan); economically, from the industry of the plantation to the 'cultural industries' of Hollywood; epistemologically, from the expertise of the philosopher to that of the politician, the novelist, the TV talk-show host and the movie actor; and lastly, in spatial terms, from a model of empire based on a network of clearly defined geographical power to one which is radically de-spatialized within the terms of postmodern time-space compression (cf. Jameson, 1985).

THE GEOGRAPHY OF POSTMODERNITY

It is often now argued that time-space compression is one of (if not the) defining characteristics of the experience of postmodernity, in which, it is claimed, we move towards an increasing sense of global interconnectedness and simultaneity of experience. More specifically, under the influence of Foucault's (1986: 22) remarks to the effect that, if the great obsession of the nineteenth century was history, the present epoch will perhaps be obsessed, above all by space, there has been, in the recent period, a flowering of work in 'postmodern geography'. In this work, the dimension of space and spatial analysis has begun to get the kind of attention which it deserves. However, as soon as we begin to proceed in this way, a whole new set of difficulties emerge. To speak of postmodernity is to speak of a period: the difficulty is that events have not only a temporal but also a spatial form. In speaking of a period of postmodernity, the temporal marker tends to override the spatial one. Quite apart from the notorious difficulties in giving a temporal delimitation to the period of postmodernity, we must also supply it with a spatial delimitation, if we are not to presuppose that everyone, everywhere, simultaneously lives in this era of postmodernity. We might ask: Where is postmodernity? While the inhabitants of Los Angeles may perhaps experience one form of postmodernity, it would be foolish to presume that the inhabitants of rural areas of India or Uganda necessarily also experience the same era in anything like the same way.

The difficulties here are manifold. Postmodernity presumes a temporal

sequence in which postmodernity supersedes 'modernity'. However, it could well be argued that 'modernity' is as much a geographical as a temporal concept. Modernity is usually equated, somewhat unproblematically, with the history of the societies of the industrial West. The correlative of that, of course, is that the societies of the Orient are then equated with the realm of tradition, and of the past. Onto the geography of East and West is directly mapped the distinction between the pre-modern and the modern. The category 'West' has long signified the positional superiority of Europe, and later of the United States, in relation to the rest of the world.

Modernization has itself long been equated with Americanization. In the writings of Fukuyama (1992) *et al.*, we see a rerun of the arguments of the modernizing sociologists of the 1960s, for whom the modernization of the 'underdeveloped' world was held to depend on the spreading of 'modern' attitudes, which would release the energies of the poor, from the constraints of tradition (cf. Lerner, 1964). As we know (and as the quotation from Johnny Carson above dramatically illustrates) things have changed. In the contemporary period, the hegemony of America in the world system is in question. Specifically, the rise of Japanese economic power and, again most dramatically, Japanese investment in Hollywood, the symbolic home of the American dream, has been seen to threaten America's position. Indeed, Japan's rise to world-power status raises a fundamentally problematic question for the West. If the West has always been modern, and the East, by definition, traditional or pre-modern, the question arises now (at the point at which Japan 'overtakes' America), of whether we are entering a period in which the world may need to be read from right to left, rather than from left to right – a period in which 'They' (the peoples of the presumed backward East) have become more modern (or indeed postmodern, perhaps) than 'Us' (the peoples of the supposedly advanced West).

As Massey (1992) has noted, contemporary writing on the question of postmodernity makes much of the fact that this period involves some supposedly new sense of dislocation. The problem which Massey raises is the sense in which this perception is, in fact, very much a First World 'take' on things. As she notes, the assumption which runs through much of the literature is that this is quite a new and remarkable situation. Her basic point is that, for the inhabitants of all the countries around the world colonized by the West, the experience of immediate, destabilizing contact with other alien cultures has a very long historical resonance. What is new is simply that this experience of dislocation is now returned, through patterns of immigration, from the peripheries, to the metropolis. Hannerz (1991) puts it another way, when he remarks that it may well be that the First World has been present in the consciousness of many Third World peoples a great deal longer than the Third World has been on the minds of most of the 'First' World (Hannerz, 1991: 110). In a similar sense, King remarks that

the culture, society, and space of early twentieth-century Calcutta or Singapore prefigured the future in a much more accurate way than did that of London or New York. 'Modernity' was not born in Paris but rather in Rio. With this interpretation, Euro-American paradigms of so-called 'postmodernism' have neither much meaning nor salience, outside the narrow geographical confines of Euro-America where they developed.

(King, 1991: 8)

There are also a further set of questions, which concern the tendency of theories of postmodernity to fall into a kind of formalist, post-structuralist rhetoric, which over-generalizes its account of 'the experience of post-modernity' so as to decontextualize and flatten out all the significant differences between the experiences of people in different situations, who are members of different social and cultural groups, with access to different forms and quantities of economic and cultural capital. The point is simply that 'we' are not all nomadic, fragmented subjectives, living in the same postmodern universe. For some categories of people (differentiated by gender, race and ethnicity, as much as by class) the new technologies of symbolic and physical communications and transport offer significant opportunities for interconnectedness. For those people, there may well be some greater sense of postmodern 'opportunities'. However, at the same time, for other categories of people, horizons may simultaneously be narrowing. Many writers have referred to the contemporary dynamic of simultaneous globalization and localization. However, for some people, the globalizing aspect of that dynamic is the dominant one, while for others it is very much the localizing aspect which is increasingly operative, as their life-chances are gradually reduced, and they increasingly remain stuck in the micro-territories in which they were born. To give but one example, the film *Boyz 'N the Hood* (director, John Singleton, Columbia Pictures, 1991) dramatizes the sense in which, for many of the most deprived black and Latino Americans, locality is in fact destiny, where the horizon, far from being global, extends only as far as the boundary of the 'hood'. All of that is to suggest that we must be very cautious when applying any abstracted notion of postmodernity, and must resist the temptation to generalize our theories in such a way as to ignore the continuing significant differences in the experience of this era, by people in different social and geographical locations. The work of postmodern geographers such as Soja (1989) or Meyrowitz (1985) alerts us to the sense in which contemporary developments in electronic forms of communication and transport have necessarily, and profoundly, transformed our understanding of place. At its simplest, these writers suggest that we now live within the terms of a postmodern geography, which is a geography of image spaces and communication networks as much, as if not more than, a geography of physical

boundaries. Here, perhaps, is the rational kernel in the postmodern argument about 'time-space compression'. At its simplest, the key point, as argued by Meyrowitz, is that what has happened is that the relationship between community and place has been transformed by these developments. As he notes, on the one hand, we are simply no longer 'in' places to the same extent, insofar as communication and contact with others is no longer necessarily premised on physical contiguity. To that extent, to live next to others is not necessarily to be part of any effective community with them. Conversely, given the ways in which many people use, for example, the telephone to stay in regular contact with family members or friends in far distant places, their physical distance does not preclude their continuing, effective participation in some forms of community. A growing number of writers, among them Gillespie (1989 and 1995) and Flores (1988), have begun to research the specific ways in which migrant communities utilize new communications technologies, such as video recorders and video-conferencing facilities, to recreate and sustain their own senses of identity and community, across the geographical spaces of their dispersion and migration. This work, on the role of communication technologies in the creation and sustenance of diasporic identities, is of profound significance.

Doreen Massey has argued that places themselves should no longer be seen as internally homogeneous, bounded areas, but as 'spaces of interaction' in which local identities are constructed out of resources (both material and symbolic) which may not be at all local in their origin, but are nonetheless 'authentic' for all that (Massey, 1991). In a similar sense, the anthropologist Daniel Miller has argued that it is unproductive to think about the question of cultural imperialism as a process in which a set of external or corrupting forces impinge on the 'pure' sphere of the local, which must then be protected from their ravages. Rather, what he suggests is that we must understand the ways in which people in particular places make their identities out of things (including, for example, American television programmes and products) that have come from somewhere else, but which are then, in Miller's phrase, subjected to a process of 'indigenization', so that the products ingested from the external world are, in the process of their local 'digestion', transformed, so as to function as cultural resources, the effects of which, he says should be assessed in terms of local consequences, not local origins (Miller, 1992).

The conventional model of cultural imperialism presumes the existence of a pure, internally homogeneous, authentic, indigenous culture, which then becomes subverted or corrupted by foreign influence. The reality, however, is that every culture has ingested foreign elements from exogenous sources, which gradually become 'naturalized' within it. The notion that there are geographical spaces with indigenous, radically different inhabitants, who can be defined on the basis of some religion, culture or

racial 'essence', proper to that geographical space, is a highly debatable idea. As many authors have noted (for example Appadurai, 1990; Bhabha, 1983 and 1994; Hall, 1990) cultural hybridity is increasingly the normal state of affairs. In an anthropological context, James Clifford (1992) takes up the same issue, noting that villages, inhabited by 'natives' and con- ceived of as bounded sites of residence, which then stand as metonyms for a whole culture, have long been the focus of anthropological fieldwork. Against this traditional model, Clifford argues that cultures are no longer 'in' places in any simple sense, that the focus on rooted, authentic or native culture and experience fails to address the wider world of cultural import- export relations in which these processes are always already enmeshed. Clifford supports Appadurai's contention that 'natives, people confined to and by the places to which they belong, groups unsullied by contact with the larger world, have probably never existed' (Appadurai, 1988: 39). Rather, Clifford suggests, we should work, not only with a model of 'ex- centric' natives, conceived in their multiple external connections, but with a notion of places as sites of travel encounters, as much as sites of residence. He suggests that we should be attentive to a culture's furthest range of travel, while also looking at its centres; to the ways in which groups negotiate themselves in external as much as internal relations; to the fact that any 'home' culture is also a site of travel for others, and that one group's core is another's periphery.

THE FOREIGN, THE COSMOPOLITAN AND THE LOCAL

The 'foreign' is always, by definition, a problematic category, perhaps best posed as an experiential question, of what is 'foreign', to whom. Posed this way, as for example, Hebdige (1988) and Worpole (1983) have demon- strated, 'foreigness' is by no means, as often supposed, necessarily a matter of nationality, so much as of class or gender, or some other form of social division. As those authors demonstrate, 'foreign' elements can frequently have progressive functions, within any given culture, insofar as they destabilize local hierarchies of taste and power. However, even if the commanding position of America, in terms of its dominance of the world's media, cannot be so taken for granted as it once was, it remains deeply problematic that the 'foreign' is represented still, in so many places, by the American. If it is formally possible for foreign elements to function to destabilize local hierarchies, it remains problematic nonetheless if, in their place, all that we get, again and again, is the American alternative. To a very large extent McLuhan's (1964) 'global village' remains, in practice, an American-dominated village. (For a more developed version of this argument, see Morley, 1994: 138–42.)

In this connection we should take note of the comments of the Latin

American cultural critic Eduardo Galleano, here describing the 'postmodern predicament' from a Latin American perspective. As he puts it:

> In Latin America we are still subject to the invisible dictatorship of the American media . . . the people in power today relegate us to an absolute present, a historical vacuum. Reality is reduced to the present, as seen in television news bulletins, and the news is becoming more and more like a television soap opera. It's a way of cutting us off from our history. If your past is erased and you don't know where you're from, you can't know where you're going to, or what other futures might exist: our present dissolves our destiny, and it's a destiny in the style of a television soap opera. Take the images of the Gulf War, for instance. We all consumed the same images and heard the same version of that television soap which had a million extras, and surely was the biggest superproduction in television history: the global village worshipping an American massacre.
>
> (Galleano, 1993)

Moreover, there remains the further problem that America, referred to by some as the paradigmatically postmodern society, imports a smaller quantity of 'foreign' material into its own media than does any other country in the world. In this sense, the supposedly 'postmodern' society of America is perhaps still more provincial and more 'localized' than many places on the periphery of the American empire (cf. Gellner, 1992: 52–3, on the provincialism of much American culture, as the explanation of why 'hermeneutic' relativist doctrines can seem so revelatory, in that particular context).

In relation to current debates about hybridity and 'nomadology' (cf. Melucci, 1989) as the (characteristic) experience of postmodernity, I would support James Clifford's comments when he argues that we need to be very wary of a 'postmodern primitivism' which, in an affirmative mode, discovers non-western travellers ('nomads'), with hybrid, syncretic, cultures, and in the process, projects onto their different histories of culture contact, migration and inequality, a homogeneous (historically 'avant-garde') predicament (Clifford, 1992: 113). Stuart Hall (1992) has argued that, in developing our analysis of postmodern and diasporic cultures, we need to differentiate ourselves from fashionable postmodernist notions of 'nomadology' – the idea that 'everyone simply goes everywhere' nowadays. This would simply be to romanticize the figure of travel, hybridity and movement, in a generalizing manner, which would be just as inadequate (if in an opposite way) as contemporary ideologies of tradition and nostalgia, in all their reactionary and regressive formations. The question is one of understanding the relationship between place and travel, between the indigenous and exogenous, between the process of indigenization and the dynamics of globalization and localization. Of course, in our attempt to develop that analysis, we must recognize that we are not, by any means, all

'postmodern' in anything like the same way. It makes all the difference in the world whether one's migrancy or 'cosmopolitanism' is a matter of choice or necessity. We must also be attentive to the extent to which the multinationals themselves increasingly recognize the necessity to present themselves as having local, user-friendly identities, rather than appearing as faceless, external forces. Coca-Cola, for instance, has recently adopted a marketing slogan in which the company claims, 'we are not a multi-national, we are a multi-local' (quoted in Webster, 1989).

The dynamics of global localization are a very complex matter. Some contemporary commentators foresee a prospect of increasing privatism, localism and 'cultural tribalism' within our postmodern electronic global village. Manuel Castells, for instance, foresees the bleak prospect of 'the coexistence of the monopoly of messages by the big networks and the increasingly narrow codes of local micro-cultures, built around their parochial cable televisions' (Castells, 1983: 16). Thus, he argues, we must be attentive to the potentially negative aspects of the process whereby the spaces of cultural power are transformed into 'image flows' over which we have less and less control, while the space of meaning available to many of us is reduced to that of the micro-territories of our newly tribalized and localized communities. Small (or 'local') is not necessarily beautiful: it can sometimes simply mean powerless.

DECENTRING EURAM MAN: STILL THE CENTRE?

Kevin Robins and I have argued elsewhere (Morley and Robins, 1992) that recent EuroAmerican panics about the 'economic threat' posed by Japan and the 'Four Tigers' of the South-east Asia economy (Taiwan, Hong Kong, South Korea and Singapore) have to be understood in the broader context of the destabilization posed by these developments to the established correlation between the concepts of West/East and modern/pre-modern. To that extent, the supposed centrality of the West as the (necessary) cultural and geographical focus for the project of modernity (or indeed postmodernity) is thus put into question. One effect of all this is then to highlight both the extent to which the Occident/Orient binary is itself a temporal (as much as a geographical) division and conversely, the extent to which the 'temporal' division between modernity and the realm of the pre-modern (or the 'traditional') has long had a crucial geographical sub-text. As Sakai notes 'the West is not simply . . . a geographic category . . . [but rather] a name which always associates itself with those regions . . . that appear economically superior . . . [thus] . . . the historical predicate is translated into a geographical one and vice versa' (Sakai, 1988: 476–7). If history is not only temporal or chronological, but also spatial and relational (and if, conversely, our understanding of geography itself is never historically innocent) then it follows that our analysis of ideas of

postmodernity must consequently be informed by this kind of geo-
historical perspective, if we are to avoid the worst excesses of Eur-
Americocentrism.

Julien and Mercer (1988: reprinted here in Part V, below) note the irony
that while there has been much talk, in contemporary cultural theory of the
'end of representation', or even of the 'end of history' it is only much more
recently that the 'political possibilities of the end of ethnocentrism' (op.
cit.: 2) have begun to receive anything like a comparable degree of
attention. They go on to argue that the crucial project for postmodern
cultural theory, in relation to questions of 'race', ethnicity and ethnocen-
trism is not simply to now celebrate that which had previously been
deemed 'marginal', but rather to attempt to deconstruct 'the structures
that determine what is regarded as culturally marginal' (1988: 2). Their
central point is clearly expressed in their very title: 'De Margin and De
Centre' – as they argue, the crucial issue is 'to examine and undermine the
force of the binary relation that *produces* the marginal as a consequence of
the authority invested in the centre' (ibid.: 3; my emphasis).

Although 'postmodernism' is often presented as a description of some
supposedly universal condition, its definition is almost always constructed
within the terms of what is, in fact, an Anglo-European (or EurAmerican,
to use the Japanese term) provincialism – indeed Huyssen speaks of what
he calls the 'specifically American character of postmodernism' (1986:
190). Writing from a Latin American perspective, Beverley and Oviedo
(1993: 2) note that Octavio Paz claims that postmodernism is simply
another imported *grand récit* that does not fit Latin America, which, they
argue 'needs to produce its own forms of cultural periodisation' (op. cit.:
2). Their point is that the dominant conceptions of postmodernism (such as
Jameson's influential (1985) version) are almost always quite ethnocentric,
and tend to involve, as Ahmad argues 'a suppression of the multiplicity of
significant difference among and within both the advanced capitalist
countries and the imperialized formations' (Ahmad, 1987: 3; quoted in
Beverley and Oviedo, op. cit.: 4).

Of course, not only postmodernism, but modernism itself, properly
understood, can take many forms: Appiah (1992: 249–50) has argued
that, in certain African contexts, modernity has, in effect, been represented
by Catholicism; Bruner (1993) argues that postmodernism itself is best
understood as the specific form that modernity takes in Latin America.
Thus Calderon (1993: 54) speaks of how, in Latin America, the very
temporalities of the culture are incomplete, mixed and dependent
'because we live in incomplete and mixed times of premodernity, modern-
ity and postmodernity' (cf. Braudel 1984 for a theoretical model for the
analysis of simultaneous, differential temporalities), each of which is
linked historically to corresponding cultures that are, or were, in turn,
epicentres of power. Bruner (1993) points to the differentiated modes of

participation in modernity (and postmodernity), as between 'centre' and 'periphery': as he puts it, 'modernity cannot be read in the fashion of Marshall Berman (1983), as a singular collective experience . . . nor as variations of that same experience that, in the long run, will tend to converge' (42). He argues that modernity is necessarily a differentiated experience in the capitalist world. Moreover, Bruner argues, this world still 'has a centre, which radiates a zone of marginal and dependent peripheries' which, despite the complex 'postmodern' dynamics of heterogeneity and displacement, 'continue to be tied to the hegemonic centre' (52). To this extent, argues Bruner, Latin Americans are

> condemned to live in a world where all the images of modernity and modernism come to us from the outside and become obsolete before we are able to materialise them . . . In all fields of culture . . . the important modern cultural syntheses are first produced in the North and descend later to us . . . This is how it has happened . . . in the long run, with our very incorporation into modernity.
>
> (ibid.: 52–3)

Beverley and Oviedo (op. cit.) go beyond the 'billiard table' theory of cultural imperialism in which nations impact on each other while remaining, themselves untransformed, 'given' entities. Their point is that the United States itself, long the 'centre of centres' in the imperial world system, is itself being transformed by demographic and linguistic change: by the year 2000, the United States will be the third largest of the world's Hispanic nations. By the advent of the tricentennial of the American revolution (2076), a majority of the United States' population will be of African, Native American, Asian or Latin descent: to this extent the 'centre' itself is not simply being invaded, but transformed by its own erstwhile margins.

However, Richard (1993) takes the matter further, when she identifies the contradictory nature of postmodernism's 'heterological disposition' which, as she notes 'would appear to benefit the resurgence of all those cultural peripheries until now censured by European-western dominance and its universalist foundation in a self-centred representation' (160). She observes that postmodernism loudly proclaims its own role in 'decreeing the end of Eurocentrism', claiming that its own critique of modernity has 'damaged the superiority of the European model, by weakening its fantasies of domination, through the relativisation of absolutes and the delegitimization of universals' (160). Thus, it seems, the erstwhile subcultures, margins and peripheries are to be invited to be prominent parts of a new 'antiauthoritarian modulation of postmodernity, finally respectful of diversity' (160). Richard, however, is sceptical about this new tendency to the 'revaluation' of the 'subaltern', insofar as, despite the apparent altruism of the 'postmodern' gesture, these subaltern categories of the margins are still

'spoken for by postmodernity, without obliging the cultural institution [of the centre – DM] to loosen its discursive monopoly over the right to speak' (160). As Richard goes on to point out, 'celebrating difference as exotic festival . . . is not the same as giving the subject of this difference the right to negotiate its own conditions of discursive control . . . [and] the identity/ difference conflict [thus] continues to be arbitrated by the discursivity of the First World' (160–1). The simple catch, as Richard observes, is that 'even when their current hypothesis is that of de-centring', intellectuals of the most powerful imperial nations continue to be situated at the centre of the debate about decentring (161).

As she puts it elsewhere (Richard, 1987), just as it appears that the very heterogeneity of the cultures of Latin America, created out of the discontinuous, multiple and hybrid parts of the continent, are deemed to have prefigured the model now approved and legitimized by the term 'postmodernism' and 'Latin America finds itself in a privileged position, in the vanguard of what is seen as novel' (10), at the same moment, that 'privilege' is withdrawn. As Richard argues 'just as it appears that, for once, the Latin American periphery might have achieved the distinction of being postmodernist *avant la lettre* . . . postmodernism abolishes any privilege which such a position might offer . . . dismantles the distinction between centre and periphery and, in so doing, nullifies its significance' (10).

HETEROLOGICAL DISPOSITIONS AND GENDERED RELATIVISMS

In Richard's view, the positive political potential which many have seen in postmodernism's valuation of plurality, heterogeneity and hybridity is illusory, insofar as, no sooner are these 'differences' – sexual, political, racial, cultural – posited and valued, than they are subsumed into the meta-category of 'Otherness' – in which the particular identity of each element is subsumed into the similarity of their generalized 'alterity'. Richard's point is that, by this means, postmodernism, in fact, 'defends itself against the destabilising threat of the "Other" – by integrating it back into a framework which absorbs all differences and contradictions' (ibid.: 11). Most importantly of all, in Richard's view, despite the appearance of liberality, pluralism and relativism, postmodern theory itself remains firmly 'centred' in the metropolis, insofar as 'the centre, through claiming to be in disintegration, still operates as a centre: filing away any divergences into a system of codes whose meanings, both semantically and territorially, it continues to administer by exclusive right' (11).

In recent years, many of these issues have also given rise to significant debates within feminist theory. As Wolff (1988) notes, initially many feminists saw postmodern theories as liberating, insofar as they functioned

to destabilize the previously 'naturalized' dominance of a white, middle-class, EuroAmerican, masculine perspective, and to open up space for the articulation of the concerns of feminists and other, previously marginalized groups. However, as she notes, more recently, a number of feminists have come to doubt the positive potential of postmodernism, insofar as the insistent relativism of most postmodern theorizing functions not simply to destabilize masculine perspectives and discourses but, more radically, to undercut *all* claims to 'truth': those of feminists included.

In this connection Mascia Lees, Sharpe and Cohen (1989) observe the troubling coincidence that it is at the point when 'western white males – who traditionally have controlled the production of knowledge – can no longer define the truth' that their response is 'to conclude that there is not a truth to be discovered' (15; see also Shohat and Stam, 1994: 345–6, on this point).

Massey (1991) quotes Hartsock's argument that

> It seems highly suspicious that it is at this moment in history, when so many groups are engaged in 'nationalisms' which involve redefinitions of the marginalised Others, that doubt arises in the academy about the possibilities for a general theory which can describe the world, about historical 'progress'. Why is it, exactly at the moment when so many of us who have been silenced begin to demand the right to name ourselves, to act as subjects rather than objects of history, that just then, the concept of subjecthood becomes problematic . . . [that] . . . just when we are forming our own theories about the world, uncertainty emerges about whether the world can be adequately theorised?
>
> (33)

In the introduction to her (1990) collection of essays on feminist debates concerning postmodernism, Nicholson returns to the 'sociology of know-ledge' question (concerning the provenance of theories of postmodernity) posed both by Mascia Lees *et al.* and by Hartsock. In particular, Nicholson points out (6) that, put simply, postmodernism may perhaps be 'a theory whose time has come for men but not for women.' Nicholson herself highlights Di Stefano's (1990) argument that 'since men have had their Enlightenment, they can afford a sense of decentred self and a humbleness regarding the truth and cohence of their claims. On the other hand, for women to take on such a position is to weaken what is not yet strong' (Nicholson, op. cit.: 6).

In calculating the theoretical consequences of these kinds of perspectives, Lloyd (1984) offers a close parallel to the arguments of Appiah (1992) and Todorov (1984) concerning the necessity of distinguishing between, on the one hand, the regrettable historical facts concerning the dominance of white EuroAmerican perspectives on modernity and rationality and on the other hand, the value or desirability of modernity and rationality, *per*

se. Thus, Lloyd argues that just because the categories of reason, truth and logic have traditionally been assumed to be the exclusive preserves of masculinity, it does not follow that feminists must reject them wholesale: 'the claim that Reason is male need not at all involve sexual relativism about truth, or any suggestion that principles of logical thought valid for men do not hold also for female reasoners' (Lloyd 1984: 109; quoted in Di Stefano 1990: 72). Lloyd's point is then that, properly understood, feminist dissatisfaction with the historical 'maleness of reason' (ibid.) need lead to the repudiation of neither reason, nor of philosophy. Here our attention must shift, from the question of reason, to the necessarily linked question of alterity and the 'Other'.

HOW OTHER IS THE OTHER?

Todorov (1984) is concerned with what he characterizes as the 'dangers of excessive relativism' (374) in contemporary cultural theory. He concedes, readily, that 'excessive universalism' is a correlative danger, insofar as the 'so-called universality of many theoreticians of the past and present is nothing more nor less than unconscious ethnocentrism, the projection of their own characteristics on a grand scale', to the extent that what has thus been presented as 'universality' has, in fact, been a set of descriptions only appropriate to 'white males in a few European countries' (374). His central point, however, is that this failure should not lead us, by way of negative reaction, to simply abandon the 'very idea of shared humanity' between and across cultures, which he argues 'would be even more dangerous than ethnocentric universalism' (374). In this connection, Todorov notes Jan-Mohammed's comments on the dangers of 'Manichean allegory', in which 'a field of diverse yet interchangeable oppositions between white and black, good and evil, superiority and inferiority' (Jan-Mohammed, 1986: 82) are produced. In that kind of 'Manichean' writing, Todorov argues, 'racial others are either noble savages or filthy cows . . . [and] whether they are judged inferior (as by those who worship civilization) or superior (as by those who embrace primitivism) they are radically opposed to European whites' (Todorov op. cit.: 377; cf. Ahmad's account, 1994: 94–5, of his discomforting discovery, on reading Jameson (1986), that 'the man whom I had . . . from a physical distance, taken as a comrade was, in his own opinion, my civilizational other').

Suleri (1992), somewhat acidically, argues that if cultural criticism is to address the uses to which it puts the agency of alterity 'then it must . . . face the theoretical question that S. P. Mohanty (1989) succinctly formulates: "Just how other, we need to force ourselves to indicate, is the other?"' (Suleri, op. cit. 9). Suleri's argument here is that, while the decentring of colonial discourses in recent social theory has been an essential step forward, there are limits beyond which an articulation of

Otherness serves merely to 'ventriloquise the fact of cultural difference' (11). As she notes, a mere rehearsal of the proven manifestations of alterity finally leads to 'a theoretical repetitiveness that . . . entrenches rather than displaces the rigidity of the self/other binarism governing traditional discourse on colonialisation' (11). The problem, as she notes, is that the language of alterity can all too easily be read as 'a postmodern variant on the obsolescent idiom of romance: the very insistence on the centrality of difference as an unreadable entity can serve to obfuscate and indeed to sensationalise that which still remains to be read' (11). Her point is that the 'fallacy of the totality of otherness' is but the necessary complement to 'the fiction of complete empowerment both claimed by and accorded to colonial domination' (13). Similarly, she argues, while 'alteritism' begins as a strategy designed to destablize Eurocentric or Orientalist perspectives 'its indiscriminate reliance on the centrality of otherness tends to replicate what, in the context of imperialist discourse, was the familiar category of the exotic' (12).

Chow (1993) argues that, strangely enough, the first cousin of the Orientalist is the Maoist (in his or her latter-day 'subaltern' form, within American cultural studies) who 'contrary to the Orientalist disdain for contemporary native cultures of the non-West' tends towards a Third Worldist fantasy which 'turns all people from non-western cultures into a generalised "subaltern" that is then used to flog an equally generalised "West" ' (13). Chow's point is that this notion of 'subalternity', 'when construed strictly in terms of the *foreignness* of race, land and language, can blind us to political exploitation as easily as it can alert us to it' (9), not least because, most particularly, 'the representation of "the other" as such ignores . . . the class and intellectual hierarchies within these other cultures' (13).

In a similar vein Ahmad (1994) criticizes much recent work on 'alterity', insofar as it displays a tendency to set the issue up as a matter of 'civilisational, primordial, difference' (64). As he notes, from this kind of perspective, the 'whole history of western textualities, from Homer to Olivia Manning' then tends to be treated as a 'history of orientalist ontology', against which is posed a simple category of 'Third World' literature as 'prima facie the site of liberationist practice' (64). Against this kind of Manichean approach, Ahmad is concerned to defend a concept of difference 'written with a lower-case "d", as something local and empirically verifiable, not . . . [as]. . . any epistemological category or perennial ontological condition' (90). He is vehemently opposed to the tendency towards the representation of the colonized (or postcolonial) Other as an undifferentiated 'mass' (cf. Raymond Williams' oft-cited comment to the effect that 'there are no masses, only ways of seeing other people as masses').

In a similar vein, Todorov's (op. cit.) argument is that what he regards as

the over-relativistic tendency in contemporary postmodern cultural theory has too often led to the affirmation of the existence of incommunicability among cultures which, in his view, 'presupposes adherence to a racialist, apartheid-like set of beliefs, postulating as it does insurmountable discontinuity within the human species' (374). His own position is founded on the premise that the comprehension of Otherness is possible, in principle, precisely because Otherness is never radical, insofar as if we are 'separated by cultural differences, we are also united by a common human identity' (374; see also West (1994) for a perspective that also goes 'Beyond Eurocentrism and multi-culturalism').

For the same reasons, Todorov is impatient with the radical critique of Orientalism, insofar as that critique often seems to suppose 'that there is no such thing as a Japanese culture or Near Eastern traditions – or that this culture and their traditions are impossible to describe . . . [or that] . . . past attempts at describing them tell us about *nothing* except the observers' prejudices' (op. cit.: 374; original emphasis). His particular scorn is reserved for that kind of relativistic cultural analysis which approaches, as he puts it 'texts which speak of tortures and lynchings . . . with a critical apparatus that precludes any interrogation concerning their truth and values, or which combats the very idea of seeking truth and values' (379). Clearly, Todorov would, in this respect, have concurred with the late Bob Scholte, when he concluded that 'while we may never know the whole truth, and may not have the literary means to tell all that we think we know of truth . . . shouldn't we nevertheless, keep trying to tell it?' (Scholte, 1987: 39). Todorov concludes his argument by quoting, with approval, Appiah's salutary comment on W. E. B. Du Bois' work on racism, to the effect that Du Bois 'throughout his life. . .was concerned not just with the meaning of race but with the truth about it' (Appiah, 1986: 22). As Todorov wryly observes, it is only within a certain kind of sheltered academic institution that it is possible to flirt with the sceptical or relativistic suspension of all values and truth-claims, and getting away from the 'worshipping (of) dogmas as immutable truth' need not entail, by any means, the abandonment of 'the idea of truth itself' (Todorov, op. cit.: 379).

THERE ARE NO 'AFRICAN' TRUTHS

Appiah (1993), in his discussion of whether the 'post' in postcolonial is the same as that in postmodern, begins from the premise that the 'modernist characterisation of modernity must be challenged' (233). More specifically, he argues that Weber's characterization of modernity, as entailing the gradual but inevitable rationalization of the world, must be rejected, not least on empirical grounds. Thus, Appiah argues, what we see around us is hardly anything so grand as 'the triumph of Enlightenment Reason . . . but

rather what Weber mistook for that . . . the incorporation of all areas of the world . . . and of formerly "private" life into the money economy' (234). Appiah's point is that, according to Weber's theory, modernist rationalization should be accompanied both by a systematic process of secularization and by the decline of charisma – neither of which have occurred. As he notes, twentieth-century politics has been dominated by a series of charismatic leaders (Stalin, Hitler, Mao, etc.) and religions (not to mention nationalisms) are growing all over the world (not least in the United States).

Appiah's claim is that Weber got modernity fundamentally wrong; that 'the beginning of postmodern wisdom' (234) is to recognize that Weberian 'rationalization' has not occurred. In large part this is, according to Appiah, because Weber sets up 'tradition' and 'modernity' too simplistically, as mutually opposed, and necessarily mutually exclusive categories. For Appiah this binary, apart from anything else, simply fails to fit the facts of his own Ghanaian childhood, in which, he recalls, if 'I grew up . . . believing in constitutional democracy . . . I also knew that we owed respect to the chiefs of the Asante' (256). For Appiah, the benefits of modernity (cf. Ahmad's critique of Bhabha) were clear from an early age: 'by the time I was old enough to be *for* democracy, I knew we were also *for* development and modernisation; that this meant roads and hospitals and schools (as opposed to paths through the bush, and juju and ignorance)' (256). However, crucially, in terms of recent debates concerning identity and alterity, Appiah notes: 'None of [this – that is, the fruits of development] of course, did we take to rule out the proper pouring of libation to the ancestors In a slogan: I grew up believing in development *and* in preserving the best of our cultural heritage' (ibid.: 256–7).

At another point in his argument, Appiah offers another useful 'slogan': he simply advises that 'we must not overstate the distance from London to Lagos' (121). He is vehemently opposed both to 'what we might call "alteritism", the constitution and celebration of oneself as other' (251) and to being 'treated as an otherness-machine' (253; cf. Suleri, 1989) by a postmodern/postcolonialism which 'seems to demand of its Africa . . . [something]. . .all-too-close to what modernism . . . demanded of it' (Appiah, op. cit.: 253–4) – that is, a source of 'primitive authenticity'. Appiah's contention is, reasonably enough, that the 'role that Africa – like the rest of the Third World – plays for EuroAmerican postmodernism . . . must be distinguished from the role that postmodernism might play in the Third World' (254).

Appiah's concern is to get away from the 'postulation of a unitary Africa over against a monolithic West' – as an unproductive binarism of self and Other which, he suggests, is 'the last of the shibboleths of the modernisers that we must learn to live without' (251). Indeed, overcoming this binarism is, according to Appiah, crucial for all concerned, insofar as he suggests

that 'the question what is to *be* modern is one that Africans and westerners may ask together. And . . . neither of us will understand what modernity is, until we understand each other' (172).

The complement to Appiah's culture of binarist theories of alterity is an equally fierce opposition to all forms of postmodern relativism, whether in matters of ethics or of epistemology. In his sympathetic reading of Yambo Ouologuem's (1968) novel *Bound to Violence* (published in English in 1971), Appiah notes approvingly that, rather than 'make common cause with a relativism that might allow the horrifying new-old Africa of exploitation to be understood – legitimated – in its own local terms', the basis for Ouologuem's 'project of deligitimation, is very much *not* the postmodernist one: rather, it is grounded in an appeal to an ethical universal. . .an appeal to a certain simple respect for human suffering' (Appiah, op. cit.: 246).

Similarly, in matters of epistemology, in his discussion of 'Ethnophilosophy and its critics', Appiah is sympathetic to Wiredu's (1979) critique of the apostles of 'Négritude', in his essay 'How not to compare African thought with western thought'. In that essay Wiredu, as a believer in the universality of reason (cf. Gellner: 1992), argues that ideas that there is something particularly 'African' about superstitions concerning spirits, etc. are quite misguided – insofar as this, Appiah notes, 'derives from a failure to notice that these beliefs are very like beliefs widely held in the European past' (Appiah op. cit.: 164). As he notes, 'what is distinctive in African traditional thought is that it is traditional; there is nothing especially African about it' (167; see also Ahmad's (1994: 289–90) critique of Jameson's theory of Third World literature as 'national allegory', for a similar argument, concerning Jameson's failure to see the relevant parallels with the literature of medieval Europe). Appiah supports both Wiredu's analytic contention, that the 'traditional' mode of thought is not specifically African (or 'Third Worldist'), and his negative evaluation of its authoritarian dimensions, which, on Enlightenment grounds, Wiredu holds to be deleterious, in that they function to hold back 'development'. This process Wiredu defines as 'a continuing world-historical process in which all peoples, Western and non-Western alike, are engaged' (quoted in Appiah, op. cit.: 166), which is to be 'measured by the degree to which rational methods have penetrated through habits' (166). For Appiah, as for Wiredu himself, 'there are no African truths [cf. Chow, 1993: 6, on this – DM], only truths – some of them about Africa' (166).

In the course of his critique of the supposed radicalism of 'playfully' relativist, postmodern theories, Appiah, in passing, notes the 'boring logical point' (227) that Lyotard's (1988) influential account of postmodernity is, of course, self-contradictory, in that it offers a 'meta-narrative of the end of meta-narratives' which presupposes 'a grand narrative of legitimation of its own, in which justice turns out to reside, unexcitingly,

in the institutionalisation of pluralism' (Appiah, op. cit.: 227). In their *Ethnography and the Historical Imagination*, Comaroff and Comaroff (1992) press the critique of what they call this 'lamentable failure of the analytic imagination' (24) rather further, offering a 'pre-emptive counter-challenge to the deconstructive impulse of the 1990s' (24). Their central point is that the tendency of postmodern theories to assert that social reality is (increasingly) fluid, unstable and fragmentary tends precisely to take the form of a largely unsupported (except by reference to 'common sense experience') assertion, whereas in their view 'absence and disconnection, incoherence and disorder, have actually to be demonstrated. They can neither be presumed nor posited by negative induction' (24). In the absence of such demonstration, they argue that we should reject

> any postmodern suggestion that, because the world is experienced as ambiguous and incoherent, it must therefore lack all systematicity [cf. Marx on the distinction between the phenomenal forms of experience and the operative structures of real social relations – DM]; that, because social life seems episodic and inconsistent, it can have no regularity; that, because we do not see its invisible forms, society is formless; that nothing lies behind its broken, multifaceted surfaces.
>
> (23–4)

The epistemological warrant for the type of postmodern social theory which the Comaroffs are concerned to criticize is commonly taken to be granted by 'deconstructionism' in philosophy. The fundamental difficulty here, as I have argued elsewhere (Morley, forthcoming), is that this 'warrant' is premised on what can be argued to be a highly partial reading of the work of the doyen of deconstructionism, Jacques Derrida.

TEXTUALITY, RHETORIC AND THE VALUE OF TRUTH

In his account of 'deconstructionist' theory, Norris (1991) offers us an illuminating analysis, which is quite at odds with that, increasingly accepted, reading of the work of Derrida *et al.*, which seems to underpin so much 'postmodern' theorizing. In what follows, I simply offer a brief account of Norris's argument.

Norris notes that among literary critics Derrida has been read as providing a series of knock-down arguments against the truth-claims of philosophy – showing that philosophical talk of reason, truth, *a priori* concepts and so on is just a form of self-deluding rhetoric. Most notably, in the social sciences, Jurgen Habermas (1987) casts Derrida as just another postmodern 'enemy of reason' a 'latter-day sophist, a skilful rhetorician whose literary gifts are placed in the service of a wholesale Nietzschean-irrationalist creed' (Norris, op. cit.: 139), a betrayer of the 'unfinished

project' of modernity and enlightenment reason. As Norris notes, this is to equate Derrida's position with Baudrillard's argument that

> Enlightenment is a thing of the past, that criteria (or theory) is a dead (or dying) enterprise, and that, henceforth, there can be no question of separating truth from falsehood, knowledge from consensually warranted belief, or of distinguishing socio-political reality from its ideological appearances.

(148)

Thus, in the writings of 'post-analytical' philosophers such as Richard Rorty (1989), 'deconstruction' comes to figure as a handy cover-term for everything that points beyond the 'old dispensation of reason, knowledge and truth' (Norris, op. cit.: 149) and Derrida comes to play the role of the arch-debunker, a latter-day sophist who dances rings round the earnest philosophical seekers-after-truth. Hence the title of Rorty's well-known essay on Derrida, 'Philosophy as a kind of writing' (1978), where he urges that we should give up thinking of philosophy as a specialized activity of thought, with privileged claims on standards of argumentative validity and truth, and think of it simply as just another voice in the 'ongoing cultural conversation of mankind', but one with delusions of grandeur that can easily be cut down to size, by insisting on its own necessarily textual status and by pointing to the final 'contingency' of *all* specialist vocabularies, that of philosophy included.

Norris's point is not simply that Rorty has got Derrida wrong: has *mis*-read him, in Richards' (1960) terms. One could not intelligibly even raise questions of interpretative validity and truth if the postmodern pragmatist argument won out, and philosophy was reduced to the standing of just another form of writing (cf. Gellner's (1992) trenchant critique of 'postmodern relativism' from the point of view of what he calls 'enlightenment rationalist fundamentalism'). More directly, Norris argues, there is a crucial problem of logic with Rorty's argument. It is one thing to show that philosophical writing often mobilizes covert tropological figures and sublimated metaphors, and it is of considerable interest to analyse philosophical texts from this point of view. However, there is simply no good reason to support Rorty's assumption that the presence of 'figural' elements in a piece of argumentative writing necessarily impugns its theoretical adequacy or undercuts its philosophical truth claims.

Hence, Norris argues, the importance of respecting the distinctive philosophical valences of Derrida's work, and of not going along with the pseudo-deconstructivist, pan-textualist or 'levelling' view of philosophy as 'just another kind of writing'. Norris argues that Derrida's own mode of argument (in 'White mythology' (1974) for example) is far from endorsing the vulgar-deconstructionist view that all concepts come down to metaphors in the end, or that philosophy enjoys no distinctive status *vis-à-vis*

literature, rhetoric or the human sciences at large. Derrida's purpose, in 'White mythology', as Norris points out, is precisely to deny that we would simply turn the tables on philosophy (or reason) in the name of literature (as metaphor, rhetoric or style): not least because there is simply no possibility, for example, of discussing 'metaphor' without falling back on some concept of metaphor elaborated in advance by philosophic reason.

Norris argues that it is precisely Derrida's point here that one has said nothing of interest on the topics of metaphor, writing or philosophy if one takes it as read (usually on Neitzsche's authority) that all concepts are simply a species of disguised metaphor, or that all philosophical truth claims come down to a play of ungrounded figural tropes and displacements. Such an approach leaves aside Derrida's equally forceful argument that every thesis on the nature of metaphor is necessarily reached according to a set of strictly philosophical oppositions, whose logic cannot be grasped – much less 'deconstructed' – by adopting the postmodern/pragmatist line and simply declaring these oppositions obsolete or redundant. The fact that rhetoric is an omnipresent dimension of language does not, in itself, mean that we can (or should) therefore abandon all philosophical standards of argumentative rigour and consistency.

Norris is rightly concerned to counter the widespread, but erroneous, supposition that due regard for the textual (or 'writerly') aspects of our work – in itself a beneficial and rewarding perspective – necessarily 'writes off' (*sic*) the traditional concerns of philosophical discourse and reason. As Norris argues, deconstruction, properly understood, involves absolutely no slackening or suspension of the standards (logical consistency, conceptual rigour, modes of truth-conditional entailment etc.) that properly determine what shall count as a genuine or valid philosophical argument. After all, as Derrida himself put it, in his debate with John Searle:

> the value of truth (and all those values associated with it) is never contested or destroyed in my writings, but only re-inscribed . . . in more powerful, larger, more stratified contexts . . . and within those contexts . . . it should be possible to involve rules of competence, criteria of discussion and of consensus, of good faith, lucidity, rigour, criticism and pedagogy.
>
> (Derrida, quoted in Norris, op. cit.: 156)

POSTMODERNISM, ANTI-IMPERIALISM AND THE ENLIGHTENMENT PROJECT

In his (1994) critique of much postmodern and postcolonial theory, Ahmad is particularly critical of metropolitan critics whose 'radicalism' in his view, can be equated with the rejection of rationalism (or the 'Enlightenment project') itself. For them, as he puts it, it seems that 'any attempt to

know the world as a whole, or to hold that it is open to rational comprehension, let alone the desire to change it . . . [is] . . . to be dismissed as a contemptible attempt to construct "grand narratives" and "totalising knowledges" '. Ahmad's epistemological position is rather hard-edged, as can be judged from his stringent assertions that 'the more recently fashionable postmodernisms offer false knowledges of real facts' (35) and that 'postmodernism . . . is, in the most accurate sense of these words, repressive and bourgeois' (35–6). For Ahmad, it is the postmodernists' 'dismissal of class and reason as so many "essentialisms" ' which is reprehensible – not least because, as he rightly notes, this leads logically (and inevitably) to a methodologically individualist standpoint (with the decentred individual as the only possible locus of meaning) while, he notes, 'the well known postmodernist scepticism about the possibility of rational knowledge impels that same "individual" to maintain only an ironic relation with the world and its intelligibility' (36).

In a parallel argument, in his review ('Goodbye to the Enlightenment') of Bhabha (1994), Eagleton notes that, like many postmodernists, Bhabha is opposed on principle to fixed binary oppositions, such as that between colony and metropolis, or any version of 'us or them'. However, Eagleton argues that Bhabha's own analysis ultimately remains trapped in these same oppositions:

> On one side we have a set of unqualifiedly positive terms: the marginal, the ambivalent, the transitional and the indeterminate. Against these, line up a set of darkly demonised notions: unity, fixity, progress, consensus, stable selfhood. Like most postmodern writers, Bhabha romanticises the marginal and the transgressive, and can find almost nothing of value in unity, coherence or consensus.
>
> (Eagleton, 1994)

The point, as far as Eagleton is concerned, is that Bhabha's analysis remains stuck in the predictable and repetitive orthodoxies of 'the language of cultural difference' which displays an orthodoxy every bit as tenacious as the one it aims to critique. As Eagleton argues, 'post-colonial thought, too, has its rigorous exclusions, its canon, its compulsory key words', and within it one is 'allowed to talk about cultural differences, but not – or not much – about economic exploitation' (Eagleton, op. cit.).

Ahmad's own critique of Bhabha's postmodernist claims, in his earlier *Nation and Narration* (Bhabha, 1990) is, in part, founded on the simple but telling observation that Bhabha himself lives in just those 'material conditions of *post* modernity which preserve the benefits of modernity as the very ground from which judgements on the past – of this *post* – may be delivered.' In Ahmad's view, 'it takes a very modern, very affluent . . . kind of intellectual to debunk both the idea of "progress" . . . not to speak of "modernity" itself, as mere "rationalisations" of "authoritarian" ten-

dencies within cultures' (1994: 68). Ahmad's point is that by way of contrast, 'those who live . . . in places where a majority of the population has been denied access to . . . [the] . . . benefits of "modernity" . . . can hardly afford [literally – DM] the terms of such thought' (68–9).

Ahmad is concerned with the 'sociology of knowledge' of postcolonial theory itself, which he provocatively characterizes as 'an upper-class émigré phenomenon, at odds with its own class origin and metropolitan location' (op. cit.: 210), which in his view, tends to the overdramatization of the 'fate of exile', often misrepresenting 'personal preference as fate ordained by repression' (209). One of the dangers Ahmad focuses on concerns the extent to which, as he puts it, the 'East, reborn and greatly expanded now as a "Third World". . . seems to have become, for many postmodern theorists again, a *career* – even for the "Oriental" this time, and within the "Occident" too' (94, original emphasis; cf. also Chow, 1993: 15: 'Even though these descendants of the Maoists [American 'subalternists' – DM] may be quick to point out the exploitativeness of Benjamin Disraeli's "The East is a Career", they remain blind to their own exploitativeness, as they make "The East" their career').

However, beyond these contentious and perhaps unnecessarily personalized barbs, Ahmad has one very serious concern in mind. It is not the simple disingenuity of the upper-class émigré that Ahmad is troubled by, when such writers focus exclusively on their exile status, and disavow their own personal class origins. The further issue concerns the effect of this disavowal, in distorting subsequent analytic work, from which the issue of class differences then tends, unsurprisingly, to be evacuated. Thus, Ahmad is acerbic about what he describes as 'the issue of post-modern, upper-class migrancy' where the 'migrant in question comes from a *nation* which is subordinated in the imperialist system of inter-state relationships but, simultaneously, from the *class* . . . which is the dominant [one] within that nation . . . [making] it possible for the migrant to arrive in the metropolitan country to join . . . the professional middle strata . . . [and] to forge a . . . rhetoric which submerges the class question and speaks of migrancy as an ontological condition' (1994: 12–13). We are back, once more, with the question of reason, alterity and the Other – and with the crucial question as to whether difference is to be (implicitly or explicitly) written with a small or a large 'D' – because the suppression of internal class difference is, in Ahmad's view, the correlative of Manichean theories of alterity. Ahmad's point is that, too often in contemporary cultural theory, 'the whole of the "Third World", with all its classes singularised into an oppositionality' is idealized as 'the site, simultaneously, of alterity and authenticity' (33). Thus, he notes that ideas of 'cultural nationalism' frequently resonate with concepts of an autonomous/indigenous 'authentic' tradition, and that in many analyses of this sort, the tradition/modernity binary of the early 'modernization' theorists (cf. Lerner, 1964) is simply

inverted, in an indigenist direction, so that tradition is then held to be superior to modernity, for the Third World, and the most obscurantist positions can then be defended in the name of cultural nationalism.

Ahmad is centrally concerned to deny that nationalism is 'some unitary thing, always progressive or always retrograde' (ibid.: 11). His criticisms are most pointedly aimed at what he describes as the patently postmodernist way of debunking *all* efforts to speak of origins, collectivities . . . [or] . . . determinate historical projects'. This tendency he views as having the disabling consequence of making critics operating from such premises incapable of distinguishing 'between the progressive and retrograde forms of nationalism' so that 'what gets debunked, rather, is nationalism, as such' (38). This is an outcome which Ahmad abhors, precisely because of the fact that, as far as he is concerned, given that 'for human collectivities in the backward zones of capital. . .all relationships with imperialism pass through their own nation-states,' the national struggle remains crucial, since 'there is simply no way of breaking out of that imperial dominance without struggling for. . .a revolutionary restructuring of one's own nation-state' (ibid.: 11; cf. Ignatieff, 1994: 'Introduction'). Ahmad is most concerned to avoid what he describes as 'monolithic attitudes towards the issue of nationalism' (41), whether those are attitudes of unconditional celebration or contemptuous dismissal: his own interest is in a conjunctural analysis of the differential functions of nationalism, in various historical circumstances (cf. Mattelart, 1979).

Brennan (1989) offers a parallel analysis to that of Ahmad, in this respect, drawing on Gramsci's argument that colonization is not simply an international but always also a domestic matter. In this he supports Mattelart's (1979) argument that

> Imperialism can only act when it is an integral part of the movement of a country's own national social forces. In other words, external forces can only appear and exercise their deleterious activities in each nation through mediation with internal forces . . . To pose the problem of imperialism therefore also means posing the problem of the classes which act as its relays in these different nations. This also means [that] . . . it is urgent to analyse the notion of *national culture*.
>
> (Mattelart, 1979: 58–9)

It is for precisely this reason, as Brennan notes, that Gramsci argued that the 'international situation has to be considered in its national aspect' (quoted in Brennan, 1989: 13).

I shall return to the question of nationalism, and of its resurgence as a troubling feature of our postmodern times, in the final section of this chapter. In that section I shall argue that what we may see, in the future of EurAm, at least, resembles not so much the 'postmodern culture of fun' (Mestrovic, 1994), as something rather darker, something indeed

associated with Europe's own 'Dark Ages'. However, before arguing that the future of EurAm may be going backwards, I want to return to some of the implications of cross-referencing the temporal and spatial perspectives which I outlined at the beginning of my argument. I noted earlier, in relation to the recent 'Japan panic' in the West, that modernity (or perhaps postmodernity) may perhaps in future, be located more in the Pacific than the Atlantic: a prospect which fundamentally undermines the long-established equation of the Occident with modernity, progress and the keys to the world's future. I now want to explore the extent to which, viewed in the *longue durée* of historical development, the West's association with (and dominance over the definition of) modernity (as constituted by reason, science and progress), amounts precisely to no more than a historical phenomenon (if one of relatively long duration) insofar as, up to about the fifteenth century, the Occident can be seen to have lagged far behind the Orient, in many respects. Put more plainly, this is to argue that the association between the Occident and modernity has to be viewed as radically contingent, in historical terms. If there is no necessary relation between these terms, then it follows that to oppose either one of them it is not necessary to oppose the other.

FROM TECHNO-ORIENTALISM TO ORIENTAL PROTO MODERNISM

I have argued at length elsewhere (see ch. 10 of Morley and Robins, forthcoming) that if postmodernity is to be understood by way of contrast to the modernity that it supersedes, the problem is that many of our assumptions about the history of that modernity itself are ludicrously EurAmericocentric. In this connection, Wolf notes that

> many of us . . . grew up believing that . . . [the] West has a genealogy, according to which ancient Greece begat Rome, Rome begat Christian Europe, Christian Europe begat the Renaissance, the Renaissance the Enlightenment, the Enlightenment political democracy and the industrial revolution. Industry, crossed with democracy, in turn yielded the United States, embodying the rights to life, liberty and the pursuit of happiness.
>
> (Wolf, 1982: 5)

Nowadays of course, a playful postmodernism is itself seen to transcend the dismal travails of modernity itself. The main burden of the work of historians such as Wolf (1982) and Wallerstein (1974) is to dislodge the narcissism of this traditional perspective, with its overemphasis on the internal, self-generating narrative of the West, and to re-situate it within the broader context of world history (cf. also Amin, 1989). The general thrust of this argument is that we must get away, finally, both from this

emphasis on EuroAmerican 'exceptionalism' and from its shadow – 'ethnohistory' – which, as Wolf observes, perhaps 'has been so called to separate it from "real" history, the study of the supposedly civilized' (Wolf, op. cit.: 19). In fact, as Wolf notes, 'the more ethnohistory we know the more clearly "their" history and "our" history emerge as part of the same story' (ibid.: 19). As he puts it, in a formulation parallel to that of Appiah (1993), 'there can be no "Black history" apart from "White history" – and of course, *vice versa*' (cf. also Davis, 1992).

In fact, within the now largely discredited field of 'Orientalism', a number of authors, such as Hourani (1992) and Hodgson (1993), offer insights similar to those of Wolf and Wallerstein. For example, it is to Hodgson (1974: xvii) that we owe the characterization of the traditional 'Mercator' projection of the map of the world, centred as it is on Europe (and thus systematically distorting our image of the Southern Hemisphere) as what he called the 'Jim Crow projection' of the world. Hodgson's project, as Burke notes, in his 'Introduction' to Hodgson's *Rethinking World History* (1993), was precisely to 'resituate the history of the West in a global context, and in the process, unhook it from Eurocentric teleologies (or what we might call, post-Foucault, the European master discourse on itself)' (in Hodgson, 1993: xii). The issue is how to think of modernity, not so much as specifically or *necessarily* 'European' (*contra* Weber's analysis in *The Protestant Ethic and the Spirit of Capitalism*, 1958) but only contingently so. Hodgson is concerned to avoid, in Burke's phrase, the kind of 'Westernism' that gives us 'the history of the West as the story of freedom and rationality . . . [and] . . . the history of the East (pick an East, any East) as the story of despotism and cultural stasis' (Burke, in Hodgson, op. cit.: xv). In Hodgson's analysis, Islam was, for long, the vastly richer and more successful Other against which the West defined itself, and it was not until around 1500 that western Europe reached the cultural level of the major Oriental civilizations. Thus, Burke notes (cf. Wolf, op. cit.) that the conventional picture of modernity, as an 'ascending curve which runs from ancient Greece to the Renaissance, to modern times' is but an optical illusion (ibid.: xix). In fact, Hodgson argues that, for most of recorded history, Europe was actually an insignificant outpost of mainland Asia. Indeed, his argument is that if the history of 'civilization' is to have a 'centre', then, from a world historical point of view, that centre is Asia. Moreover, as Burke points out in relation to the question of modernity itself, for Hodgson

> the Renaissance did not inaugurate modernity. Instead, it brought Europe up to the cultural level of the other major civilisations of the Oikoumene ('the world of settled agriculture, cities and high culture', Hourani, 1992: 3). It did so . . . by assimilating the advances of other Asian civilisations. The list of inventions which developed elsewhere and diffused subsequently to Europe is very long.
>
> (Burke, in Hodgson, op. cit.: xix)

It is, indeed, a very long list, and one of some consequence, given both the centrality of ideas of technological advance to our conception of 'progress', 'civilization' and 'modernity', and the taken-for-granted assumption that technology is largely a (if not *the*) key sphere of western superiority (but cf. the argument below, for the significance of Japan's recent 're-positioning' as the key site of current technological advancement).

Claxton (1994) observes that the English philosopher, Francis Bacon (1561–1626), selected three innovations – paper and printing, gunpowder and the magnetic compass – which had done more, he thought, than anything else to transform the world. Claxton notes that Bacon considered the origin of all these inventions to be 'obscure' and died without knowing that they were all, in fact, originally Chinese (Claxton, 1994: 27). The central point in all this is, of course, that the European Renaissance, far from being self-generated, drew very heavily on Arab cultures, not least because the European rediscovery of classical Greek knowledge in the Renaissance was based on Arabic translations, which had been, through Europe's 'Dark Ages', their principal repository (cf. Brown, 1991, on the role of the Byzantine empire in this respect). The recapture by Christian Spain of Toledo (in 1085) and of Cordoba (in 1236), two leading Muslim centres of learning, gave Christian Europe access to Muslim scientific knowledge and the Arabic system of numeration. Thus, Claxton argues, far from being something *inherently* western, 'what we call science arose as a result of new methods of experiment, observation and measurement, which were introduced into Europe by the Arabs . . . [modern] science is the most momentous contribution of the Islamic civilizations' (Claxton, op. cit.: 18).

Indeed, Claxton quotes Singer's *History of Technology* to the effect that it was in fact 'largely by imitation, and, in the end by improvement of the techniques and models that had come from or through the Near East, that the products of the West ultimately rose to eminence' (quoted in Claxton, ibid.: 18). For our purposes, one of the most interesting points is that, if this is seen to be so, then the relation of European to Muslim science and technology in the early modern period (in which inferiority rose eventually to superiority, first through imitation and later through improvement on models copied) can be seen to be in close parallel with the relation of Japanese to EuroAmerican technologies in the late twentieth century, in which the originally inferior 'imitators' finally surpass their erstwhile 'masters' (cf. Morita, 1986, for a detailed history of this 'transformation' (*sic*), in the case of Sony).

If the future is to be technological and the Orient is fast colonizing the realm of high technology (cf. Singapore as the first 'fully wired', postmodern city-state) then it must follow that the future will be Oriental too. What of the future for EurAm? As has been widely reported, the last few

years have seen the United States fundamentally rethinking its traditional 'Atlantic' orientation. First we saw the process of the gradual deconstruction of the United States' 'special relationship' with Britain; recently we have seen the rise of a more generalized conflictual relationship between the United States and the European Community as a whole (*vide* the conflicts between the United States and France in the last round of GATT negotiations and the 'teeth-gritting' nature of the EuroAmerican alliance's contortions throughout the crisis in Bosnia). Now the United States shows increasing signs of seeing its own economic future as focused on Pacific rather than Atlantic trade agreements. Perhaps President Roosevelt's pronunciation of the dawn of the 'Pacific era', made originally in 1903, is finally coming to fruition: 'The Mediterranean era died with the discovery of America, the Atlantic era is now at the height of its development and must soon exhaust the resources at its command; the Pacific era, destined to be the greatest of all, is just at its dawn' (quoted in Knightley, 1991). If so, the Parisian origins of much postmodern theory notwithstanding, what are the prospects for Europe itself, in the era of postmodernity?

POSTMODERNITY IN EURAM: THE RETURN OF THE DARK AGES?

The French historian, Alain Minc, argues that what the future of Europe offers is something rather similar to the experience of its own 'Middle Ages'. We are, in his view, going back, with the contemporary collapse of the nation-state, towards a situation of 'a lasting, semi-stabilised disorder, which feeds on itself' (Minc, 1994). This point is amplified by the British historian, Norman Stone, who similarly claims that we may well be heading towards a situation comparable to that of England during the 'Wars of the Roses' in the fifteenth century, where the dominant form of sociality was not so much nationalism as tribalism (Stone, 1994; cf. Maffesoli, 1994). Stone further offers an analogy between the current status of the European Commission and that of the papacy in the fifteenth century – as a 'shadowy sovereign body which doesn't have much in the way of teeth; which is the ultimate law-making body, but where, in fact, there are huge areas simply without the law' (Stone, op. cit.), as the nation-state disintegrates, both from above and from below.

Minc makes much the same point, when he argues that we are now well beyond the Foucaultian nightmare of the 'all-seeing eye of the state' or the 'long arm of the law'. The emergence of 'grey zones', which are effectively 'no-go' areas for agencies of social control, places where legislative power no longer exists, again parallels the experience of the Middle Ages, in his view. As he puts it, perhaps rather melodramatically, 'when you go into a "difficult" suburb of Paris today (or of Birmingham for that matter) – there is no more enforcement of social order – no more policemen, social

workers – the only form of social organisation comes from the drug economy. They are, of course, small areas, but they did not exist five years ago' (Minc, op. cit.). Many North American cities perhaps still run a little ahead of Europe in this respect.

The point is that if, for three centuries, in Europe, the state has been established to create order, today we are seeing areas developing without any kind of order or state power. Minc's view in this respect, is again reinforced by Stone:

> The writ of the central state, which had been growing [in Europe – DM] since the time of Absolutism in the 16th century, has now ceased to run in parts of many countries . . . You can see tower block estates, for example, in many European cities, which are in fact run by drug barons. In those areas, you simply have to come to terms with the local robber baron . . . and in that sense, you are then back in something very like the experience of the Middle Ages.
>
> (Stone, op. cit.)

Recently both Enzensberger (1994) and Mestrovic (1994) have also offered analyses of the tendencies towards societal disintegration with which Minc and Stone are concerned. Enzensberger offers a cogent analysis of the ways in which the end of the Cold War has in fact resulted in a new era of large numbers of uncontrollable 'civil wars', large and small. Similarly, Ignatieff (1994) argues that, in the post-Cold War period, when large sections of the world no longer come within any clearly defined sphere of imperial, or great power influence, 'huge sections of the world's population have won the right of self-determination on the cruellest possible terms – they have been simply left to fend for themselves' (Ignatieff, 1994: 8).

Both Enzensberger and Ignatieff seem to feel that we may be moving towards something unpleasantly similar to the Hobbesian 'war of all against all'. In this situation, conflicts tend to perpetually subdivide those who had previously been able to exist peaceably as neighbours (under a system of what Ignatieff, 1994, calls 'civic nationalism') into enemies (with the terms of 'ethnic nationalism'). Enzensberger offers the example of the civil war in Afghanistan, and argues that

> as long as the country was occupied by Soviet troups the situation invited interpretation along Cold War lines: Moscow was supporting its surrogates, the West the Mujahedin. On the surface it was all about national liberation, resistance to the foreigners, the oppressors, the unbelievers. But no sooner had the occupiers been driven off then the real civil war broke out. Nothing remained of the ideological shell . . . the war of everyone against everyone else took its course . . . what remains is the armed mob.
>
> (1994: 17)

Recent images of the conflicts in Somalia and in Rwanda would seem, unfortunately, to bear out many of Enzensberger's gloomy prognostications.

In precisely this vein, in his analysis of the conflicts in ex-Yugoslavia, Ignatieff argues that 'Ethnic nationalism [has] delivered the ordinary people of the Balkans straight back to the pre-political state of nature where, as Hobbes predicted, life is nasty, brutish and short' (op. cit.: 30). Mestrovic (1994) offers, as his subtitle has it, a disturbing analysis of the 'confluence of postmodernism and postcommunism' in eastern Europe, as presaging the potential 'Balkanization of the West'. He defines 'Balkanization' as a process similar to that which concerns Enzensberger (op. cit.), as 'the breaking up of a unit into increasingly smaller units that are hostile to each other' but adds immediately, lest his emphasis be misunderstood, that 'there is no good reason to understand Balkanization literally, as something that must apply only to the Balkans' (ix). Mestrovic notes that the term 'Balkanization' was, of course, invented 'to denote *those people* in the Balkans who seem likely to slaughter each other' as opposed to 'the civilised Americans, French and British' (viii, original emphasis). However, his own analysis leads him to conclude that this is no matter of there being some special tendency towards bloodlust and hatred, on the part of the people who happen to inhabit that particular geographical region (which would be, as Ignatieff observes (1994: 15), to 'make excuses for ourselves . . . [by dismissing] . . . the Balkans as a sub-rational zone of intractable fanaticism'). Rather, in Mestrovic's view, the present conflict in ex-Yugoslavia represents the beginning of a broader process of the unravelling or 'Balkanization' of both the former Soviet Union and, potentially, many parts of Europe. So much, as Mestrovic observes, for the 'postmodern culture of fun' as opposed to the 'grim realities of postcommunism' (op. cit.: 1).

Descriptively, Ignatieff's (op. cit.) account of life in ex-Yugoslavia conforms depressingly well to what might, at first sight, appear to be the rather over-pessimistic views of Minc and Stone (quoted earlier). Thus, for example, Ignatieff notes that, in the Balkans, what had been one of the most civilized parts of Europe (particularly in terms of multiculturalism: for a novelistic account see Andric, 1993) has now returned to the barbarism of the Middle Ages, where

> such law and order as there is, is administered by warlords. There is little gasoline, so the villages have returned to the era before the motor car. Everyone goes about on foot . . . Late 20th-century nationalism has delivered one part of Europe back to the time before the nation state, to the chaos of late feudal civil war.
>
> (op. cit.: 34)

Indeed, Ignatieff's own experience would seem to substantiate Minc and Stone's speculations concerning the return of medieval figures, roles and institutions. Thus, Ignatieff notes that

> Large portions of the former Yugoslavia are now ruled by figures that have not been seen in Europe since late medieval times: the warlords. They appear wherever the nation state disintegrates . . . in the Lebanon, Somalia, Northern India, Armenia, Georgia, Ossetia, Cambodia . . . With their carphones, faxes and exquisite personal weaponry, they look postmodern, but the reality is pure early medieval.
>
> <div align="right">(ibid.: 28)</div>

What is distinctive about Ignatieff's analysis is that, beyond these descriptive or generalized observations, he also offers an account of the causal dynamics which drive the processes of 'Balkanization' and ethnic hatred. He offers an account of this 'slide into hatred', as neither an expression of some innate human tendency to abhor or reject 'Otherness', nor as an irrational aberration. Rather, for Ignatieff, what we see here is the all too understandable response of frightened people to the collapse of the framework of social order which had previously been sustained, however partially, by the nation-state. The situation is perhaps not too dissimilar from that which has long confronted many young blacks in the ghettos of Los Angeles, for whom it is often not so much a matter of choosing to wear the colours of the Cripps because they hate the Bloods (or *vice versa*), but rather a matter of it being too dangerous to have no allies in a 'war-zone' and of therefore being forced into choosing sides. For any one individual, this is, of course, a fear-driven, defensive strategy. However, as Durkheim (1964) observed, social processes operate behind the backs of individuals, and the overall, if unintended, social effect of this formation of defensive allegiances is, of course, to reinforce the need for others to do the same. Thus the vicious cycle of fear becomes self-sustaining.

In the Balkan situation, Ignatieff argues that what we see now as 'ethnic hatred' is largely the result of 'the terror that arises when legitimate authority disintegrates' (ibid.: 16). In his account, what happened was that 'in the fear and panic which swept the ruins of the communist states, people began to ask: so who will protect me now?' (ibid.: 6). In Ignatieff's analysis, 'nationalism' and 'ethnic belonging' are seen to be persuasive precisely because they offer 'protection'. As Ignatieff puts it

> The warlord offers protection . . . a solution. He tells his people: if we cannot trust our neighbours, let us rid ourselves of them . . . The logic of ethnic cleansing is not just motivated by nationalist hatred. 'Cleansing' is the warlord's coldly rational solution to the war of all against all. Rid yourself of your neighbours, the warlord says, and you no longer have to

fear them. Live among your own, and you can live in peace, with me and my boys to protect you.

(ibid.: 30)

In this, perhaps, we see some of the features of the darker side of postmodernity, where alterity and heterogeneity are less cause for celebration than for fear. It is beyond dispute that the history of the 'Enlightenment project of Modernity' (cf. Habermas, 1987) is riddled with EurAmericocentrism, and with class, gender and racial biases. If, however, as I have argued earlier, the relation of the project to its geo-historical and social origins is a contingent one, then the exposure of those origins, and the critique of these disabling biases, should perhaps lead us not to abandon the project, but rather to attempt to pursue it more tenaciously, elsewhere, even if its days are numbered in EurAm.

NOTE

Some sections of my argument here have also appeared, in somewhat different form, elsewhere. Thus, parts of 'The geography of postmodernism' and of 'The foreign, the cosmopolitan and the local' also appear in my earlier 'Postmodernism: the highest stage of cultural imperialism?', in M. Perryman (ed.) *Altered States: Postmodernism Politics, Culture*, Lawrence & Wishart, London, 1994. Parts of the section on 'Textuality, rhetoric and the value of truth' also appear in my 'Theoretical orthodoxies: textualism, constructivism and the "new ethnography" in cultural studies', in M. Ferguson and P. Golding (eds) *Beyond Cultural Studies*, Sage, London, forthcoming.

REFERENCES

Ahmad, A. (1987) 'Jameson's rhetoric on otherness and the national allegory', *Social Text* 17.
――― (1994) *In Theory: Classes, Nations, Literatures*, London, Verso.
Aksoy, A. and Robins, K. (1992) 'Hollywood for the 21st century: global competition for critical mass in image markets', *Cambridge Journal of Economics* 16 (1), 1–22.
Amin, S. (1989) *Eurocentrism*, London, Zed Books.
Andric, I. (1993) *The Bridge Over the Drina*, New York, Harvill.
Appadurai, A. (1990) 'Disjuncture and difference in the global economy', in M. Featherstone (ed.) *Global Culture*, London, Sage, 295–310.
――― (1988) 'Putting hierarchy in its place', *Cultural Anthropology* 3 (1), 36–49.
Appiah, K.A. (1986) 'The uncompleted argument: Du Bois and the illusion of race', in H.L. Gates, Jr (ed.) *'Race', Writing and Difference*, Chicago, University of Chicago Press, 21–38.
――― (1993) *In My Father's House: What Does it Mean to Be an African Today?*, London, Methuen.

Berman, M. (1983) *All That Is Solid Melts into Air: The Experience of Modernity*, London, Verso.
Beverley, J. and Oviedo, J. (1993) 'Introduction', in *Boundary 2*, 20 (3), *Special Issue* on 'The postmodernism debate in Latin America', Duke University Press, 1–18.
Bhabha, H. (1983) 'The Other question', *Screen* 24 (6).
—— (ed.) (1990) *Nation and Narration*, London, Routledge.
—— (1994) *The Location of Culture*, London, Routledge.
Braudel, F. (1984) *The Perspective of the World (Civilization and Capitalism*, vol. 3), New York, Harper & Row.
Brennan, T. (1989) 'Cosmopolitans and celebrities', in *Race and Class* 31 (1), 1–19.
Brown, P. (1991) *The World of Late Antiquity*, London, Thames & Hudson.
Bruner, J. (1993) 'Notes on modernity and postmodernity in Latin American culture', *Boundary 2*, 20, 34–55.
Burke, E. (1993) 'Introduction: Marshall G.S. Hodgson and World History', in M.G.S. Hodgson (1993), *Rethinking World History: Essays on Europe, Islam and World History*, Cambridge, Cambridge University Press.
Burroughs, W. (1983) 'What Washington? What Orders?', in *The Adding Machine: Collected Essays*, New York, Seaver Publications.
Calderon, F. (1993) 'Latin American identity and mixed temporalities: or, How to be postmodern and Indian at the same time', *Boundary 2*, 20 (3), 55–65.
Castells, M. (1983) 'Crisis, planning and the quality of life: managing the new historical relationships between space and society', *Environment and Planning (D): Society and Space* 1 (1).
Chow, R. (1993) *Writing Diaspora*, Bloomington, Indiana University Press.
Claxton, M. (1994) *Culture and Development: A Study*, Paris, Unesco.
Clifford, J. (1992) 'Travelling Cultures', in L. Grossberg, C. Nelson and L. Treichler (eds) *Cultural Studies*, London, Routledge, 96–112.
Comaroff, J. and Comaroff, J. (1992) *Ethnography and the Historical Imagination*, Boulder, Colorado, Westview Press.
Davis, J. (1992) 'History and the people without Europe', in K. Hastrup (ed.) *Other Histories*, London, Routledge.
Derrida, J. (1974) 'White Mythology', *New Literary History* 6 (1), 7–74.
Di Stefano, C. (1990) 'Dilemmas of difference: feminism, modernity and postmodernism', in L. Nicholson (ed.) *Feminism/Postmodernism*, London, Routledge, 63–83.
Durkheim, E. (1964) *The Rules of Sociological Method*, New York, Free Press.
Eagleton T. (1994) 'Goodbye to the Enlightenment', *Guardian*, 5 May.
Enzensberger, H. (1994) *Civil War*, London, Granta Books.
Flores, E. (1988) 'Mass media and the cultural identity of the Puerto Rican people', Paper to International Association of Mass Communications Research Conference, Barcelona, July 1988.
Foucault, M. (1986) 'Of other spaces', *Diacritics* 16.
Fukuyama, F. (1992) *The End of History and the Last Man*, London, Penguin.
Galleano, E. (1993) Interviewed by Miguel Bonasso in *The Last Cafe*, Tx: Channel 4, London, 12 April.
Gellner, E. (1992) *Postmodernism, Reason and Religion*, London, Routledge.
Gillespie, M. (1989) 'Technology and tradition', *Cultural Studies* 3 (2); see also her (1995) *Television, Ethnicity and Cultural Change*, London, Routledge.
Habermas, J. (1987) *The Philosophical Discourse of Modernity*, Cambridge, Polity Press.

Hall, S. (1990) 'Cultural identity and diaspora', in J. Rutherford (ed.) *Identity: Community, Culture, Difference*, London, Lawrence & Wishart, 222–37.
—— (1992) in discussion with James Clifford, printed as Appendix to Clifford, 1992, op. cit.
Hannerz, U. (1991) 'Cosmopolitans and locals in world culture', in M. Featherstone (ed.) *Global Culture*, London, Sage, 237–53.
Hartsock, N. (1987) 'Rethinking modernism', *Cultural Critique* 7.
Hebdige, D. (1988) 'Towards a cartography of taste' in *Hiding in the Light*, London, Comedia/Routledge.
Hodgson, M.G.S. (1974) 'In the centre of the map: nations see themselves as the hub of history', reprinted as ch. 2 in Hodgson (1993), below.
—— (1993) *Rethinking World History: Essays on Europe, Islam and World History*, Cambridge, Cambridge University Press.
Hourani, A. (1992) *Islam in European Thought*, Cambridge, Cambridge University Press.
Huyssen, A. (1986) 'Mass culture as woman: modernism's Other', in T. Modleski (ed.) *Studies in Entertainment*, Bloomington, Indiana University Press, 188–208.
Ignatieff, M. (1994) *Blood and Belonging: Journeys into the New Nationalism*, London, Vintage.
Jameson, F. (1985) 'Postmodernism and consumer society', in H. Foster (ed.) *Postmodern Culture*, London, Pluto Press, 111–25.
—— (1986) 'Third World literature in the era of multinational capital', *Social Text* (Fall).
JanMohamed, A. (1986) 'The economy of Manichean allegory: the function of racial difference in colonialist literature', in H.L. Gates, Jr (ed.) *'Race', Writing and Difference*, Chicago, University of Chicago Press, 78–107.
Julien, I. and Mercer, K. (1988) 'De Margin and De Centre', *Screen* 30 (1), 1–10.
King, A. (1991) 'Introduction' to A. King (ed.) *Culture, Globalization and the World System*, London: Macmillan.
Knightley, P. (1991) 'Spider's web across the ocean', *Guardian Weekly*, (17 March).
Lenin, V. I. (1970) *Imperialism, the Highest Stage of Capitalism*, Moscow, Progress Publishers.
Lerner, D. (1964) *The Passing of Traditional Society*, Glencoe, Illinois, Free Press.
Lloyd, G. (1984) *The Man of Reason: 'Male' and 'Female' in Western Philosophy*, Minneapolis, University of Minnesota Press.
Lyotard, J.-F. (1988) *The Postmodern Condition*, Manchester, Manchester University Press.
McLuhan, M. (1964) *Understanding Media*, London, Routledge.
Maffesoli, M. (1994) *The Time of the Tribes*, London, Sage.
Mascia Lees, F., Sharpe, P. and Cohen, C. (1989) 'The postmodernist turn in anthropology: cautions from a feminist perspective', *Signs* 15 (1).
Massey, D. (1991) 'A Global Sense of Place', *Marxism Today* (June).
—— (1992) 'A place called home', *New Formations* 17.
Mattelart, A. (1979) 'For a class analysis of communication', in A. Mattelart and S. Siegelaub (eds) *Communication and class Struggle: Capitalism, Imperialism*, New York, International General, 23–73.
Melucci, A. (1989) *Nomads of the Present: Social Movements and Individual Needs in Contemporary Society*, London, Radius.
Mestrovic, S. (1994) *The Balkanization of the West: The Confluence of Postmodernism and Postcommunism*, London, Routledge.

Meyrowitz, J. (1985) *No Sense of Place*, Oxford, Oxford University Press.

Miller, D. (1992) '*The Young and the Restless* in Trinidad: a case of the local and the global in mass consumption', in R. Silverstone and E. Hirsch (eds) *Consuming Technologies*, London, Routledge, 163–83.

Minc, A. (1994) interviewed for *The New Middle Ages*, Tx, 'The Late Show', BBC2, London (28 November).

Mohanty, S. P. (1989) 'Us and Them', *Yale Journal of Criticism* 2 (2).

Morita, A. (1986) *Made in Japan*, New York, Dutton.

Morley, D. (1994) 'Postmodernism: the highest stage of cultural imperialism?', in M. Perryman (ed.) *Altered States*, London, Lawrence & Wishart.

——— (forthcoming) 'Theoretical orthodoxies: textualism, constructivism and the "new ethnography" in cultural studies', in M. Ferguson and P. Golding (eds) *Beyond Cultural Studies*, London, Sage.

Morley, D. and Robins, K. (1992) 'Techno-orientalism: foreigners, phobias and futures', *New Formations* 16, 136–57.

——— (forthcoming) *Spaces of Identity: Global Media, Electronic Landscapes and Cultural Boundaries*, London, Routledge.

Nicholson, L. (1990) *Feminism/Postmodernism*, London, Routledge.

Norris, C. (1991) *Deconstruction: Theory and Practice* (rev. edn.), London, Routledge.

Ouologuem, Y. (1971) *Bound to Violence*, London, Secker & Warburg.

Richard, I.A. (1960) 'Variant readings and misreading' in T. Sebeok (ed.) *Style in Language*, Cambridge, Massachussetts, MIT Press.

Richard, N. (1987) 'Postmodernism and periphery', *Third Text* 2 (Winter 1987/8), 5–12.

——— (1993) 'Cultural peripheries: Latin America and postmodernist decentring', *Boundary 2*, 20 (3), 156–62.

Rorty, R. (1978) 'Philosophy as a kind of writing', *New Literary History* X.

——— (1989) *Contingency, Irony and Solidarity*, Cambridge, Cambridge University Press.

Said, E. (1994) *Culture and Imperialism*, London, Vintage.

Sakai, N. (1988) 'Modernity and its critique: the problem of universalism and particularism', in M. Miyoshi and H. Harootunian (eds) *Postmodernism and Japan*, special issue of *South Atlantic Quarterly* 87 (3), 475–505.

Scholte, B. (1987) 'The literary turn in contemporary anthropology', *Critique of Anthropology* 7 (1), 33–47.

Shohat, E. and Stam, R. (1994) *Unthinking Eurocentrism*, London, Routledge.

Soja, E. (1989) *Postmodern Geographies*, London, Verso.

Stone, N. (1994) interviewed for *The New Middle Ages*, Tx, 'The Late Show', BBC2, London (28 November).

Suleri, S. (1989) *Meatless Days*, Chicago, University of Chicago Press.

——— (1992) *The Rhetoric of English India*, Chicago, University of Chicago Press.

Todorov, T. (1984) *The Conquest of America: The Question of the Other*, New York, Harper Collins.

Wallerstein, I. (1974) *The Modern World System*, vol. 1, New York, Academic Press.

Wark, M. (1991) 'The tyranny of difference: from Fordism to Sonyism', *New Formations* 15.

Weber, M. (1958) *The Protestant Ethic and the Spirit of Capitalism*, New York, Scribner.

Webster, D. (1989) 'Coca-colonisation and national cultures', *Over Here* 9 (2).

West, C. (1994) 'Beyond Eurocentrism and multiculturalism', *Public* (Toronto) 10.
Wiredu, J.E. (1979) 'How not to compare African thought with Western thought', in R. Wright (ed.) *African Philosophy: An Introduction*, Washington, University Press of America, 166–84.
Wolf, E. (1982) *Europe and the People without History*, Berkeley, University of California Press.
Wolff, J. (1988) 'The politics of postmodernism', (Vanhasta Unteen: Kynnys Vai Kuilu?) *Sarja, A.* 16, University of Tampere, Finland.
Worpole, K. (1983) *Dockers and Detectives*, London, Verso.

Chapter 18

On the impossibility of a global cultural studies

'British' cultural studies in an 'international' frame

Jon Stratton and Ien Ang

As we approach the end of the century, cultural studies has become one of the most lively and widely-discussed intellectual fields in the international academic world. University programmes, conferences and publications in cultural studies are proliferating massively, suggesting a clear and indisputable boom. The effect of this steady expansion is that there is less and less consensus over what 'cultural studies' means. As a label appropriated in a variety of ways by a diverse and heterogeneous constituency, the identity of cultural studies is becoming increasingly elusive. Contrary to the traditional disciplines, cultural studies refuses to define itself in terms of a distinctive object, nor in terms of fixed theoretical axioms or orthodoxies. As Stuart Hall has put it, '[cultural studies] had many trajectories; many people had and have different trajectories through it; it was constructed by a number of different methodologies and theoretical positions, all of them in contention.'[1]

Yet, this recurrent and persistent stress on the 'open and experimental'[2] nature of cultural studies by its leading practitioners does not imply an unproblematic liberal pluralism. The rhetoric of open-endedness is advanced and promoted precisely in order to demarcate the *distinctiveness* of cultural studies as a particular discursive formation and intellectual practice. Time and again we are told that cultural studies is an inter-disciplinary, even anti-disciplinary or trans-disciplinary enterprise. For example, Angela McRobbie claims that '[f]or cultural studies to survive it cannot afford to lose [its] disciplinary looseness, this feeling that (. . .) its authors are making it up as they go along,'[3] and Tony Bennett has observed that 'cultural studies comprises less a specific theoretical and political tradition or discipline than a gravitational field in which a number of intellectual traditions have found a provisional *rendez-vous*.'[4] What informs the *rendez-vous* is not a proper 'object' of study and a fixed theoretical paradigm (as is the case with the conventional academic disciplines) but, in Bennett's words, 'a shared commitment to examining cultural practices from the point of view of their intrication with, and within, relations of power'.[5] In this sense, it could be said that what

sustains the intellectual liveliness and dynamism of cultural studies is a desire to transgress established disciplinary boundaries and to create new forms of knowledge and understanding not bound by such boundaries.

But as cultural studies is rapidly becoming an internationally recognized label for a particular type of intellectual work, it is crossing not just disciplinary boundaries, but also cultural-geographical boundaries. Cultural studies is now being practised in many different parts of the world (although definitely not everywhere), and is rapidly becoming a central site for critical intellectualism in the postmodern, postcolonial, postcommunist new world (dis)order. In this development, what has become known, rather misleadingly, as 'the Birmingham School' has operated as a symbolic centre. Bennett's *rendez-vous* has to a great extent been formed, precisely through the magnetic pull and influence of the work produced by the Birmingham Centre for Contemporary Cultural Studies in the 1970s and 1980s, creating a loose and fluctuating network of people in diverse institutional locations who now consider themselves cultural studies practitioners, both inside and outside Britain.

In this paper, we want to reflect on some of the theoretical and political consequences of this internationalization of cultural studies, of 'British' cultural studies in particular. Our starting-point is two questions. Who can and does participate in the cultural studies *rendez-vous* now that it has gone 'international'? And second, how can this 'international' *rendez-vous* be meaningful according to the (political) standards of cultural studies itself?

We must recognize, for starters, that the culture of cultural studies, too, is not exempt from power relations. In other words, the cultural studies *rendez-vous* cannot be imagined as an 'ideal speech situation' in which everybody holds the same power to speak and be heard. Thus, if the *rendez-vous* is to be as open-ended and open-minded as cultural studies itself wants to be, the 'internationalization' of cultural studies cannot mean the formation of a global, universally generalizable set of theories and objects of study. At the same time, a *rendez-vous* would be useless if it were merely a juxtapositioning of already fixed positions of difference, which tends to be the case – as we shall elaborate below – when different traditions of cultural studies are defined in unreflexive national terms (and talk about 'British' cultural studies, of course, is doing exactly that). A productive *rendez-vous*, we want to argue, can only take place when we go beyond the international binary. In this chapter, we will develop a strategy to do this by carving out speaking positions and discursive trajectories which are both partial and non-exclusive, both transnationally transportable and contextually specific, both open for conversation and negotiation and subject to critique and reflexivity as these positions and trajectories meet and, sometimes, clash with each other in a continuing *rendez-vous*. In particular, we will discuss and illuminate three positions/trajectories (and the relations between them) which have already

emerged and been circulating in cultural studies: the diasporic, the post-colonial, and briefly, the subaltern. The work of Stuart Hall will serve as a major inspiration in our exploration.

DECONSTRUCTING 'INTERNATIONAL'

First of all, the seemingly innocuous observation that cultural studies is now an 'international' venture needs to be interrogated. In all the enthusiasm currently surrounding the proliferation of cultural studies, one tends to lose sight of the fact that this presumed internationalism is hardly truly international at all. Simon During, working out of Australia and the editor of the recently published *The Cultural Studies Reader* (which is itself a symptom of the cultural studies boom), states quite insouciantly that cultural studies has now become 'a genuinely global movement'.[6] Yet if we look more closely at who is included in this so-called movement, we must conclude that it doesn't quite deserve the predicate 'international', let alone 'global'.

Take, for example, the book *Cultural Studies*, edited by Lawrence Grossberg, Cary Nelson and Paula Treichler.[7] This book is the progeny of a conference on 'Cultural Studies: Now and the Future', held in 1990 at the University of Illinois, Urbana-Champaign, in the United States. According to the Preface of the book, the conference was attended by about nine hundred people.[8] The book itself is nearly eight hundred pages long, containing forty papers and articles. In many ways the book is an admirable *tour de force*. It exemplifies the extraordinary breadth of work now going under the banner of cultural studies. At the same time, however, the book can be described as monstrous. Just like Frankenstein's un-named larger-than-life creation, *Cultural Studies* is an excessive book. In an important sense, the book is untitled, as it takes the name of the field it so excessively strives to represent. Borges wrote a short piece entitled 'Of exactitude in science'. Purporting to come from an old travel book, the piece describes how:

> [i]n that Empire, the craft of Cartography attained such Perfection that the Map of a Single province covered the space of an entire City, and the Map of the Empire itself an entire Province. In the course of Time, these Extensive maps were found somewhat wanting, and so the College of Cartographers evolved a Map of the Empire that was of the same Scale as the Empire and that coincided with it point for point.[9]

Here, the most complete map is the map which corresponds in size to the area it represents. It was not long before the map fell into disuse. Borges is telling us something about the impossibility inherent in Platonic formulations of representation. He is also reminding us about the relationship between power and representation.

Cultural Studies is a book at least twice to three times as long as the average academic book. This monstrous work, excessively mapping the terrain of cultural studies, is sourced in the United States. In reviewing the book, Fredric Jameson has summed up the nationalities of those included in the book: 'there are 25 Americans, 11 British, 4 Australians, 2 Canadians, and one Hungarian and Italian, respectively.'[10] This is definitely not an evenly spread 'international', let alone 'global' *rendez-vous*. (Though it is difficult to work out quite how Jameson is defining national identity – it would seem to be on the basis of where they work, rather than, say, where they were born or raised, or what passport they have.) What we have here is more than a simple western hegemony; what we have is a new American hegemony in an English-speaking cultural studies. The fact that this American-dominated representation of 'cultural studies' could present itself so self-confidently as cultural studies *per se* is just one illustration of how hegemony derives its effectivity from a self-presentation as universal, one that does not acknowledge its own particularity.

The international dissemination of cultural studies can be compared with that of one of its predecessors: sociology. As a modern discipline, sociology has always presented itself as a universal body of knowledge. Its object of study is 'society' in general. 'Society' operates in sociological discourse as a hegemonic, all-inclusive, singular term, denoting a comprehensive, integrated totality. Driven by a functionalist problematic, this discourse accords a space for internal differences – for example, of class, gender and race – only in terms of (the problems of) inclusion and integration rather than in terms of the radicalization of difference. What constitutes the conceptual limits of a 'society' is rarely discussed; where limits *are* recognized, a society is generally defined as coterminous with the geographical territory of the nation-state: 'American society', 'Japanese society', 'French society', and so on. However, all these national particulars can be specified and described in terms of the presumably universal concepts and theories of a presumably generally-applicable sociological master narrative. In this way, sociology manages to construct a world of separate, clearly demarcated 'societies' whose differences can be contained as mere variations of the same. The 'society' serving as a universal model, of course, at least as American functionalist sociology would have it, is American society – both descriptively and prescriptively. Not only are all other 'societies' judged in terms of their deviation from the American model; they are also supposed to move towards a stage of development of which the American model was deemed the culmination. Not coincidentally, this American-centric paradigm was dominant during at least three decades after the Second World War, the high period of US global superpowerdom.

In this sense, it is ironic to witness a similar process taking place with cultural studies. In the universalizing ambitions displayed by the

publication of a book like *Cultural Studies*, there is the danger that cultural studies could become another modern discipline after all. Yet times have changed. The universalizing force of sociology lay, in the first place, in its basic theoretical claims; for example, that 'society' was a concept of universal applicability. In contrast, McRobbie and Bennett, as we saw at the beginning of this article, are arguing for a cultural studies which is always provisional, that is, not pre-determined by a universal paradigm. One manifestation of this sentiment is a constant oscillation between talk of 'cultural studies' in general and talk of particular 'American/British/Australian/Canadian cultural studies' which presumably would warrant the provisional, context-bound nature of the project as a whole. (And we need to be aware of just how much of the internationalization of cultural studies has been, in fact, occasioned by an exporting of British cultural studies to British ex-settler colonies.[11]) This acknowledgement of (national) differences has been a more generalized move, even among the Americans. For example, Nelson, Treichler and Grossberg write that '[d]ifferent traditions of cultural studies, including British and American versions, have grown out of efforts to understand the processes that have shaped modern and postwar society and culture.'[12] Jameson's resolve to categorize the contributors to the monstrous Illinois book in terms of their nationality is also an indication of the prominence accorded to national identity as the source for difference and diversity in this international gathering.

However, while this insistence on pluralism predicated on the national is strategically useful as a bulwark against creeping universalism, it also has some problems. As we have already suggested, sociology privileges the universal over national particularities, which are reduced to being versions of the universal concept of the nation-state. Some in cultural studies now seem to want to turn things around: as any tendency towards universalism is now virtually declared a taboo, it is the individual nation-state which is now earmarked as the privileged site of particularity. What we have here is a straightforward inversion of the hierarchies of modern sociology. The problem with this inversion is not so much that it remains within the disciplinary logic of sociology – although this is symptomatic of a residual attachment to some of the disabling assumptions of that discipline, such as the equation of 'nation-state' and 'society' – but that it contains a strategy which makes it difficult to think *beyond* the national. If any work in cultural studies must display its national credentials and define the nation as the constitutive context for its specificity ('British cultural studies', 'American cultural studies', 'Australian cultural studies', and so on), the resulting kind of internationalism would be, as Jameson remarks, 'a kind of United Nations plenary session', in which each group could say its piece and 'was given respectful (and "politically correct") hearing by all the others: neither a stimulating nor a very productive exercise, one would

think.'[13] Indeed. How then can we effectively develop an internationalism in cultural studies that is more than an interchange between already-constituted national constituents? It is this question which guides our explorations in this paper.

Since the Illinois conference and the publication of *Cultural Studies*, the book, several 'international' cultural studies events have been staged in other parts of the world which have explicitly problematized the power of the core and the universalizing tendency which marks that power. We mention three here: the 'Dismantle/Fremantle' conference in 1991, the 'Postcolonial Formations: Nations, Culture, Policy' conference in 1993, and the 'Trajectories: Towards an International Cultural Studies' conference in 1992. The first two took place in Australia, while the third – arguably the most subversive of the three – was organized by Kuan-Hsing Chen in Taiwan.

To date, the Taiwanese conference has proved to be so left-field in the cultural studies project, that its place in the official history of the field remains uncertain. We will return to what this conference represents at the end of this article. The two Australian conferences, on the other hand, were more direct instances of 'talking back' to the Anglo-American hegemony within 'international' cultural studies. The 'Dismantle/Fremantle' conference was organized at Murdoch University and held in the city of Fremantle, Western Australia, with the explicit aim to 'decolonize' cultural studies. As Ien Ang wrote in her introduction to the conference proceedings, published in the journal *Cultural Studies*[14]: 'What is needed (. . .) is a *dismantling* of unifying and universalizing definitions of "cultural studies", opening up a space for meaningful *conversation*.'[15] The 'Postcolonial Formations' conference was hosted by Griffith University, Brisbane, Queensland, and was set up to be an international *rendez-vous* with three participants: Australia, Canada and New Zealand. It should be noted that at the Illinois conference, as indicated in Jameson's listing, Australians and Canadians were the only two groupings apart from the Americans and the British with more than one representative; they at least were included in the universalized cultural studies 'society' as established by the Americans. However, as conference organizer Tony Bennett said in his opening address at Griffith, the 'Postcolonial Formations' conference was an initiative precisely of the Australians and Canadians who were at Illinois, as a response to what they considered the scandalous lack of awareness among American and British speakers of the specificity and partiality of their speaking positions. In other words, in this so-called international cultural studies 'society', the Australians and Canadians felt marginalized inasmuch as their positions were marked as particular *vis-à-vis* the universal. This tallies with Australian cultural critic Meaghan Morris's critical observation that 'the word "international" comes to work in cultural studies as it does in the film and record industries – as a

euphemism for a process of streamlining work to be "interesting" to American and European audiences.'[16] The response to this situation, according to Bennett, was to stage a *rendez-vous* among the marginals themselves, bypassing the presence of the hegemonic centre. Seen this way, the appropriation of the specifying category of the 'postcolonial' by Australian, Canadian and New Zealand practitioners of cultural studies can be seen as the strategic invocation of an alternative frame for the meaning of 'international', one that counters the hegemonic 'world' order led by American and British cultural studies.

It is clear, then, that it is no longer possible for a knowledge formation to unproblematically universalize itself without meeting any resistance from those at whose expense this universalizing process is carried out. In this sense, there is promise in Stuart Hall's claim for a cultural studies 'as not having an aspiration to an overall metalanguage, as always having to recognize its positioning, as a set of contested localized knowledges, etc.'[17] It is in this resistance to universalization that cultural studies can assert its difference from a modern discipline such as sociology, and it is in its insistence on the importance of local positioning that cultural studies exposes sociology's complicity in repressing those aspects of the particular which cannot be subsumed under the universal. However, what is at issue is not just a question of prioritizing the particular over the universal. Just as any invocation of the universal is never innocent, any assertion of particularity also cannot go unquestioned. Neither the universal nor the particular are natural categories. As we said before, there are problems with uncritically adopting the national as the privileged site of the particular, as it runs the risk of hypostatizing differences into static, mutually exclusive categories. In other words, what cultural studies needs to do if it wants to avoid universalization is not just valorize any asserted particularity, but reflect on the concrete processes of particularization itself, and to interrogate its politics. The adoption of the category of the postcolonial as a term of self-description by Australians and Canadians is one such strategy of particularization which has the possibility of problematizing both the universal and the national – and we will have more to say about its politics (good and bad) later.

In a more general sense, the construction of positions of particularity is a necessary condition for engendering the contested localized knowledges Hall talks about. In fact, Hall's own work eloquently exemplifies both the productiveness *and* the necessary limits of any particularizing move. As a central figure in the shaping of cultural studies, Hall has repeatedly been asked to formulate and enunciate his 'point of view' – what he calls 'the many burdens of representation' that he has to carry around; 'I carry around at least three: I'm expected to speak for the entire black race on all questions theoretical, critical, etc., and sometimes for British politics, as well as for cultural studies.'[18] In this respect, Hall occupies a unique

position in cultural studies, and over the years he has displayed an admirable flexibility in grappling with and responding to these disparate interpellations (which, of course, he has also conspired in). Of course, these three sites of representation – blackness, Britishness, and cultural studies – are not necessarily connected, but they have become increasingly obviously intertwined, especially in some of Hall's more recent work, where his speaking position has become more unapologetically autobiographical. Hall's understanding of his own intellectual and personal biography is informed by a speaking position which we want to characterize as *diasporic*, and is one trajectory which we want to mobilize in the international cultural studies *rendez-vous*. However, the ways Hall has articulated – and not articulated – the particularity of his speaking position over his career tell us much about the changing formation of cultural studies, especially 'British' cultural studies, to which we now turn.

STUART HALL AND 'BRITISH' CULTURAL STUDIES

American cultural studies didn't acquire its contested hegemony of its own accord. In fact, it is a very derivative hegemony. The symbolic centre of this hegemonic construct is not something 'American' but something 'British': 'British cultural studies'. This is one reason why Stuart Hall was one of the star speakers at the Illinois conference. The received history of cultural studies claims that it originated in Britain in the late 1950s. Its founding fathers were Richard Hoggart, Raymond Williams and, though himself young enough to be a son, Stuart Hall. It is interesting to dwell on this myth of origin, if only briefly, as it sheds some light on some of the contradictions in the whole self-understanding of cultural studies. After all, the discipline of sociology also has three founding fathers: Marx, Weber and Durkheim. The same is the case with English literary studies, the other major disciplinary predecessor of British cultural studies: its three founding fathers were Arnold, Richards and Leavis.[19] Such mythic histories are very modern, not postmodern formulations, not only because they operate within the (white) Great Man (*sic*) theory of (colonial, patriarchal) history but also because they signal their own universalization. As the cultural studies story goes, the originary 'ferment' became particularly explosive during Hall's 'rule' over the Birmingham Centre for Contemporary Cultural Studies, the place where, again according to the mythology, cultural studies as an institutionalized intellectual practice first began; where, in other words, cultural studies began to operate as a 'society' of its own. The problem with such a mythic history is that it makes it difficult for us to construct a more pluralistic de-centred account of the emergence of cultural studies in different parts of the world. To quote Meaghan Morris, taking up a point made by the Indian-Australian historian Dipesh Chakrabarty, 'the real problem may be that the genre in which "histories"

are being invented for cultural studies often leads people into positing a *single origin* for their practice – something which those same people would never do in any other context.'[20]

This problem notwithstanding, there is now a well-defined if limited genre of writing which might be called 'The way we were at the Birmingham Centre.' John Clarke has told his story in 'Cultural Studies: a British inheritance.'[21] A less personalized history forms the sub-text of Richard Johnson's 'What is cultural studies anyway?'[22]. Yet another, also less explicitly personal, history is provided by Lawrence Grossberg in his 'The formations of cultural studies: An American in Birmingham.'[23] The image produced in these stories is one of a constant but productive, and idealized, quarrelsomeness in the original cultural studies 'society'.[24] Stuart Hall himself, a great raconteur, has told the story in at least three versions: 'Cultural studies and the Centre: some problematics and problems', 'The emergence of cultural studies and the crisis of the humanities', and 'Cultural studies and its theoretical legacies'.[25]

Indeed, Hall's contribution to the origin myth – and its implications for understanding its current 'international' significance – is an ambiguous one. By the latest version, he is explicitly self-conscious about his own complicity in the historical production of the myth, describing himself as sometimes feeling like 'a *tableau vivant*, a spirit of the past resurrected, laying claim to an authority of an origin'.[26] To be sure, Hall emphatically rejects the founding father status accorded to him in the myth. Cultural studies, he says, did not 'emerge somewhere at the moment when I first met Raymond Williams, or in the glance I exchanged with Richard Hoggart.'[27] He continues, speaking at the Illinois conference:

> I don't want to talk about British cultural studies (. . .) in a patriarchal way, as the keeper of the conscience of cultural studies, hoping to police you back into line with what it really was if you only knew.[28]

Hall, then, is clearly aware of the problems of positing British cultural studies – whatever this may be – as the 'core' of an internationalized cultural studies. At the same time, as far as we know, he has never concerned himself with explaining *why* British cultural studies could have met with such a positive reception outside Britain as well (and of course there is no intrinsic reason why he should have). In his earlier work especially, Hall has tended not to be concerned with the transnational dimensions of cultural studies practice; Britain formed both the naturalized boundary and the given context for this practice. In this respect, it is significant that Hall has tended to paint the historical emergence of cultural studies in Britain as an organically British development, a development determined by internal national forces. (As we shall see, this can be debated.) For example, in 'The emergence of cultural studies and the crisis of the humanities' he writes that:

For me, cultural studies really begins with the debate about the nature of social and cultural change in postwar Britain. An attempt to address the manifest break-up of traditional culture, especially traditional class cultures, it set about registering the impact of the new forms of affluence and consumer society on the very hierarchical and pyramidal structure of British society. Trying to come to terms with the fluidity and the undermining impact of the mass media and of an emerging mass society on this old European class society, it registered the cultural impact of the long-delayed entry of the United Kingdom into the modern world.[29]

Hall's argument assumes that British culture and class relations have had a continuity which resisted the class politics characterizing European modernity elsewhere.

This argument builds on an earlier article by Perry Anderson, 'Components of the national culture', published in 1969. Anderson argues that in Britain, unlike the countries of continental western Europe, an accommodation was made between 'the agrarian aristocracy which had matured in the eighteenth century, and controlled a State formed in its image'[30] and the nineteenth-century industrial bourgeoisie. The result of this accommodation was that:

[the industrial bourgeoisie] never generated a revolutionary ideology, like that of the Enlightenment. Its thinkers were confined by the cramped horizons of their class. They developed powerful sectoral disciplines – notably the economics of Ricardo and Malthus. They advanced the natural sciences – above all evolutionist biology with Darwin. But they failed to create any general theory of society, or any philosophical synthesis of compelling dimensions.[31]

According to Anderson, it is for these reasons that there was never a theoretical sociology in nineteenth-century Britain, the modern discipline which – in the continental European context – explicitly constructed a totalized conception of 'society'. In a Lukácsian move Anderson argues that the notion of totality, what we have described as the central universalizing concept of modern disciplines, is a typifying feature of bourgeois ideology; of a bourgeoisie struggling to legitimate its position of power. Anderson goes on to suggest that in Britain's unique circumstances the concern with totalization surfaces in literary criticism, not in a sociology:

Driven out of any obvious habitats, the notion of totality found refuge in the least expected of studies (. . .) English criticism, with Leavis, assumed the responsibilities of moral judgement and metaphysical assertion.[32]

Traditional British literary criticism denies that it is a totalizing theoretical project, while presenting itself as a universal practice which naturalized the

moral order of the bourgeoisie. Hall's history bears a remarkable similarity to Anderson's, although it is shorn of Anderson's Lukácsian and structuralist marxist theoretical apparatus. The difference is crucial. Where Anderson argued that the nineteenth-century bourgeoisie was assimilated into the feudal British tradition, Hall describes the post-Second World War period as the moment when the neo-feudal structure of British society was finally destabilized. According to Anderson, literary criticism was a means of preserving the hegemonic collusion of the old (feudal) and the new (bourgeois) dominant classes. Hall, on the other hand, argues that cultural studies came from a new space. It did not originate in the old hegemonic order but came out of the very unsettling of that order, and articulated its project as both trying to understand the new socio-cultural order and critiquing the power relations, particularly those related to class, which pervaded the old order.

In Hall's argument, then, the development of cultural studies takes up the space otherwise occupied by sociological analysis as the United Kingdom finally enters 'the modern world' (or, as some might argue, the postmodern world). The lack of a strong bourgeois theoretical tradition, i.e. sociology, provided the opportunity for the development of a 'British' cultural studies in Britain. What is left out in Hall's history is the role of literary criticism, which makes cultural studies seem to come from nowhere. But we need to remember that the work of Hoggart and Williams precisely grew out of, and away from, literary criticism as the object of study shifts to working-class culture and, in Williams' expression, which still gets regularly invoked by those who identify themselves as practitioners of cultural studies, 'culture as a whole way of life'. Cultural studies, then, in this historical account, is understood as being the product of a very idiosyncratic British historical and cultural conjuncture. What we are presented with here is a uniquely British history for the emergence of cultural studies. However, the historical conditions outlined by Hall as determining this emergence – for example, the growth of the mass media and consumer society – are by no means uniquely British, but have, as we all know, fundamentally transnational dimensions and repercussions.

One problem with connecting the emergence of cultural studies so specifically with peculiar developments in British society, is that it leaves us empty-handed when it comes to accounting for the 'international' dimensions of cultural studies' expansion. At most, we are led to think about this expansion in terms of a progressive diffusion from the Birmingham Centre outwards. And more often than not it is precisely in terms of such a quasi-colonialist expansion that historical accounts of the internationalization of cultural studies have been cast. For example, John Clarke seems to take it for granted that cultural studies is a 'British inheritance' which

[b]y the end of the 1980s (. . .) had long transcended its slender origins, having established itself as a subject within British higher education and having spread internationally, both as a theoretical discourse and a distinctive means of approaching the study of the peculiarities of national cultures'.[33]

In this model, cultural studies has spread from Britain, historically one of the arch-colonialist states of the European core, to its (ex)settler colonies – including the United States – and, from there, to the rest of world. That Clarke doesn't query his own use of the term 'international', let alone that of 'national', is not only suggestive of the persistent force of the regime of truth sustained by modern sociology, but also symptomatic of the insularity of much 'British' cultural studies.

It is such a construction which makes it tempting, from a British vantage-point at least, to experience the rapid international success of cultural studies in terms of a dilution of the pure original. This is particularly the case in British responses to the American appropriation of cultural studies. (Significantly, almost no attention has been given by British commentators to appropriations of cultural studies by more peripheral others in the international 'society', such as those in Australia or Canada.) Hall himself, for example, has repeatedly expressed his profound amazement over the rapid ascendancy of cultural studies in the American academic scene. We want to quote him at length here:

I don't know what to say about American cultural studies. I am completely dumbfounded by it. I think of the struggles to get cultural studies into the institution in the British context, to squeeze three or four jobs for anybody under some heavy guise, compared with the rapid institutionalization which is going on in the US. (. . .) So the enormous explosion of cultural studies in the US, its rapid professionalization and institutionalization, is not a moment which any of us who tried to set up a marginalized Centre in a university like Birmingham could, in any simple way, regret. (. . .) And yet I have to say, in the strongest sense, that it reminds me of the ways in which, in Britain, we are always aware of institutionalization as a moment of profound danger. (. . .) Why? (. . .) There is no moment now, in American cultural studies, where we are *not* able, extensively and without end, to theorize power-politics, race, class, and gender, subjugation, domination, exclusion, marginality, Otherness etc. There is hardly anything in cultural studies which isn't so theorized. And yet, there is this nagging doubt that this overwhelming textualization of cultural studies' own discourses somehow constitutes power and politics as exclusively matters of language and textuality itself.[34]

This is an enormously rich text which says a lot about Hall's most central views of what cultural studies is and should be. His severe objections

against American cultural studies, so politely worded here, are worth
exploring further, but this is not the place to do so. Suffice it to say here
that this text signals an immense cultural gap between American and
British (and more generally, non-American) academic scholarship and
critical intellectualism. What interests us at this point is the speaking
position from which Hall articulates and constructs what he sees as the
major contrast between American and British cultural studies. Hall is very
clear that he doesn't want to make American cultural studies more like
British cultural studies ('an entirely false and empty case to try to pro-
pound'), but the above quote suggests that there are nevertheless pangs of
regret in his reflections on what could be called the Americanization of
cultural studies, regret over the loss of a 'Birmingham moment' when
cultural studies was still a marginalized practice and arguably a more
genuinely 'political' one as well, when doing cultural studies was not
primarily concerned with academic professionalism but connected with
and energized by the metaphor of the organic intellectual. In recalling
what the Centre was up to, Hall said to his American audience, with a
fine sense of irony:

> there is no doubt in my mind that we were trying to find an institutional
> practice in cultural studies that might produce organic intellectuals. We
> didn't know previously what that would mean, in the context of Britain
> in the 1970s, and we weren't sure we would recognize him or her if we
> managed to produce it. The problem about the concept of the organic
> intellectual is that it appears to align intellectuals with an emerging
> historic movement and we couldn't tell then, and can hardly tell now,
> where that emerging historical movement was to be found. We were
> organic intellectuals without any organic point of reference; organic
> intellectuals with a nostalgia or will or hope (. . .) that at some point
> we would be prepared in intellectual work for that kind of relationship,
> if such a conjecture ever appeared. More truthfully, we were prepared to
> imagine or model or simulate such a relationship in its absence:
> 'pessimism of the intellect, optimism of the will'.[35]

There is a sense in which the Birmingham moment is constructed in this
narrative, if not as the origin, then at least as representing a purer, more
authentic, more unco-opted mode of cultural studies. And one has to say
that this sentiment has been voiced by more than one early Birmingham
inhabitant. McRobbie, for instance, remarks that 'what has worried me
recently in cultural studies is when the theoretical detours become literary
and textual excursions' and when it loses its 'sense of political urgency'.[36]
And Hall himself is adamant that the concept of the organic intellectual,
despite its apparent non-effectivity in the current conjecture, should be
retained today as a guiding principle for cultural studies practice:

We never produced organic intellectuals (would that we had) at the Centre. We never connected with that rising historic movement; it was a metaphoric exercise. Nevertheless, metaphors are serious things. They affect one's practice. I'm trying to redescribe cultural studies as theoretical work which must go on and on living with that tension.[37]

What concerns us here is not the substantive value of Hall's and McRobbie's objections to the, what they see, as the depoliticization of cultural studies, especially in the United States.[38] These are serious issues concerning the place and role of intellectual work today which cultural studies needs to continue to address. However, because this criticism is cast in terms of a *departure* from what was current at the Birmingham Centre, the danger exists that the latter is over-romanticized. It is tempting to compare this with Richard Hoggart's romanticization of traditional English working-class culture in the wake of the post-war advent of American commercial mass culture in *The Uses of Literacy*! 'Americanization', then, proves to be a traumatic experience from the point of view of the British establishment,[39] and British cultural studies is clearly, in more than one way, not exempt from it. But the experience of trauma isn't the most congenial starting-point for down-to-earth self-reflection. Criticizing American cultural studies in the name of an idealized British cultural studies past doesn't lead us to understand why cultural studies took the shape and form it did in the United States (including its rapid professionalization, institutionalization and textualization), and how it could become so fashionable in the first place. We are not saying that Hall expressly took up such a British-centred view, but it has been the almost inevitable effect of his very positioning (by others more than by himself) as the Birmingham 'guru', and the authority accorded to his narrative histories where 'Birmingham' is constructed as the original birthplace of cultural studies.

Against this, we want to develop a more pluralist narrative (or set of narratives) of the history of cultural studies, which can account for local or regional variations as well as commonalities in concerns and approaches. We have to recognize that the intellectual practices which we now bring together under the category of 'cultural studies' were developed in many different (but not random) places in the world, and that there were *local* conditions of existence for these practices which determined their emergence and evolution. It is undeniable that 'Birmingham' has played a crucial role in the growth of the international cultural studies network as we know it today. But there was never just a one-sided and straightforward expansion of British cultural studies to other locations; if there ever was such an 'expansion', the reception of British work in these other locations was never passive, but always inflected by local circumstances and concerns. In fact, it is precisely the recognition of this context-boundness of cultural studies which prevents it from becoming another universalizing

discipline. As the editors of a recent Canadian volume, significantly titled *Relocating Cultural Studies*, have put it: 'Unlike established academic disciplines, cultural studies could never aspire to a subject matter capable or deemed capable of being described in terms *abstracted* from the concrete realities it sought to identify and analyse.'[40] Thus, they say, it is important to explore and recognize 'the renegotiations and changes in cultural studies in the wake of its export from Britain'.

More radically, John Frow and Meaghan Morris, in a recent reader designed to introduce *Australian Cultural Studies*, dispute – or at least vigorously relativize – the centrality of British cultural studies for the development of Australian cultural studies. They offer an alternative history which does not put British work centre-stage but gives much more credit to some enabling aspects of domestic intellectual culture:

> Our first encounter with a 'culture and society' approach in the late 1960s came not from reading Raymond Williams but from attending WEA [Workers' Educational Association] summer schools on film run at Newport Beach in Sydney by John Flaus. Flaus works as a teacher in university and adult education contexts, as a critic who uses radio as fluently as he writes for magazines, and as an actor in a variety of media from experimental film to TV drama and commercials. (. . .) we can say that Flaus (like Sylvia Lawson) helped to create a constituency for the project of cultural studies as well as to train a generation of film and media critics. Yet his work, along with the socially mixed but intensely familial urban subculture and small journals networks which sustained it (both of which were historically deeply-rooted in the inner-city life of Sydney and Melbourne) has been erased from those Australian accounts of cultural studies which take their bearings from the British tradition – and then pose problems of application.[41]

Of course, no invention of (a) history is innocent; it always represents a partial politics of truth which cannot be separated from a particular perspective. But what this Australian counter-history clearly tells us is that it makes no sense to reduce cultural studies as an 'international' project to a single source from which it all originated; that it might be better to speak about a geographically dispersed plurality of intellectual trajectories and movements, largely in the post-1960s period and in western, English-speaking countries, which, under precise historical conditions which need to be further explored, converged into the aforementioned international *rendez-vous*. How and why British cultural studies (and particularly 'Birmingham') could play a key symbolic role in this international convergence, and the power relations implied in it, remains to be examined. At the same time, it is important also to stress that today 'Britain no longer serves as the centre for cultural studies.'[42]

QUESTIONING BRITISHNESS

One way to challenge the exclusive Britishness of cultural studies would be to show how it is not enough to explain the emergence of cultural studies in Britain solely out of organic, internal forces. So while it may be true that the condition of 1950s Britain provided a uniquely productive moment for a radical rethinking of 'culture' in the British context – an historic moment which for Hall was articulated intellectually and politically through the New Left,[43] it is important not to lose sight of the larger global context which frames the British condition and in which Britain occupies a particular, and changing, position. Thus, if the 1950s signalled the break-down of traditional British class cultures as a consequence of mass con-sumerism and the proliferation of mass-mediated culture, this very development signalled not just Britain's 'long-delayed entry into the modern world', as Hall mockingly puts it, but also, more fundamentally, the final moment of the decline of the British empire, epitomized by the Suez crisis of 1956. The late 1950s was the moment when established class hierarchies inside Britain were unravelling. It was also when Britain was forced to recognize its loss of colonial power and its new subordinate position *vis-à-vis* the new western global superpower, the United States. What Hall calls 'the modern world', so to speak, is 'American'.

The ensuing cultural crisis in Britain, then, not only had to do with the unsettling effects of the impact of 'Americanized' consumption and the mass media, but also with the end of the era of British world hegemony. Furthermore, as the structures of the Age of Empire were crumbling, there was a more general eruption of the non-dominant onto the previously neatly hierarchical fabric of British cultural life. It is in this respect that the biographies of the 'founding fathers' are so interesting. They all have backgrounds marginal to hegemonic British culture: Richard Hoggart comes from a northern working-class family, Raymond Williams was Welsh, and Stuart Hall is a black Jamaican. All three occupied contra-dictory positions within the British social formation: as social subjects who stood in a decentred relation to the dominant national culture, they entered the sites of the very elite of the English academic world – Hall, for example, came to Britain in 1951 to study at Oxford. And without wanting to engage in a humanist biographical determinism, we can still point out that all three worked on a cultural studies in Britain which articulated a redefinition of culture by breaking down, in theoretical terms, the equation of the dominant culture with culture *per se*, opening up the terrain of the cultural for struggle, negotiation, and resistance. In this sense, we can suggest that the energizing impulse of British cultural studies has histori-cally precisely lain in this critical concern with, and validation of, the subordinate, the marginalized, the subaltern within Britain.

In this respect, it is perhaps worth speculating that the success of

cultural studies in the United States coincided with the historical loss of the ability of that country to control the global economy and the increasing recognition that it can no longer dictate the terms of the 'new world order', which, to a certain extent, has sustained the cohesion of American national identity. This loss led to a cultural crisis analogous to that of Britain after the Second World War, and opened up a space for divisions within American society to express themselves in a more antagonistic way than the ideology of pluralism had enabled. Thus, cultural studies has become an intellectual home for the unprecedented eruption of non-dominant race, gender and ethnic voices in the American public arena.

At any rate, the recognition that there is not one 'culture' in 'society' but that any 'society' consists of a plurality of historically specific 'cultures' structured in relations of dominance and subordination to each other, is therefore *the* key theoretical formulation which gave cultural studies the ability to focus on cultural *struggle* – arguably the central theme which interconnects all work in cultural studies, however this struggle is further theorized, together. Hall's reference to E. P. Thompson's *The Making of the English Working Class* is exemplary:

> Thompson insisted on the historical specificity of culture, on its plural, not singular, definition – 'cultures', not 'Culture': above all, on the necessary struggle, tension and conflict between cultures and their links to class cultures, class formations and class struggles – the struggles between 'ways of life' rather than the evolution of '*a* way of life'. These were seminal qualifications.[44]

It is important to point out that these qualifications are seminal in a much more profound sense than just in the British context. Indeed, they might be one of the key reasons for the 'international' attractiveness of the British cultural studies legacy. Graeme Turner, for example, argues that *The Making of the English Working Class* 'opens the way for a new "history from below" which recovers the stories of social formations, of popular cultural movements, of non-institutional and subordinated groups and places them against the large-scale administrative, institutional, and constitutional narratives of traditional histories.'[45] Speaking from an Australian point of view, Turner continues: 'White Australian histories – as distinct from imperial or colonial histories – have, in a sense, *always* been histories "from below": accounts of a subordinated (that is, a colonised) people, and of their construction of social groups and identities within an extremely repressive and authoritarian social and administrative structure.'[46] Turner's point here is that it was the opening up of the possibility of a 'history from below' which made British cultural studies relevant to Australians. That is, the point of connection between British and Australian cultural studies here is the empowering validation of the

marginal, although the naming of the marginal differs greatly from one context to the other. Importantly, as we have seen, from an Australian standpoint this general theoretical principle made it possible to foreground 'Australia' itself as marginal against a dominant 'Britain'.[47] We will return to the politics of this shift shortly, especially in relation to its consequences for the international cultural studies *rendez-vous*.

Meanwhile, Hall's comment on Thompson points to another important aspect of early British cultural studies: namely, that is has foregrounded the working class as the privileged subaltern whose cultural practices were to be theoretically understood and politically vindicated. Both Hoggart and Williams could draw, at least in part, on personal experience in this rendering visible of working-class culture as a relatively autonomous 'whole way of life' – to evoke Williams' definition of 'culture' – within the British social formation. But Hall, too, whose class background in his own account is 'lower middle class', through a passionate negotiation with marxism, has always had a deep commitment to treating class as a key category in analysing contemporary cultural relations. *Resistance through Rituals*, for example, one of the major projects conducted under Hall's directorship of the Birmingham Centre in the 1970s, is primarily about working-class youth subcultures in Britain.[48]

What we want to observe in relation to this strand of work, is that the notion of Britain itself has remained unproblematized in it. Britain was simply there as the more or less inert, pre-given space within which class relationships took shape and (mainly symbolic) working-class resistances were acted out. For example, never was the question asked what was distinctively *British* about spectacular working-class youth subcultures such as the mods, the rockers, the teddy boys and the punks. What is it about British 'culture', so to speak, that made it possible and appealing for sections of male working-class youth in post-war Britain to express and articulate themselves in such stylistically spectacular ways?[49] Even Dick Hebdige's work, which most explicitly took account of the British *context* of particular popular cultural phenomena, did not problematize the historical or geo-cultural *specificity* of that context as compared to other contexts.[50]

In other words, when Hoggart and Williams put working-class culture on the agenda, they did so without questioning the integrity of British nationhood – their intellectual struggles took place by taking Britishness for granted as a given and secure marker of identity, as it were (although Williams' work on Welsh culture as a subordinate and colonized culture did point to the regional dimensions of British imperialism). The working-class culture they both wanted to validate was securely placed *within* the established boundaries of British 'culture' and 'society'. The working class Hoggart and Williams are talking about may have its own way of life, but there is no doubt that it is a *British* way of life. In other words, what tends

to be suppressed is a questioning of what makes up the distinctive speci-
ficity of Britishness or British cultural identity, including that of British
cultural studies itself.[51]

In this, what Turner calls, 'ex-nomination' of British distinctiveness,[52]
an implicit universalism creeps in in the same way that it has crept into the
American appropriation of cultural studies, as discussed above. In this
tendency, the specifying dimension of the national remains unspoken,
unaccounted for. Hall, for one, has described this ex-nomination as the
product of what he calls the all-encompassing 'English eye':

> The 'English eye' sees everything else but is not so good at recognizing
> that it is itself actually looking at something. It becomes coterminous
> with sight itself. It is, of course, a structured representation nevertheless
> and it is a cultural representation which is always binary. That is to say,
> it is strongly centred; knowing where it is, what it is, it places everything
> else. And the thing which is wonderful about English identity is that it
> didn't only place the colonized Other, it placed *everybody* else.[53]

It is for this 'English eye', according to Hall a legacy of English imperial
power, that Turner slaps British cultural studies as being 'resolutely
parochial'.[54] Turner has been one of the most vocal resenters of the
Anglo-American hegemony in 'international' cultural studies and the
centrality of British cultural studies in it. As Turner puts it:

> The dominance of British models is not intrinsically dangerous unless
> we take it for granted but, so far, I think we have failed to interrogate the
> nature and effects of that dominance. (. . .) As long as cultural studies
> resists the challenge of more comparative studies, there will be little
> provocation to revise British models so that they 'work' for the margins
> as well as the centers. Cultural studies has a lot to gain from the margins,
> and it should do its best to investigate the ways in which their specific
> conditions demand the modification of explanations generated else-
> where. At the very least, such an expansion of the cultural studies
> project provides a hedge against the development of a new universal-
> ism.[55]

The margin, in Turner's discourse, is self-evidently 'Australia', while
universalism is another word for unacknowledged Anglocentrism, recon-
structed neo-colonialism. It is interesting to note, then, that while the
British are complaining about the new *American* hegemony, the Austra-
lians (and to a lesser extent, the Canadians) are complaining as much – if
not more – about *British* dominance. That is, although Turner, as we have
already noted, appreciates the notion of a 'history from below' which he
has borrowed from British cultural studies, the provocation he proposes is
to turn this very notion against British cultural studies itself by foreground-
ing Australia and Australian cultural studies as the new 'below'.

It should be noted that Turner's move here is, again, not an innocent one – nor is any theoretical move discussed in this paper. The position from which Turner constructs his discourse is a self-consciously *postcolonial* one. The politics of this position is to assert 'Australia' in the face of a powerful (real and perceived) 'Britain'. But this Australian postcolonial position is also, willy-nilly, profoundly informed by the former settler colony's residual preoccupation, if not obsession, with what used to be the mother country.[56] As Turner himself has put it: 'Although postcolonial identity depends on rupturing the colonial frame, the strongest evidence that such a rupture has been effected seems provided when the colonial power acknowledges it; it is as if the status of postcoloniality is dependent upon the assent of the colonizing Other.'[57] In this respect, it is telling that Turner is the author of the very first introductory textbook on the Birmingham School, simply called *British Cultural Studies*, which helped to promote the specificity of the British tradition.[58] We should remember that Frow and Morris, quoted earlier, have rejected an account of Australian cultural studies as somehow the direct result of the export of British cultural studies, favouring a more independent, locally oriented account instead. The postcolonial speaking position is thus not without ambiguity and contradiction, nor is it uncontested. In foregrounding Australia's subordinate status *vis-à-vis* Britain, it is a position with its own silences and limited horizons, not least with respect to the situation of Aborigines in Australia.[59]

One important risk of equating 'Australia' with the condition of postcoloniality we want to emphasize in this article is that it may lead to an overemphasis on nationalist preoccupations. A possible problem with privileging the 'national' as the site of particularity in cultural studies, as we said before, is that it is often accompanied by a lack of reflexivity concerning the presumed fit between cultural studies and the nation-state. The nation-state then becomes not only the naturalized context of the struggles between cultures rendered intelligible by cultural studies, but also the taken-for-granted determining context within which particular versions of cultural studies develop. The nation-state specifies the idiosyncrasies of particular national traditions of cultural studies. Seen this way, the nationalist perspective turns out to be the other side of the coin of the universalist, neo-colonialist perspective which implicitly posits the British and/or American version as the original form of, and standard for, cultural studies elsewhere. If universalism is an unconscious parochialism, nationalism, at least in its radical, self-defensive mode, is a form of *self-conscious* parochialism.

Like the modern human sciences, the nation-state is a successful global export of European modernity. It is a moment of intersection between the hegemonic universalization of European ideas and practices and, in many cases, non-European local cultures. As such, depending on the 'modern' or

'postmodern' orientation of the cultural studies invoked, the nation-state can be used as an unproblematized, generalizable given, or it can be treated as an always already problematic site for the specification of local distinctiveness. When constituted as the latter, it no longer implies 'a kind of United Nations plenary session' (to repeat Jameson's phrase) but, rather, a moment in which comparison must be fought for against uniqueness and incommensurability. It would lead to a 'national' cultural studies which foregrounds the unstable, provisional and often jeopardous status of the national itself; a radical cultural studies which not only puts into question the modern assumption of a natural equivalence between the national and the cultural, but also the inherently power-ridden relations between distinct 'national' entities.

THE POSTCOLONIAL, THE DIASPORIC AND THE SUBALTERN

The concept of the postcolonial, however contentious,[60] offers one avenue for interrogating such inter/national relations. What a critical (rather than affirmative) taking up of the position of postcoloniality enables, and herein lies its productivity, is to transpose the idea of cultural struggle to a resolutely transnational dimension: cultural struggle – as well as cultural power – is now located as enacted *between* 'societies' as well as *within* 'societies'. Of course, it is precisely this transnational dimension of cultural struggle which cultural studies still needs to come to terms with. In the international cultural studies *rendez-vous*, the postcolonial speaking position provides the vantage-point from which the universalist tendencies of the ex-nominated dominant can be interrogated from without. In Turner's words:

> I might even suggest that the postcolonial's version of *bricolage* – of continually modifying and adapting what comes to us so that it can be put to use – is not only a valuable tactic for Australians; it might also be salutary for others [read: the British – JS/IA] who can benefit from thinking how their ideas might be put to use in another hemisphere.[61]

However, we want to suggest that 'British cultural studies' can be interrogated not only from the outside from a postcolonial perspective, but also in Britain itself. Indeed, an important aspect of Stuart Hall's work offers precisely the opportunity to problematize Britishness *from within*. From Hall's (recent) work, we can distill a speaking position and discursive trajectory which, when pushed to its limits, can make British cultural studies re-nominate itself *as* British, while simultaneously questioning British national identity. This position/trajectory can be called the diasporic, the development of which, in Hall's case, was spurred by a turn towards 'race' as an intellectual and political preoccupation.

In his earlier work, Hall has apparently been as equally uninterested in deconstructing 'Britishness' as, say, Hoggart and Williams. However, over the years he has become increasingly explicit in the theoretical and political bracketing and questioning of British national identity and its symbolic core: Englishness. This coincided with a growing interest in the question of race and the politics of race and racism in his own work, and in British cultural studies more generally.

In Hall's own account, 'race' entered into the critical concerns of the Birmingham Centre only at a very late stage, and 'it was accomplished as the result of a long, and sometimes bitter – certainly bitterly contested – internal struggle against a resounding but unconscious silence.'[62] The silence, we can extrapolate, revolved around the implicit racial assumptions of Britishness and British identity. The fact that there appears to have been so much bitter contestation around the introduction of 'race' in the theoretical and political space of British cultural studies is indicative, as Paul Gilroy suggests, 'of the difficulties involved in attempts to construct a more pluralistic, postcolonial sense of British culture and national identity.'[63] That is, the subordinate status of blacks in Britain is much more exterior – and thus threatening – to the essential core of Britishness than that of English working-class men, whose belonging to 'Britain' was never in doubt. In a similar way, the (white) feminist introduction of 'gender' as a focal concern in the critical work of cultural studies – something which happened *before* 'race' came onto the agenda – did not require a break-up of British national identity, as the struggle of British women against their subordinate status in relation to British men could be – and was – firmly fought out *within* the British imagined community.[64] This is much more difficult, however, with 'race', as concisely exposed in the title of Gilroy's 1987 book, *There Ain't No Black in the Union Jack*.[65] Gilroy even claims that there are traces of 'a morbid celebration of England and Englishness' in the theoretical traditions of what he calls English – not British – cultural studies, to be found, for example, in Raymond Williams' critical reconstruction of English cultural sensibility in *Culture and Society*. That is to say, what the introduction of 'race' exposes is 'the ethno-historical specificity of the discourse of [British] cultural studies itself.'[66] While Williams (and many others) did not query the naturalized equation of Britishness with whiteness, black British cultural studies practitioners such as Gilroy and Hall have begun to problematize it and, as a result, have started to destabilize the intellectual foundation of British national identity.

There was then, in Hall's earlier work, a certain unconscious complicity with the British or English project, for example in his commitments to marxist theory and the New Left. With respect to the former, Hall now speaks about the need for 'a not-yet-completed contestation with the profound Eurocentrism of Marxist theory',[67] while he recognizes that what he calls 'the moment of the New Left' – in his own narrative the

major political influence which made him turn to cultural studies – is of course 'a profoundly English or British moment'.[68] It is against the background of this personal political trajectory that the introduction of 'race' – marked for the first time with the publication of *Policing the Crisis* in 1978[69] – 'represented a decisive turn in my own theoretical and intellectual work.'[70]

All this, of course, attests to Gilroy's remark that '[t]he entry of blacks into national life is itself a powerful factor in the formation of cultural studies.'[71] Not just *any* cultural studies, we should add, but *British* cultural studies. The large-scale entry of West Indian and Asian immigrants into Britain after the Second World War is a key marker of Britain's history as an imperial nation, and occurred at the time of the break-up of the empire. Here we have a clear instance of the fact that British cultural studies did not only emerge out of forces internal and organic to Britain, but also, in a decisive manner, by the intervention of external forces. Seen this way, the rise of British cultural studies coincided with a crisis of British identity! This connection could only be made explicit, however, by the taking up of the issue of 'race' from a speaking position that can be called *diasporic*: a position which Gilroy has described as held in suspension between 'where you're from' (Jamaica, or, more metaphorically, an imaginary black Africa) and 'where you're at' (Britain).[72] It is the sense of dislocation arising from such a double loyalty which for Hall (and Gilroy) provides the symbolic and affective reasoning for subverting, by relativizing, the self-identity of imperial British definitions of Britishness. This is the experience which Hall has begun to emphasize. As he does so he expresses a feeling of marginalization within British culture missing from his earlier work. For example, he begins the talk 'Minimal selves', published in 1987, with the assertion that '[t]hinking about my own sense of identity, I realize that it has always depended on the fact of being a *migrant*, on the *difference* from the rest of you.'[73] Through this experience of exteriority to the core of Britishness, Hall begins not only a problematization of his own experience of identity as a member of the black diaspora, but also an interrogation of the category of Britishness itself which, up to now, has remained so unqualified – and, indeed, unmarked in British cultural studies.

This new interrogation enables us to distinguish British cultural studies – defined as the specific form of cultural studies which evolved in Britain – and cultural studies of 'Britishness,' or of 'Britain'. Hall's most recent work has taken British cultural studies this one, crucial, step further, opening the way for a study of the peculiarities of 'Britishness' (to hijack the title of E. P. Thompson's 'The peculiarities of the English'),[74] something which, as we have argued, has previously been missing in the cultural studies practice associated with Hoggart, Williams and, in particular, the Birmingham Centre. In other words, what the diasporic position opens up is the possibility of developing a post-imperial British identity, one based

explicitly on an acknowledgement and vindication of the 'coming home' of the colonized Other. Here then we have one possible trajectory for a British cultural studies which does not ex-nominate Britishness but exposes it.

What makes the diasporic position particularly relevant in the context of this essay is that it is necessarily transnational in scope; it provides us with the resource to link Britain to the outside world, a position which makes explicit – through concrete historical connections – how Britain is not a self-sufficient national entity, but has not only been constitutive of, but also – in this postcolonial age – remains deeply interdependent and interconnected with, national others. Such a position, we would argue, can be usefully mobilized in an international *rendez-vous* which takes account of the claim to open-endedness of cultural studies. How then can such a *rendez-vous* operate in practice?

Let us return, first of all, to Graeme Turner's attempts to assert a distinctively Australian cultural studies which has to stake out its own terrain in a field dominated by the hegemonic claims of British and American cultural studies. As we have seen, one of Turner's reproaches against British cultural studies has been its tendency not to name its own 'identity', that is, to repress (and therefore absolutize as universal) its own Britishness. In this Turner sees a continuation of the colonial project: a form of intellectual neo-colonialism. Turner's adoption of a postcolonial position is propelled by the desire to shed off any remnants of colonial dependence, and to assert its independence by emphasizing its own specificity, its own postcolonial identity. What we have here is a distinctive cultural studies project, the construction of an Australian cultural studies which negotiates its identity through the recognition of the historical formation of Australia as, in the first place, a 'British' settler state. (The inverted commas here serve to acknowledge the problematic status of 'British' here – first of all as a national category in its own right and, second, as a recognition that 'white' Australia has been settled by many other national groups, most importantly the Irish but also, among others, the Chinese.) If, for the sake of argument, we describe the postcolonial project as a part of the inventory of an Australian cultural studies, as it is of all postcolonized countries, it would be an enlightening exercise to apply the category to Britain itself. The imbrication of the colonizer and the colonized is deep and complex. A postcolonial investigation of Britain would be just the kind of jeopardous work which we are suggesting for a radical international cultural studies.

The diasporic project and the postcolonial project are two, among many, trajectories of doing cultural studies. They meet in a concern with the effects of colonialism. The diasporic position emphasizes spatial (as well as cultural) displacement within the nation-state. In the hands of Gilroy and Hall, it articulates the experience of negotiated and problematized national identity. The postcolonial position tends to operate on a temporal axis,

emphasizing the historical connection between nation-states, and, as articulated by Turner among others, it tends to be more concerned with the modes of construction of emergent forms of national identity. The diasporic project, then, problematizes 'Britishness' from within, from the experience of the marginalized. The postcolonial project makes it possible to problematize 'Britishness' from without, situating Britain in a postcolonial world. Both projects confront the idiosyncratic specificity of 'Britain'. Of course the same situation can be read as both diasporic and postcolonial. For example, 'white Australia' has been populated by diaspora, but it is also postcolonial. At the same time, a further elaboration of the diasporic project in Australia – which arguably would foreground issues related to Australia's history of non-Anglo immigration, the politics of multiculturalism and its impact on Australian national identity[75] – would usefully complement and complicate Turner's postcolonial project and its preoccupation with the heritage of British colonialism for the construction of 'Australia'.

What we have staked out here then are two formal positions/trajectories – the diasporic and the postcolonial – which are both inherently relational and intrinsically transnational, while acquiring their concrete effectivity only in specific national contexts. The playing out of these two positions/ trajectories against each other can stimulate the reciprocal probing of both projects, the radical and continuous questioning of both national contexts. We think that it is through the elaboration of such positions that the international *rendez-vous* of cultural studies practitioners can attempt to problematize the universalisms of existing core/periphery relations, on the one hand, and avoid degenerating into a polite but ultimately indifferent conversation between particularist, mutually exclusive nationals, on the other. Both the diasporic and the postcolonial give rise to trajectories of intellectual work which, by virtue of their ability to overcome the apparent fixity of the inter/national divide through cross-cultural and transnational comparison, make the most of the provisionalness of constant renegotiation and re-articulation which has been heralded as one of the hallmarks of cultural studies.

However, these two positions are neither sufficient nor without limitations. Not only can they be mobilized to critique each other; but other positions can be put forward which may be able to illuminate the geopolitical and cultural limits of both positions, as well as their enmeshment. One such position, we suggest, would be the *indigenous* (whose voice has been scarcely heard in cultural studies anywhere);[76] another one would be the *subaltern* – a position to be distinguished from both the diasporic and the postcolonial as it tends to be spoken from a very different geo-political and geo-cultural space, namely the 'Third World'. We want to discuss the subaltern position/trajectory briefly to end this article as it clarifies how the

introduction of new speaking positions can further extend the international conversation in the cultural studies *rendez-vous.*[77]

As we said at the beginning, the most subversive 'international' cultural studies *rendez-vous* thus far, in our view, was held in Taipei, Taiwan in 1992. The driving force behind the conference, titled 'Trajectories: Towards an Internationalist Cultural Studies', was Kuan-Hsing Chen, who had worked in the United States with Lawrence Grossberg, one of the organizers of the Illinois conference and one of the editors of the book *Cultural Studies.* This personal detail helps to illuminate the complex lines of connection which exist in the deployment of transnational intellectual practices in the new global capitalist order. Taiwan, after all, occupies an unusual position. It was, apart from Hong Kong (which is itself embroiled in a complicated history of colonialism), the only part of 'China' not over-run by Mao Zedong's communist forces. It therefore remained 'free' and developed a capitalist economic system sponsored by the West. Taiwan is now one of the so-called 'Four Dragons' of Asian capitalism. What does this first international cultural studies conference in a non-western context represent for the present and future state of 'internationalism' in the field?

At the 'Trajectories' conference, speakers came from Taiwan, Korea, Thailand and Hong Kong as well as Canada, Australia and the United States. A number of British speakers, including Stuart Hall, were invited but were unable to attend. This signifies much more than a decentring of British cultural studies. What became clear in the proceedings of the conference was that the absence of representatives from Britain and British cultural studies was hardly noticed, let alone a major topic of discussion. This reflects the current intensifying formation of an Asia-Pacific network of interconnections, where Britain – and more generally, Europe – are hardly relevant.[78] Here, then, a very different configuration of the 'international' is taking shape, where the fine distinctions between neo-colonialist, post-imperialist, postcolonial and diasporic are put to a severe test. New oppositions, new hierarchies are created here: and one of the most subversive aspects of the 'Trajectories' conference may be the very relativization of all discursive self/other positionings within the Anglo-phone cultural studies community.

From a Taiwanese perspective, the United States, Canada, Britain and Australia are all part of the globally dominant English-speaking West. One of the most impressive feats of the conference was the provision of high-tech simultaneous Chinese/English and English/Chinese translation for *all* participants – highlighting the hegemony of English as the naturalized *lingua franca* in international cultural studies encounters (orally and in writing). Furthermore, the very antagonism between Britain and Australia on the grounds of British colonial history and Australian ambitions to declare its independence from its British heritage, stops being relevant here, where the notion of postcoloniality is mobilized primarily with

regard to the fifty-year long Japanese colonization of Taiwan earlier this century. The notion of diaspora, too, in this context appears in a very different inflection, to characterize the relation of Taiwan to mainland China. However, neither 'Japan' nor 'China' exist today outside of the globalizing force of capitalist modernity with which the 'West' has so identified itself. In other words, from a non-western, Taiwanese perspective the categories of postcolonial and diasporic themselves must be interrogated on their western assumptions (or more precisely: on their being predicated on the consequences of western hegemony). But so far such historically specific cultural displacements have been so beyond the repertoire of concerns of contemporary cultural studies that they have barely been responded to in the western, English-speaking mainstream. The very fact that something like 'cultural studies' is now in the process of emerging in newly industrialized countries such as Taiwan and Korea is itself something which needs to be considered further.

We would like to characterize the position of 'Taiwanese' cultural studies in relation to all versions of western cultural studies as *subaltern*. The three positions we have differentiated in this article can be described in this way: the diasporic is *in* but not *of* the West; the postcolonial is *of* but not *in* the West; the subaltern is neither in nor of the West but has been problematically constructed by the West. From the perspective of the (Taiwanese) subaltern, the complicity of the (British) diasporic and the (Australian) postcolonial can be illuminated, in so far as their concerns are shown to be bracketing their common denominator: their belonging to 'the West', and therefore the dominant pole, in the West/Rest divide. However, the subaltern cannot escape from the web created by western hegemony either. Kuan-Hsing Chen has put it this way:

> From the point of view of the geopolitical location within which I am situated, the necessity for an internationalist strategy is not an ideological position, since historical conditions themselves urge such a move. Given the fact that capital, patriarchy and racisms have no nationality, it makes no sense to insist on the priority of nationalism or national identity. (. . .) I am not suggesting that we should give up the local and only opt for the internationalist agenda; I am urging the local struggle should always be conscious about, and possibly forming connections with, the international.[79]

What Chen clearly expresses here is the necessity, from his subaltern perspective, to be both local and international at the same time, or better, to overcome the local/international dichotomy. But this is precisely what all the three positions/trajectories we have elaborated here have in common. Through them, and by juxtaposing their particular inflections under concrete historical conditions in an ongoing *rendez-vous*, we can construct practices of cultural studies which are neither universalist nor

particularist (in the nationalist sense), but are both partial (in a positive [self]critical sense) and at the same time aware of their own distinctiveness in relation to each other. In our view, a cultural studies informed by such positions would match the current condition of the new world (dis)order where the success and failure of European/western modernity (in which British imperialism was a major force) has led to both its globalization and its problematization; where all identities, national or otherwise, are being relativized as a result of their increasing interconnection and interdependence. In such a situation, if we are going to continue to speak to each other, we have to insist on the recognition, in Hall's words, that 'what [we] have to say comes out of particular histories and cultures and that everyone speaks from positions within the global distribution of power. Because these positions change and alter, there is always an engagement with politics as a "war of position".'[80]

NOTES

1 Stuart Hall, 'Cultural studies and its theoretical legacies', in Lawrence Grossberg, Cary Nelson and Paula Treichler (eds) *Cultural Studies*, New York and London, Routledge, 1992, 278.
2 Richard Johnson, 'The story so far: and further transformations?', in David Punter (ed.) *Introduction to Contemporary Cultural Studies*, London and New York, Longman, 1986, 278.
3 Angela McRobbie, 'Post-Marxism and cultural studies: a postscript', in Grossberg *et al.* (eds) *Cultural Studies*, 722.
4 Tony Bennett, 'Putting policy into cultural studies', in Grossberg *et al.* (eds) *Cultural Studies*, 33.
5 Bennett, 23.
6 Simon During, 'Introduction', in Simon During (ed.) *The Cultural Studies Reader*, London, Routledge, 1993, 13.
7 Lawrence Grossberg, Cary Nelson and Paula Treichler (eds) *Cultural Studies*, New York and London, Routledge, 1992.
8 Ibid., ix.
9 Jorge Luis Borges, *A Universal History of Infamy*, trans. Norman Thomas di Giovanni, London, Allen Lane, 1972, 141.
10 Fredric Jameson, 'On "cultural studies"', in *Social Text* 34, 1993, 25.
11 See Ien Ang and David Morley, 'Mayonnaise culture and other European follies', *Cultural Studies*, 3 (2), 1989, 133–44.
12 Cary Nelson, Paula Treichler and Lawrence Grossberg, 'Cultural studies: an introduction', in Grossberg *et al.* (eds) *Cultural Studies*, 5.
13 Jameson, 27.
14 Both the title and the history of this journal are ironical in this context. Before it became an international, US-based journal with its current unmarked, universalist title, it was an Australian based journal which defined itself explicitly in national terms and called itself *The Australian Journal of Cultural Studies*. Among Australian cultural studies practitioners there is widespread resentment about the fact that 'internationalization' has *de facto* meant the (apparently unintended though unacknowledged) Americanization of the journal.
15 Ien Ang, 'Dismantling "cultural studies"?', *Cultural Studies*, 6 (3), 1992, 312.

16 Meaghan Morris, ' "On the beach"', in Grossberg *et al.* (eds) *Cultural Studies*, 456. Morris should have said 'British' rather than 'European', as one thing that is clear is that the international cultural studies 'society' is definitely not a 'European' affair, but, on the whole, confined to English-speaking constituencies. This doesn't mean that there is no cultural studies in other languages than English (there most definitely is), but by and large these other cultural studies traditions are ignored by Anglo-American dominated, English-speaking cultural studies.

17 Hall, 'Cultural studies and its theoretical legacies', 292.

18 Ibid., 277.

19 The construction of these sets of fraternities of founding fathers leads them to bear a striking resemblance to Freud's brotherhood of the primal horde after they have killed and consumed the first Father, thus paving the way for the exchange of women and the establishment of 'society'.

20 Meaghan Morris 'On the Beach', 455.

21 John Clarke, 'Cultural studies: a British inheritance', in his *New Times and Old Enemies*, London, Harper-Collins, 1991.

22 Richard Johnson, 'What is cultural studies anyway?' *Social Text* 16, 1986/7, 38–80.

23 Lawrence Grossberg, 'The formations of cultural studies: an American in Birmingham', in Valda Blundell, John Shepherd and Ian Taylor (eds) *Relocating Cultural Studies: Developments in Theory and Research*, London, Routledge, 1993, 21–66.

24 It is worth suggesting here that this has been an exclusively male genre so far.

25 Stuart Hall, 'Cultural studies and the centre: some problematics and problems', in Stuart Hall *et al.* (eds) *Culture, Media, Language*, London, Hutchinson, 1980; Stuart Hall, 'The emergence of cultural studies and the crisis of the humanities', *October* 53, 1990, 11–23; Stuart Hall, 'Cultural studies and its theoretical legacies', in Grossberg *et al.* (eds) *Cultural Studies*.

26 Hall, 'Cultural studies and its theoretical legacies', 277.

27 Ibid.

28 Ibid.

29 Hall, 'The emergence of cultural studies', 12.

30 Perry Anderson, 'Components of the national culture', in Alexander Cockburn and Robin Blackburn (eds) *Student Power: Problems, Diagnosis, Action*, Harmondsworth, Penguin, 1969, 225.

31 Ibid.

32 Ibid., 269.

33 Clarke, 1.

34 Hall, 'Cultural studies and its theoretical legacies', 285–6.

35 Ibid., 281. In passing here we can note how the Birmingham Centre's preoccupation with the Gramscian idea of the organic intellectual can be read as a transformation of the British traditional literary critical concern with morality. From the point of view of the Birmingham Centre, where the literary critic expressed the morality of the bourgeois class as if it were universal, the organic intellectual of today spoke out for a generic political project (perhaps best associated with diverse manifestations of the 'the popular') and helped to effect a 'better' future. The morality may be different but, in both cases, it remains a central concern.

36 McRobbie, 720–1.

37 Hall, ibid., 282.

38 We tend to agree with Hall, McRobbie and others that the current dominance in

cultural studies of literary scholarship at the expense of sociology, social history and political theory has meant an impoverishment of the intellectual scope and force of a heavily textualized cultural studies.

39 The classic article on this theme is Dick Hebdige, 'Towards a cartography of taste 1935–1962', in his *Hiding in the Light*, London, Routledge (Comedia), 1988, 45–76.
40 'Editors' introduction', in Blundell, Shepherd and Taylor (eds) *Relocating Cultural Studies*, 2.
41 'Introduction', in John Frow and Meaghan Morris (eds) *Australian Cultural Studies: A Reader*, Sydney, Allen & Unwin, 1993, xxvi.
42 Blundell, Shepherd and Taylor, blurb.
43 On the role of the New Left in the formation of cultural studies in Britain, see Ioan Davies, 'Cultural theory in Britain: narrative and episteme', in *Theory, Culture and Society* 10 (1993), 115–54.
44 Hall, 'Cultural studies and the centre', 20.
45 Graeme Turner, ' "It works for me": British cultural studies, Australian cultural studies, Australian film', in Grossberg *et al.* (eds) *Cultural Studies*, 643.
46 Ibid., 643.
47 Of course, the theme of Australia's antipodean relation to Britain did not emerge with Australian cultural studies. It has a history as long as that of the British settlement of Australia and has long dominated Australian intellectual life.
48 Stuart Hall and Tony Jefferson (eds) *Resistance through Rituals*, London, Hutchinson, 1976.
49 See on this theme Jon Stratton, 'Youth subcultures and their cultural contexts', *Australian and New Zealand Journal of Sociology* 21 (2), 1985, 194–218.
50 Dick Hebdige, *Subculture: The Meaning of Style*, London, Methuen, 1979. The very title of this important book could misleadingly suggest that 'style' has a universal meaning.
51 Thus, while Thompson's *The Making of the English Working Class*, perhaps because historians are taught always to be as denotative as possible, was presented as an empirically specific history of the making of the English working class, Williams' historical reconstruction of British intellectual culture was just called *Culture and Society*, not *British* (or *English) Culture and Society*.
52 Turner, 'It works for me', 642.
53 Hall, 'The local and the global', in Anthony D. King (ed.) *Culture, Globalization and the World-System: Contemporary Conditions for the Representation of Identity*, Basingstoke, Macmillan, 21.
54 Turner, 'It works for me', 641.
55 Ibid., 650.
56 There is a long history of Australian cultural sentiment in this respect that goes under the phrase 'cultural cringe', introduced by Arthur A. Phillips in his *The Australian Tradition: Studies in a Colonial Culture*, Melbourne, University of Melbourne Press, 1958.
57 Graeme Turner, 'Of rocks and hard places: the colonized, the national and Australian cultural studies', *Cultural Studies* 6 (3), 1992, 427.
58 Graeme Turner, *British Cultural Studies: An Introduction*, Boston, Unwin Hyman, 1990.
59 The very applicability of the category of the postcolonial to contemporary Australia is, understandably, rejected by Aboriginal people, for whom living in 'Australia' means living in a permanently colonial condition, *never* postcolonial.

60 See Vijay Mishra and Bob Hodge, 'What is post(-)colonialism?', in *Textual Practice* 5 (3), (1991), 399–414.
61 Turner, 'Of rocks and hard places', 432.
62 Hall, 'Cultural studies and its theoretical legacies', 283.
63 Paul Gilroy, 'Cultural studies and ethnic absolutism', in Grossberg, Nelson and Treichler (eds) *Cultural Studies*, 190.
64 See, on this theme, Catherine Hall, *White, Male and Middle Class*, Cambridge, Polity Press, 1992.
65 Paul Gilroy, *There Ain't No Black in the Union Jack*, London, Hutchinson, 1987.
66 Gilroy, 'Cultural studies and ethnic absolutism', 187.
67 Hall, 'Cultural studies and its theoretical legacies', 279.
68 Ibid., 283. In his interview with Kuan-Hsing Chen (in this volume), Hall complicates this account by emphasizing the significance of the fact that many leading New Left activists were actually *not* English. However, this does not invalidate the fact that, as a political movement, the New Left operated and intervened in a profoundly British conjuncture.
69 Stuart Hall, Critcher, C., Jefferson, T., Clarke, J. and Roberts, B., *Policing the Crisis*, London, Hutchinson, 1978.
70 Hall, 'Cultural studies and its theoretical legacies', 283.
71 Gilroy, 'Ethnic absolutism', 190.
72 Paul Gilroy, 'It ain't where you're from, it's where you're at . . . : the dialectics of diasporic identification', *Third Text* 13, Winter 1990–1, 3–16.
73 Stuart Hall 'Minimal selves', republished in Ann Gray and Jim McGuigan (eds) *Studying Culture: An Introductory Reader*, London, Edward Arnold, 1993, 134.
74 E. P. Thompson, 'The peculiarities of the English', reprinted in his *The Poverty of Theory*, London, Merlin Press, 1978, 35–91.
75 See for example Stephen Castles *et al.*, *Mistaken Identity: Multiculturalism and the Demise of Nationalism in Australia*, Sydney, Pluto Press, 1988.
76 One of the very few examples would be the work of Gail Valaskakis, who has written to give voice to a native American perspective. See for example her article 'The Chippewa and the Other: living the heritage of Lac du Flambeau', *Cultural Studies* 2 (3), 1988, 267–93. In Australia, Aboriginal studies is still very marginal to the concerns of Australian cultural studies, though growing. See, however, Eric Michaels' work, for example his *For a Cultural Future*, Sydney and Melbourne, Art & Text Publications, 1989. See also note 59.
77 We borrow this term from the Indian work gathered around the influential journal *Subaltern Studies*, perhaps best known in the West in relation to the work of Gayatri Chakravorty Spivak. See for example Ranajit Guha and Gayatri Chakravorty Spivak (eds) *Selected Subaltern Studies*, New York, Oxford University Press, 1988.
78 Another major absence was Japan, the significance of which is extremely important for any future regional development of cross-national dialogue in cultural studies. We cannot go into this issue – i.e. the place of 'Japan' in the Asia–Pacific region – here. Work relating to this is currently being undertaken at the Program for Cultural Studies at the East–West Center, Honolulu, Hawai'i.
79 Kuan-Hsing Chen, 'Voices from the outside: towards a new internationalist localism', *Cultural Studies* 6 (3), 1992, 481–2.
80 Stuart Hall, 'The meaning of New Times', in Stuart Hall and Martin Jacques (eds) *New Times: The Changing Face of Politics in the 1990s*, London, Lawrence & Wishart, 1989, 133.

Chapter 19

Cultural studies and the politics of internationalization

An interview with Stuart Hall
by Kuan-Hsing Chen

Editor's note
'Trajectories: Towards a New Internationalist Cultural Studies', a two-week long international conference organized by the Institute of Literature, National Tsing Hua University, took place in Taipei, Taiwan in July 1992. It was the first cultural studies conference outside the English-speaking world, and its aim was to facilitate dialogues across borders, breaking down the boundary of the political nation-state. This interview, addressing the problems of the internationalization of cultural studies, was conducted almost immediately afterwards in August, and evolved from debates generated by the conference.

KHC: To address the problematics of internationalization of cultural studies, we might as well use the 'Trajectories' instance as a reference point.[1] I think you have read through some of the manuscripts presented in the conference.

SH: Yes, very quickly.

KHC: The first week of the conference was largely a historical tracing of the earlier work of cultural studies, of the historical formation of cultural studies in different contexts, and the critical evaluation of this formation itself. The second week opened up issues, because things like the Asian questions emerged. Can you reflect on it?

SH: What struck me was exactly the two stages of the conference which you refer to. Cultural studies, in its earlier stage, was very much lodged in a 'western' project: a project of critique of the West, but nevertheless within a western intellectual and philosophical framework. What arises now are all the questions about establishing reference points for a new audience, and for cultural workers and intellectuals, formed in different traditions, in different relationships to 'the West'. That's a

This interview was transcribed and edited by Naifei Ding and Kuan-Hsing Chen.

process of cultural negotiation: one can see a set of Asian questions emerging, as Asian contributors begin to speak out of a different context; and the western contributors then begin to reflect on cultural studies in a very different way, as a consequence of that shift. Cultural studies today is not only about globalization: it is being 'globalized' – a very uneven and contradictory process, which is not just a question of substituting one problematic for another and is one which we are only just beginning to understand.

What interests me about this is that, everywhere, cultural studies is going through this process of re-translation. It's going through the process of re-translation wherever it is being taken up, in the United States, Australia, Canada, particularly. Each of these places is involved in its own re-translation. In addition to that, there is also a translation between generations, even within British cultural studies itself. Cultural studies now is in a very different position from how it was when the Birmingham Centre was going. Even the first decade after the initial work of the Centre, the 1980s, was very different. So I am struck by the fact that, in a way, internationalization poses problems on a bigger scale, but not different in kind, because translation has to go on, wherever practitioners appropriate a paradigm and begin to practise within it, transforming it, at the same time, in terms of their own concerns. I like that sense of open-endedness, of opening to new contexts, to new materials, new situations, new cultures, a new symbolic universe, to new sets of problems, a new cultural politics, which emerge from the 'Trajectories' papers.

KHC: Can you specify the notion of 'translation'?

SH: The notion of 'translation' is close to 're-articulation', transcoding, transculturation, all of those concepts which we have used in other contexts. It is, of course, used in quotation marks because it doesn't mean that there is an original from which the 'translation' is a copy. All of these words were conceptualized at a time when one still held on to a notion of teleology. One isn't using it in that way any longer. For instance, identity comes out of an essentialist, teleological discourse; when I use the term, 'identity', I don't mean it in that sense, I mean identity, now, in a much more positional way, without any fixed origin. But nevertheless, what else can you say? So I say 'identity' with a quotation mark, I put it 'under erasure'. And I use 'translation' in quotation marks too: translation as a continuous process of re-articulation and re-contextualization, without any notion of a primary origin. So I am not using it in the sense that cultural studies was 'really' a fully-formed western project and is now taken up elsewhere. I mean that whenever it enters a new cultural space, the terms change; and, exactly as you find in any re-articulation and disarticulation, some elements remain the same, because clearly there are certain points,

certain terms and concepts in common, but then there are also new elements which change the configuration.

KHC: The new configuration seems to have left the 'originary' movement of British cultural studies, with everything now flowing in different directions. It seems 'British' cultural studies is no longer needed.

SH: Yes, sure. I understand declarations of independence of that kind, although I think they misrepresent what new conjunctions are really about – they are never absolute ruptures, total breaks. Undoubtedly, things have been heading in that direction in American cultural studies too. If you need British cultural studies, it's because good work is still being done there; you don't need it as the 'origin' of anything. If you want to reconstruct the genealogy, there are texts there, which it is necessary to work through. You can recover what you need from that moment through textualization and re-textualization. As I say, you need British cultural studies to the extent that good work is being done there now, but this work is already very often different from, in a different space from, what was originally done. I am not suggesting that all the links are broken; but British cultural studies in the 1990s is very significantly different from British cultural studies in the 1970s. It is overwhelmingly preoccupied now with new questions, such as national culture, ethnicity, identities. This is what British cultural studies people are working on now. Everybody is working on national formations and national identities, on race, ethnicity, postcoloniality, imperialism, and so on. And that's a very different inflexion from British cultural studies in the early stages, which is open to the critique which Paul Gilroy, among others, has made very powerfully, of being very Anglocentric.

I recently did this memorial lecture on Raymond Williams, called 'Culture, community and nation'.[2] In the first half, I talked about the importance of Williams' work on culture, on structures of feeling, and on 'lived communities', and so on. But in the end I offered a critique of that conception of culture, because of its closed nature, because of its reconstituting itself as a narrow, exclusive nationalism. The lecture explored hybridity and difference, rather than 'whole ways of life', etc., which can have a very ethnocentric focus. A lot of Raymond Williams' work is open to the critique of ethnocentrism, just as he is open to the critique of being oddly placed in relation to feminism. These absences don't mean that one has to repudiate the work. I've always opposed that absolutist way of approaching such questions, where you either advocate everything a writer says, in the manner of the convert or disciple, or you have to repudiate everything. Williams has his strengths, his important insights; he is a major figure, etc. But from the position of how British cultural studies is being practised now, one sees Williams' work differently. One begins to engage with it critically, rather than celebrate it or venerate it.

KHC: One of the important things for those who follow a Gramscian tradition of cultural studies, at this critical moment, seems to be the attempt to 'remake' the question of politics.

SH: That's partly a question of the nature of the formation in which cultural studies operates, rather than a question of the origins. Even in its different manifestations, from the 1960s onward in Britain, cultural studies has always reflected on the relation between culture and politics, the symbolic and the social, in a distinctive way. It is not that other forms of cultural studies need to borrow or imitate that, but they need to think about how that articulation can be maintained in different contexts. We are talking about how cultural studies is distinctive as an epistemic field, not about whether it is British. It is not a question of national identity, but rather, in a Foucauldian sense, of epistemic space. In its epistemic space, one can't deny that, in the British case, because of the early relation between cultural studies and the New Left, the social movements, post-coloniality, feminism and so on, the political question has always been central to cultural studies. Even when debate over specific issues was going on within the Birmingham Centre, everybody knew that the question of cultural politics was central to our concerns and practice. Not a particular sectarian political position – this we always avoided – but the relationship between culture (meaning signifying practices) and power: cultural politics. In a sense, if there is anything to be learnt from British cultural studies, it's that: the insistence that cultural studies is always about the articulation – in different contexts, of course – between culture and power. I'm speaking in terms of the epistemological formation of the field, not in the sense of practising cultural studies.

KHC: This is a problem in so far as it seems that the internationalization of cultural studies has somehow tended to undermine its political edge. What emerged in the 'Trajectories' conference was a concern with that, and thus an attempt to say what is or what is not cultural studies, in order to regain that political edge. We understand very well that, especially in the American context, in the process of institutionalization in the academy, cultural studies can easily lose that 'edge'.

SH: As you know, I have always been slightly wary of defining too precisely what is and what isn't cultural studies, because of the danger of 'policing' its boundaries. I suppose that reluctance is particularly appropriate for me, in relation to early British cultural studies, because if anybody is going to find themselves in an 'originary' position, as it were, to pronounce what British cultural studies was and was not, I'm the person in that position. And the temptation is always to police it in the name of some 'essence', which was always there. I am in a particularly difficult position because, if there was a beginning, I was there. That is not to say that there

isn't a question of what belongs within this problematic, and what belongs to a different problematic. After all, cultural studies isn't, and shouldn't claim to be, all of human knowledge. We don't have to subsume everything into it. It has to have a distinctiveness; within that distinctiveness, there are very different practices. So I think the question has to be asked, without being answered in a unitary and regulative way, 'what is distinctive about a cultural studies perspective?' I think the question of the politics of culture or the culture of politics is somewhere close to this notion, of what is at the centre of cultural studies. There are other elements, breaking across the traditional ones: for example, the attention to all of those voices, positions, experiences which have been ruled out of any dominant intellectual and political formation, etc. One could gather a number of broad structuring principles of the field without operating them in a 'policing way'. I am not interested in 'policing' a politically correct cultural studies. But I think the question of its distinctiveness as a formation is important.

Let me say something specific about the American scene. In a way, the question of definition in the American field is the paradigm instance. The American field is huge – for certain peculiar reasons, to do with the pressures on critical intellectuals in the American setting, people opt to locate what they are doing under a cultural studies umbrella. In the States, whatever you are doing, if you want to do critical work, it is called 'cultural studies'. The field is enormously heterogenous and massively funded, in comparison to the United Kingdom. The number of cultural studies posts in Britain remains very small, (despite the recent increase) when compared to the number of fully tenured jobs in the States. So in a way, the States is the leading case now, not Britain. In terms of current practice, America dominates. Thus, what cultural studies is becoming in the American context is the key question. And there, one has to recognize that, just as early British cultural studies was influenced by the fact that it was operating on the ground of the wider political terrain in Britain, the ground where the first New Left (1956) was practising, etc., you have to take into consideration what the situation is of the left, the conjunctions, the alignment of different social and intellectual forces in American society, the curious isolation of American intellectuals within the massively well-established confines of institutional academic life, before you see that when cultural studies mainly forms up on academic terrain, as is the case in the United States, it is extensive but isolated, huge but boxed in. I think American cultural studies is taking the inflection of the academic space in which it is obliged to operate. One knows that the situation of the American left is pretty difficult and complex. If you think of cultural studies in the Asian context, in the very dynamic and rapidly changing scenario of East and South-east Asia, with its distinctive brand of capitalist modernity, cultural studies is operating on the ground of an enormously active and dynamic political space, which is breaking out, contesting and

shifting everything around. American society doesn't feel that way. Indeed, in the period of this Clinton administration, it feels like a deeply reactionary form of free-enterprise modernity.

One always has to remember that cultural studies is not on an island on its own. It takes its coloration from social and cultural forces, especially if you are interested in the political articulation of cultural studies. One has to have in mind the cultural and political space in which cultural studies is obliged to operate. I think that is one of the reasons why cultural studies has very often tended to take this over-formalist turn, in the States, which I've criticized in a number of places. I don't mean that all American cultural studies is like that, but that's a very prominent tendency in the appropriation of all the major paradigms in American critical cultural theory. Gramscian cultural studies in America takes a kind of culturalist/ formalist turn; Derrida in the Yale school takes a deconstructive, formalist turn.

Take Foucault. Foucault is not a political activist in any simple sense, but when you read the Foucault interviews, you know at once that his work has a bearing on resistance, on sexual politics, on '1968', on the debate about the West, the nature of state power, and the Gulag; it has political implications. Wonderfully agile Foucauldian studies can be produced inside the American academy which invoke power all the time: every second line is power/discourse, power/knowledge, etc., whilst the actual integument of power is absolutely nowhere located in concrete institutions, as it is in *Discipline and Punish* or in the disciplinary regimes of knowledge, as it is in *The Birth of the Clinic*.

Another problem is related to the question of internationalization. In the States, you can find, in one room, largely white, cultural studies people talking about the postcolonial problem, while next door the Afro-American studies department has no money, no PhD programme, no books, no students. In this curious discrepancy, the problem becomes intellectually abstracted. So I think some of the most interesting work in the American context is the rethinking of American cultural studies in relation to American popular culture, in relation to the distinctive philosophical traditions in the American space (Cornel West's work, for example, on pragmatism), in relation to critical forces, social forces on the ground, and social movements, wherever they are, in American setting. You are finding the same thing, too, in Asia. Cultural studies is transformed once you begin to think what the Taiwanese situation is, what 'the nation' means there; how internationalization and the new global economy is transforming your society. Until you go to cultural studies through these structures, not from within cultural studies itself but from these externalities, you don't really translate it; you just borrow it, renovate it, play at recasting it.

KHC: Again, within the American context, there is an implicit battle

going on, over defining the boundaries and direction of cultural studies. For instance, Cindy Patton's work on AIDS and cultural criticism, in relation to international health policy, and Mark Reid's work on black nationalism and neo-conservatism are genuinely political work. There is a kind of a struggle not so much to police the boundaries, but to re-inject political issues onto the agenda.

SH: In that context, I think there are very significant new developments. Do I have a reservation about them? I do, because the constant pressure, not just to do good new work but always and only to do so by repudiating what went before – a sort of desire to advance only by way of wreaking an Oedipal revenge (this is very pronounced in Australian cultural studies, quite unnecessarily) feels to me like struggling over a dead body, which if only you could claim it, retrospectively, would validate what you are doing. Whether that is any way to conduct what we have agreed is a necessary struggle to renew cultural studies, I don't know. Not everything can fit in the house, I know, but I sometimes feel it's a struggle over the remains, over the corpse.

I don't really want to write about cultural studies, as such, any more. I don't mind writing about the past, in the sense that certain moments and practices are worth recovering, just as part of the story. We tried to do something innovative, for instance, at Birmingham, institutionally. I don't think anybody has come close to the Centre, in terms of producing knowledge through collective working practices. That was possible then, but would be impossible in Britain now. It's an experience that is worth preserving. There was difficulty, not just strength, so I write about cultural studies, to remind you what has been the agenda, the repertoire, what experiences we learned from. It's like writing about the past in terms of the struggle of a movement. But I don't want to write about what is and what isn't cultural studies, in a prescriptive way. Personally, I want to do some new work, to use cultural studies to open up new questions about globalization, new questions about ethnicity. I want to move it on. I don't want to wrangle with it. That is just a personal feeling. In the field as a whole, there is space for that continuous work of boundary definition; that will always go on. You can't have an intellectual field which doesn't have some sort of structure to it. That is necessary work. Myself, I don't want to do it. I don't want to be invoked in that patriarchal role. I want to leave that space, to come around from the back, look at the things we never talked about before . . .

KHC: The issue seems to be one of how to think effectively about which directions to go in, especially in the process of internationalization. New issues, new areas emerge, and they seem to require negotiation and translation, to open the field up.

SH: There certainly are interesting aspects to this question and this is an important moment at which to take it up. Certain figures at this moment are, exactly, transitional figures. They are deeply embedded in both worlds, both universes. They are what I would call truly diasporic intellectual figures, constantly translating between different languages, different worlds: Ien Ang in one sense, Tony Bennett in another, Edward Said, Gayatri Spivak, Homi Bhabha, have this 'double space'. They are located on the cusp of a shift, the shift, economically, politically, culturally, to the periphery: especially, in your case, to the Asian Pacific rim. It is very important that cultural studies can make that translation. It was always a question for many of us, me included, whether cultural studies wasn't in some way so deeply embedded, even in an unconscious way which we couldn't understand, in the problematics of western modernity, that it was untranslatable to other cultures; that there couldn't be an African or Asian cultural studies. Of course the situation has changed. Globalization itself, the historical process of globalization, means that those boundaries are not where they were, even when cultural studies started. It's not the 1960s any more. There are practically no serious, well-established forms of culture in the modern world that are self-sufficient and autonomous, out of touch or out of communication with what is going on elsewhere. Economically, or politically, those barriers are rapidly breaking down. I think those are, in a sense, the material conditions that allow the internationalization or glob-alization of cultural studies to come about, because all the problems we are writing about are global problems, which they weren't – or weren't in the same way - when we began. When you think about it, initially cultural studies was very much locked into an argument about British society, British culture, British literature, etc. Those are just not what the questions are anymore, or rather, the question of 'Britishness' can only even be framed in relation to its 'others' within the global cultural system. So I think we are being pushed towards a more global set of questions, as it were. And that presents new problems, new difficulties of translation; but it also presents new opportunities, because it is possible for us to speak, to a certain extent, a common language, across boundaries and from different positions, about what we are dealing with, in terms of the shaping of culture, processes which no longer belong to, or can be settled within, the framework of any one national culture.

KHC: In the 'Trajectories' context, a wide range of issues have been taken on board: gender, race and ethnicity, the nation-state and globaliza-tion, etc. At the 'Trajectories' conference, sexual politics was one of the most prominent themes, no longer just a token issue. But conversely, one of the self-critiques of that conference was that issues of class were not given proper emphasis. The restructuring of class formations, the continuing unequal distribution of global resources and wealth seem to force us to

address questions in that direction – in terms of the international flow of capital which, in various instances, restructures local class formations. Maybe you have something to say in terms of the relative absence of class analysis in recent cultural studies.

SH: Sexual politics has had a profound theoretical influence on cultural studies. That has meant that cultural studies has had to try to come to terms with, and define the nature of its appropriation of, concepts from psychoanalysis, the unconscious, etc. Cultural studies has been transformed by the whole question of the subjective, symbolic dimension. Earlier cultural studies, with its more strongly marxist-inflected position, was a bit dubious about all that. Cultural studies was more open to those questions than any other intellectual formation, but it was always, at the same time, concerned to keep those issues 'in their place'. That approach is gone, finished. And that does mean a radical openness, in terms of theoretical positions. There may be a line to be drawn between cultural studies and deconstruction, cultural studies and psychoanalysis, cultural studies and certain types of feminism. I know the terrains are not exactly the same, they do not exactly correspond. But there is also a massive overlapping. In my view, we need to increase the overlap rather than police the boundaries.

Then, the question of class. I do agree with you that the consequence of 'bending the twig', in the Althusserian sense, against class reductionism, against class as the master category, has been to completely silence the question of class. It's as if the question of class can only be addressed seriously if it is occupying a privileged theoretical position! As if there is no way of thinking about it in a more decentred way. I do think that that's work that urgently needs to be done. The moment you talk about globalization, you are obliged to talk about the internationalization of capital, capital in its late modern form, the shifts that are going on in modern capitalism, post-Fordism, etc. So those terms which were excluded from cultural studies, in what I would call the middle period, when we were trying to get rid of the baggage of class reductionism, of class essentialism, now need to be reintegrated; not as the dominant explanatory forms, but as very serious forms of social and cultural structure, division, inequality, unevenness in the production of culture, etc. – which we just don't have an adequate conceptual language to talk about. One of the directions in which cultural studies will go, I think, will be to take those questions more seriously than it took them in the 1970s and 1980s. But, of course, in a different way even from where they were still hovering around in cultural studies during the Gramsci period. They will be more central than they were in the 1980s. In fact, I am sure that we will return to the fundamental category of 'capital'. The difficulties lie in reconceptualizing *class*. Marx, it seems to me now, was much more accurate about 'capitalism' than he

was about class. It's the articulation between the economic and the political in marxist class theory that has collapsed.

KHC: Does this also have something to do with the identity, the class positioning, of cultural studies practitioners?

SH: People's identities are tied up with their intellectual positioning. Some people, as it were, need to take their distance from a given positioning in order to win themselves intellectual space to do their work. This is a particular sensitivity in Australia. Australia has always had a sort of dependent relationship to the British and European cultural formations. In order for people practising cultural studies there to win space, they are going to adopt quite a sharp, polemical edge against certain features of what has been held up to them as the model. The issue is how they position themselves and how that affects the work that they do.

The further question has to do with the class positioning and class formation of cultural studies practitioners in the larger sense. The majority of these people are intellectuals: middle class, highly educated, with a significant accumulation of cultural capital, etc. And you are right to notice that the important and critical emphasis on 'the personal is the political', 'the subjective is important', means that you sort of have the licence to inject your own personal experience into your intellectual work. There are some strengths to that, because it breaks down that old objectivist language that we all used to speak (or rather, ventriloquize) classes and structures, etc. But one has to be always aware of the peculiar shape of one's own existence. Ideas are not simply determined by experience; one can have ideas outside of one's own experience. But one also has to recognize that experience has a certain shape, and unless you are quite reflexive about what the boundaries of your experience are (and the need to make a conceptual shift, a translation, in order to take account of the experiences that you personally haven't had) you are likely to speak from within the continent of your own perspective, in a rather uncritical way. I think that does go on in cultural studies today.

Let me refer to another element that has contributed to that, and that is the return of the literary. 'The literary' is always speaking in the personal voice, speaking in relation to subjectivity, etc. Literary theory has a curious relationship to cultural studies, both in and out of it. British cultural studies, in its earliest days, was profoundly formed by the literary critical tradition. At the same time, we had to polemicize against it, in order to say that there must be some 'controls' on the way the literary evidence is used in the analysis of cultural formations. As Raymond Williams said, literature, after all, is the product of a highly hegemonic operation, the selective tradition. I think there has to be some limit to what I would call the subjective explosion. One needs to be aware of both its strengths – it gives one a kind of internal 'inside' insight into those cultural processes

that you don't get any other way; on the other hand, we are culturally formed, cultural subjects, and, as such, we have our limits. We are trying to understand cultures which are different from us, which have a different formation from us. The need for that analytical, theoretical and imaginative leap into experiences which are different from ours is one which I think cultural studies has lost the impetus to make. In the early stages, perhaps we spoke too much about the working class, about subcultures. Now nobody talks about them at all. They talk about myself, my mother, my father, my friends, and that is, of course, a very selective experience, especially in relation to classes and the society as a whole in which we operate, and which we are trying to transform. But I think the question of globalization, which raises issues of relativism, comparative questions, differences as well as similarities, will help in that. I think the re-theorizations of the nature of the disposition of social positionality within social structures will necessarily touch on questions larger than our own personal experiences, while never letting go of the subjective dimension. Our own personal experiences intersect with that, but they don't cover it.

These are important methodological issues for the agenda of cultural studies' future. They touch on the related issue of history and cultural studies, which remains unresolved. We know what it is to produce cultural studies after the linguistic turn. But the question of a historical approach remains unresolved.

KHC: Implicitly connected to that seems to be the constant tension between choosing the analytical objects of, say, literature and popular culture. When in his 'Coming out of English' paper Tony Bennett talked about the tradition of British cultural studies as rooted in English, he was actually talking about the literary tradition. But there are also others who choose to analyse popular culture without resorting to the literary, and one can easily criticize the purely textualist analyses of literary high modernism. So the tension is not over and done with.

SH: It's not over and done with. It depends on how you name it, because, in a sense, there is more than one object of analysis at issue here. When Tony Bennett talks about 'English', that is part of his critique of cultural studies. He wants to say that British cultural studies was very much formed in the argument around Leavis, Williams, etc., which is essentially a kind of literary-critical-moral argument; and his critique is that it hasn't lost that dimension. I think that's true, although I would want to add that that is one of the things that keeps alive certain cultural and political questions. The debate with Leavis wasn't, after all, about Leavis's analysis of D. H. Lawrence, but about Leavis's critique of advertising, of the literary tradition, popular fiction. It was about the nature of English culture as a whole. Perry Anderson has written about the way in which literary criticism functioned as a displaced arena, in which these questions of culture could

be posed, in the absence of a British sociology, and with anthropology dominated by the colonial framework, and British philosophy immersed in its empirico-linguistic black hole. So literary criticism became the space in which those things were debated. So you can't get rid of it just like that. It is written and inscribed in the formation.

I think the question of the literary is much larger than the question of the role of literary criticism in British cultural studies. It's much stronger in the American context than in the British context. It includes the American expropriation of deconstructionism, Paul de Man and the whole Yale school, it's textualism run wild. That was never the literary tradition in Britain. We were never attached to a narrowly textual definition of language: Raymond Williams opens the text to writing of different kinds. You can say Raymond was lodged in the English literary tradition; he certainly was. But he was struggling against it, to open the notion of literature as 'forms of writing'. He is the person who *most* polemicized against a narrow definition of literature. Whereas what I would call the literary, which isolates the text from any other determinations, is a form of literary textualism which is not to be associated only with the influence of British 'English studies' on British cultural studies. It affects the nature of cultural studies in general at the moment. We do, in my view, need to reopen the question of the relationship of critical theory in the literary field to cultural studies. That is, to me, one of the most complicated boundary lines of differentiation to be drawn; more difficult than the boundary with feminism or with psychoanalysis. This is not to say that I want to move away from 'the textual moment', or the notion of textuality – far from it. In my own work, the textual is the moment when culture and the discursive is recovered; and that moment is absolutely decisive for me – endlessly displacing any kind of homogeneous return to the economic or the political, the material in some simple vulgar sense. To me, cultural studies is impossible without retaining the moment of the symbolic; with the textual, language, subjectivity and representation forming the key matrix. The moment of the symbolic is critical for me. Nonetheless, I try never to think of it as autonomous. It's never self-sufficient. That's where I would draw the line. I think certain literary 'takes' on cultural studies do (in effect) treat the textual moment as autonomous.

KHC: That might explain the productivity of cultural studies, as being precisely the result of the tensions operating at different levels of abstraction. The tension with the American textualist approach, the tension within a subject-position (such as feminism), tension between East and West, etc. So what makes the field open and productive is the tension going on, from beginning to end.

SH: Absolutely. That is the point that I tried to make in the last cultural studies conference in Illinois. Living with the tensions, not trying to resolve

them. Of course, trying to, struggling to think your way through. But if thinking your way through is done with the illusion that, somehow, finally, the tension is going to be resolved, and cultural studies is going to be well defined, a pacified field, forget it. That's the end! Cultural studies has always lived off the tension inside the subject, as well as off those out there, in the field, in the culture, between different cultures, between different academic traditions, between different theoretical positions. That has always been, it seems to me, what has kept pushing it on. The cultural field is a field of proliferating antagonisms. Antagonism is the only way in which the endlessly contradictory terrain of cultural production and articulation can be grasped and grappled with, within theoretical reflection. Try to grasp it in any other, monistic, teleological, Hegelian, positivistic, or evolutionary way, and you lose the two ends of the chain. What I said earlier, about being careful about defining a field, but not policing its boundaries, has to do with that. Of course, that presents problems, because it means the field never settles down – and that is a problem, institutionally. In the new research-funding regime in British universities, there isn't yet a category for cultural studies research, and this lack of definition weakens its institutional position. This is the 'down-side' of working in a field which has no settled boundaries, no stable disciplinary definition, no settled methodology.

KHC: From what I can see, the institutionalization of cultural studies is going on in Britain at the moment. For instance, CCCS no longer exists – it is merged with sociology and is now called the Department of Cultural Studies. Can you explain or do you have anything to say about the situation?

SH: We struggled in the 1970s and early 1980s to get some cultural studies posts, in some departments, established, and one or two were. But the attack on the universities under Thatcherism, from the early 1980s, meant there was no expansion, no new areas being supported.

Since the beginning of the 1990s, there has been a huge institutional spurt in cultural studies in Britain. This is related to the rapid expansion which has taken place in British higher education. There has been a recognition that Britain is at the absolute bottom of the international educational ladder. The government reversed their position, and started to push for expansion of numbers, with all the old polytechnics becoming universities, so that there is now one unified system. Overnight, the old polytechnics were made up into universities. Of course the undeclared aspect of that strategy is that it will then re-create a two-tiered system, within the 'unified' higher education system: so there will be elite universities that will do all the research – Oxford, Cambridge, the Imperial College, Essex, etc., – and the rest will teach their hearts out, to all these masses of students who are now being encouraged to come in. But there is

no question, student numbers have been expanding; between 1990 and 1992 the number of students in higher education in Britain jumped about 16–17 per cent. Students have begun to pour in, adult students have been coming back. There's been a turnaround. It's not being funded, but there has been a turnaround. Now, what happens, what do these students want to do? They don't want to do the traditional disciplines; some of them want to do business studies, administration, that whole entrepreneurial ethos, but a lot of them want to do what is, in effect, cultural studies; they want to do media studies, media and culture, representation, etc. Since expansion is being funded in relation to student members, we are in a sort of market situation, if students want to do that. In the early 1980s, the government was cutting back: no more expansion in humanities and social sciences, only in science and technology; but now all of that is forgotten. It's a kind of market-driven Americanization of education, but it means it is much more student-sensitive. So, many of these new institutions don't necessarily know what cultural studies is, but they've got to get the students in, in large numbers, and cultural studies is what the students want to do. Suddenly, if there is any job, it's going to be in cultural studies. Suddenly everybody is creating cultural studies departments – they are expanding, they have been 'highlighted'. We are only just getting accustomed to the fact that our graduate students, who used to have to pretend to be sociologists or something else, are now able to get cultural studies jobs, maybe not in an actual cultural studies department, but nonetheless there are now cultural studies posts advertised, which there never used to be. This is a very new situation, but it does mean that there is a funny, American-style expansion going on in Britain. The expansion is really very new, and who knows how long it will last.

KHC: During the 'Trajectories' conference, your work was heavily cited as an influence on the younger generation. When you think back, could you have predicted the take-off of cultural studies and the direction it is going in? Can you project any possibilities for the future?

SH: The answer to both questions is really no. I couldn't have predicted it. You have to remember, that although it feels, to you, as if I'm in that position, in relation to your generation, I feel it's the generation before me, I think it's Raymond who is 'responsible'. Raymond has an important essay, in which he slightly takes issue with a number of us cultural studies people, to remind us that cultural studies has a pre-history, which people who think that cultural studies was suddenly born in Birmingham in 1964, forget; *all* of us, we are serially placed in relation to what went before us, which formed us. We have to think of this as a process which passes through us, with us as the bearers, the sites. Of course that doesn't mean that we are just ciphers; the citing of earlier work in a particular essay, by a particular person giving the earlier thing a certain shape. We transmit it in a

certain way, differently from how it would be transmitted if somebody else did it. So I'm not trying to erase responsibility for that citing in my own work, but the process is very much larger than that, it has always been more heterogeneous, more diverse, than it could ever be in the keeping of any one single person. I look back to Raymond, but cultural studies is not Raymond any more, it couldn't be retrospectively squeezed back into his bag; therefore it's not me, it can't be squeezed back into my bag either. That's just to remind you that all of us have a pre-history, we live that moment, within different histories and futures, but the next generation will perhaps talk about you in exactly the same way. You have to live that thing which is inside you, but outside you as well, to live that space in which you will be interpellated in your own way.

The reason why I said no to the second question is that we all have inklings about possible future directions, but not in any hard-edged way. Sometimes I have a curious, sort of anticipatory sense of some of the directions of cultural studies, without really knowing why. Nowadays, in Britain, everybody's writing about questions of identity, race and ethnicity, writing about the nation. When I started writing about Thatcherism, I knew we were actually also writing about questions of race and ethnicity, quite a long time ago now. Now nobody's writing about anything but the post-colonial question – but that's actually a very recent development. I am not trying to claim any hindsight, I just mean if you are working in the field, you sort of feel when new tendencies take off, you feel the germs growing, you find yourself asking, 'Why is everybody suddenly talking about that? What a very funny thing to be going on.' You should just follow your instincts, because quite often, two years later, these things turn out to be the issues that everybody is chasing. That's as far as I would go, in trying to predict. What I would say is that there are very large forces, outside of cultural studies – the world historical question, the globalization of culture – that are not determined by us, but by the world; it's not only us who have that question to consider, but we are framing it in cultural studies in a rather distinctive way, and we're framing it in different cultures, different national locations, in different regions of the world, in different ways.

KHC: Do you have anything to add to what you think are the interesting things going on in cultural studies in relation to the 'Trajectories' conference?

SH: The thing which struck me, which I mentioned in the beginning, is the process of re-translation. Participants in the conference were rethinking the questions of cultural studies, yet in ways which were very familiar to me. I see we are speaking within the same universe, and I'm astonished by that. I'm astonished to find that 'conversation' going on, which was unthinkable in an Asian context a decade ago, and that's an important shift. Second, I'm struck by the important role which Australian cultural

studies is playing, precisely because it mediates this antagonistic relation-ship to the West. I'm struck by the fact that many of the themes that have reorganized cultural studies, here and in the United States, in the last three or four years, have a real resonance, although they are differently inter-preted, in your context. So, questions about the relationship to feminism, the question of postcoloniality, questions of the globalization of culture, etc. – these are questions that we have been coming to, which are also central questions for you.

Clearly, as I said before, globalization itself makes it possible for us all to address those issues from within the 'local' specificities of our own cultural situations. Here, too, we find not a rupture between the local and the global, but new local/global re-articulations. There are certain common themes, because we are all being globalized. The West is being globalized, too. Part of what I have been trying to argue in my recent work, is the idea that globalization is not just a western process; of course it is very dominated by the West, but one has to look at the unevenness in all globalizing processes. The notion that somewhere out there are still pure, untouched traditional cultures, and that our cultural struggles could be to preserve those purities, that is not really a project which is tenable. That is what we say, looking at globalization, breaking up the national cultures which we have been struggling against. One didn't know whether that would strike a chord, when cultural studies indigenized itself, in so-called marginal and peripheral cultures. One of the things I felt, in reading the material from the 'Trajectories' conference was that it had struck a chord. You are not speaking of cultural studies as the preservation of some pure and autonomous cultural position, outside of this confusing interchange and nexus which is globalization. You are living the time/space condensa-tions of globalization from within your own space and time. You are living globalization, as we are living globalization. The destruction of centres, the dissemination of centres that is going on, opens a conversation between spaces.

Of course, I'm arguing that globalization must never be read as a simple process of cultural homogenization; it is always an articulation of the local, of the specific and the global. Therefore, there will always be specificities – of voices, of positioning, of identity, of cultural traditions, of histories, and these are the conditions of enunciation which enable us to speak. We speak with distinctive voices; but we speak within the logic of a cultural-global, which opens a conversation between us, which would not have been possible otherwise. When cultural studies becomes relocated, in a culture like Taiwan, it recovers some of that openness to cultural politics, which I was beginning to think it had lost forever. I am delighted to find that rush of cultural/political blood to the head, so to speak, once it finds itself in a new cultural/political space, confronting differential times, histories, trajec-tories. Whatever the culture you are operating in, cultural studies will

always be involved in contesting traditional roles, the traditional boundary lines of sexuality, of subjectivity, etc. In this sense, in this general process of contestation, there is something like a general language of cultural studies beginning to emerge. Though it is not a universal language, it is a language in which the tensions between similarity and difference can be negotiated, by people in different positions.

NOTES

1 Papers read in the conference will be published under the title *Trajectories: Toward a New Internationalist Cultural Studies*, edited by Kuan-Hsing Chen with Hsiu-ling Kuo and Hans Huang.
2 The lecture was later published as 'Communities, nation and culture', *Cultural Studies* 7 (3), (1993), 349–63.

Part V

Diasporic questions

'Race', ethnicity and identity

Chapter 20

Gramsci's relevance for the study of race and ethnicity

Stuart Hall

I

The aim of this collection of essays[1] is to facilitate 'a more sophisticated examination of the hitherto poorly elucidated phenomen of racism and to examine the adequacy of the theoretical formulations, paradigms and interpretive schemes in the social and human sciences . . . with respect to intolerance and racism and in relation to the complexity of problems they pose.' This general rubric enables me to situate more precisely the kind of contribution which a study of Gramsci's work can make to the larger enterprise. In my view, Gramsci's work does *not* offer a *general* social science which can be applied to the analysis of social phenomena across a wide comparative range of historical societies. His potential contribution is more limited. It remains, for all that, of seminal importance. His work is, precisely, of a 'sophisticating' kind. He works, broadly, within the marxist paradigm. However, he has extensively revised, renovated and sophisticated many aspects of that theoretical framework to make it more relevant to contemporary social relations in the twentieth century. His work therefore has a direct bearing on the question of the 'adequacy' of existing social theories, since it is precisely in the direction of 'complexifying existing theories and problems' that his most important theoretical contribution is to be found. These points require further clarification before a substantive résumé and assessment of Gramsci's theoretical contribution can be offered.

Gramsci was not a 'general theorist'. Indeed, he did not practise as an academic or scholarly theorist of any kind. From beginning to end, he was and remained a political intellectual and a socialist activist on the Italian political scene. His 'theoretical' writing was developed out of this more organic engagement with his own society and times and was always intended to serve, not an abstract academic purpose, but the aim of 'informing political practice'. It is therefore essential not to mistake the

Reprinted from *Journal of Communication Inquiry* (1986), 10(2), 5–27.

level of application at which Gramsci's concepts operate. He saw himself as, principally, working within the broad parameters of historical materialism, as outlined by the tradition of marxist scholarship defined by the work of Marx and Engels and, in the early decades of the twentieth century, by such figures as Lenin, Rosa Luxemburg, Trotsky, Labriola, Togliatti, etc. (I cite those names to indicate Gramsci's frame of reference within marxist thought, not his precise position in relation to those particular figures – to establish the latter is a more complicated issue.) This means that his theoretical contribution has, always, to be *read* with the understanding that it is operating on, broadly, marxist terrain. That is to say, marxism provides the general limits within which Gramsci's developments, refinements, revisions, advances, further thoughts, new concepts and original formulations all operate. However, Gramsci was never a 'marxist' in either a doctrinal, orthodox or 'religious' sense. He understood that the general framework of Marx's theory had to be constantly developed theoretically; applied to new historical conditions; related to developments in society which Marx and Engels could not possibly have foreseen; expanded and refined by the addition of new concepts.

Gramsci's work thus represents neither a 'footnote' to the already completed edifice of orthodox marxism nor a ritual evocation of orthodoxy which is circular in the sense of producing 'truths' which are already well known. Gramsci practises a genuinely 'open' marxism, which develops many of the insights of marxist theory in the direction of new questions and conditions. Above all, his work brings into play concepts which classical marxism did not provide but without which marxist theory *cannot* adequately explain the complex social phenomena which we encounter in the modern world. It is essential to understand these points if we are to situate Gramsci's work against the background of existing 'theoretical formulations, paradigms and interpretive schemes in the social and human sciences'.

Not only is Gramsci's work not a *general* work of social science, of the status of, say, the work of such 'founding fathers' as Max Weber or Emile Durkheim, it does not anywhere appear in that recognizable general, synthesizing form. The main body of Gramsci's theoretical ideas are scattered throughout his occasional essays and polemical writing – he was an active and prolific political journalist – and of course, in the great collection of *Prison Notebooks* which Gramsci wrote, without benefit of access to libraries or other reference books, either during his enforced leisure in Mussolini's prison in Turin after his arrest (1928–33) or, after his release, but when he was already terminally ill, in the Formal Clinic (1934–5). This fragmentary body of writing, including the *Notebooks* (the *Quaderni del carcere*), are mainly to be found now in the Istituto Gramsci in Rome, where a definitive critical edition of his work is still in the course of completion for publication.[2]

Not only are the writings scattered; they are often fragmentary in form rather than sustained and 'finished' pieces of writing. Gramsci was often writing – as in the *Prison Notebooks* – under the most unfavourable circumstances: for example, under the watchful eye of the prison censor and without any other books from which to refresh his memory. Given these circumstances, the *Notebooks* represent a remarkable intellectual feat. Nevertheless, the 'costs' of his having to produce them in this way, of never being able to go back to them with time for critical reflection, were considerable. The *Notebooks* are what they say: *Notes* – shorter or more extended; but not woven into a sustained discourse or coherent text. Some of his most complex arguments are displaced from the main text into long footnotes. Some passages have been reformulated, but with little guidance as to which of the extant versions Gramsci regarded as the more 'definitive' text.

As if these aspects of 'fragmentariness' do not present us with formidable enough difficulties, Gramsci's work may appear fragmentary in another, even deeper sense. He was constantly using 'theory' to illuminate concrete historical cases or political questions; or thinking large concepts in terms of their application to concrete and specific situations. Consequently, Gramsci's work often appears almost *too* concrete: too historically specific, too delimited in its references, too 'descriptively' analytic, too time and context-bound. His most illuminating ideas and formulations are typically of this conjunctural kind. To make more general use of them, they have to be delicately dis-interred from their concrete and specific historical embeddedness and transplanted to new soil with considerable care and patience.

Some critics have assumed that Gramsci's concepts operate at this level of concreteness only because he did not have the time or inclination to raise them to a higher level of conceptual generality – the exalted level at which 'theoretical ideas' are supposed to function. Thus both Althusser and Poulantzas have proposed at different times 'theorizing' Gramsci's insufficiently theorized texts. This view seems to me mistaken. Here, it is essential to understand, from the epistemological viewpoint, that concepts can operate at very different *levels of abstraction* and are often consciously intended to do so. The important point is not to 'misread' one level of abstraction for another. We expose ourselves to serious error when we attempt to 'read off' concepts which were designed to operate at a high level of abstraction as if they automatically produced the same theoretical effects when translated to another, more concrete, 'lower' level of operation. In general, Gramsci's concepts were quite explicitly designed to operate at the lower levels of historical concreteness. He was not aiming 'higher' – and missing his theoretical target! Rather we have to understand this level of historico-concrete descriptiveness in terms of Gramsci's relation to marxism.

Gramsci remained a 'marxist', as I have said, in the sense that he developed his ideas within the general framework of Marx's theory: that is, taking for granted concepts like 'the capitalist mode of production', the 'forces and relations of production', etc. These concepts were pitched by Marx at the most general level of abstraction. That is to say, they are concepts which enable us to grasp and understand the broad processes which organize and structure the capitalist mode of production when reduced to its bare essentials, and at *any* stage or moment of its historical development. The concepts are 'epochal' in their range and reference. However, Gramsci understood that as soon as these concepts have to be applied to specific historical social formations, to particular societies at specific stages in the development of capitalism, the theorist is required to move from the level of 'mode of production' to a lower, more concrete, level of application. This 'move' requires not simply more detailed historical specification, but – as Marx himself argued – the application of new concepts and further levels of determination in addition to those pertaining to simple exploitative relations between capital and labour, since the latter serve to specify 'the capitalist mode' only at the highest level of reference. Marx himself, in his most elaborated methodological text (the 1857 'Introduction' to *Grundrisse*), envisaged the 'production of the concrete in thought' as taking place through a succession of analytic approximations, each adding further levels of determination to the necessarily skeletal and abstract concepts formed at the highest level of analytic abstraction. Marx argued that we could only 'think the concrete' through these successive levels of abstraction. That was because the concrete, in reality, consisted of 'many determinations' – which, of course, the levels of abstraction we use to think about it with must approximate, in thought. (On these questions of marxist epistemology, see Hall, 'Marx's notes of method', *Working Papers in Cultural Studies* 6, 1977.)

That is why, as Gramsci moves from the general terrain of Marx's mature concepts (as outlined, for example, in *Capital*) to specific historical conjunctures, he can still continue to 'work within' their field of reference. But when he turns to discuss in detail, say, the *Italian* political situation in the 1930s, or changes in the complexity of the class democracies of 'the West' after imperialism and the advent of mass democracy, or the specific differences between 'eastern' and 'western' social formations in Europe, or the type of politics capable of resisting the emerging forces of fascism, or the new forms of politics set in motion by developments in the modern capitalist state, he understands the necessity to adapt, develop and *supplement* Marx's concepts with new and original ones. First, because Marx concentrated on developing his ideas at the highest level of application (as in *Capital*) rather than at the more concrete historical level (for example, there is no real analysis in Marx of the specific structures of the British nineteenth-century state, though there are many suggestive insights).

Second, because the historical conditions for which Gramsci was writing were not the same as those in and for which Marx and Engels had written (Gramsci had an acute sense of the historical conditions of theoretical production). Third, because Gramsci felt the need of new conceptualizations at precisely the levels at which Marx's theoretical work was itself at its most sketchy and incomplete: that is, the levels of the analysis of specific historical conjunctures, or of the political and ideological aspects – the much neglected dimensions of the analysis of social formations in classical marxism.

These points help us, not simply to 'place' Gramsci in relation to the marxist tradition but to make explicit the level at which Gramsci's work positively operates and the transformations this shift in the level of magnification required. It is to the generation of new concepts, ideas and paradigms pertaining to the analysis of political and ideological aspects of social formations in the period after 1870, especially, that Gramsci's work most pertinently relates. Not that he *ever* forgot or neglected the critical element of the economic foundations of society and its relations. But he contributed relatively little by way of original formulations to *that* level of analysis. However, in the much-neglected areas of conjunctural analysis, politics, ideology and the state, the character of different types of political regimes, the importance of cultural and national-popular questions, and the role of civil society in the shifting balance of relations between different social forces in society – on *these* issues, Gramsci has an enormous amount to contribute. He is one of the first original 'marxist theorists' of the historical conditions which have come to dominate the second half of the twentieth century.

Nevertheless, in relation specifically to *racism*, his original contribution cannot be simply transferred wholesale from the existing context of his work. Gramsci did *not* write about race, ethnicity or racism in their contemporary meanings or manifestations. Nor did he analyse in depth the colonial experience or imperialism, out of which so many of the characteristic 'racist' experiences and relationships in the modern world have developed. His principal preoccupation was with his native Italy; and, behind that, the problems of socialist construction in western and eastern Europe, the failure of revolutions to occur in the developed capitalist societies of 'the West', the threat posed by the rise of fascism in the inter-war period, the role of the party in the construction of hegemony. Superficially, all this might suggest that Gramsci belongs to that distinguished company of so-called 'western marxists' whom Perry Anderson identified, who, because of their preoccupations with more 'advanced' societies, have little of relevance to say to the problems which have arisen largely in the non-European world, or in the relations of 'uneven development' between the imperial nations of the capitalist 'centre' and the englobalized, colonized societies of the periphery.

To read Gramsci in *this* way would, in my opinion, be to commit the error of literalism (though, with qualifications, that is how Anderson reads him). Actually, though Gramsci does not write about racism and does not specifically address those problems, his *concepts* may still be useful to us in our attempt to think through the adequacy of existing social theory paradigms in these areas. Further, his own personal experience and formation, as well as his intellectual preoccupations, were not in fact quite so far removed from those questions as a first glance would superficially suggest.

Gramsci was born in Sardinia in 1891. Sardinia stood in a 'colonial' relationship to the Italian mainland. His first contact with radical and socialist ideas was in the context of the growth of Sardinian nationalism, brutally repressed by troops from mainland Italy. Though, after his movement to Turin and his deep involvement with the Turin working-class movement, he abandoned his early 'nationalism', he never lost the concern, imparted to him in his early years, with peasant problems and the complex dialectic of class and regional factors (see G. Nowell Smith and Q. Hoare, 'Introduction' to *Prison Notebooks*, 1971). Gramsci was acutely aware of the great line of division which separated the industrializing and modernizing 'North' of Italy from the peasant, under-developed and dependent 'South'. He contributed extensively to the debate on what came to be known as 'the Southern question'. At the time of his arrival in Turin in 1911, Gramsci almost certainly subscribed to what was known as a 'Southernist' position. He retained an interest throughout his life in those relations of dependency and unevenness which linked 'North' and 'South': and the complex relations between city and countryside, peasantry and proletariat, clientism and modernism, feudalized and industrial social structures. He was thoroughly aware of the degree to which the lines of separation dictated by class relationships were compounded by the cross-cutting relations of regional, cultural, and national difference; also, by differences in the tempos of regional or national historical development. When, in 1923, Gramsci, one of the founders of the Italian Communist Party, proposed *Unitá* as the title of the party's official newspaper, he gave as his reason 'because . . . we must give special importance to the Southern question'. In the years before and after the First World War, he immersed himself in every aspect of the political life of the Turin working class. This experience gave him an intimate, inside knowledge of one of the most advanced strata of the industrial 'factory' proletarian class in Europe. He had an active and sustained career in relation to this advanced sector of the modern working class – first, as a political journalist on the staff of the Socialist Party weekly, *Il Grido del Popolo*; then during the wave of unrest in Turin (the so-called 'Red Years'), the factory occupations and councils of labour; finally, during his editorship of the journal, *Ordine Nuovo*, up to the founding of the Italian Communist Party. Nevertheless he continued to reflect, throughout, on the strategies and forms of political action and

organization which could *unite* concretely different kinds of struggle. He was preoccupied with the question of what basis could be found in the complex alliances of and relations between the different social strata for the foundation of a specifically *modern* Italian state. The preoccupation with the question of regional specificity, social alliances and the social foundations of the state also directly links Gramsci's work with what we might think of today as 'North/South', as well as 'East/West', questions.

The early 1920s were taken up, for Gramsci, with the difficult problems of trying to conceptualize new forms of political 'party', and with the question of distinguishing a path of development specific to Italian *national* conditions, in opposition to the hegemonizing thrust of the Soviet-based Comintern. All this led ultimately to the major contribution which the Italian Communist Party has made to the theorization of the conditions of 'national specificity' in relation to the very different concrete historical developments of the different societies, East and West. In the later 1920s, however, Gramsci's preoccupations were largely framed by the context of the growing threat of fascism, up to his arrest and internment by Mussolini's forces in 1929. (For these and other biographical details, see the excellent 'Introduction' to *The Prison Notebooks*, by G. Nowell Smith and Q. Hoare, 1971.)

So, though Gramsci did not write directly about the problems of racism, the preoccupying themes of his work provide deeper intellectual and theoretical lines of connection to many more of these contemporary issues than a quick glance at his writings would suggest.

II

It is to these deeper connections, and to their fertilizing impact on the search for more adequate theorizations in the field that we now turn. I will try to elucidate some of those core conceptions in Gramsci's work which point in that direction.

I begin with the issue which, in some ways, for the chronological student of Gramsci's work, comes more towards the end of his life: the question of his rigorous attack on all vestiges of 'economism' and 'reductionism' within classical marxism. By 'economism' I do not mean – as I hope I have already made clear – to neglect the powerful role which the economic foundations of a social order or the dominant economic relations of a society play in shaping and structuring the whole edifice of social life. I mean, rather, a specific theoretical approach which tends to read the economic foundations of society as the *only* determining structure. This approach tends to see all other dimensions of the social formation as simply mirroring 'the economic' on another level of articulation, and as having no other determining or structuring force in their own right. The approach, to put it simply, reduces everything in a social formation to the economic

level, and conceptualizes all other types of social relations as directly and immediately 'corresponding' to the economic. This collapses Marx's somewhat problematic formulation – the economic as 'determining in the last instance' – to the reductionist principle that the economic determines, in an immediate way, in the first, middle and last instances. In this sense, 'economism' is a theoretical reductionism. It simplifies the structure of social formations, reducing their complexity of articulation, vertical and horizontal, to a single line of determination. It simplifies the very concept of 'determination' (which in Marx is actually a very complex idea) to that of a mechanical function. It flattens all the mediations between the different levels of a society. It presents social formations – in Althusser's words – as a 'simple expressive totality', in which every level of articulation corresponds to every other, and which is from end to end, structurally transparent. I have no hesitation in saying that this represents a gigantic crudification and simplification of Marx's work – the kind of simplification and reductionism which once led him, in despair, to say that 'if that is marxism, then I am not a marxist.' Yet there certainly are pointers in this direction in some of Marx's work. It corresponds closely to the orthodox version of marxism, which did become canonized at the time of the Second International, and which is often even today advanced as the pure doctrine of 'classical marxism'. Such a conception of the social formation and of the relationships between its different levels of articulation – it should be clear – has little or no theoretical room left in it for ways of conceptualizing the political and ideological dimensions, let alone ways of conceptualizing other types of social differentiation such as social divisions and contradictions arising around race, ethnicity, nationality and gender.

Gramsci, from the outset, set his face against this type of economism; and in his later years, he developed a sustained theoretical polemic against precisely its canonization within the classical marxist tradition. Two examples from different strands in his work must suffice to illustrate this point. In his essay on 'The modern prince' Gramsci is discussing how to set about analysing a particular historical conjuncture. He substitutes, for the reductionist approach which would 'read off' political and ideological developments from their economic determinations, a far more complex and differentiated type of analysis. This is based, not on a 'one-way determination', but on the analysis of 'the relations of force' and aims to differentiate (rather than to collapse as identical) the 'various moments or levels' in the development of such a conjuncture. (*Prison Notebooks* 180–1, hereafter *PN*). He pinpoints this analytic task in terms of what he calls 'the decisive passage from the structure to the spheres of the complex superstructures'. In this way he sets himself decisively against any tendency to reduce the sphere of the political and ideological superstructures to the economic structure or 'base'. He understands this as the most critical site in the struggle against reductionism. 'It is the problem of the relations

between structure and superstructure which must be accurately posed if the forces which are active in the history of a particular period are to be correctly analysed and the relations between them determined' (*PN*, 177). Economism, he adds, is an inadequate way, theoretically, of posing this critical set of relationships. It tends, among other things, to substitute an analysis based on 'immediate class interests' (in the form of the question 'Who profits directly from this?') for a fuller, more structured analysis of 'economic class formations . . . with all their inherent relations' (*PN*, 163). It may be ruled out, he suggests, 'that *immediate* economic crises of themselves produce fundamental historical events' (my italics). Does this mean that the economic plays no part in the development of historical crises? Not at all. But its role is rather to 'create a terrain more favourable to the dissemination of certain modes of thought, and certain ways of posing and resolving questions involving the entire subsequent development of national life' (*PN*, 184). In short, until one has shown how 'objective economic crises' actually develop, via the changing relations in the balance of social forces, into crises in the state and society, and germinate in the form of ethical-political struggles and formed political ideologies, influencing the conception of the world of the masses, one has not conducted a proper kind of analysis, rooted in the decisive and irreversible 'passage' between structure and superstructure.

The sort of immediate infallibility which economic reductionism brings in its wake, Gramsci argues, 'comes very cheap'. It not only has no theoretical significance – it has only minimal political implications or practical efficacy. 'In general, it produces nothing but moralistic sermons and interminable questions of personality' (*PN*, 166). It is a conception based on 'the iron conviction that there exist objective laws of historical development similar in kind to natural law, together with a belief in a predetermined teleology like that of a religion.' There is no alternative to this collapse – which, Gramsci argues, has been incorrectly identified with historical materialism – except 'the concrete posing of the problem of hegemony'.

It can be seen from the general thrust of the argument in this passage that many of Gramsci's key concepts (hegemony, for example) and characteristic approaches (the approach via the analysis of 'relations of social forces', for example) were consciously understood by him as a barrier against the tendency to economic reductionism in some versions of marxism. He coupled, with his critique of 'economism', the related tendencies to positivism, empiricism, 'scientism' and objectivism within marxism.

This comes through even more clearly in 'The problems of Marxism', a text explicitly written as a critique of the 'vulgar materialism' implicit in Bukharin's *Theory of Historical Materialism: A Manual of Popular Sociology*. The latter was published in Moscow in 1921, went through many editions and was often quoted as an example of 'orthodox' marxism (even

though Lenin observed about it that Bukharin was unfortunately 'ignorant of the dialectic'). In the 'Critical notes on an attempt at popular sociology', which forms the second part of his essay 'The problems of Marxism', Gramsci offers a sustained assault on the epistemologies of economism, positivism and the spurious search for scientific guarantees. They were founded, he argues, on the falsely positivistic model that the laws of society and human historical development can be modelled directly on what social scientists conceived (falsely, as we now know) as the 'objectivity' of the laws governing the natural scientific world. Terms like 'regularity', 'necessity', 'Law', 'determination', he argues, are not to be thought of 'as a derivation from natural science but rather as an elaboration of concepts born on the terrain of political economy'. Thus 'determined market' must *really* mean a 'determined relation of social forces in a determined structure of the productive apparatus', this relationship being guaranteed (that is, rendered permanent) by a 'determined political, moral and juridical superstructure'. The movement in Gramsci's formulation from an analytically reduced positivistic formula to a richer, more complex conceptualization framed with social science is lucidly clear from that substitution. It lends weight to Gramsci's summarizing argument, that:

> The claim presented as an essential postulate of historical materialism, that every fluctuation of politics and ideology can be presented and expounded as an immediate expression of the structure, (i.e., the economic base) must be contested in theory as primitive infantilism, and combated in practice with the authentic testimony of Marx, the author of concrete, political and historical works.

This shift of direction, which Gramsci set himself to bring about within the terrain of marxism, was quite self-consciously accomplished – and decisive for the whole thrust of his subsequent thought. Without this point of theoretical departure, Gramsci's complicated relationship to the tradition of marxist scholarship cannot be properly defined.

If Gramsci renounced the simplicities of reductionism, how then did he set about a more adequate analysis of a social formation? Here we may be helped by a brief detour, provided that we move with caution. Althusser, (who was profoundly influenced by Gramsci) and his colleagues in *Reading Capital* (Althusser and Balibar, London: New Left Books, 1970), make a critical distinction between 'mode of production', which refers to the basic forms of economic relations which characterize a society, but which is an analytic abstraction, since no society can function by its economy alone; and, on the other hand, what they call the 'social formation'. By this latter term they meant to invoke the idea that societies are necessarily complexly structured totalities, with different levels of articulation (the economic, the political, the ideological instances) in different combinations; each combination giving rise to a different configuration of social

forces and hence to a different type of social development. The authors of *Reading Capital* tended to give as the distinguishing feature of a 'social formation' the fact that, in it, more than one mode of production could be combined. But, though this is true, and can have important consequences (especially for postcolonial societies, which we take up later), it is not, in my view, the most important point of distinction between the two terms. In 'social formations' one is dealing with complexly structured societies composed of economic, political and ideological relations, where the different levels of articulation do not by any means simply correspond or 'mirror' one another, but which are – in Althusser's felicitous metaphor – 'over-determining' on and for one another (Althusser, *For Marx*, New York: Pantheon, 1969). It is this complex structuring of the different levels of articulation, not simply the existence of more than one mode of production, which constitutes the difference between the concept of 'mode of production' and the necessarily more concrete and historically specific notion of a 'social formation'.

Now this latter concept *is* the conception to which Gramsci addressed himself. This is what he meant by saying that the relationship between 'structure' and 'superstructures', or the 'passage' of any organic historical movement right through the whole social formation, from economic 'base' to the sphere of ethico-political relations, was at the heart of any non-reductionist or economistic type of analysis. To pose and resolve *that* question was to conduct an analysis, properly founded on an understanding of the complex relationships of over-determination between the different social practices in any social formation.

It is this protocol which Gramsci pursued when, in 'The modern prince', he outlined his characteristic way of 'analysing situations'. The details are complex and cannot be filled out in all their subtlety here, but the bare outlines are worth setting out, if only for purposes of comparison with a more 'economistic' or reductionist approach. He considered this 'an elementary exposition of the science and art of politics – understood as a body of practical rules for research' and of detailed observations useful for awakening an interest in effective reality and for stimulating more rigorous and more vigorous political insights' – a discussion, he added, which must be *strategic* in character.

First of all, he argued, one must understand the fundamental structure – the objective relations – within society or 'the degree of development of the productive forces', for these set the most fundamental limits and conditions for the whole shape of historical development. From here arise some of the major lines of tendency which *might* be favourable to this or that line of development. The error of reductionism is then to translate these tendencies and constraints *immediately* into their absolutely determined political and ideological effects; or, alternatively, to abstract them into some 'iron law of necessity'. In fact, they structure and determine only

in the sense that they define the terrain on which historical forces move – they define the horizon of possibilities. But they can, neither in the first nor last instance, fully determine the content of political and economic struggles, much less objectively fix or guarantee the outcomes of such struggles.

The next move in the analysis is to distinguish between 'organic' historical movements, which are destined to penetrate deep into society and be relatively long-lasting, from more 'occasional, immediate, almost accidental movements'. In this respect, Gramsci reminds us that a 'crisis', if it is organic, can last for decades. It is not a static phenomenon but rather, one marked by constant movement, polemics, contestations, etc., which represent the attempt by different sides to overcome or resolve the crisis and to do so in terms which favour their long term hegemony. The theoretical danger, Gramsci argues, lies in 'presenting causes as immediately operative which in fact only operate indirectly, or in asserting that the immediate causes are the only effective ones'. The first leads to an excess of economism; the second to an excess of ideologism. (Gramsci was preoccupied, especially in moments of defeat, by the fatal oscillation between these two extremes, which in reality mirror one another in an inverted form.) Far from there being any 'law-like' guarantee that some law of necessity will inevitably convert economic causes into immediate political effects, Gramsci insisted that the analysis only succeeds and is 'true' *if* those underlying causes become a new reality. The substitution of the conditional tense for positivistic certainty is critical.

Next, Gramsci insisted on the fact that the length and complexity of crises cannot be mechanically predicted, but develop over longer historical periods; they move between periods of relative 'stabilization' and periods of rapid and convulsive change. Consequently *periodization* is a key aspect of the analysis. It parallels the earlier concern with historical specificity. 'It is precisely the study of these "intervals" of varying frequency which enables one to reconstruct the relations, on the one hand, between structure and superstructure, and on the other between the development of organic movement and conjunctural movement in the structure.' There is nothing mechanical or prescriptive, for Gramsci, about this 'study'.

Having thus established the groundwork of a dynamic historical analytic framework, Gramsci turns to the analysis of the movements of historical forces – the 'relations of force' – which constitute the actual terrain of political and social struggle and development. Here he introduces the critical notion that what we are looking for is *not* the absolute victory of this side over that, nor the total incorporation of one set of forces into another. Rather, the analysis is a relational matter – that is, a question to be resolved *relationally*, using the idea of 'unstable balance' or 'the continuous process of formation and superseding of unstable equilibria'. The critical question is the 'relations of forces *favourable or unfavourable to this or that tendency*' (my italics). This emphasis on 'relations' and

'unstable balance' reminds us that social forces which lose out in any particular historical period do not thereby disappear from the terrain of struggle; nor is struggle in such circumstances suspended. For example, the idea of the 'absolute' and total victory of the bourgeoisie over the working class or the total incorporation of the working class into the bourgeois project are totally foreign to Gramsci's definition of hegemony – though the two are frequently confused in scholarly commentary. It is always the tendential balance in the relations of force which matters.

Gramsci then differentiates the 'relations of force' into its different moments. He assumes no *necessary teleological evolution* between these moments. The first has to do with an assessment of the objective conditions which place and position the different social forces. The second relates to the political moment – the 'degree of homogeneity, self-awareness and organization attained by the various social classes' (*PN*, 181). The important thing here is that so-called 'class unity' is never *assumed, a priori*. It is understood that classes, while sharing certain common conditions of existence, are also crosscut by conflicting interests, historically segmented and fragmented in this actual course of historical formation. Thus the 'unity' of classes is necessarily complex and has to be *produced* – constructed, created – as a result of specific economic, political and ideological practices. It can never be taken as automatic or 'given'. Coupled with this radical historicization of the automatic conception of classes lodged at the heart of fundamentalist marxism, Gramsci elaborates further on Marx's distinction between 'class in itself' and 'class for itself'. He notes the different stages through which class consciousness, organization and unity can – under the right conditions – develop. There is the 'economic corporate' stage, where professional or occupational groups recognize their basic common interests but are conscious of no wider class solidarities. Then there is the 'class corporate' moment, where class solidarity of interests develops, but only in the economic field. Finally, there is the moment of 'hegemony', which transcends the corporate limits of purely economic solidarity, encompasses the interests of other subordinate groups, and begins to 'propagate itself throughout society', bringing about intellectual and moral as well as economic and political unity, and 'posing also the questions around which the struggle rages . . . thus creating the hegemony of a fundamental social group over a series of subordinate groups'. It is this process of the coordination of the interests of a dominant group with the general interests of other groups and the life of the state as a whole, that constitutes the 'hegemony' of a particular historical bloc (*PN*, 182). It is only in such moments of 'national popular' unity that the formation of what he calls a 'collective will' becomes possible.

Gramsci reminds us, however, that even this extraordinary degree of organic unity does not *guarantee* the outcome of specific struggles, which can be won or lost on the outcome of the decisive tactical issue of the

military and politico-military relations of force. He insists, however, that 'politics must have priority over its military aspect and only politics creates the possibility for manoeuvre and movement' (*PN*, 232).

Three points about this formulation should be particularly noted. First 'hegemony' is a very particular, historically specific, and temporary 'moment' in the life of a society. It is rare for this degree of unity to be achieved, enabling a society to set itself a quite new historical agenda, under the leadership of a specific formation or constellation of social forces. Such periods of 'settlement' are unlikely to persist forever. There is nothing automatic about them. They have to be actively constructed and positively maintained. Crises mark the beginning of their disintegration. Second, we must take note of the multi-dimensional, multi-arena character of hegemony. It cannot be constructed or sustained on *one* front of struggle alone (for example, the economic). It represents a degree of mastery over a whole series of different 'positions' at once. Mastery is not simply imposed or dominative in character. Effectively, it results from winning a substantial degree of popular consent. It thus represents the installation of a profound measure of social and moral authority, not simply over its immediate supporters but across society as a whole. It is this 'authority', and the range and the diversity of sites on which 'leadership' is exercised, which makes possible the 'propagation', for a time, of an intellectual, moral, political and economic collective will throughout society. Third, what 'leads' in a period of hegemony is no longer described as a 'ruling class' in the traditional language, but a historic bloc. This has its critical reference to 'class' as a determining level of analysis; but it does *not* translate whole classes directly on to the political-ideological stage as unified historical actors. The 'leading elements' in a historic bloc may be only one fraction of the dominant economic class – for example, finance rather than industrial capital; national rather than international capital. Associated with it, within the 'bloc', will be strata of the subaltern and dominated classes, who have been won over by specific concessions and compromises and who form part of the social constellation but in a subordinate role. The 'winning over' of these sections is the result of the forging of 'expansive, universalizing alliances' which cement the historic bloc under a particular leadership. Each hegemonic formation will thus have its own, specific social composition and configuration. This is a very different way of conceptualizing what is often referred to, loosely and inaccurately, as the 'ruling class'.

Gramsci was not, of course, the originator of the term *hegemony*. Lenin used it in an analytic sense to refer to the leadership which the proletariat in Russia was required to establish over the peasantry in the struggles to found a socialist state. This in itself is of interest. One of the key questions posed for us by the study of developing societies, which have not passed through the 'classic' path of development to capitalism which Marx took as

his paradigm case in *Capital* (that is, the English example), is the balance of and relations between different social classes in the struggle for national and economic development; the relative insignificance of the industrial proletariat, narrowly defined, in societies characterized by a relatively low level of industrial development; above all, the degree to which the peasant class is a leading element in the struggles which found the national state and even, in some cases (China is the outstanding example, but Cuba and Vietnam are also significant examples) the *leading* revolutionary class. It was in this sort of context that Gramsci first employed the term hegemony. In his 1920 'Notes on the Southern question', he argued that the proletariat in Italy could only become the 'leading' class in so far as it 'succeeds in creating a system of alliances which allows it to mobilize the majority of the working population against capitalism and the bourgeois state . . . [which] means to the extent that it succeeds in gaining the consent of the broad peasant masses.'

In fact, this is already a theoretically complex and rich formulation. It implies that the actual social or political force which becomes decisive in a moment of organic crisis will not be composed of a single homogeneous class but will have a complex social composition. Second, it is implicit that its basis of unity will have to be, not an automatic one, given by its position in the mode of economic production, but rather a 'system of alliances'. Third, though such a political and social force has its roots in the fundamental class division of society, the actual forms of the political struggle will have a *wider* social character – dividing society not simply along 'class versus class' lines, but rather polarizing it along the broadest front of antagonism ('the majority of the working population'): for example, between *all* the popular classes on the one side, and those representing the interests of capital and the power bloc grouped around the state, on the other. In fact, in national and ethnic struggles in the modern world, the actual field of struggle is often actually polarized precisely in this more complex and differentiated way. The difficulty is that it often continues to be described, theoretically, in terms which *reduce* the complexity of its actual social composition to the more simple, descriptive terms of a struggle between two, apparently, simple and homogeneous class blocs. Further, Gramsci's reconceptualization puts firmly on the agenda such critical strategic questions as the terms on which a class like the peasantry can be won for a national struggle, not on the basis of compulsion but on the basis of 'winning their consent'.

In the course of his later writings, Gramsci went on to expand the conception of hegemony even further, moving forwards from this essentially 'class alliance' way of conceptualizing it. First, 'hegemony' becomes a general term, which can be applied to the strategies of *all* classes; applied analytically to the formation of all leading historical blocs, not to the strategy of the proletariat alone. In this way, he converts the concept

into a more general analytic term. Its applicability in this more general way is obvious. The way, for example, in which in South Africa the state is sustained by the forging of alliances between white ruling-class interests and the interests of white workers against blacks; or the importance in South African politics of the attempts to 'win the consent' of certain subaltern classes and groups – for example, the coloured strata or 'tribal' blacks – in the strategy of forging alliances against the mass of rural and industrial blacks; or the 'mixed' class character of all the decolonizing struggles for national independence in developing, postcolonial societies – these and a host of other concrete historical situations are significantly clarified by the development of this concept.

The second development is the difference Gramsci comes to articulate between a class which 'dominates' and a class which 'leads'. Domination and coercion can maintain the ascendancy of a particular class over a society. But its 'reach' is limited. It has to rely consistently on coercive means, rather than the winning of consent. For that reason it is not capable of enlisting the positive participation of different parts of society in a historic project to transform the state or renovate society. 'Leadership' on the other hand has its 'coercive' aspects too. But it is 'led' by the winning of consent, the taking into account of subordinate interests, the attempt to make itself popular. For Gramsci there is no pure case of coercion/consent – only different combinations of the two dimensions. Hegemony is not exercised in the economic and administrative fields alone, but encompasses the critical domains of cultural, moral, ethical and intellectual leadership. It is only under those conditions that some long-term historic 'project' – for example, to modernize society, to raise the whole level of performance of society or transform the basis of national politics – can be effectively put on the historical agenda. It can be seen from this that the concept of 'hegemony' is *expanded* in Gramsci by making strategic use of a number of distinctions: for example, those between domination/leadership, coercion/consent, economic-corporate/ moral and intellectual.

Underpinning this expansion is another distinction, based on one of Gramsci's fundamental historical theses. This is the distinction between state/civil society. In his essay on 'State and civil society', Gramsci elaborated this distinction in several ways. First, he drew a distinction between two types of struggle – the 'war of manoeuvre', where everything is condensed into one front and one moment of struggle, and there is a single, strategic breach in the 'enemy's defences' which, once made, enables the new forces 'to rush in and obtain a definitive (strategic) victory'. Second, there is the 'war of position', which has to be conducted in a protracted way, across many different and varying fronts of struggle; where there is rarely a single break-through which wins the war once and for all – 'in a flash', as Gramsci puts it (*PN*, 233). What really counts in a

war of position is not the enemy's 'forward trenches' (to continue the military metaphor) but 'the whole organizational and industrial system of the territory which lies to the rear of the army in the field' – that is, the whole structure of society, including the structures and institutions of civil society. Gramsci regarded '1917' as perhaps the last example of a successful 'war of maneouvre' strategy: it marked 'a decisive turning-point in the history of the art and science of politics'.

This was linked to a second distinction – between 'East' and 'West'. These stand, for Gramsci, as metaphors for the distinction between eastern and western Europe, and between the model of the Russian revolution and the forms of political struggle appropriate to the much more difficult terrain of the industrialized liberal democracies of 'the West'. Here, Gramsci addresses the critical issue, so long evaded by many marxist scholars, of the failure of political conditions in 'the West' to match or correspond with those which made 1917 in Russia possible – a central issue, since, despite these radical differences (and the consequent failure of proletarian revolutions of the classic type in 'the West'), marxists have continued to be obsessed by the 'Winter Palace' model of revolution and politics. Gramsci is therefore drawing a critical analytic distinction between pre-revolutionary Russia, with its long-delayed modernization, its swollen state apparatus and bureaucracy, its relatively undeveloped civil society and low level of capitalist development; and, on the other hand, 'the West', with its mass democratic forms, its complex civil society, the consolidation of the consent of the masses, through political democracy, into a more consensual basis for the state:

> In Russia the State was everything, civil society was primordial and gelatinous; in the West, there was a proper relation between State and civil society, and when the State trembled, a sturdy structure of civil society was at once revealed. The State was only an outer ditch, behind which there stood a powerful system of fortresses and earthworks: more or less numerous from one state to another . . . this precisely necessitated an accurate reconnaissance of each individual country.
>
> (*PN*, 237–8).

Gramsci is not merely pinpointing a difference of historical specificity. He is describing a historical *transition*. It is evident, as 'State and civil society' makes clear, that he sees the 'war of position' *replacing* the 'war of manoeuvre' more and more, as the conditions of 'the West' become progressively more characteristic of the moden political field in one country after another. (Here, 'the West' ceases to be a purely *geographical* identification, and comes to stand for a new terrain of politics, created by the emerging forms of state and civil society and new, more complex relations between them.) In these more 'advanced' societies, 'where civil society has become a very complex structure . . . resistant to the

catastrophic "incursions" of the immediate economic element . . . the superstructures of civil society are like the trench-systems of modern warfare.' A different type of political strategy is appropriate to this novel terrain. 'The war of manoeuvre [is] reduced to more of a tactical than a strategic function' and one passes over from 'frontal attack' to a 'war of position' which requires 'unprecedented concentration of hegemony' and is 'concentrated, difficult and requires exceptional qualities of patience and inventiveness' because, once won, it is 'decisive definitively' (*PN*, 238–9).

Gramsci bases this 'transition from one form of politics to another' historically. It takes place in 'the West' after 1870, and is identified with 'the colonial expansion of Europe', the emergence of modern mass democracy, a complexification in the role and organization of the state and an unprecedented elaboration in the structures and processes of 'civil hegemony'. What Gramsci is pointing to, here, is partly the diversification of social antagonisms, the 'dispersal' of power, which occurs in societies where hegemony is sustained, not exclusively through the enforced instrumentality of the state, but rather, it is grounded in the relations and institutions of civil society. In such societies, the voluntary associations, relations and institutions of civil society – schooling, the family, churches and religious life, cultural organizations, so-called private relations, gender, sexual and ethnic identities, etc. – become, in effect, 'for the art of politics . . . the "trenches" and the permanent fortifications of the front in the war of position: they render merely "partial" the element of movement which before used to be "the whole" of war' (*PN*, 243).

Underlying all this is therefore a deeper labour of theoretical redefinition. Gramsci in effect is progressively transforming the limited definition of the state, characteristic of some versions of marxism, as essentially reducible to the coercive instrument of the ruling class, stamped with an exclusive class character which can only be transformed by being 'smashed' with a single blow. He comes gradually to emphasize, not only the complexity of the formation of modern civil society, but also the parallel development in complexity of the formation of the modern state. The state is no longer conceived as simply an administrative and coercive apparatus – it is also 'educative and formative'. It is the point from which hegemony over society as a whole is ultimately exercised (though it is not the only place where hegemony is constructed). It is the point of condensation – not because all forms of coercive domination necessarily radiate outwards from its apparatuses but because, in its contradictory structure, it *condenses* a variety of different relations and practices into a definite 'system of rules'. It is, for this reason, the site for conforming (that is, bringing into line) or 'adapting the civilization and the morality of the broadest masses to the necessities of the continuous development of the economic apparatus of production'.

Every state, he therefore argues, 'is ethical in as much as one of its most important functions is to raise the great mass of the population to a particular cultural and moral level (or type) which corresponds to the needs of the productive forces for development, and hence to the interests of the ruling class' (*PN*, 258). Notice here how Gramsci foregrounds *new* dimensions of power and politics, new areas of antagonism and struggle – the ethical, the cultural, the moral. How, also, he ultimately returns to more 'traditional' questions – 'needs of the productive forces for development', 'interests of the ruling class': but *not* immediately or reductively. They can only be approached *indirectly*, through a series of necessary displacements and 'relays': that is, via the irreversible 'passage from the structure to the sphere of the complex superstructures . . . '.

It is within this framework that Gramsci elaborates his new conception of the state. The modern state exercises moral and educative leadership – it 'plans, urges, incites, solicits, punishes'. It is where the bloc of social forces which dominates over it not only justifies and maintains its domination but wins by leadership and authority the active consent of those over whom it rules. Thus it plays a pivotal role in the construction of hegemony. In this reading, it becomes, not a *thing* to be seized, overthrown or 'smashed' with a single blow, but a complex *formation* in modern societies which must become the focus of a number of different strategies and struggles because it is an arena of different social contestations.

It should now be clearer how these distinctions and developments in Gramsci's thinking all feed back into and enrich the basic concept of 'hegemony'. Gramsci's actual formulations about the state and civil society vary from place to place in his work, and have caused some confusion (P. Anderson, 'The antinomies of Antonio Gramsci', *New Left Review* 100, 1977). But there is little question about the underlying thrust of his thought on this question. This points irrevocably to the increasing complexity of the interrelationships in modern societies *between* state and civil society. Taken together, they form a complex 'system' which has to be the object of a many-sided type of political strategy, conducted on several different fronts at once. The use of such a concept of the state totally transforms, for example, much of the literature about the so-called 'postcolonial state', which has often assumed a simple, dominative or instrumental model of state power.

In this context, Gramsci's 'East'/'West' distinction must not be taken too literally. Many so-called 'developing' societies already have complex democratic political regimes (that is, in Gramsci's terms, they belong to the 'West'). In others, the state has absorbed into itself some of the wider, educative and 'leadership' roles and functions which, in the industrialized western liberal democracies, are located in civil society. The point is therefore not to apply Gramsci's distinction literally or mechanically but to use his insights to unravel the changing complexities in state/civil

society relationships in the modern world and the decisive shift in the predominant character of strategic political struggles – essentially, the encompassing of civil society as well as the state as integral arenas of struggles – which this historic transformation has brought about. An enlarged conception of the state, he argues at one point (stretching the definitions somewhat), must encompass 'political society and civil society' or 'hegemony protected by the armour of coercion' (*PN*, 263). He pays particular attention to how these distinctions are differently articulated, in different societies – for example, within the 'separation of powers' characteristic of liberal parliamentary democratic states as contrasted with the collapsed spheres of fascist states. At another point, he insists on the ethical and cultural functions of the state – raising 'the great mass of the population to a particular cultural and moral level'; and to the 'educative functions of such critical institutions as the school (a "positive educative function") and the courts ("a repressive and negative educative function").' These emphases bring a range of new institutions and arenas of struggle into the traditional conceptualization of the state and politics. It constitutes them as specific and strategic centres of struggle. The effect is to multiply and proliferate the various fronts of politics, and to differentiate the different kinds of social antagonisms. The different fronts of struggle are the various sites of political and social antagonism and constitute the objects of modern politics, when it is understood in the form of a 'war of position'. The traditional emphases, in which differentiated types of struggle, for example, around schooling, cultural or sexual politics, institutions of civil society like the family, traditional social organizations, ethnic and cultural institutions and the like, are *all* subordinated and reduced to an industrial struggle, condensed around the workplace, and a simple choice between trade union and insurrectionary or parliamentary forms of politics, is here systematically challenged and decisively overthrown. The impact on the very conception of politics itself is little short of electrifying.

Of the many other interesting topics and themes from Gramsci's work which we could consider, I choose, finally, the seminal work on ideology, culture, the role of the intellectual and the character of what he calls the 'national-popular'. Gramsci adopts what, at first, may seem a fairly traditional definition of ideology, a 'conception of the world, any philosophy, which becomes a cultural movement, a "religion", a "faith", that has produced a form of practical activity or will in which a philosophy is contained as an implicit theoretical "premise"'. 'One might say,' he adds, 'ideology . . . on condition that the word is used in its best sense of a conception of the world that is implicitly manifest in art, in law, in economic activity and in all manifestations of individual and collective life.' This is followed by an attempt clearly to formulate the problem ideology addresses in terms of its social function: 'The problem is that of preserving the ideological unity of the entire social bloc which that

ideology serves to cement and unify' (*PN*, 328). This definition is not as simple as it looks, for it assumes the essential link between the philosophical nucleus or premise at the centre of any distinctive ideology or conception of the world, and the necessary elaboration of that conception into practical and popular forms of consciousness, affecting the broad masses of society, in the shape of a cultural movement, political tendency, faith or religion. Gramsci is *never* only concerned with the philosophical core of an ideology; he always addresses *organic* ideologies, which are organic because they touch practical, everyday, common sense and they 'organize human masses and create the terrain on which men move, acquire consciousness of their position, struggle, etc'.

This is the basis of Gramsci's critical distinction between 'philosophy' and 'common sense'. Ideology consists of two, distinct 'floors'. The coherence of an ideology often depends on its specialized philosophical elaboration. But this formal coherence cannot guarantee its organic historical effectivity. That can only be found when and where philosophical currents enter into, modify and transform the practical, everyday consciousness or popular thought of the masses. The latter is what he calls 'common sense'. 'Common sense' is not coherent: it is usually 'disjointed and episodic', fragmentary and contradictory. Into it the traces and 'stratified deposits' of more coherent philosophical systems have sedimented over time without leaving any clear inventory. It represents itself as the 'traditional wisdom or truth of the ages', but in fact, it is deeply a product of history, 'part of the historical process'. Why, then, is common sense so important? Because it is the terrain of conceptions and categories on which the practical consciousness of the masses of the people is actually formed. It is the already formed and 'taken-for-granted' terrain, on which more coherent ideologies and philosophies must contend for mastery; the ground which new conceptions of the world must take into account, contest and transform, if they are to shape the conceptions of the world of the masses and in that way become historically effective:

> Every philosophical current leaves behind a sediment of 'common sense'; this is the document of its historical effectiveness. Common sense is not rigid and immobile but is continually transforming itself, enriching itself with scientific ideas and with philosophical opinions which have entered ordinary life. Common sense creates the folklore of the future, that is as a relatively rigid phase of popular knowledge at a given place and time
>
> (*PN*, 362, fn. 5)

It is this concern with the structures of *popular thought* which distinguishes Gramsci's treatment of ideology. Thus, he insists that everyone is a philosopher or an intellectual in so far as he/she thinks, since all thought, action and language is reflexive, contains a conscious line of

moral conduct and thus sustains a particular conception of the world
(though not everyone has the specialized function of 'the intellectual').

In addition, a class will always have its spontaneous, vivid but not
coherent or philosophically elaborated, instinctive understanding of its
basic conditions of life and the nature of the constraints and forms of
exploitation to which it is commonly subjected. Gramsci described the
latter as its 'good sense'. But it always requires a further work of political
education and cultural politics to renovate and clarify these constructions
of popular thought – 'common sense' – into a more coherent political
theory or philosophical current. This 'raising of popular thought' is part
and parcel of the process by which a collective will is constructed, and
requires extensive work of intellectual organization – an essential part of
any hegemonic political strategy. Popular beliefs, the culture of a people –
Gramsci argues – are not arenas of struggle which can be left to look after
themselves. They 'are themselves material forces' (*PN*, 165).

It thus requires an extensive cultural and ideological struggle to bring
about or effect the intellectual and ethical unity which is essential to the
forging of hegemony: a struggle which takes the form of 'a struggle of
political hegemonies and of opposing directions, first in the ethical field
and then in that of politics proper' (*PN*, 333). This bears very directly on
the type of social struggles we identify with national, anti-colonial and
anti-racist movements. In his application of these ideas, Gramsci is never
simplistically 'progressive' in his approach. For example, he recognizes, in
the Italian case, the absence of a genuine popular national culture which
could easily provide the groundwork for the formation of a popular
collective will. Much of his work on culture, popular literature and reli-
gion explores the potential terrain and tendencies in Italian life and society
which might provide the basis of such a development. He documents, for
example, in the Italian case, the extensive degree to which popular Cath-
olicism can and has made itself a genuinely 'popular force', giving it a
unique importance in forming the traditional conceptions of the popular
classes. He attributes this, in part, to Catholicism's scrupulous attention to
the organization of ideas – especially to ensuring the relationship between
philosophical thought or doctrine and popular life or common sense.
Gramsci refuses all notions that ideas move and ideologies develop spon-
taneously and without direction. Like every other sphere of civil life,
religion requires organization: it possesses its specific sites of develop-
ment, specific processes of transformation, specific practices of struggle.
'The relation between common sense and the upper level of philosophy',
he asserts, 'is assured by "politics",' (*PN*, 331). Major agencies in this
process are, of course, the cultural, educational and religious institutions,
the family and voluntary associations; but also, political parties, which are
also centres of ideological and cultural formation. The principal agents are
intellectuals who have a specialized responsibility for the circulation and

development of culture and ideology and who either align themselves with the existing dispositions of social and intellectual forces ('traditional' intellectuals) or align themselves with the emerging popular forces and seek to elaborate new currents of ideas ('organic' intellectuals). Gramsci is eloquent about the critical function, in the Italian case, of traditional intellectuals who have been aligned with classical, scholarly or clerical enterprises, and the relative weakness of the more emergent intellectual strata.

Gramsci's thinking on this question encompasses novel and radical ways of conceptualizing the *subjects* of ideology, which have become the object of considerable contemporary theorizing. He altogether refuses any idea of a pre-given unified ideological subject – for example, the proletarian with its 'correct' revolutionary thoughts or blacks with their already guaranteed current anti-racist consciousness. He recognizes the 'plurality' of selves or identities of which the so-called 'subject' of thought and ideas is composed. He argues that this multi-faceted nature of consciousness is not an individual but a collective phenomenon, a consequence of the relationship between 'the self' and the ideological discourses which compose the cultural terrain of a society. 'The personality is strangely composite', he observes. It contains 'Stone Age elements and principles of a more advanced science, prejudices from all past phases of history . . . and intuitions of a future philosophy . . . ' (*PN*, 324). Gramsci draws attention to the contradiction in consciousness between the conception of the world which manifests itself, however fleetingly, in action, and those conceptions which are affirmed verbally or in thought. This complex, fragmentary and contradictory conception of consciousness is a considerable advance over the explanation by way of 'false consciousness' more traditional to marxist theorizing but which is an explanation that depends on self-deception and which he rightly treats as inadequate. The implicit attack which Gramsci advances on the traditional conception of the 'given' and unified ideological class subject, which lies at the centre of so much traditional marxist theorizing in this area, matches in importance Gramsci's effective dismantling of the state, on which I commented earlier.

In recognizing that questions of ideology are always collective and social, not individual, Gramsci explicitly acknowledges the necessary complexity and inter-discursive character of the ideological field. There is never any one, single, unified and coherent 'dominant ideology' which pervades everything. Gramsci in this sense does not subscribe to what Abercrombie *et al.* (*The Dominant Ideology Thesis*, Boston: Allen & Unwin, 1980) call 'the dominant ideology thesis'. His is not a conception of the incorporation of one group totally into the ideology of another, and their inclusion of Gramsci in this category of thinkers seems to me deeply misleading. 'There co-exist many systems and currents of philosophical thought.' The object of analysis is therefore not the single stream of

'dominant ideas' into which everything and everyone has been absorbed, but rather the analysis of ideology as a differentiated terrain, of the different discursive currents, their points of juncture and break and the relations of power between them: in short, an ideological complex, ensemble or discursive *formation*. The question is 'how these ideological currents are diffused and why in the process of diffusion they fracture along certain lines and in certain directions.'

I believe it is a clear deduction from this line of argument that, though the ideological field is always, for Gramsci, articulated to different social and political positions, its shape and structure do *not* precisely mirror, match or 'echo' the class structure of society. Nor can they be reduced to their economic content or function. Ideas, he argues, 'have a centre of formation, of irradiation, of dissemination, of persuasion . . . ' (*PN*, 192). Nor are they 'spontaneously born' in each individual brain. They are not psychologistic or moralistic in character 'but structural and epistemological'. They are sustained and transformed in their materiality within the institutions of civil society and the state. Consequently, ideologies are not transformed or changed by replacing one, whole, already formed, conception of the world with another, so much as by 'renovating and making critical an already existing activity'. The multi-accentual, inter-discursive character of the field of ideology is explicitly acknowledged by Gramsci when, for example, he describes how an old conception of the world is gradually displaced by another mode of thought and is internally reworked and transformed:

> what matters is the criticism to which such an ideological complex is subjected. . . . This makes possible a process of differentiation and change in the relative weight that the elements of the old ideologies used to possess . . . what was previously secondary and subordinate . . . becomes the nucleus of a new ideological and theoretical complex. The old collective will dissolve into its contradictory elements since the subordinate ones develop socially.

This is an altogether more original and generative way of perceiving the actual process of ideological struggle. It also conceives of culture as the historically-shaped terrain on which all 'new' philosophical and theoretical currents work and with which they must come to terms. He draws attention to the given and determinate character of that terrain, and the complexity of the processes of de-construction and re-construction by which old alignments are dismantled and new alignments can be effected between elements in different discourses and between social forces and ideas. It conceives ideological change, not in terms of substitution or imposition but rather in terms of the articulation and the dis-articulation of ideas.

III

It remains, now, to sketch some of the ways in which this Gramscian perspective could potentially be used to transform and rework some of the existing theories and paradigms in the analysis of racism and related social phenomena. Again, I emphasize that this is *not* a question of the immediate transfer of Gramsci's particular ideas to these questions. Rather, it is a matter of bringing a distinctive theoretical *perspective* to bear on the seminal theoretical and analytic problems which define the field.

First, I would underline the emphasis on historical specificity. No doubt there are certain general features to racism. But even more significant are the ways in which these general features are modified and transformed by the historical specificity of the contexts and environments in which they become active. In the analysis of particular historical forms of racism, we would do well to operate at a more concrete, historicized level of abstraction (that is, not racism in general but racisms). Even within the limited case that I know best (that is, Britain), I would say that the differences between British racism in its 'high' imperial period and the racism which characterizes the British social formation now, in a period of relative economic decline, when the issue is confronted, not in the colonial setting but as part of the indigenous labour force and regime of accumulation within the domestic economy, are greater and more significant than the similarities. It is often little more than a gestural stance which persuades us to the misleading view that, because racism is everywhere a deeply anti-human and anti-social practice, that therefore it is everywhere *the same* – either in its forms, its relations to other structures and processes, or its effects. Gramsci does, I believe, help us to interrupt decisively this homogenization.

Second, and related, I would draw attention to the emphasis, stemming from the historical experience of Italy, which led Gramsci to give considerable weight to *national* characteristics, as an important level of determination, and to *regional* unevenness. There is no homogenous 'law of development' which impacts evenly throughout every facet of a social formation. We need to understand better the tensions and contradictions generated by the uneven tempos and directions of historical development. Racism and racist practices and structures frequently occur in some but not all sectors of the social formation; their impact is penetrative but uneven; and their very unevenness of impact may help to deepen and exacerbate these contradictory sectoral antagonisms.

Third, I would underline the non-reductive approach to questions concerning the interrelationship between class and race. This has proved to be one of the most complex and difficult theoretical problems to address, and it has frequently led to the adoption of one or another extreme positions. Either one 'privileges' the underlying class relationships, emphasizing that

all ethnically and racially differentiated labour forces are subject to the same exploitative relationships within capital; or one emphasizes the centrality of ethnic and racial categories and divisions at the expense of the fundamental class structuring of society. Though these two extremes appear to be the polar opposites of one another, in fact, they are inverse, mirror-images of each other, in the sense that, *both* feel required to produce a single and exclusive determining principle of articulation – class *or* race – even if they disagree as to which should be accorded the privileged sign. I believe the fact that Gramsci adopts a non-reductive approach to questions of class, coupled with his understanding of the profoundly historical shaping to any specific social formation, does help to point the way towards a non-reductionist approach to the race/class question.

This is enriched by Gramsci's attention to what we might call the culturally specific quality of class formations in any historically specific society. He never makes the mistake of believing that, because the general law of value has the tendency to homogenize labour power across the capitalist epoch, that therefore, in any concrete society, this homogenization can be assumed to exist. Indeed, I believe Gramsci's whole approach leads us to question the validity of this general law in its traditional form, since, precisely, it has encouraged us to neglect the ways in which the law of value, operating on a global as opposed to a merely domestic scale, operates through and *because* of the culturally specific character of labour power, rather than – as the classical theory would have us believe – by systematically eroding those distinctions as an inevitable part of a world-wide, epochal historical tendency. Certainly, whenever we depart from the 'Eurocentric' model of capitalist development (and even within that model) what we actually find is the many ways in which capital can preserve, adapt to its fundamental trajectory, harness and exploit these particularistic qualities of labour power, building them into its regimes. The ethnic and racial stucturation of the labour force, like its gendered composition, may provide an inhibition to the rationalistically conceived 'global' tendencies of capitalist development. And yet, these distinctions have been maintained, and indeed *developed and refined*, in the global expansion of the capitalist mode. They have provided the means for differentiated forms of exploitation of the different sectors of a fractured labour force. In that context, their economic, political and social effects have been profound. We would get much further along the road to understanding how the regime of capital can function *through* differentiation and difference, rather than through similarity and identity, if we took more seriously this question of the cultural, social, national, ethnic and gendered composition of historically different and specific forms of labour. Gramsci, though he is not a general theorist of the capitalist mode, does point us unalterably in that direction.

Moreover, his analysis does also point to the way different modes of

production can be *combined* within the same social formation; leading not only to regional specificity and unevenness, but to differential modes of incorporating so-called 'backward' sectors within the social regime of capital (for example, southern Italy within the Italian formation; the 'Mediterranean' South within the more advanced 'northern' sectors of industrial Europe; the 'peasant' economies of the hinterland in Asian and Latin American societies on the path to dependent capitalist development; 'colonial' enclaves within the development of metropolitan capitalist regimes; historically, slave societies as an integral aspect of primitive capitalist development of the metropolitan powers; 'migrant' labour forces within domestic labour markets; 'Bantustans' within so-called sophisticated capitalist economies, etc.). Theoretically, what needs to be noticed is the persistent way in which *these* specific, differentiated forms of 'incorporation' have consistently been associated with the appearance of racist, ethnically segmentary and other similar social features.

Fourth, there is the question of the non-homogeneous character of the 'class subject'. Approaches which privilege the class, as opposed to the racial, structuring of working classes or peasantries are often predicated on the assumption that, because the mode of exploitation *vis-à-vis* capital is the same, the 'class subject' of any such exploitative mode must be not only economically but politically and ideologically unified. As I have just argued (above) there is now good reason for qualifying the sense in which the operation of modes of exploitation towards different sectors of the labour force *are* 'the same'. In any case, Gramsci's approach, which differentiates the conditional process, the different 'moments', and the contingent character of the passage from 'class in itself' to 'class for itself', or from the 'economic-corporate' to the 'hegemonic' moments of social development, does radically and decisively problematize such simple notions of unity. Even the 'hegemonic' moment is no longer conceptualized as a moment of *simple* unity, but as a process of unification (never totally achieved), founded on strategic alliances between different sectors, not on their pre-given identity. Its character is given by the founding assumption that there is no automatic identity or correspondence between economic, political and ideological practices. This begins to explain how ethnic and racial difference can be constructed as a set of economic, political or ideological antagonisms, *within* a class which is subject to roughly similar forms of exploitation with respect to ownership of and expropriation from the 'means of production'. The latter, which has come to provide something of a magical talisman, differentiating the marxist definition of class from more pluralistic stratification models and definitions, has by now long outlived its theoretical utility when it comes to explaining the actual and concrete historical *dynamic* within and between different sectors and segments within classes.

Fifth, I have already referred to the lack of assumed correspondence in

the Gramscian model, between economic, political and ideological dimensions. But here I would pull out for specific emphasis the *political* consequences of this non-correspondence. This has the theoretical effect of forcing us to abandon schematic constructions of how classes *should*, ideally and abstractly, behave politically in place of the concrete study of how they actually *do* behave, in real historical conditions. It has frequently been a consequence of the old correspondence model that the analysis of classes and other related social forces *as* political forces, and the study of the terrain of politics itself, has become a rather automatic, schematic and residual activity. If, of course, there is 'correspondence', plus the 'primacy' of the economic over other determining factors, then why spend time analyzing the terrain of politics when it only reflects, in a displaced and subordinate way, the determinations of the economic 'in the last instance'? Gramsci certainly would not entertain that kind of reductionism for a moment. He knows he is analysing structurally complex, not simple and transparent, formations. He knows that politics has its own 'relatively autonomous' forms, tempos, trajectories, which need to be studied in their own right, with their own distinctive concepts, and with attention to their real and retroactive effects. Moreover, Gramsci has put certain key concepts into play which help to differentiate this region, theoretically, of which such concepts as hegemony, historical bloc, 'party' in its wider sense, passive revolution, transformism, traditional and organic intellectuals, and strategic alliance, constitute only the beginnings of a quite distinctive and original range. It remains to be demonstrated how the study of politics in racially structured or dominated situations could be positively illuminated by the rigorous application of these newly formulated concepts.

Sixth, a similar argument could be mounted with respect to the state. In relation to racial and ethnic class struggles, the state has been consistently defined in an exclusively coercive, dominative and conspiratorial manner. Again, Gramsci breaks irrevocably with all three. His domination/direction distinction, coupled with the 'educative' role of the state, its 'ideological' character, its position in the construction of hegemonic strategies – however crude in their original formulation – could transform the study, both of the state in relation to racist practices, and the related phenomenon of the 'postcolonial state'. Gramsci's subtle use of the state/civil society distinction – even when it fluctuates in his own work – is an extremely flexible theoretical tool, and may lead analysts to pay much more serious attention to those institutions and processes in so-called 'civil society' in racially structured social formations than they have been encouraged to do in the past. Schooling, cultural organizations, family and sexual life, the patterns and modes of civil association, churches and religions, communal or organizational forms, ethnically specific institutions, and many other such sites play an absolutely vital role in giving, sustaining

and reproducing different societies in a racially structured form. In any Gramscian-inflected analysis, they would cease to be relegated to a superficial place in the analysis.

Seventh, following the same line of thought, one might note the centrality which Gramsci's analysis always gives to the *cultural* factor in social development. By culture, here, I mean the actual, grounded terrain of practices, representations, languages and customs of any specific historical society. I also mean the contradictory forms of 'common sense' which have taken root in and helped to shape popular life. I would also include that whole distinctive range of questions which Gramsci lumped together under the title, the 'national-popular'. Gramsci understands that these constitute a crucial site for the construction of a popular hegemony. They are a key stake as objects of political and ideological struggle and practice. They constitute a national resource for change as well as a potential barrier to the development of a new collective will. For example, Gramsci perfectly well understood how popular Catholicism had constituted, under specific Italian conditions, a formidable alternative to the development of a secular and progressive 'national-popular' culture; how in Italy it would have to be engaged, not simply wished aside. He likewise understood, as many others did not, the role which Fascism played in Italy in 'hegemonizing' the backward character of the national-popular culture in Italy and refashioning it into a reactionary national formation, with a genuine popular basis and support. Transferred to other comparable situations, where race and ethnicity have always carried powerful cultural, national-popular connotations, Gramsci's emphasis should prove immensely enlightening.

Finally, I would cite Gramsci's work in the ideological field. It is clear that 'racism', if not exclusively an ideological phenomenon, has critical ideological dimensions. Hence, the relative crudity and reductionism of materialist theories of ideology have proved a considerable stumbling block in the necessary work of analysis in this area. Especially, the analysis has been foreshortened by a homogeneous, non-contradictory conception of consciousness and of ideology, which has left most commentators virtually undefended when obliged to account, say, for the purchase of racist ideologies within the working class or within related institutions like trade unions which, in the abstract, ought to be dedicated to anti-racist positions. The phenomenon of 'working-class racism', though by no means the *only* kind requiring explanation, has proved extraordinarily resistant to analysis.

Gramsci's whole approach to the question of the formation and transformation of the ideological field, of popular consciousness and its processes of formation, decisively undercuts this problem. He shows that subordinated ideologies are necessarily and inevitably contradictory: 'Stone Age elements and principles of a more advanced science, preju-

dices from all past phases of history . . . and intuitions of a future philosophy. . . .' He shows how the so-called 'self' which underpins these ideological formations is not a unified but a contradictory subject and a social construction. He thus helps us to understand one of the most common, least explained features of 'racism': the 'subjection' of the victims of racism to the mystifications of the very racist ideologies which imprison and define them. He shows how different, often contradictory elements can be woven into and integrated within different ideological discourses; but also, the nature and value of ideological struggle which seeks to transform popular ideas and the 'common sense' of the masses. All this has the most profound importance for the analysis of racist ideologies and for the centrality, within that, of ideological struggle.

In all these different ways – and no doubt in other ways which I have not had time to develop here – Gramsci proves, on closer inspection, and *despite* his apparently 'Eurocentric' position, to be one of the most theoretically fruitful, as well as one of the least known and least understood, sources of new ideas, paradigms and perspectives in the contemporary studies of racially structured social phenomena.

NOTES

1 This paper was originally delivered to the colloquium on 'Theoretical Perspectives in the Analysis of Racism and Ethnicity' organized in 1985 by the Division of Human Rights and Peace, UNESCO, Paris. (The original title of this article was 'Gramsci's relevance to the analysis of racism and ethnicity'.)
2 Some volumes of the planned eight-volume critical edition of the collected works have already been published, at the time of writing, as *Scriti* by Einaudi in Turin. A number of collections of his work, under various headings, exist in English including the excellent edition of *Selections from the Prison Notebooks* by G. Nowell Smith and Q. Hoare (New York: International Publications, 1971; London: Lawrence & Wishart), the two volumes of selected *Political Writings 1910–1920, 1921–1926* (New York: International Publications, 1977, 1978) and the more recent *Selections from Cultural Writings* (Cambridge: Harvard University Press, 1985), edited by D. Forgacs and G. Nowell Smith. The references and quotations in this essay are all from the English translations cited above.

Chapter 21

New ethnicities

Stuart Hall

I have centred my remarks on an attempt to identify and characterize a significant shift that has been going on (and is still going on) in black cultural politics. This shift is not definitive, in the sense that there are two clearly discernible phases – one in the past which is now over and the new one which is beginning – which we can neatly counterpose to one another. Rather, they are two phases of the same movement, which constantly overlap and interweave. Both are framed by the same historical conjuncture and both are rooted in the politics of anti-racism and the post-war black experience in Britain. Nevertheless I think we can identify two different 'moments' and that the difference between them is significant.

It is difficult to characterize these precisely, but I would say that the first moment was grounded in a particular political and cultural analysis. Politically, this is the moment when the term 'black' was coined as a way of referencing the common experience of racism and marginalization in Britain and came to provide the organizing category of a new politics of resistance, among groups and communities with, in fact, very different histories, traditions and ethnic identities. In this moment, politically speaking. 'The black experience', as a singular and unifying framework based on the building up of identity across ethnic and cultural difference between the different communities, became 'hegemonic' over other ethnic/racial identities – though the latter did not, of course, disappear. Culturally, this analysis formulated itself in terms of a critique of the way blacks were positioned as the unspoken and invisible 'other' of predominantly white aesthetic and cultural discourses.

This analysis was predicated on the marginalization of the black experience in British culture; not fortuitously occurring at the margins, but placed, positioned at the margins, as the consequence of a set of quite specific political and cultural practices which regulated, governed and

Reprinted from *ICA Documents 7: Black Film, British Cinema*, edited by Kobena Mercer, 1989.

'normalized' the representational and discursive spaces of English society. These formed the conditions of existence of a cultural politics designed to challenge, resist and, where possible, to transform the dominant regimes of representation – first in music and style, later in literary, visual and cinematic forms. In these spaces blacks have typically been the objects, but rarely the subjects, of the practices of representation. The struggle to come into representation was predicated on a critique of the degree of fetishization, objectification and negative figuration which are so much a feature of the representation of the black subject. There was a concern not simply with the absence or marginality of the black experience but with its simplification and its stereotypical character.

The cultural politics and strategies which developed around this critique had many facets, but its two principal objects were: first the question of *access* to the rights to representation by black artists and black cultural workers themselves. Second, the *contestation* of the marginality, the stereotypical quality and the fetishized nature of images of blacks, by the counter-position of a 'positive' black imagery. These strategies were principally addressed to changing what I would call the 'relations of representation'.

I have a distinct sense that in the recent period we are entering a new phase. But we need to be absolutely clear what we mean by a 'new' phase because, as soon as you talk of a new phase, people instantly imagine that what is entailed is the *substitution* of one kind of politics for another. I am quite distinctly not talking about a shift in those terms. Politics does not necessarily proceed by way of a set of oppositions and reversals of this kind, though some groups and individuals are anxious to 'stage' the question in this way. The original critique of the predominant relations of race and representation and the politics which developed around it have not and cannot possibly disappear while the conditions which gave rise to it – cultural racism in its Dewesbury form – not only persists but positively flourishes under Thatcherism.[1] There is no sense in which a new phase in black cultural politics could replace the earlier one. Nevertheless it is true that as the struggle moves forward and assumes new forms, it does to some degree *displace*, reorganize and reposition the different cultural strategies in relation to one another. If this can be conceived in terms of the 'burden of representation', I would put the point in this form: that black artists and cultural workers now have to struggle, not on one, but on *two* fronts. The problem is, how to characterize this shift – if indeed, we agree that such a shift has taken or is taking place – and if the language of binary oppositions and substitutions will no longer suffice. The characterization that I would offer is tentative, proposed in the context of this essay mainly to try and clarify some of the issues involved, rather than to pre-empt them.

The shift is best thought of in terms of a change from a struggle over the relations of representation to a politics of representation itself. It would be

useful to separate out such a 'politics of representation' into its different elements. We all now use the word representation, but, as we know, it is an extremely slippery customer. It can be used, on the one hand, simply as another way of talking about how one images a reality that exists 'outside' the means by which things are represented: a conception grounded in a mimetic theory of representation. On the other hand the term can also stand for a very radical displacement of that unproblematic notion of the concept of representation. My own view is that events, relations, structures do have conditions of existence and real effects, outside the sphere of the discursive; but that it is only within the discursive, and subject to its specific conditions, limits and modalities, do they have or can they be constructed within meaning. Thus, while not wanting to expand the territorial claims of the discursive infinitely, how things are represented and the 'machineries' and regimes of representation in a culture do play a *constitutive*, and not merely a reflexive, after-the-event, role. This gives questions of culture and ideology, and the scenarios of representation – subjectivity, identity, politics – a formative, not merely an expressive, place in the constitution of social and political life. I think it is the move towards this second sense of representation which is taking place and which is transforming the politics of representation in black culture.

This is a complex issue. First, it is the effect of a theoretical encounter between black cultural politics and the discourses of a Eurocentric, largely white, critical cultural theory which in recent years, has focused so much analysis of the politics of representation. This is always an extremely difficult, if not dangerous, encounter. (I think particularly of black people encountering the discourses of post-structuralism, postmodernism, psychoanalysis and feminism.) Second, it marks what I can only call 'the end of innocence', or the end of the innocent notion of the essential black subject. Here again, the end of the essential black subject is something which people are increasingly debating, but they may not have fully reckoned with its political consequences. What is at issue here is the recognition of the extraordinary diversity of subjective positions, social experiences and cultural identities which compose the category 'black'; that is, the recognition that 'black' is esentially a politically and culturally *constructed* category, which cannot be grounded in a set of fixed trans-cultural or transcendental racial categories and which therefore has no guarantees in nature. What this brings into play is the recognition of the immense diversity and differentiation of the historical and cultural experience of black subjects. This inevitably entails a weakening or fading of the notion that 'race' or some composite notion of race around the term black will either guarantee the effectivity of any cultural practice or determine in any final sense its aesthetic value.

We should put this as plainly as possible. Films are not necessarily good because black people make them. They are not necessarily 'right-on' by

virtue of the fact that they deal with the black experience. Once you enter the politics of the end of the essential black subject you are plunged headlong into the maelstrom of a continuously contingent, unguaranteed, political argument and debate: a critical politics, a politics of criticism. You can no longer conduct black politics through the strategy of a simple set of reversals, putting in the place of the bad old essential white subject, the new essentially good black subject. Now, that formulation may seem to threaten the collapse of an entire political world. Alternatively, it may be greeted with extraordinary relief at the passing away of what at one time seemed to be a necessary fiction. Namely, either that all black people are good or indeed that all black people are *the same*. After all, it is one of the predicates of racism that 'you can't tell the difference because they all look the same'. This does not make it any easier to conceive of how a politics can be constructed which works with and through difference, which is able to build those forms of solidarity and identification which make common struggle and resistance possible but without suppressing the real hetero- geneity of interests and identities, and which can effectively draw the political boundary lines without which political contestation is impossi- ble, without fixing those boundaries for eternity. It entails the movement in black politics, from what Gramsci called the 'war of manoeuvre' to the 'war of position' – the struggle around positionalities. But the difficulty of conceptualizing such a politics (and the temptation to slip into a sort of endlessly sliding discursive liberal-pluralism) does not absolve us of the task of developing such a politics.

The end of the essential black subject also entails a recognition that the central issues of race always appear historically in articulation, in a formation, with other categories and divisions and are constantly crossed and recrossed by the categories of class, of gender and ethnicity. (I make a distinction here between race and ethnicity to which I shall return.) To me, films like *Territories, Passion of Remembrance, My Beautiful Laundrette* and *Sammy and Rosie Get Laid*, for example, make it perfectly clear that this shift has been engaged; and that the question of the black subject cannot be represented without reference to the dimensions of class, gender, sexuality and ethnicity.

DIFFERENCE AND CONTESTATION

A further consequence of this politics of representation is the slow recog- nition of the deep ambivalence of identification and desire. We think about identification usually as a simple process, structured around fixed 'selves' which we either are or are not. The play of identity and difference which constructs racism is powered not only by the positioning of blacks as the inferior species but also, and at the same time, by an inexpressible envy and desire; and this is something the recognition of which fundamentally

displaces many of our hitherto stable political categories, since it implies a process of identification and otherness which is more complex than we had hitherto imagined.

Racism, of course, operates by constructing impassable symbolic boundaries between racially constituted categories, and its typically binary system of representation constantly marks and attempts to fix and naturalize the difference between belongingness and otherness. Along this frontier there arises what Gayatri Spivak calls the 'epistemic violence' of the discourses of the Other – of imperialism, the colonized, Orientalism, the exotic, the primitive, the anthropological and the folk-lore.[2] Consequently the discourse of anti-racism had often been founded on a strategy of reversal and inversion, turning the 'Manichean aesthetic' of colonial discourse upside-down. However, as Fanon constantly reminded us, the epistemic violence is both outside and inside, and operates by a process of splitting on both sides of the division – in here as well as out here. That is why it is a question, not only of 'black-skin' but of *'Black-Skin, White Masks'* – the internalization of the self-as-other. Just as masculinity always constructs feminity as double – simultaneously Madonna and Whore – so racism contructs the black subject: noble savage and violent avenger. And in the doubling, fear and desire double for one another and play across the structures of otherness, complicating its politics.

Recently I have read several articles about the photographic text of Robert Mapplethorpe – especially his inscription of the nude, black male – all written by black critics or cultural practitioners.[3] These essays properly begin by identifying in Mapplethorpe's work the tropes of fetishization, the fragmentation of the black image and its objectification, as the forms of their appropriation within the white, gay gaze. But, as I read, I know that something else is going on as well in both the production and the reading of those texts. The continuous circling around Mapplethorpe's work is not exhausted by being able to place him as the white fetishistic, gay photographer; and this is because it is also marked by the surreptitious return of desire – that deep ambivalence of identification which makes the categories in which we have previously thought and argued about black cultural politics and the black cultural text extremely problematic. This brings to the surface the unwelcome fact that a great deal of black politics, constructed, addressed and developed directly in relation to questions of race and ethnicity, has been predicated on the assumption that the categories of gender and sexuality would stay the same and remain fixed and secured. What the new politics of representation does is to put that into question, crossing the questions of racism irrevocably with questions of sexuality. That is what is so disturbing, finally, to many of our settled political habits about *Passion of Remembrance*. This double fracturing entails a different kind of politics because, as we know, black radical politics has frequently been stabilized around particular conceptions of

black masculinity, which are only now being put into question by black women and black gay men. At certain points, black politics has also been underpinned by a deep absence or more typically an evasive silence with reference to class.

Another element inscribed in the new politics of representation has to do with the question of ethnicity. I am familiar with all the dangers of 'ethnicity' as a concept and have written myself about the fact that ethnicity, in the form of a culturally constructed sense of Englishness and a particularly closed, exclusive and regressive form of English national identity, is one of the core characteristics of British racism today.[4] I am also well aware that the politics of anti-racism has often constructed itself in terms of a contestation of 'multi-ethnicity' or 'multi-culturalism'. On the other hand, as the politics of representation around the black subject shifts, I think we will begin to see a renewed contestation over the meaning of the term 'ethnicity' itself.

If the black subject and black experience are not stabilized by Nature or by some other essential guarantee, then it must be the case that they are constructed historically, culturally, politically – and the concept which refers to this is 'ethnicity'. The term ethnicity acknowledges the place of history, language and culture in the construction of subjectivity and identity, as well as the fact that all discourse is placed, positioned, situated, and all knowledge is contextual. Representation is possible only because enunciation is always produced within codes which have a history, a position within the discursive formations of a particular space and time. The displacement of the 'centred' discourses of the West entails putting in question its universalist character and its transcendental claims to speak for everyone, while being itself everywhere and nowhere. The fact that this grounding of ethnicity in difference was deployed, in the discourse of racism, as a means of disavowing the realities of racism and repression does not mean that we can permit the term to be permanently colonized. That appropriation will have to be contested, the term dis-articulated from its position in the discourse of 'multi-culturalism' and transcoded, just as we previously had to recuperate the term 'black' from its place in a system of negative equivalences. The new politics of representation therefore also sets in motion an ideological contestation around the term, 'ethnicity'. But in order to pursue that movement further, we will have to re-theorize the concept of *difference*.

It seems to me that, in the various practices and discourses of black cultural production, we are beginning to see constructions of just such a new conception of ethnicity: a new cultural politics which engages rather than supresses *difference* and which depends, in part, on the cultural construction of new ethnic identities. Difference, like representation, is also a slippery, and therefore, contested concept. There is the 'difference' which makes a radical and unbridgable separation: and there is a

'difference' which is positional, conditional and conjunctural, closer to Derrida's notion of *differance*, though if we are concerned to maintain a politics it cannot be defined exclusively in terms of an infinite sliding of the signifier. We still have a great deal of work to do to *decouple* ethnicity, as it functions in the dominant discourse, from its equivalence with nationalism, imperialism, racism and the state, which are the points of attachment around which a distinctive British or, more accurately, English ethnicity have been constructed. Nevertheless, I think such a project is not only possible but necessary. Indeed, this decoupling of ethnicity from the violence of the state is implicit in some of the new forms of cultural practice that are going on in films like *Passion* and *Handsworth Songs*. We are beginning to think about how to represent a non-coercive and a more diverse conception of ethnicity, to set against the embattled, hegemonic conception of 'Englishness' which, under Thatcherism, stabilizes so much of the dominant political and cultural discourses, and which, because it is hegemonic, does not represent itself as an ethnicity at all.

This marks a real shift in the point of contestation, since it is no longer only between anti-racism and multi-culturalism but *inside* the notion of ethnicity itself. What is involved is the splitting of the notion of ethnicity between, on the one hand the dominant notion which connects it to nation and 'race' and on the other hand what I think is the beginning of a positive conception of the ethnicity of the margins, of the periphery. That is to say, a recognition that we all speak from a particular place, out of a particular history, out of a particular experience, a particular culture, without being contained by that position as 'ethnic artists' or film-makers. We are all, in that sense, *ethnically* located and our ethnic identities are crucial to our subjective sense of who we are. But this is also a recognition that this a not an ethnicity which is doomed to survive, as Englishness was, only by marginalizing, dispossessing, displacing and forgetting other ethnicities. This precisely is the politics of ethnicity predicated on difference and diversity.

The final point which I think is entailed in this new politics of representation has to do with an awareness of the black experience as a *diaspora* experience, and the consequences which this carries for the process of unsettling, recombination, hybridization and 'cut-and-mix' – in short, the process of cultural *diaspora-ization* (to coin an ugly term) which it implies. In the case of the young black British films and film-makers under discussion, the diaspora experience is certainly profoundly fed and nourished by, for example, the emergence of Third World cinema; by the African experience; the connection with Afro-Caribbean experience; and the deep inheritance of complex systems of representation and aesthetic traditions from Asian and African culture. But, in spite of these rich cultural 'roots', the new cultural politics is operating on new and quite distinct ground – specifically, contestation over what it means to be 'British'. The relation of this cultural politics to the past; to its different 'roots' is

profound, but complex. It cannot be simple or unmediated. It is (as a film like *Dreaming Rivers* reminds us) complexly mediated and transformed by memory, fantasy and desire. Or, as even an explicitly political film like *Handsworth Songs* clearly suggests, the relation is inter-textual – mediated, through a variety of other 'texts'. There can, therefore, be no simple 'return' or 'recovery' of the ancestral past which is not re-experienced through the categories of the present: no base for creative enunciation in a simple reproduction of traditional forms which are not transformed by the technologies and the identities of the present. This is something that was signalled as early as a film like *Blacks Britannica* and as recently as Paul Gilroy's important book, *There Ain't No Black in the Union Jack*.[5] Fifteen years ago we didn't care, or at least I didn't care, whether there was any black in the Union Jack. Now not only do we care, we *must*.

This last point suggests that we are also approaching what I would call the end of a certain critical innocence in black cultural politics. And here, it might be appropriate to refer, glancingly, to the debate between Salman Rushdie and myself in the *Guardian* some months ago. The debate was not about whether *Handsworth Songs* or *The Passion of Remembrance* were great films or not, because, in the light of what I have said, once you enter this particular problematic, the question of what good films are, which parts of them are good and why, is open to the politics of criticism. Once you abandon essential categories, there is no place to go apart from the politics of criticism and to enter the politics of criticism in black culture is to grow up, to leave the age of critical innocence.

It was not Salman Rushdie's particular judgement that I was contesting, so much as the mode in which he addressed them. He seemed to me to be addressing the films as if from the stable, well-established critical criteria of a *Guardian* reviewer. I was trying perhaps unsuccessfully, to say that I thought this an inadequate basis for a political criticism and one which overlooked precisely the signs of innovation, and the constraints, under which these film-makers were operating. It is difficult to define what an alternative mode of address would be. I certainly didn't want Salman Rushdie to say he thought the films were good because they were black. But I also didn't want him to say that he thought they weren't good because 'we creative artists all know what good films are', since I no longer believe we can resolve the questions of aesthetic value by the use of these transcendental, canonical cultural categories. I think there is another position, one which locates itself *inside* a continuous struggle and politics around black representation, but which then is able to open up a continuous critical discourse about themes, about the forms of representation, the subjects of representation, above all, the regimes of representation. I thought it was important, at that point, to intervene to try and get that mode of critical address right, in relation to the new black film-making. It is extremely tricky, as I know, because as it happens, in intervening, I got

the mode of address wrong too! I failed to communicate the fact that, in relation to his *Guardian* article I thought Salman was hopelessly wrong about *Handsworth Songs*, which does not in any way diminish my judgement about the stature of *Midnight's Children*. I regret that I couldn't get it right, exactly, because the politics of criticism has to be able to get both things right.

Such a politics of criticism has to be able to say (just to give one example) why *My Beautiful Laundrette* is one of the most riveting and important films produced by a black writer in recent years and precisely for the reason that made it so controversial: its refusal to represent the black experience in Britain as monolithic, self-contained, sexually stabilized and always 'right-on' – in a word, always and only 'positive', or what Hanif Kureishi has called, 'cheering fictions':

> the writer as public relations officer, as hired liar. If there is to be a serious attempt to understand Britain today, with its mix of races and colours, its hysteria and despair, then, writing about it has to be complex. It can't apologize or idealize. It can't sentimentalize and it can't represent only one group as having a monopoly on virtue.[6]

Laundrette is important particularly in terms of its control, of knowing what it is doing, as the text crosses those frontiers between gender, race, ethnicity, sexuality and class. *Sammy and Rosie* is also a bold and adventurous film, though in some ways less coherent, not so sure of where it is going, overdriven by an almost uncontrollable, cool anger. One needs to be able to offer that as a critical judgement and to argue it through, to have one's mind changed, without undermining one's essential commitment to the project of the politics of black representation.

NOTES

1 The Yorkshire town of Dewesbury became the focus of national attention when white parents withdrew their children from a local school with predominantly Asian pupils, on the grounds that 'English' culture was no longer taught on the curriculum. The contestation of multicultural education from the right also underpinned the controversies around Bradford headmaster Ray Honeyford. See, Paul Gordon, 'The New Right, race and education'; *Race and Class* XXIX (3), Winter 1987.
2 Gayatri C. Spivak, In *Other Worlds: Essays in Cultural Politics*, Methuen, 1987.
3 Kobena Mercer 'Imaging the black man's sex' in Patricia Holland *et al.* (eds), *Photography/Politics: Two*, Comedia/Methuen, 1987 and various articles in *Ten.8* 22, 1986, an issue on 'Black experiences' edited by David A. Bailey.
4 Stuart Hall, 'Racism and reaction', in *Five Views on Multi-Racial Britain*, Commission for Racial Equality, 1978.
5 Paul Gilroy, *There Ain't No Black in the Union Jack: The Cultural Politics of Race and Nation*, Hutchinson, 1988.
6 Hanif Kureishi, 'Dirty washing', *Time Out*, 14–20 November 1985.

Chapter 22

De Margin and De Centre

Isaac Julien and Kobena Mercer

Film culture in the 1980s has been marked by volatile reconfigurations in the relations of 'race' and representation. Questions of cultural difference, identity and otherness – in a word, ethnicity – have been thrown into the foreground of contestation and debate by numerous shifts and developments. Within the British context, these trends have underpinned controversies around recent independent films like *Handsworth Songs*, *My Beautiful Laundrette* and *The Passion of Remembrance* – films which have elicited critical acclaim and angry polemic in roughly equal measure. The fragmented state of the nation depicted from a black British point of view in the films themselves contradicts (literally, speaks against) the re-mythification of the colonial past in mainstream movies such as *Ghandi* or *A Passage to India*; yet, the wave of popular films set in imperial India or Africa also acknowledge, in their own way, Britain's postcolonial condition in so far as they speak to contemporary concerns. The competing versions of narrative, memory and history in this conjuncture might be read symptomatically as a state of affairs that speaks of – articulates – conflicting identities within the 'imagined community' of the nation.

In the international context, certain moments and trends suggest further shifts, adjustments, in the articulation of ethnicity *as* ideology. The ratings success-story of *The Cosby Show* – 'number one' in South Africa as well as the United States – has fulfilled the innocent demand for 'positive images' with a (neo-conservative) vengeance. And the very *idea* of a Hollywood director like Steven Spielberg adapting the Alice Walker novel *The Color Purple* (in the context of the unprecedented publication of black women writers) still seems extraordinary, however commercially astute. In addition, the widening circulation of Third World films among western audiences, or the televisual 'presence' of Third World spaces like Ethiopia *via*

This chapter first appeared as the 'Introduction' to *Screen* 29(4), 1988, 2–10. The issue was entitled 'The Last "Special Issue" on Race?'. See the 'Editors' note' at the end of the chapter.

events such as Live Aid in 1985, implies something of a shift within the boundaries that differentiated the First and Third Worlds.

One issue at stake, we suggest, is the potential break-up or deconstruction of structures that determine what is regarded as culturally central and what is regarded as culturally marginal. Ethnicity has emerged as a key issue as various 'marginal' practices (black British film, for instance) are becoming de-marginalized at a time when 'centred' discourses of cultural authority and legitimation (such as notions of a trans-historical artistic 'canon') are becoming increasingly de-centred and destabilized, called into question from within. This scenario, described by Craig Owens as a crisis, 'specifically of the authority vested in western European culture and its institutions',[1] has of course already been widely discussed in terms of the characteristic aesthetic and political problems of postmodernism. However, it is ironic that while some of the loudest voices offering commentary have announced nothing less than the 'end of representation' or the 'end of history', the political possibility of the *end of ethnocentrism* has not been seized upon as a suitably exciting topic for description or inquiry.[2] We would argue, on the contrary, that critical theories are just *beginning* to recognize and reckon with the kinds of complexity inherent in the culturally constructed nature of ethnic identities, and the implications this has for the analysis of representational practices.

We chose to call this the 'last special issue' as a rejoinder to critical discourses in which the subject of race and ethnicity is still placed on the margins conceptually, despite the acknowledgement of such issues indicated by the proliferation of 'special issues' on race in film, media and literary journals.[3] The problem, paradoxically, is that as an editorial strategy and as a mode of address, the logic of the 'special issue' tends to reinforce, rather than ameliorate, the perceived otherness and marginality of the subject itself. There is nothing intrinsically different or 'special' about ethnicity in film culture, merely that it makes fresh demands on existing theories, methods and problematics. Rather than attempt to compensate the 'structured absences' of previous paradigms, it would be useful to identify the relations of power/knowledge that determine which cultural issues are intellectually prioritized in the first place. The initial stage in any deconstructive project must be to examine and undermine the force of the binary relation that produces the marginal as a consequence of the authority invested in the centre.

At a concrete level the politics of marginalization is an underlying issue in the overview of black film-making in Europe sketched by Maureen Blackwood and June Givanni. The negotiation of access to resources in training, production and distribution emerges as a common factor facing practitioners in a migrant or 'minority' situation. While highlighting the different conditions stemming from the colonial past, the comparative dimension also draws attention to the specificity of British conditions in

the present, where black film-making has flourished in the state-subsidized 'independent' sector. Data compiled by June Givanni elsewhere[4] indicates some of the characteristics that constitute black British film as a 'minor' cinema: the prevalence of material of short duration, shot on video, and in the documentary genre, indicates a pattern of underfunding, or rather, taking the variety of work into consideration, a considerable cultural achievement that has been won against the odds of meagre resourcing. Moreover, shifts in the institutional framework of public funding in the United Kingdom were brought about in the 1980s as a result of a wider social and political struggle to secure black rights to representation. It was said at the time of the 1981 'riots' that this was the only way in which those excluded from positions of power and influence could make themselves heard: in any case, the events were read and widely understood as expressing protest at the structural marginalization of the black presence in British public institutions.

The consequent demand for *black representation* thus informed shifts in multicultural and 'equal opportunity' policy among institutions such as Channel Four, the British Film Institute and local authorities such as the Greater London Council. More generally, this took place in the context of a re-articulation of the category 'black' as a political term of identification among diverse minority communities of Asian, African and Caribbean origin, rather than as a biological or 'racial' category. Together, these aspects of the cultural politics of 'black representation' informed the intense debates on aesthetic and cinematic strategies within the black British independent sector. Far from homogenizing these differences, the concept has been the site of contestation, highlighted in numerous events and conferences, such as 'Third Cinema' at the Edinburgh International Film Festival in 1986 and more recently, the conference on 'Black Film/ British Cinema' at the Institute of Contemporary Arts in London.[5] It has become apparent that what is at stake in the debates on 'black representation' is not primarily a dispute over realist or modernist principles, but a broader problematic in cultural politics shaped, as Paul Gilroy suggests, by the tension between representation as a practice of depiction and representation as a practice of delegation.[6] Representational democracy, like the classic realist text, is premised on an implicitly mimetic theory of representation as correspondence with the 'real': notionally, the political character of the state is assumed to 'correspond' to the aspiration of the masses in society. However, not unlike the civil disruptions, aspects of the new wave in black British film-making have interrupted these relations of representation: in cinematic terms the challenge to documentary realism that features so prominently in more recent work, such as *Territories*, is predicated on a relational conception of representation as a practice of selection, combination and articulation. At a textual level, such shifts have contested the hegemony of documentary realism underlying the formal

codification of what Jim Pines calls the master discourse of the 'race-relations narrative'.[7] This also entails awareness of extra-textual factors, such as funding, as important determinants on black film-making and its modes of enunciation, such as 'the moral imperative which usually characterizes black films, which empowers them to speak with a sense of urgency', as John Akomfrah of Black Audio Film Collective has put it.[8]

What is at issue in this problematic is the question of power, as Judith Williamson argues in her review of *The Passion of Remembrance*, 'The more power any group has to create and wield representations, the less it is required to be representative'.[9] Where access and opportunities are rationed, so that black films tend to get made only one-at-a-time, each film text is burdened with an inordinate pressure to be 'representative' and to act, like a delegate does, as a statement that 'speaks' for the black communities as a whole. Martina Attille, producer of the film, suggests that the 'sense of urgency to say it all' stems less from the artistic choices made by black film-makers and more from the material constraints in which 'sometimes we only get the one chance to make ourselves heard'.[10] Contemporary shifts have brought these problems into view, for as Williamson adds, in relation to the invisible demand to be 'representative' implicit in the rationing and rationalization of public funding, 'what is courageous in Sankofa's project is that they have chosen to speak from, but not for, black experience(s) in Britain.'

Marginality circumscribes the enunciative modalities of black film as cinematic discourse and imposes a double bind on black subjects who speak in the public sphere: if only one voice is given the 'right to speak', that voice will be heard, by the majority culture, as 'speaking for' the many who are excluded or marginalized from access to the means of representation. This of course underlines the problem of tokenism: the very idea that a single film could 'speak for' an entire community of interests reinforces the perceived secondariness of that community. The double bind of expedient inclusion as a term for the legitimation of more general forms of exclusionary practice is also the source of a range of representational problems encountered not just by black subjects, but by other groups marginalized into minority status. In the gay documentary *Word is Out* (Mariposa Film Group, 1978) the nature of this problematic is pointed out in a performative mode by a black woman who carefully describes the predicament she is placed in as a result of the editing strategy of the text:

What I was trying to say when I asked you if I would be the only black lesbian in the film is: do you know we come in all shapes and colours and directions to our lives? Are you capturing that on the film? As a black lesbian-feminist involved in the movement, so often people try to put me in the position of speaking for all black lesbians. I happen to be *a*

black lesbian among many, and I woudn't want to be seen as *this is how all black lesbians are*.[11]

Within such a regime of representation, the restricted economy of ethnic enunciation is a political problem for at least two important reasons. First, individual subjectivity is denied because the black subject is positioned as a mouthpiece, a ventriloquist for an entire social category which is seen to be 'typified' by its representative. Acknowledgement of the diversity of black experiences and subject-positions is thereby foreclosed. Thus, secondly, where minority subjects are framed and contained by the monologic terms of 'majority discourse', the fixity of boundary relations between centre and margin, universal and particular, returns the speaking subject to the ideologically appointed place of the stereotype – that 'all black people are the same'.

Stuart Hall's account of the shifts taking place in contemporary black British cultural production offers a means of making sense of the 'politics of representation' at issue here. His argument that current shifts demand the recognition of the 'end of the innocent notion of the essential black subject' enables us to analyse and unpack the burden of racial representation. The recognition that 'black' is a politically and culturally constructed category, and that our metaphorical fictions of 'white' and 'black' are not fixed by Nature but by historical formations of hegemony, brings into play 'the recognition of the immense diversity and differentiation of the historical and cultural experiences of black subjects'. This has major consequences for the critical evaluation of different aesthetic and discursive strategies that articulate race at the level of language and representation.

> Films are not necessarily good because black people make them. They are not necessarily *right-on* by virtue of the fact that they deal with the black experience. Once you enter the politics of the end of the essential black subject you are plunged headlong into the maelstrom of a continuously contingent, unguaranteed, political argument and debate: a critical politics, a politics of criticism. You can no longer conduct black politics through the strategy of a simple set of reversals, putting in place of the bad old essential white subject, the new essentially good black subject.[12]

The deconstruction of binary relations thus entails the relativization and rearticulation of 'ethnicity'. This is an importantly enabling argument as it brings a range of critical issues into an explanatory structure, however tentative.

At one level, it contextualizes Salman Rushdie's point, expressed in his polemic against *Handsworth Songs*,[13] that 'celebration makes us lazy'. Because black films have been so few and far between, up till now, there has been a tendency to 'celebrate' the fact that they ever got made at all;

but this has inhibited the formulation of criticism and self-criticism and perpetuated the moral masochism of 'correctness' so pervasive in opposi-tional 'left' cultural politics (especially in Britain). Judith Williamson takes up this point and argues that the moralism of being ideologically 'right-on' has been conflated with aesthetic judgement and thus the formal properties of the recent 'experimental' films have been subsumed into their 'black-ness' (that is, the racial identity of the authors) giving the films an 'aura of untouchability' that further pre-empts critical analysis. The problem which arises, is that such responses threaten to frame the films as merely replacing the avant-garde (as the 'latest thing') rather than as displacing the ortho-doxies that have led the Euro-American vanguard (especially its formalist variant) into its current stasis. At another level, Perminder Dhillon-Kashyap argues that the debates on black British film have in turn made Asian experiences and interventions 'secondary', thus risking the replica-tion of essentialist versions of race precisely when the re-articulation of subaltern ethnicities as 'black' seeks to undermine 'ethnic absolutism' (anchoring the culturalist terms of the 'new racism' that fixes hybridized experiences in terms of alien cultures').[14] Coco Fusco's assessment of two major conferences in the United States examines the way in which two kinds of essentialist tendency, manifest in the contradictory reception of black British film, mutually forestall the politics of criticism. The impetus to 'celebrate' black cinema, on the one hand, invokes a unitary notion of blackness that precludes elucidation of 'internal' differences and diversity. The desire to 'correct' the omissions of the past within the western avant-garde, on the other hand, has led to a one-sided fixation with ethnicity as something that 'belongs' to the Other alone, thus white ethnicity is not under question and retains its 'centred' position; more to the point, the white subject remains the central reference point in the power ploys of multicultural policy. The burden of representation thus falls on the Other, because as Fusco argues, 'to ignore white ethnicity is to redouble its hegemony by naturalising it.'

While such discursive events acknowledge contemporary shifts, their logic evades the implications of Hall's insight that the point of contesta-tion is no longer between multiculturalism and anti-racism, but inside the concept of ethnicity itself. Within dominant discourses, 'ethnicity' is structured into a negative equivalence with essentialist versions of 'race' and 'nation' which particularize its referent, as the pejorative connotation of 'ethnic minority' implies (who, after all, constitutes the 'ethnic major-ity'?). On the other hand, just as it was necessary to re-appropriate the category 'black', Hall argues that 'ethnicity' is a strategically necessary concept because it

acknowledges the place of history, language and culture in the construc-tion of subjectivity and identity, as well as the fact that all discourse is

placed, positioned, situated, and all knowledge is contextual. Representation is possible only because enunciation is always produced within codes that have a history, a position within the discursive formations of a particular space and time.[15]

In this sense, 'we are all ethnically located', but the cultural specificity of white ethnicity has been rendered 'invisible' by the epistemic violence that has, historically, disavowed difference in western discourses. The re-articulation of ethnicity as an epistemological category thus involves,

> the displacement of the *centred* discourses of the West (and) entails putting into question its universalist character and its transcendental claims to speak for everyone, while being itself everywhere and no-where.

Richard Dyer's article, 'White', inaugurates a paradigmatic shift by precisely registering the re-orientation of 'ethnicity' that Hall's argument calls for. Dyer shows how elusive white ethnicity is as a representational construct (and the difficulties this presents for constituting it as a theoretical object of analysis) and notes that, 'Black is, in the realm of categories, always marked as a colour . . . is always particularising; whereas white is not anything really, not an identity, not a particularising quality, because it is everything.' In other words, whiteness has secured universal consent to its hegemony as the 'norm' by masking its coercive force with the invisibility that marks off the Other (the pathologized, the disempowered, the dehumanized) as all too visible – 'coloured'.[16] Significantly, in relation to the films that Dyer discusses, whiteness only tends to become visible when its hegemony is under contestation.

The complex range of problems now coming into view in film studies around the site of ethnicity, partly as a result of developments elsewhere in literary and social theory,[17] enables a more adequate understanding of contemporary forms of contestation. The 'differences' between various black independent film practices have, to some extent, been overplayed, as the key underlying objective across each of the strategies, is to displace the binary relation of the burden of representation, most clearly pinpointed by Horace Ove:

> Here in England there is a danger, if you are black, that all you are allowed to make is films about black people and their problems. White film-makers on the other hand, have a right to make films about whatever they like.[18]

Theoretically, the displacement of binarisms has been most important in the analysis of stereotyping – the marginalization of ethnicity has been held in place by the logical impasse of the 'positive/negative' image polarity. *Screen* has contributed to the productive displacement of this stasis in a

number of ways: from Steve Neale's analysis of the impossibility of the 'perfect image' sought by idealist and realist arguments, to Homi Bhabha's influential reading of colonial discourse, which emphasizes the psychic ambivalence, the fear and fascination, that informs the 'Manichean delirium' of classical regimes of racial representation.[19] However, the range of textual readings here suggests that we need to go much further towards a reflexive examination of the mutual inscription of self and other in the analysis of ethnic boundary-ness. This involves questioning the way that, during its 'centred' role in the discursive formation of film theory during the 1970s, *Screen* participated in a phase of British left culture that inadvertently marginalized race and ethnicity as a consequence of the centrifugal tendency of its 'high theory'.

During this period, one was more likely to encounter the analysis of racial stereotyping in sociology than cultural theory, where class and gender took precedence in debates on ideology and subjectivity.[20] Furthermore, without imputing maleficent intentions (because such relations are beyond the control of individual intentionality), it can be said that even within *Screen*'s important acknowledgement of ethnic differences in previous 'special issues',[21] the explanatory concept of 'Otherness' distances and particularizes ethnicity as something that happens far away, either in the United States or in the Third World.[22] Space prohibits an adequate exploration of the intellectual milieu that *Screen* helped to form, but recent comments on the institutionalization of film studies have argued that '*Screen* theory', so-called, came to function as a kind of corporate 'name of the father', a 'theoretical super-ego' or even a 'phallic mother' – a centred point of reference that, like a doctrine or orthodoxy, featured a number of 'disciplinary' characteristics.[23] Jane Gaines recalls that, in the translation of '*Screen* theory' into the North American academic environment in the 1970s, leftist enthusiasm for theoretical 'correctness' was heard to speak in an unmistakably English accent.

This background is important because what emerges in the current situation is not a 'new' problematic, but a critical return to issues unwittingly 'repressed' in some of the 'old' problematics and debates. It would be useful, therefore, to tentatively draw out some of the directions in which the field is being remapped and in which the *lacunae* of previous paradigms are excavated.

First, the analysis of ethnic binarisms at the level of narrative codes returns to the question of how dominant ideologies naturalize their domination, underlying previous debates on the classic realist text. Clyde Taylor's inter-textual examination of racialized repetition across two 'epic' Hollywood films suggests that the ethnic iconography that drives the reproduction of racist ideology is not simply indicative of capitalist commodification or a bourgeois world view. *Star Wars,* argues Taylor, repeats the 'blood and purity' mythology of *The Birth of a Nation*, not as a

defiant assertion of WASP 'superiority' but as an embattled recoding of the master text in response to the encroaching presence of the Third World. The racial discourse sub-textualized by binary oppositions acknowledges the crises of (US) hegemony. The 'liberal' inflections in the films discussed by Richard Dyer also acknowledge the destabilization of prevailing race relations, albeit within a different set of generic and narrative conventions. Common to both readings is a concern to 'typify' textual structures that position racial and ethnic signifiers in the fixed relation of a binary opposition, whether it be one of antagonism, accommodation or subordination.

There is, in addition, a historical emphasis that relativizes the kinds of claims once extrapolated from the formal structures of the 'CRT', as it was known. Aspects of Bhabha's theorization of the stereotype in colonial discourse replicate this trans-historical or de-historicized emphasis.[24] The move towards a more context-oriented view, on the other hand, indicates that although dominant discourses are characterized by closure, they are not themselves closed but constantly negotiated and restructured by the conjuncture of discourses in which they are produced. The way in which ethnic 'types' are made afresh in contemporary movies like *An Officer and a Gentleman* and *Angel Heart* – or more generally in current advertising – demands such a conjunctural approach. The theory of the stereotype cannot be abandonded as it also needs to be able to explain how and why certain ethnic stereotypes are at times recirculated, in the British context, in the work of black film and television authors.[25]

Secondly, there is a note of caution about reproducing binarisms at the level of theory. Cameron Bailey's reading of the accretion of 'ethnic' signifiers around the construction of (white) femininity as a source of pleasure and danger in *Something Wild* demonstrates that, rather than the familiar 'race, class, gender' mantra, analysis needs to take account of the intersections of differences, in particular of the representation of sexuality as a recurring site upon which categories of race and gender intersect. Feminist theories of the fetishistic logic inherent in the sexualization of gender-difference have provided an invaluable inventory for the reading of the eroticized othering of the black (male and female) subject. Yet, as Jane Gaines argues, the gender binarism implicit in the heterosexist presumption so often unwittingly reproduced in feminist film theory (or FFT; the acronym already indicates an orthodoxy) remains 'colour blind' to the racial hierarchies that structure mastery over the 'look'. The scenario of voyeurism, sadism and objectification played out across Diana Ross's star image in *Mahogany* enacts a patriarchal discourse of masculine 'desire', but also demands a historical understanding of the pre-textual and the contextual discourses of race that placed the black woman in the 'paradox of non-being' – a reference to the period in Afro-American history when

the black female did not signify 'woman' on account of the racial ideology that made the black subject less than human.

The historical violation of black bodies in social formations structured by slavery gives rise to a discourse (encoded in both the rationalization of and resistance to such pre-modern forms of power as lynching) which has indeed the countervailing force to rival the problematic of castration rhetorically placed at the centre of psychoanalytic theory by the Oedipal grand narrative. Just as lesbian critiques of FFT have questioned the explanatory capacity of Freudian and Lacanian theory to account for the inscription of female pleasure and desire[26] – demonstrating the contradictory subject positions occupied by different spectators – the reorientation of the spectatorship problematic in the articles by Gaines and Manthia Diawara identifies the ethnocentrism of psychoanalytic discourse as a barrier to further inquiry. Both question the universalist claims anchored in the Oedipus story and imply that uncritical adherence to psychoanalytic theory (however enabling as a method) risks the disavowal of its Eurocentric 'authority'; Freud closes his essay on fetishism by commenting that the acknowledgement and disavowal of difference 'might be seen in the Chinese custom of mutilating the female foot and then revering it like a fetish after it has been mutilated'[27] – surely this culture-bound aesthetic judgement is the starting-point for a more circumspect appropriation of psychoanalytic theory.

Diawara identifies the mythic 'castration' and 'visual punishment' of the black male as a term of the 'narrative pleasures' offered by Hollywood spectacle (and also as a narratological term of closure, analogous to the 'punishment' of feminine transgression in *film noir*). By raising the issue of spectatorial resistance, Diawara opens up an interesting question about the place of the black spectator in the ideological machinery of interpellation. How is the black subject sutured into a place that includes it only as a term of negation? What does the black spectator identify with when his/her mirror image is structurally absent or present only as Other? In the past, it was assumed that all social subjects acceded to the narcissistic pleasure of the 'mirror phase' in their misrecognition of themselves as the subject of enunciation, returned thus as normalized and passified 'subjects' of ideological subjection (this was the basis of Barthes' distinction between 'pleasure' and 'bliss'[28]). But what if certain social categories of spectator do not have access, as it were, to the initial moment of recognition? The question of how black subjects psychically manage to make identifications with white images is thus signposted as an important area for further inquiry.[29] Perhaps one reason why, for example, *The Cosby Show* is so popular among black audiences is that it affords the pleasure of a basic or primary narcissism even though it interpellates the minority subject, in particular, into ideological normalization.[30] A contemporary black star, like Eddie Murphy – popular with both white and black audiences – offers

another source of 'bad pleasure', partly on account of the pastiche of the stereotype that he performs in his star-image as the street-credible, but ideologically unthreatening, macho loudmouth.

This is also where class comes back into the calculation of difference. An appreciation of differentiated regimes of racial representation necessitates acknowledgement of different audiences or, taken together, recognition of the different forms of ideological articulation characteristic of First and Second Cinemas, as described by the concept of Third Cinema.[31] The inscription of ethnic indeterminacy does not take place 'inside' the text, as if it were hermetically sealed, but in-between the relations of author, text and reader specific to the construction of different discursive formations. Blackness is not always a sign of racial codification (as the term *film noir* admits): its representational aura in auteurist and avant-garde traditions conventionally serves to mark off the status of the author (as white subject of enunciation) in relation to the discourse authorized in the text (as black subject of the statement). Ethnic alterity is a consistent trope of modernist differentiation in various Euro-American canons: the play of black signs that inscribe the authorial voice self-referentially in Jonathan Demme's *Something Wild* can be seen as drawing on elements of the romanticist image-reservoir, where blackness is valorized as emblematic of outsider-ness and oppositionality, that might be read off Jean Genet's *Chant d'amour* (1953), Jean-Luc Godard's *One Plus One/Sympathy for the Devil* (1969) or Laura Mulvey and Peter Wollen's *Riddles of the Sphinx* (1976). This arbitrary list (indexing disparate debates on independent film-making[32]) is made merely to point out another set of questions; namely, how to differentiate diverse appropriations of the same stock of signs and meanings built up around different discursive formations of 'race' and ethnicity? This question bears upon the broader underlying issue of the multi-accentual nature of the signs characteristic of the flashpoints of ideological contestation and cultural struggle.[33] It also alludes to the paradox identified in Richard Dyer's reading of Paul Robeson as a cine-matic icon that meant different things to radically differentiated readers:

> Black and white discourses on blackness seem to be valuing the same things – spontaneity, emotion, naturalness – yet giving them a different implication. Black discourses see them as contributions to the develop-ment of society, white as enviable qualities that only blacks have.[34]

The issue of 'envy' confirms that white identifications are as problematic (conceptually) as the ability of black readers – or readers of subaltern status – to appropriate alternative 'sub-textual' readings from the racial discourse of dominant cultural texts. *King Kong* – to cite one of the most centred mythologies of modern popular cinema – has been read as the tragic story of a heroic beast and/or the fate of a black man punished for the transgres-sive coupling with the white woman that he/the monster desires. These

questions appear to be 'new', hence very difficult, yet we have returned, by a rather circuitous route, to the hotly contested terrain of the debates on class and culture, hegemony and subjectivity that were territorialized with such passion in the mid-1970s.[35] We must conclude that this cannot possibly be the last word on 'race' as these complicated issues are only now coming into view as a result of the critical dialogue that has engaged with the blind-spots and insights of earlier conversations. And further, that such dialogism is a necessary discursive condition for understanding contestation in film culture and other formations of cultural practice and cultural politics.

Editors' note

The contents of *Screen* 29(4), 1988, 'The last "special issue" on race?', in which this chapter initially appeared as the 'Introduction', were as follows:

Jane Gaines: 'White privilege and looking relations – race and gender in feminist film theory'.
Cameron Bailey: 'Nigger/lover – the thin sheen of race in "Something Wild" '.
Richard Dyer: 'White'.
Manthia Diawara: 'Black spectatorship – problems of identification and resistance'.
Coco Fusco: 'Fantasies of oppositionality – reflections on recent conferences in Boston and New York'.
Clyde Taylor: 'The master text and the Jeddi doctrine'.
Judith Williamson: 'Two kinds of Otherness – Black film and the avante-garde'.
Maureen Blackwood and June Givanni: 'Black film-making in Europe'.
Perminder Dhillon-Kashyap: 'Locating the Asian Experience'.

NOTES

1 Craig Owens, 'The discourse of others: feminists and post-modernism' in Hal Foster (ed.), *Postmodern Culture*, London: Pluto, 1985, 57.
2 The assertion of the 'end' of everything is exemplified in Jean Baudrillard, *Simulations*, New York: Semiotext(e), 1984 and Victor Burgin, *The End of Art Theory*, London: Macmillan, 1986. More considered reflections on postmodernism, which focus on the problems of its ethnocentrism, are offered by Stuart Hall, 'On postmodernism and articulation: an interview edited by Lawrence Grossberg', in *Communications Inquiry* 10(2), 1986 (University of Iowa) and Andreas Huyssens, 'Mapping the post-modern', in *After the Great Divide*, London: Macmillan, 1987.
3 For instance, 'Black experiences', *Ten-8* 22, 1986; 'Race, writing and difference', *Critical Inquiry* 12(3),1985 and 13(1), 1986; 'The inappropriate Other', *Discourse* 8, 1986; 'Colonialism', *Oxford Literary Review* 9, 1987 and 'The nature and context of minority discourse', I and II *Cultural Critique*, Spring and Fall, 1987.
4 *Black and Asian Film List*, compiled by June Givanni and edited by Nicky North, London, British Film Institute Education, 1988. A transatlantic comparison is offered by James A. Snead, 'Black independent film: Britain and America', in Kobena Mercer (ed.), *Black Film/British Cinema, ICA Document 7*/British Film Institute Production Special, 1988.

5 Symposia organized by the Greater London Council in 1985 are documented in *Third Eye: Struggles for Black and Third World Cinema*, Race Equality Unit, London, GLC 1986; the Edinburgh conference is documented in Jim Pines and Paul Willemen (eds), *Third Cinema: Theories and Practices*, London, BFI (forthcoming); and the ICA conference is documented in Kobena Mercer (ed.), op.cit.

6 'Nothing but sweat inside my hand: diaspora aesthetics and Black arts in Britain', in Kobena Mercer (ed.), op.cit. See also Pierre Bourdieu, 'Delegation and political fetishism', *Thesis Eleven* 10/11, 1984–5 (Sydney), 56–70.

7 See Jim Pines, 'The cultural context of Black British cinema', in Mbye Cham and Claire Andrade-Watkins (eds), *BlackFrames: Critical Perspectives on Black Independent Cinema*, Celebration of Black Cinema, Inc/MIT Press 1988 and Kobena Mercer, 'Diaspora culture and the dialogic imagination: the aesthetics of black independent film in Britain', ibid.

8 In Paul Gilroy and Jim Pines, 'Handsworth songs: audiences/aesthetics/independence, an interview with Black Audio Film Collective', *Framework* 35, 1988, 11.

9 *New Statesman*, 5 December 1986.

10 In 'The Passion of Remembrance: background and interview with Sankofa', *Framework* 32/33, 1986, 101.

11 In Nancy Adair and Casey Adair (eds), *Word is Out: Stories of Some of Our Lives*, New York: New Glide/Delta, 1978, 203.

12 Stuart Hall, 'New ethnicities' in this volume. Also in Kobena Mercer (ed.), *Black Film/British Cinema*, op.cit. See also Stuart Hall, 'Minimal selves', in Lisa Appignanesi (ed.), *Identity, ICA Document 6*, 1988, 44–6.

13 'Songs doesn't know the score', *Guardian*, 12 January 1987, reprinted in Kobena Mercer (ed.), *Black Film/British Cinema*, op.cit.

14 Discursive formations of British racism are discussed in Paul Gilroy, *There Ain't No Black in the Union Jack*, London: Hutchinson, 1987. Gilroy proposes the concept of syncretism to examine cultural resistance in the 'hybridized' context of black Britain, see especially chapter 5, 'Diaspora, Utopia and the critique of capitalism'.

15 Stuart Hall, 'New ethnicities', in Kobena Mercer (ed.), *Black Film/British Cinema*, op.cit. Also in this volume.

16 The term 'people of color' operates in the United States as a political term analogous to 'black' in the British context. In both instances, such terms have engendered intense semantic ambiguity and ideological anxiety as the racial mythology of 'colour' is put under erasure, cancelled out but still legible, in a deconstructive logic that depends on the same system of metaphorical equivalences and differences. Semantic indeterminacy as a condition of political contestation is discussed in Chantal Mouffe and Ernesto Laclau, *Hegemony and Socialist Strategy*, London: Verso, 1985.

17 See Stuart Hall, 'Race, articulation and societies structured in dominance', in *Sociological Theories: Race and Colonialism*, Paris: UNESCO, 1980; Edward Said, *Orientalism*, London: Routledge & Kegan Paul, 1978, and *The World, the Text and the Critic*, London: Faber, 1984; Gayatri Chakravorty Spivak, *In Other Worlds*, London: Methuen 1987; Cornel West, 'The dilemma of a Black intellectual', *Cultural Critique* 1(1), 1986; 'Race and social theory', in M. Davis, M. Marrable, F. Pfiel and M. Sprinker (eds), *The Year Left 2*, London: Verso, 1987 and 'Marxist theory and the specificity of Afro-American oppression', in Cary Nelson and Lawrence Grossberg (eds), *Marxism and the Interpretation of Culture*, London: Macmillan, 1988.

18 Interview with Sylvia Paskin, *Monthly Film Bulletin* 54(647), December 1987.
19 Steve Neale, 'The same old story: stereotypes and difference', *Screen Education*, Autumn–Winter 1979–80, nos 32 and 33, 33–7 and Homi K. Bhabha, 'The Other question: the stereotype and colonial discourse', *Screen*, November–December 1983, 24(6), 18–36.
20 In both Weberian and marxist variants, see Charles Husband, *White Media and Black Britain*, London: Arrow, 1975 and Stuart Hall *et al.*, *Policing the Crisis*, London: Macmillan, 1978. Cultural struggles over media racism are documented in Phil Cohen and Carl Gardner (eds), *It Ain't Half Racist, Mum*, London: Comedia/Campaign Against Racism in the Media, 1982. CARM's BBC 'Open Door' programme is discussed in Stuart Hall, 'The whites of their eyes: racist ideologies and the media', in Bridges and Brunt (eds), *Silver Linings*, London: Lawrence & Wishart, 1981.
21 'Racism, colonialism and the cinema', *Screen*, March–April 1983, 24(2), and 'Other cinemas, Other criticisms', *Screen*, May–August 1985, 26(3–4).
22 Black British perspectives have rarely featured in *Screen*, but see Hazel Carby, 'Multiculture', *Screen Education*, Spring 1980, 34, 62–70; Paul Gilroy, 'C4 – Bridgehead or Bantustan?', *Screen*, July–October 1983, 24(4–5), 130–6; Robert Crusz, 'Black cinemas, film theory and dependent knowledge', *Screen*, May–August 1985, 26(3–4), 152–6.
23 The description of a 'theoretical super ego' in film studies is made by Paul Willemen in 'An avant-garde for the 80s', *Framework* 24, 1982 and in 'The Third Cinema question: notes and reflections', *Framework* 34, 1987. The characterization of orthodoxies in terms of the demands of a 'phallic mother' is made by Lesley Stern in her tribute, 'Remembering Claire Johnston', in *Film News*, 19(4), May 1988 (Sydney), reprinted in *Framework* 35, 1988. An interesting case of another translation this time in the postcolonial periphery, is provided by Felicity Collins, 'The Australian Journal of Screen Theory', in *Framework* 24, 1982.
24 Methods employed by Homi Bhabha and Gayatri Chakravorty Spivak are the subject of a critique by Benita Parry, 'Problems in current theories of colonial discourse', *Oxford Literary Review* 9, 1987.
25 An issue raised in Jim Pines' reading of sociological stereotypes in Horace Ove's *Pressure* (1975), discussed in 'Blacks in films: the British angle', *Multiracial Education* 9(2), 1981. Some of the paradoxical consequences of documentary realism in black independent film are also discussed in Kobena Mercer, 'Recoding narratives of race and nation', in *Black Film/British Cinema*, op.cit.
26 See Jackie Stacey, 'Desperately seeking difference', *Screen*, Winter 1987, 28(1), 48–61; reprinted in a slightly different version in Lorraine Gamman and Margaret Marshment (eds), *The Female Gaze*, London: Women's Press, 1988.
27 Sigmund Freud, 'Fetishism', in *On Sexuality*, Harmondsworth: Pelican Freud Library 7, 1977, 357.
28 Roland Barthes, *The Pleasure of the Text*, New York: Hill & Wang, 1975.
29 This again is by no means a 'new' topic. The starting-point for James Baldwin's autobiographical reflections on cinema is his adolescent identification with Bette Davis' star image; see *The Devil Finds Work*, London: Michael Joseph, 1976, 4–7.
30 *The Cosby Show* is the subject of two conflicting readings – as a 'breakthrough' and as a 'sell out': see Mel Cummings, 'Black family interactions on television', presented at the International Television Studies Conference, London,

1986 and Pat Skinner, 'Moving way up: television's "new look" at Blacks', presented at the International Television Studies Conference, London, 1988. Both ITSC conferences sponsored by the British Film Institute and the Institute of Education, University of London.

31 The concept of 'Third Cinema' was originally proposed by Fernando Solanas and Octavio Gettino; see their 'Towards a Third Cinema', in Bill Nichols (ed.), *Movies and Methods*, London and Berkeley: University of California, 1976. It has subsequently been expanded, with particular reference to African cinema, by Teshome Gabriel, *Third Cinema in the Third World: The Aesthetics of Liberation*, Ann Arbor: UMI Research Press, 1982.

32 Jean Genet's film is the subject of intense debate in the Cultural Identities seminar on 'Sexual identities: questions of difference', in *Undercut* 17, 1988. Maxine, the black woman in *Riddles of the Sphinx*, is identified as a signifier of 'dark continent' mythology in Judith Williamson's critique of the film, 'Two or three things we know about ourselves', in *Consuming Passions*, London: Calder & Boyars, 1986, 134. Frankie Dymon Jr was involved in Godard's *One Plus One* and subsequently directed his own film, *Death May Be Your Santa Claus* (1969), described as a 'pop fantasy' by Jim Pines, in 'The cultural context of Black British cinema', op.cit.

33 Identified as indicative of class struggle, in V. N. Volosinov, *Marxism and the Philosophy of Language*, New York: Seminar Press, 1983. From another point of view, similar concepts are explored in Homi K. Bhabha's reinterpretation of Fanon's *Wretched of the Earth* (Penguin, 1970) in his essay, 'The commitment to theory', in *New Formations* 5, 1988, 20–2.

34 Richard Dyer, 'Paul Robeson: crossing over', in *Heavenly Bodies: Film Stars and Society*, London: BFI/Macmillan, 1987, 79.

35 See Rosalind Coward, 'Class, "culture" and the social formation', *Screen*, Spring 1977, 18(1) 75–105 and the response, from Iain Chambers *et al.*, 'Marxism and culture', *Screen*, Winter 1977–8, 18(4), 109–19. On authorship, enunciation and textual analysis, see Paul Willemen, 'Notes on subjectivity: on reading Edward Branigan's "Subjectivity under siege"', *Screen*, Spring 1978, 19(1), 41–69. And on critiques of *'Screen'* theory' from the Centre for Contemporary Cultural Studies, see David Morley, 'Texts, readers, subjects' and Stuart Hall, 'Recent developments in theories of language and ideology: a critical note', both in Stuart Hall *et al.* (eds), *Culture, Media, Language*, London: Hutchinson, 1980.

Chapter 23

What is this 'black' in black popular culture?

Stuart Hall

I begin with a question: What sort of moment is this in which to pose the question of black popular culture? These moments are always conjunctural. They have their historical specificity; and although they always exhibit similarities and continuities with the other moments in which we pose a question like this, they are never the same moment. And the combination of what is similar and what is different defines not only the specificity of the moment, but the specificity of the question, and therefore the strategies of cultural politics with which we attempt to intervene in popular culture, and the form and style of cultural theory and criticizing that has to go along with such an intermatch. In his important essay, 'The new cultural politics of difference',[1] Cornel West offers a genealogy of what this moment is, a genealogy of the present that I find brilliantly concise and insightful. His genealogy follows, to some extent, positions I tried to outline in an article that has become somewhat notorious,[2] but it also usefully maps the moment into an American context and in relation to the cognitive and intellectual philosophical traditions with which it engages.

According to West, the moment, this moment, has three general co-ordinates. The first is the displacement of European models of high culture, of Europe as the universal subject of culture, and of culture itself in its old Arnoldian reading as the last refuge ... I nearly said of scoundrels, but I won't say who it is of. At least we know who it was against – culture against the barbarians, against the people rattling the gates as the deathless prose of anarchy flowed away from Arnold's pen. The second co-ordinate is the emergence of the United States as a world power and, consequently, as the centre of global cultural production and circulation. This emergence is both a displacement and a hegemonic shift in the *definition* of culture – a movement from high culture to American mainstream popular culture and its mass-cultural, image-mediated, technological forms. The third co-ordinate is the decolonization of the Third World,

culturally marked by the emergence of the decolonized sensibilities. And I read the decolonization of the Third World in Frantz Fanon's sense: I include in it the impact of civil rights and black struggles on the decolonization of the minds of the peoples of the black diaspora.

Let me add some qualifications to that general picture, qualifications that, in my view, make this present moment a very distinctive one in which to ask the question about black popular culture. First, I remind you of the ambiguities of that shift from Europe to America, since it includes America's ambivalent relationship to European high culture and the ambiguity of America's relationship to its own internal ethnic hierarchies. Western Europe did not have, until recently, any ethnicity at all. Or didn't recognize it had any. America has always had a series of ethnicities, and consequently, the construction of ethnic hierarchics has always defined its cultural politics. And, of course, silenced and unacknowledged, the fact of American popular culture itself, which has always contained within it, whether silenced or not, black American popular vernacular traditions. It may be hard to remember that, when viewed from outside of the United States, American mainstream popular culture has always involved certain traditions that could only be attributed to black cultural vernacular traditions.

The second qualification concerns the nature of the period of cultural globalization in progress now. I hate the term 'the global postmodern', so empty and sliding a signifier that it can be taken to mean virtually anything you like. And, certainly, blacks are as ambiguously placed in relation to postmodernism as they were in relation to high modernism: even when denuded of its wide-European, disenchanted marxist, French intellectual provenance and scaled down to a more modest descriptive status, postmodernism remains extremely unevenly developed as a phenomenon in which the old centre peripheries of high modernity consistently reappear. The only places where one can genuinely experience the postmodern ethnic cuisine are Manhattan and London, not Calcutta. And yet it is impossible to refuse 'the global postmodern' entirely, insofar as it registers certain stylistic shifts in what I want to call the cultural dominant. Even if postmodernism is not a new cultural epoch, but only modernism in the streets, that, in itself, represents an important shifting of the terrain of culture toward the popular – toward popular practices, toward everyday practices, toward local narratives, toward the decentring of old hierarchies and the grand narratives. This decentring or displacement opens up new spaces of contestation and affects a momentous shift in the high culture of popular culture relations, thus presenting us with a strategic and important opportunity for intervention in the popular cultural field.

Third, we must bear in mind postmodernism's deep and ambivalent fascination with difference – sexual difference, cultural difference, racial difference, and above all, ethnic difference. Quite in opposition to the

blindness and hostility that European high culture evidenced on the whole toward ethnic difference – its inability even to speak ethnicity when it was so manifestly registering its effects – there's nothing that global postmodernism loves better than a certain kind of difference: a touch of ethnicity, a taste of the exotic, as we say in England, 'a bit of the other' (which in the United Kingdom has a sexual as well as an ethnic connotation). Michele Wallace was quite right, in her seminal essay 'Modernism, postmodernism and the problem of the visual in Afro-American culture',[3] to ask whether this reappearance of a proliferation of difference, of a certain kind of ascent of the global postmodern, isn't a repeat of that 'now you see it, now you don't' game that modernism once played with primitivism, to ask whether it is not once again achieved at the expense of the vast silencing about the West's fascination with the bodies of black men and women of other ethnicities. And we must ask about that continuing silence within post-modernism's shifting terrain, about whether the forms of licensing of the gaze that this proliferation of difference invites and allows, at the same time as it disavows, is not really, along with Benetton and the mixed male models of *The Face*, a kind of difference that doesn't make a difference of any kind.

Hal Foster writes – Wallace quotes him in her essay – 'the primitive is a modern problem, a crisis in cultural identity'[4] – hence, the modernist construction of primitivism, the fetishistic recognition and disavowal of the primitive difference. But this resolution is only a repression; delayed into our political unconscious, the primitive returns uncannily at the moment of its apparent political eclipse. This rupture of primitivism, managed by modernism, becomes another postmodern event. That managing is certainly evident in the difference that may not make a difference, which marks the ambiguous appearance of ethnicity at the heart of global postmodernism. But it cannot be only that. For we cannot forget how cultural life, above all in the West, but elsewhere as well, has been transformed in our lifetimes by the voicing of the margins.

Within culture, marginality, though it remains peripheral to the broader mainstream, has never been such a productive space as it is now. And that is not simply the opening within the dominant of spaces that those outside it can occupy. It is also the result of the cultural politics of difference, of the struggles around difference, of the production of new identities, of the appearance of new subjects on the political and cultural stage. This is true not only in regard to race, but also for other marginalized ethnicities, as well as around feminism and around sexual politics in the gay and lesbian movement, as a result of a new kind of cultural politics. Of course, I don't want to suggest that we can counterpose some easy sense of victories won to the eternal story of our own marginalization – I'm tired of those two continuous grand counter-narratives. To remain within them is to become trapped in that endless either/or, either total victory or total incorporation,

which almost never happens in cultural politics, but with which cultural critics always put themselves to bed.

What we are talking about is the struggle over cultural hegemony, which is these days waged as much in popular culture as anywhere else. That high/popular distinction is precisely what the global postmodern is displacing. Cultural hegemony is never about pure victory or pure domination (that's not what the term means); it is never a zero-sum cultural game; it is always about shifting the balance of power in the relations of culture; it is always about changing the dispositions and the configurations of cultural power, not getting out of it. There is a kind of 'nothing every changes, the system always wins' attitude, which I read as the cynical protective shell that, I'm sorry to say, American cultural critics frequently wear, a shell that sometimes prevents them from developing cultural strategies that can make a difference. It is as if, in order to protect themselves against the occasional defeat, they have to pretend they can see right through everything – and it's just the same as it always was.

Now cultural strategies that can make a difference, that's what I'm interested in – those that can make a difference and can shift the dispositions of power. I acknowledge that the spaces 'won' for difference are few and far between, that they are very carefully policed and regulated. I believe they are limited. I know, to my cost, that they are grossly under-funded, that there is always a price of incorporation to be paid when the cutting edge of difference and transgression is blunted into spectacularization. I know that what replaces invisibility is a kind of carefully regulated, segregated visibility. But it does not help simply to name-call it 'the same'. That name-calling merely reflects the particular model of cultural politics to which we remain attached, precisely, the zero-sum game – our model replacing their model, our identities in place of their identities – what Antonio Gramsci called culture as a once and for all 'war of manoeuvre', when, in fact, the only game in town worth playing is the game of cultural 'wars of position'.

Lest you think, to paraphrase Gramsci, my optimism of the will has now completely outstripped my pessimism of the intellect, let me add a fourth element that comments on the moment. For, if the global postmodern represents an ambiguous opening to difference and to the margins and makes a certain kind of decentring of the western narrative a likely possibility, it is matched, from the very heartland of cultural politics, by the backlash: the aggressive resistance to difference; the attempt to restore the canon of western civilization; the assault, direct and indirect, on multi-culturalism; the return to grand narratives of history, language and litera-ture (the three great supporting pillars of national identity and national culture); the defence of ethnic absolutism, of a cultural racism that has marked the Thatcher and the Reagan eras; and the new xenophobias that are about to overwhelm fortress Europe. The last thing to do is read me as

saying the cultural dialectic is finished. Part of the problem is that we have forgotten what sort of space the space of popular culture is. And black popular culture is not exempt from that dialectic, which is historical, not a matter of bad faith. It is therefore necessary to deconstruct the popular once and for all. There is no going back to an innocent view of what it consists of.

Popular culture carries that affirmative ring because of the prominence of the word 'popular'. And, in one sense, popular culture always has its base in the experiences, the pleasures, the memories, the traditions of the people. It has connections with local hopes and local aspirations, local tragedies and local scenarios that are the everyday practices and everyday experiences of ordinary folks. Hence, it links with what Mikhail Bakhtin calls 'the vulgar' – the popular, the informal, the underside, the grotesque. That is why it has always been counterposed to elite or high culture, and is thus a site of alternative traditions. And that is why the dominant tradition has always been deeply suspicious of it, quite rightly. They suspect that they are about to be overtaken by what Bakhtin calls 'the carnivalesque'. This fundamental mapping of culture between the high and the low has been charted into four symbolic domains by Peter Stallybrass and Allon White in their important book *The Politics and Poetics of Transgression*. They talk about the mapping of high and low in psychic forms, in the human body, in space, and in the social order.[5] And they discuss the high/ low distinction as a fundamental basis to the mechanism of ordering and of sense-making in European and other cultures despite the fact that the contents of what is high and what is low change from one historical moment to another.

The important point is the ordering of different aesthetic morals, social aesthetics, the orderings of culture that open up culture to the play of power, not an inventory of what is high versus what is low at any particular moment. That is why Gramsci, who has a side of common sense on which, above all, cultural hegemony is made, lost, and struggled over, gave the question of what he called 'the national-popular' such strategic importance. The role of the 'popular' in popular culture is to fix the authenticity of popular forms, rooting them in the experiences of popular communities from which they draw their strength, allowing us to see them as expressive of a particular subordinate social life that resists its being constantly made over as low and outside.

However, as popular culture has historically become the dominant form of global culture, so it is at the same time the scene, *par excellence*, of commodification, of the industries where culture enters directly into the circuits of a dominant technology – the circuits of power and capital. It is the space of homogenization where stereotyping and the formulaic merci- lessly process the material and experiences it draws into its web, where control over narratives and representations passes into the hands of the

established cultural bureaucracies, sometimes without a murmur. It is rooted in popular experience and available for expropriation at one and the same time. I want to argue that this is necessarily and inevitably so. And this goes for black popular culture as well. Black popular culture, like all popular cultures in the modern world, is bound to be contradictory, and this is not because we haven't fought the cultural battle well enough.

By definition, black popular culture is a contradictory space. It is a sight of strategic contestation. But it can never be simplified or explained in terms of the simple binary oppositions that are still habitually used to map it out: high and low; resistance versus incorporation; authentic versus inauthentic, experiential versus formal; opposition versus homogenization. There are always positions to be won in popular culture, but no struggle can capture popular culture itself for our side or theirs. Why is that so? What consequences does this have for strategies of intervention in cultural politics? How does it shift the basis for black cultural criticism?

However deformed, incorporated, and inauthentic are the forms in which black people and black communities and traditions appear and are represented in popular culture, we continue to see, in the figures and the repertoires on which popular culture draws, the experiences that stand behind them. In its expressivity, its musicality, its orality, in its rich, deep, and varied attention to speech, in its inflections towards the vernacular and the local, in its rich production of counter-narratives, and above all, in its metaphorical use of the musical vocabulary, black popular culture has enabled the surfacing, inside the mixed and contradictory modes even of some mainstream popular culture, of elements of a discourse that is different – other forms of life, other traditions of representation.

I do not propose to repeat the work of those who have devoted their scholarly, critical, and creative lives to identifying the distinctiveness of these diasporic traditions, to exploring their modes and the historical experiences and memories they encode. I say only three inadequate things about these traditions, since they are germane to the point I want to develop. First, I ask you to note how, within the black repertoire, *style* – which mainstream cultural critics often believe to be the mere husk, the wrapping, the sugar-coating on the pill – has become *itself* the subject of what is going on. Second, mark how, displaced from a logocentric world – where the direct mastery of cultural modes meant the mastery of writing, and hence, both of the criticism of writing (logocentric criticism) and the deconstruction of writing – the people of the black diaspora have, in opposition to all of that, found the deep form, the deep structure of their cultural life in music. Third, think of how these cultures have used the body – as if it was, and it often was, the only cultural capital we had. We have worked on ourselves as the canvases of representation.

There are deep questions here of cultural transmission and inheritance, and of the complex relations between African origins and the irreversible

scatterings of the diaspora, questions I cannot go into. But I do believe that these repertoires of black popular culture, which, since we were excluded from the cultural mainstream, were often the only performative spaces we had left, were over-determined from at least two directions: they were partly determined from their inheritances; but they were also critically determined by the diasporic conditions in which the connections were forged. Selective appropriation, incorporation, and rearticulation of European ideologies, cultures, and institutions, alongside an African heritage – this is Cornel West again – led to linguistic innovations in rhetorical stylization of the body, forms of occupying an alien social space, heightened expressions, hairstyles, ways of walking, standing and talking, and a means of constituting and sustaining camaraderie and community.

The point of underlying over-determination – black cultural repertoires constituted from two directions at once – is perhaps more subversive than you think. It is to insist that in black popular culture, strictly speaking, ethnographically speaking, there are no pure forms at all. Always these forms are the product of partial synchronization, of engagement across cultural boundaries, of the confluence of more than one cultural tradition, of the negotiations of dominant and subordinate positions, of the subterranean strategies of recoding and transcoding, of critical signification, of signifying. Always these forms are impure, to some degree hybridized from a vernacular base. Thus, they must always be heard, not simply as the recovery of a lost dialogue bearing clues for the production of new musics (because there is never any going back to the old in a simple way), but as what they are – adaptations, moulded to the mixed, contradictory, hybrid spaces of popular culture. They are not the recovery of something pure that we can, at last, live by. In what Kobena Mercer calls the necessity for a diaspora aesthetic, we are obliged to acknowledge they are what the modern is.

It is this mark of difference *inside* forms of popular culture – which are by definition contradictory and which therefore appear as impure, threatened by incorporation or exclusion – that is carried by the signifier 'black' in the term 'black popular culture'. It has come to signify the black community, where these traditions were kept, and whose struggles survive in the persistence of the black experience (the historical experience of black people in the diaspora), of the black aesthetic (the distinctive cultural repertoires out of which popular representations were made), and of the black counter-narratives we have struggled to voice. Here, black popular culture returns to the ground I defined earlier. 'Good' black popular culture can pass the test of authenticity – the reference to black experience and to black expressivity. These serve as the guarantees in the determination of which black popular culture is right-on, which is ours and which is not.

I have the feeling that, historically, nothing could have been done to

intervene in the dominated field of mainstream popular culture, to try to win some space there, without the strategies through which those dimensions were condensed onto the signifier 'black'. Where would we be, as bell hooks once remarked, without a touch of essentialism? Or, what Gayatri Spivak calls strategic essentialism, a necessary moment? The question is whether we are any longer in that moment, whether that is still a sufficient basis for the strategies of new interventions. Let me try to set forth what seem to me to be the weaknesses of this essentializing moment and the strategies, creative and critical, that flow from it.

This moment essentializes differences in several senses. It sees difference as 'their traditions versus ours', not in a positional way, but in a mutually exclusive, autonomous and self-sufficient one. And it is therefore unable to grasp the dialogic strategies and hybrid forms essential to the diaspora aesthetic. A movement beyond this essentialism is not an aesthetic or critical strategy without a cultural politics, without a marking of difference. It is not simply re-articulation and re-appropriation for the sake of it. What it evades is the essentializing of difference into two mutually opposed either/ors. What is does is to move us into a new kind of cultural positionality, a different logic of difference. To encapsulate what Paul Gilroy has so vividly put on the political and cultural agenda of black politics in the United Kingdom: blacks in the British diaspora must, at this historical moment, refuse the binary black *or* British. They must refuse it because the 'or' remains the sight of *constant contestation* when the aim of the struggle must be, instead, to replace the 'or' with the potentiality or the possibility of an 'and'. That is the logic of coupling rather than the logic of a binary opposition. You can be black *and* British, not only because that is a necessary position to take in the 1990s, but because even those two terms, joined now by the coupler 'and' instead of opposed to one another, do not exhaust all of our identities. Only some of our identities are sometimes caught in that particular struggle.

The essentializing moment is weak because it naturalizes and de-historicizes difference, mistaking what is historical and cultural for what is natural, biological, and genetic. The moment the signifier 'black' is torn from its historical, cultural, and political embedding and lodged in a biologically constituted racial category, we valorize, by inversion, the very ground of the racism we are trying to deconstruct. In addition, as always happens when we naturalize historical categories (think about gender and sexuality), we fix that signifier outside of history, outside of change, outside of political intervention. And once it is fixed, we are tempted to use 'black' as sufficient in itself to guarantee the progressive character of the politics we fight under the banner – as if we don't have any other politics to argue about except whether something's black or not. We are tempted to display that signifier as a device which can purify the impure, bring the straying brothers and sisters who don't know what

they ought to be doing into line, and police the boundaries – which are of course political, symbolic and positional boundaries – as if they were genetic. For which, I'm sorry to say, read 'jungle fever' – as if we can translate from nature to politics using a racial category to warrant the politics of a cultural text and as a line against which to measure deviation.

Moreover, we tend to privilege experience itself, as if black life is lived experience outside of representation. We have only, as it were, to express what we already know we are. Instead, it is only through the way in which we represent and imagine ourselves that we come to know how we are constituted and who we are. There is no escape from the politics of representation, and we cannot wield 'how life really is out there' as a kind of test against which the political rightness or wrongness of a particular cultural strategy or text can be measured. It will not be a mystery to you that I think that 'black' is none of these things in reality. It is not a category of essence and, hence, this way of understanding the floating signifier in black popular culture now will not do.

There is, of course, a very profound set of distinctive historically defined black experiences that contribute to those alternative repertoires I spoke about earlier. But it is to the diversity, not the homogeneity, of black experience that we must now give our undivided creative attention. This is not simply to appreciate the historical and experiential differences within and between communities, regions, country and city, across national cultures, between diasporas, but also to recognize the other kinds of difference that place, position, and locate black people. The point is not simply that, since our racial differences do not constitute all of us, we are always different, negotiating different kinds of differences – of gender, of sexuality, of class. It is also that these antagonisms refuse to be neatly aligned; they are simply not reducible to one another; they refuse to coalesce around a single axis of differentiation. We are always in negotiation, not with a single set of oppositions that place us always in the same relation to others, but with a series of different positionalities. Each has for us its point of profound subjective identification. And that is the most difficult thing about this proliferation of the field of identities and antagonisms: they are often dislocating in relation to one another.

Thus, to put it crudely, certain ways in which black men continue to live out their counter-identities as black masculinities and replay those fantasies of black masculinities in the theatres of popular culture are, when viewed from along other axes of difference, the very masculine identities that are oppressive to women, that claim visibility for their hardness only at the expense of the vulnerability of black women and the feminization of gay black men. The way in which a transgressive politics in one domain is constantly sutured and stabilized by reactionary or unexamined politics in another is only to be explained by this continuous cross-dislocation of one identity by another, one structure by another. Dominant ethnicities are

always underpinned by a particular sexual economy, a particular figured masculinity, a particular class identity. There is no guarantee, in reaching for an essentialized racial identity of which we think we can be certain, that it will always turn out to be mutually liberating and progressive on all the other dimensions. It *can* be won. There *is* a politics there to be struggled for. But the invocation of a guaranteed black experience behind it will not produce that politics. Indeed, the plurality of antagonisms and differences that now seek to destroy the unity of black politics, given the complexities of the structures of subordination that have been formed by the way in which we were inserted into the black diaspora, is not at all surprising.

These are the thoughts that drove me to speak, in an unguarded moment, of the end of the innocence of the black subject or the end of the innocent notion of an essential black subject. And I want to end simply by reminding you that this end is also a beginning. As Isaac Julien said in an interview with bell hooks in which they discussed his new film *Young Soul Rebels*, his attempt in his own work to portray a number of different racial bodies, to constitute a range of different black subjectivities, and to engage with the positionalities of a number of different kinds of black masculinities:

> blackness as a sign is never enough. What does that black subject do, how does it act, how does it think politically . . . being black isn't really good enough for me: I want to know what your cultural politics are.[6]

I want to end with two thoughts that take that point back to the subject of popular culture. The first is to remind you that popular culture, commodified and stereotyped as it often is, is not at all, as we sometimes think of it, the arena where we find who we really are, the truth of our experience. It is an arena that is *profoundly* mythic. It is a theatre of popular desires, a theatre of popular fantasies. It is where we discover and play with the identifications of ourselves, where we are imagined, where we are represented, not only to the audiences out there who do not get the message, but to ourselves for the first time. As Freud said, sex (and representation) mainly takes place in the head. Second, though the terrain of the popular looks as if it is constructed with single binaries, it is not. I reminded you about the importance of the structuring of cultural space in terms of high and low, and the threat of the Bakhtinian carnivalesque. I think Bakhtin has been profoundly misread. The carnivalesque is not simply an upturning of two things which remain locked within their oppositional frameworks; it is also cross-cut by what Bakhtin calls the dialogic.

I simply want to end with an account of what is involved in understanding popular culture, in a dialogic rather than in a strictly oppositional way, from *The Politics and Poetics of Transgression* by Stallybrass and White:

> A recurrent pattern emerges: the 'top' attempts to reject and eliminate the 'bottom' for reasons of prestige and status, only to discover, not only

that it is in some way frequently dependent upon the low-Other . . . but also that the top *includes* that low symbolically, as a primary eroticized constituent of its own fantasy life. The result is a mobile, conflictual fusion of power, fear, and desire in the construction of subjectivity: a psychological dependence upon precisely those others which are being rigorously opposed and excluded at the social level. It is for this reason that what is socially peripheral is so frequently *symbolically* central . . . [7]

NOTES

1 Cornel West, 'The new cultural politics of difference', in *Out There: Marginalization and Contemporary Cultures*, ed. Russell Ferguson *et al.* (Cambridge: MIT Press in association with the New Museum of Contemporary Art, 1990), 19–36.

2 Stuart Hall, 'New ethnicities', *Black Film/British Cinema, ICA Document 7*, ed. Kobena Mercer (London: Institute of Contemporary Arts, 1988), 27–31.

3 Michele Wallace, 'Modernism, postmodernism and the problem of the visual in Afro-American culture', in *Out There: Marginalization and Contemporary Cultures*, 39–50.

4 Hal Foster, *Recodings: Art, Spectacle, and Cultural Politics* (Port Townsend, Wash.: Bay Press, 1985), 204.

5 Peter Stallybrass and Allon White, *The Politics and Poetics of Transgression* (Ithaca: Cornell University Press, 1986), 3.

6 bell hooks, 'States of desire' (interview with Isaac Julien), *Transition* 1, no. 3, 175.

7 Stallybrass and White, *The Politics and Poetics of Transgression*, 5.

Dialogues with Stuart Hall

Isaac Julien and Mark Nash

PREFACE

This dialogue took place in New York, where Isaac was working as senior producer for a US television series on gay and lesbian civil rights. The fact of his being invited to creatively shape this innovative TV programme says something about the respect for and interest in Isaac's work in North America. During Isaac's stay in New York we met up with Stuart several times as he visited to contribute to panels on Pan-African cinema, cultural studies, etc. It says something about the currency of both their work that Isaac and Stuart have been able to meet in North America almost as regularly as they do in London, even if one of the topics for discussion has been the degree to which America misunderstands and misrepresents what their work is about. The very different structures of racism in Britain (until recently still pursuing its colonial war with the Irish) and the United States (where its colonial relation to its black citizens has never been adequately discussed), would be one of the starting-points for a fuller discussion. What follows here however is a preliminary to a more focused collaboration.

For this discussion I asked Isaac to focus on the influence of Stuart's work on Isaac's and black British cinema more generally, Stuart's collaboration in that work and the reverse influence of black British film and artistic practice onto Stuart.

Mark Nash

CHRONOLOGY

MN: Isaac, you were aware of Stuart's writing when you were studying for your BA in Fine Art Film at Central St Martin's School of Art in London. When did you first become involved in dialogue with him?

IJ: Well, I first saw Stuart out at clubs in London. It was only later that I realized 'Oh, that was Stuart Hall.' I think our first formal meeting was

when Martina Attille, Nadine Marsh-Edwards, Maureen Blackwood and myself invited him to Sankofa when we were developing our film *The Passion of Remembrance*. I remember he talked to us about the history of the British Black Power movement, and we tried to incorporate his ideas, together with those of C. L. R. James, the *Race Today* collective as well as African American feminist writing such as June Jordan's into the debate which takes place in the desert scene in the film – a barren landscape where a black woman activist figure critiques the phallocentrism of the black British power movement.

Stuart was very supportive of *Passion* . . . , using it in his 'New ethnicities' paper at the ICA,[1] as an example of a 'new politics of representation' which crosses 'questions of racism irrevocably with questions of sexuality'.

MN: Part of Stuart's work has been about balance, weighing up contributions to debate, and placing his own contributions in relation to other's. I see that as, in part, a sensitivity to voices that have been historically excluded from debates, as well as referencing those voices – his relatives in Jamaica or your parents relatives in Saint Lucia – whose experiences you are also concerned to witness and in some way present.

So Stuart was involved with the Sankofa film and video workshop from early on?

IJ: Stuart was an active supporter of the Ethnic Minority Arts Committee of the Greater London Council, who funded Sankofa originally. In particular he had argued politically for the support of the black arts in London. The Sankofa workshop[2] received funding from Channel 4, the GLC and the local (Camden) council. We invited Stuart onto the Council of Management to help formulate policy. It was also one of the terms of our receiving grant-aid that we should have a group of independent people advising us about our work.

So we discussed most of our projects with him at different stages, often in quite an informal context. With Homi Bhabha, Stuart contributed to discussions on Martina Attille's short film *Dreaming Rivers* which I think he related to particularly because it was our first attempt at reconstructing the experiences of our parents' generation, which was also his generation. Stuart points out[3] that the relation of this cultural politics to the diaspora experience, to the past, to its different 'roots', is profound but complex: 'It is (as a film like *Dreaming Rivers* reminds us) complexly mediated and transformed by memory, fantasy and desire.'

MN: The film is about the memories of an older woman from the Caribbean, whose dreams conflict with the experiences of her British born children. At one point I think she has your and her mother speaking patois?

IJ: That's right. Maybe I should say that our relationship to Stuart at that time was not an exclusive one. Others involved in this work included Jim

Pines, one of the pioneers of the study of the representation of blacks in cinema, who came to edit *Framework* magazine, as well as Homi Bhabha.

MN: But you worked with Stuart on nearly every project. I remember you working with him on the narration of *Looking for Langston*.

IJ: It was very important to feel that Stuart shared in the project of the film; he was very accommodating to what I was trying to say. And he has such a good speaking voice!

MN: Jumping forward for a moment to *Darker Side of Black*, which was only finished this year, 1994. Was there a reason you didn't ask him to contribute to that voice-over?

IJ: I think I had the feeling that Stuart saw that film as coming from a black British rather than Jamaican perspective, which was one of the reasons why Paul Gilroy was more appropriate. Also, I think it would have involved him in making too definitive judgements about Jamaica. He was, however, the main source of our Jamaican contacts: Caroline Cooper, Rex Nettleford, Michael Manley. Without him I doubt if we would have been able to get access to the major Jamaican voices we include in that film.

MN: Yes, with friends, family and relatives there, much of Stuart's work is also a dialogue with Jamaica as well as Britain. Shall we return to *Young Soul Rebels*? That was your first film made under the industrial conditions of the British film industry, and your ability to involve other people was restricted. I remember that well myself.

IJ: Yes, well I think the concept and script, as I developed it initially with Derrick McClintock was as a response to British cultural studies' work on particular working-class youth cultures: Paul Gilroy's book, *Ain't No Black in the Union Jack* and Dick Hebdige's *Subcultures: the meaning of style* were important influences. Though subsequently Dick and I disagreed about the film. I think he was upset at what he saw as the misrepresentation of white working-class skinheads, punks and stereotyping of white male Scottish football supporters.

MN: Or the over-valuation of soul at the expense of punk. But that was partly because few academics and intellectuals involved in British cultural studies apart from Paul Gilroy and Stuart were able to deal with the complexities that race introduces.

IJ: Actually, it is the contrary, it seemed to me that British cultural studies was full of academics and intellectuals who were involved in trying to deal with the complexities that race introduced, but Dick's objections to what he called the white male stereotyping in *Young Soul Rebels* read to me as a response to him feeling displaced as a white male subject himself – that these white masculinities were no longer at the centre of the frame or the

story and therefore in making them peripheral, they do become 'ciphers of whiteness' which of course for me becomes really an interesting reversal of my experience of watching British cinema, where the visual culture of black life is continuously marginalized.

MN: Could you discuss your work with Stuart on *Black and White in Colour* (1992), the archival history project on 'Television – Memory and Race'?

IJ: With *Black and White in Colour*, I was working on a project actually initiated by Stuart at the British Film Institute (BFI). They had been conducting an archival research project on the study of race and ethnicity in British television to produce a database for the BFI for several years. Kobena Mercer headed this project before he left for the States to teach Art History at the University of California, Santa Cruz. It was natural that we would interview Stuart as well as work with him on the voice-over which he narrated for the film.

MN: In *The Attendant*, Stuart has a cameo role in the art gallery. It's a particularly resonant use of his persona, given that one of your ideas here is to foreground the double-lives of black British men who guard most of the nation's treasures and institutions – often talented individuals denied other forms of employment. Stuart then comes to represent an other possible identity for the attendant, visitor, intellectual or participant.

IJ: Yes, we see him walking past the F. A. Biard *Scene on the Coast of Africa*, or rather the counter-tableau that I had constructed. He's looking rather serious. In some of the out-takes (that is, parts which are not in the finished film), Stuart smiles. He didn't know what he was smiling at, because with the blue screen procedure we were using, there was no image in the frame. He didn't know what he was smiling at because with the blue screen procedure we were using, there was no image in the frame.

MN: As the producer of *The Attendant*, apart from our technical problems in setting up the blue screen, which of course we overcame, I remember Stuart was fascinated with the mix of personalities we'd assembled in that studio to participate in the tableaux.

IJ: Yes, because I had assembled friends like singer/pop star Jimmy Somerville and made him dress as a fallen angel in cut-off leather shorts along with others who for the tableaux scenes wore bondage things!

MN: In your next film *The Darker Side of Black* I remember you having several discussions with Stuart about the film at different stages.

IJ: In *The Darker Side of Black*, I should mention that both Stuart and Catherine Hall had a long discussion with me about the role of religion in

Jamaica. Coming from an anti-religious family I have inherited something of my mother's antipathy to religion. The Roman Catholic church in Saint Lucia prevented my mother's going on to higher education, and she, seeing it as such an oppressive force, refused to let us having anything to do with it.

Catherine Hall had done research on missionaries in Jamaica. Emphasizing the contradictory nature of religion, some missionaries helping the same Jamaicans whose enslavement the church had previously sanctioned. There was also one image which we cut from the film of a Bible burning. Partly for technical reasons, it didn't burn quite rightly, also because we had very strong reactions against it. I think Stuart felt it was too definitive a statement.

MN: Yes, I remember having a similar conversation with you about that scene. I think my objection was that it was too condensed a literalism, that the violence you were enacting on the book, which was equivalent to the violence of religiously-inspired hatred of gays and lesbians, would have worked to undermine comments from the priests and preachers you interview, to the effect that actually there is very little of this hatred articulated directly in the Bible, but a lot in the hearts of men and women.

Perhaps we should now turn to projects that you/we are developing with Stuart.

IJ: We've been talking with Stuart and David A. Bailey about two projects. One developing Stuart's work on identity to consider the relationship that black diasporan artists have to their own sense of identity. Stuart has come up with an interesting dialectical approach to this. He wanted to emphasise the connection between three sets of different generations of blacks' responses to the work produced by black artists, by way of asking mothers and fathers about the work, then interviewing the artists themselves, then the people who taught them!

And then there is our documentary on Frantz Fanon with the BBC, for which Stuart is an advisor and interviewee.

DEBATES

MN: Here I'd like to ask you for a bit more detail of the debates and issues which you took from Stuart, or in which Stuart was involved and which were particularly significant for you.

IJ: Perhaps a good place to start would be Stuart's essay 'New ethnicities' given at a conference 'Black film/British Cinema' organized for the ICA by Kobena Mercer in 1988. Stuart particularly instances black British film as a place where we are beginning to see a new cultural politics which engages difference, and which is concerned with the construction of new ethnic

identities. He references the specific contestation of what it means to be British, and the putting into question of race irrevocably with sexuality.

MN: That's how I read your construction of his reaction to the tableaux in *The Attendant*, which portrays the abolitionist pathos of the Biard painting (which hangs in the William Wilberforce Museum in Hull) being transformed into a vision of desire, which makes the point that in 1992 while slavery may be abolished, we do not yet allow black men, specifically black gay men their liberty.

In fact where Stuart says that *Passion of Remembrance* involved a different kind of politics to that radical politics which has 'frequently been stabilized around particular conceptions of black masculinity', one could argue that because of the rigid fixing of gender roles and the disavowal of homosexuality in black politics, that black women and black gay men were in a position to make that break.

IJ: Perhaps, but for us, it was Stuart's paper which signalled this key idea around the constructedness of blackness. For me, in that paper, it's the notion of the end of the innocent essential black subject, and the freeing up of positions from which black artists and film-makers can speak. There was also a discussion of white ethnicities at that conference as well and I think it's interesting that Richard Dyer was one of the few white cultural critics to engage with an analysis of 'whiteness' as guarantor of truth and beauty in representation – as a culturally constructed category, which complemented Stuart's essay on the construction of black political subject positions, in the 'New ethnicities' essay.

MN: In the 'New ethnicities' article, Stuart also refers to the controversy around the Black Audio Film Collective's *Handsworth Songs*. In particular he critiques Salman Rushdie's addressing the film from the pages of the *Guardian* as if it were just like any other film the *Guardian* might review.

IJ: Black Audio were insisting on their right to make a self-reflexive, experimental film about a contemporary political event – riots in Handsworth. Previous riots had paradoxically enfranchised a whole section of the black community, releasing funds for what I call 'social work-type' projects. At this time both Black Audio and Sankofa were insisting on our rights to a full range of artistic expression – black film-makers should not be restricted to the ghetto of realism.

MN: I think Stuart, much more so than Raymond Williams, an important influence on him, is much more receptive to anti-realist aesthetics. In his essay 'Cultural identity and diaspora' he discusses the formation of new kinds of cultural identity grounded in the re-telling of the past, through memory, desire and the assertion of difference as essential to the undertaking of this project.

IJ: I saw the making of *Looking for Langston* as very much part of what Stuart describes. Taking the identity of perhaps one of the better-known black literary figures, in black British circles and in the United States, and trying to indicate both how Langston Hughes was, in a sense, imprisoned by his own and the black communities' hetero-normative construction of him as straight, but at the same time finding a precursor for contemporary black gay culture, in the homosexual subculture of the Harlem Renaissance.

MN: It also represents your engagement with Négritude. In this essay Stuart quotes Fanon on the discovery of 'some very beautiful and splendid era whose existence rehabilitates us, both in regard to ourselves and in regard to others'.

Early in 1994 you and Stuart both spoke at a conference on Pan-African cinema at New York University. Looking again at Stuart's essays 'What is this "black" in black popular culture?' and 'Old and new identities, old and new ethnicities', I'm struck by the disjuncture between the debate in the United Kingdom and United States.

IJ: One of the most striking features of this conference was that issues relating to the diaspora and diasporan artists and intellectuals were relegated to a single panel. Almost as though Stuart's insistence on this as a category if not condition of experience were yet to happen. And I do think that in some ways the African-American academic community has yet to come to terms with the demands of his work.

MN: Or black British film-making for that matter. On the one hand they admire your ability, for instance in *Darker Side of Black*, to interrogate the construction of homophobic and hetero-normative black masculinities, on the other there can be defence from the wildest sources, of those masculinities as themselves fragile and endangered. I'm thinking in particular of Andrew Ross's recent article in the *Nation*, 'The gangsta and the diva'.[4]

IJ: In 'What is this "black" in black popular culture?' Stuart says that it is necessary to deconstruct the popular once and for all. Which was the point of *The Darker Side of Black* – to question both masculinities and also the popular cultures that gave rise to them.

MN: I can remember being at a Media Alliance conference here in New York in 1987 in which Black Audio showed *Handsworth Songs*. Yet the buzz was with *She's Gotta Have It*. Black American cinema apparently needed more Spike Lees!

IJ: What interests me is that, on the whole, African-American cinema has been so resistant to Stuart's linkage of cultural identity with diaspora, that it constantly has to recreate that essential black subject that Stuart critiques.

Look at Spike Lee's opposition to inter-racial relationships, for instance, despite the fact that many more Americans and colonial Europeans are discovering their 'mixed' heritage . . .

New York, December 1994

NOTES

1 'New ethnicities', in *Black Film, British Cinema, ICA Document* 7, London, 1988, 29.
2 See Coco Fusco, *Young, British and Black: The Work of Sankofa and Black Audio Film Collective*, Buffalo, NY: Hallwalls Contemporary Arts Center, 1988.
3 'New ethnicities', ibid., 30.
4 Andrew Ross, 'The gangsta and the diva', *Nation*, 22/29 August 1994, 259(6), 191–4.

Chapter 25

The formation of a diasporic intellectual

An interview with Stuart Hall by Kuan-Hsing Chen

THE COLONIAL SITUATION

KHC: In your later work on race and ethnicity, diaspora seems to have become a central figure – one of the critical sites on which the question of cultural identity is articulated; bits and pieces of your own diasporic experiences have, at certain points, been narrated quite powerfully, to address both theoretical and political problematics.[1] What I am interested in is how the specificities of the various historical trajectories came to shape your diasporic experiences, your own intellectual and political position.

SH: I was born in Jamaica, and grew up in a middle-class family. My father spent most of his working life in the United Fruit Company. He was the first Jamaican to be promoted in every job he had; before him, those jobs were occupied by people sent down from the head office in America. What's important to understand is both the class fractions and the colour fractions from which my parents came. My father's and my mother's families were both middle-class but from very different class formations. My father belonged to the coloured lower-middle-class. His father kept a drugstore in a poor village in the country outside Kingston. The family was ethnically very mixed – African, East Indian, Portuguese, Jewish. My mother's family was much fairer in colour; indeed if you had seen her uncle, you would have thought he was an English expatriate, nearly white, or what we would call 'local white'. She was adopted by an aunt, whose sons – one a lawyer, one a doctor, trained in England. She was brought up in a beautiful house on the hill, above a small estate where the family lived. Culturally present in my own family was therefore this lower-middle-class, Jamaican, country manifestly dark skinned, and then this lighter-skinned English-oriented, plantation-oriented fraction, etc.

So what was played out in my family, culturally, from the very beginning, was the conflict between the local and the imperial in the colonized context. Both these class fractions were opposed to the majority culture of

poor Jamaican black people: highly race and colour conscious, and identi-
fying with the colonizers.

I was the blackest member of my family. The story in my family, which
was always told as a joke, was that when I was born, my sister, who was
much fairer than I, looked into the crib and she said, 'Where did you get
this coolie baby from?' Now 'coolie' is the abusive word in Jamaica for a
poor East Indian, who was considered the lowest of the low. So she
wouldn't say 'Where did you get this black baby from?', since it was
unthinkable that she could have a black brother. But she *did* notice that I
was a different colour from her. This is very common in coloured middle-
class Jamaican families, because they are the product of mixed liaisons
between African slaves and European slave-masters, and the children then
come out in varying shades.

So I always had the identity in my family of being the one from the
outside, the one who didn't fit, the one who was blacker than the others,
'the little coolie', etc. And I performed that role throughout. My friends at
school, many of whom were from good middle-class homes, but blacker in
colour than me, were not accepted at my home. My parents didn't think I
was making the right kind of friends. They always encouraged me to mix
with more middle-class, more higher-colour, friends, and I didn't. Instead, I
withdrew emotionally from my family and met my friends elsewhere. My
adolescence was spent continuously negotiating these cultural spaces.

My father wanted me to play sport. He wanted me to join the clubs that
he joined. But I always thought that he himself did not quite fit in this
world. He was negotiating his way into this world. He was accepted on
sufferance by the English. I could see the way they patronized him. I hated
that more than anything else. It wasn't just that he belonged to a world
which I rejected. I couldn't understand how *he* didn't see how much they
despised him. I said to myself, 'Don't you understand when you go into
that club they think you are an interloper?' And, 'But you want to put me
into that space, to be humiliated in the same way?'

Because my mother was brought up in this Jamaican plantation context,
she thought she was practically 'English'. She thought England was the
mother country, she identified with the colonial power. She had aspirations
for us, her family, which materially we couldn't keep up with, but which
she aspired to, culturally.

I'm trying to say that those classic colonial tensions were lived as part of
my personal history. My own formation and identity was very much
constructed out of a kind of refusal of the dominant personal and cultural
models which were held up for me. I didn't want to beg my way like my
father into acceptance by the American or English expatriate business
community, and I couldn't identify with that old plantation world, with
its roots in slavery, but which my mother spoke of as a 'golden age'. I felt

much more like an independent Jamaican boy. But there was no room for that as a subjective position, in the culture of my family.

Now, this is the period of the growth of the Jamaican independence movement. As a young student, I was very much in favour of that. I became anti-imperialist and identified with Jamaican independence. But my family was not. They were not even identified with the ambitions for independence of the national bourgeoisie. In that sense, they were different from even their own friends, who thought, once the transition to national independence began, 'Well, at least we'll be in power.' My parents, my mother especially, regretted the passing of that old colonial world, more than anything else. This was a huge gap between their aspirations for me and how I identified myself.

KHC: So you are saying that your impulse to 'revolt' partly came from the Jamaican situation. Can you elaborate?

SH: Going to school as a bright, promising scholar and becoming politically involved, I was therefore interested in what was going on politically, namely, the formation of Jamaican political parties, the emergence of the trade unions and the labour movement after 1938, the beginnings of a nationalist independence movement at the end of the war; all of these were part of the postcolonial or de-colonizing revolution. Jamaica began to move toward independence once the war was over. So bright kids like me and my friends, of varying colours and social positions, were nevertheless caught up in that movement, and that's what we identified with. We were looking forward to the end of imperialism, Jamaica governing itself, self-autonomy for Jamaica.

KHC: What was your intellectual development, during this early period?

SH: I went to a small primary school, then I went to one of the big colleges. Jamaica had a series of big girls' schools and boys' schools, strongly modelled after the English public school system. We took English high school exams, the normal Cambridge School Certificate and A-level examinations. There were no local universities, so if you were going to university you would have to go abroad, off to Canada, United States or England to study. The curriculum was not yet indigenized. Only in my last two years did I learn anything about Caribbean history and geography. It was a very 'classical' education; very good, but in very formal academic terms. I learned Latin, English history, English colonial history, European history, English literature, etc. But because of my political interest, I also became interested in other questions. In order to get a scholarship you have to be over eighteen and I was rather younger, so I took the final A-level exam twice, I had three years in the sixth form. In the last year, I started to read T.S. Eliot, James Joyce, Freud, Marx, Lenin and some of the surrounding literature and modern poetry. I got a wider reading than the usual,

narrowly academic British-oriented education. But I was very much formed like a member of a colonial intelligentsia.

KHC: Can you recall any figure who influenced your intellectual development at that point in time?

SH: There was no single one. There was a whole series of them, and they did two things for me. First of all, they gave me a strong sense of self-confidence, of academic achievement. Second, they themselves being teachers, were identified with these emerging nationalist tendencies. Although they were strongly academic and English-oriented, they were also attentive to the rising Caribbean nationalist movement. So I learned a good deal about that from them. For instance, a Barbadian who studied at Codrington College taught me Latin and ancient history. A Scottish, ex-Corinthian footballer made me do the modern current affairs paper in my final history exam. The current affairs paper was about post-war history, about the war and afterwards, which wasn't taught formally. I learned for the first time about the Cold War, I learned about the Russian revolution, about American politics. I became interested in international affairs and about Africa. He introduced me to certain political texts – though mainly to 'innoculate' me against dangerous 'marxist' ideas. I devoured them. I belonged to a local library, called the Institute of Jamaica. We would go down there on Saturday mornings, we would read books about slavery. It introduced me to Caribbean literature. I started to read Caribbean writers. Much of that time, I read on my own, trying to make sense of them, and dreaming of one day becoming a creative writer.

The war was very important to me. I was a child during the war; the war was a dominating experience. It's not that we were attacked or anything like that, but it was a real presence. I was very aware of that. I used to play games about the war and learned a lot about where these places were, about them. I learned about Asia following the American war in the Philippines. I learned about Germany. I just followed current historical events through the war. When I think back, I learned a lot, just by looking at the maps about the war, about the invasion of the Far East, and playing 'war games' with my friends (I was often a German general, and wore a monocle!).

KHC: How important was Marx, or the tradition of marxist literature?

SH: Well, I read Marx's essays – the *Communist Manifesto, Wage Labour* and *Capital*; I read Lenin on imperialism. It was important for me more in the context of colonialism, than about western capitalism. The questions of class were clearly present in the political conversation about colonialism going on in Jamaica, the question of poverty, the problem of economic development, etc. A lot of my young friends, who went to university at the same time I did, studied economics. Economics was supposed to be the answer to the poverty which countries like Jamaica experienced, as a

consequence of imperialism and colonialism. So I was interested in the economic question from a colonial standpoint. If I had an ambition at that point, the ambition was not to go into business like my father, but to become a lawyer; becoming a lawyer was already, in Jamaica, a major route into politics. Or, I could become an economist. But actually, I was more interested in literature and history than in economics. When I was seventeen, my sister had a major nervous breakdown. She began a relationship with a young student doctor who had come to Jamaica from Barbados. He was middle-class, but black and my parents wouldn't allow it. There was a tremendous family row and she, in effect, retreated from the situation into a breakdown. I was suddenly aware of the contradiction of a colonial culture, of how one lives out the colour–class–colonial dependency experience and of how it could destroy you, subjectively.

I am telling this story because it was very important for my personal development. It broke down forever, for me, the distinction between the public and the private self. I learned about culture, first, as something which is deeply subjective and personal, and at the same moment, as a structure you live. I could see that all these strange aspirations and identifications which my parents had projected onto us, their children, destroyed my sister. She was the victim, the bearer of the contradictory ambitions of my parents in this colonial situation. From then on, I could never understand why people thought these structural questions were not connected with the psychic – with emotions and identifications and feelings because, for me, those structures are things you live. I don't just mean they are personal, they are, but they are also institutional, they have real structural properties, they break you, destroy you.

It was a very traumatic experience, because there was little or no psychiatric help available in Jamaica, at that time. My sister went through a series of ECT treatments given by a GP, from which she's never properly recovered. She never left home after that. She looked after my father until he died. Then she looked after my mother until she died. She took care of my brother who became blind, until he died. That's a complete tragedy, which I lived through with her, and I decided I couldn't take it; I couldn't help her, I couldn't reach her, although I understood what was wrong. I was seventeen, eighteen.

But it crystallized my feelings about the space I was called into by my family. I was not going to stay there. I was not going to be destroyed by it. I had to get out. I felt that I must never put myself back into it, because I would be destroyed. When I look at the snapshots of myself in childhood and early adolescence, I see a picture of a depressed person. I don't want to be who they want me to be, but I don't know how to be somebody else. And I am depressed by that. All of that is the background to explain why I eventually migrated.

KHC: From then on, you maintained a very close relationship with your sister, psychoanalytically speaking, you identified with her?

SH: No, not really. Though the whole system had messed up her life, she never revolted. So I revolted, in her place, as it were. I'm also guilty, because I left her behind, to cope with it. My decision to emigrate was to save myself. She stayed.

I left in 1951 and I didn't know until 1957 that I wasn't going back; I never really intended to go back, though I didn't know it at the same time. In a way, I am able to write about it now because I'm at the end of a long journey. Gradually, I came to recognize I was a black West Indian, just like everybody else, I could relate to that, I could write from and out of that position. It has taken a very long time, really, to be able to write in that way, personally. Previously, I was only able to write about it analytically. In that sense, it has taken me fifty years to come home. It wasn't so much that I had anything to conceal. It was the space I couldn't occupy, a space I had to learn to occupy.

You can see that this formation – learning the whole destructive, colonized experience – prepared me for England. I will never forget landing there. My mother brought me, in my felt hat, in my overcoat, with my steamer trunk. She brought me, as she thought, 'home', on the banana boat, and delivered me to Oxford. She gave me to the astonished college scout and said, 'There is my son, his trunks, his belongings. Look after him.' She delivered me, signed and sealed, to where she thought a son of hers had always belonged – Oxford.

My mother was an overwhelmingly dominant person. My relationship with her was close and antagonistic. I hated what she stood for, what she tried to represent to me. But we all had a close bond with her, because she dominated our lives. She dominated my sister's life. It was compounded by the fact that my brother, who was the eldest, had very bad sight, and eventually went blind. From a very early age, he was very dependent on my parents. When I came along, this pattern of mother–son dependency was clearly established. They tried to repeat it with me. And when I began to have my own interests and my own positions, the antagonism started. At the same time, the relationship was intense, because my mother always said I was the only person who fought her. She wanted to dominate me, but she also despised those whom she dominated. So she despised my father because he would give in to her. She despised my sister, because she was a girl, and as my mother said, women were not interesting. In adolescence, my sister fought her all along, but once my mother broke her, she despised her. So we had that relationship of antagonism. I was the youngest. She thought I was destined to oppose her, but she respected me for that. Eventually when she knew what I had become in England – fulfilling all her most paranoid fantasies of the rebellious son – she didn't

want me to come back to Jamaica, because by then I would have represented my own thing, rather than her image of me. She found out about my politics and said, 'Stay over there, don't come back here and make trouble for us with those funny ideas.'

I felt easier in relation to Jamaica, once they were dead, because before that, when I went back, I had to negotiate Jamaica through them. Once my parents were dead, it was easier to make a new relationship to the new Jamaica that emerged in the 1970s. This Jamaica was not where I had grown up. For one thing, it had become, culturally, a black society, a post-slave, postcolonial society, whereas I had lived there at the end of the colonial era. So I could negotiate it as a 'familiar stranger'.

Paradoxically, I had exactly the same relationship to England. Having been prepared by the colonial education, I knew England from the inside. But I'm not and never will be 'English'. I know both places intimately, but I am not wholly of either place. And that's exactly the diasporic experience, far away enough to experience the sense of exile and loss, close enough to understand the enigma of an always-postponed 'arrival'.

It's interesting, in relation to Jamaica, because my close friends whom I left behind, then went through experiences which I didn't. They lived 1968 there, the birth of black consciousness and the rise of Rastafarianism, with its memories of Africa. They lived those years in a different way from me, so I'm not of their generation either. I was at school with them, and I've kept in touch with them, but they have an entirely different experience from mine. Now that gap cannot be filled. You can't 'go home' again.

So you have what Simmel talked about: the experience of being inside and outside, the 'familiar stranger'. We used to call that 'alienation', or deracination. But nowadays it's come to be the archetypal late-modern condition. Increasingly, it's what everybody's life is like. So that's how I think about the articulation of the postmodern and the postcolonial. Postcoloniality, in a curious way, prepared one to live in a 'postmodern' or diasporic relationship to identity. Paradigmatically, it's a diasporic experience. Since migration has turned out to be *the* world-historical event of late modernity, the classic postmodern experience turns out to be the diasporic experience.

KHC: But when was the diasporic experience registered, in a conscious way?

SH: In modern times, since 1492, with the onset of the 'Euro-imperial' adventure – in the Caribbean, since European colonization and the slave trade: since that time, in the 'contact zones' of the world, culture has developed in a 'diasporic' way. When I wrote about Rastafarianism, about reggae, in the 1960s, when I thought about the role of religion in Caribbean life, I've always been interested in this relationship of the 'translation' between Christianity and the African religions, or the mixtures in

Caribbean music. I've been interested in what turns out to be the thematic of the diaspora for a long time, without necessarily calling it that. For a long time, I wouldn't use the term diaspora, because it was mainly used in relation to Israel. That was the dominant political usage, and it's a usage I have problems about, in relation to the Palestinian people. That is the originary meaning of the term 'diaspora', lodged in the sacred text, fixed in the original landscape, which requires you to expel everybody else, and reclaim a land already settled by more than one people. That diasporic project, of 'ethnic cleansing' was not tenable for me. Although, I also have to say, there are certain very close relations between the Black diaspora and the Jewish diaspora – for example, in the experience of suffering and exile, and the culture of deliverance and redemption, which flow out of it. That is why Rastafarianism uses the Bible, why reggae uses the Bible, because it is a story of a people in exile dominated by a foreign power, far from 'home' and the symbolic power of the redemptive myth. So the whole narrative of coloniality, slavery and colonization is re-inscribed in the Jewish one. And in the post-emancipation period, there were a lot of African–American writers who used the Jewish experience, very powerfully, as a metaphor. For the black churches in the States, escape from slavery and deliverance from 'Egypt' were parallel metaphors.

Moses is more important for the black slave religions than Jesus, because he led his people out of Babylon, out of captivity. So I've always been interested in this double text, this double textuality. Paul Gilroy's book *The Black Atlantic*,[2] is a wonderful study of 'the black diaspora' and of the role of that concept in African–American thought. Another landmark text for me, in this respect, is Bakhtin's *The Dialogic Imagination*,[3] which develops a range of related concepts about language and meaning – heteroglossia, carnival, or multi-accentuality, from Bakhtin–Volosinov – which we developed in cultural studies theoretically, really in the context of the question of language and ideology, but which turned out to be discursive tropes classically typical of diaspora.

MOMENTS OF THE NEW LEFT

KHC: Then you went to England in 1951. What happened then?

SH: Arriving on a steamer in Bristol with my mother, getting on the train to come to Paddington, I'm driving through this West Country landscape; I've never seen it, but I know it. I read Shakespeare, Hardy, the Romantic poets. Though I didn't occupy the space, it was like finding again, in one's dream, an already familiar idealized landscape. In spite of my anti-colonial politics, it had always been my aspiration to study in England. I always wanted to study there. It took quite a while to come to terms with Britain,

especially with Oxford, because Oxford is the pinnacle of Englishness, it's the hub, the motor, that creates Englishness.

There were two phases. Up until 1954, I was saturated in West Indian expatriate politics. Most of my friends were expatriates, and went back to play a role in Jamaica, Trinidad, Barbados, Guyana. We were passionate about the colonial question. We followed the expulsion of the French from Indochina with a massive celebration dinner. We discovered, for the first time, that we were 'West Indians'. We met African students for the first time. With the emerging postcolonial independence, we dreamt of a Caribbean federation, merging these countries into a larger entity. If that had happened, I would have gone back to the Caribbean.

Several West Indian students actually lived together, for a while, in this house in Oxford, which also spawned the New Left. They were the first generation, black, anti-colonial or postcolonial intelligentsia, who studied in England, did graduate work, trained to be economists. A lot of them were sent by their governments and went back, to become the leading cadre of the post-independence period. I was very much formed, politically and personally, in conversation with that, in the early Oxford days.

At that time, I was still thinking of going back to Jamaica having a political career, being involved in West Indian federation politics, or teaching at the University of the West Indies. Then I got a second scholarship, and decided to stay on in Oxford to do graduate work. At that point, most of my immediate Caribbean circle went home. During that time, I also got to know people on the left, mainly from the Communist Party and the Labour Club. I had a very close friend, Alan Hall, to whom I dedicated an essay on the New Left in *Out of Apathy*.[4] He was a Scotsman, a classical archeologist, who was interested in cultural and political questions. We met Raymond Williams together. We were very close to some people in the Communist Party then, but never members of it – people like Raphael Samuel, Peter Sedgwick. Another close friend was the philosopher Charles Taylor. Charles was another person, like Alan Hall and me, who was of the 'independent left'. We were interested in marxism, but not dogmatic marxists, anti-stalinist, not defenders of the Soviet Union; and therefore we never became members of the Communist Party, though we were in dialogue with them, refusing to be cut off by the Cold War, as the rulers of the Labour Club of that time required. We formed this thing called the Socialist Society, which was a place for meetings of the independent minds of the left. It brought together postcolonial intellectuals and British marxists, People in the Labour Party and other left intellectuals. Perry Anderson, for example, was a member of that group. This was before 1956. Many of us were foreigners or internal immigrants: a lot of the British people were provincial, working-class, or Scottish, or Irish, or Jewish.

When I decided to stay on to do graduate work, I opened a discussion with some of the people in this broad left formation. I remember going to a

meeting and opening a discussion with members of the Communist Party, arguing against the reductionist version of the marxist theory of class. That must have been in 1954, and I seem to have been arguing the same thing ever since. In 1956, Alan Hall, myself and two other friends, both of them painters, went away for a long summer vacation. Alan and I were going to write this book on British culture. We took away three chapters of *Culture and Society*,[5] *The Uses of Literacy*,[6] Crossland's book on *The Future of Socialism*, Strachey's book, *After Imperialism*, we took away Leavis, with whose work we'd had a long engagement. The same issues were also breaking culturally. We took away the novelist Kingsley Amis's *Lucky Jim*, new things that were happening in cinema in the British documentary movement – like Lindsay Anderson's essay in *Sight and Sound*. In August, while we were in Cornwall, the Soviet Union marched on Hungary and by the end of August, the British invaded Suez. That was the end of that. The world turned. That was the formation, the moment of the New Left. We were into something else.

Most of the people who had been in our circles, in the Communist Party left it, and the Oxford branch collapsed. For a moment in Oxford, this funny grouping, around the Socialist Society, became the conscience of the left, because we had always opposed stalinism *and* opposed imperialism. We had the moral capital to criticize *both* the Hungarian invasion and the British invasion. That is the moment – the political space – of the birth of the first British New Left. Raphael Samuel persuaded us to start this journal, the *Universities and Left Review*, and I got caught up in that. I became more and more involved in the journal. There were four editors, Charles Taylor, Raphael Samuel, Gabriel Pearson and myself. Once I decided to leave Oxford, in 1957, I came to London and taught in secondary school as a supply teacher, mainly in Brixton and the Oval in south London. I used to leave the school at four o'clock and go to the centre of London, to Soho, to edit the journal. So I didn't leave England, at first, because I became involved, in a new kind of way, in British politics.

It's important to say what my feelings are now about that second moment. I never felt defensive about the New Left, but in a broader political sense, I remain identified with the project of the *first* New Left. I always had problems in that period, about the pronoun 'we'. I didn't know quite who I meant, when I said 'We should do X.' I have a funny relationship to the British working-class movement, and the British institutions of the labour movement: the Labour Party, the trade unions, identified with it. I'm in it, but not culturally of it. I was one of the people, as editor of *Universities and Left Review*, mainly negotiating that space, but I didn't feel the continuity that people who were born in it did, or like people for whom it was an essential part of their 'Englishness', like Edward Thompson; I was still learning about it, in a way, as well as negotiating with it. I did have a diasporic 'take' on my position in the New Left. Even if I was

not then writing about the diaspora, or writing about black politics (there weren't yet many black settlers in Britain), I looked at the British political scene very much as somebody who had a different formation. I was always aware of that difference. I was aware that I'd come from the periphery of this process, that I was looking at it from a different vantage point. I was learning to appropriate it, rather than feeling that the culture was already mine. I was always reluctant to go canvassing for the Labour Party. I don't find it easy to say, straight, face to face with an English working-class family, 'Are you going to vote for us?' I just don't know how to utter that sentence.

KHC: Was the New Left essentially an intellectual formation or did it have an organized mass basis?

SH: It had no organized mass base. In the high period of the New Left, during the years between 1956 and 1962, it had much stronger links with political forces and social movements on the ground. The New Left Club in London was not just composed of intellectuals. The New Left's work on race, during the 1958 racial upheaval in Notting Hill was organizing on the ground, organizing tenants' associations, organizing defence grouping for black people. We set up the clubs, *Universities and Left Review* and New Left Review Clubs, and at one stage there were twenty-six clubs. They had people from the Labour Party, the trade unions, students, and so on. So they were not only intellectuals; though since the journal, *Universities and Left Review*, played the leading role, it was the intellectuals who took the lead. Then we made a very strong link with the CND, anti-nuclear movement. The link with the CND, with the peace movement, was again not only a class movement; but it did represent a deep involvement with what was one of the earliest 'new social movements'; thus we were in the forefront of what was to become, post-1968, the 'new politics'.

I am not trying to present the New Left as wider, in its social composition, than it actually was. But it is not true that at its high point it was composed exclusively of students and intellectuals, in an American sense. Remember, in Britain, universities were never large enough to form the autonomous space of politics. So, for a long time, the New Left had a wider formation. It emerged in that very moment of the 1960s, when there was a major shift in class formation going on. There were a lot of people in transition between the traditional classes. There were people with working-class backgrounds, who were scholarship boys going to colleges and art schools for the first time, beginning to get professional jobs, to be teachers, and so on. The New Left was in touch with people who were themselves moving between classes. A lot of our clubs were in new towns where people had parents who might have been manual workers, but they themselves got a better education, had gone to university, and come back as teachers. Hoggart and Williams, who both were from a working-class

backgrounds, and became intellectuals through the adult education move-
ment, are the classic members of the New Left, representative of the
audience for the New Left Clubs, of readers of the New Left journals.
We were more a 'new social movement' than a proto-political party.

KHC: Why wasn't there an attempt to get these 'audiences' organized into
something?

SH: What a very much pre-'new social movements' question. That's what
we kept asking ourselves – not knowing that the 'tyranny of structureless-
ness' was a problem for all 'new social movements'. But there were two
reasons. One was the presence of the Labour Party. The overwhelming fact
of the Labour Party, as a mass social democratic party, suggested that if
only one could build a new alliance within the Labour Party, there already
was a mass movement of the left, which could be penetrated by New Left
ideas. The Labour Party was like a prize waiting to be won, if only that
transformation, from an Old Left to a New Left Party, could be brought
about. Is all this beginning to have a familiar ring? It is the dilemma of the
left in Britain, writ large.

Secondly, because the New Left was, from its origins, anti-stalinist, and
because is was opposed to the bureaucracy of the Cold War, to the
bureaucratic apparatuses of the party during the early 1950s, and so on,
it anticipated the new social movements, in being very anti-organizational.
So we didn't want any structure, we didn't want any leadership, we didn't
want any permanent party apparatuses. You belonged to the New Left by
affiliating with it. We didn't want anybody to pay any dues. We may have
been quite wrong about that, in many ways, but we were very anti-
organizational. In very much the same way in which early feminism was
anti-structure. It was the spirit of 1968, *avant la lettre*.

KHC: So there was this possibility of forming, or articulating, an alliance,
without any organizational hierarchy?

SH: Yes, that was the ambition, but I don't think we knew how to do it.
One couldn't just set up the New Left because, after all, the working class
already had its own institutions, the Labour Party, the trade unions. And
there were people sympathetic to New Left ideas in the Labour and trade
union movements. We were in the light of the stalinist experience, deeply
suspicious of the bureaucratic apparatus of the political party. So we
decided to sidestep that question. What matters, we argued, was what
new ideas the left subscribed to, not which party label it adopted. It was
a struggle for the renewal of socialist ideas, not for the renovation of the
party. 'One foot in, one out', we said. What is interesting is 'What are you
doing on the ground? Do you have a local CND, are you going into the
local market?' It was like occupying a space without organizing it, without
imposing on people a choice of institutional loyalty.

Remember, there was no such thing as a 'new social movement' then. We hadn't identified this as a new phase (or form) of politics. We thought we were still in the old political game but conducting it in a rather new way. It's only retrospectively that we came to understand that New Left as an early anticipation of the era of the 'new social movements'. Exactly what I'm describing was what later happened in CND: the anti-nuclear movement as an autonomous, independent movement.

KHC: Now about the *New Left Review*, what was the situation which put you on the spot, with all the more established or earlier generation people, such as Thompson and Williams, around?

SH: The situation was this: there were originally two groups, the *New Reasoner* and *Universities and Left Review*. People on the *New Reasoner*'s editorial board – Edward and Dorothy Thompson, John Saville, Alasdair McIntyre – were from a slightly older generation, one basically formed in the old Communist tradition, the dissident Communist tradition that grew up, especially amongst marxist historians of the 1930s and 1940s, the same generation as Raymond Williams, although Raymond was only briefly, as a student at Cambridge, a member of the party. Raymond then broke off and had an independent formation, and, as a consequence, became one of the mediating figures, belonging to the *Reasoner* generation in age, but closer to us in his preoccupations. We were the next generation, who started the *Universities and Left Review*. We were related to marxism, but much more critical of it, more willing to think new things, especially to open new spaces in relation to questions of popular culture, television, etc. – which the older generation did not regard as politically significant. Nevertheless, these two formations were so close together, shared so much in common, and found it so difficult, in financial terms, to keep two different journals going, that gradually the two editorial boards began to meet together. Then the idea emerged to form one journal. The obvious editor was Edward Thompson, the leading figure on the *New Reasoner*. But Edward, by then, had been locked into the struggle since 1956; first of all fighting inside the Communist Party after the horrors of stalinism were exhumed in Khrushchev's twentieth Congress speech, then being expelled, then trying to keep the *New Reasoner* going with very little funds, etc. He had two kids, and I think he and Dorothy simply couldn't go on any longer living like that. So the editorship passed to me, though the ambiguity of Edward's position, in relation to me, continued to be a source of tension on the editorial board.

KHC: What about Raymond Williams, was he the mediator?

SH: Yes, Raymond played a different role. Raymond never took on a detailed editorial role. He was a major figure, his writing influenced all of us. He wrote for both journals, especially the *Universities and Left Review*, and his writing helped to give the project of the New Left a

distinctive and original identity. I was very much influenced by his work. Then there was the younger generation, Charles Taylor, myself, Raphael Samuel. Raphael was the dynamo and inspiration, absolutely indispensable, full of energy and ideas, though he wasn't the person to put in charge of getting the journal out regularly. By 1958, in effect I had become the full-time editor of the *Universities and Left Review*. Charles Taylor had already gone to Paris to study with Merleau-Ponty. Charles was very important to me, personally. I remember the first discussions of Marx's 1844 *Economic and Philosophical Manuscripts*, which he brought back from Paris, and the discussions about alienation, humanism and class.

KHC: You mentioned, in *Out of Apathy*, Doris Lessing. What role did she play?

SH: Doris was not involved in the editorial work of the journal. She contributed to it. She was very close to the Edward Thompson generation, and was one of those independent intellectuals in the Communist Party in the 1940s. She joined the *New Left Review* editorial board, but she was already taking her distance from active politics.

KHC: Then, after two years' editorship, in 1961, you were completely burned out. What did you do after that?

SH: I left the *Review* to teach media, film and popular culture at Chelsea College, University of London. I went to teach what was then called complementary studies, and what we would now call cultural studies. I was brought in by a group of people teaching there, who were sympathetic towards the New Left, interested in the work of Hoggart and Williams, but also in the work which Paddy Whannel and I were doing in film studies for the BFI (British Film Institute). I was appointed at Chelsea to teach film and mass media studies. I don't think there was a lectureship in film and mass media studies anywhere at that time. I had done work on film and TV with Paddy Whannel, through the Education Department of the British Film Institute. And there was also the connection with 'Free Cinema', the British documentary movement associated with Lindsay Anderson *et al.*, then *Screen* and the Society for Education in Film and Television. Between 1962 and 1964, Paddy and I did the work which finally resulted in *The Popular Arts*.[7]

KHC: Before that, you were going to write your dissertation on Henry James. Did you give it up because of the *New Left Review*?

SH: I gave it up literally because of 1956. I gave it up in a deeper sense because I was increasingly using my research time to read about culture and to follow that line of interest. I spent a great deal of time in Rhodes House library, reading the anthropological literature and absorbing the debate about African 'survivals' in Caribbean and New World culture.

Actually, my thesis on Henry James was not as distant from these pre-occupations as all that. It was on the theme of 'America' *vs.* 'Europe' in James's novels. It dealt with the cultural-moral contrasts between America and Europe, one of the great cross-cultural themes in James. I was also interested in James in terms of the destablization of the narrative 'I', the last such moment in the modernist western novel, before Joyce. Joyce represented the dissolution of the narrative 'I'; James is poised perilously on the edge of that. His language is almost overrunning the capacity of the narrative 'I'. So I was interested in these two questions, which have major cultural studies implications. On the other hand, I didn't feel it was right for me to go on thinking cultural questions in 'pure' literary terms.

While teaching at Chelsea, I kept in touch with Williams and Hoggart. I organized the first occasion at which Richard Hoggart and Raymond Williams met. It was for a conversation republished in the *Universities and Left Review*. They discussed *Culture and Society* and *The Uses of Literacy*. Hoggart had then decided to leave Leicester and go to Birmingham as the Professor of English. He wanted to continue graduate work in the area covered by *The Uses of Literacy*, rather than straight literary studies. And Birmingham University said to him, 'You can do that but we don't have any money to support you.' But he had testified in the *Lady Chatterley's Lover* trial, for Penguin Books, and he went to the head of the Penguin Books, Sir Allen Lane, and persuaded him to give us some money, to start a research centre. So Allen Lane gave Hoggart a few thousand pounds a year, which Penguin could write off against tax, because it was an education covenant. With this money, Hoggart decided to hire somebody who would look after this end of the work, while he remained Professor of English, and he invited me to Birmingham, to take it on. Hoggart had read *Universities and Left Review* and *New Left Review*, and *The Popular Arts*, and he thought that, with my combination of interests in television, film and popular literature, my knowledge of the Leavis debate and my interest in cultural politics, I would be a good person. I went to Birmingham in 1964, and got married to Catherine – who transferred to Birmingham from Sussex – the same year.

THE BIRMINGHAM PERIOD

KHC: There is a wide spread impression that, historically, CCCS in the beginning was only interested in the question of class. On the other hand, there is also a story that the first collective project in the Centre was one analysing women's magazines, but somehow the manuscript of this project got lost in the production process, without ever being xeroxed.[8] Is this true?

SH: Oh yes, it's absolutely true. Both of these are true. First of all, cultural studies was interested in class, in the beginning, in Hoggart's and Wil-

liams' sense, not in the classic marxist sense. Some of us were formed in critical relation to marxist traditions. We were interested in the class question, but it was never the only question: for instance, you can see important work on subcultures, which was done even in the early stages of the Centre. Secondly, when you talk about cultural studies theoretically, we actually went around the houses to avoid reductionist marxism. We read Weber, we read German idealism, we read Benjamin, Lukács, in an attempt to correct what we thought of as the unworkable way class reductionism had deformed classical marxism, preventing it from dealing with cultural questions seriously. We read ethnomethodology, conversational analysis, Hegelian idealism, iconographic studies in art history, Mannheim; we were reading all of these, to try to find some alternative sociological paradigms (alternatives to functionalism and positivism), which were not open to the charge of reductionism. Both empirically and theoretically the idea that CCCS was *only* originally interested in class isn't right. Thirdly, we got ourselves into the question of feminism, (actually pre-feminism) and the question of gender. We took on fiction in women's magazines. We spent ages on a story called 'Cure for Marriage', and all those papers, which were supposed to be written up into a book, then disappeared; which means that moment from the history of cultural studies is lost. That was the Centre's 'pre-feminist' moment.

At a certain point, Michael Green and myself decided to try and invite some feminists, working outside, to come to the Centre, in order to project the question of feminism into the Centre. So the 'traditional' story that feminism originally erupted from *within* cultural studies is not quite right. We were very anxious to open that link, partly because we were both, at that time, living with feminists. We were working in cultural studies, but were in conversation with feminism. People inside cultural studies were becoming sensitive to the gender question at that time, but not very sensitive to feminist politics. Of course, what is true is that, as classical 'new men', when feminism did actually emerge autonomously, we were taken by surprise by the very thing we had tried – patriarchally – to initiate. Those things are just very unpredictable. Feminism then actually erupted into the Centre, on its own terms, in its own explosive way. But it wasn't the first time cultural studies had thought of, or been aware of, feminist politics.

KHC: Then in the late 1970s, you left CCCS for the Open University; why was that?

SH: I had been at the Centre since 1964, and I left in 1979, it was a long time. I was concerned about the fact of the 'succession'. Somebody, the next generation, has to succeed. The mantle has to pass on, or the whole venture would die with you. I knew that, because when Hoggart finally decided to go, I became acting director. He went to UNESCO in 1968, I

'acted' for him for four years. When, in 1972, he decided not to come back, there was a huge attempt by the University to close the Centre down, and we had to struggle to keep it open. I realized that, in a way, while I was there, they wouldn't close it down. They went to lots of academics to ask advice, and everyone said, 'Stuart Hall will carry on Hoggart's tradition, so don't close it down.' But I knew that, as soon as I went, they would try to close it down again. So I had to secure the transition. I didn't think, until the end of the 1970s, that the position was secure. When I did, I felt free to leave.

On the other hand, I felt also I'd been through the internal crises of each cultural studies year once too often. New graduate students came in October, November; then there was always the first crisis, the MA not doing well, everything in turmoil. I'd seen this happen time, time and time again. I thought to myself, 'You're becoming like a typical disenchanted academic, you must get out, while the experience is good, before you are obliged to fall into these ancient habits.'

Then the question of feminism was very difficult to take, for two reasons. One is that, if I had been opposed to feminism, that would have been a different thing, but I was for it. So, being targeted as 'the enemy', as the senior patriarchal figure, placed me in impossibly contradictory position. Of course, they had to do it. They were absolutely right to do it. They had to shut me up; that was what the feminist political agenda was all about. If I had been shut up by the right, that was OK, we would all have struggled to the death against that. But I couldn't fight my feminist students. Another way of thinking about that contradiction is as a contradiction between theory and practice. You can be for a practice, but that's a very different thing from a living feminist in front of you, saying 'Let us get Raymond Williams out of the MA programme, and put Julia Kristeva in, instead.' Living the politics is different from being abstractly in favour of it. I was checkmated by feminists; I couldn't come to terms with it, in the Centre's work. It wasn't a personal thing. I'm very close to many of the feminists of that period. It was a structural thing. I couldn't any longer do any useful work, from that position. It was time to go.

In the early days of the Centre, we were like the 'alternative university'. There was little separation between staff and students. What I saw emerging was that separation between generations, between statuses – students and teachers – and I didn't want that. I preferred to be in a more traditional setting, if I had to take on the responsibility of being the teacher. I couldn't live part of the time being their teacher, and being their father, being hated for being their father, and being set up as if I was an anti-feminist man. It was an impossible politics to live.

So I wanted to leave, because of all these reasons. Then the question was, leave to do what. There was no other cultural studies department. I didn't want to go somewhere to be the head of a sociology department. Then the thing at the Open University came up. I'd been doing work with the Open

University anyway. Catherine had been a tutor there from the very begin-
ning. I thought, the Open University was a more possible option. In that
more open, interdisciplinary, unconventional setting, some of the aspira-
tions of my generation – of talking to ordinary people, to women and black
students in a non-academic setting – might be just possible. It served some
of my political aspirations. And then, on the other hand, I thought, here is
also an opportunity to take the high paradigm of cultural studies, generated
in this hothouse atmosphere of Centre graduate work, to a popular level,
because Open University courses are open to those who don't have any
academic background. If you are going to make cultural studies ideas live
with them, you have to translate the ideas, be willing to write at *that* more
popular and accessible level. I wanted cultural studies to be open to that
sort of challenge. I didn't see why it wouldn't 'live', as a more popular
pedagogy.

The Centre was hothouse stuff: the brightest graduate students doing
their PhDs. They aspired to connect, as organic intellectuals, to a wider
movement, but they themselves were at the pinnacle of a very selective
education system. The Open University was not. It was challenging the
selectivity of higher education as a system. So, the question was 'Can
cultural studies be done there?'

KHC: Getting back to the question of the diaspora. Some of the diasporic
intellectuals I know of have exercised their power, for better or worse, back
home, but you have not. And some of them are trying to move back, in
whatever way. So, in that sense, you are very peculiar.

SH: Yes. But remember, the diaspora came to me. I turned out to be in the
first wave of a diaspora over here. When I came to Britain, the only blacks
here were students; and all the black students wanted to go back after
college. Gradually, during my postgraduate and early New Left days, a
working black population settled here, and this became the diaspora of a
diaspora. The Caribbean is already the diaspora of Africa, Europe, China,
Asia, India, and this diaspora re-diasporized itself here. So that's why more
of my recent work is not only just about the postcolonial, but has to be with
black photographers, black film-makers, with black people in the theatre,
it's with the third generation black British.

KHC: But you never tried to exercise your intellectual power back home.

SH: There have been moments when I have intervened in my home parts.
At a certain point, before 1968, I was engaged in dialogue with the people I
knew in that generation, principally to try to resolve the difference between
a black marxist grouping and a black nationalist tendency. I said, you ought
to be talking to one another. The black marxists were looking for the
Jamaican proletariat, but there were no heavy industries in Jamaica; and
they were not listening to the cultural revolutionary thrust of the black

nationalists, and Rastafarians, who were developing a more persuasive cultural, or subjective language. But essentially I never tried to play a major political role there. It's partly because the break in the politics there – the cultural revolution that made Jamaica a 'black' society for the first time in the 1970s – coincided with a break in my own life. I would have gone back, had the Caribbean Federation lasted, and tried to play a role there. That dream was over at the moment in the 1950s when I decided to stay, and to open a 'conversation' with what became the New Left. The possibility of the scenario in which I might have been politically active in the Caribbean closed at the very moment when personally I found a new kind of political space here. After that, once I decided I was going to live here rather than there, once Catherine and I got married, the possibility of return became more difficult. Catherine was an English social historian, a feminist; her politics were here. Of course, paradoxically, she is now working on Jamaica, and the imperial relationship, and she now knows more Jamaican history than I do, and she loves being there. But in the 1960s, it was very difficult for a white British feminist to feel anything but an outsider, in relation to Jamaican politics. My 'reconnection' with the Caribbean happened because of the formation of a Black diasporic population here. I began to write about it again in the context of the studies of ethnicity and racism for UNESCO, then I wrote about it in *Policing the Crisis*,[9] focusing on race and racism, and their internal relation to the crisis of British society, and now I write very much in terms of cultural identities.

KHC: So diaspora is defined by the historical conjunctures both personally and structurally, and the creative energies and power of the diaspora come, in part, from these unresolvable tensions?

SH: Yes, but is very specific and it never loses its specificities. That is the reason why the way in which I'm trying to think questions of identity is slightly different from a postmodernist 'nomadic'. I think cultural identity is not fixed, it's always hybrid. But this is precisely because it comes out of very specific historical formations, out of very specific histories and cultural repertoires of enunciation, that it can constitute a 'positionality', which we call, provisionally, identity. It's not just anything. So each of those identity-stories is inscribed in the positions we take up and identify with, and we have to live this ensemble of identity-positions in all its specificities.

8 August 1992

NOTES

1 For Stuart Hall's work on race and ethnicity, see 'Gramsci's relevance for the study of race and ethnicity' *Journal of Communication Inquiry* 10(2), 1986; 'Minimal selves', *ICA Document 6*, 1987; 'New ethnicities', *ICA Document 7*,

1988; 'Ethnicity: identity and difference', *Radical America* 23(4), 1989; 'Cultural identity and diaspora', in Jonathan Rutherford (ed.), *Identity: Community, Culture, Difference*, London: Lawrence & Wishart, 1990; 'The local and global: globalization and ethnicity', 'Old and new identities, old and new ethnicities', in Anthony D. King (ed.), *Culture, Globalization and the World-System*, London: Macmillan, 1991; David A. Bailey and Stuart Hall (eds), 'Critical decade: Black British photography in the 80s', *Ten 8* 2(3); 'What is this 'Black' in Black popular culture?' in Gina Dent (ed.), *Black Popular Culture*, Seattle: Bay Press, 1992; 'The question of cultural identities', in Stuart Hall, David Held and Tony McGrew (eds), *Modernity and Its Futures*, Cambridge: Polity Press and the Open University, 1992.

2 Paul Gilroy, *The Black Atlantic*, Chicago: Harvard University Press, 1993.

3 Mikhail Bakhtin, *The Dialogic Imagination*, Austin: University of Texas Press, 1981.

4 Stuart Hall, 'The "first" New Left: life and times', in Oxford University Socialist Discussions Group, *Out of Apathy: Voices of the New Left 30 Years On*, London, Verso, 1989.

5 Raymond Williams, *Culture and Society: 1780–1950*, London: Penguin, 1958.

6 Richard Hoggart, *The Uses of Literacy*, London: Penguin, 1958.

7 Paddy Whannel and Stuart Hall, *The Popular Arts*, London: Hutchinson, 1964.

8 We thank Larry Grossberg for providing this information; personal conversation, July 1992.

9 Stuart Hall, Chas Critcher, Tony Jefferson, John Clarke, Brian Robert, *Policing the Crisis: Mugging, the State, and Law and Order*, London: Macmillan, 1978.

A working bibliography
The writings of Stuart Hall

1958
'A sense of classlessness', *Universities and Left Review* 1(5), 26–32.

1960
'Crosland territory', *New Left Review* 2, 24.
'Crowther in cold storage', *New Left Review* 3, 59–60.
'Lady Chatterley's Lover', *New Left Review* 6, 32–6.
'Sergeant Musgrave's Dance', *New Left Review* 1, 50–1.
'The supply of demand', in E. Thompson (ed.), *Out of Apathy*, London: New Left
 Books.

1961
'The New Frontier', *New Left Review* 8, 47–8.
(with N. Fruchter) 'Notes on the Cuban dilemma', *New Left Review* 9, 2–11.
(with P. Anderson) 'Politics of the Common Market', *New Left Review* 10, 1–15.
'Student journals', *New Left Review* 7, 50–1.

1964
'Liberal studies', in P. Whannel and P. Harcourt (eds), *Studies in the Teaching of
 Film within Formal Education*, London: British Film Institute, 10–27.
(with P. Whannel) *The Popular Arts*, London: Hutchinson and Boston: Beacon
 Press.

1966
'Class and the Mass Media', in R. Mabey (ed.) *Class: A Symposium*, London:
 Blond.
'The formation of political consciousness', in S. Clements and L. Bright (eds), *The
 Committed Church*, London: Darton, Longman & Todd.

1967
'The condition of England question', *People and Politics* (Easter).
'Cultural analysis', *Cambridge Review* 89.
'People, personalities and personalization', in R. Hoggart (ed.), *Writers and their
 Work*, London: London University Press.
'The world of the gossip column', in R. Hoggart (ed.), *Your Sunday Paper*,
 London: London University Press.

The Young Englanders, London: National Committee of Commonwealth Immigrants.

1969
'The hippies, an American moment', in J. Nagel (ed.), *Student Power*, London: Merlin Press.
'Popular press and social change', *Rowntree Report*, London: Joseph Rowntree Social Services Trust.

1970
'Black Britons', *Community* 1(2/3).
'Leisure, entertainment and mass communication', *Society and Leisure* 2, 28–47.
'Riflessioni sull'informazione in Gran Bretagna', *Information Radio TV*, Rome: RAI 12 (translated reprint).
'A world at one with itself', *New Society* 403, 1056–8.

1971
'Innovation and decline in cultural programming on television', *UNESCO Report*, Birmingham: CCCS, University of Birmingham.
'Life and death of Picture Post', *Cambridge Review* 92.
'Le rôle des programmes culturels dans la télévision Britannique', in *Essais sur les mass media et la culture*, Paris: UNESCO.
'Introduction', 'Response to people and culture', *Working Papers in Cultural Studies* 1, 5–7; 97–102.

1972
'Black Britons', in E. Butterworth and D. Weir (eds), *Social Problems of Modern Britain*, London: Fontana.
'The determination of news photographs', *Working Papers in Cultural Studies* 3, Birmingham: University of Birmingham, 53–88.
'External/internal dialectic in broadcasting', in *Fourth Symposium on Broadcasting*, Department of Extra-Mural Studies, University of Manchester.
'The hippies: dissent in America', in P. Worsley (ed.), *Problems of Modern Society*, Harmondsworth: Penguin.
'The limitations of broadcasting', *Listener* 16.
'The social eye of Picture Post', *Working Papers in Cultural Studies* 2, Birmingham: University of Birmingham, 71–120.

1973
'The determination of news photographs', in S. Cohen and J. Young (eds), *The Manufacture of News*, London: Constable.
'Deviancy, politics and the media', in P. Rock and M. McIntosh (eds), *Deviance and Social Control*, London: Tavistock.
'Encoding and decoding in the media discourse', Stencilled Paper 7, Birmingham: CCCS.
'Introduction', in P. Walton and S. Hall (eds), *Situating Marx*, London: Human Context Books, 1–6.
'The limitations of broadcasting', *The Second Listener Anthology*, London: BBC.
'The "structured communication" of events', in *Obstacles to Communication Symposium*, Paris: UNESCO.

'The television discourse', in *Criteria and Functions of Television Criticism* (Prix Italia: proceedings), Turin: Edizioni Radiotelevisione Italiana.

1974

'Between two worlds', in T. Berker (ed.), *The Long March of Everyman*, London: André Deutsch.

'Education and the crisis of the urban school', in J. Raynor (ed.), *Issues in Urban Education*, Milton Keynes: Open University Press.

'Encoding and decoding', *Broadcasters and the Audience*, Venice: Prix Italia Symposium.

'Marx's notes on method: a "reading" of the "1857 Introduction"', *Working Papers in Cultural Studies* 6, Birmingham: University of Birmingham, 132–71.

'Media power: the double blind', *Journal of Communication* 24(4), 19–26.

(with A. Schuttleworth, C. Heck, and A. Lloyd), *Television Violence: Crime, Drama and the Analysis of Content*, Birmingham: CCCS.

1975

Africa is Alive and Well and Living in the Diaspora, Paris: UNESCO.

'Introduction', in A. C. Smith, *Paper Voices: The Popular Press and Social Change, 1935–1965*, London: Chatto & Windus.

(with T. Jefferson) *Mugging and Law 'n Order*, Stencilled Papers 36, Birmingham: CCCS.

'News and current affairs television', in *Proceedings of the XXVII Prix Italia, Media Research Conference*, Florence: Edizioni Radiotelevisione Italiana.

(with C. Critcher, J. Clarke, T. Jefferson and B. Roberts) 'Newsmaking and crime', Stencilled Paper 27, Birmingham: CCCS.

'Newsmaking and Crime', in *Journalism, Broadcasting and Urban Crime*, London: NACRO.

Television as a Medium and Its Relation to Culture, Birmingham: CCCS.

'Television, violence and crime', in *Research Methods and Results Concerning the Relationship between Violence, Television and Criminality*, Florence: Prix Italia.

1976

'Broadcasting, politics and the state: the independent – impartiality couplet', paper to 10th International Association for Mass Communication Research Symposium, University of Leicester.

'Economic determinations on television fiction production', in *Proceedings of the XXVIII Prix Italia Research Seminar on Organization and Structure of Fiction in Television Production*, Bologna: ERI/Radiotelevisone Italia.

'Introduction', to D. Selbourne, *An Eye on China*, London: Black Liberation Press.

'Literature, society and the sociology of literature: a critical survey', in F. Barker, P. Hulme *et al.* (eds), *Literature, Society and the Sociology of Literature: Proceedings of the Conference*, Colchester: University of Essex.

(with T. Jefferson) (eds), *Resistance through Rituals: Youth Subcultures in Postwar Britain*, (reproduction of *Working Papers in Cultural Studies* 7/8), London: Hutchinson.

(with J. Clarke, T. Jefferson, and B. Roberts) 'Subcultures, cultures and class: a theoretical overview', *Working Papers in Cultural Studies* 7/8, Birmingham: University of Birmingham, 9–74.

'Television and culture', *Sight and Sound* 45(4).

(with I. Connell and L. Curti) 'The "unity" of current affairs television', Working Papers in Cultural Studies 9, Birmingham: University of Birmingham, 51–94.

1977

'A critical survey of the theoretical and practical achievements of the last ten years', in F. Barker, et al. (eds) Literature Society and the Sociology of Literature, University of Essex, 1–7.
'Culture, the media, and the "ideological effect"', in J. Curran et al. (eds), Mass Communication and Society, London: Edward Arnold, 315–48.
'Developments in British youth culture', Teaching London Kids 10.
'The hinterland of science: ideology and the "sociology of knowledge"', Working Papers in Cultural Studies 10, Birmingham: University of Birmingham, 9–32.
'Journalism of the air under review', Journalism Studies Review 1(1), 43–5.
(with B. Lumley and G. McLennan) 'Politics and ideology: Gramsci', Working Papers in Cultural Studies 10, Birmingham: University of Birmingham, 45–76.
(with I. Connell, L. Curti, I. Chambers and T. Jefferson) 'Marxism and culture: a reply to Rosalind Coward', Screen 18 (4) (4).
'Rethinking the "base and superstructure" metaphor', in J. Bloomfield et al. (eds), Class, Hegemony and Party, London: Lawrence & Wishart.
Schooling and Society: A Review of Theories, Milton Keynes: Open University Press.
'Uber die arbeit das Centre for Contemporary Cultural Studies', Gulliver 2, Deutsch–Englishche Jahrbucher 2, Berlin: Argument Verlag.

1978

'Developments in British youth cultures', Hard Times 3/4, Berlin. Deutsch–Britishen Gesellschaft.
(with B. Lumley and G. McLennan) (eds), On Ideology (reproduction of Working Papers in Cultural Studies 10), Hutchinson/CCCS.
'Marxism and culture', Radical History Review 18, 5–14.
'Newspapers, politics and classes', in J. Curran (ed.), The British Press: A Manifesto, London: Macmillan.
'Pluralism, race and class in Caribbean society', in Race and Class in Post-Colonial Society, Paris: UNESCO.
(with C. Critcher, T. Jefferson, J. Clarke and B. Roberts) Policing the Crisis: 'Mugging', the State, and Law and Order, London: Macmillan.
'The "Political" and the "Economic" in Marxist theory of classes', in A. Hunt (ed.) Class and Class Structure, London: Lawrence & Wishart, 15–60.
'Race and poverty', in T. Blair (ed.), The Inner Cities, London: Central London Polytechnic Papers on the Environment.
'Racism and reaction', in Five Views of Multi-Racial Britain, London: Commission on Racial Equality.
'The racist within', Listener, 20 July.
'Die soziale optik der "Picture Post"', in E. Nierlich (ed.), Fremdsprachliche Literaturwissenschaft und Massenmedien, Meisenheim am Glan: Verlag Anton Hain.
'The television Feuilleton and the domestication of the world', in Television, Proceedings of the Prix-Italia Conference, Venice: ERI.
'The treatment of "football hooliganism" in the press', in R. Ingham (ed.), Football Hooliganism: The Wider Context, London: Inter-Action.

1979
'Cultures of resistance and "moral panics"', *Afras Review*, University of Sussex.
'The great moving right show', *Marxism Today*, January, 14–20.
'Some problems with the ideology/subject couplet', *Ideology and Consciousness* 3, 113–21.

1980
'Cultural studies and the Centre: some problematics and problems'; 'Introduction to media studies at the Cente', 'Encoding/decoding'; and 'Recent developments in theories of language and ideology', in S. Hall, D. Hobson, A. Lowe, and P. Willis (eds), *Culture, Media, Language: Working Papers in Cultural Studies (1972–1979)*, Hutchinson/CCCS, 15–47, 117–21, 128–38, 157–62.
'Cultural studies: two paradigms', *Media, Culture and Society* 2, 57–72.
Drifting into a law and order society, Cobden Trust lecture, London: Cobden Trust.
'Nicos Poulantzas: state, power, socialism', *New Left Review* 119, 60–9.
'Popular-decomcratic vs. authoritarian-populism: two ways of "taking democracy seriously"', in A. Hunt (ed.), *Marxism and Democracy*, London: Lawrence & Wishart, 157–85.
'Race, articulation, and societies structured in dominance', in *Sociological Theories: Race and Colonialism*, Paris: UNESCO, 305–45.
'Race, class and Ideology', *Das Argument*, July.
'The Raymond Williams Interviews', *Screen Education* 34, 94–104.
'Reformism and the legislation of consent', in J. Clarke, M. Fitzgerald *et al.* (eds), *Permissiveness and Control*, Macmillan and the National Deviancy Conference.
'Thatcherism: a new stage?', *Marxism Today*, February, 22–7.

1981
'Conformity, consensus and conflict: introduction', in D. Potter *et al.* (eds), *Society and the Social Sciences*, London: Routledge & Kegan Paul, 221–5.
(with P. Scraton) 'Law, class and control', in M. Fitzgerald *et al.* (eds), *Crime and Society*, London: Routledge & Kegan Paul.
'The "little Caesars" of social democracy', *Marxism Today*, April, 11–15.
'Moving Right', *Socialist Review* 55, 113–37.
'Notes on deconstructing "the Popular"'; and 'In defence of theory', in R. Samuel (ed.), *People's History and Socialist Theory*, London: Routledge & Kegan Paul, 227–40, 378–85.
'Representations of race in the media: viewpoint 2', *Multi-Racial Education* 9(2).
'Schooling, state and society', in R. Dale *et al.* (eds), *Education and State* 1: *Schooling and National Interest*, Sussex: Falmer Press, 3–29.
'The whites of their eyes: racist ideologies and the media', in George Bridges and Ros Brunt (eds), *Silver Linings*, London: Lawrence & Wishart, 28–52.

1982
'The battle for socialist ideas in the 1980s' in R. Milibond and J. Saville (eds), *Socialist Register*, London: Merlin Press.
'Culture and the state', in *Popular Culture and the State* 1, Block 7, Unit 28, Milton Keynes: Open University.
'The empire strikes back', *New Socialist*, July/August.
'A long haul', *Marxism Today*, November, 16–21.
'The rediscovery of "ideology": return of the repressed in media studies', in M.

Gurevitch, T. Bennett, J. Curran and S. Woollacott (eds), *Culture, Society, and the Media*, London: Methuen, 56–90.

1983
'Construction of race in the media', *Das Argument* 134.
'Ideologies, racisms and the populism of the New Right', *Hard Times* 23, 16–21.
'The impact of the cultural industries on western European societies', in Peter Duelund (ed.), *Kulturindustri og nordisk kulturpolitik*, Kobenhaven: Nord, 20–44.
(with M. Jacques) 'Introduction', in S. Hall and M. Jacques (eds), *The Politics of Thatcherism*, London: Lawrence & Wishart.
'The problem of ideology: marxism without guarantees', in B. Matthews (ed.), *Marx 100 Years on*, London: Lawrence & Wishart.
'Punk in the UK: an interview with Stuart Hall', *Shades*, 26–9.
'Teaching race', *Early Child Development* 10(4).
'Thatcherism: rolling back the welfare state', *Thesis Eleven* 7, 6–19.
'Whistling in the void', *New Socialist*, May/June, 8–12.

1984
'Conjuring Leviathan: Orwell on the state', in C. Norris (ed.), *Inside the myth – Orwell: views from the Left*, London: Lawrence & Wishart, 217–41.
'The crisis of Labourism', in J. Curran (ed.), *The Future of the Left*, Cambridge: Polity Press, 23–36.
'The culture gap', *Marxism Today*, January, 18–23.
'Education in crisis', in J. Donald and H. Wolpe (eds), *Is There Anyone Here from Education?*, London: Pluto Press.
'Face the future', *New Socialist*, September, 37–9.
'Introduction', Block 1; 'Unpacking Orwell', Block 1, Unit 1; 'The state in question', Block 1, Unit 2; 'Introduction: the state and civil society', Block 3; 'The representative–interventionist state, 1880s to 1920s', Block 3, Unit 7; 'Conclusion', Block 3, in Open University Course Blocks, Course D, 209), *The State and Society*, Milton Keynes: Open University Press.
'Labour's Love Still Lost', *New Socialist*, January/February, 7–9.
'The narrative construction of reality: an interview with Stuart Hall', *Southern Review* 17(1), 3–17.
'Reconstruction work', *Ten–8 16*, 2–9.
'The rise of the representative/interventionist state', in G. McLennan, D. Held, and S. Hall (eds), *State and Society in Contemporary Britain*, New York: Polity Press, 7–49.
'The state in question', in G. McLennan, D. Held, and S. Hall (eds), *The Idea of the Modern State*, Milton Keynes: Open University Press, 1–28.
'The state: socialism's old caretaker', *Marxism Today*, January, 15–19.

1985
'Authoritarian populism: a reply to Jessop *et al.*', *New Left Review* 151, 115–24.
'Cold Comfort Farm', *New Socialist*, November, 10–12.
'Faith, hope or clarity', *Marxism Today*, January, 15–19.
'Realignment: for what?', *Marxism Today*, December, 12–17.
'Religious ideology and social movement in Jamaica', in R. Bocock and K. Thompson (eds), *Religion and Ideology*, Manchester: Manchester University Press, 269–96.

(with Umberto Eco) 'The role of the intellectual is to produce crisis: a conversation', *Listener*, May 16, 14–16.
'Signification, representation, ideology: Althusser and the post-structuralist debates', *Critical Studies in Mass Communication* 2(2), 91–114.
(with Bill Schwarz) 'State and Society, 1880–1930', in M. Langan and B. Schwarz (eds), *Crises in the British State, 1880–1930*, London: Hutchinson, 7–32.

1986

(with James Anderson) 'Absolutism and other ancestors', in J. Anderson (ed.), *The Rise of the Modern State*, Brighton: Wheatsheaf, 21–40.
(with B. Campbell) (ed.), *Class and Politics after Thatcherism*, Cambridge: Polity Press.
'Foreword', in John Hargreaves, *Sport, Power and Culture*, London: Polity Press, xi–xii.
'Gramsci's relevance for the study of race and ethnicity', *Journal of Communication Inquiry* 10(2), 5–27.
'Introduction' to W. F. Haug, *Commodity Aesthetics, Ideology and Culture*, New York: International General, 1–4.
'Introduction', in David Morley, *Family Television: Cultural Power and Domestic Leisure*, London: Comedia, 7–10.
'Introduction' and 'Variants of liberalism', in J. Donald and S. Hall (eds), *Politics and Ideology*, Milton Keynes: Open University Press, ix–xx, 34–69.
'Media power and class power', in J. Curran *et al.* (eds), *Bending Reality: the State of the Media*, London: Pluto, 5–14.
'No light at the end of the tunnel', *Marxism Today*, December, 12–16.
(with M. Jacques) 'People aid: a new politics sweeps the land', *Marxism Today*, July, 10–14.
'Popular culture and the state', in T. Bennett, C. Mercer and J. Woollacott (eds), *Popular Culture and Social Relations*, Milton Keynes: Open University Press, 22–49.
'On postmodernism and articulation: an interview with Stuart Hall', *Journal of Communication Inquiry* 10(2), 45–60.
'The problem of ideology: marxism without guarantees', *Journal of Communication Inquiry* 10(2), 28–43.

1987

'Blue election, election blues', *Marxism Today*, July, 30–5.
'Gramsci and us', *Marxism Today*, June, 16–21.
'Introduction' to J. Hargreaves, *Sport and Power*, New York: International General.
'Kodowanie i dekoduanie', *Przekazy I Opinie* 1/2 (47/48), 58–72.
'The mirror or the lens?'; 'Prospects', in N. Goldman and S. Hall, *Pictures of Everyday Life: The People, Places and Cultures of the Commonwealth*, London: Comedia, 9–15, 148–51.
'Popular culture as a factor of intercultural understanding', in *Human Rights Teaching* vi, Paris: UNESCO.
'In praise of the peculiar', *Marxism Today*, April (Gramsci Supplement), vi–vii.
'Urban unrest in Britain', in J. Benyon and I. Solomos (eds), *The Roots of Urban Unrest*, Oxford: Pergamon Press, 45–50.

1988

'Brave New World', *Marxism Today*, October, 24–9.

'Death of the welfare state', *New Internationalist* 188.

'Introduction' to *Forty Years On: Memories of Britain's Postwar Caribbean Immigrants*, Lambeth Council.

The hard road to renewal: Thatcherism and the crisis of the Left, London: Verso.

'Kulttuuritaistelu ja vastarinta' (Cultural struggle and resistance), in Katarina Eskola and Erkki Vainikkala (eds), *Maailmankulttuurin äärellä* (On the verge of a world culture; essays by Erik Allardt, Stuart Hall and Immanuel Wallerstein), Publications of the Research Unit for Contemporary Culture, University of Jyväskylä, 11, 68–86.

'Migration from the English-speaking Caribbean to the UK, 1950–80', in R. Appleyard (ed.), *International Migration Today*, 1: *Trends and Prospects*, Paris, UNESCO.

'Minimal selves', in *Identity: The Real Me, ICA Documents* 6, London: Institute of Contemporary Arts, 44–6.

'New ethnicities', in K. Mercer (ed.), *Black Film, British Cinema*, BFI/*ICA Documents* 7, 27–31.

(with M. Jacques) '1968', *Marxism Today*, May, 24–7.

'Only connect: the life of Raymond Williams', *New Statesman* 5, February, 20–1.

'Thatcher's lessons', *Marxism Today*, March, 20–7.

'The Toad in the garden: Thatcherism amongst the theorists', and 'Discussion', in C. Nelson and L. Grossberg (eds), *Marxism and the Interpretation of Culture*, Champaign: University of Illinois Press, 35–57, 58–73.

'The work of art in the electronic age', *Block* 14.

1989

'Authoritarian populism' in B. Jessop, *et al.*, (eds), *Thatcherism*, Cambridge: Polity Press, 99–107.

Ausgewahlte Schriften: Ideologie, Kultur, Medien, Neue Rechte, Rassismus, Hamburg: Argument Verlag (trans. Nora Rathzel).

'Cultural identity and cinematic representation', *Framework* 36, 68–81.

'Ethnicity: identities and difference', *Radical America* 23(4), 9–20.

'The "first" New Left: life and times' and 'Then and now: a re-evaluation of the New Left' (discussion), in Oxford University Socialist Group (ed.), *Out of Apathy: Voices of the New Left Thirty Years On*, London: Verso, 11–38, 143–70.

'Ideology' in *International Encyclopedia of Communications*, New York: Oxford University Press, 307–11.

'Ideology and communication theory', in B. Dervin *et al.* (eds), *Rethinking Communication*, vol. I: *Paradigm Issues*, Newbury Park: Sage, 40–52.

(with M. Jacques) 'Introduction', in S. Hall and M. Jacques (eds), *New Times: The Changing Face of Politics in the 1990s*, London: Lawrence & Wishart, 11–20.

'C.L.R. James: the life of a Caribbean historian', *New Statesman and Society*, 9 June, 21–7.

(with D. Held) 'Left and rights', *Marxism Today*, June, 16–23.

'New Times', *Irish Times*, 30 December.

'O postmodern-igmu i arrikulajciji', *Nose Teme* 33(9), 2301–16.

'Rassismus als ideologischer Diskurs', *Das Argument* 178, 913–21.

'Sons and daughters of the diaspora: Review of Armet Francis' *Children of the Black Triangle*, *Artrage* (Spring), 46–7.

1990

(with F. Jameson) 'Clinging to the wreckage: a conversation', *Marxism Today*, September, 28–31.
'Coming up for air', *Marxism Today*, March, 22–5.
'Cultural identity and diaspora', in Jonathan Rutherford (ed.), *Identity: Community, Culture, Difference*, London: Lawrence & Wishart, 222–37 (the same as 'Cultural identity and cinematic representation', *Framework* 36/1989).
'The emergence of cultural studies and the crisis of the humanities', *October* 53, 11–23.
(with M. Jacques) 'March without vision', *Marxism Today*, December, 26–31.
'Thatchers regime: Linke Identitaten', *Sozialismus* 1, 73–6.
The Voluntary Sector under Attack, Voluntary Action Council Pamphlets, London, 1–22.
'The whites of their eyes' (revised) in M. Alvarado and J.O. Thompson (eds), *The Media Reader*, London: British Film Institute, 7–23.

1991

'Brave New World: the debate about post-Fordism', *Socialist Review* 21(1), San Francisco, 57–64.
'Chopping logic: Jameson's postmodernism or the cultural logic of late capitalism', *Marxism Today: Review of Books*.
'Europe's other self', *Marxism Today*, August, 18–19.
'Gramsci och ir', *Semit* 3, University of Lund, Sweden, 61–9.
'Ideologie und Okonomie–Marxismus ohne Gewähr', *European Journal for Semiotic Studies* 3(1–2), 229–54.
'The local and the global: globalization and ethnicity' and 'Old and new identities, old and new ethnicities', in Anthony D. King (ed.), *Culture, Globalization and the World System*, London: Macmillan, 19–39, 41–68.
Het Minimale Zelf en Andere Opstallen (The Minimal Self and Other Essays), Selected Essays, Amsterdam: Leitgeverji Sua, 1–221
'And Not a Shot Fired', *Marxism Today*, December 1991/January 1992, 10–15.
'Das Okologie-Problem un die Notwendigkeiten linker Politik', *Argument* 189, Berlin, 665–74.
'Reading Gramsci', in Roger Simon (ed.), *Gramsci's Political Thought*, London: Lawrence & Wishart, 7–10.
'Reconstruction work: images of post-war black settlement' in Jo Spence and Patricia Holland (eds), *Family Snaps: The Meaning of Domestic Photography*, London: Virago, 152–64.
'Vasemmiston on kohdattava marginaalit' (The left must cope with the margins), *Ydin* 3, 4–8.
'You Can't Go Home Again' (review of Salman Rushdie's *Imaginary Homelands*), *Sight and Sound*, July.

1992

(with D.A. Bailey), 'Critical decade: an introduction', and 'Vertigo of displacement: shifts within black documentary practices', *Ten–8* 20(3), *Critical Decade: Black British Photography in the 80s*, 4–7, 14–23.
'Crossing boundaries: stitching the self in place', in *Nothing Stands Still*, Crossing Boundaries Seminar, European Network for Cultural and Media Studies, Amsterdam, 4–13.

'Cultural identity and cinematic representation', in Mbye Cham (ed.), *Exiles: Essays on Caribbean Cinema*, London: Africa World Press, 220–36.

'Cultural studies and its theoretical legacies', in L. Grossberg, C. Nelson and P. Treichler (eds), *Cultural Studies*, New York: Routledge, 277–94.

'The election: no new vision, no new votes', *New Statesman and Society*, 17 April.

'Identity and the black photographic image', 'Reconstruction work', *Ten–8* 20 (3 op. cit.), 24–31, 106–13.

Kulttuurin ja politiikan murroksia (Stuart Hall's essays on culture and politics), Tampere: Vastapaino.

'Our mongrel selves', Raymond Williams Memorial Lecture, *Borderlands* supplement, *New Statesman*, 19 June.

'New ethnicities', in J. Donald and A. Rattansi (eds), '*Race', Culture and Difference*, London: Sage, 252–60.

'On postmodernism and articulation: an interview with Stuart Hall', in Kuan-Hsing Chen and Ming-ming Yang (eds), *Cultural Studies: The Implosion of McDonald*, Taipei: Isle Margin (a Chinese translation).

'The question of cultural identity', in S. Hall, D. Held, T. McGrew (eds), *Modernity and Its Future*, Cambridge: Polity Press, 274–316.

'Race, culture and communication: looking backward and forward at cultural studies', *Rethinking Marxism* 5(1), 11–18.

'The rediscovery of "ideology": return of the repressed in media studies' in Kuan-Hsing Chen (ed.), *Culture, Society, and the Media*, Taipei: Yuan-Liu Press (a Chinese translation).

'The West and the rest: discourse and power', in S. Hall and Bram Gieben (eds), *Formations of Modernity*, Cambridge: Polity Press, 275–320.

'What is this "black" in black popular culture?', in Gina Dent (ed.), *Black Popular Culture*, Seattle: Bay Press, 21–33.

1993

'For Allon White: metaphors of transformation', 'Introduction' to Allon White, *Carnival, Hysteria, Writing*, Cambridge: Cambridge University Press.

'Culture, community, nation', *Cultural Studies* 7(3), 349–63.

'Deviancy, politics and the media', reprinted in H. Abelove, *et al.* (eds), *The Lesbian and Gay Studies Reader*, London: Routledge.

'European cinema on the verge of a nervous breakdown', in Duncan Petrie (ed.), *Screening Europe: Image and Identity in European Cinema*, London: British Film Institute, 45–53.

'Minimal selves', reprinted in *Studying Culture*, op. cit., 134–9.

Minimal Selves, Taiwan: Isle Margin, no. 8 (a Chinese translation).

'The new Europe', in Sunil Gupta (ed.), *Disrupted Borders,* London: Rivers Oram Press.

'Reflections upon the encoding/decoding model: an interview with Stuart Hall', in Jon Cruz and Justin Lewis (eds), *Viewing, Reading, Listening: Audiences and Cultural Reception*, Boulder: Westview Press, 253–74.

'The television discourse: encoding and decoding', reprinted in Ann Gray and Jim McGuigan (eds), *Studying Culture*, London: Edward Arnold, 28–34.

'Vanley Burke and the desire for blackness', in Mark Sealy (ed.), *Vanley Burke: A Retrospective*, London: Lawrence & Wishart, 12–15.

'What is this "black" in black popular culture?', reprinted in special issue 'Rethinking Race', *Social Justice* 20(1–2), 101–14.

'Which public, whose service?', in W. Stevenson (ed.), *All Our Futures: The*

Changing Role and Purpose of the BBC, BBC Charter Review Series, London: British Film Institute.
'The Williams interviews', in M. Alvarado, *et al.* (eds), *The Screen Education Reader*, London: Macmillan.

1994
'Cultural identity and diaspora', in P. Williams and L. Chrisman (eds), *Colonial Discourse and Post-Colonial Theory: A Reader*, London: Harvester Wheatsheaf, 392–401.
'Cultural studies: two paradigms', in R. Davis and R. Schleafer (eds), *Contemporary Literary Criticism: Literary and Cultural Studies*, New York and London: Longman, 609–25.
'Cultural studies: two paradigms', in N. Dirks, E. Eley and S. Ortner (eds), *Culture, Power, Harmony: A Reader in Contemporary Social Theory*, Princeton: Princeton University Press, 520–38.
'Encoding/decoding', in D. Graddel and O. Boyd Barrett (eds), *Media Texts: Authors and Readers*, Milton Keynes: Open University Press and Multi-Lingual Matters.
'Myths of Caribbean identity', text of the Walter Rodney Memorial Lecture, Centre for Caribbean Studies, Warwick University.
'Some incorrect paths through political correctness, in S. Dunant (ed.), *The War of Words*, London: Virago.
'Whose English?', in C. Bazalgette (ed.), *Balancing Literature, Language and Media in the National Curriculum: Report of Commission of Inquiry into English*, London: British Film Institute.

Editors' note
We have updated the 1986 JCI version of Stuart Hall's writings, partly incorporating the bibliography compiled by Juha Koivisto for the Finnish collection of Stuart Hall's essays, *Kulttuurin ja politiikan murroksia* (Vastapaino 1992). Not all of the translations of Hall's work into other languages are included here. We thank Larry Grossberg for his help with the 1986 compilation, Sut Jhally for supplying additional information, and Stuart Hall for making available his own records.

David Morley and Kuan-Hsing Chen.

Index